D1161258

THE NEW DEAL FINE ARTS PROJECTS
A Bibliography, 1933–1992

by
Martin R. Kalfatovic

The Scarecrow Press, Inc.
Metuchen, N.J., & London
1994

British Library Cataloguing-in-Publication data available

Library of Congress Cataloging-in-Publication Data

Kalfatovic, Martin R., 1961–
 The New Deal fine arts projects : a bibliography, 1933–
1992 / by Martin R. Kalfatovic.
 p. cm.
 Includes indexes.
 ISBN 0-8108-2749-2 (acid-free paper)
 1. Federal aid to art—United States—Bibliography.
2. Art—Conservation and restoration—United States—
Bibliography. 3. New Deal, 1933–1939. I. Title.
Z5961.U5K36 1994
[N8837]
016.3530085′4—dc 20 93-31116

TABLE OF CONTENTS

Acknowledgments vii
A New Deal Fine Arts Project Chronology ix
List of Abbreviations and Acronyms xix
Introduction: A Silver Lining to the Great Depression xxi

Annotated Bibliography
 1933–1934 1
 1935 28
 1936 48
 1937 78
 1938 115
 1939 158
 1940 190
 1941–1943 213
 1944–1969 241
 1970–1974 272
 1975–1979 290
 1980–1985 309
 1986–1992 336

APPENDIX A: Who's Who in the New Deal Fine Arts
 Projects 367
APPENDIX B: Exhibitions of New Deal Art, 1934–1990 374
APPENDIX C: Section Competitions, October 16, 1934,
 to July 1943 417
APPENDIX D: WPA/FAP Community Art Centers 441
APPENDIX E: PWAP Regions and Regional Directors 446
APPENDIX F: Legislation for a Permanent Art Project 448

Author Index 451
Subject Index 467
About the Author 505

ACKNOWLEDGMENTS

Thanks to the staff of the Archives of American Art, past, present, and future, without whom research on the New Deal art projects would be a much more difficult task.

Thanks also to the staff of the Library of Congress.

A very special thanks to the inter-library loan librarians of Arlington Public Library, particularly Sally Dewey; and at The Catholic University of America, Ann Hiller, for finding all those obscure master's theses and endless rolls of micro-film.

And thanks to my wife, Mary, for putting up with having every museum visit turned into a game of "who's who in the New Deal."

A NEW DEAL FINE ARTS PROJECT CHRONOLOGY

1929

October 1929
Stock market plunge heralds beginning of the Great Depression

1932

November 1932
FDR elected President

1933

March 20, 1933
FDR inaugurated

May 9, 1933
The artist George Biddle writes to FDR urging the implementation of a Federal program to support the artists of America

May 12, 1933
Federal Emergency Relief Act of 1933 approved; creates the Federal Emergency Relief Administration with Harry L. Hopkins as administrator

June 1933
Procurement Division created within the Treasury Department

November 9, 1933
President Roosevelt, by executive order, creates the Civil Works Administration under which the PWAP was initiated

December 8, 1933
PWAP initiated

1934

February 1934
Artists' Union formed to protect and forward the rights of the artist

April 24–May 20, 1934
"National Exhibition of Art by the Public Works of Art Project" opens at the Corcoran Gallery of Art in Washington, DC

May 20, 1934
PWAP terminated; projects already begun continue under various funding schemes until July 1935

October 16, 1934
Section of Painting and Sculpture created by order of Henry Morgenthau

November 1934
First issue of *Art Front*

1935

May 6, 1935
Executive Order 7034 creates the Works Progress Administration

July 25, 1935
TRAP established with WPA funds

August 2, 1935
Federal Project Number One announced; Holger Cahill named national director of the FAP

August 29, 1935
First Federal monies allocated to Federal One

November 26, 1935
Administrative Order No. 35 issued by Hopkins; the order exempts up to 25% of Federal One employees from meeting relief requirements (the rest of the WPA is limited to 10% non-relief employees)

December 27, 1935
Federal Art Project Gallery opened in New York City

1936

June 30, 1936
Employment on Federal One peaks at 44,797

July 1936
Jacob Baker, assistant head of the WPA and active promoter of Federal One, resigns; Ellen S. Woodward replaces Baker

August 1936
Colonel Brehon B. Somervell named head of WPA in New York City

September 14–October 12, 1936
"New Horizons in American Art" opens at the Museum of Modern Art

December 1, 1936
Protesting changes in the FAP, artists riot in New York City; 219 arrested

1937

January 1, 1937
Sirovich bill, H.J. Res. 79, introduced

August 16, 1937
Coffee bill, H.R. 8239, introduced

November 1937
Harlem Community Art Center opens

1938

January 21, 1938
Revised Coffee bill, H.R. 9102, introduced, Pepper bill, S. 3296, introduced; in Senate

June 15, 1938
Sirovich bill (H.R. 671) tabled by a vote of 195 to 35, effectively killing it

June 27, 1938
Administrative Order No. 62 cuts monthly wages on Federal One (average wage in New York City goes from $103.40 to $96.00)

July 1, 1938
TRAP discontinued

October 1938
Section of Painting and Sculpture renamed Section of Fine Arts

December 1938
Hopkins resigns as head of WPA to become Secretary of Commerce

Ellen S. Woodward resigns as head of Women's and Professionals' Projects

December 24, 1938
Francis C. Harrington named as head of WPA

1939

January 3, 1939
Florence Kerr named head of Women's and Professionals' Projects

April 4 through October 15, 1939
"Frontiers of American Art," opens at the M.H. de Young Museum in San Francisco

July 1, 1939
FDR's Reorganization Plan takes effect transferring the Works Progress Administration to the newly created Federal Works Agency and renaming it the Work Projects Administration

Under the same Reorganization Plan, the Section is transferred from the Treasury Department to the Federal Works Agency

July 31, 1939
General Letter No. 278 demands that all WPA Federal One projects have non-WPA sponsorship and changes their name to the WPA Arts Projects

September 1939
World War II begins in Europe; in the United States, governmental activity begins to shift from relief to defense

November 2–21, 1939
Section art show: "Exhibition: Painting and Sculpture Designed for Federal Buildings" at the Corcoran Gallery of Art, Washington, DC

September 1939
New York World's Fair, a major showcase of WPA/FAP and Section work, opens

December 17, 1939
Death of Congressman William I. Sirovich, staunch sup-
porter of the New Deal art projects and sponsor of fine arts
legislation

1940–1945

February 10, 1940
Operating Procedure No. G-5 puts the WPA/FAP under
the Division of Community Service

September 30, 1940
Francis C. Harrington dies; replaced as head of WPA by
Howard O. Hunter

November 25–December 1, 1940
"National Art Week" sponsored by the Section and WPA/
FAP

December 7, 1941
Attack on Pearl Harbor draws the United States into World
War II

February 10, 1942
Division of Community Service (under which the WPA/
FAP was operating) becomes the Service Division

April 18, 1942
Service Letter No. 3 discontinues nearly all WPA/FAP
activities

January 27, 1943
Death of Edward Bruce

June 30, 1943
All arts projects of the WPA officially come to an end with
the termination of the WPA

July 1943
Section ceases to operate

February 1944
Hundreds of WPA/FAP canvases sold by the pound to a New Jersey junk dealer as surplus material

June 1944
Tax Payer's Murals, first dissertation on New Deal art projects after their completion, written by Erica B. Rubenstein at Harvard University

April 12, 1945
Death of FDR

1946–1960

January 29, 1946
Death of Harry L. Hopkins, former WPA administrator

1950
Publication of Erwin O. Christensen's *The Index of American Design*

May 31, 1960
Death of Forbes Watson

July 8, 1960
Death of Holger Cahill

1961–1970

September 16–October 7, 1961
"Art of the Thirties" at Smolin Gallery, New York; first exhibition of New Deal art since the end of the projects.

1962
Archives of American Art acquires the papers of Edward Bruce, laying the groundwork for its massive documentation of the New Deal art projects

1963

Archives of American Art begins major collection project of material related to the New Deal art projects

July 9, 1963

"The U.S. Government Art Project: Some Distinguished Alumni" opens at the Washington Gallery of Modern Art; first major exhibition of New Deal art

April 6–May 13, 1966

"Federal Patronage: 1933–1943" exhibition of New Deal art at the University of Maryland organized by Dr. Francis V. O'Connor begins a major reevaluation of the New Deal art projects

1969

Francis V. O'Connor publishes *Federal Support for the Visual Arts*

1969 to 1985

Major phase of New Deal art project scholarship, that of documenting the projects and locating works of art, documents, and artists involved on the various projects; exhibitions and monographs reintroduce the public to this "art for the people"

1973–1990

1973

Francis V. O'Connor publishes *Art for the Millions,* a collection of essays planned by Holger Cahill for publication in 1936

1979

Karal Ann Marling's "New Deal Iconography" in *Prospects* among the first to initiate second phase of New Deal art project scholarship, that of interpreting, aesthetically, socially, and semiotically, the meaning of the art works

produced; Marling expands this in *Wall to Wall America* (1982)

1980
First publication (on microfiche) of the complete collection of Index of American Design

1982–1983
In honor of the 50th anniversary of the Roosevelt Administration, many museums and galleries hold New Deal art project exhibitions

1989–1990
The National Endowment for the Arts faces cutbacks and has its existence threatened for many of the same reasons the New Deal art projects were gutted 50 years earlier in 1939

LIST OF ABBREVIATIONS AND ACRONYMS

AAA	Archives of American Art (Smithsonian Institution)
AAPL	American Artists' Professional League
AIA	American Institute of Architects
B/W	Black and white illustration
CWA	Civil Works Administration
DAI	Dissertations Abstracts International
FAP	Federal Art Project
FERA	Federal Emergency Relief Administration
FMP	Federal Music Project
FTP	Federal Theatre Project
FVO	See Entry # 1335
FWA	Federal Works Agency
FWP	Federal Writers' Project
GPO	General Printing Office
GSA	General Services Administration
HARPURS	Harpur's Index to Master's Theses in Art
HMSG	Hirshhorn Museum and Sculpture Garden (Smithsonian Institution)
IAD	Index of American Design
MAI	Masters Abstracts International
MCDONALD	See Entry # 1334
MET CAT	Library catalog of the Metropolitan Museum of Art
MOMA	Museum of Modern Art
NCFA	National Collection of Fine Arts (Smithsonian Institution); Later NMAA
NMAA	National Museum of American Art
OCLC	Online Computer Library Catalog
PWA	Public Works Administration
PWAP	Public Works of Art Project

Section	Treasury Department Section of Painting and Sculpture (later, Section of Fine Arts)
TDAP	Treasury Department Art Projects (covering both the Section and TRAP)
TERA	Temporary Emergency Relief Administration
TRAP	Treasury Relief Art Project
VF	Vertical File
WILCOX	See Entry # 0134
WPA	Works Progress Administration (after 1939, Work Projects Administration)
WPA/FAP	General term covering all art projects of the WPA, 1935–1943

INTRODUCTION:
A SILVER LINING TO THE GREAT
DEPRESSION

Prelude

When in October 1929 the New York Stock Exchange plunged dramatically and heralded the start of the Great Depression, artists soon felt the impact of this financial calamity. Former patrons quickly turned their fiscal attention to their own increasingly desperate situation. Even more than before, art was seen as a luxury America could not afford.

As the economic crisis worsened, President Hoover's attempts to assuage the damage to the nation's economy met with little success. By the time the 1932 election rolled around, Hoover stood little chance of re-election.

When FDR was inaugurated on March 4, 1933, American artists had no promise of assistance. Their plight was so precarious that Audrey McMahon (director of the College Art Association and editor of its journal *Parnassus*) felt compelled to ask "May the Artist Live?"[1] McMahon answered her own question with a qualified yes. Drawing from the examples of community and state relief projects for artists in New York, McMahon asked for more of the same. Additionally, she called for a concerted national effort to aid the American artist, both for his/her own good and the good of America:

> In all industries we are making use of our national resources, to aid our own people. Let us make use of the talents of our own artists. Let us aid ourselves and our children to a better and clearer understanding, and thus improve the condition of the community, keep

> unemployed boys and girls constructively occupied,
> beautify our public buildings, put teachers into our
> neighborhood houses and schools. Let us banish apathy
> and misunderstanding and open our minds to an ap-
> preciation of the beautiful. Let us so condition our-
> selves that it may be said of us by posterity that this was
> an era of cultural development. And let us help the
> American artist to live.[2]

In just a few months, and after prodding and prompting
from a number of quarters, FDR's New Deal made its first
effort to include the American artist.

Uncle Sam: Patron of the Arts

The New Deal created not one, but four art projects: three
distinct and one related. The Public Works of Art Project
(PWAP), the WPA's Federal Art Project (WPA/FAP), and the
Section of Painting and Sculpture (the Section) were sepa-
rate entities with little or no overlapping of functions. The
Treasury Relief Art Project (TRAP), though administered by
the Section, was funded with WPA monies and generally
employed Federal Art Project or Section artists.

The distinctions were not always clear to the public even at
the time. In our own era they have become even more
blurred as the passing years have stirred the New Deal's
alphabet soup into an incomprehensible goulash of initials
and acronyms. A later statement by McMahon claimed that
the projects were "one and the same thing."[3] However, this
was not so; each of the New Deal art projects was a distinct
entity with its own rules, regulations, and goals.

Biddle, Bruce, and the PWAP

CREATION OF THE PWAP

> The younger artists of America are conscious as they
> have never been of the social revolution that our coun-
> try and civilization are going through; and they would

be eager to express these ideals in a permanent art form
if they were given the government's co-operation.[4]

George Biddle was already an established artist when he
wrote the above to the newly elected FDR in 1933. Biddle was
a graduate of both Harvard and Groton, as was FDR. Though
it has been debated whether this nudge from a schoolboy
acquaintance sparked FDR's interest in providing some sort
of Federal assistance to the American artist, FDR's quick
response ("It is very delightful to hear from you and I am
interested in your suggestion")[5] as well as the enthusiasm
both he and Eleanor Roosevelt expressed for the art projects
indicate that Biddle's suggestion fell on fertile ground.

Whether it was Biddle's prompting or that and a combina-
tion of other factors, on November 29, 1933, Assistant
Secretary of the Treasury Lawrence W. Robert, Jr., invited
Frederic A. Delano, Charles Moore, Rexford Tugwell, Harry
L. Hopkins, Henry T. Hunt, and Edward Bruce to serve on a
committee known as the Advisory Committee to the Treasury
on Fine Arts. First meeting on December 8 at Edward Bruce's
Washington home with all the members of the committee as
well as Eleanor Roosevelt and an impressive list of the
directors of America's foremost museums present, the Com-
mittee soon drew up a working plan for an effort to assist
America's artists.

By five o'clock that afternoon, the foundations of the
Public Works of Art Project (PWAP) as well as its basic
operating procedure were settled upon. Being a governmen-
tal agency and bound by the red tape such an association
entails, among the first acts of the PWAP were the hiring of
clerks, accountants, and disbursers. All was not bureaucracy,
however, and within four days of the founding of the PWAP
(on December 12, 1933), the first of the allocated 2,500 artist
slots were being filled.

EDWARD BRUCE AND THE ORGANIZATION OF THE PWAP

If George Biddle was an instigator of the plan of the PWAP,
Edward Bruce brought about its reality. Bruce, a lawyer and
business executive, had abandoned his private practice for a

career in public service. A respected artist by 1933, Bruce was able to bring the varying sensibilities of the artist, the lawyer, the businessman, and the politician together for the advancement of the PWAP and later the Section.[6]

The PWAP divided the country into 16 regions, each one of which was supervised by a Regional Committee, usually chaired by a prominent figure in the art world (see Appendix E for a list of the regions and the chairmen).

From December 11, 1933, through June 30, 1934, the PWAP employed a total of 3,749 different artists. The total cost of the PWAP was $1,312,177.93 of which $1,184,748.32 (90.29%) went to artists' salaries.

In April and May of 1934, a huge display of PWAP work was exhibited at the Corcoran Gallery of Art in Washington. The exhibition consisted of 511 items (out of 15,663 completed) including eight large murals, seven galleries of oil paintings, two more of watercolors and prints, a number of sculptures, a selection of Indian arts (rugs, paintings, pottery), and a sampling of modern crafts.

The exhibition was an almost unanimous critical success. Mary Morsell commented in *Art News* that "the work of many of the P.W.A.P. artists seems to show a certain psychological relief and gratitude for this opportunity to paint without the subconscious necessity of following and anticipating the latest trends in modern style."[7] Large crowds filled the galleries at the Corcoran and Edward Bruce's PWAP appeared to be one of the early successes of the New Deal.

CONTROVERSY

The PWAP was not without controversy. Much of the trouble centered around the hiring practices of the PWAP offices in New York City. Juliana Force, director of the Whitney Museum of American Art, was first attacked by more conservative artist organizations (such as the Society of Mural Painters and the American Artists Professional League) for promoting "modern" art at their expense; more radical elements accused her of ignoring radical and militant artists. By early January 1934, a series of misunderstandings and confrontations between Force and the radical artists led to skirmishes with the police and

eventually forced Force to move the PWAP's New York office from the Whitney Museum.

Though stylistic controversies did occur within the PWAP, it was thematic content and the politics of the artists themselves that were most controversial. They would continue to dog all government sponsorship of the arts down to the present.

The Coit Memorial Tower in San Francisco was completed in 1933 and in the early months of 1934, the PWAP was commissioned to decorate the interior with murals. When journalists inspected the murals before the opening, it was noticed that many of the panels contained such "un-American" images as portrayals of radical union leaders, Communist literature in library and newsstand scenes, and a red star.

After much heated debate and a flurry of memos between Washington and San Francisco, the Tower eventually opened to the public a few months late with only the red star removed.

END OF THE PWAP

Funding for the PWAP was limited. Though there were a number of protests by artists and others to continue the PWAP, on June 30, 1934, the project came to an end. Lawrence W. Roberts, Jr., Assistant Secretary of the Treasury in his final *Report* on the PWAP concludes his comments thus:

> It [the PWAP] has enriched the country to an extent that cannot be estimated, and taught us definitely that some organization like the Public Works of Art project will always deserve the support of an enlightened government.[8]

The Section of Fine Arts

CREATION

Perhaps to prove itself an enlightened government, the Roosevelt Administration soon found a governmental body

capable, if not always willing, to inherit the brief legacy of the
PWAP. Through one of those odd quirks of administrative
bureaucracy, the United States Treasury Department
(through its Procurement Division and that divisions'
predecessors) had been responsible for all Federal architec-
ture since the eighteenth century. This set-up made the
Treasury Department responsible for the construction of all
Federal buildings, including local post offices throughout
the country.

With the memory of the success of the PWAP and contin-
ued calls for further governmental sponsorship of the arts,
the Secretary of the Treasury Henry Morganthau Jr. (on
October 16, 1934) established the Section of Painting and
Sculpture.*

FUNDING AND ADMINISTRATION

The Section, as it came to be known, was administratively
placed in the Procurement Division Public Works Branch
(after July 1, 1936, the Public Buildings Branch) of the
Treasury Department. The Procurement Division had been
created in 1933 in an attempt to simplify government con-
tracting by bringing the architecture, engineering, and sup-
ply aspects of the Federal government under the control of a
single Director of Procurement. That the decoration of
Federal buildings would be another key element, just like the
design or engineering of the buildings, was the logic of
placing the Section within the Procurement Division.[9]

The Section's administration was full of familiar faces from
the days of the PWAP: Edward Bruce was the new director of
the Section; Edward Rowan was named assistant director;
and Forbes Watson was appointed as advisor.

The primary function of the Section was to

> be directed toward the selection of art objects of high
> quality for the decoration of public buildings in those
> cases where funds for this purpose are available. The
> cooperation of people throughout the country inter-

*In October of 1938, the Section of Painting and Sculpture was renamed the Section
of Fine Arts.

ested in art will be sought, and the artists of the
communities selected will be encouraged to submit
their works for acceptance. . . . The quality of the work
will be the test in all cases.[10]

Relief, it should be noted, was never among the stated goals
of the Section. Unlike any of the other New Deal art projects,
the Section was concerned only with an artist's ability and not
his financial status.

It was Edward Bruce's initial goal to have the Section
supported through money that had already been appropri-
ated. Existing rules set aside up to 1% of the cost of Federal
buildings for decoration. The Section was to use this money
to commission artists to adorn Federal buildings with murals,
sculpture, and other "art objects." As it turned out, the 1%
figure was more often a hope than a reality for most Federal
construction. Bruce spent much of his time fighting with
architects, planners and Treasury officials for his funds.[11]

COMPETITIONS AND COMMISSIONS

To parcel out the commissions for the work that would be
generated by this funding, the Section began a series of
competitions that would be its hallmark and distinguish it in
concept from the WPA/FAP.

Not all Section work—and in fact only a small percen-
tage*—was actually commissioned by competition. A great
deal of Section work was actually completed by artists who
were chosen directly by the official staff of the Section or by
commissions appointed by Section officials.

The competitions, which were announced in the Section's
irregularly issued *Bulletin,*** were not usually open to the
general artistic public. Most of the competitions were re-
stricted in some way. Many of the competitions were by
invitation only; others were open only to artists who lived in a
particular state or region.[12]

The competitions did give the Section a great deal of

*The Section held just over 200 competitions, but awarded in excess of 1,300
commissions.
**Twenty-four issues of greatly varying length were issued on a very irregular
schedule between 1934 and 1941.

The competitions did give the Section a great deal of publicity. Announcements of the competitions and the winners were often reprinted in the art press and even occasionally in the general press.

Though the Section did sponsor a single competition for water colors, a number of sculptural competitions, and a few miscellaneous competitions, the vast majority of the competitions were for murals that were to be installed in public buildings. Post offices and courthouses in small, medium, and large cities and towns across the country were filled with Section murals, in most cases to the great delight of the townspeople.

Littleton, Colorado; Salina, Illinois; Fort Scott, Kansas; Deer Lodge, Montana; Hot Springs, New Mexico; and Boone, North Carolina, are just a few of the communities that received Section murals.

In the fall of 1939, the Section held its most ambitious competition when it announced the "48 State Competition." The goal of the Section in this competition was to place a Section mural in every state of the union. The competition was a huge success on nearly every level, garnering the Section a large spread in *Life* magazine with illustrations of every winning mural.[13]

The Section would also become responsible for decorating the huge expanses of new Federal buildings that were being created in the Federal Triangle of Washington, DC. The Federal Triangle, bounded by Pennsylvania Avenue on the north, Constitution Avenue on the south, and 15th Street on the west, was planned in the 1920s and 1930s as a great enclave of Federal buildings. Located here were the Department of Justice, the Internal Revenue Service, the Department of Commerce, the Federal Trade Commission, and the Post Office Department (since relocated), most of which were decorated with Section-commissioned art.

The Section also ran a competition for other agencies. The US Maritime Commission and the New York World's Fair were beneficiaries of this program. A competition conducted by the Section for the Treasury Department in the spring of 1938 resulted in a bit of art that has touched nearly every American since that time. The competition, which

closed on April 15, 1938, was for a new five-cent piece to replace the buffalo nickel. The winner of the competition was Felix Schlag, who created the Jefferson nickel, which has been in circulation ever since.

"DEMOCRATIC" ART

The work championed by the Section aspired to be both "democratic" as well as of the highest quality. Artists who could create the high quality art demanded by the Section were sometimes not interested in putting in the time and effort required to plan for a Section commission when there was the possibility the design would be turned down or changed. At other times, the "democratic" art created by Section artists was criticized by the art establishment, or even the Section itself, for being too radical or even un-American.[14]

Often at odds with the WPA's own Federal Art Project, great changes awaited both art projects when 1939 came around.

The Treasury Relief Art Project (TRAP)

The Treasury Relief Art Project (TRAP) mingled the commitment to the highest artistic standards as advocated by the Section and the relief element that distinguished the WPA's Federal Art Project.

Begun on July 25, 1935, with $530,784 in WPA funds allocated to the Treasury Department, the TRAP was envisioned by Edward Bruce as a vehicle to put the best and neediest artists to work decorating Federal buildings.

Though the TRAP was strictly a relief project, with the artists having to meet the various income and employment standards set by the WPA, Bruce made certain that the program was kept small enough so that only the highest quality artists would be employed. The TRAP always employed only a small number of artists and at its height had only 356 workers.[15]

Headed by the artist Olin Dows, who was assisted by Henry
LaFarge, Cecil Jones, and Alice Sharkey, the entire project
was overseen directly by Bruce. The TRAP produced work, as
did the Section, primarily for Federal buildings; owing to its
unique position, however, it also undertook a number of
special projects. Amongst the most important of these special
projects was creating murals and sculpture for housing
projects constructed under the Public Works Administration
in New York, Boston, Chicago, Washington, Camden, and
Cleveland.[16]

Though generally a successful program, the financial
situation in 1938 was not conducive to the continuance of the
TRAP and it came to a close on June 30, 1938, after allocating
a total of $771,521.[17]

The Works Progress Administration's Federal Art Project

BEGINNINGS

On May 6, 1935, Executive Order 7034 issued by FDR
created the Works Progress Administration. With the exam-
ple of the PWAP as a semi-relief project for artists, Harry L.
Hopkins of the WPA announced on August 2, 1935, the
creation of the WPA's Federal Project Number One. Federal
One, as it came to be known, provided for the direct relief
employment of creative people in four categories: theatre
arts (the Federal Theatre Project), literature (the Federal
Writers' Project), music (the Federal Music Project), and the
visual arts (the Federal Art Project).

The purposes and functions of the Federal Art Project
(WPA/FAP) was clearly stated a number of times:

> The primary objectives of [the Federal Art Project is] to
> conserve the talent and skill of artists who, through no
> fault of their own, found themselves on the relief rolls
> and without means to continue their work; to encour-
> age young artists of definite ability; to integrate the fine
> with the practical arts and, more especially, the arts in
> general with the daily life of the community.[18]

The Works Progress Administration itself was created with the idea of providing work relief to the American population unable to find employment in their professions. It was only logical that artists too should find a home in the WPA. Once the idea of work relief for the American artist had been broached at the WPA, artists found the first of their many friends in the person of Jacob Baker, the WPA's assistant administrator.

Jacob Baker almost at once began drafting a plan for the relief of artists funded through the WPA, and on September 30, 1935, the basic outline of the plan—which eventually became Federal One—was issued in *Supplement #1 to the Bulletin #29*, a publication of the WPA.

Federal One was placed under Baker's control, and on August 2, 1935, the four national directors of the four projects were announced: Hallie Flanagan for the Federal Theatre Project; Nikolai Sokoloff for the Federal Music Project; Henry Alsberg for the Federal Writers' Project; and Holger Cahill for the Federal Art Project.[19]

HOLGER CAHILL

Born Sveinn Kirstján Bjarnarson in Snaefellsnessysla, Iceland, on January 13, 1887, Holger Cahill moved with his family at an early age first to Canada and later to South Dakota.

He lived in poverty for most of his childhood, and when he was eleven, his father deserted the family. With his mother ill, Cahill was sent to live with another Icelandic family fifty miles away. Treated badly, he ran away to Canada at age thirteen and worked at a wide variety of jobs until his late teens. Cahill—still Bjarnarson—eventually decided on a writing career and rode a freight train to New York City where he took night courses in journalism at New York University.

Changing his name, he worked for a number of suburban New York papers and took more courses at Columbia University, and became influenced by the work of the philosopher John Dewey. Building up a series of friendships with his Greenwich Village artist-neighbors, Cahill began to write about modern art. In 1922, at age thirty-five, he joined the

Newark Museum working under John Cotton Dana on the museum's modern art and folk art collections.

In 1932, he became exhibitions director at the Museum of Modern Art and was soon a well-known authority on American art. In addition to organizing a number of important exhibitions at the Newark Museum and the Museum of Modern Art, Cahill was writing novels and short stories (*Profane Earth,* his first novel, appeared in 1927; numerous short stories had appeared in *Scribner's Magazine, The American Mercury,* and others). In 1935, he had just begun to devote his energies full time to writing fiction when he was called upon to direct the WPA/FAP.[20]

ADMINISTERING THE ARTS

For the first year of its existence, the projects of Federal One led a charmed life. As "Federal" projects, they were directed from the Washington headquarters of their national directors, answering in effect only to Harry Hopkins and FDR. "Federal" projects differed from other WPA projects, which had to have a base of local support and would be subject to much more local control.

In November 1935 Federal One projects were made exempt from the general WPA rule that 90% of all employees be eligible for relief. Instead, the Federal One projects were required to have only 75% of their employees as relief eligible. In other WPA projects, exemptions were used to hire administrators and other specialized help. Federal One, however, often used its exemptions to hire better artists or to keep good artists once they no longer qualified for relief. Though the exemptions were eventually retracted, the granting of such exemptions was one of a number of special considerations received by Federal One.

Among these special considerations, Federal One was also exempt from the usual WPA regulations concerning pay caps, working hours, and scheduling, all in the name of their nature as "professional" projects.[21]

During this first year, the administrators of Federal One, on all levels, were able to operate fairly independently from the other WPA administrators, from the Washington offices to the local offices. Due to a number of complaints from the

state WPA administrators, however, this was changed in July 1936, when Jacob Baker resigned from the WPA and Federal One was placed in the newly created Division of Women's and Professionals' Project under the supervision of Ellen S. Woodward. This reorganization made the Federal One Projects more acceptable to the state administrators of the WPA and made for smoother operations on all levels.[22]

FUNDING

The WPA—and thus the Federal One projects—was never funded by statute, but by annual appropriations acts (Emergency Relief Appropriations Act of 1935, 1936, etc.); for this reason it was essentially held hostage to the whims of the president and Congress and was in constant threat of termination.[23]

A peculiarity of the structure of Federal One was that since the projects were sponsored directly by the WPA their budgets—unlike other WPA projects that were sponsored by state, local, or other federal agencies—were submitted, through Harry Hopkins and Ellen Woodward, directly to the President for examination and approval.[24]

Though the exact funding procedures for Federal One varied, it was not until 1939 that any major changes occurred. The projects were officially reorganized in that year and were required to have local sponsorship.

PURPOSES AND FUNCTIONS

The WPA/FAP rated employees (in accordance with WPA guidelines) as "Professional and Technical" (including artists, teachers of art, photographers, lecturers, and research workers); "Skilled" (same as the above, but at a lesser level of quality); "Intermediate" (the above, but in need of a great deal of guidance and supervision); and "Unskilled" (all others needed by the WPA/FAP, but generally not artists, e.g., messengers, gallery attendants, and handymen).[25]

Throughout the life of WPA/FAP, most workers—well over 65%—were "skilled" and the WPA/FAP had the highest level of "Skilled" of Federal One.[26]

Of course, the methods of classifying artists was never satisfactory and often the subject of controversy. In the end,

the classification of artists was defined by the *Federal Art Project Manual* to be

> based upon information furnished by the artists and on the quality of work submitted. Major consideration should be given to professional background, experience, quality of work performed, and present ability to perform work.[27]

Those in the administration, and even FDR himself, seemed to view Federal One primarily as a social service experiment in bringing art to the people. The national directors and the artists themselves, however, viewed Federal One as a way to create art. This led to a number of problems in the arts projects. If art was funded only in those areas where the best (and, this being a relief project, neediest) artists were found, the projects would be concentrated in the major cities of the east and west coasts and Chicago.

On the other hand, if the money was equally allocated across the country, the number of artists able to create works of a high quality would be severely limited.

One possible solution would have been to distribute the needy artists from the major cities to those areas that were in need of professionally trained and skilled artists. This plan would have accomplished two goals; the first, to have some of the nation's best artists flung into a new environment that could stimulate their talents; and second, through contact with these mostly proven artists, men and women throughout the country would be stimulated into engendering an even better "American" art.

Two equally insurmountable problems faced this solution. The first is that by the rules of the WPA, workers could not, with few exceptions, be moved from one region of the country to another. The second problem, perhaps more difficult to solve than the first, was that most of the artists had no desire to leave the urban milieu that most of them had consciously sought.[28]

This does not mean that good artists did not exist in the hinterlands or that the WPA/FAP did not try to find them. During the life of the WPA/FAP, every state had the opportu-

nity to receive funds for art projects and WPA/FAP activities of some kind took place in each of the forty-eight states.[29]

ACCOMPLISHMENTS

> The public's new awareness of art, its place in everyday life, is reflected in the work produced by the painters, sculptors, muralists, and graphic artists of the WPA Federal Art Project who have brought into salience the multifarious aspects of the American scene. A richer significance has been given to the lives of those who have come closer to art through the works produced and presented by the WPA Federal Art Project and to those who have experienced the stimulation of creating it themselves For the first time, government patronage in art has been initiated without the binding red tape which makes some "official art" a useless, ineffective expression. Government patronage of the WPA Federal Art Project enables the artists of the country to continue the practice of their art and the development of their skill.[30]

To fulfill the promises made in the above statement, the WPA/FAP divided its activities into a number of clearly defined areas. A brief overview of the major activities and accomplishments of these areas follows.

EASEL DIVISION

Largest single employer of artists, the easel division of the WPA/FAP was responsible for the creation of oil paintings, watercolors, and gouaches.[31]

The control of easel painters was one of the stickiest problems to face WPA/FAP administrators. How could anyone expect true artists to punch a clock and turn in paintings on demand? And where were the artists to work? Should they work at home in their own studios? Or should they work in some kind of central facility?

One answer was given in an early publication of the WPA/FAP:

> It should not be necessary for artist to leave their work to make formal appearance before timekeepers. This

kind of interruption seriously interferes with creative work and is entirely unreliable as a check on the time the artist has actually worked.[32]

None of these questions were easily answered, and the above answer, so certain, would be changed over and over again in the coming years.

Still, in the eight years of the WPA/FAP, artists working in the easel division were able to create 108,099 oils and watercolors, a remarkable achievement.[33]

Completed easel works were disposed of in a process called allocation. In allocating works, the WPA/FAP placed the works created for it on permanent loan to publicly supported institutions such as libraries, schools, and museums. Many of these works are still located in the institutions they were allocated to. Sadly, some institutions, considering the work to be "only WPA," discarded the works or allowed them to deteriorate.

SCULPTURE

Like artists in the easel division, sculptors on the WPA/FAP were expected to complete works either in their own studios or in studios run by the WPA/FAP. Over the course of its history, the WPA/FAP employed about 500 sculptors.[34]

Total sculptural work completed for the WPA/FAP amounted to a total of 17,744 items.[35] These sculpture went into public buildings, public parks, zoos, botanical gardens, and public fountains.[36]

Sculpture is a much more expensive medium than easel work and this is one reason for the smaller number of artists employed and works produced. Additionally, newer, less expensive materials were often used. Though such traditional materials as marble and cast bronze were used in some WPA/FAP works, there was also widespread usage of cast concrete and wood carving.

MURALS

The most picturesque and dramatic of all the projects are, of course, those devoted to murals, since they are

most widely seen by the general public and most widely
commented upon.[37]

Murals, created by the WPA/FAP for federal and quasi-
public buildings, were spread throughout the nation.
Though the number of murals eventually created was small
in comparison to either the easel works or sculpture—2,566
murals were completed by the end of the project[38]—their
impact on the public's perception of the WPA/FAP, and
indeed of all the New Deal art projects, was enormous.
WPA/FAP murals were generally quite popular with their
intended public, though, as with the Section, there were
disputes over subject matter and artistic technique. Still,
throughout

> the life of the project requests consistently outran the
> project's ability to fulfill them, and at the close of the
> Federal Art Project a backlog of orders had been
> accumulated that would have occupied its workers for a
> considerable time.[39]

Though accounting for only a small fragment of the entire
artistic output of the WPA/FAP, the mural division will
forever be remembered in the public mind as the primary
achievement of the entire project.

GRAPHIC ARTS

The contributions to graphic arts by the WPA/FAP far
outnumber the over 240,000 prints made from over 11,000
designs.[40] Though these figures in themselves are quite
amazing, two events stand out. The first is the creation of an
entirely new printing process, the carborundum print tech-
nique created by Dox Thrash and others in the Philadelphia
projects of the WPA/FAP. Using carborundum as a grinding
agent to prepare engraving plates, the artists were able to
achieve new levels of shade and tone in their prints.
 The second contribution was the virtual rediscovery of the
silk-screen printing process. Though the silk-screen process
had been invented in the late nineteenth century, it had
been little used in the creation of fine arts.

Anthony Velonis, who joined the WPA/FAP's poster division in 1935, made a number of technical and artistic improvements in the silk-screen process. Under his direction, the Silk-screen Unit of the WPA/FAP's Graphics Division was formed in 1938. Velonis was also the author of *Technique of the Silk-screen Process,* a publication of the WPA/FAP that was distributed in the thousands, promoting the technique to other artists and the general public.[41]

PHOTOGRAPHY AND FILMS

Most photography completed for the WPA/FAP was for strictly documentary purposes. Photographers took pictures of WPA/FAP work being done, of the artists at work, and of teachers working with students. Literally thousands of photographs of this kind were taken, providing an invaluable record of the work and accomplishments of the project.[42]

In addition to this purely documentary photography, however, there was artistic photographic work done on the WPA/FAP. Perhaps the best known, as well as the most important, was a project begun in 1935 in the New York office of the WPA/FAP.

The project, undertaken by the photographer Berenice Abbott, came to be called *Changing New York.* Abbott traveled throughout the city, taking pictures of immigrant neighborhoods, shop signs, docks, and many other scenes of the city that were passing away. The results of this project were exhibited in the Federal Art Gallery in New York City and the Museum of the City of New York; later, selected images from the project were published in book form. The images have had numerous showings since and stand as an important artistic portrayal of New York City in the 1930s.

In addition to these still-photography projects, the WPA/FAP made a number of films. WPA/FAP film crews worked on a number of documentary subjects including mural and mosaic makings, as well as subjects far removed from the art world like dysentery and syphilis.[43]

TECHNICAL PROJECTS

The WPA/FAP worked vigorously to improve the technical side of the artistic profession. Testing paints and materials and doing other research work, the technical projects of the WPA/FAP did much to establish standards for artists' materials throughout the United States.

The Federal Art Project's Paint Testing and Research Laboratory in Massachusetts was jointly sponsored with Harvard University's Fogg Art Museum. The work done by this laboratory on pigments was eventually adopted, with modification, by the Bureau of Standards.[44]

Other work on canvas adhesives was done for the WPA/FAP in New York by Raphael Doktor and published as a popular pamphlet (*Technical Problems of the Artist: Canvas Adhesives*, 1939) by the WPA/FAP.

ART EXHIBITIONS

Operating under the direction of Mildred Holzhauer, art exhibitions of the WPA/FAP took a number of forms. The first was the circulation of WPA/FAP exhibitions to locations throughout the country. This program brought the work of WPA/FAP artists to the American people in department stores and hotels as well as more traditional venues such as museums, art centers, and galleries. By August of 1938,

> the Federal Art Project reported that it had, since January, 1936, circulated 228 exhibitions to its arts centers and other places, had presented 1,116 individual showings, and had included in these exhibits some 8,000 works of art.[45]

The other form of exhibition organized by the WPA/FAP were its own Federal Art Galleries. A number of Federal Art Galleries were set up, including large, active ones in Boston, Chicago, and Philadelphia. By far the most prominent and successful Federal Art Gallery was in New York City.

The Federal Art Gallery in New York City acted as "a show window for the numerous enterprises of the WPA Federal Art

Project."[46] Opening in December 1935, the gallery put on forty major exhibitions in just under four years before closing in the spring of 1939. Originally located on East 38th Street, it was a sign of the gallery's growing importance that during the summer of 1937, it moved to West 57th Street, "art gallery row," and home to the most powerful and influential art galleries in New York City.[47]

Though exhibitions in such traditional modes as easel paintings, sculpture, and mural sketches were the gallery's mainstays, it also branched out and exhibited work done by children on the WPA/FAP as well as an exhibition, "Art in the Making," that explored just how the artists created works of art.[48]

Unfortunately, the Federal Art Galleries ceased to operate with the reorganization of the WPA/FAP in late 1939, and many of the exhibition projects were terminated.

ART EDUCATION

The education of the American public was one of the most important goals of the organizers of the WPA/FAP. Believing that the reason Americans did not buy more art, buy more American art, or become artists was that they lacked an art experience, the WPA/FAP sought to remedy the situation in two ways.

The first was through the exposure of the public to art. This was the job of the WPA/FAP artists who, by creating art, would give the public art to see. Additionally, through its Federal Art Galleries and Community Art Centers, the WPA/FAP would created locations in communities across the country where original works of art would be seen, in many cases for the first time.

But this was just one part of the program. The other was the instruction of hundreds of thousands of Americans, the young and the old, in creating their own art:

> No phase of its work is of greater social significance than its teaching. Hundreds of highly trained teachers of art, displaced by depression economy, are holding classes in boy's clubs, girl's service leagues, in schools after hours, in churches and settlements.[49]

In 1939, 19% of the employees of the WPA/FAP were involved in educational services. Many of these teachers were also artists, and through their jobs on the WPA/FAP were not only able to survive, but to impart their expertise to the next generation.[50]

THE INDEX OF AMERICAN DESIGN

Perhaps the most massive and ambitious undertaking of the Federal Art Project was the Index of American Design (IAD). Artists employed on the IAD, using a number of techniques but primarily watercolor, rendered a diverse number of items of folk art, crafts, and decorative art (from textiles, to wooden Indians, to silverware, to children's toys). Tagged with information about the original objects, the renderings were sent to Washington where together they constituted a record of American design for the use of craftspeople and historians.

When Holger Cahill came to head the Federal Art Project in October 1935 the ideal of collecting the documentary evidence of American design, folk art, and decorative arts found an enthusiastic and knowledgeable patron.

Cahill may rightly be called one of the first scholars of American folk art. In his early days at the Newark Museum, he organized two important shows of folk art ("American Primitives," 1930, and "American Folk Sculpture," 1931). During his career as exhibition director at the Museum of Modern Art, he prepared the book-length catalog *American Folk Art* (1932) to accompany the exhibition of Abby Aldrich Rockefeller's collection of folk art. His encouragement of the IAD was not surprising.

The idea of the Index of American Design cannot be claimed by any one person, of course. In addition to a number of European efforts to chronicle their nations' contributions to craft and design, the 1930s saw such American efforts as the Denver Art Museum's recording of Native American design, the Department of Interior's Historic American Buildings Survey, and the Smithsonian Institution's Historic American Merchant-Marine Survey.

But the real seed from which the IAD grew came from
Romana Javitz, head of the New York Public Library's Picture
Collection. In the spring of 1935, Javitz and Ruth Reeves, a
textile designer and painter, discussed the need for a com-
prehensive record of American design. For funding, Reeves
approached Frances Pollak, head of Educational Projects for
the New York City Emergency Relief Administration who saw
it as the perfect solution for the relief employment of
commercial artists. The idea circulated through the agencies
of government relief, but without an appropriate agency to
handle the project, the idea of the IAD remained in the
planning stages until October 1935 and the creation of the
Federal Art Project.

Meeting on December 7 and 8, 1935, the national staff of
the Federal Art Project reformulated the basic plan of the
New York idea into what became the IAD. Indian arts were
eliminated from the plan under the assumption that such
work had been done in the past and was continuing to be
carried out by ethnologists. Likewise, architecture and ma-
rine engineering were left out since these were being cov-
ered by the Historic American Buildings Survey and the
Historic American Merchant-Marine Survey. The subject of
the IAD was to be, in Holger Cahill's words, "limited to the
practical, popular and folk arts of the peoples of European
origin who created the material culture of this country as we
know it today"[51]

The IAD was based in Washington as a program of the
Federal Art Project. Constance Rourke was named national
editor and Ruth Reeves, national co-ordinator (Adolph Cook
Glassgold replaced Reeves in the spring of 1936 and was in
turn replaced by Benjamin Knotts in 1940). Research staffs
were set up in Washington and New York. Since the prime
objective of the IAD was to record design throughout the
nation, research staffs were set up in the individual states. By
the time the IAD was terminated in early 1942, thirty-five
states had set up IAD projects.

By January 1936, the first *Manual of the Index of American
Design* was printed. In it, the Federal Art Project outlined

the scope of the new activity, its purpose, plan of organization, methods of recording, research, classification and filing, together with specimen copies of data sheets to accompany each drawing.[52]

The activity that was the IAD was carried out in the following manner: the state research staffs would make a survey of the material in local history museums and private collections, selecting objects to be recorded and verifying their authenticity. Each object was then analyzed by a research supervisor and such information as maker or manufacturer of the object, materials used, owner and location of object, date of creation, place of creation, and its name were recorded on a data sheet. The object was then assigned to an artist for rendering. Though various watercolor techniques were the primary media for IAD artists, oil paintings, pen and ink, scratchboard, and (in a few instances) photography were used. The data sheets prepared earlier were then pasted to the back of the finished rendering and the complete plate sent to Washington.

Though it quickly became one of the most staunchly defended and widely praised programs of the Federal Art Project (in a review of a show of IAD plates, the reviewer noted that "no other phase of the entire Federal Art Project has engaged the unanimity of praise or has been as free from criticism as the Index of American Design,"[53]) the IAD did not meet with immediate and universal acceptance. Many wondered whether the IAD could be more quickly and efficiently carried out using only photography. To this Holger Cahill replied:

The camera, except in the hands of its greatest masters, cannot reveal the essential character and quality of objects as the artist can. Problems of distortion and of lighting are difficult. The camera cannot search out the forms of objects deeply undercut or modeled in high relief, match color as closely as the artist, or render the subtle interplay of form and texture which creates the characteristic beauty of so many products of early Amer-

ican craftsmen. Color photography approximating the
quality of Index drawings is an expensive process with
many problems which have not been fully solved. The
color photograph is perishable, while water color is one
of the most durable of art media.[54]

To which he added, on a more practical note, that the
Federal Art Project, and thus the IAD, was primarily a relief
program, the purpose of which was to create work for
artists.

A second criticism came from the artists themselves. Be-
cause the concept of the IAD was a faithful and exact
rendering of an object, there was no room for creative
expression or inventive uses of color and form. Though
Cahill claimed that the artists "discovered that documentary
art may become a free creative activity even within severe
discipline and limitations,"[55] Elzy J. Bird of the Utah IAD
perhaps gives a more accurate view of the artists' feelings:

When I became director of the project I had been
working on an Index plate and I remember the amount
of sweat that went into the finished product. Most of the
artists seemed to feel as I did, that it was merely copy
work and didn't give them free rein to anything creative
. . . . I remember one artist doing a remarkable textile
piece—just one. He said he'd sooner starve than do
another.[56]

Fittingly, a large number of IAD plates were created by
commercial artists and craftspeople—the same men and
women who created the objects their descendants were now
recording for the IAD. By the end of the programs, approxi-
mately 800 artists had created over 15,000 plates—a figure
made more impressive when one considers the amount of
research that was also involved in each plate.

With the winding down of the New Deal art projects and
the termination of the IAD at the onset of the American entry
into the Second World War, the question arose as to the
disposition of the thousands of plates created by the IAD.
Holger Cahill believed that they should be made available for

study by designers and students of design and he favored the placing of the IAD in a museum setting. To this end, Cahill had custody of the IAD transferred to the Metropolitan Museum of Art in New York in March of 1942.

Not all quarters agreed with this plan, however, and Librarian of Congress Archibald MacLeish (who as early as November of 1940 discussed the deposit of the IAD at the Library of Congress)[57] lobbied vigorously to have the IAD deposited in the Library of Congress. Even though the Library of Congress had at the time, and continues to have, a vast collection of art works and non-traditional library material, Cahill did not feel it was a suitable location for the IAD. Even after the transfer of the IAD to the Metropolitan, MacLeish pressed General Fleming, director of the Federal Works Agency and Cahill's boss, to have the IAD located permanently in a national collection. Fleming eventually agreed and at the start of 1944 the IAD was transferred again to the National Gallery of Art in Washington.[58] The IAD found a permanent home at the National Gallery and resides there today, the drawings

> stored on shelves alphabetically under about 600 entries ranging from 'Advertisement for Branding Irons, Adzes, Altars, Amana, Ammunition Bags, Anchor Links, Andirons, Animals, Apple Peelers,' etc. to 'Whirligigs, Windlasses, Wreathers, Wrenches, Writing Desks, Yokes, Zoar.'[59]

From its inception, Holger Cahill envisioned the IAD as a tool of the designer to be made available in schools, libraries, and museums. From the start, attempts were made to reproduce the plates using color lithography and hand-colored linocuts and thus make them more widely available. No cost-effective method was ever realized during the life of the IAD, and it was not until 1950 when Erwin O. Christensen of the National Gallery of Art published a necessarily small selection (about 350 plates) in *The Index of American Design*. Grouping the plates under such colorful subjects as "Our Wide Land," "The Years Pass," and "About the House,"

Christensen's work drew nearly undiluted praise for itself and the IAD.

Twenty-five years later the National Gallery of Art and Chadwyck-Healey finally realized Cahill's dream by publishing the entire IAD collection of 15,000 plus plates on color microfiche. Edited by Sandra Shaffer Tinkham, the fiche were grouped in ten collections, including "Toys and Musical Instruments," "Domestic Utensils," and "Utopian and Religious Communities" and could be acquired separately.

The collection again received nearly universal acclaim, but one review—though admitting the technical excellence of the fiche project—questioned the research value and relevance of the IAD in our own time, consigning the IAD to the fate of a mere historical curiosity and relic of 1930s enthusiasm.[60]

COMMUNITY ART CENTERS

One of the primary goals of the Federal Art Project was to reinvigorate the artistic life of all Americans. One of the "problems" seen by many administrators of the Federal Art Project was that the big cities were draining native regional America of its best talent, thus creating two problems: loss of art for the people and a lack of nativist/regional influence on the artists.

> The draining off of America's best talent from the native soil of the small town to the strange pavements of the big city . . . has inundated certain sections of America and left others high and dry as potential cultural wastelands.[61]

Thus, "to correct this inequal distribution of cultural advantage,"[62] the Federal Art Project organized what it termed community art centers to provide the public with the option not only to view art in the form of locally produced and nationally organized exhibitions, but also to actively participate in crafts and the fine arts.

Beginning in January 1936, the Federal Art Project, primarily through the efforts of Daniel S. Defenbacher, began to open community art centers throughout the nation.

Working in conjunction with local people, Defenbacher and the WPA/FAP had opened thirty-eight Community Art Centers, mostly in the South and West, by October of 1937.[63]

Perhaps the most prestigious of the community art centers was the Harlem Community Art Center which opened in November 1937. The opening ceremony was attended by Eleanor Roosevelt and hundreds of prominent artists of all races. In addition to a number of successful exhibitions, the Center was known for its art classes run by, among others, the African-American artist Gwendolyn Bennett.[64]

The community art centers, though usually organized by the Federal Art Project, had to have the support of local sponsors. The local sponsors could consist of specially formed community committees or be already existing organizations.[65]

Defenbacher and the administrators of the community art centers felt that

> the aesthetic experience put in motion by the object of art is the same aesthetic experience that in varying degrees pervades a broad range of human activity. As medicine influences our diet, our clothes, and our habits, so art influences our dress, our conduct, and our environment.[66]

The purpose of the FAP's community art centers was to put "art in action" so that the "average man" can recognize

> the uses of art in life—as an object for aesthetic enjoyment and guidance; as an action for the professional, the avocationalist, the spectator, the consumer, the industrialist, and the citizen.[67]

To reach these goals, the activities in a community art center included instruction in arts and crafts, lectures (both locally organized and those arranged by state or Federal offices), exhibitions of locally produced art as well as circulating exhibitions,[68] meeting places for clubs such as "Index of American Design Discussion groups, Sketch Clubs, Junior Gallery and School Clubs, Craft Clubs of various kinds, etc."[69]

The community art center program had its share of troubles. Often, existing cultural institutions felt competition from the centers, even though all attempts were made to assuage these fears.[70] Well over a hundred community art centers were eventually created (see Appendix D for a list), mostly in the smaller towns and cities of America. The list of the locations rings with the quintessential sound of the American small town: Topeka, Sunflower County, Salem, Anderson County, Laramie, Ottumwa.

After Federal founding was cut off, many of the art centers continued to function with local support and became established and successful cultural focuses of their communities, the Sioux City Community Art Center being one of the most prominent examples that continues in existence today.

"Be it Enacted": Legislating a Permanent New Deal for the Artist

When discussing the New Deal art projects, it must be remembered that the projects were without any legislated permanence. The PWAP was from the start a purely temporary project and this impermanence carried over into the Federal Art Project. Though the Section was more firmly imbedded in the Federal bureaucracy, as later events would show, the lack of any legislated niche would lead to the quick and unobstructed termination of the program.

The fiscal instability and inherently temporary nature of the projects led many in the arts to press for permanent, legislated Federal support for the art projects the government had undertaken.

A FALSE START

Congressman William I. Sirovich (D-NY) was the first to attempt such legislation. On March 18, 1935, Sirovich introduced H.J. Res. 220, a resolution providing for the establishment of a "Department of Science, Art, and Literature." The resolution was in many ways a manifesto on what government

support for the arts should be. It stated that "in art there are two elements, one in which the expression sought is for beauty, irrespective of utility, and the other in which utilities are beautified."[71] To serve these two elements of art as well as to serve the sciences, a new Federal Department would be created.

Sirovich's department would have been a cabinet level position, and in effect, the secretary of the department would become the nation's "Minister of Culture." The proposed department would take over and consolidate most of the various departments, bureaus, and offices of the Federal government dealing with the arts.

Assisting the secretary would be three undersecretaries, one each for science, art, and literature. The new department would be housed in a suitable building on Capitol Hill that would architecturally be keeping with "the beauty of art, the dignity of science, and the vision of literature."[72]

Hearings were held by the Committee on Patents (of which Sirovich was the chairman) in April and May 1935. Sirovich brought in a number of people from the arts and sciences to testify in favor of the resolution. Gutzon Borglum sculptor of Mount Rushmore; Anthony J. Atchison, an artist; Edward Bruce, of the recently created Section of Painting and Sculpture; and Bruce's boss, Admiral Christian J. Peoples, director of the Treasury Department's Procurement Division.

Nearly everyone was strongly in support of the resolution. Borglum gave close to sixteen pages of purple prose in its favor. Bruce and Peoples were more reticent in their support, and though supporting the resolution, firmly advocated keeping the Section within the Treasury Department.

After the hearings, Sirovich's department never received any active support outside Congress—or in it for that matter—and the resolution died in committee.

The time was not quite right. Soon after the hearings on the Sirovich resolution, the WPA/FAP was set up within the Works Progress Administration. The Section's program of adorning Federal buildings was functioning with great success as part of the Treasury Department. Little need was seen for Sirovich's Department.

THE FEDERAL ARTS BILL

By January 1937, the New Deal art projects had been successful for a number of years, but they were also encountering a series of crises. Though the Section was experiencing few problems, the entire WPA was facing financial cuts. The WPA/FAP was being criticized for its supposed Left Wing ties. The time to establish the New Deal art projects as a permanent Federal presence seemed to have come.

Thus, on January 5, 1937, Sirovich again introduced a resolution (H.J. Res. 79) that would, again, attempt to create a Department of Science, Art, and Literature. H.J. Res. 79 was a word-for-word copy of Sirovich's resolution of 1935. For a second time, the resolution was sent to the Committee on Patents, and hearings were held in February 1938. Again Sirovich called on a long list of artists and celebrities for support of his proposed Department.

COFFEE AND PEPPER

By February 1938, Sirovich had some competition in establishing a national arts department. On August 16, 1937, James M. Coffee (D-WA) introduced H.R. 8239, "A Bill to Provide for a Permanent Bureau of Fine Arts."[73] Like the earlier Sirovich resolutions, the Coffee bill was couched in terms of rhetorical eloquence:

> During the entire history of our Nation and up to the time of the creation of [the Federal Arts projects], the arts were the jealously guarded possessions of the few and were not made available to the majority. Works of art were confined to privately incorporated museums, difficult to visit, and to the completely inaccessible and private collections of wealthy patrons.[74]

The bill goes on for another full page or so praising the work of the Federal Arts projects (art, theatre, music, and literature) before getting down to the business of establishing a Bureau of Fine Arts.

Unlike Sirovich's Department of Science, Art, and Literature, Coffee's bureau would be an independent bureau, and

not a cabinet-level position. All the duties and functions presently carried out by the WPA's Federal One would be transferred to the Bureau. Additionally, all

> artists employed upon Federal projects . . . shall con-
> tinue in such employment without interruption under
> the jurisdiction of the Bureau of Fine Arts. The Bureau
> shall immediately increase the number of artists em-
> ployed . . . by a minimum of 20 per centum.[75]

Other sections of the bill defined the administrative nature of the Bureau and the tenure, vacation time, and sick leave for its artist/employees.

The Coffee bill, as originally written, embraced fully the WPA's arts projects and received support from various artists' unions. For this very reason, criticism from the arts establishment—which was already dissatisfied with the WPA/FAP and the concept of Federal support for the arts—did not want to see any further promotion of the arts along the lines of the WPA's Federal One projects.

Thus, on January 21, 1938, Senator Claude Pepper (D-FL) and Congressman Coffee introduced the same bill into their respective houses of Congress—Pepper's S. 3296 and Coffee's H.R. 9102.

The Coffee-Pepper bill as it came to be known, was identical to Coffee's earlier bill in intent and purpose. A number of significant changes were made in the wording of the various sections to make the bill more palatable to the more conservative elements of the Congress and the arts community.

Chief amongst these changes was that the new Bureau of Fine Arts would not take *all* artists employed by Federal One, but instead, the new Bureau would accept only those "who are competent to carry out the objectives of this Act."[76] Neither would the Bureau be able to increase the number of artists employed by the WPA by 20%, but would be encouraged to "employ as many more artists as possible in order to carry out the purposes of this Act."[77] Still other minor changes were made in the structure of the bureau in an attempt to conciliate those opposed to the bureau. These changes, however, served to alienate the more radical sup-

porters of the original Coffee bill who found the Coffee-Pepper version weaker and less supportive of artists.

As in most cases, however, the middle way pleased no one, and the Coffee-Pepper bill seemed to be headed for the quiet demise that faces most legislation—death in committee. But it did not quite turn out that way.

SIROVICH'S LAST STAND

Seeing his hopes for his own Department of Science, Art and Literature fading and the Coffee-Pepper Bureau of Fine Arts suffocating from criticism from all sides, Sirovich introduced H.J. Res. 671 on May 4, 1938. A jury-rigged vehicle nailed together from the least objectional aspects of Sirovich's original resolution and the Coffee-Pepper bill, H.J. Res. 671 called for the creation of a Bureau of Fine Arts in the Department of the Interior "for the promotion of art and literature."[78]

The resolution allowed for the transfer of artists from the WPA's Federal One, but only after a number of criteria had been met. Additional artists could be hired, but only with the authorization of the Secretary of the Interior.

On June 15, 1938, H.J. Res. 671 came to the floor of the House of Representatives. Congressman Sirovich delivered an impassioned and eloquent plea for the Bureau of Fine Arts:

> There exists in our country potentialities for the development of a great culture. This is an important part of our national wealth, and it must be safeguarded and fostered. It is the function of democratic government to secure the benefits of education and cultural enlightenment for all the people. By so doing, it guarantees the perpetuation of democracy.[79]

Unfortunately, other distinguished members of the House were more in the mood for slapstick humor than great culture. Congressman Harold Knutson informed the House that a puppeteer is one who "raises puppies;"[80] Congressman Taylor of Tennessee added that though no specific

provision had been made for Charlie McCarthy, the Congressman was confident that Charlie "is able to take care of himself" and not be "dependent upon Federal charity."[81]

Congressman Dewey Short, after a long mocking monologue, informed the House that

> Milton never wrote his *Paradise Lost* until he was blind. Beethoven never wrote his Moonlight Sonata until he was deaf. Mozart struggled through poverty to render his immortal masterpieces. Subsidized art is no art at all. Anyone who has ever graduated even from a grade school knows this.[82]

The debate continued on for a little over an hour. Finally, it was moved that the resolution be tabled, effectively killing it. When the vote was tallied, there were 195 in favor of tabling it and 35 against. Sirovich's plans, as well as those of Congressman Coffee and Senator Pepper, had come to naught.

TWO ADDITIONAL ATTEMPTS

The year 1937 would also see two other attempts to create some type of fine arts establishment within the Federal government. On the same day that Sirovich introduced H.J. Res. 79, Allard H. Gasque (D-SC) would introduce H.R. 1512, a bill to establish a National Bureau of Fine Arts in the Department of Interior, the primary duty of which would be to collect "such statistics and facts as should show the condition and progress of the fine arts and the cultural development in the several States and Territories."[83] Gasque's vision for a National Bureau of Fine Arts was conceived on a small scale, with the commissioner of the bureau serving primarily as a presidential fact-finder.

A few months after the Gasque and Sirovich bills, on August 3, 1937, James P. McGranery (D-PA) introduced H.R. 8132, a bill to establish a Division of Fine Arts in the Office of Education, Department of Interior. McGranery's Division of

Fine Arts, would, be responsible for collecting (as in
Gasque's bill)

> statistics, data, and information, and conduct surveys
> and studies, relating to education in the fine arts,
> including music, art, and dramatic art and speech, and
> to disseminate such information relating thereto as will
> promote education in the fine arts.[84]

McGranery, however, was a bit more generous monetarily.
His bill stated that $100,000 be authorized for the mainte-
nance of the division; Gasque's bill only called for $17,000 in
salaries for four staff people.

Neither bill received any serious attention and both died
in Committee. Though this would be Allard Gasque's only
entry in the arts bill derby, McGranery would try three more
times with slightly modified versions of his bill.*

ONE LAST TRY

Though both Sirovich and Pepper had their plans for a
Bureau of Fine Arts defeated in 1938, they both were to try
one last time in 1939.

On February 3, 1939, Sirovich introduced H.J. Res. 149, a
word-for-word reintroduction of H.J. Res. 671. The resolu-
tion was sent to the Committee on Patents, but Sirovich's
death on December 17, 1939, stopped all action on the
resolution and it never left committee.

Senator Pepper introduced S. 2967 on August 5, 1939, to
create a Bureau of Fine Arts. The proposed Bureau would
reside in the Federal Security Agency and "establish and
maintain a fine-arts program for the benefit of the people of
the United States."[85] Though the Bureau was ordered to
"employ as many artists and incidental craftsmen as are
necessary to carry out the purposes of this Act,"[86] no men-
tion was made of the WPA/FAP.

*H.R. 2319, 76th (1), introduced January 11, 1939; H.R. 600, 77th (1), introduced
January 1, 1941; and H.R. 900, 78th (1), introduced January 8, 1943. Like his first
bill, none of these ever left committee.

CONCLUSION

As the recent example of the National Endowment of the Arts has shown, governmental support for the creation of art continues to be a controversial issue, still open to charges of radicalism and triviality.

In the heated atmosphere of 1937–1938, when the very foundations of the New Deal were beginning to be challenged, any attempt to make permanent the projects that were seen by many to be the essence of New Deal "boondoggling" were sure to be met by failure.

Congressman Sirovich, from New York City and himself a playwright, failed to realize that his fellow congressmen and many citizens could not see that cultural subsidies were as important as farm subsidies.

Likewise, Congressman Coffee and Senator Pepper saw the arts ennobling the common man while at the same time glorifying the artist. It must have been quite a disappointment to find the common man did not want to be ennobled and the art world was ungrateful.

With the defeat of the Fine Arts legislation of 1937–1939, the path to the eventual dissolution of the New Deal art projects was made easier and an important chapter in their history closed.

The Artist in the 1930s

THE AMERICAN MILIEU

One of the primary reasons for the creation of the New Deal art projects was the promotion and cultivation of "American" art. This same idea was regularly used to defend and expand the projects. Art critics had regularly and vigorously debated the notion of an "American" art since the turn of the century. Whether such a thing even existed, how best to nourish and promote it, or if it was even worth encouraging were popular topics in the art press. Further controversy was certain to ensue when the New Deal art projects were suddenly thrust into this already heated environment, pro-

jects whose stated purpose was the glorification and funding
of American art.

THE AMERICAN SCENE

An American art clearly did exist by the 1930s, and all its
major themes and currents found expression—to a greater
or lesser extent—in the various New Deal art projects. Two
particular aspects of American art, one societal and the other
aesthetic, shaped the artistic production of New Deal artists.

Though the Armory Show of 1913 had introduced Ameri-
cans to "Modern" and "Abstract" art, by the 1920s, a new
movement, the American Scene, had come to dominate
American art. A precise definition of "American Scene"
does not seem possible. To some critics the term covers only
the idyllic rural works of artists like John Steuart Curry, Grant
Wood, and other artists frequently labeled Regionalists. The
critic Matthew Baignell, however, in his work, *American
Scene*,[87] takes a more expansive view and includes those
artists included under the rubric of Social Realists—artists
such as Ben Shahn, Moses and Raphael Soyer, William
Gropper, and George Biddle.

The fact that artists in the two groups often hated one
another and carried on heated public debates on the merits
of their own and the flaws of their opponent's works matters
little to Baignell. He emphasizes in such shared notions as
the rejection of elitist attitudes toward art and the portrayal
of the common man in heroic settings.[88]

REGIONALISM

Though it is reasonable to include both groups under some
common term, there were extreme differences. The Regional-
ists were mostly from the Midwest and utilized a "cornfed
iconography and an illustrative style . . . [that] rapidly became
the guilty secret of post war, jet-set aesthetics."[89]

This style, relying as it did on themes drawn from Ameri-
can myths and folklore, was well suited to the goals of Edward
Bruce's Section. Additionally, many of the artists, such as
Curry and Thomas Hart Benton, were established artists who

could meet the Section's stringent requirements for "quality."

SOCIAL REALISM

The Social Realists had a much different agenda as they portrayed American life. Coming from or working in an almost exclusively urban environment, Social Realists were surrounded by the despair of the urban poor, the jobless millions, and bread lines. Their work was affected by the Socialist and Communist ideas of left-wing thinkers of the time and inspired by the work of the modern Mexican mural painters José Clemente Orozco, David Alfaro Siqueiros, and Diego Rivera who sought to bring depictions of the underclass into their art. This commitment to radical change and leftist thought by the Social Realists was used by critics of the art projects to label the artists themselves, the WPA/FAP, and the whole idea of Federal support for the arts as "un-American."

ABSTRACT ART

Though there were always some abstract works done on the projects (particularly in the easel division of the WPA/FAP), only a few names stood out. Burgoyne Diller (head of the New York City mural project), Arshile Gorky, and Stuart Davis were amongst the few major abstract painters to continue their work in the face of Regionalism and Social Realism. In later years, such well-known abstract expressionists as Jackson Pollock and Mark Rothko would have their roots in the WPA/FAP revealed.

By the final years of the projects, influence of both the Regionalists and the Social Realists had waned while that of exiled European artists like André Breton, Max Ernst, and Yves Tanguy gave a more international outlook to the American art world and paved the way for the establishment of New York City as the post-war capital of the art world.[90]

COMMUNISTS AND UNIONS

The radicalization of the American artist—most visible in the work of the Social Realists—became a major factor in the

life of the New Deal artist, particularly in urban centers and New York City.

Radical artists had been joining the Communist Party for years and forming their own left-wing organizations since the early 1930s. Unemployed artists in New York City began organizing in the early days of the New Deal and after a number of name changes, the Artists' Union was formed in February 1934.[91]

The Artists' Union and its official organ, *Art Front,* had an active love-hate relationship with the New Deal art projects. Members of the Artists' Union regularly picketed, sat-in, wrote letters, and published cartoons against those who sought to cut back or eliminate the projects, particularly the WPA/FAP. At the same time they railed against real and exaggerated deficiencies and slights.

With the threat of war growing in Europe by the late 1930s, the activities of the Artists' Union and other organizations like the American Artists' Congress or publications like the *New Masses* were unable to hold the attention of either the public or those in power. Indeed, critics of the art projects used the left-wing activities of many of the New York–based artists to attack not only the WPA/FAP, but the entire WPA and New Deal.

Changes of a radical nature were soon coming to the New Deal art projects, but they were not the radical changes many of the artist had hoped and fought for.

1939: The World Turned Upside Down

UP TO NOW

Though the New Deal art projects had been loudly criticized by certain camps since their instigation, through the support and influence of those in power, they had weathered the relatively minor cutbacks and adjustments that had been made in the first years of their existence. It appeared that an active support for the arts would become a continuing, if not permanent, aspect of the Federal government.

But 1939 was not to be a good year for Federal support of the arts. The defeat of the various Federal Arts Bureau bills of the previous year meant that the projects of Federal One would continue on a year-to-year, dollar-to-dollar basis. With no permanent base of support, William I. Sirovich and Claude Pepper would again introduce bills to make the art projects permanent, but the bills would go nowhere. With Sirovich's death in December 1939, support for the existing art projects, not to mention the hope for a permanent fine arts project, lost a major voice on Capitol Hill.

CHANGES ON THE HORIZON

The New Deal had already brought sweeping changes to the way the United States did business. In 1937, FDR sought to solidify these changes with a massive and radical reorganization of the Federal bureaucracy. With his landslide victory in the 1936 election behind him, FDR thought he could get what he wanted. It was not to be, and a number of events, including the "Roosevelt Recession," FDR's Supreme Court–packing scheme, and vague fears in Congress of the President's growing power served to defeat the plan.

On April 3, 1939, however, a far less dramatic series of changes known as the Reorganization Plan of 1939 took effect, with a major impact on the arts projects of the Federal government.

THE FEDERAL WORKS AGENCY

The reorganization plan created an entirely new Federal agency known as the Federal Works Agency (FWA). The FWA, under the leadership of John Carmody, absorbed both the Treasury Department's Section of Fine Arts and the entire WPA, including the Federal Art Project.

The most drastic changes occurred to the WPA. No longer an independent agency, it was now just one of many agencies within the FWA. Additionally, to reflect a growing concern over achieving tangible results for the hundreds of millions

of dollars being spent, the name of the WPA was changed from the Works Progress Administration to the Work Projects Administration.

With FDR's close friend and advisor Harry Hopkins no longer in charge of the WPA (having left in December 1938 to become Secretary of Commerce) and its submersion deeper in the Federal bureaucracy, the WPA and the art projects became less visible to those in power at both ends of Pennsylvania Avenue.

EFFECTS ON THE FEDERAL ART PROJECT

The two most drastic changes to occur to the arts projects were the total elimination of the Federal Theatre Project (long the target of red-baiters and conservatives), and the elimination of Federal sponsorship of the projects of Federal One.

The provision of the Emergency Relief Act of 1939 mandating local sponsorship of the arts projects was thought by many to be the death knell for the three remaining projects of Federal One. Though all would survive, they would be in much changed circumstances.

Again, a name change reflected the changes. The projects of Federal One were now known as the Arts Projects of the WPA, with the name of the sponsoring state added. Thus, in New York, the WPA/FAP now became known as the WPA Art Program/New York.*

Because the Federal government no longer provided most of the money for the art projects, the state and other funding agencies were now determining the nature of the projects.

Artists continued to be employed; in some cases total employment actually rose. Throughout the country murals continued to be painted, sculptures created, and work on the IAD continued. However, the primary focus of new WPA/FAP was in the community art centers and art education, less controversial and more easily quantifiable projects.

*This name change has lead to the present day confusion as to what to call the projects of the WPA. Following the convention established by Francis V. O'Connor, the term "WPA/FAP" is used for all the fine arts projects under the WPA and succeeding agencies, 1935–1943.

Many artists who would later become well-known were dropped from or voluntarily left the WPA/FAP at this time. In later interviews with artists who served before and after the reorganization, the sense that things had changed for the worse was a frequently expressed sentiment.

During the period of transition, Holger Cahill was on a leave of absence from the WPA/FAP, working on the exhibitions of American art at the New York World's Fair. Though the national directors of the four other projects of Federal One would leave their posts permanently within months of the reorganization, Cahill would return from his sabbatical and oversee the eventual termination of the WPA/FAP.

EFFECTS ON THE SECTION OF FINE ART

At the Section, changes were much less obvious. Edward Bruce had spent much of 1938–1939 in trying to have the Section made an independent agency housed in a proposed new Smithsonian Gallery of Art. When the proposed Smithsonian Gallery of Art became lost in the gathering war clouds, the Section had no choice but to become part of the FWA.[92]

Outwardly, moving the Section from the Treasury Department to the FWA appeared to have no effects. Competitions continued to be organized; murals continued to be commissioned and painted in Federal buildings and post offices.

The real survival of the Section, however, depended on the notion of patronage. When the Section was located in the Treasury Department, Edward Bruce could count on the artistic and political patronage of both the Treasury Secretary Henry Morganthau and his wife, as well as the President. John M. Carmody, administrator of the FWA, lacked Morganthau's interest in art, and FDR, his time increasingly occupied by events in Europe, could find less and less time for his old friend Bruce's project.[93]

Bruce's fear that having both the WPA/FAP and the Section in the same agency would lead to the eventual elimination of one or the other as superfluous, never came true. World War II would eventually terminate both projects.[94]

THE END

The start of the war in Europe in 1939 had already begun to cut into Federal support for both relief and the arts. With the entry of the United States in late 1941, cuts to both relief and art programs accelerated. At the same time, the New Deal art projects tried to find themselves a new niche in a war environment. WPA/FAP artists were taught camouflage techniques, and the Section commissioned easel paintings for military hospitals. Yet none of these attempts would stave off the final termination of either project.

THE WPA/FAP

After Pearl Harbor, the survival of the WPA itself and the art program in particular became tenuous. Between March 1942 and July 1943 (when the WPA was finally liquidated), the WPA/FAP went by a number of different names, including the Graphic Section of the War Services Division, the Graphic Section of the Division of Program Operations, and the Graphic Phase of the War Services Project.[95]

Administration officials promised Congress that the WPA would be eliminated by the end of June 1943. FWA administrators carried out this promise, and with the termination of the WPA, the WPA/FAP, now nearly unrecognizable, ended with it.

In those last months as the WPA/FAP quickly came to an end, administrators hastily began to allocate the remaining works at a frantic pace. By some error, hundreds of canvases stored in a warehouse in New Jersey were declared to be surplus government property and sold by the pound to a junk dealer. Among the artists included in the junk sale were Mark Rothko and Jackson Pollack.[96]

THE SECTION

The Section too had been struggling because of the war. Though Edward Bruce had attempted to make his agency relevant to the war effort by conducting competitions for art to be places in military hospital and to raise funds for the Red

Cross, his efforts to have the Section create posters for the war effort and at enrolling the Section in the Office of Facts and Figures work of creating propaganda posters came to nothing.[97]

The Section struggled along for most of 1942 and the beginning of 1943. Edward Bruce continued to fight for the Section, but it was a hopeless cause. He suffered a heart attack in 1942 and on January 27, 1943, died. With him died the Section of Fine Arts.

Documenting the New Deal Art Projects

In 1936, Audrey McMahon predicted,

> Nothing is to be gained by the separate consideration of these various programs. It is safe, I believe, to prophesy that retrospectively they will be envisaged by art historians as one and the same thing.[98]

Though most art historians are able to distinguish between the relief projects of the WPA/FAP and the commission-driven projects of the Treasury Department, the public at large tends to lump them—plus a great deal of non-government-produced art of the 1930s—all together as "WPA art."

This blurring of the lines between the projects both in their own time and in our own adds to the difficulty in finding the source documents of the projects.

THE POWER OF THE MIMEOGRAPH

The alphabetical bureaus of the New Deal, and especially the art projects, utilized the mimeograph machine as at no other time in history. The use of the mimeograph freed the various agencies of the New Deal art projects from using precious funds for printing and allowed newsletters, exhibition catalogs, technical circulars, summary reports, and a host of other "printed" material to flow from the offices of art project administrators and participants in a seemingly unrelenting—and untraceable—stream.

Adding to the difficulty in tracking the publications is the plethora of sponsoring bodies. At various times, the Works Progress Administration; the Work Projects Administration of the Federal Works Agency; the Section of Painting and Sculpture of the Treasury Department; the Section of Fine Arts of first the Treasury Department and later the Federal Works Agency; the Public Works of Art Project of the Treasury Department; and various state offices of the WPA Art Program all contributed to the creation of these records.

Since many of these documents were not considered "official" government documents,

> Publications prepared by this project [the Federal Art Project—though the same may be said for the Treasury Department projects] during the period of this catalog have been issued for the use of regional offices or have been sponsored and published by agencies other then Federal and therefore are not considered Government publications and are not entered in the 74th Document catalog.[99]

THREE-TENTHS OF ONE PERCENT

Though the New Deal art projects made a lot of political noise and created works of art that were seen by millions, in the vast budget of the United States, they were for all intents and purposes fiscally invisible.

In 1938, for example, total expenditures for all the art programs of the WPA accounted for only 0.3% of the WPA's budget.[100] Comparable figures could be shown for the Treasury Department projects.

Thus, when seeking information on the projects in such documents as Congressional hearings, agency budgets, and legislation, the art projects are often afforded only a single line, or at most a paragraph or two.

THE ARCHIVES OF AMERICAN ART

Since 1962, the Archives of American Art (AAA) of the Smithsonian Institution has assiduously tracked the records of the New Deal art projects. The AAA has microfilmed the

relevant materials in the collections of the National Archives and Records Agency and has collected the personal papers and documents of artists and administrators of the projects.

The collections thus assembled by the AAA are without a doubt the starting point for any in-depth research on the New Deal Art Projects.

THE WILDERNESS YEARS

In their time, the New Deal art projects received extensive coverage from both the art press as well as the popular press. With the end of the projects, coverage naturally decreased.

Throughout the 1940s and early 1950s, the projects are rarely mentioned in an art world concentrating on the latest trend, Abstract Expressionism. What coverage there is of the projects tends to dwell on the Index of American Design, particularly after the publication of Edwin O. Christensen's *Index of American Design* in 1950.

Small exhibitions of New Deal art were held at the Smolin Gallery in New York City in 1961 and 1962. In 1963, "The U.S. Government Art Projects: Some Distinguished Alumni" was held at the Washington Gallery of Modern Art. This show, organized by Dorothy C. Miller, Holger Cahill's widow, for the Museum of Modern Art, was the first to reintroduce the public to the New Deal art projects.

THE FLOODGATES OPEN

In 1966, Francis V. O'Connor of the University of Maryland organized "Federal Art Patronage 1933 to 1943," at the university's art gallery. This, the first large-scale exhibition of New Deal art in nearly a quarter century, proved to be a turning point.

Soon, dissertations, thesis, monographs, articles, and exhibitions on the New Deal art projects were pouring forth from the nation's universities and museums.

Much of the early work on the projects concentrated on simply explaining what the projects were and what they did. Detailed explications of the bureaucracy of the projects were given and lists of artists and works compiled.

This first generation of New Deal art project scholars, though interested in the art itself, were most often concerned with simply telling the public that it did exist. By the early 1980s, however, a second generation of scholars began to look at New Deal art and ask what it meant. Karal Ann Marling in her book *Wall to Wall America* (on the Treasury Department murals) was among the first to examine the iconography of New Deal art.

With this latest scholarly advance, New Deal art now moves out of the realm of mere curiosity and can join the mainstream of American art.

Coda

On March 15, 1944, the American Artists' Professional League, long an opponent to the government's art programs, gleefully proclaimed in an editorial in *Art Digest,* "WPA-RIP!"

The editorial came about ten months after the last of the New Deal art projects was officially terminated and just over eleven years since Franklin D. Roosevelt was inaugurated. In his memorable inaugural address March 4, 1933, Roosevelt told Americans that

> a host of unemployed citizens face the grim problem of existence, and an equally great number toil with little return. Only a foolish optimist can deny the dark realities of the moment Happiness lies not in the mere possession of money; it lies in the joy of achievement, in the thrill of creative effort. The joy and moral stimulation of work no longer must be forgotten in the mad chase of evanescent profits. These dark days will be worth all they cost us if they teach us that our true destiny is not to be ministered unto but to minister to ourselves and to our fellow men.[101]

". . . the joy of achievement, in the thrill of creative effort"—the New Deal art projects cost a total of 50 million dollars over a period of nearly eleven years, an average of less

than 5 million dollars per year. In comparison to the expenditures made in other relief efforts this was a bargain.

Perhaps no Michelangelos or da Vincis were discovered by the New Deal art projects. No Sistine ceilings were created to adorn the Federal buildings in Washington or the thousands of post offices and courthouses across America. Still, established and respected artists were given publicly visible commissions by the Federal government via the Section.

At the same time, the Federal Art Project did, in Audrey McMahon's words, "let the artist survive." Artists like Jackson Pollock, Willem de Kooning, Mark Rothko, Lee Krasner, Berenice Abbott, Ben Shahn, Jacob Kainen, and many more later well-known and successful artists were employees of the WPA/FAP or the Section at a time when employment of any kind was hard to find.

In that time many thousands of artists were employed, many tens of thousands of works were created, a number of which even the most virulent critic must admit to be, if not the greatest expression of the creative spirit, at least a document of the creative spirit of American art at a particular time in the nation's history.

May the artist live? For a brief time, the Federal government said yes and backed that affirmative answer with Federal dollars for the good of the artists and the enjoyment of the American people.

References

Allyn, Nancy Elizabeth. *Defining American Design. A History of the Index of American Design, 1935–1942*. MA Thesis, University of Maryland, 1982.

Ames, Kenneth L. "Review of *The Index of American Design*." *Journal of the Society of Architectural Historians* 41 (March 1982): 68–69.

Baigell, Matthew. *The American Scene: American Painting of the 1930's*. Praeger: New York, 1974.

Biddle, George. *An American Artist's Story*. Little, Brown, and Co.: Boston, 1939.

"Bureau of Fine Arts." *Congressional Record* 83 (June 15, 1938): 9490093, 9496–99.

Cahill, Holger. *The Reminiscences of Holger Cahill.* Transcript of interviews conducted by the Oral History Office of Columbia University in 1957. (#1281 in bib.).

Christensen, Erwin O. *The Index of American Design.* Macmillan: New York, 1950.

Coffee, John M. *A Bill to Provide for a Permanent Bureau of Fine Arts.* H.R. 8239, 75th Congress, First Session (August 16, 1937).

———. *A Bill to Provide for a Permanent Bureau of Fine Arts.* H.R. 9102, 75th Congress, Third Session (January 21, 1938).

Dows, Olin. *Government in Art; the New Deal's Treasury Art Program. A Memoir by Olin Dows.* University of Wisconsin Press: Madison, 1963[?].

Federal Art Project. *Federal Art Project Manual.* Federal Art Project: Washington, 1935.

———. *The Federal Art Project throughout the Nation: A Summary.* FAP: Washington, April, 1939b.

———. *Federally Sponsored Community Art Centers.* FAP: Washington, 1937.

———. *40 Exhibitions at New York's Federal Art Gallery. A Preview of the Future.* FAP: New York, 1939a.

———. *Purposes, Functions and Techniques, Federal Art Project Exhibitions, Works Progress Administration.* Federal Art Project: Washington, 1936[?].

———. *Report on Art Projects.* Federal Art Project: Washington, 1936.

———. New Jersey. *The Federal Art Project in New Jersey. The WPA Federal Art Project. Summary of Activities and Accomplishments.* Newark, 1935[?].

Gasque, Allard H. *A Bill to Establish a National Bureau of Fine Arts.* H.R. 1512, 75th Congress, First Session (January 5, 1937).

"Index of Design; Exhibition at R.H. Macy's." *Art Digest* 12 (July 1938): 34.

Marling, Karal Ann. "Foreword," pp. vii–xiv. In *Regionalist Art, Thomas Hart Benton, John Steuart Curry, and Grant Wood: A Guide to the Literature,* by Mary Scholz Guedon. Scarecrow Press: Metuchen, NJ, 1982.

McDonald, William Francis. *Federal Relief Administration and the Arts: The Origins and Administrative History of the Arts Projects of the Works Progress Administration.* Ohio State University Press: Columbus, 1969.

McGranery, James P. *A Bill to Establish a Division of Fine Arts in the Office of Education, Department of Interior.* H.R. 8132, 75th Congress, First Session (August 3, 1937).

McKinzie, Richard. *The New Deal for Artists.* Princeton University Press: Princeton, NJ, 1973.

McMahon, Audrey. "May the Artist Live?" *Parnassus* (October 1933): 1–4.

———. "The Trend of the Government in Art" *Parnassus* 8 (January 1936): 3–6.

Monroe, Gerald M. *The Artists' Union of New York.* Ed.D. dissertation, New York University, 1971.

Morris, Richard B., ed. *Great Presidential Decisions.* Fawcett: New York, 1969.

Morsell, Mary. "Selected Works of PWAP Project at the Corcoran." *Art News* 32 (May 5, 1934): 3, 14.

O'Connor, Francis V., ed. *Art for the Millions.* New York Graphic Society, Ltd.: Greenwich, CT, 1973.

———. *Federal Support for the Visual Arts: The New Deal, Then and Now.* New York Graphic Society: New York, 1969.

Pepper, Claude D. *A Bill to Provide for a Bureau of Fine Arts.* S. 2967, 76th Congress, First Session (August 5, 1939).

Public Works of Art Project. *Report of the Assistant Secretary of the Treasury to Federal Emergency Relief Administrator.* Government Printing Office: Washington, 1934.

Sirovich, William I. *A Joint Resolution to Create a Bureau of Fine Arts in the Department of Interior.* H.J. Res. 671, 75th Congress, Third Session (May 4, 1938).

"Speaking of Pictures . . . This is Mural America for Rural Americans." *Life* 7 (December 4, 1939): 12–13, 15.

Tinkham, Sandra Shaffer, ed. *The Consolidated Catalog to the Index of American Design.* Somerset House: Teaneck, NJ; Chadwyck-Healey: Cambridge, England, 1980.

US Congress. House of Representatives. *A Joint Resolution Providing for the Establishment of an Executive Department to be Known as the Department of Science, Art, and Literature.* Hearings held April–May, 1935, House of Representatives, Committee on Patents. H.J. Res. 220, 74th Congress, First Session. Government Printing Office: Washington, March 18, 1935.

US Superintendent of Documents. *Catalog of the Public Documents of the 74th Congress.* Government Printing Office: Washington, 1935.

White, John Franklin, ed. *Art in Action. American Art Centers and the New Deal.* Scarecrow Press: Metuchen, NJ, 1987.

Whiting, Philippa. "Speaking About Art." *American Magazine of Art* 28 (April 1935): 230–33.

Whitney Museum of American Art. *Treasury Department Art Projects. Sculpture and Paintings for Federal Buildings.* Whitney Museum of American Art: New York, 1936.

Works Progress Administration. *Inventory. An appraisal of the results of the Works Progress Administration, Washington, DC.* Government Printing Office: Washington, 1938.

Notes

1. McMahon (1933), pp. 1–4.
2. *Ibid.,* p. 4.
3. McMahon (1936), p. 3.
4. Biddle (1939), p. 268.
5. *Ibid.,* p. 269.
6. McDonald (1969), p. 360.
7. *Art News* (May 5, 1934), p. 14.
8. Public Works of Art Project (1934), p. 9.
9. Whitney Museum of American Art (1936), introduction.
10. Whiting (1934), p. 569.
11. McKinzie (1973), p. 37.
12. *Ibid.,* p. 54.
13. *Life* (December 4, 1939), pp. 12–13, 15.
14. McKinzie (1973), p. 60.
15. McDonald (1969), p. 117.
16. Dows (1963?), pp. 20–23.
17. McDonald (1969), p. 370.
18. Federal Art Project (1936), p. 3.
19. McDonald, p. 130.
20. Cahill (1957), ff.
21. McDonald (1969), p. 184.
22. *Ibid.,* p. 171.
23. *Ibid.,* pp. 203–4.
24. *Ibid.,* pp. 208–9.
25. Federal Art Project (1935), pp. 3–4.
26. McDonald (1969), p. 389.
27. Federal Art Project (1935), p. 5.
28. McDonald (1969), pp. 185–86.
29. *Ibid.,* p. 385.
30. Federal Art Project. New Jersey (1935?), p. 7.
31. McDonald, p. 424.
32. Federal Art Project (1935), pp. 22–23.
33. McDonald, p. 105.
34. *Ibid.,* pp. 430–31.
35. *Ibid.,* p. 105.
36. Federal Art Project (1936?), p. 3.

37. Federal Art Project (1936), p. 6.
38. McDonald, p. 105.
39. *Ibid.*, p. 430.
40. *Ibid.*, p. 105.
41. O'Connor (1973), p. 294.
42. McDonald, p. 458.
43. *Ibid.*, p. 459.
44. *Ibid.*, p. 460.
45. *Ibid.*, p. 476.
46. Federal Art Project (1939a), p. ii.
47. *Ibid.*, p. 3.
48. *Ibid.*, p. 32.
49. Federal Art Project (1939b), p. 3.
50. *Ibid.*, p. 1.
51. Christensen (1950), p. xii.
52. *Ibid.*
53. *Art Digest* 12 (July 1938), p. 34.
54. Christensen (1950), pp. xiv–xv.
55. *Ibid.*, p. xiii.
56. *Ibid.*, p. xiv.
57. Allyn (1982), p. 39.
58. *Ibid.*, pp. 42–43.
59. Tinkham (1980), p. 2.
60. Ames (1982), pp. 68–69.
61. White (1987), p. 2.
62. Federal Art Project (1937), p. 1.
63. *Ibid.*, pp. 1–2.
64. McDonald, p. 413.
65. Federal Art Project (1937), p. 6.
66. O'Connor (1973), p. 224.
67. *Ibid.*, p. 226.
68. Federal Art Project (1937), pp. 15–16.
69. *Ibid.*, p. 25.
70. White (1987), p. 7.
71. US Congress. House of Representatives (1935), p. 1.
72. *Ibid.*, p. 2.
73. H.R. 8239, p. 1.
74. *Ibid.*
75. *Ibid.*, p. 5.
76. H.R. 9102, p. 4.
77. *Ibid.*
78. H.J. Res. 671, p. 1.
79. *Congressional Record* (June 15, 1938), p. 9,492.
80. *Ibid.*, p. 9,496.

81. *Ibid.,* p. 9,497.
82. *Ibid.*
83. H.R. 1512, p. 1.
84. H.R. 8132, pp. 1–2.
85. S.2967, p. 1.
86. *Ibid.,* p. 3.
87. Baignell, p. 13.
88. *Ibid.,* p. 59.
89. Marling, p. vii.
90. McKinzie, pp. 107–8.
91. Monroe, pp. 39–52.
92. McKinzie, pp. 44–45.
93. *Ibid.,* pp. 45–46.
94. *Ibid.,* p. 45.
95. O'Connor (1969), p. 130.
96. *Newsweek* (March 6, 1944), pp. 96–97.
97. McKinzie, pp. 49–50.
98. McMahon (1936), p. 3.
99. US Superintendent of Documents, p. 3,187.
100. Works Progress Administration, p. 81.
101. Morris, pp. 410–11.

1933–1934

0001 McMahon, Audrey. "May the artist live?" *Parnassus* 5 (October 1933): 1–4.

Calling for Federal aid to artists, McMahon outlines the steps taken in New York for artists. B/W illustrations of work done by artists in New York. Written before PWAP began.

0002 "American artists and the NRA code of fair competition." *Commercial Artist* 15 (December 1933): 249–50.

NOT SEEN.

0003 Howard, Henry T. "The Coit Memorial Tower." *The Architect and Engineer of California and the Pacific Coast States* 115 (December 1933): 11–15.

NOT SEEN.

0004 "Millions for laborers, not one cent for artists." *American Magazine of Art* 26 (December 1933): 521–22.

Call for relief efforts to be expanded to include artists.

0005 "CWA art project." *Art Digest* 8 (December 15, 1933): 31.

American Artists Professional League's (AAPL) digest of what the CWA has planned. Includes a full outline of the basic premises of the art project.

0006 "Federal funds available to museums in new ways." *Museum News* 11 (December 15, 1933): 1–2.

Explanation of the ways that governmental funds will be

available to museums through the PWA. Includes partial text of the announcement.

0007 "Jobs for artists." *Art Digest* 8 (December 15, 1933): 6–7.

Harry L. Hopkins of the Federal Emergency Relief Administration (FERA) announces plans to give 2,500 artists jobs through the PWAP. Discusses the setting up of regional committees and includes comments by a number of people on the pros and cons of government involvement in the arts.

0008 "Federal art plan to provide funds for needy artists." *Art News* 32 (December 16, 1933): 1, 3–4.

Announcement of the creation of the PWAP; the appointment of Juliana Force as New York director; and lists the other regional committees being formed.

0009 "Latest data on CWA plan." *Art News* 32 (December 16, 1933): 10.

Latest news on the PWAP; text of remarks by: Edward Bruce, Forbes Watson, Eleanor Roosevelt, Rexford G. Tugwell, Francis Henry Taylor, Homer Saint-Gaudens, and Juliana Force.

0010 "The Public Works of Art Project." *Art News* 32 (December 16, 1933): 10.

Editorial cautiously endorsing the PWAP. "The mere formation of a Public Works of Art Project is a epoch making event in America" (reprinted in November 1977 *Art News* See **1439**).

0011 Beer, Richard. "Voice from the country." *Art News* 32 (December 23, 1933): 14.

Satiric article; Beer "converses" with a woman from Kansas on the idea of the PWAP, the woman feels artists should paint boxcars so people everywhere could really see the art they create.

0012 "Government and art." *Art News* 32 (December 23, 1933): 10.

Editorial on the PWAP; fears the effects of throwing large sums of money at artists without a good plan; feels federal money should be spent on adornment of public buildings.

0013 Morsell, Mary. "Inquiring reporter goes forth on mural interview." *Art News* 32 (December 23, 1933): 12.

Satiric article; Morsell asks the man on the street his response to the PWAP; tongue in cheek account as she "talks" to the New York Public Library's lions.

0014 "Row follows allotment of relief funds to painters." *Newsweek* 2 (December 23, 1933): 30.

Announcement of PWAP plans and how some have found that the administrators chosen are too biased towards modern art.

0015 "Government aid to artists." *Literary Digest* 116 (December 30, 1933): 22.

Brief note on the creation of the PWAP; how it will work; the formation of the regional committees; and a comment by Forbes Watson.

0016 "Jobless artists score PWA charging bias in selections." *Art News* 32 (December 30, 1933): 6.

Summary of New York *Times* account of artists accusing Juliana Force of favoritism in PWAP hiring.

MONOGRAPHS

0017 Public Works of Art Project. "Civil works administration to employ artists on Public works of art." In *U.S. Federal Emergency Relief Administration. Press Release no. 464.* Mimeographed, issued December 11, 1933. 9 pp.

NOT SEEN. CITED IN WILCOX.

0018 Public Works of Art Project. "[Press release], no. 1." Mimeographed, issued December 19, 1933.

NOT SEEN. CITED IN WILCOX.

0019 Roosevelt, Franklin D. *Executive Order No. 6420B.* November 9, 1933.

With this Executive Order, FDR established the Federal Civil Works Administration under which the PWAP was eventually formed.

1934

0020 "Art for PWA." *Architectural Forum* 60 (January 1934, supplement): 24.

Announcement of the formation of the PWAP; lists members of the advisory committee.

0021 "Public Works of Art Project." *Carnegie Magazine* 7 (January 1934): 245–46.

Note on the creation of the PWAP; how it will work and what projects it will undertake. B/W photograph of Edward Bruce, Forbes Watson, Eleanor Roosevelt, and Lawrence W. Roberts.

0022 Watson, Forbes. "The Public Works of Art Project: Federal, Republican or Democratic?" *American Magazine of Art* 27 (January 1934): 6–9.

Watson defends the early work of the PWAP and makes the claim that though geniuses may not be created by the truckload, a few great works of art will come from the project; includes a map of the PWAP regions. An excellent article.

0023 Watson, Forbes. "The USA challenges the artists." *Parnassus* 6 (January 1934): 1–2.

Forbes Watson recounts the foundation of the PWAP and his association with it; explains that it is wonderful to bring art to

the people. "We are obliged either to say that geniuses are century plants or to say that lilacs don't count. The Public Works of Art Project takes the broader point of view. It believes that the artist is not the rare blossom that blooms once in a hundred years and it also believes that the life of the spirit may quite well be carried on by men whose names will not go down permanently in history," p. 2.

0024 "CWA can aid museums." *Art Digest* 8 (January 1, 1934): 15.

Summary of a *Museum News* piece on how museums can take advantage of CWA and FERA projects.

0025 "CWA murals in Dallas." *Art Digest* 8 (January 1, 1934): 29.

Alexander Hogue and Jerry Bywaters collaborate on nine PWAP murals in the Dallas City Hall.

0026 "CWA project." *Art Digest* 8 (January 1, 1934): 8–9.

Summary of early PWAP work. Joseph A. Danysh of the San Francisco *Argonaut* discusses how the art projects are to employ artists and not to simply put them on relief. Includes a list of the official personnel (non-artists) in the sixteen regions of the project.

0027 "Edna Reindel, one of first picked by CWA." *Art Digest* 8 (January 1, 1934): 19.

Edna Reindel is named as one of the first artists hired by the PWAP. B/W illustration of work by Reindel.

0028 "For living artists." *Art Digest* 8 (January 1, 1934): 14.

Open letter signed by many artists and headed by Leon Kroll asking the art world to supplement the CWA project with additional funds.

0029 "Portentous project." *Art Digest* 8 (January 1, 1934): 3–4.

Editorial praising the efforts of the government to support the arts.

0030 "[Plan of relief for unemployed artists.]" *New Republic* 77 (January 3, 1934): 209.

Editorial praising the formation of the PWAP: "In setting up the organization through which its plan of relief for unemployed artists is to be carried out, the administration has acted with an intelligence unusual in governmental dealings with art and artists."

0031 "Public art project." *Commonweal* 19 (January 5, 1934): 257.

Note on the creation of the PWAP. "We have lately spoken from our hearts about the misanthropy and aridity that distinguishes so much of our native secular art, and we hope this trend, sometimes dubiously distinguished as 'modern,' will not characterize these works supposedly done for the public as well as the artists. Perhaps the latter with a few regular meals in prospect will see something in the American scene other than 'jazzmania,' unflattering likenesses of subway crowds already sad enough, barren-looking farms and distorted women."

0032 "New court house in New York gets first murals under CWA plan." *Art News* 32 (January 6, 1934): 17.

County Court House in New York gets first PWAP mural; the mural will be created by PWAP artists after old sketches by Attilio Pusterla recently discovered.

0033 "PWAP active in New England." *Art News* 32 (January 13, 1934): 11.

Forty-four New England artists on PWAP payroll; list of New England regional committee.

0034 "The art project." *Art Digest* 8 (January 15, 1934): 30.

Weekly column by the American Artists Professional League

(AAPL); brief summary of the PWAP and a plea to keep it free of government interference.

0035 "CWA peril." *Art Digest* 8 (January 15, 1934): 6.

Junius Craven of the San Francisco *News* warns artists in the PWAP that they must succeed or the public will turn against them.

0036 Danysh, Joseph A. "Dejected genius: American art or bust." *Art Digest* 8 (January 15, 1934): 7.

Summary of Danysh's article in the San Francisco *Argonaut*. A "creative" writing piece in dialogue form where Danysh criticizes the haste in which artists and projects were chosen in the CWA project.

0037 De Kruif, Henry. "The New Ideal." *Art Digest* 8 (January 15, 1934): 24.

A plea by the artist Henry De Kruif for an American art commensurate with the greatness of America. Mentions the Mexican government's art project.

0038 "Directors names for CWA art project in sixteen districts." *Museum News* 11 (January 15, 1934): 2.

List of the regional directors names by the PWAP.

0039 "Judgement pending." *Art Digest* 8 (January 15, 1934): 4, 32.

Editorial on the complaints of artists who were not selected in the first round of PWAP projects. Description of the protests by the Unemployed Artists' Association. Comments by Juliana R. Force, chairman of the New York Regional Committee.

0040 "PWA officers view one of first works done under project." *Art Digest* 8 (January 15, 1934): 7.

Officers of the PWAP gather around one of the first works completed under the project (an illustration of the National

Archives building under construction by Dorsey Doniphan).
Illustrated with a photograph of the officers gathered around
the work.

0041 "White Plains CWA unit." *Art Digest* 8 (January 15,
1934): 8.

Mrs. Chester G. Marsh, director of the Westchester Work-
shop, announces the creation of a CWA unit.

0042 Bruce, Edward. "Public Works of Art Project—
address by Edward Bruce." *Congressional Record* 78 (January
17, 1934): 765–67.

Address by Edward Bruce to the Cosmopolitan Club of
Washington, DC, on the PWAP; read into the *Congressional
Record* by Senator Joseph T. Robinson of Arkansas. Bruce
describes the PWAP and reads letters from artists on the
project praising what it has done for them. Bruce concludes:
"If we can, through this project, develop the love and the
wish for beauty, an intolerance for the ugliness in our lives
and our surroundings, a demand for slum clearance, a
hatred of the utter drabness of the average city and village in
this country, especially in its outskirts, we may be building
better than we know, not only spiritually but materially. It
may form the stimulus and create a demand for an America
beautiful, and such a demand is what everyone is seeking to
lift us out of the depression," p. 767. NOTE: Reprinted as a
separate document by the US GPO, 1934 (8 pp.).

0043 "PWAP projects in New Jersey." *Art News* 32 (January
20, 1934): 19.

Beatrice Winser, Chairman of the Northern New Jersey
PWAP, announces committee members and list of New
Jersey projects.

0044 Weaver, John Henry. "Plan for Public Works of Art."
Art News 32 (January 20, 1934): 17.

Letter to the editor; Weaver, founder of Art Interests, the
Artists' Cooperative, feels the public should be more in-

volved in choosing artists for PWAP; this will increase their interest in the art done.

0045 "New England quotas of employed artists has been reached." *Art News* 32 (January 27, 1934): 11.

Frances Henry Taylor announces that the New England region PWAP allotments have been filled; comments by Forbes Watson that the PWAP may be extended.

0046 "What price public art? Speculation over results." *Literary Digest* 117 (January 27, 1934): 20.

Comments by local papers (Baltimore *Sun* and Troy *Times*), Harry W. Watrous (president of the National Academy of Design), and Jo Davidson (sculptor) on the creation of the PWAP. Davidson comments on fears about an 'official art': "Official art! What was Greece, what was Egypt, what was India? Wasn't that official art? Did it matter to the artists of India that Buddha had to be pictured with definite, immutable gestures?" Illustrated with a cartoon depicting the "modern artist" getting all the PWAP commissions while "conservative artist" sits on the sidelines.

0047 *Public Works of Art Project Bulletin* 1 (February 1934): 7 pp.

Edited by Ann Craton, the first of two (*See* **0053**) *PWAP Bulletin's* contained an introduction by Edward Bruce to the PWAP and a note by Edward Rowan.

0048 Armitage, Merle and Thomas Carr Howe, Jr. "Public works of art project." *California Arts and Architecture* 45 (February 1934): 20, 30.

Explanation of the PWAP by Armitage (regional director for Southern California) and Howe (vice-chairman, Northern California, Nevada, and Utah); they discuss what the PWAP will do, and what type of projects it will undertake in their respective regions. Photographs of Eleanor Roosevelt, Lawrence W. Roberts (Assistant Secretary of the Treasury), Edward Bruce, and Forbes Watson.

0049 La Follette, Suzanne. "Government recognizes art."
Scribner's Magazine 95 (February 1934): 131–32.

General article on government patronage of the arts, praises
the formation of the PWAP. Gives a good background sketch
as to the artistic reasons the PWAP was created.

0050 "Murals by the day." *Arts and Decoration* 40 (February
1934): 46–47.

A bit of backhanded praise of PWAP works, claiming that
unlike other government commissioned art work (examples
given include the high prices paid for nineteenth century
murals in the Capitol), these are so cheap, they can just be
painted over if no one likes them in a few years: "If now the
government sets a few thousand mural painters and easel
painters and etchers of the American scene to work at $35 or
$40 a week, the taxpayer will be more willing to have the
space repainted if it does not stand the test of time."

0051 Rowan, Edward. "Will plumber's wages turn the
trick?" *American Magazine of Art* 27 (February 1934): 80–83.

Primarily a list of PWAP works undertaken; includes a
photograph of PWAP administrators accepting one of the
first works finished.

0052 Wessels, Glenn. "Value received." *Art Digest* 8 (February 1, 1934): 22.

Comments by Wessels from the San Francisco *Argonaut*
discussing an exhibition of PWAP works at the De Young
Museum (San Francisco). Claims a bright future for the
project.

0053 *Public Works of Art Project Bulletin* 2 (March 1934): 8 pp.

Edited by Ann Craton, the second of two (*See* **0047**) *PWAP
Bulletin* contains the text of Edward Bruce's comments at an
address at the New York City Municipal Gallery and reports
from the various PWAP regions.

0054 Bruce, Edward. "Implications of the Public Works of Art Project." *American Magazine of Art* 27 (March 1934): 113–15.

A brief history of the inception of the PWAP; Bruce praises the quality of work done under PWAP and sees it as invigorating local talent and living proof of the wonders that the democratic patronage of art can accomplish.

0055 "New Jersey PWAP extends time limit for artists' work." *Art News* 32 (March 10, 1934): 11.

Beatrice Winser of the Northern New Jersey PWAP announces that employment will continue till May 1, 1934, in New Jersey.

0056 Force, Juliana R. "Art appreciation believed advanced by CWA project." *Art News* 32 (March 17, 1934): 11.

Force claims PWAP has increased art appreciation in the general public. "It will prove to the individual that all good art is not expensive, and that the average person can afford and should own works of art."

0057 "Exhibition of work by PWA artists." *Minneapolis Institute of Art Bulletin* 23 (March 24, 1934): 63–64.

Account of "Exhibition of Paintings, Water Colors, and Sculpture by Artists Enrolled in the Public Works of Art Project" (March through August 1934) at the Minneapolis Institute of Art. Includes a partial list of artists.

0058 "Prophet without honor." *Art News* 32 (March 24, 1934): 10.

Editorial critical of the mixing of relief and art in the PWAP; still, cautiously hopeful for the future.

0059 "PWAP artists show their work in group exhibit." *Cleveland Art News* 32 (March 24, 1934): n.p.

NOT SEEN.

0060 "PWAP criticized in local press." *Art News* 32 (March 24, 1934): 10.

Report from the New York *Herald Tribune* critical of PWAP; includes response by Juliana Force claiming she showed no favoritism in hiring; and letter from William Zorach saying he received no money from PWAP.

0061 Eglinston, Laurie. "Whitney Museum falsely identified with relief work." *Art News* 32 (March 31, 1934): 3, 19–20.

Critical of artists protesting the PWAP in front of New York regional director Juliana Force's museum, the Whitney. Major part of article is comments by leading figures of the art world on PWAP; included are:
John Taylor Arms, President of the Society of Etchers;
Edward Bruce, PWAP;
Sarah E. Cowan, Secretary, American Society of Miniature Painters;
Francis S. Dixon, Secretary, Artists' Fellowship;
John Ward Dunsmore, Secretary, Artists' Federation of the City of New York;
George Pearse Ennis, AAPL;
Emily A. Frances, President of Contemporary Arts;
Anne Goldthwaite, Chairman, American Print Makers' Society;
Edith Halpert, Downtown Galleries;
Alexandrina Robertson Harris, National Association of Women Painters and Sculptors;
Selma Koller, Grand Central Art Galleries;
Leon Kroll, Chairman, American Society of Painters, Sculptors and Gravers;
Robert W. Macbeth, Macbeth Galleries;
Audrey McMahon, College Art Association;
Leonora Morton, Morton Galleries;
Dorothy Paris, Eighth Street Gallery;
Ernest Peixotto, President, National Society of Mural Painters;
Frederic Newlin Price, Feragil Galleries;
Mary Turlay Robinson, Argent Galleries;

Manfred Schwartz, Gallery 144 West 13th Street;
Harry W. Watrous, President, National Academy of Design;
plus remarks from other societies too loosely organized to
make a joint statement.

0062 "Artists work for the government." *Studio* 107 (April
1934): 221.

Brief note on the formation of the PWAP.

0063 Breeskin, Adelyn D. "Exhibition of Public works of
art project for Maryland." *Baltimore Museum of Art News-Record*
5 (April 1934): 2.

Brief account of "Exhibition of Public Works of Art Project
for Maryland" (1st three weeks in April) at the Baltimore
Museum of Art. Thirty-plus artists, all from Maryland, repre-
sented.

0064 Brodinsky, Ben P. "CWA art brightens schools." *School
Arts* 19 (April 1934): 160–61.

Explanation of how the PWAP has used artists for educa-
tional purposes; some examples of educational projects.
B/W illustrations of murals.

0065 "Public Works of Art Project." *Kansas City Art Institute
Bulletin* (April 1934): 1–2.

Note on the purpose and functions of the PWAP; note on the
exhibition of local PWAP artists' work: "[Public Works of Art
Project Exhibition]" at the Kansas City Art Institute (April 1
through ?, 1934).

0066 "Public Works of Art Project Exhibition." *Cincinnati
Museum Bulletin.* 5 (April 1934): 63.

Entry in exhibition schedule noting the exhibition, "Public
Works of Art Project Exhibition" would appear at the mu-
seum April 13–29, 1934.

0067 Watson, Forbes. "Steady job." *American Magazine of
Art* 27 (April 1934): 168–82.

"The government's methods of employing the American artist should be continued by artists and laymen in their future financial relationships," p. 169. Watson makes a call to private industry to stay a factor in the art world. Many B/W illustrations of works.

0068 "Tragedy." *Art Digest* 8 (April 1, 1934): 3–4, 11.

Editorial stating that 50,000 people claim to be artists but only 1,000 to 2,000 deserve the name. Since the PWAP cannot employ them all, those dissatisfied "artists" are ruining it for the real artists. Includes the text of Juliana Force's (Chairman of the New York Regional Committee and director of the Whitney Museum) remarks on temporarily closing the Whitney (where the PWAP New York offices were located) due to threats by artists.

0069 "Official reports on artists' relief work." *Art News* 32 (April 7, 1934): 11, 15–16.

Selected texts of speeches by Juliana Force, Forbes Watson, John S. Ankeney, Grace Gosselin, Leon Kroll, Charles J. Kraemer, Jonas Lie, Raymond W. Houston, and Audrey McMahon given at the College Art Association meeting, March 30, 1934, on the subject, "The Community Recognizes the Artist."

0070 "PWAP art work recently exhibited in middle west." *Art News* 32 (April 14, 1934): 17.

Notice of exhibits of PWAP work at Minneapolis Institute of Arts (partial list of artists; favorable comments); and Kansas City Art Institute.

0071 "John Cunning discovered." *Art Digest* 8 (April 15, 1934): 14.

Review of a show by John Cunning at the Kleemann-Thorman Gallery (New York City) that included work he had done for the PWAP.

0072 "Let us judge the results." *Art Digest* 8 (April 15, 1934): 31.

Editorial by the AAPL asking for support of the PWAP (slated to close down April 28, 1934).

0073 "Showdown." *Art Digest* 8 (April 15, 1934): 3–4.

Editorial apologizing for the strident tones of earlier (*See* **0068**) editorial, "Tragedy." Includes details on how a continuation of the PWAP is coming up for review.

0074 "Public works of art exhibition." *Minneapolis Institute of Art Bulletin* 23 (April 28, 1934): 85–86.

Review/comments on "Exhibition of Paintings, Water Colors, and Sculpture by Artists Enrolled in the Public Works of Art Project" (March through August 1934) at the Minneapolis Institute of Art. Includes some comments, mostly favorable, from visitors.

0075 Watson, Forbes. "Artist becomes a citizen." *Forum* 91 (May 1934): 277–79.

Essay by Watson on the nature of the PWAP, feeling that it should not be a simple relief project, but rather a project to raise the dignity of the American artist.

0076 Boswell, Peyton. "Adjudged." *Art Digest* 8 (May 1, 1934): 3–4.

Editorial on the exhibition at the Corcoran Gallery of Art (Washington, DC) of PWAP art. Includes some statistics: 15,000 art works acquired for $1.408 million; employed 3,521 artists. Feels that overall the government received a good deal.

0077 Boswell, Peyton. "A plague—" *Art Digest* 8 (May 1, 1934): 4, 12.

Editorial apologizing further for the "Tragedy" (*See* **0068**) editorial. Includes the full text of a "Resolution Passed by the Artists Committee of Action for the Municipal Art Gallery and Center (April 17, 1934)," condemning the *Art Digest* and Peyton Boswell for the "Tragedy" editorial.

0078 "PWAP wins praise at its 'preliminary' hearing in Washington." *Art Digest* 8 (May 1, 1934): 5–6, 32.

Edward Bruce comments on Corcoran Gallery of Art show of PWAP art. B/W illustrations of works by Gerald Foster, Xavier Gonzales (mural on which he was assisted by Rudolph Staffel and John A. Griffith), Schomer Lichtner, Malvin Gray Johnson, Dorothy Gilbert, Glenn Wessels, and Thomas Savage.

0079 Morsell, Mary. "Selected works of PWAP project at the Corcoran." *Art News* 32 (May 5, 1934): 3, 14.

Favorable review of "National Exhibition of Art by the Public Works of Art Project" at the Corcoran Gallery of Art. "The work of many of the P.W.A.P. artists seems to show a certain psychological relief and gratitude for this opportunity to paint without the subconscious necessity of following and anticipating the latest trends in modern style," p. 14. Detailed critiques of many of the works.

0080 "Paintings chosen by the President." *Art News* 32 (May 5, 1934): 17.

A list of the thirty-two PWAP works selected from the "National Exhibition of Art by the Public Works of Art Project" at the Corcoran Gallery by FDR to hang in the White House.

0081 "PWAP murals to be completed." *Art News* 32 (May 5, 1934): 5.

Announcement by Edward Bruce that all PWAP artists working on murals will be paid until the work is done, though at a reduced rate.

0082 "PWA art government officials take sides in aesthetic war." *Newsweek* 3 (May 5, 1934): 37–38.

Account of the struggle between Edward Bruce of the PWAP and the architects of the Post Office Building on the style of the mural to be installed. Recounts the story of Gilbert White's Agriculture Building mural and the controversy the mural's conservatism aroused. Brief mention of PWAP exhibition at the Corcoran Gallery.

0083 Adams, Katherine Langhorne. "Uncle Sam becomes an art patron." *Literary Digest* 117 (May 12, 1934): 42.

Favorable review of "National Exhibition of Art by the Public Works of Art Project" at the Corcoran Gallery (DC). B/W illustration of work by Julius Bloch.

0084 " 'Beyond their intelligence.' " *Art Digest* 8 (May 15, 1934): 10.

Louise Pershing did a mural in the Dormont, PA, school that was so controversial that the local PTA claimed it was unfit for children. Said Pershing: "I consider it a compliment that the people of Dormont feel they cannot accept my mural. That shows it is beyond their intelligence and understanding."

0085 Boswell, Peyton. "Questionings." *Art Digest* 8 (May 15, 1934): 3–4.

Discussion of Gilbert White's mural for the Agriculture Building and whether "Classical" representation is a valid visual vocabulary in the 20th century.

0086 "Keep PWAP alive!" *Art Digest* 8 (May 15, 1934): 30.

AAPL editorial pleading to keep the PWAP alive.

0087 "PWAP gets the credit." *Art Digest* 8 (May 15, 1934): 8.

Brief notice from the Philadelphia *Public Ledger* that interest in American art has been so stimulated by the PWAP that the Philadelphia Museum of Art extended a show of American art.

0088 "PWAP vindicated." *Art Digest* 8 (May 15, 1934): 7.

Summary of reviews of "National Exhibition of Art by the Public Works of Art Project" at the Corcoran Gallery.

0089 "Public Works of Art Project—address by Edward Bruce." *Congressional Record* 78 (May 22, 1934): 9227–28.

Extension of remarks by Sen. Frederic C. Walcott of Connecticut reprints a speech by Edward Bruce to the American Association of Adult Education (May 21, 1934) that gives a general account of the PWAP. NOTE: Reprinted as a separate document by the U.S. GPO, 1934 (9 pp.).

0090 Buchalter, Helen. "Uncle Sam's art show." *New Republic* 79 (May 23, 1934): 43–44.

Fairly favorable, but with reservations, review of "National Exhibition of Art by the Public Works of Art Project" at the Corcoran Gallery.

0091 "Art as public works: Washington exhibition." *Scholastic* 24 (May 26, 1934): 14.

Note on "National Exhibition of Art by the Public Works of Art Project" at the Corcoran Gallery; mostly excerpted text from other sources by Edward Bruce and Edwin Alden Jewell of the New York *Times*. B/W illustrations of two murals.

0092 Biddle, George. "Art renascence under federal patronage." *Scribner's Magazine* 95 (June 1934): 428–31.

Editorial preface includes the text of Biddle's letter to FDR, and FDR's reply. In this important article on the PWAP, Biddle describes the project, gives a brief history of art in America, and praises the Roosevelt Administration for having the courage to initiate such a program. "As long as we have a President who has recognized the necessity of art in life, and among his administration's leaders who are intelligently putting that recognition into practice, the government has paved the way for a national revival in American art, and the artist need not feel too gloomy about the future ahead of him," p. 431.

0093 Kellogg, Florence Loeb. "Art becomes public works." *Survey Graphics* 23 (June 1934): 279–82.

A laudatory look back at the PWAP. Includes excerpts from comments by artists: " 'Never in my career,' to quote from one letter, 'have I experienced such a lift as I feel now in my work for the government. No newspaper criticism, however kind, no exhibition of my work, no scholarship, no patronage, has fired me as does this project,' " p. 282. B/W illustrations of works by Millard Sheets, Julia Eckle, E. Dewey Albinson, Julius Bloch, Tyrone, and Robert Tabor.

0094 "Report of work in New Haven district of Connecticut." *Yale Associates Bulletin* 6 (June 1934): 29–31.

NOT SEEN.

0094a "A referendum on the desirability of an under secretary of arts in the Federal government." *Art Digest* 8 (June 1, 1934): 31.

Editorial by the AAPL on a referendum it sponsored amongst its members on a Federal bureau of art; reprints a number of comments on the proposal, including one critical of the PWAP.

0095 "Philadelphia holds museum exhibition of PWAP work." *Art News* 32 (June 16, 1934): 15.

Favorable review of an exhibition of forty-two PWAP works at the Philadelphia Museum of Art; partial list of artists.

0096 Biddle, George. "Mural painting in America." *American Magazine of Art* 27 (July 1934): 361–71.

Biddle traces the history of mural painting, from the earliest times, in the United States, the Mexican experience, and the recent PWAP murals. B/W illustrations of classic and recent murals.

0097 "Public Works of Art Project." *Cincinnati Museum Bulletin.* 5 (July 1934): cover, 67–71.

Announcement that William M. Milliken has been named regional director of the PWAP for the midwest; list of other

regional directors. B/W illustrations of works by Paul Craft, Mathias J. Noheimer, and William Gebhardt.

0098 Stanley-Brown, Katherine. "Department of fine arts, USA." *Forum* 92 (July 1934): 56–58.

Essay supporting the concept of a Department of Fine Arts; no specific reference to the PWAP, but implied.

0098a "Results of the League's referendum on the desirability of an under-secretary of fine arts in our Federal government." *Art Digest* 8 (July 1, 1934): 31.

Final results of the AAPL's referendum on a Bureau of Fine Arts (*See* **0094a**). The AAPL's members came out in favor of a such a bureau; further note in article is critical of lack of support shown by the PWAP of the AAPL's activities.

0099 "Communist propaganda in three of the frescos by artists of Public Works of Art Project in the Coit Memorial Tower, San Francisco." *California Arts and Architecture* 46 (August 1934): 4.

Editorial claiming some of the murals in the Coit Tower are Communist propaganda; the writer feels that the artists have been given a great opportunity by the government and should be giving "loyal support to that government, do their best work for it, and thereby increase the possibility of the government's being able, through popular appeal by the people, to continue and enlarge the work it has undertaken on behalf of the artists."

0100 "Appraising the PWAP." *Art Digest* 8 (August 1, 1934): 30.

AAPL editorial reports that Gilbert White says that the PWAP failed to create good art. White thinks it was a bad idea of FDR to choose thirty PWAP works for the White House.

0101 Seeley, Evelyn. "Frescoed tower clangs shut amid gasps; revolutionary scenes in the Coit memorial on San

Francisco's Telegraph hill." *Literary Digest* 118 (August 25, 1934): 24, 31.

Good account from the time of the controversy surrounding the Leftist nature (real and imagined) of the PWAP murals done for the Coit Tower. Seeley likes the murals. Photograph of the Tower and an illustration of a mural by John Langley Howard.

0102 "Denver Art Museum notes." *Western Artist* 1 (September 1934): 4.

Note that forty-seven of Lester Varian's prints of Colorado scenes done for the PWAP will be given to the Denver Art Museum.

0103 Roosevelt, Eleanor. "The new governmental interest in the arts." *American Magazine of Art* 27 (September 1934, supplement): 47.

Speech by Eleanor Roosevelt at the 25th Annual Convention of the American Federation of the Arts (held in New York City, May 16, 1934). Roosevelt praises the PWAP and comments on the Corcoran show.

0104 Rowan, Edward B. "Art exhibits for schools." *School Life* 20 (September 1934): 2, 9.

Rowan explains to educators how to get PWAP works for exhibition in their schools. Describes the five exhibits that the PWAP has available for circulation through the American Federation of Arts. B/W illustration of work by Nancy Maybin Ferguson.

0105 Biddle, George, et al. "Public Works of Art Project: a New Deal for the artist." *American Magazine of Art* 27 (September 1934, supplement): 29–34.

Proceedings of the 25th annual convention of the American Federation of Arts. Transcriptions of sessions for Tuesday, May 15, and Wednesday, May 16, 1934, held at the Corcoran Gallery, Washington, DC. Speakers included George Biddle,

Forbes Watson, and William M. Milliken. Subject of the speakers' talks centered on the good work the PWAP was doing.

0106 "Indiana's own PWAP." *Art Digest* 9 (October 15, 1934): 7.

Indiana forms its own version of the PWAP with Wilbur D. Peat as chairman.

0107 "Judges fear laughter." *Art Digest* 9 (October 15, 1934): 20.

Two Clearwater, FL, judges ordered a mural by George Hill depicting nude bathers on a Florida beach and five other murals created under the PWAP to be removed from their courthouse.

0108 "National Art Week." *Art Digest* 9 (October 15, 1934): 30, 29.

AAPL editorial on its National Art Week which was praised by the PWAP.

0109 "A store's gesture." *Art Digest* 9 (October 15, 1934): 23.

Wanamaker's Department store organizes an art exhibition in its New York and Philadelphia stores inspired by the PWAP.

0110 "PWAP work considered in relation to Newark Museum." *Art News* 33 (October 20, 1934): 9.

Note on the exhibition of thirty works in various media at the Newark Museum; statement by Bernice Winser on the accomplishments of the PWAP; partial list of artists and critiques of a number of the works.

0111 Comstock, Helen. "Public works of art project." *Connoisseur* 94 (November 1934): 334, 337.

Brief explanation and praise of the PWAP; gives some statistics.

0112 "For a federal permanent art project." *Art Front* 1 (November 1934): 1.

Call for a permanent federal art project; lists how Artists' Union will fight for the project.

0113 Gridley, Katherine. "If this be art." *Art Front* 1 (November 1934): 2.

Mocking article on the New Deal and art.

0114 "Nation buys art." *Arts and Decoration* 42 (November 1934): 31.

Commentary on the PWAP; it did some good work, encouraged young painters (examples include Mildred Jerome, Frank Mechau, Charles Kassler, Helen Dickson, and Millard Sheets) who painted people and landscapes.

0115 "National art exhibit." *Design* 36 (November 1934): 32.

Brief comments on "National Exhibition of Art by the Public Works of Art Project" at the Corcoran Gallery, April 24 through May 20, 1934. Includes brief history of PWAP and text of comments by Edward Bruce.

0116 Watson, Forbes. "Innocent bystander; Museum of modern art exhibition of the work done under the Public Works of Art Project." *American Magazine of Art* 27 (November 1934): 601–606.

Comments on the PWAP works on view at MOMA. Watson praises Alfred Barr for taking the show. Also includes a review of Edward Bruce's show at Milch Galleries (NYC).

0117 Whiting, F.A., Jr. "Further answer." *American Magazine of Art* 27 (November 1934): 569–70.

Editorial praising the creation of the Section.

0118 "Cost—$1,312,177. Worth???" *Art Digest* 9 (November 15, 1934): 12.

Statistics on the PWAP: 3,749 artists employed; $1,312,177 spent; 15,660 works created; 3,800 oil paintings; 2,900 watercolors; 1,000 etchings; and 600 sculptures.

0119 Ryder, Worth. "PWAP in Berkeley." *San Francisco Art Association Bulletin* 1 (December 1934): 2, 4.

Brief description of three PWAP projects in Berkeley; includes biographies of the three artists (E. Sievert Weinberg, Sargent Watson, and Marian Simpson) involved.

0120 Boswell, Peyton. "Uncle Sam's Plan." *Art Digest* 9 (December 1, 1934): 3–4, 18.

Praise of the announcement by Edward Bruce that a Section of Painting and Sculpture will be created within the Treasury Department. Includes a list of objectives of the Section.

0121 "Bruce as painter emerges from PWAP toil." *Art Digest* 9 (December 1, 1934): 7.

Review of show of Edward Bruce at Milch Galleries (NYC). Bruce was an artist as well as in charge of the PWAP and the Section. B/W illustration of work by Bruce.

0122 "Murals for Los Angeles." *Art Digest* 9 (December 1, 1934): 29.

Nelson H. Partridge of the PWAP regional committee in California urges the formation of a California State Art Project similar to Indiana's (*See* **0106**). Partridge claims Los Angeles is a great place for murals.

0123 *American Art Annual* 31 (1934).

Overview of the year in art, covering the PWAP and Section (pp. 6–8). Also, entry listing the staff and purpose of the Section (p. 60).

EXHIBITIONS

0124 Los Angeles County Museum. *The Public Works of Art Project: 14th Region—Southern California.* Los Angeles County Museum: Los Angeles, 1934. 8 pp.

Exhibition, March 1934. Checklist of 217 works in all media done by member of the 14th region of the PWAP (Southern California). Brief text describes the purposes and functions of the PWAP. B/W cover illustration by Stanislaw Szukalski.

0125 Public Works of Art Project. *National exhibition of art by the Public Works of Art Project, April 24, 1934, to May 20, 1934, at the Corcoran Gallery of Art, Washington.* Washington, DC, 1934. 30 pp.

Exhibition, April 24 through May 20, 1934. Catalog of 504 works in all media (murals, paintings, graphics, photographs). Foreword by Edward Bruce. Indexed by region.

0126 National Museum. Smithsonian Institution. "[Exhibition of the works produced in Washington, Maryland, and Virginia, Public Works of Art Project.]" Invitation card. NMAA/NPG Library VF.

Exhibition, May 6 through 13, 1934. No catalog for show.

MONOGRAPHS

0127 Alsberg, Henry G. *America fights the Depression. A photographic record of the Civil Works Administration.* Coward-McCann: New York, 1934. 160 pp.

Includes a section of photographs of artists at work on the art projects. Grant Wood, J.J. Greitzer, Zacrer Consulex, Michael Sarisky, Andy Tsihnahjinnie, Peter Bloom, Gale Stockwell, and Maurice Glickman. Introduction by Harry L. Hopkins; includes text of executive order creating the CWA. Alsberg later became head of the FWP.

0128 Public Works of Art Project. *Indiana authors; original woodblock prints.* PWAP: Bloomington?, 1934?. 7 pp.

NOT SEEN. CITE IN OCLC. "Portfolio includes portraits of George Ade, Albert J. Beveridge, Theodore Dreiser, Meredith Nicholson, James Whitcomb Riley, Booth Tarkington and Lew Wallace."

0129 Public Works of Art Project. *Pictures selected by the President.* GPO: Washington, DC, 1934. 1 p.

NOT SEEN. CITED IN U.S. GPO, *Catalog of the Public Documents of the 73rd Congress* (1937).

0130 Public Works of Art Project. *Regional map of the United States.* PWAP: Washington, DC, 1934. 21.25 × 16 inches. Positive photostat.

NOT SEEN. CITED IN WILCOX.

0131 Public Works of Art Project. *Report of the Assistant Secretary of the Treasury to Federal Emergency Relief Administrator.* Washington, DC, 1934. 89 pp.

Excellent resource for the study of the PWAP. Includes a list of all PWAP administrative personnel, and names and addresses of PWAP artists. Includes a photograph of regional and national staff plus numerous B/W illustrations of works.

0132 Public Works of Art Project. *Santa Monica Library murals.* PWAP: Los Angeles, 1934. 16 pp.

Guide to the murals created in the Santa Monica Public Library by Stanton Macdonald-Wright for the PWAP. The murals were begun February 8, 1934, under the PWAP and completed August 25, 1935. B/W illustrations of the murals. Mcdonald-Wright was assisted by Henry Hibbard and Fred Bessinger, primarily with technical details (preparing canvases, etc.).

0133 US Congress. *The statutes at large of the United States of America from March 1933 to June 1934.* Vol. 48, part 1, pp. 200–10. GPO: Washington, DC, 1934.

48 Statute Chapter 90, Title II (June 16, 1933) "Public Works and Construction Projects" is the law under which the PWAP was put into effect. No specific mention of the PWAP.

0134 Wilcox, Jerome Kear, comp. *Guide to the official publications of the New Deal administrations.* American Library Association: Chicago, 1934. 113 pp.

In addition to a list of the art project parent organizations, Wilcox provides brief sketches of the agencies; covers period March 1933 through April 15, 1934. NOTE: Supplement covering April 15, 1934, through December 1, 1935, issued in 1936 (183 pp.) and second supplement, covering December 1, 1935, through January 1, 1937, in 1937 (190 pp.).

1935

0135 Witte, Ernest F. "The Nebraska FERA art exhibit." *Nebraska History Magazine* 16 (January-March 1935): 57–60.

Account of an exhibition of PWAP work at the Nebraska State Historical Society October 4–5, 1934; includes list of twenty-eight artists and sixty works. Explains what the PWAP was about.

0136 "Artists' Union Federal Art Bill." *Art Front* 1 (January 1935): 2.

Text of a bill proposed by the Artists' Union for a Federal Art program. "It incorporates much of the PWAP on a more inclusive scale, and summarized the several plans that have been advertised from time to time by the Artists' Union."

0137 "New frescoes in the Southwest." *Survey Graphic* 24 (January 1935): 23–25.

Primarily B/W illustrations of murals by Victor Higgins, Emil Bisttram, Bert G. Phillips, and Ward Lockwood for the Taos County Court House, Taos, NM (a PWAP project).

0138 Watson, Forbes. "Art and government in 1934." *Parnassus* 7 (January 1935): 12–16.

Good account by Watson of his work with the PWAP; humorous at the expense of the Civil Servant. Discusses the Section and how it differs from the other art projects. B/W illustrations of works by Vinal Winter, Rinaldo Cuneo, Ben Knotts, Anne Guy MacCoy, Ben Shahn.

0139 "What now, Mr. Bruce?" *Art Front* 1 (January 1935): 3.

An article critical of Edward Bruce's and Forbes Watson's plans for the Section.

0140 The Commercial Artists Section of the Artists' Union. "What is rock-bottom?" *Art Front* 1 (February 1935): 2.

Proposed program for commercial artists; support for the Federal Art bill.

0141 "H.R. 2827." *Art Front* 1 (February 1935): 3.

Discussion of H.R. 2827, an unemployment insurance bill; comments on Federal Art bill proposed by Artists' Union.

0142 Jourdan, Albert. "Sidelights on othergraphers and photographers." *American Photography* 29 (February 1935): 98–107.

Jourdan, photographer-in-chief for a PWAP region (in charge of photographing the works of art created), makes a case for classifying photography as an art (as the "othergraphies" of printing and drawing are arts). Includes a reproduction of a letter from Edward Bruce to Jourdan on the art projects.

0143 "Exhibition of mural painting contrasts early style with new." *Art Digest* 9 (February 15, 1935): 12.

Showing the history of wall decoration in the United States, an exhibition at the Grand Central Art Galleries (NYC) show included work by PWAP artists. The mural by PWAP artist Louis G. Ferstadt (illustrated in B/W) for the Abraham Lincoln High School in Brooklyn, NY, was the centerpiece of the show.

0144 "Calm after the storm." *Art News* 33 (February 23, 1935): 8.

Editorial critique of the PWAP, particularly the mural project; mixed encouragement of the concept of federal patronage.

0145 Alexander, Stephen. "Art: mural painting in America." *New Masses* 14 (February 26, 1935): 28.

Alexander feels that there was no freedom of expression for the PWAP artists and thus they never were able to create truly revolutionary works.

0146 Burck, Jacob and Aaron Berkman. "Revolution in the art world." *American Mercury* 34 (March 1935): 332–42.

Burck argues for the proletarian art, such as was done by the PWAP and Section; Berkman is against such art.

0147 US Treasury Department. Section of Painting and Sculpture. *Bulletin. Section of Painting and Sculpture* 1 (March 1, 1935): 10 p.

General introduction on how the Section will operate. Announcement of 13 competitions:
Washington, DC, Post Office Building, $95,128;
Washington, DC, Department of Justice, $75,000;
Bridgeport, CT, Post Office, $2,120, (later won by Arthur S. Covey and Robert Lynn Lambdin);
Louisville, KY, Marine Hospital, $1,925 (later won by Henrik Martin Mayer);
Merced, CA, Post Office, $1,450 (later won by Dorothy Puccinelli and Helen K. Forbes);
Ravenna, OH, Post Office, $778 (later won by Clarence H. Carter);
Springfield, OH, Post Office, $960 (later won by H.H. Wessel);
Wichita, KS, Post Office, $1,880 (later won by Richard Haines and Ward Lockwood);
Beverly Hills, CA, Post Office, $2,980 (later won by Charles Kassler);
Barnesville, OH, Post Office, $1,296 (later won by Michael Sarisky);
Cleveland, OH, Post Office, $3,400 (later won by Jack J. Greitzer);

Portsmouth, OH, Post Office, $4,158 (later won by Clarence
 H. Carter and Richard Zoellner);
Lynn, MA, Post Office, $3,712 (later won by William Rise-
 man).

0148 "Last frontier; mural panels by V. Hunter for the new
courthouse at Fort Sumner." *Survey Graphic* 24 (April 1935):
175–77.

Primarily B/W illustrations of the mural for the Fort Sumner
Court House (TX) by Vernon Hunter.

0149 Pearson, Ralph M. "Renaissance in American art."
Forum 93 (April 1935): 202–204.

Pearson feels that public support for the arts—particularly
the New Deal projects—is leading the way in a Renaissance of
American art.

0150 "Wages for artists." *Art Front* 1 (April 1935): 3.

Editorial complaining of the low wages paid artists on the
projects; calls for more federal aid to the arts.

0151 Whiting, Philippa. "Speaking about art." *American
Magazine of Art* 28 (April 1935): 230–33.

Praise for the founding of the Section, covering how now the
government can truly support the arts and not just provide
relief: "The Government, however, answers that its artists are
workers and citizens, not incompetents for whom no one but
the Government itself has any use," p. 231.

0152 "U.S. projects." *Art Digest* 9 (April 1, 1935): 7, 29.

The Section announces jobs for decorating the Department
of Justice and Post Office buildings in Washington. Expendi-
ture will be $170,128 and twenty-two painters and ten sculp-
tors will be chosen. The advisory committee is named. An
overview of the program is included as well as a list of
regional projects.

0153 US Treasury Department. Section of Painting and Sculpture. *Bulletin of the Section of Painting and Sculpture* 2 (April 1, 1935): 14 pp.

List of the winners of the Department of Justice and Post Office Buildings competitions as well as the manner in which they were selected; also includes a list of suggested topics they will work on. Announcement of ten competitions:

Pittsburgh, PA, Post Office and Courthouse, $9,850 (later won by Howard Cook, Kindred McLeary, and Stuyvesant Van Veen);

Philadelphia, PA, U.S. Custom House, $4,890 (later won by George Harding);

New London, CT, Post Office, $4,437 (later won by Thomas La Farge);

Hempstead, NY, Post Office, $4,425 (later won by James Brooks);

New Bern, NC, Courtrooms of the Post Office, $3,129 (later won by David Silvette);

Norristown, PA, Post Office, $1,950 (later won by Paul Mays);

Stockton, CA, Post Office, $1,138 (later won by Frank Bergman and Moya Del Pino);

Newark, NJ, Post Office and Courthouse, $6,500 (for statue, later won by Romuald Kraus) and $1,920 (for a mural, later won by Tanner Clark);

Chattanooga, TN, Post Office and Courthouse, $1,500 (later won by Hilton Leech);

Freehold, NJ, Post Office, $882 (later won by Gerald Foster).

0154 "U.S. projects." *Art Digest* 9 (April 15, 1935): 16.

List of competitions opened for local art projects run by the Treasury Department.

0155 US Treasury Department. Section of Painting and Sculpture. *Bulletin of the Section of Painting and Sculpture* 3 (May–June 1935): 16 pp.

Reprints some of the testimony of Christian J. Peoples (Director of Procurement), Edward Bruce, and Louis A. Simon (Supervisory Architect, Department of the Treasury) before the Committee on Patents, 74th Congress, 1st Session

on the proposed Bureau of Fine Arts (*See* **0213**). Announcement of fifteen competitions:
Buffalo, NY, Marine Hospital, $2,800 (later won by William B. Rowe);
Carthage, IL, Post Office, $470 (later won by Karl Kelpe);
Dubuque, IA, Post Office, $1,925 (later won by William Bunn and Bertrand Adams);
East Alton, IL, Post Office, $360 (later won by Francis Foy);
East Moline, IL, Post Office, $560 (later won by Edgar Britton);
Fairfield, IL, Post Office, $240 (later won by William S. Schwartz);
Gillespie, IL, Post Office, $320 (later won by Gustaf Dalstrom);
Holyoke, MA, Post Office, $2,400 (later won by Ross Moffett);
Jackson, MS, Post Office and Courthouse, $4,450 (NO AWARD);
Jeannette, PA, Post Office, $925 (later won by T. Frank Olson);
Melrose Park, IL, Post Office, $650 (later won by Edwin B. Johnson);
Moline, IL, Post Office, $1,100 (later won by Edward Millman);
St. Johns, OR, Post Office, $1,050 (later won by John Ballator);
Vandalia, IL, Post Office, $750 (later won by Aaron Bohrod).

0156 "Boon-doggling." *Art Front* 1 (May 1935): 3.

Editorial critical of those who call the art projects "boon-doggling."

0157 "Competition with-out pay." *Art Front* 1 (May 1935): 3.

Critical of Section process which forces artists to work on competition entries for which only the winners receive payment.

0158 "Nobody loves him." *Art Front* 1 (May 1935): 3.

Highly critical article of Jonas Lie, member of Municipal Art Commission and no friend of the projects.

0159 "30,000 more jobs." *Art Front* 1 (May 1935): 1.

Call to increase work relief for artists.

0160 Weaver, John Henry. "Practical plan for public works of art." *Design* 37 (May 1935): 35.

Due to the dissatisfaction expressed by PWAP artists, Weaver (founder of Art Interest, Artists' Cooperative, and the Career Clinic) suggests local jurisdictions (press, public, museums, schools, libraries, etc.) vote on the worth and value of art; he feels this will increase the public's interest in art.

0160a "Art and nation; hearings on establishment of a department of science, art and literature." *Art Digest* 9 (May 7, 1935): 7.

Note on the hearings held on H.R. Res. 220 in Washington. (*See* **0213**). Reprints some of the testimony of Edward Bruce.

0160b Boswell, Peyton. "Secretary of arts." *Art Digest* 9 (May 15, 1935): 3–4, 10.

Boswell editorializes in favor of H.J. Res. 220, the creation of a Department of Science, Art and Literature.

0161 "Let us work together for a division of portraiture in our federal government." *Art Digest* 9 (May 15, 1935): 31.

AAPL editorial to include a portraiture division in the Section.

0162 Boswell, Peyton. "American 'Annual.' " *Art Digest* 9 (June 1935): 3–4.

Boswell reprints C.J. Bulliet's comments from the New York *Daily News* on Boswell's article on American art from the *Encyclopedia Americana Annual* in which Boswell wrote extensively on the PWAP.

0163 "Murals, murals everywhere, for felons, students—and art critics." *Art Digest* 9 (June 1, 1935): 10.

Overview of the mural projects and the criticism and controversy they caused. B/W illustration of work by Moses Soyer.

0164 "Our government in art." *Milwaukee Art Institute Bulletin* 9 (June 1935): 3.

Announcement of exhibition of PWAP work from nine regions, "Our Government in Art" (June 6–30, 1935). Lists two Milwaukee artists included (Peter Rotier and Richard Janson).

0165 Sizer, T., "Art project for Connecticut." *Yale Associates Bulletin* 6 (June 1935): 60–62.

NOT SEEN.

0165a Watson, Forbes. "The innocent bystander." *American Magazine of Art* 28 (June 1935): 371–74.

Watson, himself a strong supporter of the Section and PWAP, is highly critical of H.J. Res. 220, the establishment of a Department of Science, Art and Literature; Watson fears it will regiment art.

0166 US Treasury Department. Section of Painting and Sculpture. *Bulletin of the Section of Painting and Sculpture* 4 (July–August 1935): 16 pp.

Statements by Edward Rowan and Olin Dows on the progress of the Section; note on the division that would become TRAP; biographies of previous competition winners Charles Kassler, Robert Lynn Lambdin, Arthur Covey, Paul Mays, Clarence H. Carter, Henrik Martin Mayer, William Riseman, and Michael Sarisky. Announcement of three main and four auxiliary competitions:
Ames, IA, Post Office, $1,300 (later won by Lowell Houser);
Cresco, IA, Post Office, $500 (later won by Richard Haines);
Harlan, IA, Post Office, $480 (later won by Richard Gates);
Independence, IA, Post Office, $450 (later won by Robert Taber);

Hagerstown, MD, Post Office, $2,700 (later won by Frank
 Long);
Hyattsville, MD, Post Office, $620 (later won by Eugene
 Kingman);
LaFayette, IN, Post Office and Courthouse, $700 (later won
 by Hendrik Martin Mayer).

0167 Davis, Stuart. "We reject—the art commission." *Art Front* 1 (July 1935): 4–5.

Davis gives a history of the Riker's Island Penitentiary (NYC)
murals by Ben Shahn which the New York City Municipal Art
Commission rejected because of their "psychological unfit-
ness." Davis is critical of Jonas Lie, chairman of the commis-
sion, a painter, and president of the National Academy of
Design, calling him a "Fascist Censor." B/W illustration of
Shahn's mural.

0168 Pearson, Ralph M. "Impotent America; the trouble
with the arts." *Forum* 94 (July 1935): 34–37.

Essay explaining how anti- or unbalanced intellectualism in
America has inspired poor government sponsored art; cites
the Section's Post Office and Justice Department murals as
examples of this poor work; includes a number of other
examples from other areas of the arts.

0169 "Morals in murals." *Art Front* 1 (July 1935): 3.

Editorial commenting that only bad murals will meet with
official approval. Ben Shahn, Lou Block, and Louis Ferstadt
are listed as artists who did good work that was not liked.

0170 "$19–$94 or fight." *Art Front* 1 (July 1935): 3.

Editorial commenting that artists must unionize to keep
government wages at adequate levels. Brief history of relief
wage scales.

0171 Bruce, Edward. "Art and democracy." *Atlantic
Monthly* 156 (August 1935): 149–52.

An excellent statement of Bruce's beliefs on what the government should do for art, what a democracy means to the artist, and what America means. A description of what the PWAP was and what the Section will become. "What we need is not official art, pompous art, but the fostering and cultivation throughout the country of the creative spirit which is ready to spring up everywhere," p. 152.

0172 Davis, Stuart. "The artist of today." *Magazine of Art* 28 (August 1935): 476–78, 506.

Overview of the work of the Artists' Union; brief comments on its relationship to the New Deal art projects.

0173 "Paint, time, and talent working." *Literary Digest* 120 (August 24, 1935): 22.

Account of the Section murals in New York schools. B/W illustration of mural by Eric Mose.

0173a Watson, Forbes. "Comments and criticism." *American Magazine of Art* 28 (August–September 1935): 489–91.

Watson reprints the mostly negative readers' reactions to H.J. Res. 220, a Department of Science, Art and Literature. *See also* **0165a**.

0174 "With the artist." *Western Artist* 2 (September 1935): 7.

From Santa Fe the news is that forty-five paintings done by Navajos, Pueblos, and Kiowas were sent to the Section in Washington; from Taos, Emil Bisttram, E.L. Blumenschein, Kenneth Adams, Herbert Dunton, Victor Higgins, and Ward Lockwood are involved in Section competitions.

0175 U.S. Treasury Department. Section of Painting and Sculpture. *Bulletin of the Section of Painting and Sculpture* 5 (September 1935): 20 pp.

Statement by Edward Bruce on the Section; biographies of Jack J. Greitzer, Richard Haines, Ward Lockwood, Gerald Foster, George Harding, Richard Zoellner, Tom La Farge,

and James Brooks; instructions on how to apply for TRAP projects. Announcement of one competition:
Summit, NJ. Post Office, $1,450 (later won by Fiske Boyd).

0176 Grafly, Dorothy. "Who is an artist?" *Art Digest* 9 (September 1, 1935): 25.

Dorothy Grafly of the Philadelphia *Inquirer* claims that PWAP and other projects did not find the best people for the jobs done.

0177 Millier, Arthur. "Murals and Men." *Art Digest* 9 (September 1, 1935): 6.

Arthur Millier's view of the government's murals; he gives advice to modern day muralists.

0178 "Murals, murals in every post office, but what do they express?" *Art Digest* 9 (September 1, 1935): 7–8.

Overview of the Section's Post Office mural projects. B/W illustrations of works by Paul Mays and Tom La Farge.

0179 "Relief for Artists." *Art Digest* 9 (September 1, 1935): 11.

Announcement of the Treasury Relief Art Project. The TRAP will employ 400–500 artists. Though relief is still the major goal the TRAP will also have quality art as a motive.

0180 "Uncle Sam as a patron of the brush, lyre, pen and mask." *Newsweek* 6 (September 21, 1935): 40.

Announces the creation of Federal One; lists the four directors for FAP, FMP, FWP, FTP.

0181 US Treasury Department. Section of Painting and Sculpture. *Bulletin of the Section of Painting and Sculpture* 6 (October–November 1935): 16 pp.

Note on the functions of TRAP; biographies of the winners of the Post Office Building competition Stirling Calder, Arthur Lee, Berta Margoulies, Oronzio Maldarelli, Attilio Piccirilli,

Concetta Scaravaglione, Carl L. Schmitz, Sidney Waugh, Heinz Warneke, Gaetano Cecere, Alfred D. Crimi, Carl Free, Frank A. Mechau, and William C. Palmer. Announcement of one competition:
Rochester, NY. Post Office, $2,210 (later won by David Granahan).

0182 Schwankovsky, Frederick J. "A mural in search of a wall." *California Arts and Architecture* 48 (October 1935): 15, 34.

History of the PWAP mural done for the Frank Wiggins Trade School, Los Angeles, in 1934 by Leo Katz. Due to the controversy surrounding the center panel which portrayed a man torn between good and a very graphic depiction of evil; ironically calls for artist to depict only what is good and ideal in life. An excellent article on the controversies that became tied up in the government work. B/W illustration of the controversial section of the rather excellent mural.

0183 "With the artist." *Western Artist* 2 (October 1935): 5.

From Boulder, the University of Colorado opens an exhibition of prints by PWAP artists; from Colorado Springs, Frank Mechau is placed in charge of the Section's work on government buildings in Denver.

0184 "Call for an American Artists' Congress." *New Masses* 17 (October 1, 1935): 33.

Primarily a discussion of why an American Artists' Congress is needed; New Deal art projects are only mentioned in passing.

0185 "Wright's huge mural, 200 figures, is in place." *Art Digest* 10 (October 1, 1935): 7.

Stanton Macdonald-Wright completes a mural for the Santa Monica Library. Includes commentary on the mural and an illustration.

0186 "Federal pulmotor for the arts." *Literary Digest* 120 (October 12, 1935): 24.

Brief account of the activities of Federal One; all four projects (FAP, FMP, FTP, and FWP) are discussed.

0187 "Federal art project is outlined in detail by its supervisors; with a list of the members of the national committee." *Art News* 34 (October 19, 1935): 13.

Excellent outline of the FAP as proposed by Holger Cahill and Audrey McMahon; list of national committee members.

0188 "Frank Mechau Colorado artist wins at Chicago." *Western Artist* 2 (November 1935): cover, 15–16.

Note that Frank Mechau has won a Section competition for the Post Office Department building in Washington. B/W illustration of work.

0189 "New federal art shown, Washington, D.C." *American Magazine of Art* 28 (November 1935): 690, 700–701.

Review of Treasury Department show at the Corcoran Gallery (Washington, DC, October 29, 1935 ff.); includes a partial list of artists and the jury.

0190 "Watkins and Bear regional WPA art directors." *Museum News* 13 (November 1, 1935): 2.

C. Law Watkins and Donald Bear are named regional directors of the FAP; names of the other regional directors also given.

0191 "Artists get their own New Deal; commissions for murals and statues in new post office at Washington." *Literary Digest* 120 (November 2, 1935): 22.

Account of the first Section contest for the Post Office building in Washington. B/W illustrations of works by Alfred D. Crimi, Stirling Calder, and Sidney Waugh.

0192 "Postal art test winners named." *Art News* 34 (November 16, 1935): 23.

Announcement of Section winners for Post Office murals and sculpture; list of jury members.

0193 Danysh, Joseph A. "WPA assists San Francisco Artists." *San Francisco Art Association Bulletin* 2 (December 1935): 4.

Explanation of how the FAP will operate in the San Francisco area.

0194 US Treasury Department. Section of Painting and Sculpture. *Bulletin of the Section of Painting and Sculpture* 7 (December 1935): 18 pp.

Reprint of statement by Olin Dows to the Mural Painters Association on what the Section and TRAP are doing; list of all Post Office and Justice Department Building winners; list of fourteen TRAP projects underway with a description of the projects and a list of the artists; biographies of Dorothy Puccinelli, Helen Forbes, John R. Ballator, David Silvette, Howard Cook, Kindred McLeary, Ross Moffett,and William B. Rowe.

0195 "Federal winners." *Art Digest* 10 (December 1, 1935): 26.

Winners of the Post Office and Justice Department mural competitions are announced. Includes a list of the winners and jury members.

0196 Hopper, Inslee A. "America in Washington; designs to be executed under the supervision of the Section of Painting and Sculpture." *American Magazine of Art* 28 (December 1935): 719–25.

Further review of the Corcoran Gallery show of Section mural work; very highly praised. Includes B/W illustrations of works.

0197 "Mechau mural is feature of exhibition inspired by PWAP work." *Art Digest* 10 (December 1, 1935): 13.

In a group show of painters associated with the PWAP at the Midtown Galleries (NYC) through December 9, 1935, a work by Frank Mechau (illustrated) is focused on.

0198 "US projects gave artists a chance to spread themselves." *Newsweek* 6 (December 7, 1935): 29.

Brief account of the Section, specifically Section artist William C. Palmer ("supervising [artist] of the New York WPA project"]. Photograph of Palmer.

0199 "WPA to offer gallery tours." *Art News* 34 (December 7, 1935): 5.

FAP to organize a program of tours of art galleries to be called Art Gallery Tours; supervised by Lincoln Rothschild.

0200 *American Art Annual* 32 (1935).

"The Federal Government and Art," by F.A. Whiting (pp. 5–10) covers organization and operations of the Section and TRAP; gives a list of projects contemplated or begun. Staff and purposes of the Treasury Department Art Project (Section and TRAP) given on p. 71.

EXHIBITIONS

0201 Public Works of Art Project. *Catalog of exhibits. United States Department of Labor.* Washington: GPO, 1935. 6 pp.

Exhibition, 1935?. Checklist of 150 works on loan from the PWAP to the Department of Labor; these works were shown in the PWAP's Corcoran show (*See* **0125**).

0202 Grand Central Art Galleries. *Mural painting in America.* Grand Central Art Galleries: New York, 1935. 3 pp.

Exhibition, February 14 through 16, 1935. Checklist of works in show. Includes a selection of photographs of PWAP murals.

0203 Federal Art Gallery. *Mural Sketches.* 1935.

Exhibition, December 27, 1935, through January 11, 1936. No catalog. CITED IN *40 Exhibitions at the New York Federal Art Gallery,* (*See* **0915**).

MONOGRAPHS

0204 Federal Art Project. *The Federal Art Project. A summary of activities and accomplishments.* New York, 1935?. Mimeographed. 6 ll.

A number of these "surveys" were published during the lifetime of the FAP, both by the national and regional offices. The general tone and purpose was to present an upbeat, enthusiastic endorsement of the FAP.

0205 Federal Art Project. *The WPA Federal Art Project. A summary of activities and accomplishments.* New York, 1935?. Mimeographed. 5 ll.

A number of these "surveys" were published during the lifetime of the FAP, both by the national and regional offices. The general tone and purpose was to present an upbeat, enthusiastic endorsement of the FAP.

0206 Federal Art Project. *Federal Art Project manual.* Washington, DC, 1935. 23 pp. mimeographed.

The perfect example of the Federal bureaucracy at work. Detailed explanation of the structure of the hierarchy of the FAP; definitions of what constitutes an art "project," definitions of skill levels for workers (who can be an "artist," who is a "technician," who is "unskilled"); copies of employment forms and instructions for filling out the paperwork required for timekeeping, disposal of art works, and supervision.

0207 Federal Art Project. New Jersey. *The Federal Art Project in New Jersey. The WPA Federal Art Project. A summary of activities and accomplishments.* Newark, 1935?. Mimeographed. 8 ll.

A good review/summary of the FAP activities in New Jersey.

0208 Miller, Dorothy Canning. "Painting and sculpture." In *Collier's Yearbook 1935*, pp. unknown.

NOT SEEN.

0209 Public Works of Art Project. *Twelve examples of Navajo weaving from drawings cut on linoleum blocks.* Santa Fe, NM, 1935. 1 l; 12 plates.

Ruth Connely of the PWAP and the New Mexico Relief Administration did 12 linocuts to "provide colored prints for use by the United States Indian service, in encouraging a revival of the order designs in Navajo weaving, as a part of its broad program in Indian arts and crafts" [from accompanying mimeograph]. Each plate is dated on verso "1934." Plates 1–6 are from designs at the Laboratory of Anthropology and Indian Arts Fund in Santa Fe; Plates 7–8 are from the American Museum of Natural History (NYC); and 9–12 from private collections. In portfolio.

0210 Roosevelt, Franklin D. *Executive Order No. 7034.* May 6, 1935.

Under the authority of the "Emergency Relief Appropriation Act of 1935," approved April 8, 1935 (Public Resolution No. 11, 74th Congress), FDR issued Executive Order 7034 which established the Works Progress Administration under which the FAP was created.

0211 Treasury Department. Procurement Division. Public Works branch. Section of Painting and Sculpture. *Operating plan of the section of painting and sculpture.* Washington, DC, 1935. Mimeographed. 2 pp.

NOT SEEN. CITED IN WILCOX.

0212 US Congress. House of Representatives. *A joint resolution providing for the establishment of an Executive department to be known as the Department of Science, Art, and Literature.* H.J. Res. 220, 74(1), 1935. 3 pp.

Joint Resolution introduced March 18, 1935, by William I. Sirovich that would have created a Cabinet position of Secretary of Science, Art and Literature. First important attempt to make the New Deal art projects a permanent,

legislated part of government. *See* **0213** for hearings on the resolution. Never reached the floor.

0213 US Congress. House of Representatives. Committee on Patents. *Department of Science, Art, and Literature.* Hearings held April 15, 16, 23–25, May 14, 21, 1935. 74(1). GPO: Washington, DC, 1935. 404 pp.

Hearings held on H.J. Res. 220. Near universally favorable testimony for William I. Sirovich's proposed Department of Science, Art, and Literature. Those testifying from the field of fine arts were: Gutzon Borglum (sculptor, pp. 155–71); Anthony J. Atchison (painter and sculptor, pp. 198–202); Edward Bruce (pp. 21–28, 54–67; Bruce makes some interesting comments, though he favors the resolution, he makes it plain that the Section should not be included in the new Department); Christian J. Peoples (pp. 171–79; like Bruce, Peoples makes it clear the Section does not belong in the proposed Department).

0214 Works Progress Administration. *WP-7, August 2, 1935.* WPA: Washington, DC, 1935. 1 p.

"WPA Sponsored Professional and Service Projects." This document announces the creation of the Federal One projects to all state WPA administrators, signed by FWP assistant administrator. REPRINTED IN: Pt. 7, p. 6. of US Works Progress Administration. *Digest of Publications Released by the Works Progress Administration and the National Youth Administration.* WPA: Washington, DC, 1936. Various pagination.

0215 Works Progress Administration. *WPA-60, September 28, 1935.* WPA: Washington, DC, 1935. 1 p.

"Nation-wide Arts, Music, Theatre and Writing Projects." This document announces the creation of the Federal One projects and names each unit's director to all state WPA administrators, signed by Harry L. Hopkins. REPRINTED IN: Pt. 8, p. 9. of US Works Progress Administration. *Digest of*

Publications Released by the Works Progress Administration and the National Youth Administration. WPA: Washington, DC, 1936. Various pagination.

0216 Works Progress Administration. *Professional and Service Projects, Bulletin No. 29, September 4, 1935.* WPA: Washington, DC, 1935.

WPA issued bulletin defining the basic operating procedures of the Federal One projects. REPRINTED IN MCDONALD, pp. 130–31.

0217 Works Progress Administration. *Letter. WPA-60. September 29, 1935.* WPA: Washington, DC, 1935.

General instructions for state WPA administrators regarding Federal One; signed Holger Cahill. REPRINTED IN MC-DONALD, pp. 131–32.

0218 Works Progress Administration. *Professional and Service Projects, Bulletin No. 29, Supplement No.1, September 30, 1935.* WPA: Washington, DC, 1935. 1 p.

"WPA Sponsored Federal Project No.1—Art, Music, Theatre, and Writing." This document announces the creation of the Federal One projects. REPRINTED IN: Pt. 3, p. 6. of US Works Progress Administration. *Digest of Publications Released by the Works Progress Administration and the National Youth Administration.* WPA: Washington, DC, 1936. Various pagination.

0219 Works Progress Administration. *Administrative order no.35, November 26, 1935.* WPA: Washington, DC, 1935. 1 p.

"Exemptions of Certain Works from the 90% Rule." This document states: "Jacob Baker is authorized to exempt any unit of the WPA sponsored Federal Project No.1 and O.P. 12-141, Treasury Relief Art Project, from the 90% rule and to permit the employment of up to 25% of the workers on such units without regard to the relief requirement." REPRINTED IN: Pt. 2, p. 5. of US Works Progress Administration. *Digest of Publications Released by the Works Progress Adminis-*

tration and the National Youth Administration. WPA: Washington, DC, 1936. Various pagination.

0220 Works Progress Administration. *Adjustment order no.13, December 6, 1935.* WPA: Washington, DC, 1935. 1 p.

"Adjustment of Personnel on the Federal Art Project of the Works Progress Administration Sponsored Federal Project No.1." This document states: "Not less than 75% of all workers on the Federal Art Project shall be taken from the public relief rolls in the states listed herein." REPRINTED IN: Pt. 1, p. 2. of US Works Progress Administration. *Digest of Publications Released by the Works Progress Administration and the National Youth Administration.* WPA: Washington, DC, 1936. Various pagination.

0221 Works Progress Administration. *Adjustment order no.14, December 6, 1935.* WPA: Washington, DC, 1935. 1 p.

"Adjustment of Personnel on O.P. 12-141, Treasury Relief Art Project." This document states: "Not less than 75% of all workers on the Treasury Relief Art Project, O.P. 12-141, shall be taken from the public relief rolls. The Chief of TRAP will be responsible for keeping the records of relief and non-relief personnel of this project." REPRINTED IN: Pt. 1, p. 2. of US Works Progress Administration. *Digest of Publications Released by the Works Progress Administration and the National Youth Administration.* WPA: Washington, DC, 1936. Various pagination.

1936

0222 US Treasury Department. Section of Painting and Sculpture. *Bulletin. Treasury Department Art Projects* 8 (January–February 1936): 35 p.

Overview of Section accomplishments; list of thirty-seven approved projects and thirty TRAP projects just undertaken; amusing comments by Reginald Marsh on his work for the Section; biographies of Edgar Britton, Moya Del Pino, Frances Foy, and W. Vladimir Rousseff. Announcement of six competitions:

Bronx, NY, Post Office sculpture, $7,500 (later won by Henry Kreis and Charles Rudy);

Washington, DC, Justice Department, Three additional murals, $2,000 (later won by John R. Ballator, Emil Bisttram, and Symeon Shimin);

Iron Mountain, MI, Post Office, $620 (later won by W. Vladimir Rousseff);

Huntington Park, CA, Post Office, $950 (later won by Norman Chamberlain);

International Falls, MN, Post Office, $1,440 (later won by Lucia Wiley);

Hudson Falls, NY, Post Office, $710 (later won by George Picken).

0223 McMahon, Audrey. "The trend of the government in art." *Parnassus* 8 (January 1936): 3–6.

McMahon feels that government patronage of the arts has been a good thing and hopes that the government will stay a permanent patron. An excellent article on what the projects were doing. "Nothing is to be gained by the separate consideration of these various programs. It is safe, I believe,

to prophesy that retrospectively they will be envisaged by art historians as one and the same thing," p. 3. B/W illustrations of works by Lucienne Bloch, Seymour Fogel, Moses Soyer, James Penney, Concetta Scaravaglione, Beniamino Bufano, Frank Mechau.

0224 "25% non-relief." *Art Front* 2 (January 1936): 4.

A cry to repeal the "pauper's oath"—the requirement that a certain percentage of FAP workers meet a relief needs test; report on the FAP's announcement raising from 10% to 25% the number of artists that must meet the relief requirements to be in program; article calls for a 100% exemption from a needs test.

0225 "Federal artists; commissions awarded to 19 sculptors and 44 painters." *Art Digest* 10 (January 1, 1936): 21.

Section awards commissions to nineteen sculptors and forty-four painters. List of artists and juries included.

0226 "Government buys Cassidy's 'Breaking Camp.'" *Art Digest* 10 (January 1, 1936): 17.

A painting by Gerald Cassidy, who died in 1934 while working for the PWAP in New Mexico, is purchased for the Department of Interior building in Washington.

0227 "WPA gallery opens." *Art Digest* 10 (January 1, 1936): 10.

The Federal Art Gallery of the FAP opens at 7 E. 38th Street (in mid-December); will show artists associated with the FAP.

0228 "Murals on view at city gallery, by artists working on the Federal Art Project since 1934." *Art News* 34 (January 11, 1936): 14.

Favorable review of "Mural Sketches" at the Federal Art Gallery; partial list of artists.

0229 Taylor, Francis Henry. "American artist: 1935." *Atlantic Monthly* 157 (February 1936): 182–88.

Taylor writes on the concept of government as patron, feeling that it should do more to help the young artist; looks towards the future as a good time for the artist if the government continues its patronage so that in another time there will have been developed a body of artists nurtured on government patronage.

0230 Clements, Grace. "Natural organization." *Art Front* 2 (February 1936): 2, 14–15.

Writing from Los Angeles, Clements praises the formation of the Artists' Union and hopes to do the same on the West Coast. Decries censorship in the PWAP and is critical of the needs test for artists in federal programs.

0231 "Design laboratory, New York." *American Magazine of Art* 29 (February 1936): 117.

Note on the Design Laboratory at 10 E. 39th Street in New York City, a program of the FAP. " 'It is a free school for instruction in industrial design, graphic arts and fine arts,' " according to Design Lab brochure.

0232 "For a permanent art project." *Art Front* 2 (February 1936): 3.

Editorial demanding a permanent fine arts project. "Political speeches and tram-rides are not the answer to our problem. What we want is a permanent Federal Art Project."

0233 "July 1st, 1936." *Art Front* 2 (February 1936): 3–4.

The title is in reference to the date the FAP was to be terminated; urges Congress to extend the FAP.

0234 Groschwitz, Gustav von. "Making prints for the U.S. government; W.P.A. graphic arts project in New York City." *Prints* 6 (February 1936): 135–42.

Discussion of the Graphics Division of FAP; how prints are actually made; detailed comments on the work of a number of artists. B/W illustrations of prints by Harold Le Roy

Taskey, Mabel Dwight, Albert Abramovitiz, and Albert J. Webb.

0235 US Treasury Department. Section of Painting and Sculpture. *Bulletin. Treasury Department Art Projects* 9 (March–April–May 1936); 24 pp.

Notes on the TRAP projects; biographies of Bertrand R. Adams, Aaron Bohrod, Fiske Boyd, William Bunn, David Granahan, Lowell Houser, H.H. Wessel, and Ray Boynton. Announcement of seven competitions:
Santa Barbara, CA, Post Office sculpture, $3,900 (later won by William Atkinson);
Decatur, IL, Post Office, $7,050 (later won by Edgar Britton, Mitchell Siporin, and Edward Millman);
Somerville, MA, Post Office, $2,000 (later won by Ross Moffett);
Arlington, NJ, Post Office, $2,350 (later won by Albert Kotin);
Binghamton, NY, Post Office, $3,900 (later won by Kenneth Washburn);
North Philadelphia, PA, Post Office, $5,300 (later won by George Harding);
Petersburgh, VA, Post Office, $4,700 (later won by William Calfee and Edwin S. Lewis).

0236 "The public use of art." *Art Front* 2 (March 1936): 3–4.

Notice of the opening (in December 1935) of the Federal Art Gallery (NYC); urges the creation of a permanent art project.

0237 Watson, Forbes. "The return to the facts." *American Magazine of Art* 29 (March 1936): 146–53.

A polemic in favor of Realism and "democratic" art and against Academicism and abstract effetism; explains how the work of the PWAP, FAP, and the Section show the vigor of Realism. Watson feels the FAP art is a great improvement over work done earlier in the century. An excellent summary of the beliefs of one of the important administrators of the art projects. Many B/W illustrations of works.

0238 "With the artist." *Western Artist* 2 (March 1936): 17–18.

From Albuquerque, Dorothy Stewart was chosen for the FAP mural project at the Little Theatre Building in Albuquerque, assisted by Samuel Moreno; from Salt Lake City, in early March there will be an exhibition of about 20 FAP artists in the State Capitol.

0239 "Index of American Design planned by WPA." *Museum News* 13 (March 1, 1936): 4.

Note that the FAP will begin the IAD.

0240 "Government inspiration; with colored supplement, 'Mural painting in the United States.' " *Time* 27 (March 2, 1936): 42–43.

Overview of the mural work done under the New Deal projects; includes photographs of artists at work and a color supplement reproducing the murals of Daniel Boza, Gerald Foster, Frank Mechau, Douglas Crockwell, Kenneth Adams, and John Steuart Curry.

0241 Sayre, A.H. "Federal art project costume exhibition at R.H. Macy & Company." *Art News* 34 (March 7, 1936): 9.

Exhibition of costumes from all periods of American history held jointly by the FAP and Macy's Department store in New York City; costumes from the Metropolitan Museum of Art, the Cooper Union, Museum of the City of New York, and the Brooklyn Museum.

0242 "WPA opens fourteen art galleries in South." *Museum News* 13 (March 15, 1936): 1, 4.

Note that the FAP is opening fourteen art galleries in the South; call to donate publications to these new facilities.

0243 "The 40,000 lay-off threat." *Art Front* 2 (April 1936): 3–4.

Critical of plans to lay off 40,000 of the WPA's workers in the New York area.

0244 Friedman, Arnold. "Government in art." *Art Front* 2 (April 1936): 8–10.

Paper read at the American Artists' Congress; gives history of the art projects with guarded praise.

0245 "Harlem hospital murals." *Art Front* 2 (April 1936): 3.

Critical of racist criticism ("Too much Negro subject matter") of murals for the Harlem Hospital; urges greater presence of African-Americans in the art projects.

0246 K., J. "The project graphic show." *Art Front* 2 (April 1936): 12.

A highly favorable review of "Graphic Prints" at the Federal Art Gallery (NYC); includes a list of artists participating. "Out of such exhibitions will mature culture develop."

0247 "Sidney Waugh: Stage Driver, U.S.P.O. (1789–1836), detail." *American Magazine of Art* 29 (April 1936): cover.

Reproduction of a detail of Sidney Waugh's "Stage Driver, U.S.P.O. (1789–1836)," done for the Post Office Building, Washington, DC, for the Section.

0248 "Treasury Department." *Western Artist* 2 (April 1936): 27.

Announcement of five Section competitions.

0249 "WPA art work shown in museum." *El Palacio* 40 (April 15, 22, 29, 1936): 92–94.

Account of exhibition of FAP work shown in the Museum of New Mexico (Santa Fe). Partial list of artists included.

0250 Danysh, Joseph A. "The Federal art project." *San Francisco Art Association Bulletin* 3 (May 1936): 2, 4.

Explanation of the FAP, both its creative and educational aspects, with some statistics of its implementation in the Bay Area.

0251 Godsoe, Robert Ulrich. "Another project graphics show." *Art Front* 2 (May 1936): 15.

Favorable review of "Graphic Prints" at the Federal Art Gallery (NYC); list of artists and work.

0252 "Mass meeting." *Art Front* 2 (May 1936): 3.

A call for artists to fight for the preservation of the FAP.

0253 "Modern history of art." *Art Front* 2 (May 1936): 4.

Artists picket the FAP's NYC headquarters; highly critical of Audrey McMahon.

0254 "Towards permanent projects." *Art Front* 2 (May 1936): 5.

Editorial in favor of a federal art bill; reprints important sections.

0255 "With the artist." *Western Artist* 2 (May 1936): 17.

From Deming (NM), Lew Tree Himmun will do a FAP mural for the WPA office in Denver; from Gallup, J.R. Willis will do a Section mural for the Gallup High School; and from Taos, Gene Kloss, Regina Tatum Cooke, Patrocino Barcla, and Gisella Lacher exhibit Section work at the Santa Fe museum.

0256 Angly, Edward. "Not boondoggling." *Art Digest* 10 (May 1, 1936): 13, 17.

Excerpted from the New York *Herald-Tribune*. Angly claims that the work done under government auspices has been good: "Unlike the amateur leaf rakers and snow shovelers and those who scrape the lateral roads of a nation in the name of work relief, a P.W.A.P job for an artists usually evokes arduous labor," p. 17.

0257 Hartmann, Sadakichi. "Misapplied relief?" *Art Digest* 10 (May 1, 1936): 12, 28.

Essay by Hartmann expressing his belief that good art cannot be done under the circumstances that the government is commissioning it. A good analysis of the issue.

0258 "Data on projects." *Art Digest* 10 (May 15, 1936): 6.

Statistics on the FAP from Audrey McMahon. McMahon feels that private industry is doing little to absorb artists into the work force.

0259 Mumford, Lewis. "The art galleries." *New Yorker* 12 (May 16, 1936): 44.

Note on the Federal Art Gallery (NYC) and the exhibition of prints on display. "Politics aside, such an exhibition gives an answer to a question that might be asked about our artists as well as our children: why keep them alive?" p. 44.

0260 Limbach, Russell T. "Art: Artists Union convention." *New Masses* 19 (May 19, 1936): 28.

Brief note on the Federal Art Bureau bill in article primarily about the Artists' Union convention.

0261 US Treasury Department. Section of Painting and Sculpture. *Bulletin. Treasury Department Art Projects* 10 (June–July–August 1936): 20 pp.

Note on the upcoming Whitney Museum and Corcoran Gallery shows of Section work; note on the Delaware Swedish Tercentenary Commemorative Coin competition; excerpts from "Fresco Painting Today" by Lewis Rubenstein, reprinted from *American Scholar;* biographies of Simkha Simkhovitch, Stuart Holmes, Charles Turzak, Henry Kreis, Charles Rudy, Henrietta Shore, H. Louis Freund, Aldis B. Brown, Frederick A. Brunner, Walter Gardner, Tanner M. Clark, Kenneth Callahan, Glady Caldwell, Charles Campbell, Norman Chamberlain, Grant W. Christian, and Thomas Donnelly. Announcement of two competitions:
San Pedro, CA, Post Office, $4,900 (later won by Fletcher Martin);
Fort Scott, KS, Courthouse, $2,600 (later won by Oscar Berninghaus).

0262 "Federal arts project holds national exhibition." *Western Artist* 2 (June 1936): 16.

Favorable review of "National Exhibition. Mural Sketches, Oil Paintings, Water Colors and Graphic Arts. Federal Art Project" at the Phillips Collection (Washington, DC).

0263 Godsoe, Robert Ulrich. "Another project graphic show." *Art Front* 2 (June 1936): 15.

Favorable review of FAP show "Exhibition of graphic prints, etchings, lithographs, wood cuts" at the Federal Art Gallery (NYC); includes a list of artists in show.

0264 "Mass meeting." *Art Front* 2 (June 1936): 3.

Editorial urging artists to unite to protest proposed FAP cuts; specifically suggests writing Congress, the press and WPA; organizing actions to expand FAP; holding a mass meeting in Madison Square; and sending a delegation to Washington.

0265 "Modern art history." *Art Front* 2 (June 1936): 4.

Account of a delegation of 37 artists that went to the FAP headquarters in New York on May 13, 1936, to ask for jobs; but are turned away by Audrey McMahon. Eventually they occupied her office and had to be removed by the police.

0266 "Treasury Department competitions." *Western Artist* 2 (June 1936): 16, 23.

Announcement of six Section competitions.

0267 "With the artist." *Western Artist* 2 (June 1936): 10.

From Santa Fe it is announced that Emilio Padilla has completed a wood carving for the FAP.

0268 "Organize against lay-offs." *Art Front* 2 (July–August 1936): 3.

Editorial comparing FAP layoffs to Hitler's tactics; proposes plans to protest layoffs.

0269 "With the artist." *Western Artist* 2 (July–August 1936): 11–12, 17.

From Denver, Louis Ross has completed models of Indian houses for the Denver Museum of Art for the FAP; from Taos, Emil Bisttram wins Section mural competition; and from Cheyenne, Bob True works on FAP project for the Cheyenne High School.

0270 "Cream of Project; at the Duncan Phillips memorial gallery, Washington, DC." *Art Digest* 10 (July 1, 1936): 23.

Review of show at the Phillips' Collection (June 15 through July 5) of 100 FAP works selected by Duncan Phillips. Includes a partial list of artists.

0271 "Muralist! Designs invited for north Philadelphia post office." *Art Digest* 10 (July 1, 1936): 23.

Section mural competition announced for Philadelphia post office; list of jury members.

0272 "WPA rainbow: artists and sculptors rise from obscurity to Washington display." *Literary Digest* 122 (July 4, 1936): 23.

Highly favorable review of "National Exhibition. Mural Sketches, Oil Paintings, Water Colors and Graphic Arts" at the Phillips' Collection (June 15 through July 5) of 100 FAP works selected by Duncan Phillips. B/W illustrations of works by Samuel L. Brown and Michaell Siporin.

0273 "Two lithographs." *New Masses* 20 (July 7, 1936): 13.

Two lithographs by Elizabeth Olds done for the FAP ("Brokers," and "Miss Manchester's Musical Program for Homeless Men").

0274 Rourke, Constance. "Artists on relief." *New Republic* 87 (July 15, 1936): 286–88.

Rourke praises Holger Cahill and the FAP administrators he selected; she feels the FAP is destined for greatness. "A

flexible and well organized movement has been brought into existence, proceeding from a concept of art not as a possession of the few but as a free impulse that should have a large and natural place in our society for pleasure and use," p. 288.

0275 Whiting, F.A., Jr. "New Horizons." *American Magazine of Art* 29 (August 1936): 493.

Praises the art projects and mentions "National Exhibition. Mural Sketches, Oil Paintings, Water Colors and Graphic Arts" exhibition at the Phillips' Collection; expects great things from upcoming "New Horizons" show at MOMA.

0276 "WPA takes stock at Washington; Phillips memorial gallery exhibition." *American Magazine of Art* 29 (August 1936): 504–506, 550.

Review of "National Exhibition. Mural Sketches, Oil Paintings, Water Colors and Graphic Arts" at the Phillips' Collection (Washington, DC); preview of MOMA "New Horizons" show. Primarily B/W illustrations of works in shows.

0277 US Treasury Department. Section of Painting and Sculpture. *Bulletin. Treasury Department Art Projects* 11 (September 1936–February 1937): 19 pp.

Comments on the Corcoran and Whitney shows of Section work; text of FDR and Henry Morganthau's remarks at the opening of the Corcoran show. Competitions announced:
San Antonio, TX, Post Office, $12,000 (later won by Howard Cook);
Phoenix, AZ, Post Office, $6,800 (later won by LaVerne Block and Oscar Berninghaus);
Wilmington, DE, Post Office, $1,900 (later won by Albert Pels and Harry Zimmerman);
Miami, FL, Post Office, $3,800 (later won by Denman Fink in a second competition);
El Paso, TX, Court House, $3,700 (later won by Tom Lea).
Biographies of Kenneth M. Adams, Conrad A. Albrizzio, Richard Brooks, William H. Calfee, Xavier Gonzales, Paul Manship, Edward Millman, Brenda Putnam, Louis Slobodkin, Robert Tabor, and Kenneth Washburn.

0278 Noble, Elizabeth. "New horizons." *Art Front* 2 (September–October 1936): 7–9.

Favorable review of "New Horizons" show at MOMA, but feels the artists need more freedom. B/W illustration of work by Karl Knaths. NOTE: "Elizabeth Noble" was the pseudonym used by Elizabeth McCausland when writing for Left Wing journals.

0279 "Treasury art projects exhibition at Whitney museum." *Western Artist* 3 (September-October 1936): 15.

Review of "Treasury Department Art Projects: Sculpture and Painting" (October 6 through November 6, 1936) at the Whitney Museum.

0280 "Two Treasury mural competitions." *Western Artist* 3 (September–October 1936): 25.

Announcement of two Section competitions.

0281 "With the artist." *Western Artist* 3 (September-October 1936): 9.

From Taos, Joseph Fleck completes the Raton Post Office mural for the Section.

0282 "Five more WPA art galleries in south." *Museum News* 14 (September 1, 1936): 2.

Note that new FAP art galleries have opened in Jacksonville, FL; Miami, FL; Greenville, SC; Lynchburg, VA; and Greensboro, NC. More are planned for Mississippi, Georgia, and Arkansas.

0283 Marshall, Margaret. "Art on relief." *Nation* 143 (September 5, 1936): 271–75.

Praises the FAP for bringing real art to the average American in his/her school, home, through art education, and local museum. B/W illustrations of works by Ralph Austin, Lester O. Schwartz, Gene Kloss, Nan Lurie, John Gross-Bettelheim.

0284 "Relief work." *Time* 28 (September 21, 1936): 42–43.

Mixed review of "New Horizons in American Art" at MOMA; finds the show to be generally mediocre, but praises Patrocino Barcla's (photograph of the artist) work highly, as well as that of the IAD and the children's sections.

0285 Kaufman, Sidney. "The fine arts." *New Masses* 20 (September 22, 1936): 29.

Notice that "New Horizons in American Art" will open at MOMA.

0286 Mumford, Lewis. "The art galleries." *New Yorker* 12 (September 26, 1936): 57.

Mumford expresses his enthusiasm for the FAP on the event of MOMA's "New Horizons in American Art" exhibition.

0287 Genauer, Emily. "New horizons in American art." *Parnassus* 8 (October 1936): 2–7.

A favorable review of the "New Horizons" show at MOMA that expands into a treatise on government and art. An attempt to express the "man on the street" view to art. B/W illustrations of works by Concetta Scaravaglione, Hester Miller Murray, Samuel L. Brown, Andre Rexroth, Mike Mosco, Karle Zerbe.

0288 McCausland, Elizabeth. "Lithographs to the fore." *Prints* 7 (October 1936): 16–30.

Overview of the lithography process; covers the contributions of the FAP Graphics Division to the recent developments in lithography. B/W illustration of print by Arnold Blanch.

0289 Rohde, Gilbert. "The Design Laboratory." *American Magazine of Art* 29 (October 1936): 638–43, 686.

Excellent account of the FAP's Design Laboratory in New York City; shows the practical side of FAP work. Illustrated with B/W photographs of the lab and work done there.

0290 Schack, William. "Lost chapter in New York history: Blackwell survey of New York, 1860–1864." *Landscape Architecture* 27 (October 1936): 12–17.

Article on the discovery of the Blackwell plan of gardens for upper Manhattan by the Historic Gardens Unit of the IAD; B/W illustrations of the plans.

0291 "Western work praised." *San Francisco Art Association Bulletin* 3 (October 1936): 5.

Ernest Peixotto, WPA administrator and muralist, on a swing through California in September, praises the work being done in California by FAP artists.

0292 Works Progress Administration. Division of Women's and Professional Services. *Federal Art Project. Bi-Monthly Bulletin* 1 (October 1, 1936). 23 pp.

Includes "Excerpts from ten reviews by leading American critics of the 'New Horizons in American Art' show at the Museum of Modern Art''; the ten critics were Lewis Mumford, Malcolm Vaughn, Carlyle Burrass, Melville Upton, Edward Alden Jewell, Walter Rendell Storey, H.I. Brock, Jerome Klein, William Gepmain Dooley, and Emily Genauer. NOTE: No other issues located.

0293 "Are they Bona Fide?" *Art Digest* 11 (October 1, 1936): 7.

Edmund H. Levy, department administrator of New York City's WPA project is appointed to determine if workers on the arts projects are qualified for the work they are doing.

0294 "Meet Uncle Sam, world's greatest collector of a nation's art." *Art Digest* 11 (October 1, 1936): 5–6.

A summary of reviews of "New Horizons in American Art" show at MOMA where nearly 500 FAP works were shown. B/W illustrations of works by Jack Levine, Karl Kelpe, Arnold Wiltz, Mick Arsena. Also discusses the mural project and the IAD.

0295 "Oh, Jimmy can draw! He's gonna be a artist if the WPA keeps up." *Art Digest* 11 (October 1, 1936): 7.

A cartoon by Wortman reprinted from the New York *World Telegram,* August 11, 1936.

0296 Davidson, Martha. "Government as a patron of art." *Art News* 35 (October 10, 1936): 10–12.

Reviews of "New Horizons in American Art" at MOMA, and "Treasury Department Art Projects: Sculpture and Painting" at the Whitney. Praises the "American-ness" of the works in the shows: "In both exhibitions it is evident that the roots of this new art are in its own soil," p. 12. B/W illustrations of works by Concetta Scarvaglione, John Ballatar, Alfred Crimi, Paul Cadmus, Michael Von Meyer, and Heinz Warneke.

0297 Bulliet, C.J. "Day after next: 'New Horizons in American art.' " *Art Digest* 11 (October 15, 1936): 23.

Reprint of, and critique, of Bulliet's comments in the Chicago *Daily News* where he expresses fears that the FAP will lead to a regimentization of American art. Critical of the MOMA "New Horizons" show.

0298 "Politics prevail?" *Art Digest* (October 15, 1936): 13.

Glenn Wessels of the San Francisco *Argonaut* complains of the low salaries paid to FAP artists.

0299 "Uncle Sam faces new test of his connoisseurship in art." *Art Digest* 11 (October 15, 1936): 9, 29.

A review of the Whitney Museum of American Art's show of works from the U.S. Treasury Department's Art Program. "Presents Uncle Sam as the discerning connoisseur rather than the benevolent patron—art for beauty, not relief's sake." B/W illustrations of works by Reginald Marsh, William Zorach, and George Biddle.

0300 "A silver lining to the depression; workers in Treasury art project refurbish federal buildings." *Literary Digest* 122 (October 17, 1936): 22.

Favorable review of "Treasury Department Art Projects—Sculpture and Paintings for Federal Buildings (October 10 through November 6, 1936) at the Whitney Museum. A good account of the Section is included.

0301 Binsse, Harry Lorin. "WPA art exhibit." *America* 56 (October 24, 1936): 71.

Mixed review of "New Horizons in American Art" at MOMA.

0302 Kaufman, Sidney. "The fine arts." *New Masses* 21 (October 27, 1936): 27–28.

In an article about Living American Artists, Inc., New York, Kaufman says, "One of the most astounding facts in the current political campaign is the failure of Landon to jibe at W.P.A. support of artists: less than thirty years ago an administration that thought artists needed to live would have been laughed out of office."

0303 'Isis.' "The U.S. Federal art project." *Builder* 151 (October 30, 1936): 823.

Comments on the government art projects from a British point of view. The pseudonymous author feels that the aesthetic and relief goals of the projects are antagonistic, but praises the educational aspects of the FAP and comments on the possible applications in Britain; he also feels that the FAP administration is too reactionary. "The failure in democracy to-day is that it despises what it cannot understand, and values only at is own level. It has not that wider sense of responsibility to value what is above itself. And the danger in the Federal Relief Scheme is that without this understanding it may be captured by the wrong people."

0304 Benson, E.M. "Art on parole." *American Magazine of Art* 29 (November 1936): 709, 770.

Benson is critical of some of the mediocrity he's seen in mural projects (too many Pony Express riders and backwoodsmen "emasculate" the spirit of American art), still he feels hopeful for the future of the FAP. Includes a list of

artists Benson feels are doing good work. An excellent critique of the projects. Illustrated with many B/W photographs of works.

0305 Noble, Elizabeth. "Official art." *Art Front* 2 (November 1936): 8–10.

Review of "Treasury Department Art Projects—Sculpture and Paintings for Federal Buildings" at the Whitney Museum (NYC); critical of work, feels it to be retrogressive. NOTE: "Elizabeth Noble" was the pseudonym used by Elizabeth McCausland when writing for Left Wing journals.

0306 Breuning, Margaret. "Exhibition consisting of work executed under the Treasury Department art projects." *Parnassus* 8 (November 1936): 25–27.

Review of "Treasury Department Art Projects—Sculpture and Paintings for Federal Buildings" at the Whitney Museum, enjoys the social realism of the works. B/W illustrations of work by Helen Sardeau.

0307 "Owned by the United States government." *Survey Graphic* 25 (November 1936): 616–17.

Primarily B/W illustrations of FAP works by Gregario Prestopirio, Jack Greitzer, Samuel J. Brown, Raymond Breinin, and Ralf Henricksen.

0308 "Sculpture and paintings for federal buildings; exhibition at Whitney Museum of American Art." *Pencil Points* 17 (November 1936): 623–32, 638.

Descriptive article, mostly B/W illustrations of works, of "Treasury Department Art Projects—Sculpture and Paintings for Federal Buildings," at Whitney Museum.

0309 "Voice of art; provisions of a bill providing for a Federal Bureau of Fine Arts, prepared for presentation to Congress." *Art Digest* 11 (November 15, 1936): 6, 15.

Summary of the Fine Arts Bureau bill prepared by the Artists' Congress of Chicago; includes full text of the proposed bill.

0310 "Child art." *Life* 1 (November 30, 1936): 44.

Reproductions of watercolors done by children under the FAP. Illustrations of work by Alphonse Basile, Donald Liguore, Tiberio Benevento, and Louis Novar.

0311 "The artist must survive." *Art Front* 3 (December 1936): 18.

Announcement of planned demonstration of support for the FAP to take place at the Daly Theater (NYC); includes a list of speakers.

0312 "Curtailment." *Art Front* 3 (December 1936): 3.

Editorial questioning why the FAP is being cut; claims it is politics and not money behind the cuts.

0313 Holme, B. "New Horizons in American art." *Studio* 112 (December 1936): 347–50.

Generally favorable review of "New Horizons in American Art" exhibition. B/W illustrations of work by Frede Vidar, Adolf Dehn, Thomas Hart Benton, Karl Kelpe, Louis Guglielmi, George Constant,and Wanda Gag.

0314 "Junipero Serra." *California Arts and Architecture* 50 (December 1936): 6.

The FAP sculpture of Junipero Serra by John Palo-Kangas is unveiled in front of the Ventura County Courthouse; photograph and caption only.

0315 Kiesler, Frederick T. "Murals without walls." *Art Front* 3 (December 1936): 10–11.

An account of Arshile Gorky's murals for the Newark Airport. B/W illustration of work.

0316 Pearson, Ralph M. "The artist's point of view." *Forum* 96 (December 1936): 293.

Article in support of the New Deal art projects, glad they are going out to the people: "Art is being pulled out of the

studio, the museum, and the pink tea. It is at work in buildings. It is being used!" B/W illustrations of work by George Biddle and Marion Greenwood.

0317 Rothman, Henry. "WPA poster show." *Art Front* 3 (December 1936): 17.

Review of "Posters" show at the Federal Art Gallery (NYC). B/W illustration.

0318 Sears, Arthur W. "A revival of mosaics sponsored by the Federal Art Project." *California Arts and Architecture* 50 (December 1936): 2–3, 5.

Explanation of how mosaics are done, why they are popular in California and a discussion of some examples (Marian Simpson, Maxine Albro, and Helen Bruton); photographs of the mosaicists at work.

0319 Weinstock, Clarence. "Public art in practice." *Art Front* 3 (December 1936): 8–10.

A dissertation on the nature of public art; states, "The art projects, ostensibly devoted to the widest communication between the artists and the people, have actually been bound by the philistine opinion of the Administration that public art must be confined to murals and canvases in official and semi-official places," p. 8.

0320 "Brewing storm over nation-wide pruning." *Art Digest* 11 (December 1, 1936): 11.

After Holger Cahill announced a 20% cut in the FAP, the Artists' Union issued a statement that "only permanent government art projects can provide a culture commensurate to the wealth and needs of America." Additional comments by J.B. Neumann, art lecturer, and Harry Gottlieb, president of the Artists' Union.

0321 Butler, Harold E. "Fore-doomed? Movement for a Federal bureau of fine arts in Washington." *Art Digest* 11 (December 1, 1936): 25.

Butler, dean of the College of Fine Arts, Syracuse University, comments on the proposed Federal Bureau of Fine Arts. Critical of the proposal's concentration on the visual arts, pointing out that the WPA Arts Projects took in all aspects of creativity.

0322 "Don't sell out relief." *Nation* 143 (December 12, 1936): 691–92.

Editorial decrying the cuts in the WPA, particularly those to the art projects. "It is ironic commentary on the state of our civilization and on the high-sounding words of President Roosevelt that when prosperity comes in at the door, however fleetingly, an important cultural development is thrown out the window," p. 692.

0323 "Out-of-town galleries follow customers to New York." *Newsweek* 8 (December 12, 1936): 30.

Note that Hudson D. Walker's Minneapolis gallery keeps an eye on the work of FAP artists for good prospects.

0324 "Project artists score." *Art Digest* 11 (December 15, 1936): 23.

At the Fourth International Exhibit of Etchings and Engravings at the Art Institute of Chicago, 11 of the 193 prints are from artists associated with the Graphic Arts Division of FAP. Comments by Audrey F. McMahon.

0325 "Relief riots." *Art Digest* 11 (December 15, 1936): 13.

Account of the December 1, 1936, riot that erupted between artists protesting WPA layoffs and police at the New York City FAP offices, leading to the arrest of 219 artists. Includes statements by Audrey F. McMahon (FAP New York office director) and Elmer Englehorn (business administrator of the WPA Arts Projects). Artists Philip Evergood and Helen West Heller contribute statements. Full text of the Executive Board of the Artists' Union of New York City included. From the New York *Herald Tribune*.

0326 "Stieglitz is blunt." *Art Digest* 11 (December 15, 1936): 10.

Desire Weidinger, an FAP art lecturer, and twenty-five listeners arrived at Alfred Stieglitz's gallery, An American Place. Stieglitz criticized the concept and politics of the FAP, and commented on the work of Georgia O'Keeffe and Diego Rivera. Taken from the New York *Herald Tribune.*

0327 "Underground art." *Art Digest* 11 (December 15, 1936): 12.

The Artists' Union proposal that FAP artists create work for New York City's subways is commented on by the New York *Times Herald,* New York *Post,* and New York *Sun.*

0328 Draper, Theodore. "Roosevelt and the WPA." *New Masses* 21 (December 22, 1936): 14–16.

A discussion of WPA funding cuts in the context of specific cuts to Federal One. A long and passionate description of police beating up artists sitting in at the WPA New York Headquarters is used to gain support.

0329 Mumford, Lewis. "Letter to the president; on the arts projects of the WPA." *New Republic* 89 (December 30, 1936): 263–65.

Elegant, if a bit purple, plea by historian Mumford to FDR to keep the four projects of Federal One alive: "These projects have given the artist a home; and they have planted the seed of the fine arts, hitherto raised under glass in a few metropolitan hothouses, in every village and byway in the country, renovating soils that have become sour with neglect, and opening up new areas for cultivation," p. 264.

0330 *American Art Annual* 33 (1936).

"The Year in Art," (pp. 5–8) praises the government's increased role in the art world; overview of major government art programs. List of Treasury Department Art Project administrators and its organization, p. 73.

0331 "The WPA art project." *Rochester Memorial Art Gallery. Annual Report.* 24 (1936–1937): 12–13.

Note that Isabel C. Herdle has been the Rochester FAP director since February 1936; has employed ten artists on five projects.

EXHIBITIONS

0332 Federal Art Project. *Purposes; mosaics at the University of California art gallery.* San Francisco, 1936. 7 pp.

Exhibition, 1936? Held at the University of California, Berkeley Art Gallery and the M.H. de Young Museum in San Francisco. NOT SEEN. CITED IN OCLC.

0333 Federal Art Project. *Exhibition of graphic prints, etchings, lithographs, wood cuts.* Federal Art Gallery: New York, 1936. 1 p.

Exhibition, April 30 through May 13, 1936, extended through June 25, 1936. No catalog found, invitation to opening (1 sheet) in AAA.

0334 Federal Art Project. Southern California. *The Federal Art Project. Southern California.* Los Angeles Museum: Los Angeles, 1936. 1 sheet pamphlet.

Exhibition, June 5 through 30, 1936. Checklist of 190 works from all media. Brief description of FAP and the mural project in Southern California. Illustrated with a woodblock print by Viktor Von Pribosic.

0335 Federal Art Project. *National exhibition. Mural sketches, oil paintings, water colors and graphic arts. Federal Art Project. Phillips Memorial Gallery.* WPA: Washington, DC, 1936. 9 pp.

Exhibition, June 15 through July 5, 1936. Press release issued by office of Harry Hopkins; gives a description of the exhibition and a list of the seventy-eight works in the show organized by state of origin.

0336 Federal Art Project. *Drawings for Index of American Design.* Federal Art Project: New York, 1936. 3 pp.

Exhibition, June 20 through July 15, 1936, at the R.H. Macy & Co., New York City. Text discusses the purpose of the IAD and mentions that many of the plates will appear in *House and Garden* (*See* **0661**). **No checklist. FOUND IN AAA Reel 1085.467–69.**

0337 Federal Art Project. *Exhibition of oil paintings.* Federal Art Gallery: New York, 1936. 4 p. mimeographed.

Exhibition, June 26 through July 24, 1936. Checklist of 79 works.

0338 Museum of Modern Art. *New horizons in American art; with an introduction by Holger Cahill.* Museum of Modern Art: New York, 1936. 171 p.

Exhibition, September 14 through October 12, 1936. "New Horizons in American Art," a show of 435 works from all aspects of the FAP (including a rotating selection of plates from the IAD) was one of the most important and influential exhibitions of Federal art work in its time. After opening at MOMA, the show traveled throughout the United States receiving generally favorable reviews; Cahill's introduction became one of the most cited references to the purposes and functions of the FAP and still reads well as an essay on American art. Introduction by Holger Cahill also printed as a 20-page mimeographed booklet.

0339 Section of Painting and Sculpture. *Treasury Department Art Projects sculpture and paintings for Federal buildings. October sixth to November sixth, 1936.* Whitney Museum of American Art: New York, 1936. 22 pp.

Exhibition, October 6 through November 6, 1936, Whitney Museum of American Art. Catalog of 166 works, mostly mural sketches. Includes an excellent history of the Treasury Department projects by Forbes Watson. Numerous B/W illustrations.

0340 Federal Art Project. *Exhibition by teachers of the Federal Art Project.* Federal Art Gallery: New York, 1936. 6 ll. mimeographed.

Exhibition, October 19 through November 6, 1936, of work by instructors of the FAP's art instruction program. Checklist of 175 works. "The art teachers of the WPA Federal Art Project instruct children in fine and applied arts in schools of the Board of Education and in settlement houses. This exhibition shows the teachers' work which is executed during the time allotted them each week for research at home," p. 1 (explanatory note).

0341 University of California, Berkeley Art Gallery. *Exhibition of Federal Art Project Work.* UC Berkeley Art Gallery: Berkeley, 1936. 7 pp. mimeographed.

Exhibition, November 1 through 27, 1936. Checklist of ninety-two works. Includes general comments on the FAP and text on the FAP mosaics in the Art Gallery designed by Florence Swift.

0342 Section of Painting and Sculpture. *Treasury Department Art Projects. Painting and sculpture for Federal buildings.* Corcoran Gallery of Art: Washington, 1936. 16 pp.

Exhibition, November 17 through December 13, 1936. Checklist of over one hundred works from the TDAP. "The present exhibition consists of characteristic examples of the various phases of work done under the TDAP program." Introduction by Forbes Watson.

MONOGRAPHS

0343 American Artists' Congress. *First American Artists' Congress.* American Artists' Congress: New York, 1936. 104 pp.

Proceedings of the American Artists' Congress held in New York City February 14–16, 1936. Paper entitled "Government in Art," delivered by Arnold Friedman (but written with Jacob Kainen, Louis Ferstadt, and Ralph M. Pearson) is critical of the Section and claims much more must be done for the artists of America.

0344 Architectural League of New York. *Catalogue of the fifty-first annual exhibition.* The League: New York, 1936.

NOT SEEN. Some FAP works were shown.

0345 Bruce, Edward and Forbes Watson. *Art in Federal buildings: an illustrated record of the Treasury Department's new program in painting and sculpture. Volume 1: Mural designs, 1934–1936.* Art in Federal Buildings: Washington, DC, 1936. 309 pp.

An important work by the two top administrators of the Section project. The book is a large folio with numerous reproductions of work accomplished under the Section. A full account of the Section projects through 1936. Numerous illustrations. No second volume ever published.

0346 Federal Art Project. *Federal Art Project; a summary of activities and accomplishments.* New York, 1936? 19 ll. mimeographed.

Description of the FAP projects and plans. NOTE: A number of publications came out under this or similar titles, usually with no date; the text is usually quite similar with some figures updated; dating is based on internal evidence.

0347 Federal Art Project. *General rules for all drawings and special projects.* Washington, DC, 1936. Mimeographed. 9 pp.

NOT SEEN. CITED IN WILCOX. "Includes general rules, rules for special subjects, preferred layouts and quilt standards (illustrated)."

0348 Federal Art Gallery. *Guide to the Federal Art Gallery.* Federal Art Gallery: New York, 1936? 13 ll. mimeographed.

Brief description of the Federal Art Gallery (NYC); primarily a description of the art techniques used on the FAP.

0349 Federal Art Project. *Index of American Design.* Washington, DC, 1936? Mimeographed. 22 pp.

Brief guide to the functions and purposes of the IAD.

0350 Federal Art Project. *Index of American Design reference bibliography of illustrated books.* Washington, DC, 1936. Mimeographed. 17 pp.

NOT SEEN. CITED IN WILCOX.

0351 Federal Art Project. *Manual for the Index of American Design. Supplement No.1.* Washington, DC, 1936. Mimeographed. 2 pp.

Dated March 9, 1936. Further instructions on the operation of the IAD.

0352 Federal Art Project. *Manual for the Index of American Design. Supplement No. 2.* Washington, DC, 1936. Mimeographed. 2 pp.

Dated March 30, 1936. Further instructions on the operation of the IAD.

0353 Federal Art Project. *The old merchant's house. Architectural Section, New York City Unit, Index of American Design, a Federal Art Project.* WPA: Washington, DC, 1936. 9 pp. mimeographed.

NOT SEEN. CITED IN OCLC.

0354 Federal Art Project. *Purposes, functions, techniques, Federal Art Project exhibitions, Works Progress Administration.* Washington, DC, 1936? 18 p.

Scope and activities of the FAP; includes a list of definitions of art techniques.

0355 Federal Art Project. *Report of the Winston-Salem Art Center. April 15, 1936.* FAP: Winston-Salem, NC, 1936. 20 pp.

Report of the FAP's community art center in Winston-Salem, NC. Text by Daniel S. Defenbacher, State Director of the FAP in North Carolina. Includes a calendar of events as well as general information on the art center. FOUND IN AAA Reel 1085.95–117.

0356 Federal Art Project. *Report on art projects . . . February 15, 1936.* Washington, 1936. 18 pp. mimeographed.

Part I covers the formation of the FAP; part II is a preliminary survey of the FAP. The report states that 4,300 artists have

been employees, 327 projects have been approved, 125 murals in New York have been assigned, plus a plethora of other facts and statistics. "Artists, like all other professionals and skilled workers, want a job to do. And if the result of their activity is a better America, a more complete and well-rounded life for the community, they as well as the Federal Government have the satisfaction of supporting, in one of the richest fields of culture, an enterprise worthy of the best the creative workers of America can give," p. 18.

0357 Federal Art Project. *"The story of Richmond Hill,"* a *mural in the Richmond Hill branch of the Queens Borough library.* FAP: New York, 1936? Mimeographed. 3 pp.

Description of the FAP mural in the Richmond Hill Library (Queens, NY); plus a brief life of the artist, Philip Evergood.

0358 Federal Art Project. *Supplement no. 1 to the Federal Art Project manual. Instructions for the Index of American Design.* Washington, DC, 1936. 11 pp. mimeographed.

Definition and scope of the IAD, how to assign work to artists, examples and instructions on filling out the required paperwork. Includes sample forms.

0359 Federal Works Progress Administration. *Negro Project Workers Annual Report 1937.* FWPA: Washington, DC, 1937. 24 pp.

A general report on African-Americans and work relief, a brief note is included on their achievements on Federal One, including the FAP. Text by Alfred Edgar Smith. Cover illustration by FAP artist Samuel Brown. FOUND ON AAA Reel 1084.572–96.

0360 Miller, Dorothy Canning. "Painting and sculpture." In *Collier's Yearbook 1936*, pp. unknown.

NOT SEEN.

0361 National Park Service. *Report of Field Division of Education, National Park Service, San Diego photographic unit, with*

cooperation of Federal Art Project, San Diego, California, May 1, 1936–November 1, 1936. San Diego, 1936? 1 v. (unpaged), mounted photographs, mimeographed text. NOT SEEN. CITED IN OCLC.

0362 Raleigh Art Center. *First yearbook of the Raleigh Art Center.* WPA: Raleigh, NC, 1936. 15 pp.

Summary report of the Raleigh (NC) Art Center, a FAP organized project. Foreword by the State Director, Daniel S. Defenbacher. Yearbook includes a full list of staff (indicating their race); a calendar of events; other events and lectures; future plans for the center; and letters of commendation. No more may have been published.

0363 US Federal Emergency Relief Administration. *The Emergency Work Relief Program of the F.E.R.A.: April 1, 1934–July 1, 1935.* GPO: Washington, DC, 1936. 125 pp.

Pp. 103–16 cover the arts projects under the supervision of FERA—primarily the completion of work begun under the PWAP; includes B/W photographs of artists at work.

0364 Works Progress Administration. *Digest of Publications Released by the Works Progress Administration and the National Youth Administration.* WPA: Washington, DC, 1936. Various pagination.

Reprints or cites a number of WPA documents; principally official publications (*See* **0214, 0215, 0218, 0219, 0220,** and **0221**). Additionally, there is a list of telegrams sent regarding the arts projects (September 12, 13, and November 5, 23, 1935) in part 10), and part 11 notes that WPA FAP procedures are covered in Series E-9 of the regulations manual.

0365 Works Progress Administration. *Government aid during the depression to professional, technical and other service workers.* WPA: Washington, DC, 1936. 75 pp. mimeographed.

Covering all the "white collar" relief projects of the WPA, this report includes excerpts from newspaper account of the

FAP and an overview of the FAP and the other projects of Federal One; pp. 23–26 devoted to the FAP. "The federal art project has already brought about a healthier psychological attitude among artists, who now feel themselves to be, as never before, a normal part of society," p. 26. Also includes excerpts from articles in the popular press on the FAP: pp. 55–56, Philip Wright, "Lyman Soules' sculpture first in local art show," from the Kalamazoo *Gazette* (n.d.), about how WPA artist Lyman Soules has won a local prize; pp. 57–59, Edward Angly, "WPA art not 'terrible things' on walls of city buildings, but good works experts say," from the New York *Herald-Tribune* (March 15, 1936), about the praise the FAP mural projects have received; p. 60, "Visitors turn critics at WPA art exhibit," from the New York *Times* (April 10, 1936), a review of the opening show at the Federal Art Gallery (NYC); pp. 66–67, William Germain Dooley, "Government in art business makes its bow," from the Boston *Evening Transcript Magazine* (March 28, 1936), a review of the opening of the Federal Art Gallery (Boston).

0366 Works Progress Administration. *Operating procedure No. W-1.* Issued December 14, 1936.

Superseded earlier rules defining the structure of Federal One. CITED IN MCDONALD.

0367 Works Progress Administration. *Principal addresses. Conference of state directors. Division of Women's and Professional Projects.* WPA: Washington, DC, 1936. 207 pp.

Conference held May 4–6, 1936 in Washington for top WPA officials. Holger Cahill spoke on behalf of the FAP on May 5, 1936 (pp. 118–27), explaining what the FAP was and giving examples of the projects it had done and hoped to do.

0368 Works Progress Administration. *Report on the Works Program.* GPO: Washington, DC, 1936. 106 pp.

Pp. 33–34 cover the FAP with a healthy dose of statistics; B/W photographs of artists at work on a mural.

0369 Works Progress Administration. *Timberline Lodge.* WPA: Portland, OR, 1936? 13 pp.

NOT SEEN. CITED IN OCLC.

0370 Works Progress Administration. New York. *Quarterly report on Women's Service and Professional Projects for the period December 1, 1935 to March 1, 1936.* GPO: New York, 1936. 293 ll. Mimeographed.

Statistics on the FAP in New York. Pp. 226–27 cover the FAP: the FAP employed 1,962 people during this period; 350 on mural projects; 208 on easel works; 446 on art education; 28 at the Design Laboratory; 59 in the poster division; 37 in photography; and 209 on the IAD. A total of 7,550 people visited the Federal Art Gallery (NYC).

1937

0371 "Congress to push drive for federal arts bill." *American Artist (Artists' League)* 1 (Winter 1937): 1.

Comments on the need for a federal arts bill and the actions presently being taken in Congress to pass one.

0372 "Destruction of art—American style." *American Artist (Artists' League)* 1 (Winter 1937): 2.

Note on the destruction of a mural by Allen Flavelle in the Glenn Dale Tuberculosis Sanitarium (MD). Ordered destroyed by Dr. Daniel Leo Finucane.

0373 "Mural battle raises question of democratic procedure." *American Artist (Artists' League)* 1 (Winter 1937): 3.

Comments on Rockwell Kent's struggle with the Section over his mural for the Post Office Building in Washington.

0374 Dows, Olin. "Bruce: an appraisal." *Magazine of Art* 30 (January 1937): 6–12.

Dows covers Edward Bruce's life both as an artist and as administrator of arts projects. Illustrated with B/W photograph of Bruce and his work; one color illustration of his work.

0375 "Federal index." *Antiques* 31 (January 1937): 9–10.

Editorial praising the IAD and hoping that it will not be cut.

0376 Gorelick, Boris. "The artists begin to fight." *Art Front* 3 (January 1937): 5–6.

Text of a speech delivered November 30, 1936, at the Washington Irving High School in support of the FAP.

0377 Harrington, M.R. "Federal art exhibit at museum." *Masterkey* 11 (January 1937): 23.

Account of exhibition at the Southwest Museum (Los Angeles), from December 1, 1936 to an unknown date, of paintings, costumes, figures, maps, and photographs done by FAP workers on Native American subjects.

0378 Payant, Felix. "Index of American Design." *Design* 38 (January 1937): 1.

Editorial outlining the purpose of the IAD; feels it is a wonderful project.

0379 Pearson, Ralph M. "The artist's point of view." *Forum* 97 (January 1937): 53.

As FAP funds are being cut, Pearson advocates expanding the art project to include requests by non-Federal organizations to supply decoration. B/W illustration of work by Frank Mechau.

0380 Boswell, Peyton. "Your voice is needed." *Art Digest* 11 (January 1, 1937): 3–4, 22.

Boswell criticizes the presence of non-artists in the FAP who are padding the rolls and taking work away from legitimate artists. He is also critical of Audrey F. McMahon (FAP New York City office director) and the methods used to choose artists. The control by "artists' unions" of the FAP in New York and Chicago is also criticized.

0381 "No social protest." *Art Digest* 11 (January 1, 1937): 21.

Coverage of the Downtown Gallery (NYC) show of FAP artist David Fredenthal. The Downtown Gallery attempted to give commercial access to the works of FAP artists. Fredenthal's show included drawings, watercolors, and tempera studies. B/W illustration of one of Fredenthal's works.

0382 " 'Prints for the people' reveal work of WPA in graphic media." *Art Digest* 11 (January 1, 1937): 23.

Review of the show "Prints for the People," at the International Art Center (NYC) held January 4–31, 1937. Included 250 prints by 238 artists of the Graphic Arts Division. Includes a brief history of the Graphic Arts Division.

0383 "The New Deal decorated the old deal's buildings." *Life* 2 (January 4, 1937): 4–8.

Photo essay on the Section's work of adorning government buildings with murals; color illustrations of works by Henry Varnum Poor, Reginald Marsh, and George Biddle.

0384 "He worked at night." *Art Digest* 11 (January 15, 1937): 12.

Review of show at Hudson D. Walker Gallery (NYC) of the works of William Waltemath (an FAP artist who did these works at night). Includes a brief biography of the artist.

0385 Broun, Heywood. "Laurels for the living." *Nation* 144 (January 30, 1937): 128.

Article critical of the lack of support given living artists; claims the New Deal art projects have done the best job yet; critical of Andrew Mellon's gift of the National Gallery of Art, saying an equal effort should go to living artists.

0386 K., J. "Abraham Harriton." *Art Front* 3 (February 1937): 12, 19.

Review of Abraham Harriton's show at the ACA Gallery (NYC); one work in show depicts FAP artists being arrested, "219 Arrested," illustrated on p. 12.

0387 Kiesler, Frederick T. "Architect in search of . . . ; exhibition of works produced by Federal Art Project and Treasury Relief Art Projects." *Architectural Record* 81 (February 1937): 7–12.

Facetious review of "New Horizons in American Art" at MOMA and "Treasury Department Art Projects—Sculpture and Paintings for Federal Buildings" at the Whitney.

0388 "For a permanent project." *Art Front* 3 (February 1937): 3–5.

Editorial demanding the continuance of the art projects. Comments on the Artists' Union rally of December 1, 1936, for the FAP; coverage of the January 9, 1937, artists' parade for the FAP. An excellent article in support of the art projects with a strong leftist slant. B/W photographs of the rally and parade.

0389 Ludins, Ryah. "A child's point of view." *Art Front* 3 (February 1937): 16–17.

Review of the Federal Art Gallery's (NYC) show of children's work. Praises the FAP education program and comments on children and art. B/W illustration of work by Louise Rauso.

0390 "New York landscape." *Art Front* 3 (February 1937): 18.

B/W illustration of "New York Landscape," a woodcut by Fred Becker; from "Prints for People" show.

0391 "Question and answer." *Art Front* 3 (February 1937): 9–12.

The results of a questionnaire sent to FAP mural artists on their opinions on theory, education, technique, and policy. Adapted from a questionnaire used by Herbert Read to query British artists. Detailed responses of Philip Evergood, Balcomb Greene, and Helen West Heller included. B/W illustrations of works by Fritz Eichenberg and Abraham Harriton.

0392 Steinbach, Sophia. "Community art through federal sponsorship; WPA Federal Art Project." *Design* 38 (February 1937): 5, 35.

Good account of children's and adults' education programs run by the FAP. Photographs of children in art classes.

0393 "Pericles and FDR." *Art Digest* 11 (February 1, 1937): 24.

A New York *World Telegram* review of "Treasury Department Art Projects. Painting and Sculpture for Federal buildings" at the Corcoran Gallery; compares FDR to Pericles.

0394 "Review of *Art in Federal Buildings: Mural Designs, 1934–36.*" *Art Digest* 11 (February 1, 1937): 31.

Review of *Art in Federal Buildings: Mural Designs, 1934–1936* by Edward Bruce and Forbes Watson (*See* **0345**); mostly quotations from the work.

0395 Keyes, Helen Johnson. "American folk art rediscovered." *Christian Science Monitor Weekly Magazine* (February 3, 1937): 8–9, 15.

General account of the activities of the IAD. Illustrations of IAD plates.

0396 "$30,000 for murals, Treasury department art projects." *Art Digest* 11 (February 15, 1937): 8.

Announcement of one national and four regional mural competitions. The national competition was for the San Antonio Post Office and courthouse; regional competitions: Phoenix Post Office, Wilmington, DE, Post Office, Miami Post Office, courthouse, and custom building, and the El Paso courthouse. Reginald Marsh and Ward Lockwood were on the selection committee.

0397 Rugg, Harold. "Government and the arts." *Scholastic* 30 (February 20, 1937): 17–19.

After a brief account of the PWAP, Rugg discusses all of Federal Project One; basic discussion of issues for school children. B/W illustrations of mural by James D. Brooks.

0398 Mac-Gurrin, Buckley. "Art stuff." *Script* 17 (February 27, 1937): 20.

Very favorable comments on the FAP show at the Stendahl Galleries in Los Angeles.

0399 US Treasury Department. Section of Painting and Sculpture. *Bulletin. Treasury Department Art Projects* 13 (March–June 1937): 21 pp.

Technical note on the installation of murals. Competitions announced:
Apex Building, Washington, DC, $22,800 (later won by Michael Lantz);
Postage Stamp design, $500 (later won by Elaine Rawlinson);
Dillon, MT, Post Office (later won by Elizabeth Lochrie).
Biographies of Byron B. Boyd, Albert Pels, Herman E. Zimmerman, Oscar E. Berninghaus, Tom Lea, LaVerne Black, Edmond Amateis, Knud Anderson, William Atkinson, George Biddle, and Louis Bouche.

0400 Gosliner, Leo S. "New Horizons." *California Arts and Architecture* 51 (March 1937): 7.

Very unfavorable review of "New Horizons in American Art" at the Palace of the Legion of Honor (SF). "Currently, within the walls of the Legion, are 'New Horizons,' a survey of WPA art—horizons, which are too obscured and bleak—horizons befogged with lack of clarity, understanding or feeling."

0401 Lamade, Eric. "Letter to the Editor." *Art Front* 3 (March 1937): 15.

A report from Oregon that the Oregon State Capitol may be decorated by non-union artists.

0402 "Local WPA project exhibition." *Portland Art Museum Bulletin* 4 (March 1937): 7.

Exhibition ("Local WPA Project," February 2, 1937, through ?) of the work of three local WPA artists, C.S. Price, Darral Austin, and Aimee Gorham. B/W illustration of one of Austin's works.

0403 "National conference of Artists' Union held in Baltimore, January 16, 1937." *Art Front* 3 (March 1937): 6.

Account of the Artists' Union meeting in Baltimore; the FAP was one of the major topics discussed; the FAP's failure to give jobs to all unemployed artists or provide culture to local communities.

0404 "New horizons in American art." *Portland Art Museum Bulletin* 4 (March 1937): 1–6.

Review/account of "New Horizons in American Art" (March 24 through April 21, 1937); explanation of what the show is about. Numerous B/W illustrations of works.

0405 "No firing!" *Art Front* 3 (March 1937): 3.

Editorial demanding that FDR keep faith with his election promise to not cut any WPA programs.

0406 Whiting, F.A., Jr. "Review of *Art in Federal Buildings: Mural Designs, 1934–36.*" *Magazine of Art* 30 (March 1937): 182.

Very favorable review of *Art in Federal Buildings: Mural Designs, 1934–1936* by Edward Bruce and Forbes Watson (*See* **0345**).

0407 "WPA competitions." *Professional Art Quarterly* 3 (March 1937): 25.

Announcement of Section competitions; Department of Interior, San Antonio Post Office, and Phoenix Post Office. NOTE: title incorrect, the competitions are Section, not WPA.

0408 "Federal competition." *Art Digest* 11 (March 1, 1937): 6.

Nationwide competition for the mural on the walls of the Department of Interior's auditorium announced. Prize worth $5,500. Judged by the staff of the Section of Painting and Sculpture.

0409 Adlow, Dorothy. "Beauty for America's walls; murals for Procurement Division." *Christian Science Monitor Weekly Magazine* (March 10, 1937): 4.

An account of the life and work of Harold Weston, who worked for the Section; general overview of the Section and its work. B/W reproductions of Weston's work.

0410 "Silt or mud? New Horizons in American Art, Federal art project exhibition organized by the Museum of Modern Art." *Art Digest* 11 (March 15, 1937): 13.

Summary of California reviews of the "New Horizons" show as it stops at the California Palace of the Legion of Honor in San Francisco. West Coast reviews were mixed.

0411 "Paul Cadmus of Navy fame has his first art show." *Life* 2 (March 29, 1937): 44–47.

In an article about Paul Cadmus' exhibition at the Midtown Galleries (NYC), mention is made of the controversy surrounding his PWAP work, "The Fleet is In." Photograph of Cadmus and the work.

0412 "The Artists' Union builders of a democratic culture." *Art Front* 3 (April–May 1937): 3–4.

Explanation of the Artists' Union's role in the art projects and its fight to save them; claims more work needs to be done; an excellent statement by the Artists' Union on its place in the history of the art projects.

0413 Bennett, Gwendolyn. "The Harlem Artists' Guild." *Art Front* 3 (April-May 1937): 20.

An account of the Harlem Artists' Guild's attempts to increase the African-American presence in the art projects. B/W illustration of work by Harry Gottlieb.

0414 Godsoe, Robert Ulrich. "A project for the people." *Art Front* 3 (April–May 1937): 10–11.

Text of a speech delivered to the New York Artists' Union. Deals primarily with the Artists' Union's Public Use of Art Committee. Calls for an enlarged easel project in the FAP.

0415 Klein, Jerome. "Recent fine prints." *Art Front* 3 (April-May 1937): 24.

Favorable review of "Recent Fine Prints" at the Federal Art Gallery (NYC). Praise for the FAP.

0416 Vane, Peter. "Big words by bigwigs; what art officials think about while the artist fights for a permanent project." *Art Front* 3 (April–May 1937): 5–7, 26–31.

An often biting and unfair account of those who ran the various art projects including Edward Bruce, Olin Dows, Edward Rowan, and Forbes Watson; very supportive of Holger Cahill and his work on the FAP. "It is our purpose here to examine the developments in Government policy in relation to the support of art since the time of the first venture [the PWAP]." A very important piece. B/W illustrations of work by Dan Rico, Herbert Kallen, and Earl Baizerman.

0417 "American arts and crafts from colonial times to the dawn of the 20th century." *Design* 38 (April 1937): 36b–36c.

Account of IAD exhibited at the Federal Art Gallery.

0418 Lindeman, Eduard C. "Farewell to Bohemia." *Survey Graphic* 26 (April 1937): 207–11.

An exhaustive paean to the democratization of art thanks to Federal Project One. "American artists have come out of the alleys of Bohemia and are now trudging the highways of the American continent," p. 207. An excellent article. Illustrated with a number of B/W works (no artists mentioned).

0419 Rourke, Constance. "Index of American Design." *Magazine of Art* 30 (April 1937): 207–11, 260.

Good overview of the IAD, its nature and the work done. Illustrated with B/W plates from IAD.

0420 "Cadmus, satirist of modern 'Civilization.'" *Art Digest* 11 (April 1, 1937): 17.

Review of Paul Cadmus' show at the Midtown Gallery (NYC).

Review mentions Cadmus' association with the PWAP; show includes five works done for the FAP.

0421 "Hired by Uncle Sam: twelve painters and three sculptors to execute decorations for the new building of the Interior department." *Art Digest* 11 (April 1, 1937): 12.

Twelve painters and three sculptors win Treasury Department art division competition.

0422 "Exhibit reflects success of graphic project." *Art Digest* 11 (April 15, 1937): 25.

Review of "Recent Fine Prints," a show of eighty-three works of the FAP's Graphic Arts Division at the Federal Art Project Gallery (NYC). B/W illustration of a work by Chuzo Tamatzo.

0423 Federal Art Project. *Federal Art Project Bulletin* (May 1937): 25 pp.

Mimeographed bulletin that from its California orientation seems to have been done for the California FAP. General description of the FAP with statistics on its accomplishments in California. "Federal Art Project Murals in Administration Building on Government Island" by Charlotte Morton. Notes on the following upcoming exhibitions:
"Index of American Design," Los Angeles Exposition Park, June through July 11, 1937;
"General Exhibition," Oregon State Museum Association, Salem, June 15 though 22, 1937;
"General Exhibition," San Mateo Library, June 15 through 22, 1937;
"Exhibition of Wood Carvings by Patrocino Barcla," Palace of the Legion of Honor, San Francisco, May 24 through June 4, 1937;
"Exhibition of Four Mural Panels by Arthur Murray," San Francisco Museum of Art, May 25 through June 4, 1937;
"Exhibition of Lithographs," Glendora Public Library, June 1 through July 1, 1937;
"California Index of American Design," San Francisco Public Library, through June 3, 1937 and then traveled to other California sites.

Discovered in the AAA. No other issues located.

0424 Graeme, Alice. "Water colors of the Virgin Islands; Treasury department art project." *Magazine of Art* 30 (May 1937): 301–305.

The Section sent Mitchell Jamieson, Robert Gates, and Steve Dohanos to the Virgin Islands to do some work. Graeme has a favorable impression of what they did. Includes a brief biography of each artist. Illustrated with B/W illustrations of each of their works.

0425 Naylor, Blanche. "Play method produces good design; children's work develops individuality." *Design* 39 (May 1937): 8–9.

Good account of art training for children by FAP. Photographs of children at work.

0426 "Review of *Art in Federal Buildings: Mural Designs, 1934–36.*" *Architectural Forum* 66 (May 1937 supplement): 30, 83.

Very favorable review of *Art in Federal Buildings: Mural Designs, 1934–1936* by Edward Bruce and Forbes Watson (*See* **0345**); B/W illustrations of works by George Biddle, Edward Millman, and Richard Zoellner.

0427 "The summer exhibition." *Springfield Museum of Fine Arts Bulletin* 3 (May 1937): 1–2.

Note on exhibition, "Federal Art in New England, 1933–1937" (August 1 through September 12, 1937) of FAP work by New England artists. Includes a partial list of artists.

0428 "Unemployed arts; WPA's four arts projects: their origins, their operation." *Fortune* 15 (May 1937): 108–21.

Short history of all four arts projects (music, theatre, writing, and art); covers IAD; generally full of praise, finding no boondoggling. "Granted that the Arts Projects are good, are they that good? The answer is fairly clear. As relief projects they are definitely very good. They have not only carried 40,000 artists but they have permitted those 40,000 artists to

share in one of the most thoroughly useful and exciting jobs
ever done in America." Numerous B/W and color photo-
graphs of artists and their works.

0429 "Congress aftermath." *Art Digest* 11 (May 1, 1937): 11.

A comparison of the American Artists' Congress First Na-
tional Members' exhibition and the "New Horizons in
American Art" show.

0430 "Culture for America is under fire—an editorial." *Art
Front* 3 (June–July 1937): 3.

Editorial protesting the $750,000 cut in the WPA. Decries the
"emasculation and demolition of the first and brilliant
beginnings in the building of a truly democratic culture for
our country."

0431 "James D. Brooks." *Art Front* 3 (June–July 1937): 6.

Illustration of James D. Brooks' FAP mural, "Acquisition of
Coney Island" from the Woodside Library, Long Island.

0432 K., J. "Project painters in union shops." *Art Front* 3
(June–July 1937): 17.

Easel painters in the FAP display of non-project work at the
New School for Social Research (NYC). Includes a partial list
of participating artists.

0433 "Letters." *Art Front* 3 (June–July 1937): 5.

Letters to the editor by Philip N. Yountz, Harry Overstreet,
Alfred H. Barr jr., and Ford Madox Ford in defence of the art
projects and against the proposed cuts.

0434 "Some letters received by the committee." *Art Front* 3
(June–July 1937): 7, 17–18.

Letters from the following:
Helen Hall (President of the Board of Directors of the
 National Federation of Settlements) feels the FAP has
 done so well, it must continue;

Robert Kohn (former head of the National Housing Com-
mission and president of the American Association of
Architects) feels art projects should not be cut due to
prosperity;

B.F. McLaurin (International Field Organizer, Brotherhood
of Sleeping Car Porters) the Brotherhood of Sleeping
Car Porters goes on record as supporting the art pro-
jects;

Jacob Rosenburg (President, local 802, American Federation
of Musicians), thanks the Artists' Union for help in
setting up the FAP show it held;

John Dewey expresses support of projects;

William Zorach calls for support of FAP sculpture projects
and art in New York's subways;

Michael Quill announces support of the Transport Union for
the art projects.

0435 "To the American people." *Art Front* 3 (June–July
1937): 5.

Open letter signed by fifty artists, politicians, critics, and
others protesting cuts in all the federal art programs.

0436 "Index of American Design: a portfolio." *Fortune* 15
(June 1937): 103–10.

Primarily color reproductions of plates from the IAD; brief
text.

0437 "Four years of federal art in New England." *Art Digest*
11 (June 1, 1937): 9.

Review of a "Federal Art in New England" originating at the
Addison Gallery, Phillips Academy, Andover, MA, of FAP
works from the New England area. B/W illustration of work
by Jack Levine.

0438 Friend, Leon. "Graphic design." *Professional Art Quar-
terly* 3 (June 1937): 8–13.

Account of what the world of graphic design is doing; brief
mention of the FAP program; numerous B/W illustrations of

work by Nan Lurie, Adolf Dehn, Raphael Soyer, Elizabeth Olds, Bernard P. Schardt, and Boris Gorelick.

0439 P., N.H. "Review of *Art in Federal Buildings: Mural Designs, 1934–36.*" *California Arts and Decoration* 51 (June 1937): 38–39.

A well-written, informative review of *Art in Federal Buildings: Mural Designs, 1934–1936* by Edward Bruce and Forbes Watson (*See* **0345**); makes note of the California artists mentioned in the book.

0440 Schoonmaker, Nancy. "Sawkill experiment." *Magazine of Art* 30 (June 1937): 370–73.

The Sawkill Painters and Sculptors, a group of artists who attempted to create an artists' group outside the FAP, are profiled.

0441 "Yankee painters on federal projects." *Art News* 35 (June 5, 1937): 15.

Very favorable review of "Federal Art in New England" at Addison Gallery, Phillips Academy (Andover, MA). B/W illustrations of works by Karle Zerbe and John Steuart Curry.

0442 Von Wiegand, Charmion. "The fine arts." *New Masses* 24 (June 15, 1937): 29–30.

In a report on art sales in Greenwich Village, Von Wiegand notes that the number of painters hawking their works on the streets is "proof that the W.P.A. Federal Art Project has not been able to take care of all the artists, and that further curtailment would cause havoc among those who have in the last years had a small measure of security."

0443 Section of Painting and Sculpture. *Bulletin. Treasury Department of Fine Arts Program* 14 (July 1937-January 1938): 33 pp.

Seven competitions announced:
Dallas, TX, Post Office, $1,000 (later won by Peter Hurd);
Miami, FL, Post Office, $3,650 (later won by Denman Fink);
Bronx, NY Post Office, $7,000 (later won by Henry Kreis);

Worcester, MA, Post Office, $2,400 (later won by Ralf Nickel-
son);
Vicksburg, MS, Court House and Post Office, $2,900 (later
won by H. Amiard Oberteuffer);
Forest Hills, NY, Post Office, $2,250 (later won by Sten
Jacobsson);
Nickel Competition, $1,000 (later won by Felix Schlag).
Biographies of Ernest Blumenschein, Anne Goldthwaite,
Rockwell Kent, Leon Kroll, William McVey, John Steuart
Curry, Boardman Robinson, and Paul Sample.

0444 Calverton, V.F. "Cultural barometer." *Current History*
46 (July 1937): 90–95.

Overview of American art history followed by a report on the
good deeds being done by the FAP; includes some comments
on the "New Horizons" show. B/W illustration of works by
James Michael Newell and Jared French.

0445 "Wooden Indians." *Coronet* (July 1937): 86–94.

B/W and color reproductions of 8 IAD plates depicting
wooden Indians.

0446 "Art project cut." *Art Digest* 11 (July 1, 1937): 16.

A 25% cut in the arts projects is announced. The visual arts
section will go from 2,083 to 1,558 artists with those on the
project longest the first to go. Comments by Audrey McMa-
hon and Harold Stone (project administrator).

0447 "Kohn for WPArts." *Architectural Forum* 67 (July 1937
supplement): 12.

Robert D. Kohn, former head of the AIA, speaks out in favor
of the FAP. B/W photographs of various FAP administrators.

0448 "Prodigious." *Art Digest* 11 (July 1, 1937): 17.

Superlative statistics of the FAP in New York: 200,000 posters
created and 7,620 other works of art.

0449 "Trying their wings; exhibition of adult education art
division." *Art Digest* 11 (July 1, 1937): 23.

Account of the "Fourth Annual Exhibition of Student Work by the Art Division of WPA—Adult Education Program of the New York City Board of Education," 200 exhibits on display at the Metropolitan Museum of Art. Burton J. Jones, organizer.

0450 Von Wiegand, Charmion. "The fine arts." *New Masses* 24 (July 6, 1937): 30–31.

Description of and praise for the FAP's Design Laboratory in New York City. Describes an exhibition of the students' work at the Design Laboratory. Notes that due to cutbacks in the FAP, private funding is taking over the work of the Design Laboratory.

0451 "Governmental vandalism." *New Republic* 91 (July 14, 1937): 265–66.

Editorial claiming governmental cutbacks and dismissals at the FAP are vandalism of the worst sort; calls for a permanent art bureau.

0452 McCausland, Elizabeth. "Save the arts projects." *Nation* 145 (July 17, 1937): 67–69.

Call to save all aspects of Federal One; urges the creation of a permanent art bureau.

0453 "Gentle Hogarth." *Time* 30 (July 26, 1937): 46.

Article praising the mural work of the FAP and Section. Finds the work of James Daugherty (B/W illustration of a work) particularly interesting; compares him to Hogarth.

0454 Von Wiegand, Charmion. "The fine arts." *New Masses* 24 (July 27, 1937): 29–31.

Very favorable review of "Pink Slips Over Culture" at the ACA Gallery (NYC). Includes a partial list of participating artists.

0455 "Acknowledgments." *Antiques* 32 (August 1937): frontispiece, 57.

Editorial thanking the IAD for help in creating a map of New York State glass works. B/W illustration on frontispiece.

0456 "Recent murals by eight American painters." *American Architect and Architecture* (August 1937): pages unknown.

NOT SEEN. CITED IN Crum (*See* **1048**).

0457 "Jason Herron." *California Arts and Architecture* 52 (August 1937): 6.

B/W photograph of Jason Herron's "Modern Youth," a monumental sculpture for the Belmont High School, Los Angeles; a FAP project.

0458 Clough, F. Gardner. "Mess of pottage?" *Art Digest* 11 (August 1, 1937): 16.

A letter to the *Art Digest* by Clough critical of the FAP. "American artists, in the minds of many sideline observers, are by their association with WPA, in grave danger of being unsmocked and dishonored: WPA is social security if it is, but would money—money security—guarantee any high-minded, honest-talented creation of great art?"

0459 "Pink slip waifs." *Art Digest* 11 (August 1, 1937): 14.

Review of "Pink Slips Over Culture," an exhibition of works by seventy artists dismissed by the FAP at the ACA Gallery (NYC).

0460 "Rescued by WPA." *Art Digest* 11 (August 1, 1937): 18.

Two murals first done by two unknown Italian artists years before in the Indianapolis courthouse are being saved by Harold McDonald under the auspices of WPA project foreman Bernice Hamilton.

0461 Halpert, Edith. "American folk art painting." *Design* 39 (September 1937): 9.

In commenting on children's art in general, Halpert (who was involved in the FAP as well as the Downtown Gallery,

which actively supported New Deal artists), discusses the FAP's role in children's art.

0462 "A la Thomas Moran; WPA painters sent to Alaska." *Art Digest* 11 (September 1, 1937): 15.

Summary of a report in the New York *Herald-Tribune* that Harold L. Ickes (Secretary of the Interior) was sending twelve FAP artists to Alaska to paint landscapes for the Department of Interior at a cost of $26,800.

0463 "Art notes." *California Arts and Architecture* 52 (September 1937): 7.

Note that Olinka Hrdy does a sculptural facade for the Santa Monica High School Auditorium; praise of and description of the project.

0464 Cahill, Holger. "Mural America." *Architectural Record* 82 (September 1937): 63–68.

A brief history of American murals and a summary of FAP mural work and activities; primarily illustrated; B/W illustrations of work by Eric Mose, Edward Millman, Mitchell Siporin, Watt Davis, Max Spivak, Karl Knaths, Rainey Bennett, and Lucienne Bloch.

0465 Harrington, M.R. "The national park service art project." *Masterkey* 11 (September 1937): 65–67.

Account of the work done for the Southwest Museum (Los Angeles) by the FAP in conjunction with the National Park Service. Project in effect from April 1936 through July 10, 1937.

0466 "Answer to Washington." *Art Front* 3 (October 1937): 3–5.

Editorial protesting FAP cuts; praises project for stimulating a "broad and progressive movement in art." Lends support to H.R. 8239, the Bureau of Fine Arts bill.

0467 "Blanche Grambs." *Art Front* 3 (October 1937): 6.

B/W reproduction of Blanche Grambs's aquatint "Mood."

0468 Carroll, Gordon. "How the WPA buys votes." *American Mercury* 42 (October 1937): 194–213.

Virulent attack on the WPA and Federal One; though mostly critical of the FTP, Carroll feels the whole WPA is a ploy by FDR to build a Democratic machine or open America to Communism: "Thousands of words have been written in the past three years about the manner in which the Comrades have taken over [Federal One Projects] as open or covert mediums of Soviet dogma," p. 203.

0469 Cunningham, Ben. "The artist, the art project and the public." *San Francisco Art Association Bulletin* 4 (October 1937): 1, 5.

Cunningham feels that the projects are enabling the government to acquire much great art, that artists love to work for the project and that the public is learning to like art. B/W illustration of work by and photograph of Bernard Zakheim.

0470 "Flag waving vs. art." *Art Front* 3 (October 1937): 3–4.

Protest against the firing (due to a new law) by the FAP of alien artists. Specifically mentions muralist Emmanuel Romano.

0471 "H.R. 8239." *Art Front* 3 (October 1937): 5–9.

Full text of H.R. 8239.

0472 Hugh-Jones, E.M. "Art and the community; what Americans are doing." *London Mercury* 36 (October 1937): 542–47.

Hugh-Jones covers the activities of Federal One for a British audience. Full explanation of the project. Highly favorable.

0473 Jewell, Edward Alden. "Tomorrow inc." *Parnassus* 9 (October 1937): 3–7.

Comments on the coming New York World's Fair; includes statements by Audrey McMahon and Holger Cahill on FAP contributions to the Fair. B/W illustration of work by Eric Mose.

0474 Labaudt, Lucien. "An American renaissance." *San Francisco Art Association Bulletin* 4 (October 1937): 2.

Artist, frescoist Labaudt, compares the projects to the works sponsored by the Church during the Renaissance; feels that government has not limited artists, but rather artists create better art when working within guidelines.

0475 Morsell, Mary. "California mosaicists." *Magazine of Art* 30 (October 1937): 620–25.

Morsell states that California art has come of age under the FAP and is bringing forth vibrant mural work. Covers a number of projects in Los Angeles and San Francisco. "Project murals in California have proved conclusively that mosaics may, like murals, be a democratic art form," p. 622. B/W illustrations of works by Helen Bruton, Florence Swift, Maxine Albro.

0476 "New horizons in American art." *Milwaukee Art Institute Bulletin* 12 (October 1937): 2.

Review/account of "New Horizons in American Art" (October 8 through November 7, 1937); explains what the show is about and quotes from Holger Cahill's introduction to catalog.

0477 "One of the largest true frescoes." *California Arts and Architecture* 52 (October 1937): 7.

B/W photograph with caption of mural by Frank Bowers and Arthur Ponier for the Ruth High School, El Monte, CA.

0478 Weber, Max. "Weber to Roosevelt." *Art Front* 3 (October 1937): 6–7.

Letter from Max Weber (National Chairman of the American Federation of Artists) to FDR asking him to protect aliens from FAP dismissals.

0479 "Children's art gallery under WPA open at Washington." *Museum News* 15 (October 1, 1937): 1.

Note that the FAP's Children's Art Gallery has opened in Washington under the direction of Mary Steele.

0480 L., J. "Sculpture in American folk art; exhibition, Downtown gallery." *Art News* 36 (October 2, 1936): 15.

Favorable review of "American Folk Art; drawings of objects displayed by the Index of American Design," at the Downtown Gallery (NYC), September 28 through October 9, 1937. Forty-seven works in various media plus IAD plates.

0481 "America's newest big city gets free hospital art." *Life* 3 (October 11, 1937): 40–42.

Photo essay on William C. Palmer's FAP work for Queens General Hospital. Notes that sketches for the murals are on display at Midtown Galleries. Color reproductions of murals.

0482 Boswell, Peyton. "Resolution 79; with comment." *Art Digest* 12 (October 15, 1937): 3, 17.

Editorial on H.J. Res. 79 introduced by William I. Sirovich of New York on the creation of a Department of Art, Science, and Literature. Full text of H.J. Res. 79 on p. 17.

0483 Dungan, H.L. "Leaf raking/Art project; exhibition, California Palace of the legion of honor." *Art Digest* 12 (October 15, 1937): 12–13.

Examples from the US Treasury Department's art project are on exhibit at the California Palace of the Legion of Honor. Summary of reviews from California papers. Mural sketches and sculptures were included in exhibit.

0484 Millier, Arthur. "Millier advocates federal art program—'when relief need wanes.' " *Art Digest* 12 (October 15, 1937): 12.

Arthur Millier of the Los Angeles *Times* feels artists should get relief only until they are financially better off; the

government should continue to commission art. Includes a list of artists he likes. B/W illustration of San Francisco mural by Edith Hamilton.

0485 "Murals in the making." *Art Digest* 12 (October 15, 1937): 11.

FAP mural sketches by William C. Palmer for "History of Medicine" to be places in the Queens General Hospital are on display until October 26 at the Midtown Galleries (NYC).

0486 Parker, Thomas C. "Community art centers." *Museum News* 15 (October 15, 1937): 7–8.

The text of Parker's paper given at the American Association of Museums meeting (May 3–5, 1937) in New Orleans. Parker (assistant to Holger Cahill) explains the goals and plans of the FAP's community art centers.

0487 "A shy artist paints bold murals. James Daugherty's favorite subject is America." *Life* 3 (October 25, 1937): 48–50.

Photo essay on the work of TRAP artist, James Daugherty. Color and B/W reproductions of his work.

0488 Davidson, Martha. "WPA art marches on; federal patronage justifies itself." *Art News* 36 (October 30, 1937): 11.

Announcement of the move of the Federal Art Gallery and the "New Horizons in American Art" show; look back at three years of federal art. B/W illustrations of works by Ruffino Tamayo and Zoltan Hecht.

0489 "Elizabeth Olds." *Art Front* 3 (November 1937): cover.

B/W reproduction of Elizabeth Olds's FAP work, "Bike Race."

0490 "H.R. 8239—an editorial." *Art Front* 3 (November 1937): 3–4.

Editorial proclaiming that the Fine Arts Bureau is a fitting successor to the FAP.

0491 "It is consistent with democratic government." *Art Front* 3 (November 1937): 4.

Text of a CIO conference endorsing H.R. 8239 and praising the FAP.

0492 Leboit, Joseph and Hyman Warsager. "The graphic project: revival of print making." *Art Front* 3 (November 1937): 9–13.

Article proclaiming that the Graphic Division of the FAP is stimulating print making in America; praises the many prints exhibits done by projects. B/W illustrations of prints by Nan Lurie, Chet La More, and Will Barnett.

0493 Rogers, Bob. "Artists congress news." *Art Front* 3 (November 1937): 9, 11.

Rogers comments that the FAP is responsible for finding new paths in American art and must continue.

0494 "American art week." *Art Digest* 12 (November 1937): 32.

AAPL editorial on American Art Week. States that Wyoming is the first to have a state WPA art project relating to American Art Week.

0495 "WPA gallery in New York opened." *Museum News* 15 (November 1, 1937): 5.

Announcement that the FAP opened the Federal Art Gallery in New York at its new location on October 11, 1937.

0496 Boswell, Peyton. "Regarding resolution 79." *Art Digest* 12 (November 15, 1937): 3–4.

Summery of letters received on William I. Sirovich's H.J. Res. 79 (*See* **0556**).

0497 "California tries new mural medium." *Art Digest* 12 (November 15, 1937): 8.

Alameda County Courthouse murals designed by Marian Simpson (executed by Gaetano Duccinii) will be done with a special new inlay mosaic method.

0498 "Mother and child classes." *Art Digest* 12 (November 15, 1937): 8.

Note on that mothers in FAP classes at the Queensboro Art Center in New York may bring new children and enroll them in pre-school classes.

0499 "On changing chiefs." *Art Digest* 12 (November 15, 1937): 6.

The Post Office Building mural by Rockwell Kent showing Alaskans and Puerto Ricans with the motto (in an Alaskan language) "Let's change chiefs," causes controversy. Postmaster James A. Farley wants the words removed, Kent refuses and Farley insists that it be done and deducted from his pay.

0500 Kent, Rockwell. "The artist tells the whole story." *New Masses* 25 (November 16, 1937): 6–11.

Rockwell Kent gives his side of the controversy surrounding his Section mural for the Post Office Building. Kent supports his argument with letters and documents from Section officials. B/W illustration of the mural.

0501 Rourke, Constance. "Traditions for young people." *Nation* 145 (November 20, 1937): 562–64.

In a review of children's literature, Rourke, who worked on the IAD, describes how IAD will help make older traditions accessible for today's children and future generations.

0502 Noble, Elizabeth. "The fine arts." *New Masses* 25 (November 30, 1937): 27–29.

Favorable review of "Changing New York" at the Museum of the City of New York. Comments on the social content of the photographs and the nature of photography as an art. NOTE: "Elizabeth Noble" was the pseudonym used by Elizabeth McCausland when writing for Left Wing journals.

0503 "Exhibition of the work of the Rochester Federal arts project." *Rochester Memorial Gallery of Art. Gallery Notes.* (December 1937): 3.

Account of FAP activities in the Rochester area, presently under the directorship of Erik Hans Krause. Announcement of exhibition of ten Rochester FAP artists, "Representative Exhibition of the Work of the Rochester Federal Arts Project" (December 3, 1937 through January 2, 1938).

0504 "George Biddle—art and propaganda." *Rochester Memorial Gallery of Art. Gallery Notes.* (December 1937): 5.

George Biddle to speak on December 13, 1937 at the Gallery ("Art and Propaganda") on his work for the Section at the Department of Justice building in Washington.

0505 McCausland, Elizabeth. "Color lithography." *Prints* 8 (December 1937): 71–80, 120.

After a discussion of color lithography, McCausland explains the work done in this process by the WPA/FAP Graphics Division; includes a list of color lithographs done on the project in NYC. B/W illustrations of work by Chet Le More, Hyman Warsager, and Emil Ganso.

0506 Reeves, Ruth. "Untangling our art traditions." *School Arts* 37 (December 1937): 101–105.

A full account of the IAD with B/W illustrations of plates.

0507 "Review of *Art in Federal Buildings: Mural Designs, 1934–36.*" *Pencil Points* 18 (December 1937 supplement): 42.

Favorable review of *Art in Federal Buildings: Mural Designs, 1934–1936* by Edward Bruce and Forbes Watson (*See* **0345**).

0508 Whiting, F.A., Jr. "Vandalism at Glenn Dale." *Magazine of Art* 30 (December 1937): 745–46.

Murals by Alan Flavelle in the Glenn Dale Children's Tuberculosis Sanatorium (MD) are ordered destroyed by sanatorium administrators (including Dr. Daniel Leo Finucane) because they just do not like them. Whiting also brings up the fate of murals by Bernice Cross, which are also in danger.

0509 "WPA Federal Art Project." *Direction* 1 (December 1937): 13.

Four photographs of children in FAP art classes.

0510 "Uncle Sam settles." *Art Digest* 12 (December 1, 1937): 12.

Rockwell Kent mural at the Post Office Building in Washington is paid for by the government. The Puerto Rican senate, however, feels it is an insult to the island.

0511 Gold, Michael. "No more nudes, no more fish." *New Masses* 25 (December 14, 1937): 18–19.

Amusing parable/fable of one Cadwalader Bones, an artist who has his consciousness raised when his marine paintings no longer sell to the wealthy once the Depression hits. Taken on by the FAP, he paints what he really wants to paint, and when better times come and his marine paintings are wanted again, he is able to turn down the offers of easy money because soon H.R. 8239 will pass, creating a permanent Bureau of Fine Arts which will allow him to continue to paint his scenes of social realism. Full text of the bill follows.

0512 Boswell, Peyton. "Government and art." *Art Digest* 12 (December 15, 1937): 3.

Report on H.C. Dungan, art critic of the Oakland *Tribune* who is against the Federal Art Bill.

0513 "Dodgson notes American's 'vigorous output.'" *Art Digest* 12 (December 15, 1937): 24.

Note/review of *Review of Fine Prints of the Year 1937* by Campbell Dodgson. Eight prints of the Graphic Arts Division and three by artists associated with the FAP projects are represented in the book. Illustration by Fritz Eichenberg.

0514 "WPA internationalists." *Art Digest* 12 (December 15, 1937): 25.

The FAP is represented by thirty-nine printmakers at the Sixth International Exhibition of Lithography and Wood Engraving at the Art Institute of Chicago. Complete list of artists.

0515 Wechsler, James. "Record of the boondogglers." *Nation* 145 (December 25, 1937): 705, 715–17.

Praise for the activities of Federal One.

0516 *American Art Annual* 34 (1937–1938).

The most extensive coverage in the *American Art Annual* yet of the government art projects. Florence S. Berryman in "Treasury Department Art Projects" (pp. 9–11) covers the Section and TRAP; in "Federal Art Project" (pp. 11–14) she covers the FAP; and in "Federal Arts Bills" (pp. 14–15) she covers the attempts to make the art projects permanent. Staff and the administration of the FAP are listed on pp. 75–77 and those of the TDAP on pp. 86–87.

EXHIBITIONS

0517 Garfield Park Art Gallery. *Sculpture and paintings for Federal buildings for the Treasury art projects.* Garfield Park Art Gallery: Chicago, 1937.

Exhibition, 1937. NOT SEEN. CITED IN Smith, Clark Sommer (*See* **1311**).

0518 International Art Center. *Prints for the People.* International Art Center: New York, 1937. 18 pp.

Exhibition, January 4 through 31, 1937. Checklist of 212 FAP prints. Foreword by Gustave von Groschwitz. NOTE: small size format.

0519 Index of American Design. *Index of American Design exhibition, January 27–February 10, 1937, Fogg Museum of Art, Harvard University.* Fogg Art Museum: Cambridge, 1937. 28 pp.

Exhibition, January 27 through February 10, 1937; checklist of 114 IAD plates on exhibit at the Fogg Museum; B/W illustration on cover. Text by Constance Rourke.

0520 Federal Art Project. Boston. *Mural studies.* Federal Art Gallery: Boston, 1937. pamphlet.

Exhibition, February 16 through March 13, 1937. Checklist of forty-nine mural sketches.

0521 Federal Art Project. *Exhibition of oil paintings by artists in the easel division of the U.S. Works Progress Administration Federal Art Project.* Federal Art Gallery: New York, 1937. 1 p.

Exhibition, February 23 through March 23, 1937. Catalog not seen. Invitation to opening (1 page) in the AAA.

0522 Marshall Field and Company. *National Exhibition Index of American Design.* Marshal Field: Chicago, 1937. 6 pp.

Exhibition, March 15 through April 3, 1937. No checklist; text discusses the IAD.

0523 Federal Art Project. *Recent fine prints: lithographs, etchings, drypoints, monotypes, wood engravings: made by artists in the Graphic Arts Division of the Works Progress Administration Federal Art Project.* Federal Art Gallery: New York, 1937. 10 pp.

Exhibition, March 30 through April 27, 1937. Checklist of eighty-three works; foreword by John Taylor Arms.

0524 Works Progress Administration. *Federal art in New England, 1933–1937. Arranged by the officers of the Federal art projects in New England in cooperation with New England museums. With a history of the Art projects in New England by Richard C. Morrison.* Washington, DC, 1939. 64 pp.

Exhibition, May 22 through June 23, 1937, at the Addison Gallery, Phillips Academy, Andover, MA. Checklist of 111

works. Numerous B/W illustrations of works. Includes statistics on completed projects in New England. Essay by Richard C. Morrison traces the history of the FAP in New England. Traveled to the following sites in New England: Springfield Museum of Fine Arts (August 1 through September 12, 1937); Worcester Art Museum (September 18 through October 10, 1937); Wadsworth Atheneum (October 16 through November 14, 1937); Gallery of Fine Arts, Yale University (November 20 through December 11, 1937); Currier Gallery of Art, Manchester, NH (January 8 through February 6, 1938); L.D.M. Sweat Memorial Art Museum, Portland, ME (February 12 through March 6, 1938); and Robert Hull Flemming Museum, Burlington, VT (March 12 through April 3, 1938).

0525 Citizens' Committee for Support of the WPA. *An art and theatre for the people.* ACA Gallery: New York, 1937. 1 large folded sheet.

Exhibition, July 19 through 31, 1937 at the ACA Gallery (NYC); checklist of sixty-eight paintings and ten sculptures; excerpts from Ford Madox Ford's radio talk in support of the WPA and from Lewis Mumford's *New Republic* article (*See* **0329**); other text in support of WPA. Printed on pink paper (symbolizing the "pink slips" given to artists).

0526 Federal Art Project. *All-California process exhibition. Sculpture, mosaics, lithographs, murals.* Stendahl Galleries: Los Angeles, 1937. 1 sheet pamphlet.

Exhibition, August 2 through 31, 1937. Checklist of fifty-five artists; exhibition of how works of art are created that took place at the Stendahl Galleries which donated the space to the FAP. "Intended to give a clear understanding of various techniques employed by the Project artists and a glimpse of the complicated processes which are involved in the completion of public works of art."

0527 ACA Gallery. *4 out of 500 artists dismissed from WPA.* ACA Gallery: New York, 1937. 1 sheet.

Exhibition, August 30 through September 11, 1937; checklist of twenty-eight works (seven FAP) from four artists (Jacob

Kainen, Katherine Von Minckwitz, Louis Nisonoff, and Gyula Zilzer); text is a letter sent by Max Weber to FDR in support of WPA/FAP. Printed on pink paper (as in "pink slip" to artists).

0528 The Downtown Gallery. *Index of American Design, WPA Federal Art Project.* Downtown Gallery: New York, 1937. 6 pp.

Exhibition, September 28 through October 9, 1937. Checklist of 94 items (47 IAD paintings and photographs and 47 original works of folk art).

0528a Renaissance Society of the University of Chicago. [Index of American Design Exhibition]. October, 1937. 1 sheet.

Exhibition, October, 1937 of IAD works. 1 page sheet announcement of exhibition. No checklist. FOUND IN AAA reel 2401.823.

0529 Federal Art Project. *Watercolors and drawings.* Federal Art Gallery: New York, 1937. Mimeographed. 8 pp.

Exhibition, October 12 through 30, 1937. Checklist of 100 works. Foreword by Audrey McMahon. Includes quotations from Holger Cahill, Lewis Mumford, John Taylor Arms, and Jerome Klein in support of the art projects (from published sources).

0530 Federal Art Project. Pennsylvania. *Posters and prints. WPA Federal Art Project, Pennsylvania. Sponsored by the Chester County Art Association and the School Board of West Chester.* Chester County Art Association: Chester County, PA, 1937. 4 pp. pamphlet.

Exhibition, October 30 through November 14, 1937. Checklist of fifty-seven works of posters and prints; IAD plates also on display.

0531 Federal Art Project. *Regional art exhibition.* Federal Art Gallery: New York, 1937. 1 p.

Exhibition, November 10 through 24, 1937. Work by artists of New York State (none from NYC) and New Jersey. Catalog not seen. Invitation to opening in AAA.

0532 Federal Art Project. *Exhibition. Posters and art processes, methods, materials and tools in sculpture, graphic art, fresco and poster processes.* Federal Art Gallery: New York, 1937. 1 p.

Exhibition, December 1 through 20, 1937. Catalog not seen. Invitation to opening in AAA.

0533 Pennsylvania State Museum. *State Museum exhibition.* Privately printed: Harrisburg, 1937? 6 pp.

Exhibition December 17, 1937, through January 13, 1938 (years are estimated). List of artists, no works given.

0534 Federal Art Project. *Children's art.* Federal Art Gallery: New York, 1937. Mimeographed. 14 ll.

Exhibition, December 23, 1937, through January 8, 1938. Checklist of 361 works (artist, age, school attended) by hundreds of the over 30,000 that partook of the New York City FAP children's art program. "The teaching staff of the WPA Federal Art Project is adapting democratic principles to art instruction" (foreword).

MONOGRAPHS

0535 Cahill, Holger. *American design, an address by Holger Cahill, made at the opening of the exhibit "Old and New Paths in American Design," at the Newark Museum, November 6, 1936.* Newark, 1937. 19 pp.

Text of remarks by Holger Cahill at the opening of the exhibit, "Old and New Paths in American Design" at the Newark Museum; Cahill discusses the work of the IAD and the origins of the FAP.

0536 Federal Art Project. *Art as a function of government.* WPA: Washington, DC, 1937. 32 pp.

An excellent essay on the relationship of art and state in other countries, in the United States (including an historical survey), and a description of the FAP. Includes charts showing foreign spending on the arts.

0537 Federal Art Project. *A Community Art Center for Harlem.* FAP: New York, 1937. 9 pp.

Description of what the FAP hopes to accomplish with the Harlem Community Art Center. FOUND IN AAA Reel 1085.167–77.

0538 Federal Art Project. *Federal Art Project; a summary of activities and accomplishments.* New York, 1937? 12 ll. mimeographed.

Description of the WPA/FAP projects and plans. NOTE: A number of publications came out under this or similar titles usually with no date; the text is usually quite similar with some figures updated; dating is based on this internal evidence.

0539 Federal Art Project. *Federally sponsored community art centers.* [WPA Technical Service Art Circular #1]. Washington, DC, 1937. 49 ll. Mimeographed.

A good explanation of the function and purposes of the FAP's community art centers ("to provide the public with opportunities to participate in the experience of art [and] also provide useful work for unemployed artists," p. 1). An outline of how to set up an art center is included. Examples of forms needed are included.

0540 Federal Art Project. *Public response to a federal arts program.* Washington, DC, 1937?. 6 ll. mimeographed.

Excerpts of remarks (all favorable) from a wide range of critics and artists on all aspects of the arts projects (writers', theater, music, art).

0541 Federal Art Project. *Report on art projects.* FAP: Washington, DC, 1937. 18 pp. Mimeographed.

Revised version of the *Report* issued in 1936 (*See* **0356**). Covers the scope of the FAP (teaching, painting, mural work, sculpture, etc.); why the FAP exhibits work, and a description of the techniques used by FAP artists. Dated December 13, 1937.

0542 Federal Art Project. *Report on Federal Art Project activities through March 31, 1937.* FAP: New York, 1937. 5 ll.

Summary of FAP activities through March 31, 1937.

0543 Federal Art Project. New York City. *Federal Art Centers of New York.* FAP: New York, 1937? 8 pp.

A brief overview of art in America and the functions of the FAP. Brief description of what the FAP art centers do, particularly in New York City. Brief descriptions of the four art centers in New York: Contemporary Art Center; Brooklyn Community Art Center; Harlem Community Art Center; and the Queensboro Community Art Center. FOUND IN AAA Reel 1085.19–27.

0544 Federal Art Project. *Users' manual for Federal Project No. 1.* WPA: Chicago, 1937.

NOT SEEN. CITED IN *The Federal Art Project in Illinois* (*See* **1658**). Dated December 15, 1937.

0545 Federal Writers' Project. New Mexico. *Calendar of events.* Federal Writer's Project: Santa Fe, 1937. 32 pp.

Calendar of cultural events in New Mexico illustrated with twelve woodblock prints by Manville Chapman of the FAP.

0546 Hailey, Gene, ed. *California art research.* WPA: San Francisco, 1936–37. 20 volumes.

California Art Research, the fruit of WPA Project 2874, was a massive undertaking to compile a history of art in California from the earliest times to the present. Done under the auspices of James B. Sharp (WPA Coordinator for California) and Joseph A. Danysh (FAP Regional Director), Hailey compiled a number of monographs on California artists (mostly from San Francisco), unfortunately, the project was terminated before completion. Still, the results are an invaluable tool for researchers of California art and artists. Volume 20 includes an account of Maxine Albro who worked on art projects. *See* **1624** for a recent microfiche update of the project.

0547 Hamlin, Gladys E. *Mural paintings in Iowa.* MA Thesis, Columbia University (MO), 1937.

NOT SEEN. CITED IN OCLC.

0548 Kopenhaven, Josephine. *A design for a mural painting for the post office and customs house, San Pedro, California.* MA Thesis, University of Southern California, 1937.

NOT SEEN.

0549 Lindin, I. and Archie Thompson. *Bishop Hill Colony.* Index of American Design: Chicago, 1937.

NOT SEEN. CITED IN Smith, Clark Sommer (*See* **1311**).

0550 Miller, Dorothy Canning. "Painting and sculpture." In *Collier's Yearbook 1937,* n.p.

NOT SEEN.

0551 Roosevelt, Franklin D. "A letter of appreciation for the WPA, January 11, 1937, to the Speaker of the House," pp. 660–67. In *The Public Papers and Addresses of Franklin Delano Roosevelt,* V.5. Random House: New York, 1938. 721 pp.

Letter praising the WPA; in the Note to the letter, FDR appends statistics on the WPA including the FAP.

0552 Rosenwald, Janet. *Early American decorative art.* Index of American Design: New York, 1937. 40 ll.

Historical overview of the decorative arts (ceramics, costume, furniture, glass, metalwork, pewter, silver, and textile and textile handicrafts) in the United States. Includes suggested further readings.

0553 US Congress. House of Representatives. *A bill to establish a Division of Fine Arts in the Office of Education, Department of Interior.* H.R. 8132, 75(1). 3 pp.

Introduced by James P. McGranery on August 3, 1937, the bill would create a Division of Fine Arts within the Office of Education in the Department of Interior. The purpose of the

Division would be to "collect statistics, data, and information, and conduct surveys and studies, relating to education in the fine arts, including music, art, and dramatic art, and speech, and to disseminate such information relating thereto as will promote education in the fine arts," pp. 1–2. No mention of the WPA cultural projects. Sent to the House Committee on Education. Never left Committee. McGranery introduced this bill with minor variations three more times (*See* **0935, 1123,** and **1205**).

0554 US Congress. House of Representatives. *A bill to establish a National Bureau of Fine Arts.* H.R. 1512, 75(1). 3 pp.

Introduced by Allard H. Gasque on January 5, 1937, the bill would create a National Bureau of Fine Arts within the Department of Interior. The Bureau would collect "such statistics and facts as shall show the condition and progress of fine arts and the cultural development in the several States," p. 1. No mention of the WPA cultural projects. Sent to the House Committee on Education. Never left Committee.

0555 US Congress. House of Representatives. *A bill to provide for a permanent Bureau of Fine Arts.* H.R. 8239, 75(1). 7 pp.

Introduced by John M. Coffee on August 16, 1937, the bill would create a Bureau of Fine Arts. All present WPA cultural activities would be transferred to the new Bureau and be increased by 20%. Also known as the "Fine Arts Act." Sent to the Education Committee. Bill latter was modified and became H.R. 9102 (*See* **0780**). The preamble to the bill expresses the concept of "art for the people" that was one of the major goals of Federal One (kept in H.R. 9102): "During the entire history of our Nation and up to the time of the creation of these projects [Federal One], the arts were the jealously guarded possessions of the few and were not made available to the majority. . . . The enjoyment of culture has, in the county's past, been predicated too much on the ability of the individual to pay," p.1.

0556 US Congress. House of Representatives. *A joint resolution providing for the establishment of an executive department to be known as the Department of Science, Art and Literature.* H.J. Res. 79, 75(1). January 5, 1937. 6 pp.

Introduced by William I. Sirovich on January 5, 1937, the bill would create a Department of Science, Art and Literature with Cabinet status and transferring all present WPA cultural activities to the new department. Sent to the Committee on Patents. Never left Committee. *See also* **0783** for Congressional hearing related to the bill. When the Coffee-Pepper bill failed, a modified version of it and this bill became H.J. Res. 671.

0557 US Congress. House of Representatives. Committee on Appropriations. *Emergency relief appropriations act of 1938.* Hearing, May 5–6, 1937. GPO: Washington, 1937. 377 pp.

Pp. 293, 309–11 cover the testimony of Harry L. Hopkins on the value of the FAP; consists mostly of statistics.

0558 Works Progress Administration. *The Builders of Timberline Lodge.* WPA: Portland, OR, 1937. 29 pp.

Text by the WPA FWP on Timberline Lodge. B/W copies of prints by FAP artists Martina Gangle, H.S. Sewall, and Virginia Darce.

0559 Works Progress Administration. *Color schemes of the bedrooms at Timberline Lodge.* WPA, Oregon, 1937?

NOT SEEN. CITED IN *Timberline Lodge: A Love Story* (*See* **1605**). Workbook of color coordination schemes for the bedrooms at Timberline Lodge. Only known copy in the Multnomah County (OR) Library.

0560 Works Progress Administration. *Handbook of procedures for state and district Works Progress Administration.* GPO: Washington, DC, 1937 (revised April 15, 1937). Loose-leaf.

Chapter IX, Section 6 (3 pp.) covers the procedures for Federal Project No. 1. How the projects are organized plus special regulations, procedures, features of employment, and financial procedures are covered.

0561 Works Progress Administration. *Historical map of the old Northwest Territory.* WPA: Marietta, OH, 1937. Map.

Done with the assistance of the FAP. NOT SEEN. CITED IN OCLC. Facsimile reprint, 1987.

1938

0562 "Expanding educational opportunities." *The American Teacher* 22 (January–February 1938): 16–17.

Call for support of the Coffee fine arts bill (H.R. 8239); "The scale of culture has been adjusted to greater accuracy" by the FAP and should be made permanent.

0563 Danysh, Joseph A. "Trends in modern art." *California Arts and Architecture* 53 (January 1938): 7, 40.

Explanation of the FAP (IAD, children's programs etc.) and how it is encouraging art of all types in California.

0564 "Index of American Design." *Rochester Memorial Gallery of Art. Gallery Notes.* (January 1938): 3.

Explanation of the IAD, selected plates of which are now on display at the Gallery ("Index of American Design," January 7 through February 6, 1938). Associated gallery talk by Mabel Truthen Wright on January 6, 1938.

0565 "New horizons in American art." *Rochester Memorial Gallery of Art. Gallery Notes.* (January 1938): 2.

Explanation of "New Horizons in American Art" to be exhibited at the Gallery January 7 through February 6, 1938. Associated Gallery talks by Isabel C. Herdle on January 1 and 30.

0566 "Personalities and art news." *Direction* 1 (January 1938): 30–31.

Note on the opening of the Harlem Art Center; mainly photographs of work by Nathaniel Dirk and Louise Brann.

0567 Randolph, A. Philip. "Harlem's art center." *Art Digest* 12 (January 1, 1938): 15.

Harlem Community Art Center (270 Lenox Avenue) sponsored by the FAP and the Harlem Citizen's Sponsoring Committee opened December 20, 1937. Includes the text of the comments by A. Philip Randolph, president of the Brotherhood of Sleeping Car Porters and chairman of the Harlem Citizen's Sponsoring Committee.

0568 Woodward, Ellen S. "WPA museum projects." Museum News 15 (January 1, 1938): 7–8.

Account by WPA administrator Woodward of what the WPA has done for museums; nothing specifically on the FAP.

0569 "A woman photographs the face of a changing city." *Life* 3 (January 3, 1938): 40–45.

Photo essay utilizing Berenice Abbott's FAP photographs of New York City.

0570 "Bruce honored." *Art Digest* 12 (January 15, 1938): 6.

Edward Bruce, father of the PWAP, chief of the Section, is given the Friedsan Medal of the Architectural League of New York for outstanding achievement in the decorative arts.

0571 "Maintain the arts projects." *Publishers Weekly* 133 (January 22, 1938): 301.

Call to keep Federal One alive; mostly concerned with the FWP.

0572 "Federal bureau of fine arts." *Magazine of Art* 31 (February 1938): 118–19.

Comments on H.R. 9102 (a revised version of H.R. 8239). Includes a summary of H.R. 9102; urges American Federation of Arts members to read the bill and let their legislators know how they feel about it.

0573 Steinbach, Sophia. "Community art through federal sponsorship; WPA federal art project." *Design* 38 (February 1938): 24–25, 35.

A good account of the adult and children's education projects of the FAP. Photographs of art students at work.

0574 "Thirty thousand children paint." *Design* 38 (February 1938): 2.

Photograph of a child in a New York City FAP art class with caption "Thirty thousand children paint."

0575 "WPA art comes to Harlem." *Architectural Forum* 68 (February 1938 supplement): 8.

Account of the opening of the Harlem Community Art Center; B/W photographs of those attending the opening: Augusta Savage (artist); Asa Philip Randolph (labor leader); Holger Cahill, and James Weldon Johnson (poet).

0576 Boswell, Peyton. "Rule by minority; Coffee and Sirovich bills." *Art Digest* 12 (February 1, 1938): 3.

Comments on H.R. 9102 (establishment of a Federal Arts Bureau) by Peyton Boswell, and a summary of comments by others.

0577 "Color lithography." *Art Digest* 12 (February 1, 1938): 24.

Review of "Printmaking—a new tradition" at the Federal Art Gallery (NYC). Sixteen prints in show. Includes a list of the artists.

0578 "Olin Downes speaks against the passage of the Coffee bill." *Art Digest* 12 (February 1, 1938): 17.

Olin Downes, music critic for the New York *Times*, comments on H.R. 9102. He fears there will be too much control of the arts by the government and the hiring of unqualified people.

0579 "Re: the Coffee bill." *Art Digest* 12 (February 1, 1938): 16.

Comments by Dorothy Grafly, of the Philadelphia *Record* on H.R. 9102. Grafly has mixed feelings about the bill.

0580 Noble, Elizabeth. "The federal arts bill." *New Masses* 26 (February 3, 1938): 17–18.

Favorable comments on S. 3296 and H.R. 9102 (Bureau of Fine Arts bills); gives a partial list of organizations and individuals supporting the bills. B/W illustration of "Negro Children" by Joseph Leboit of the FAP. NOTE: "Elizabeth Noble" was the pseudonym used by Elizabeth McCausland when writing for Left Wing journals.

0581 "Bills would create arts bureau or department of science and art." *Museum News* 15 (February 15, 1938): 4.

Note on the bills introduced to create a Bureau of Fine Arts (S. 3296, H.R. 9102, and H.J. Res. 79).

0582 "Coffee-Pepper bill; text." *Art Digest* 12 (February 15, 1938): 22.

Full text of H.R. 9102, the Coffee-Pepper bill.

0583 "Fine arts federation opposes Coffee bill." *Art Digest* 12 (February 15, 1938): 12–13.

The Fine Arts Federation of New York officially comes out against both the Coffee-Pepper and Sirovich Fine Arts Bureau bills; the Federation feels the bills will be a permanent Relief for artists.

0584 "Taylor's suggestion." *Art Digest* 12 (February 15, 1938): 22.

Henry White Taylor, editor of the Philadelphia *Art News,* points out weaknesses in the Coffee-Pepper bill; he is against it in principle.

0585 Tobias, Beatrice. "[Cartoon]." *New Masses* 26 (February 15, 1938): 27.

Cartoon of an artist and a woman with the caption: "Darling, promise me you'll never let the Pepper-Coffee bill regiment your art."

0586 "Theatrical and music fields support Coffee." *Art Digest* 12 (February 15, 1938): 12–13.

Support for the Coffee-Pepper bill comes from the theatre and music fields.

0587 "Subway art." *New Masses* 26 (February 22, 1938): 21.

Photo essay on the effort by the United American Artists and the New York FAP to put art in the subways. B/W illustrations of work by Helen West Heller, Ben Karp, Max Ratskor, Joseph Ringola, and Ruth Cheney.

0588 Coffee, John M. "The permanent Federal Bureau of Fine Arts." *Congressional Record. Appendix* 83, pt. 9 (February 24, 1938): 818–21.

John M. Coffee comments on the Coffee-Pepper (H.R. 9102) bill as well as William I. Sirovich's H.J. Res. 79 calling for a permanent Fine Arts Bureau to replace Federal One. "Art is no longer a matter of solitude or sequestration; no longer a matter of the wealthy patron financing a museum; it becomes now the urgent need of society and the concern of its well-being," p. 819. Includes a list of the bills' supporters.

0589 "Bread and circuses and other things: $9,000,000,000 in work relief." *Life* 4 (February 28, 1938): 41–46.

Photo essay on the accomplishments of the WPA; p. 43 has a photograph of Timberline Lodge; p. 45 has "work of art, Washington," and "art studio, Richmond, VA."

0590 US Treasury Department. Section of Painting and Sculpture. *Bulletin. Treasury Department Art Projects* 15 (March 1938): 11 pp.

Special issue devoted to the competition for the mural for the US Government Building at the New York World's Fair (worth $10,000); competition for murals later won by George Harding and James O. Mahoney; sculpture competition won by Harry P. Camden.

0591 "American stuff." *Direction* 1 (March 1938): entire issue, 128 pp.

Special issue entitled "American Stuff" consisted of writings by members of the FWP and eight prints by members of the FAP (William S. Schwartz, Dorothy Rutka, Albert Webb, Richard Hood, Isami Doi, Gene Kloss, and Fred Becker). Editor, Harold Rosenberg.

0592 Bennett, Charles Alpheus. "Index of American Design and what it suggests." *Industrial Education Magazine* 40 (March 1938): 87–91.

Overview of the IAD and how it is of use (and will be of greater use in the future) to the education of designers. B/W illustrations of IAD plates.

0593 Biddle, George. "Federal arts bill snag; Coffee-Pepper bill." *Magazine of Art* 31 (March 1938): 156, 187–88.

Comments on H.R. 9102 (Coffee-Pepper bill); feels the bill will create a permanent relief project which will not be good for art; Biddle does agree in principle with it, however. Includes a self-portrait of Biddle.

0594 "Bill to provide for a permanent bureau of fine arts." *Magazine of Art* 31 (March 1938): 190, 199.

Full text of the Coffee-Pepper bill, H.R. 9102.

0595 Holme, B. "Government and art." *Studio* 115 (March 1938): 160–62.

Explanation of the FAP and the other government projects; meditation on the future. "At this time it is expected that the most ambitious cultural scheme that any government has ever attempted will either become permanent or terminate altogether," p. 161. B/W illustrations of work by Dennis Bernardinelli and Edward Laning.

0596 "Fine arts federation opposes Coffee-Pepper and Sirovich bills." *Magazine of Art* 31 (March 1938): 173–74.

The Fine Arts Federation of New York comes out against the Coffee-Pepper bill (H.R. 9102). Gives a chronology of the bills.

0597 "More competitions." *Art Instruction* 2 (March 1938): 31.

Announcement of Treasury Department competitions for thirteen murals in the Bronx Central Post Office and one sculptural project in Forest Hills Post Office.

0598 Taylor, Francis Henry. "Pork barrel renaissance." *Magazine of Art* 31 (March 1938): 157, 186–87.

Comments on H.R. 9102 (Coffee-Pepper bill); cautious praise of FAP, but totally against the bill, feeling it will increase the bureaucracy. Taylor believes that a Federal Art Bureau will be of use only if totally divorced from the concept of relief. Includes a photograph of Taylor.

0599 Boswell, Peyton. "Quantitative culture; Coffee-Pepper bill." *Art Digest* 12 (March 1, 1938): 3.

Editorial on the nature of the Coffee-Pepper bill (H.R. 9102); an answer to critics by Boswell of his stance on the bill.

0600 "Re: Coffee-Pepper; Federal arts committee replies to H.W. Taylor." *Art Digest* 12 (March 1, 1938): 14.

Statement by the Federal Art Committee responding to Henry White Taylor's (*See* **0584**) criticism of the Coffee-Pepper bill.

0601 "Two years of the WPA." *Art Digest* 12 (March 1, 1938): 9.

Summary of WPA report of October 1937; gives statistics on WPA art projects.

0602 "US competitions, with list of competitions now open." *Art Digest* 12 (March 1, 1938): 11.

List of Treasury Department Art Projects now open for competition. Six mural competitions listed.

0603 "Uncle Sam sums up; complete summary of 186 painting and sculpture projects executed from its inception through January 4, 1938." *Art Digest* 12 (March 1, 1938): 22, 31.

Summary of 186 projects; lists only completed projects; many have full costs listed.

0604 Boswell, Peyton. "Where credit is due." *Art Digest* 12 (March 1, 1938): 3.

In praise of Edward Bruce on the occasion of his receiving the Friedsan Medal (*See* **0570**).

0605 Davidson, Martha. "Artists of Illinois on the federal payroll; exhibition, New York Federal Art Gallery." *Art News* 36 (March 5, 1938): 14.

Favorable review of Federal Art Gallery show, "Illinois Federal Art Project." B/W illustration of work by William S. Schwartz; partial list of participating artists.

0606 Boswell, Peyton. "Philadelphia steps in; Philadelphia writes own Federal arts bill." *Art Digest* 12 (March 15, 1938): 3.

Boswell's comments on a group of Philadelphia artists who wrote their own version of an arts bill; though presently unsponsored in Congress, they hope to find one.

0607 "King succeeds MacGurrin." *Art Digest* 12 (March 15, 1938): 14.

Southern California FAP chief Buckley MacGurrin resigns; replaced by Albert Henry King.

0608 Lewis, R. Edward. "'O' both your houses! Coffee-Pepper bill." *Art Digest* 12 (March 15, 1938): 10.

R. Edward Lewis, art critic for the Philadelphia *Inquirer*, criticizes both pro- and anti-Coffee-Pepper bill people since they have both lost sight of the larger issue, Art.

0609 "Pepper-Coffee bills." *Art Digest* 12 (March 15, 1938): 33.

AAPL editorial critical of H.R. 9102 (creation of a Federal Art Bureau).

0610 "From left and right; excerpts of articles by F.H. Taylor and G. Biddle in the *Magazine of Art.*" *Art Digest* 12 (March 15, 1938): 11.

George Biddle, comments on the arts projects from the Left; F.H. Taylor, from the Right. Articles appear in March 1938 *Magazine of Art* (*See* **0593**).

0611 "The battle goes on." *American Artist (Artists' League).* 2 (Spring 1938): 1.

Article criticizing the cuts and attacks on the FAP coming from Washington.

0612 "News from the branches." *American Artist (Artists' League).* 2 (Spring 1938): 4–5.

News from New Orleans, St. Louis, Salt Lake City, New York City, Los Angeles, Baltimore branches of the Artists' League; discusses various FAP and American Artists' Congress issues.

0613 "Toward a democratic culture." *American Artist (Artists' League).* 2 (Spring 1938): 1, 3.

Update on the status of the federal arts bills.

0614 Benson, Elmer A. "Federal arts bill." *Design* 39 (April 1938): 2.

Statement of support for the Federal Arts bill (H.R. 9102) by Elmer A. Benson, governor of Minnesota.

0615 "Black art: paintings by Negroes." *Direction* 1 (April 1938): 16–17.

Praise for the creation of the Harlem Art Center; mostly illustrations. B/W photographs of work by Vertis Hayes, Henry Holmes, and Palmer Hayden.

0616 Evergood, Philip. "Should the nation support its art?" *Direction* 1 (April 1938): 2-7.

Evergood calls for governmental support of the arts; everyone should support the Federal Arts Bill. B/W illustrations of works by James Guy and Louis Guglielmi.

0617 "Jobless find outlet in ceramics." *American Ceramic Society Bulletin* 17 (April 1938): 181-82.

Survey of FAP ceramics projects from throughout the country; lists a number of the projects and artists. B/W photographs of ceramics.

0618 Kellner, Sidney. "Federal Art Project posters develop art form." *Signs of the Times* (April 1938): n.p.

NOT SEEN.

0619 "WPA art exhibit." *Chicago Art Institute Bulletin* 32 (April 1938): 58.

Note on upcoming exhibition ("Art for the Public by Chicago Artists") of FAP work from Illinois artists; a description of what will be in the show. Exhibition to take place July 28 through October 9, 1938, at the Art Institute of Chicago.

0620 "WPA Federal Art Project." *Current History* 48 (April 1938): 68-71.

Account of the FAP, explaining its purpose and extolling its virtues: "The work of the Project will outlive the cause that made it possible." Numerous B/W illustrations.

0621 "Clearing the air; Federal arts committee willing to compromise." *Art Digest* 12 (April 1, 1938): 26.

Letter from Stevens Maxey, executive secretary of the Federal Art Committee saying that the Committee is willing to compromise on the Coffee-Pepper bill.

0622 "Federal sculpture." *Art Digest* 12 (April 1, 1938): 10.

Review of "Sculpture" at the Federal Art Gallery (NYC). Seventy works by fifty-six sculptors. Favorable.

0623 "WPA opens forty-eighth federal art center at Sioux City." *Museum News* 15 (April 1, 1938): 1, 4.

Sioux City Art Center opens on February 20, 1938. Also notes that Butte, MT, has plans for an art center; other proposed sites include Spokane, WA; Salem, OR; Sacramento, CA; Long Beach, CA; Poughkeepsie, NY; and Key West, FL.

0624 Frost, Rosamund. "Political and architectural monuments by WPA sculptors." *Art News* 36 (April 2, 1938): 8, 22.

Favorable review of "Sculpture" at the Federal Art Gallery. B/W illustrations of work by Maurice Glickman, Max Baum, and Cesare Stea.

0625 Brenner, Anita. "America creates American murals." *New York Times Magazine* (April 10, 1938): 10–11, 18–19.

Note on the creation of murals by the FAP for the New York World's Fair. Numerous B/W illustrations.

0626 Boswell, Peyton. "You who oppose—." *Art Digest* 12 (April 15, 1938): 3.

Boswell asks that those who oppose the Coffee-Pepper bill come up with something better.

0627 "If not Pepper-Coffee bill, what?" *Art Digest* 12 (April 15, 1938): 33–34.

AAPL editorial asking for something better than the Coffee-Pepper bill.

0628 Binsse, Harry Lorin. "Government as patron of fine arts." *America* 59 (April 23, 1938): 71.

Binsse praises the relief efforts of the FAP, but feels the government should not act as "fairy godmother to a lot of untalented escapists who get self-satisfaction from smearing paint on canvas." Against a permanent art project.

0629 "Attorney General of the United States." *Life* 4 (April 25, 1938): 38.

B/W photograph of Attorney General Homer Stillé Cummings sitting in his "Mussoliniesque" office under the Section mural "Triumph of Justice" by Leon Kroll.

0630 Bell, Philip. "An art gallery for children in Washington." *Journal of the Education Association of the District of Columbia* (May 1938): n.p.

NOT SEEN. CITED IN MILDRED BAKER PAPERS, AAA.

0631 Reeves, Ruth. "American art in American life." *Progressive Education* 15 (May 1938): 402–404.

Reeves explains how introducing children to art has been one of the greatest accomplishments of the FAP since, by bringing art to areas of the country where art is looked on as suspect, it will create a generation that will be less likely to feel this way about art. B/W illustrations of work by children.

0632 Parker, Thomas C. "Artist teaches." *Progressive Education* 15 (May 1938): 387–92.

Excellent account of the educational programs of the FAP by Parker (Assistant National Director of the FAP). Covers both the programs to encourage children as creators and viewers of art. Photographs of children looking at art; B/W illustrations of work by children (Ann Michalov, Mike Mosco, Hyman Doreman, Aaron Goodelman, A. Cocchini, and Stanford Fenelle).

0633 Cooper, Charlotte Gowing. "Ceramics in the Federal art project in Ohio." *Design* 40 (May 1938): 10.

Explanation of the ceramics aspect of the FAP by Cooper (director of the FAP, Ohio); includes section on how ceramics are made.

0634 Hutson, Ethel. "Against the federal art bill." *Art Digest* 12 (May 1, 1938): 4.

Ethel Hutson's, secretary/treasurer of the Southern States Art League (SSAL), letter commenting that the SSAL is still against the Coffee-Pepper bill.

0635 "Continuing opposition to the Pepper-Coffee bill." *Art Digest* 12 (May 1, 1938): 33.

AAPL editorial asking readers' help in killing the Coffee-Pepper bill.

0636 Boswell, Peyton. "Treasury department competitions." *Art Digest* 12 (May 1, 1938): 3.

Boswell urges all artists to enter the various Treasury competitions; gives a partial list of past winners to prove that there is no favoritism or prejudice.

0637 "Syracuse gets a Coye, 'Pearl from WPA oyster.'" *Art Digest* 12 (May 1, 1938): 7.

Lee Brun Coye, discovered by the FAP, has a work, "Just across the street," bought by Syracuse Museum of Fine Arts. Includes a brief biography of Coye.

0638 "WPA sculptor wins." *Art Digest* 12 (May 1, 1938): 7.

Thomas G. Lo Medico, a FAP artist, is the winner of the Metropolitan Life insurance company's $8,000 commission for the Metropolitan exhibition at the New York World's Fair. Includes a brief biography of Lo Medico. Honorable mention went to William Van Beek (also an FAP artist) and Albert Wein.

0639 Boswell, Peyton. "Logical and fair to all." *Art Digest* 12 (May 15, 1938): 3.

Boswell proposes eliminating all direct governmental support for the arts and replacing it with a tax deduction for all art work produced by living American artists.

0640 "WPA and culture: arts projects covering US near third birthday." *Newsweek* 11 (May 30, 1938): 20–21.

General praise for Federal One on its third birthday.

0641 Douglas, Elizabeth A. "A WPA experiment at Hawthorne." *Art and Artists of Today* 6 (June–July 1938): 17.

Eighteen paintings by pupils of the Hawthorne School (taught by FAP teachers) are on display at the New School for Social Research. Douglas feels the art education aspect of the FAP is a success by all measures.

0642 Pousette-Dart, Nathaniel. "Freedom of expression." *Art and Artists of Today* 6 (June–July 1938): 3.

Comments on the Coffee-Pepper bill; includes a list of suggestions on how bill could be improved.

0642a "Federal Art Project in Laguna." *The Western Woman* 9 (June 1938): 44.

Sketch of the life of Virginia Woolley, official in charge of the FAP in Laguna Beach, California. B/W reproduction of one of her paintings.

0643 US Treasury Department. Section of Painting and Sculpture. *Bulletin. Treasury Department Art Projects* 16 (June 1938): 8 pp.

Second special issue devoted to the competition for the mural for the US Government Building at the New York World's Fair (worth $10,000).

0644 "From our foreign correspondent, Washington, DC." *Royal Architectural Institute of Canada. Journal.* 15 (June 1938): 136–38.

A discussion of the mural work done under all the federal projects; explanation of how the Section works and an overview of mural painting in America. Compares the work of N.C. Wyeth and George Biddle (one illustration of each of their murals), finding that of Wyeth extremely old fashioned.

0645 "Medical murals." *Direction* 1 (June 1938): cover, 14–15.

Photo essay on murals with medical themes in hospitals by Eric Mose and Ruth Egri (Lincoln Hospital, NYC), and Rudolph Crimi (Harlem Hospital). Cover photograph of Mose at work.

0646 Parker, Thomas C. "Children's Federal Art galleries." *Democratic Digest* 15 (June 1938): 12–13.

Overview of FAP children's programs. Focuses on the opening of the Children's Art Gallery in Washington. B/W photographs of children in Gallery.

0647 "Proposed fine arts bureau brings stormy discussion." *Architectural Record* 83 (June 1938): 72.

Report on proposal for a Fine Arts Bureau (Coffee-Pepper and Sirovich bills).

0648 "The Bronx—a typical Treasury competition." *Art Digest* 12 (June 1, 1938): 26.

Ben Shahn and Bernada Bryson are announced as the winners of the Treasury competition for the Bronx Central Post Office. Includes a list of seventeen others who will do other Post Office murals around the country. B/W illustration of the Shahn/Bryson mural designs.

0649 "New fine arts bill before Congress; with text." *Art Digest* 12 (June 1, 1938): 10–11.

Full text and comments on H.J. Res. 671, a quickly and greatly revised version of the Coffee-Pepper bill introduced by William I. Sirovich.

0650 Boswell, Peyton. "Why not for art?" *Art Digest* 12 (June 1, 1938): 3, 8–9.

A further explanation/defense of Boswell's plan for tax breaks based on the purchase of art works by living American artists (*See* **0639**); includes a selection of letters supporting his plan.

0651 "Federal art project murals." *Pictures on Exhibit* 1 (June 1938): 10–11.

Praise of FAP murals being shown at the Federal Art Gallery
(NYC) in "Murals for the Community." B/W illustration of
work by Anton Refregier.

0652 Marin, C.S. "The campaign for the Federal Arts Bill."
The Communist 17 (June 1938): 562–70.

Marin urges enthusiastic support for the various Federal Arts
bills coming before Congress that would make the projects of
Federal One permanent. Cites numerous statistics showing
the good work they are doing.

0653 "More praise for the 'Index.'" *Art Digest* 12 (June 1,
1938): 14.

Review of show of IAD works at the San Francisco depart-
ment store, the Emporium. Highly praised by Alexander
Fried of the San Francisco *Examiner.*

0654 "'Projects' murals avoid 'sweetness and light.'" *Art
Digest* 12 (June 1, 1938): 15.

Review of "Murals for the Community" at the Federal Art
Gallery (NYC). Includes a partial list of participating artists;
mixed reviews. B/W illustration of work by Philip Guston.

0655 Lowe, Jeannette. "New murals for US communities."
Art News 36 (June 4, 1938): 15, 19.

Favorable review of "Murals for the Community" at the
Federal Art Gallery. B/W illustrations of works by Francis
Criss and Louis Schanker.

0656 "Print processes in a show by WPA artists at Brooklyn
museum." *Art News* 36 (June 4, 1938): 17.

Favorable review of "Color Prints in Various Techniques by
Four Young WPA Artists" at the Brooklyn Museum; covers
the color lithographs in the show as well as the work the
WPA/FAP is doing; B/W illustration of work by Russell
Limbach, three other artists are: Augustus Pech, Louis
Schanker, and Hyman Warsager.

0657 "Bureau of Fine Arts." *Congressional Record* 83 (June 15, 1938): 9490–93, 9496–99.

Transcription of the House of Representative's floor debate on H.J. Res. 671, the Bureau of Fine Arts legislation. After a stirring speech by William I. Sirovich, opponents of the legislation rise up to mock and deride the very idea of the US government having any type of permanent support for the arts. After well over an hour of arts bashing, the resolution is tabled by a vote of 195 to 35.

0658 "Cultural front." *Direction* 1 (July-August 1938): 26.

Notes on the FAP art classes for children; that two FAP artists from New Jersey are having non-FAP work shown; that Macy's is showing IAD plates; that twenty-five sculptures have been allocated to the Mount Morris Hospital; that the ACA Gallery will show New Deal work in August; and that the Federal Art Bill was defeated.

0659 Public Use of Arts Committee. "An open letter to the American public." *Direction* 1 (July–August 1938): 14–15.

Call to defend the Federal One from wage cuts that are to take effect July 1, 1938. B/W photographs of various Federal One projects.

0660 Biddle, George. "Notes on fresco painting." *Magazine of Art* 31 (July 1938): 406–409.

Treatise on fresco painting from earliest times to the present Section work. Includes Biddle's comments on the subject matter of the Justice Department's frescos. Illustrated with B/W photographs of Biddle's Justice Department work.

0661 Cahill, Holger and Rita Wellman. "All America issue; historic examples from the Index of American Design." *House and Garden* 74 (July 1938): 13–43.

Brief text on what the IAD is by Holger Cahill; explanation of individual plates by Rita Wellman; complete list of artists who worked on the IAD; numerous B/W and color plates.

0662 "Camden wins federal contest, Slobodkin second."
Art Digest 12 (July 1, 1938): 11.

A Treasury Art project jury selected John Poole Camden
(illustration of work) for a $5,000 commission for World's
Fair sculpture. Second place won by Louis Slobodkin (illus-
tration of work). Includes a list of honorable mentions.

0663 Hartmann, Sadakichi. "Era of whitewashing?" *Art
Digest* 12 (July 1, 1938): 6.

Reprint of Hartmann's letter to the New York *Herald-Tribune;*
a satirical letter mocking the overly narrative/historical na-
ture of post office murals. An excellent bit of commentary.

0664 "Index of design; exhibition at R.H. Macy's." *Art
Digest* 12 (July 1, 1938): 34.

Review of IAD works on display at Macy's department store in
NYC.

0665 "Second report on the Treasury art projects." *Art
Digest* 12 (July 1, 1938): 22–23.

Complete summary of 243 Treasury Department art projects
complete as of January 4, 1938. Most are murals and sculp-
ture.

0666 "Sirovich bill ridiculed!" *Art Digest* 12 (July 1, 1938):
17.

H.J. Res. 671 tabled on June 15, 1938 by a vote of 195 to 35.
Includes comments by Sirovich; a good summary of the
debate; some critics of the bill simply mocked it, others
feared it would increase the bureaucracy.

0667 "US offers its finest mural plum." *Art Digest* 12 (July 1,
1938): 14.

Edward Bruce announces Treasury Department art project's
$10,000 competition of murals in the US government's build-
ing at the World's Fair. B/W rendering of the space in the
building the mural will go. Includes a list of jury members.

0668 Boswell, Peyton. "A mural problem." *Art Digest* 12 (July 1, 1938): 3, 14.

Boswell comments on the lack of press coverage of the competition for the mural project for the US building at the World's Fair; finds it a symptom of decline in general interest.

0669 "Early American designs copied, indexed, and displayed after roundup by WPA." *Newsweek* 12 (July 4, 1938): 28.

Brief account of the IAD and how department stores around the country will be displaying plates. B/W illustrations of plates.

0670 "Federal Art Project exhibit at the Art Institute of Chicago." *Art Institute of Chicago. Weekly News Letter.* (July 16, 1938): 1.

Notice that "Art for the Public" will soon be coming to the Art Institute.

0671 "Mr. Stokes and the WPA; New York Public Library panels." *Time* 32 (July 18, 1938): 22, 24.

Account of how Isaac Newton Phelps Stokes (architect and President of the New York City Art Commission) succeeded in persuading the Board of the New York Public Library to accept the WPA and Edward Laning as the artistic forces to paint murals in the Library. B/W photograph of Laning.

0672 "The Federal art exhibit." *Art Institute of Chicago. Weekly News Letter.* (July 30, 1938): 1–2.

Brief comments on "Art for the Public" at the Art Institute.

0673 Berdanier, Paul F. "Social justice, bah." *Magazine of Art* 31 (August 1938): 492, 494–95.

Letter to the editor commenting on George Biddle's earlier article on frescos (*See* **0660**). Very mean-spirited letter lashing out at FAP (Biddle's work actually done under the

Section), Biddle, Communism, and anything else Berdanier can think of. "When will the American public have satiation of this orgy of disgusting, horrible, madhouse creations? From the Renaissance to Whistler, art improved; then it began to deteriorate until the stuff called art is nothing but a bad copy of the lowest Congo Negro symbolism lacking, however, a reason for being," p. 495. *See* **0691** for Biddle's reply.

0674 Driscoll, H.Q. "Government art today." *San Francisco Art Association Bulletin* 5 (August 1938): 1.

Survey of government and art in other countries; mixed feeling about "state paternalism" in American art. B/W illustration of work by Dorothy Puccinelli.

0675 "Federal art; mosaic completed on the north facade of the Long Beach municipal auditorium." *California Arts and Architecture* 54 (August 1938): 7.

Brief note on the FAP mosaic at the Long Beach Auditorium. Original sketch by Henry A. Nord; mosaic design by Stanton Macdonald-Wright and Albert King. Includes photograph of the finished work.

0676 Piper, Natt. "Mosaic tile mural for the Long Beach, California auditorium." *Pencil Points* 19 (August 1938): 495–98.

Step-by-step process of the creation of the FAP mosaic at the Long Beach Auditorium. Original sketch by Henry A. Nord; mosaic design by Stanton Macdonald-Wright and Albert King. Includes photographs of the finished work and the mosaic process.

0677 "Chicago examines WPA federal art now in its third—'Balanced'—phase." *Art Digest* 12 (August 1, 1938): 5–6.

Review of "Art for the Public by Chicago Artists" at the Art Institute of Chicago; includes 368 works. B/W illustrations of

work by Norman McLeish, Todros Geller, and William S. Schwartz.

0678 "Defeat for fine arts bill." *Art Digest* 12 (August 1, 1938): 33.

AAPL editorial praising the defeat of the Fine Arts Bureau bill.

0679 "Harlem goes to Chicago." *Art Digest* 12 (August 1, 1938): 6.

Note on the exhibition of forty works done by children and adults at the Harlem Community Art Center at the Chicago YWCA through August 20, 1938.

0680 "'Pink smoke.'" *Art Digest* 12 (August 1, 1938): 17.

Los Angeles *Times* critic Arthur Millier criticizes FAP consultant Emanuel Benson for being critical of Leon Kroll and others, as well as general leftist leanings.

0681 "Sacramento's center." *Art Digest* 12 (August 1, 1938): 6.

Opening of a Federal Art Center in Sacramento, California.

0682 "WPA man awaited since Whistler." *Art Digest* 12 (August 1, 1938): 10.

Note that Edward Laning has been given the job of painting the murals for New York Public Library that have been waiting for the right painter since Whistler. Includes a brief biography of Laning; a history of the project; and a comparison to the Boston Public Library's great murals. B/W illustration of a mural panel.

0683 "WPA teachers show." *Art Digest* 12 (August 1, 1938): 18.

Notice of a show by FAP art teachers ("Art Teacher's Division") from the New York project at the Federal Art Gallery (NYC). One hundred works in show.

0684 "Some more about the federal art exhibit." *Art Institute of Chicago. Weekly News Letter.* (August 7, 1938): 1–2.

Text of newspaper reviews and telegram from Eleanor Roosevelt on the "Art for the Public" show at the Art Institute.

0685 "Chicago project: WPA show at the Art Institute." *Time* 32 (August 8, 1938): 34.

Favorable review of "Art for the Public" at the Art Institute of Chicago. "Possibly just as influential on Chicago's WPA painting are certain restrictions on subject matter imposed by the assistant to the national director, shrewd, brown-eyed Mrs. Increase Robinson. They are: no nudes, no dives, no social propaganda." B/W illustrations of work by Mary Anderson, Edouard Chassaing, and Joseph Christian Leyendecker.

0686 "The federal art exhibition." *Art Institute of Chicago. Weekly News Letter.* (August 13, 1938): 2.

Comments from *Time* magazine (*See* **0685**) on "Art for the Public" at the Art Institute.

0687 "The Index of American Design." *Art Institute of Chicago. Weekly News Letter.* (August 13, 1938): 2–3.

Explanation of the IAD section of the "Art for the Public" show at the Art Institute.

0688 "Cultural front." *Direction* 1 (September–October 1938): 28.

Note that "Art in Democracy" is the subject of a series of weekly radio shows created by the FAP and aired over WEVD Fridays at 8:45 pm.

0689 US Treasury Department. Section of Painting and Sculpture. *Bulletin. Treasury Department Art Projects* 17 (September 1938): 17 pp.

List of runners-up in the competition for the US Government Building, New York World's Fair competition. Seventeen competitions announced:

Salina, KS, Post Office, $7,000 (later won by Carl Mose);
Evanston, IL, Post Office, $8,800 (later won by Armia A. Scheler);
Burbank, CA, Post Office, $1,900 (later won by Barse Miller);
Bethesda, MD, Post Office, $1,000 (later won by Robert Gates);
East Detroit, MI, Post Office, $650 (later won by Frank Cassera);
Jasper, IN, Post Office, $650 (later won by Jesse H. Mayer);
St. Paul, MN, Post Office, $650 (later won by Don Humphrey);
Marion, IA, Post Office, $650 (later won by Dan Rhodes);
Dear Lodge, MT, Post Office, $675 (later won by Verona Burkhard);
St. Louis, MO, Wellston Post Office, $1,220 (later won by Lumen Winter);
New Rochelle, NY, Post Office, $2,300 (later won by David Hutchinson);
Burlington, NC, Post Office, $1,900 (later won by Arthur Bairnsfather);
Medina, OK Post Office, $730 (later won by unknown);
Salem, OR, Post Office, $2,300 (later won by Andrew Vincent);
Mayaguez, PR, Post Office, $2,000 (later won by José Maduro);
Wentatchee, WA, Post Office, $2,600 (later won by Peggy Strong);
Wausau, WI, Post Office, $1,600 (later won by Gerrit Sinclair).

Biographies of Boris Gilbertson, Erwin Springweiler, Amy Jones, Tom Lea, Alexander Sambugnac, Romuald Kraus, Nicolai Cikovsky, Denman Fink, Peter Hurd, Sten Jacobsson, Ralf E. Nickelsen, Henriette A. Oberteuffer, Ben Shahn, and Bernarda Bryson.

0690 Adams, Grace. "The white collar chokes." *Harper's Magazine* 177 (September 1938): 474–84.

General, mostly negative, article on the WPA professional projects; brief discussion of the FAP on pp. 477–78.

0691 Biddle, George. "Social justice, bah; reply." *Magazine of Art* 31 (September 1938): 545–46.

Biddle's reply to the letter to the editor by Paul S. Berdanier (*See* **0673**). Explains the mural subjects were suggested by Judge Harold M. Stephens and approved by the Attorney General and Supreme Court justices Harlan J. Stone and Stanley Reed.

0692 Gardner, Albert Teneyck. "Art for the public; exhibition at the Art Institute of Chicago." *Magazine of Art* 31 (September 1938): 526–33, 550.

Highly favorable review of "Art for the Public" at the Art Institute of Chicago of Illinois FAP work. Includes list of all artists in show. B/W illustrations of many of the works.

0693 "Index of American Design." *Design* 40 (September 1938): 3–6.

Good, enthusiastic account of what the IAD is and does.

0694 "Looking for fire." *Art Digest* 12 (September 1, 1938): 19.

Paul Edwards, NYC FAP administrator, proposes investigating all artists on projects for Communist sympathies.

0695 "WPA's premier at Chicago institute." *Art News* 36 (September 1938): 10.

Very favorable review of "Art for the Public—by Chicago Artists" at the Art Institute of Chicago. B/W illustrations of work by Todros Geller and Julio De Diego.

0696 "Youth is served at children's art gallery." *Mayflower's Log* (September 1938): n.p.

NOT SEEN. CITED IN MILDRED BAKER PAPERS, AAA.

0697 "In the business district." *Time* 32 (September 5, 1938): cover, 35–38.

Account of the FAP's Community Art Centers; biographical sketch of Holger Cahill and the work he has done for the FAP. Color photograph of Cahill on the cover. B/W photograph of FAP Assistant Director Thomas C. Parker, and miscellaneous B/W photographs of art centers. Important article for the biographical information on Cahill.

0698 "National director of the WPA gives statistics." *Art Institute of Chicago. Weekly News Letter* (September 10, 1938): 1.

Holger Cahill gives a talk at the Art Institute of Chicago in conjunction with the "Art for the Public" show; reprint of selected remarks.

0699 "Artists in every state eligible; Section of Painting and Sculpture announces fifteen competitions." *Magazine of Art* 31 (October 1938): 598.

Announcement of fifteen Section competitions.

0700 "Brockton's art project." *Recreation* 32 (October 1938): 395.

Under director Daniel M. Creedon and instructor Sidney V. Wright twenty artists created a FAP mural for Brockton, MA. Brief account of how the mural was done and other FAP projects in Brockton. B/W illustration of the mural.

0701 Calverton, V.F. "Cultural barometer." *Current History* 49 (October 1938): 45–46.

General account of Federal One; defends the arts projects from attacks calling them Communist; very little on FAP. B/W illustration of work by William Palmer.

0702 "Chicago's art for the public. The WPA show. A revelation in its scope." *Pictures on Exhibit* 2 (October 1938): 8–9.

Favorable review of "Art for the Public" at the Art Institute of Chicago. B/W illustration of work by Edward Millman.

0703 "Federal arts: boondoggle or renaissance." *Arts in Philadelphia* 1 (October 1938): cover, 4–7, 29–31.

History of the FAP in Philadelphia (and the rest of Federal One); interviews many Philadelphia project administrators. B/W illustrations of work by Thomas Flavel and Michael Gallagher. Cover illustration of FAP stone cutting room.

0704 "Index of American Design." *Design* 40 (October 1938): 7–10.

More enthusiasm for the IAD (*See* **0693**).

0705 "Students present mosaic panels to school." *San Francisco Art Association Bulletin* 5 (October 1938): 5.

Six mosaic panels are given to the Oakland High School on September 30, 1938 by the FAP; design by Joseph Sheridan, executed by Clifford Pyle.

0706 "Surprising World's Fair mural awards." *Magazine of Art* 31 (October 1938): 594.

Mixed review of the winners of the New York World's Fair competition for the WPA building. Praises winner George Harding, but does not like the work of James O. Mahoney. Feels the work of runner-up Kindred McLeary was better. B/W illustrations of the three works.

0707 Toomey, Anne. "Uncle Sam, art patron." *Southwest Review* 24 (October 1938): 57–61.

Overview of the PWAP and the Section. Concentrates on the work done in Texas. B/W illustrations of works by Frank Mechau and Jerry Bywaters.

0708 "Ah! That ivory tower; exhibition at the Chicago Art Institute." *Art Digest* 13 (October 1, 1938): 18–19.

Summary of reactions to FAP exhibition at the Art Institute of Chicago.

0709 Boswell, Peyton. "Two Dictators meet." *Art Digest* 13 (October 1, 1938): 3.

Editorial on C.J. Bulliet, who labeled the FAP a failure; Bulliet drew criticism from the Left for mentioning Hitler and Stalin together. Boswell praises Bulliet for his stance.

0710 "Columbus: WPA showing at the state fair." *Art News* 37 (October 1, 1938): 18.

Charlotte Gowing Cooper, Ohio WPA director of the FAP, has eighteen oils by twelve Ohioans and a number of watercolors on display at the Ohio State Fair; includes a list of artists and works; also on display were a number of IAD plates.

0711 "Harding and Mahoney win mural awards—and the flood descends." *Art Digest* 13 (October 1, 1938): 8–9.

George Harding and James Owen Mahoney win competition for US Government building's mural at World's Fair; selection brings on a flood of criticism. Illustrations of designs by both artists. Also includes a composite photograph by Frank Reilly created to show how unoriginal Mahoney's work was.

0712 "Hear ye, Buckeyes! Mural competition for the decoration of the Medina post office." *Art Digest* 13 (October 1, 1938): 11.

Announcement of a Section mural for Ohio Post Office; done tongue in cheek, asking artists to avoid the Pony Express theme since the public is tiring of it.

0713 "Project's art caravan." *Art Digest* 13 (October 1, 1938): 14.

Truck carrying FAP work from New York City goes on a nationwide tour; Judson Smith travels with the works to lecture in local communities.

0714 "WPA art centers opened at Salem, Spokane, Sacramento." *Museum News* 16 (October, 1, 1938): 1, 4.

Note that FAP art centers have opened in Salem (June 1938); Sacramento (June 1938): and Spokane (September 29, 1938). Lists of staff and how they will be funded.

0715 "WPA children." *Art Digest* 13 (October 1, 1938): 16.

Demonstrations of arts and crafts by children (done under the auspices of the FAP) take place in Central Park.

0716 "WPA lecturers give art courses at Philadelphia." *Museum News* 16 (October 1, 1938): 2.

Note that WPA employees (possibly FAP workers) will give free public lectures at the Philadelphia Museum of Art.

0717 "Carved in wood." *Art Digest* 13 (October 15, 1938): 17.

An exhibition at the Clay Club (NYC) includes the work of FAP artist Thomas Gaetano Lo Medico; includes an illustration of his work, "Shopping."

0718 "New York art project moves." *Art Digest* 13 (October 15, 1938): 10.

Headquarters of the NYC FAP moves from 42nd Street to 110 King Street in Greenwich Village. Includes a description of the new space.

0719 "200 of the 61,174 prints done under the WPA in Washington." *Art Digest* 13 (October 15, 1938): 25.

Exhibition at the US National Museum (Smithsonian Institution) of 200 WPA prints shown through October 30, 1938. Organized by the National Collection of Fine Art (Smithsonian Institution). Includes B/W illustration by Michael Gallagher.

0720 "Washington: new techniques in WPA graphic arts show." *Art News* 37 (October 15, 1938): 18.

Favorable review of "National Exhibition of Two Hundred Prints by Graphic Artists" at the US National Museum

(Smithsonian Institution) under the auspices of the NCFA. Includes excerpts from Holger Cahill's opening remarks; B/W illustrations of work by Minetta Good.

0721 "US Government and Bellevue hospital exhibit art of insane patients." *Life* 5 (October 24, 1938): 26–27.

Account of the FAP art classes at Bellevue Hospital. Comments from Dr. Karl M. Bowan, chief psychiatrist, on the project. Numerous illustrations of the patients' work. *See* **0759** for exhibition catalog.

0722 "American painting comes of age." *Life* 5 (October 31, 1938): 27–38.

Photo essay on the history of American art; includes work by Fletcher Martin ("Trouble in Frisco," p. 30) a "discovery of the US Government."

0723 Rothschild, Lincoln. "Art and democracy: Edward Laning's Ellis Island murals." *Direction* 1 (November–December 1938): 14–15.

Account of the creation of Edward Laning's murals for Ellis Island. B/W illustrations of the murals.

0724 "Cultural front." *Direction* 1 (November–December 1938): 28.

Note on a benefit dance to support the Harlem Art Center to be held November 12, 1938; note on the "Four Unit Exhibition" being held at the Federal Art Gallery (NYC).

0725 "Competitions for thirteen mural and two sculpture projects." *Pencil Points* 19 (November 1938, supplement): 38.

Announcement of fifteen Section competitions.

0726 Dows, Olin. "Art for housing tenants." *Magazine of Art* 31 (November 1938): 616–23, 662.

Excellent account of the use of FAP work in Harlem tenements. Numerous B/W illustrations of the work (many works

of sculpture); feels the tenements project is a good idea and needs to be expanded.

0727 Hood, Richard. "Carborundum tint: a new print-maker's process." *Magazine of Art* 31 (November 1938): 643, 670–71.

Discussion of the new copper plate intaglio printmaking method developed by the Philadelphia print department of the FAP. A good explanation of the process. B/W illustration of a work by Michael Gallagher done with the process.

0728 "In the business district." *Reader's Digest* 33 (November 1938): 99–100.

Abridged version of "In the Business District" in *Time* (*See* **0697**).

0729 "Mural competition." *San Francisco Art Association Bulletin* 5 (November 1938): 2.

Section mural competition for Burbank Post Office announced.

0730 "Mural for Texas post office." *San Francisco Art Association Bulletin* 5 (November 1938): 1.

B/W illustration of mural for a Texas post office by Victor Arnautoff; caption and quote from a letter from Edward Rowan to Arnautoff praising the work.

0731 Stanton, Gideon T. "Art in the WPA." *Arts and Antiques (New Orleans)* (November 1938): n.p.

NOT SEEN. CITED IN MILDRED BAKER PAPERS, AAA.

0732 "Thirteen mural competitions and two sculpture competitions for post offices." *Architectural Forum* 69 (November 1938, supplement): 78.

Announcement of fifteen Section competitions.

0733 "Treasury's Section of Fine Arts." *Magazine of Art* 31 (November 1938): 658.

Excerpt from a Washington *Post* editorial in praise of Henry Morgenthau for making the Section permanent.

0734 "Treasury sets up permanent art unit." *Art Digest* 13 (November 1, 1938): 13.

Henry Morgenthau, Secretary of the Treasury, approves of the creation of a permanent Section of Fine Arts.

0735 Boswell, Peyton. "Uncle Sam is satisfied." *Art Digest* 13 (November 1, 1938): 3.

Boswell comments favorably on Edward Bruce's announcement of the Section of Fine Arts to be made permanent under the auspices of the Treasury Department.

0736 "Artists wanted column; competitions announced for 13 mural and two sculpture projects by the Section of Painting and Sculpture." *Art Digest* 13 (November 15, 1938): 16, 28.

The Section announces thirteen mural and two sculpture projects in the following states: Kansas, Illinois, California, Maryland, Michigan, Indiana, Minnesota, Iowa, Montana, Mississippi, New York, North Carolina, Ohio, Oregon, Washington, and Wisconsin. Includes all facts necessary to enter.

0737 "Contemporary American art at World's Fair: the plan." *Art News* 37 (November 19, 1938): 21.

Announcement of the plan for art works to be displayed at the New York World's Fair; under the direction of Holger Cahill.

0738 Grow, M.E. "Men of the arts in Philadelphia: George T. Biddle." *Arts in Philadelphia* 1 (December 1938): 11–12.

Profile of George Biddle; includes an account of his contacting FDR about Federal support for the arts; a summary of his work on the Section.

0739 McCausland, Elizabeth. "Murals from the Federal art project for the World's fair." *Parnassus* 10 (December 1938): 8.

Preview of mural work by FAP that will appear at the World's Fair. Includes a list of artists. B/W illustrations of works by Abraham Lishinsky and Witold Gordon.

0740 "WPA posters make commercial art history." *Design* 40 (December 1938): 9–10.

Good account of the poster project of the FAP and its director, Richard Floethe. Illustrated with reproductions of four posters.

0741 "WPA art center opened in Salt Lake City." *Museum News* 16 (December 1, 1938): 1–2.

Salt Lake City Art Center opened in November 1938. Note that the Laramie, WY, Federal Art Center opened in 1936 and has had an average of 2,800 visitors per month.

0741a "Fine arts bureau?" *Art Digest* 13 (December 15, 1938): 11.

Comments on the various plans (including the Coffee-Pepper bill) for a proposed Bureau of Fine Arts; supports the plan put forward by Walter Damrosch (*See* **0766**).

0742 "Buffalo: WPA show of Americana drawings." *Art News* 37 (December 31, 1938): 19.

Favorable review of IAD plates at the Albright Art Gallery (Buffalo).

0743 Foley, John P. and Anne Anastasi. "Work of the Children's Federal Art Gallery." *School and Society* 48 (December 31, 1938): 859–61.

Good description of the work being done at the Children's Federal Art Gallery in Washington (opened November 11, 1937). Includes a description of the types of exhibits done and praises the work the FAP has done with and for children.

EXHIBITIONS

0744 Index of American Design. *National Exhibition, Index of American Design, Federal Art Project of the Works Progress Administration.* Stix, Baer, and Fuller: St. Louis, 1938. 8 pp.

Exhibition, January 3 through 22, 1938; brochure to accompany exhibit of IAD plates; text by Holger Cahill discusses the IAD.

0745 Works Progress Administration. *An exhibition of selected skills of the unemployed. As demonstrated on WPA non-construction projects.* WPA Division of Women's and Professional Services: Washington, DC, 1938. 28 ll.

Exhibition, January 10 through 31, 1938, in the US National Museum (Smithsonian Institution). Exhibition of a wide range of "white collar" activity of the WPA; includes items from the FAP, IAD. Checklist of 207 items.

0746 Federal Art Project. *Printmaking, a new tradition.* Federal Art Gallery: New York, 1937. 12 pp.

Exhibition, January 19 through February 9, 1938. Text by Russell Limbach, Gustave von Groschwitz, and Carl Zigrosser; checklist of 150 prints including 23 color lithographs. B/W illustration of work by Isaac J. Sanger.

0747 Federal Art Project. *Illinois Federal Art Project Exhibition.* Federal Art Gallery: New York, 1938. 1 p.

Exhibition, February 16 through March 12, 1938. Catalog not seen; forty artists represented. Invitation to opening in AAA.

0748 Federal Art Project. *Exhibition. Sculpture.* Federal Art Gallery: New York, 1938. 1 p.

Exhibition, March 23 through April 16, 1938. Catalog not seen (foreword by Girolamo Piccoli). Invitation to opening in AAA.

0749 Federal Art Project. *Exhibition: easel and water-color.* Federal Art Gallery: New York, 1938. 8 pp.

Exhibition, April 27 through May 11, 1938. Checklist of ninety-six works from the FAP easel project. Explanation of what the FAP in New York does; foreword by Robert M. Coates. "The foundation of the WPA Federal Art Project is perhaps the first time in Western history that the Government itself, as a democratic mass expression of the people's will, has set itself up on a large scale and in a remarkably liberal fashion as a patron of native, contemporary art."

0750 Federal Art Gallery. Boston. *Exhibition. WPA Prints, Water colors.* Federal Art Gallery: Boston, 1938. 4 pp.

Exhibition, May 10 through 28, 1938. Checklist of 100 works.

0751 Federal Art Project. *Murals for the community.* Federal Art Gallery: New York, 1938. Mimeographed. 21 pp.

Exhibition, May 24 through June 15, 1938, at the Federal Art Gallery, NYC. More of a guide than an exhibition catalog. The booklet describes twenty-five selected murals in the greater New York area. Text by Lillian Somons.

0752 Index of American Design. *Drawings for the Index of American Design.* Federal Art Project: New York, 1938. Mimeographed. 2 pp.

Exhibition, June 21 through July 15, 1938, at Macy's Department Store. No checklist, just a brief description of the IAD.

0753 ACA Gallery. *1938 Dedicated to the New Deal.* ACA Gallery: New York, 1938. 24 pp.

Exhibition, July, 1938; catalog of twenty-one works, many done for the FAP; (B/W photographs of works taken by Mark Nadir); text signed H. Baron, comments on the success of the FAP and the need for it to continue.

0754 Federal Art Project. Chicago. *Summer print show*. Federal Art Gallery: Chicago, 1938. 8 pp.

Exhibition, July 11 through August 12, 1938. Checklist of forty-one items.

0755 Federal Art Project. *Exhibition of work by teachers in art teaching divisions*. Federal Art Gallery: New York, 1938. 1 p.

Exhibition, July 20 through August 11, 1938. Catalog not seen (text by Alex R. Stavenitz). Invitation to opening in AAA.

0756 Chicago. Art Institute. *Art for the public by Chicago artists of the Federal Art Project Works Progress Administration*. Art Institute: Chicago, 1938. 16 pp.

Exhibition, July 28 through October 9, 1938. Checklist of the 373 objects from all aspects of the FAP in this important show of work by Illinois artists. Introduction by Daniel Catton Rich. Includes the schedule of gallery talks on FAP subjects.

0757 Federal Art Project. *East side—west side*. Federal Art Gallery: New York, 1938. 9 pp.

Exhibition, September 20 through October 11, 1938. Checklist of 291 photographs (listed only by photographer, not title) of both creative work and illustrative material (for FWP work etc.). Foreword by Ralph Gutieri (head of Photography Division).

0758 Federal Art Project. *Paintings, prints, sculpture, murals. Four unit exhibition*. Federal Art Gallery: New York, 1938. 1 p.

Exhibition, October 21 through November 11, 1938. Works from four divisions of the FAP (Easel Painting, Graphic Arts, Sculpture, and Mural Division). Catalog not seen. Invitation to opening in AAA.

0759 Federal Art Project. *Exhibition: art and psychopathology. Jointly sponsored by the psychiatric division Bellevue Hospital and the Federal Art Project, Works Progress Administration*. Federal Art Project: New York, 1938. 9 pp.

Exhibition, October 24 through November 10, 1938. Checklist of 106 works in all media by patients in Bellevue's psychiatric division; arranged by mental illness. Text by Alex R. Stavenitz (head of Art Teaching Division, FAP).

0760 Federal Art Project. *Regional poster exhibition.* Federal Art Gallery: New York, 1938. 6 pp.

Exhibition, November 18 through December 8, 1938. Checklist of 122 posters from New York City, New York State, and New Jersey.

0761 Federal Art Project. Allocations Gallery, District of Columbia. *Federal art.* Allocations Gallery: Washington, DC, 1938. Silkscreened and mimeographed. 3 ll.

Exhibition, December 10 through ?, 1938. Small pamphlet describing the purpose and functions of the Allocations Gallery (for WPA artists from Washington to display their work so that tax-supported institutions could select it for permanent loan). Attractive little pamphlet with silkscreened cover.

0762 Federal Art Project. *Exhibition. Paintings, prints, murals, sculpture, crafts by children.* Federal Art Gallery: New York, 1938. 6 l. Mimeographed.

Exhibition, December 22, 1938, through January 10, 1939. Checklist of 211 works by children of the New York City FAP. Foreword by Victor E. D'Amico.

0763 Spokane Art Center. *Modern design in everyday life.* Spokane Art Center: Spokane, WA, 1938. 8 pp.

Exhibition, December 22, 1938, through January 22, 1939. Exhibition of everyday objects (coffee pots, radios, cars, kitchens, etc.) showing the effects of modern design. "The premise of this exhibition is that each new era in history is inevitably accompanied by a new approach to design."

MONOGRAPHS

0764 Art in Federal Buildings, Inc. *Art guides. Number 1. A guide to the painting and sculpture in the Justice Department Building. Washington, District of Columbia.* Art in Federal Buildings, Inc.: Washington, DC, 1938. 27 pp.

Well done little guide to the art work (primarily Section work) in the Justice Department Building. B/W illustrations with explanations of work by Emil Bisttram, Boardman Robinson, C.P. Jennewein, John R. Ballator, Symeon Shimin, George Biddle, John Steuart Curry, Louis Bouche, Leon Kroll, Maurice Sterne, and Henry Varnum Poor.

0765 Art in Federal Buildings, Inc. *Art guides. Number 2. A guide to the painting and sculpture in the Post Office Department Building. Washington, District of Columbia.* Art in Federal Buildings, Inc.: Washington, DC, 1938. 32 pp.

Well done little guide written in a guided tour style to the art work (primarily Section work) in the Post Office Department Building. B/W illustrations with explanations of many of the works.

0766 Damrosch, Walter. *Proposed plan for the establishment of a Federal Bureau of Fine Arts.* New York, 1938. 7 pp.

Damrosch, a well-known conductor, offers an alternative plan to the defeated Coffee-Pepper bill for a Bureau of Fine Arts. Found on AAA reel NDA 1.79–83.

0767 Federal Art Project. *A brief outline of the Federal Art Project of the Works Progress Administration.* Washington, DC, 1938. 3 pp. pamphlet.

Brief, concise history of the FAP.

0768 Federal Art Project. *Mosaic, Long Beach California Municipal Auditorium.* Long Beach, 1938? 3 mounted plates, 51 cm.

NOT SEEN. CITED IN OCLC.

0769 Federal Art Project. *Portfolio of Spanish Colonial design in New Mexico.* Federal Art Project: Santa Fe, NM, 1938. 40 pp. 50 colored plates.

NOT SEEN. CITED IN MOMA CATALOG. Limited edition of 200 portfolios of Spanish Colonial design in New Mexico as recorded by the IAD.

0770 Federal Art Project. *The WPA Federal Art Project. A summary of activities and accomplishments.* FAP: New York, 1938. 24 pp. Mimeographed.

Description of the FAP projects and plans. NOTE: a number of publications came out under this or similar titles usually with no date; the text is usually quite similar with some figures updated.

0771 Federal Art Project. New York City. *Art in a democracy. Sponsors, friends and members of the Federal Art Project, Works Progress Administration.* New York, 1938. 57 ll.

Program for a dinner in honor of the FAP held in New York city. Program includes a summary of the project by Audrey McMahon, a list of the speakers, a description of Federal One, and a detailed description of the FAP.

0772 Federal Art Project. New York City. *Program of the Federal Arts Projects for the City of New York, June 25–July 1, 1938.* WPA: New York, 1938. 10 pp.

NOT SEEN. CITED IN OCLC. "Prepared for the 1938 convention of the National Education Association."

0773 Federal Writers' Project. Massachusetts. *An almanack for Bostonians. "Being a truly amazing and edifying compendium of fact and fancy, designed primarily for the delectation of those who live within the shadow of the Bulfinch dome, but one which may be used with profit and pleasure by dwellers in the outer darkness of Cambridge, Somerville, Chelsea, Newton, and even more out landish places, the whole compiled in a most prim and scholarly fashion by*

workers of the Federal Art Project in Massachusetts; Poor Richard Associates, sponsor." M. Barrows and Company: New York, 1938. 120 pp.

Just what the title says; "delineator" of the art work that graces the pages is Curtis Smith Hamilton of the FAP.

0774 Federal Writers' Project. New York City. *Birds of the world. An illustrated natural history.* Albert Whitman and Company: Chicago, 1938. 205 pp.

Ornithological book illustrated with small print designs (of birds, naturally) between the chapters by Ad Reinhardt.

0775 Federal Writer's Project. San Francisco. *Almanac for thirty-niners.* James L. Delkin: Stanford University, 1938. 127 pp.

Almanac written by the FWP and illustrated by Lloyd Wulf of the FAP.

0776 Hart, Henry. *Philadelphia's shame; an analysis of the un-American administration of the Federal Art Project in Philadelphia.* Friends of Art and Education: Philadelphia, 1938. 15 pp.

A highly critical phillipic against Mary Curran, FAP Regional Director, Pennsylvania. Hart accuses her of a multitude of sins including favoritism, dictatorship, and anti-unionism. "The evidence presented herewith should leave no doubt in the mind of any unbiased person that the Philadelphia W.P.A. art project has been inhumanely, inefficiently and illegally administered by the Regional Director for Pennsylvania, Miss Mary Curran, and that she should be dismissed immediately" (inside cover).

0777 Miller, Dorothy Canning. "Painting and sculpture." In *Collier's Yearbook 1938*, pp. 529–34.

General overview of the New Deal art projects for the year 1934.

0778 *1938: Prints by artists of the Federal Art Project.* Private printing: New York, 1938. Spiral bound calendar.

Calendar for 1938, "Printed through the courtesy of a
private sponsor," with twelve prints by FAP artists and a color
lithograph by Russel T. Limbach. Found on AAA reel NDA
14.1078–1090.

0779 Treasury Relief Art Project. *Artists on relief.* GPO:
Washington, DC, 1938?

NOT SEEN.

0780 US Congress. House of Representatives. *A bill to
provide for a permanent Bureau of Fine Arts.* H.R.9102 75(3). 6
pp.

Introduced January 21, 1938, by Rep. John M. Coffee, the bill
would create a Bureau of Fine Arts. Senate version of the bill
(S. 3296) sponsored by Claude Pepper); this revised version
of Coffee's earlier H.R. 8239 became known as the Coffee-
Pepper bill. Sent to House Education Committee. Never left
committee.

0781 US Congress. House of Representatives. *A joint resolu-
tion to create a Bureau of Fine Arts in the Department of Interior.*
H.J. Res. 671 75(3). 7 pp.

Introduced May 4, 1938, by Rep. William I. Sirovich, the bill
would create a Bureau of Fine Arts under the Department of
the Interior. Sent to Committee on Patents. This was a
last-ditch attempt by the supporters of a Bureau of Fine Arts
to get a bill passed. When the Coffee-Pepper bill died in
committee, Sirovich brought out this plan which modified
some of the more troublesome passages in the Coffee-Pepper
bill. The bill stated that "Resolved . . . that it is the policy of
Congress to encourage the development in our country of
cultural institutions as an important and integral part of the
national life and history in order that our people now and in
the future will have the benefits arising from the develop-
ment of talented cultural personalities and institutions native
to our country and its people," p.1. The bill allowed for the
transfer of the WPA cultural activities to the new bureau, and
created a director of the bureau and five assistant directors
(for theatre, literature, music, graphic and plastic arts, and

dance). On June 15, 1938, however, the bill was tabled in the House by a vote of 195 to 35 to the accompaniment of jeers, jokes, and laughter. Sirovich attempted to create the Bureau one last time in 1939 (*See* **0937**), but died before any action was taken.

0782 US Congress. House of Representatives. *Creating a Bureau of Fine Arts.* House Report 2486 75(3). 2 pp.

House report issued May 26, 1938, making minor adjustments in William I. Sirovich's H.J.Res. 671. Committee on Patents unanimously accepts the revised version and sends it to the full House.

0783 US Congress. House of Representatives. Committee on Patents. *Department of Science, Art and Literature.* Hearings held February 7–11, 1938. GPO: Washington, DC, 1938. 282 pp.

Hearings held on H.R. 9102 and H.J. Res. 79. Witnesses, in favor of the bill (unless otherwise noted) included A.F. Brinckerhoff (President of the Fine Arts Federation and against the Bill), Holger Cahill, Bernard Godwin (artist), Chet La More (artist), Rockwell Kent, Martin Popper (Federal Arts Committee, General Counsel), and Ellen S. Woodward.

0784 US Congress. Senate. *A bill to provide for a permanent Bureau of Fine Arts.* S. 3296 75(3). 10 pp.

Introduced January 21, 1938, by Senator Claude Pepper, the bill would create a Bureau of Fine Arts, absorbing all present WPA cultural activities. Senate version of H.R. 9102 sponsored by John M. Coffee; a duplicate of Coffee's bill; known as the Coffee-Pepper bill. Sent to Senate Committee on Education and Labor. Never left committee. *See* **0786** for hearings on bill.

0785 US Congress. Senate. Committee on Appropriations. *Work relief and public works appropriation act of 1938.* Hearing, May 16, 1938. GPO: Washington, DC, 1938. 327 pp.

Inserted statements by Martin Popper (representing the Arts Union Conference), Rep. William I. Sirovich, and Marvic McIntyre (Secretary to the President) regarding the FAP (pp. 252–54).

0786 US Congress. Senate. Committee on Education and Labor. *Bureau of Fine Arts.* Hearings on S. 3296, February 28, March 1–2, 1938. GPO: Washington, DC, 1938. 217 pp.

Testimony by a number of art professionals from all fields (music, theatre, fine arts, writing) in favor of a Bureau of Fine Arts. Fine arts representatives were: Stuart Davis for the American Artists' Union, Jeffery Norman for the National Society of Mural Painters, and Waldo Pierce a painter. Testifying against the bill was Gutzon Borglum, creator of the Mount Rushmore memorial. A number of WPA and FAP administrators (Thomas C. Parker, Lawrence S. Morris, and Ellen S. Woodward) also testified. Claude Pepper chaired the Subcommittee. *See also* **0784** for the text of the bill.

0787 Works Progress Administration. *Handbook of procedures for state and district Works Progress Administration.* GPO: Washington, DC, 1938. Looseleaf.

Chapter IX, Section 6 (3 pp.) covers the procedures for Federal Project No. 1. How the projects are organized, special regulations, procedures, features of employment and financial procedures are covered. NOTE: FAP regulations did not change since 1937 edition of *Handbook* (*See* **0560**).

0788 Works Progress Administration. *Index of American Design manual.* [WPA Technical series. Art circular #3]. WPA Division of Women's and Professional Services: Washington, DC, 1938. 38 pp.

Detailed, step-by-step instructions for supervisors and workers on how the IAD works; includes instructions on filling out forms (plus an appendix with the forms), how to prepare the plates, how to select material, and suggestions on how to render the objects.

0789 Work Progress Administration. *Inventory. An appraisal of the results of the Works Progress Administration, Washington, D.C., Harry Hopkins, administrator.* WPA: Washington, DC, 1938. 100 pp.

Informative, publicity work, illustrating, in words and pictures, the accomplishments of the WPA through October 1, 1937. Pp. 79–82 cover the FAP. Notes that the "fine art" projects account for only 3% of WPA expenditures. P. 91 includes FAP statistics. B/W photographs of artists at work. NOTE: pp. 79–82 also published separately by the GPO as "American art, work that is being done by the WPA artists."

1939

0790 "Cultural front." *Direction* 2 (January–February 1939): 26–27.

Note that the FAP will be reduced in size; that there will be a new attempt to create a Federal Art Bureau; and that Elizabeth Olds of the FAP Graphics Division won an award in Philadelphia.

0790a Hamlin, T.F. "Federal arts bill, 1939." *Pencil Points* 20 (January 1939): 9–10.

Comments on the Bureau of Fine Arts bills of 1939.

0791 Payant, Felix. "Art teachers in public schools should support and sponsor important art program." *Design* 40 (January 1939): 1.

Editorial in support of FAP art education programs.

0792 Petersen, William J. "The territorial centennial of Iowa." *Iowa Journal of History and Politics* 37 (January 1939): 3–51.

A note on p. 31 mentions the work done by the FAP in supplying a mural and photographic exhibit on livestock production for the Iowa Centennial.

0793 "Treasury as an agent." *Fortune* 19 (January 1939): 126.

As part of a longer article on the functions of the Department of Treasury, the Procurement Division (which oversaw the Section) is discussed. Calls the governmental art produced by the Section "Lively, full of local significance."

0794 Boswell, Peyton. "Some friendly advice: defence against threat to kill the cultural phase of the Works Progress Administration." *Art Digest* 13 (January 1, 1939): 3.

Boswell's proposals on how to best save the art projects; his suggestions include the following: deciding if the project is for the sake of relief or art; if for art, then remove the relief element; eliminate politics and controversy; continue public exhibitions; and encourage private patronage.

0794a "The Bureau bills." *Art Digest* 13 (January 1939): 9.

Comments on the various plans (including the Coffee-Pepper bill) for a proposed Bureau of Fine Arts; supports the plan put forward by Walter Damrosch (*See* **0766**).

0795 "WPA art report." *Art Digest* 13 (January 1, 1939): 15.

Summary report by Harry L. Hopkins of five years of WPA art work.

0796 "WPA supervisors." *Art Digest* 13 (January 15, 1939): 8.

List of the supervisory staff of FAP with full titles.

0797 "Don't burn the books! Protest cuts in WPA arts projects: a survey." *New Masses* 30 (January 24, 1939): 14–16.

Comments by Stanley M. Isaacs (President of the Borough of Manhattan), Donald Ogden Stewart (President, League of American Writers), Bennett A. Cerf (publisher), Muriel Draper (writer), Robert M. Coats (art critic), Edward C. Aswell (publisher), John Howard Lawson (playwright), Whit Burnett (editor), Sylvia Sidney (actress), Franchot Tone (actor), George Seldes (writer), Carl Randau (newspaperman), Arthur Kober (playwright), and Louis P. Birk (editor) on the importance of Federal One and why it should be saved. Cartoon by Mischa Richter showing a "Capitalist" dropping a bomb on the temple of the arts projects with the caption "First Objective."

0798 US Treasury Department. Section of Fine Arts. *Bulletin. Section of Fine Arts* 18 (February 1939): 20 pp.

Note on the history of the Section; note on the non-Section competition to design the new gallery of art for the Smithsonian Institution. Competitions announced:
St. Louis, MO, Post Office, $29,000 (later won by Edward Millman and Mitchell Siporin);
Los Angeles, CA, Post Office and Courthouse, $7,200 (later won by James Hanson);
Amarillo, TX, Post Office, $6,500 (later won by Julius Woeltz);
Wilmington, NC, Post Office and Courthouse, $2,300 (later won by William Pfehl);
Poughkeepsie, NY, Post Office, $4,200 (later won by George Klitgaard and Charles Rosen);
Baron, KY, Post Office, $740 (later won by Frank Long).
Biographies of David Hutchinson, Jesse Hull Mayer, Gerrit V. Sinclair, and Richard Zoellner. B/W illustrations of work by Mitchell Jamieson, Wendell Jones, Ethel Magafan, Henry Varnum Poor, Peter Hurd, Clay Spohn, Joe Jones, and Rainey Bennett.

0799 Pemberton, Murdock. "Painting America's portrait; mural art in this country." *Travel* 72 (February 1939): 6–13.

Pemberton explains the purpose of the FAP in creating murals throughout the country and acts as a tour guide to some of his favorites across the nation; praises the "American-ness" of the subjects of the murals; numerous B/W illustrations of murals.

0800 "Artists in a democracy; federal art projects of New York City, Wisconsin and New Mexico." *Progressive Education* 16 (February 1939): 105–15.

Statements by ten people associated with the FAP as artists, administrators, and advisors on the project. Statements include general praise for the FAP, statistics, and comments on the specific state projects. B/W photographs of works by Edwin S. Knutesen and Alonzo Hauser.

0801 Judd, Maurice B. "Art and the doctors." *Hygeia* 17 (February 1939): 135.

B/W reproductions of five FAP posters created to fight cancer. Notes that these may by purchased from the Treasury Department for 20–35 cents each.

0802 "WPA prints." *Art Digest* 13 (February 1, 1939): 31.

Notice of Federal Art Gallery (NYC) show, "99 Prints" by WPA/FAP artists; includes a list of outstanding prints from the show.

0803 "CIO shows its teeth." *Art Digest* 13 (February 15, 1939): 6.

Announcement of an exhibition to be held by the Congress of Industrial Organizations (CIO) at the Brooklyn Museum May 19th to September 1939, that will be open only to union artists; specifically excludes non-union WPA artists. "All American artists are eligible to submit prints for this exhibition except non-union artists employed on the Federal Art Project, WPA." *See also* **0810** for more on this issue.

0804 "13 million for WPA arts." *Art Digest* 13 (February 15, 1939): 21.

Notice that WPA spent $13.825 million on art according to Agnes S. Cronin, administrative assistant for the WPA.

0805 "WPA muralist gets into trouble by copying from photographs." *Life* 6 (February 27, 1939): 62–63.

Photo essay on Jared French's WPA work for the New York State Vocational Institution in West Coxsackie, NY, for which he copied the figures from art anatomy books.

0806 "A mural and a show." *New Masses* 30 (February 28, 1939): 14.

Note on William Gropper's mural for the Department of Interior ("Building a Dam"). B/W reproduction of sketch of

the mural. Also comments on an unrelated show of Gropper's work at the ACA Gallery.

0807 "Minnesota artists' union." *Direction* 2 (March–April 1939): 14–15.

A mostly illustrated account of the Walker Art Gallery and FAP's attempt, in conjunction with the Minnesota Artists' Union, to open a community art center. B/W illustration of works by Bill Norman, Jeanne Taylor, Syd Fossum, and Olaf Aalbu.

0808 Hunt, Edwyn A. "Henrietta Shore, artist." *California Arts and Architecture* 55 (March 1939): 7.

Discussion of the life and work of Henrietta Shore, including her Section work on the Santa Cruz Post Office murals; B/W illustration of the Santa Cruz Post Office mural.

0809 "A portfolio of toy banks." *Coronet* (March 1939): 10–14.

B/W and color reproductions of IAD plates depicting toy banks.

0810 "CIO pulls in its horns." *Art Digest* 13 (March 1, 1939): 12.

The CIO retracts its earlier statement on its print show (*See* **0803**), and opens it to all artists, unionized or otherwise.

0811 "Federal art friends." *Art Digest* 13 (March 1, 1939): 12.

FDR asks Congress to reinstate $150 million cut from WPA. Friends of the Federal Art Project seeks to keep it alive; includes address to join the Friends of the Federal Art Project, c/o Grace H. Gosselin, secretary.

0812 "From the ringside." *Art Digest* 13 (March 1, 1939): 17.

Note on the controversy surrounding Jared French's FAP mural for the New York State Vocational Institution in West

Coxsackie, NY, entitled "The Tropics." French had copied models in an art textbook for the mural, and now Audrey McMahon of the New York FAP does not think the mural will be used.

0813 "Project artists show paintings in minor key in New York." *Art Digest* 13 (March 1, 1939): 12.

The third annual exhibition of paintings done by regional FAP ("Work of New Jersey Artists. Plates from the Index of American Design. Painting and Sculpture") artists is held at the Newark Museum; includes seventy-six artists; mixed reviews. Includes a B/W illustration of work by Dennis Burlingame.

0814 "Providence: watercolor renderings of American crewel embroidery." *Art News* 37 (March 4, 1939): 17–18.

Favorable review of a show of IAD textile plates at the Museum, School of Design, Providence (RI). Full account of the textiles represented.

0815 "How to paint a fresco." *Newsweek* (March 13, 1939): 37–38.

Note on the FAP film, *The Technique of Fresco Painting*, and a description (illustrated with B/W photographs from the film) on fresco techniques.

0816 Watson, Forbes. "New forces in American art." *Kenyon Review* 1 (Spring 1939): 119–34.

Overview of the New Deal art projects; defends the programs as a way to encourage the creation of art by a wider spectrum of the population. A very good article. B/W illustrations of works by William Gropper and Ward Lockwood. NOTE: Reprinted in condensed pamphlet form by the Government Printing Office (1939, 13 pp.).

0817 Levitas, Louise. "Cafeteria society; from Greenwich Village nickel night life to WPA and $23.86 a week." *Scribner's Magazine* 105 (April 1939): 14–15, 42–43.

Levitas (a FAP art model) reminisces about artists organizing for Federal support; she is a bit rueful about the passing of the old radical days now that all the Village artists are drawing a regular government salary. Interesting.

0818 "A portfolio of hitching posts." *Coronet* (April 1939): 11–14.

B/W and color reproductions of IAD plates depicting hitching posts.

0819 "'Fascist!' cries Burg." *Art Digest* 13 (April 1, 1939): 14.

Copeland Burg of the Chicago *American* calls the art of the FAP fascist in the sense that it is government dictated.

0820 "Frontiers of American art." *Art Digest* 13 (April 15, 1939): 24.

Notice of FAP show, "Frontiers of American Art," opening at the De Young Museum (San Francisco).

0821 "Third report." *Art Digest* 13 (April 15, 1939): 21.

List of 110 commissions done through July 1, 1939. Compiled with the assistance of Edward Bruce and Forbes Watson.

0822 "WPA Federal Art Project." *Direction* 2 (May–June 1939): 16–17.

Works by FAP artists done for the New York World's Fair; photographs of art and artists at work. B/W illustrations of works by Eric Mose (misprint, actually Seymour Fogel), Philip Guston, and Cesare Stea.

0823 Cahill, Holger. "American art today." *Parnassus* 11 (May 1939): 14–15, 35.

Comments excerpted from the introduction to "American Art Today" catalog to the show of the same name at the New York World's Fair.

0824 "Frontiers of American art at the M.H. de Young memorial museum." *Magazine of Art* 32 (May 1939): 309–10.

Note on the "Frontiers of American Art" exhibition at the M.H. de Young museum (San Francisco).

0825 Kerr, Florence. "Leisure-time activities and the WPA Federal Art Projects." *Childhood Education* 15 (May 1939): 388.

Editorial praising the work of Federal One, particularly its work with children. "Experience under the Federal Art Project has revealed that the imagination of children finds fresh and spontaneous expression in murals, painting, sculpture, print-making and the arts and crafts."

0826 Morsell, Mary. "Murals enliven school walls with vivid tales." *Nation's Schools* 23 (May 1939): 22–25.

Morsell explains how to get a mural for your local school, describes the murals created as vigorous and thematically interesting, and gives a selection of ones she thinks are particularly good. B/W illustrations of murals by Russell Spekman, Ann Michalov, Ralf Hendricksen, Karl Kelpe, and Emanuel Jacobsen.

0827 "Portfolio of wood carvings." *Coronet* (May 1939): 98–102.

Color reproductions of IAD plates depicting various forms of wood carvings.

0828 "Review. *Changing New York.*" *Architectural Forum* 70 (May 1939, supplement): 20.

Favorable review of *Changing New York* by Berenice Abbott and Elizabeth McCausland.

0829 "$29,000 federal mural competition." *Architectural Record* 85 (May 1939): 10, 12.

Announcement of Section competition for St. Louis Post Office mural and others.

0830 Weisenborn, Fritzi. "Lauds federal art." *Art Digest* 13 (May 1, 1939): 17.

Fritzi Weisenborn, critic for the Chicago *Times,* praises the FAP.

0831 "What of federal art?" *Art Digest* 13 (May 1, 1939): 16.

Excerpted from article by Lee G. Miller in the New York *World-Telegram* expressing the fear that a new bill sponsored by Senator Byrnes (D, SC) that will require the states to help pay the costs art projects will go through, killing them off.

0832 Broun, Heywood. "Save the arts projects." *New Republic* 99 (May 10, 1939): 17.

Critical attack on the cutbacks made to Federal One and the Congressional investigatory committee looking into WPA projects led by H. Ralph Burton.

0833 "Middletown: prints and paintings of the WPA pass in review." *Art News* 37 (May 13, 1939): 17–18.

Favorable review of show of eighty prints and eighteen oils on exhibition at the Davidson Art Rooms, Olin Memorial Library, Wesleyan University, CT; partial list of artists.

0834 "Federal art on parade in San Francisco." *Art Digest* 13 (May 15, 1939): 5–6.

Highly favorable review of "Frontiers of American Art" at the De Young Museum (San Francisco). Includes B/W illustrations of works by Julian Levi, Edward Millman, Robert Russin.

0835 Boswell, Peyton. "Frontiers of American art." *Art Digest* 13 (May 15, 1939): 3.

Editorial in praise of the show, "Frontiers of American Art" at the De Young Museum (San Francisco). Boswell praises the carrying of FAP art to the West Coast.

0836 "Making a wood engraving; Lynd Ward explains process of how it's done." *Newsweek* 13 (May 15, 1939): 31.

Lynd Ward of the FAP Graphics Division gives the step-by-step process of creating a wood engraving.

0837 "To paint pageant of America for *Life.*" *Art Digest* 13 (May 15, 1939): 16.

Edward Laning, a FAP artist, is chosen by *Life* magazine to do a painting in its art program. B/W illustration.

0838 Starobin, Joseph. "The United States arts projects." *New Masses* 31 (May 16, 1939): 12–14.

Intelligent, well-written defense of Federal One during the Congressional investigation of the WPA. Cartoon by Mischa Richter showing a large fish being dropped on a temple labeled Federal Art Projects with the caption "Congressman Woodrum Investigates."

0839 Rugg, Harold. "Creative America today: American artists working at the American problem." *Scholastic* 34 (May 20, 1939): 13s–15s.

General views on "art" in America; some discussion of the New Deal Art Projects as being a good idea.

0840 "The Federal arts projects have become the focal point for the continuing attack on the standards and methods of relief symbolized by WPA." *Nation* 148 (May 27, 1939): 602–603.

Editorial calling for protection of the arts projects, adding that under local sponsorship they would lose their vitality. "Nobody loves an artist. Ridiculing him or condescending to him is an old American pastime. Let any politician point to an artist drawing government money with which to draw pictures and the stage is set for loud laughs," p.602.

0841 "Federal art activity." *Arts in Philadelphia* 1 (June–July 1939): 17–18.

Note on the attempts by the Philadelphia art world, particularly the Citizens Art Committee, to save the FAP. Describes the work done by the FAP in Philadelphia.

0842 US Treasury Department. Section of Fine Arts. *Bulletin. Section of Fine Arts* 19 (June 1939): 30 pp.

Note on the number of competitions completed; note on how the "48 State Competition" will be run; drawing of the proposed location in each of the 48 Post Offices of each mural in the "48 State Competition."

0843 "Convincing WPA achievements in five artistic departments." *Art News* 37 (June 10, 1939): 17.

Favorable review of "Functions of the Art Project" at the Federal Art Gallery.

0844 "Back to pamphleteering." *New Masses* 32 (June 27, 1939): 8–9.

Reproduction of six of the twelve cartoons published by the American Artists' Congress (*See* **0907**) defending the FAP. Text describes the pamphlet and compares it to those done in the past to promote causes. Cartoons by Abe Ajay, Hugo Gellert, David Fitzpatrick, John Groth, A. Birnbaum, and Maurice Becker are reproduced.

0845 "Cultural front." *Direction* 2 (July–August 1939): 20–21.

Note on Edward Laning's work appearing in *Life*.

0846 "Save the Federal Arts Projects." *Direction* 2 (July–August 1939): inside front cover.

Editorial calling readers to save Federal One from budget cuts.

0847 Larson, Cedric. "The cultural projects of the WPA." *Public Opinion Quarterly* 3 (July 1939): 491–96.

Summary overview of the Federal One projects with statistics; calls for support of H.J. Res. 149 (creating a Federal Arts Bureau).

0848 Whiting, F.A. "Artists' ambition." *Magazine of Art* 32 (July 1939): 389.

In praise of the projects, but feels care should be taken in carrying them out. "Relief, in its application to art, creates for those in the business of applying it, obligation of high order. The possibilities of maladjustment, of undermining real artists by supporting false ones is serious."

0849 Hamlin, Gladys E. "Mural painting in Iowa." *Iowa Journal of History and Politics* 37 (July 1939): 227–307.

A very thorough history of murals in Iowa; only a short section on the New Deal mural projects in Iowa. Condensed version of the author's thesis (*See* **0547**).

0850 "Treasury contests." *Art Digest* 13 (July 1, 1939): 31.

Section announces the nationwide "Forty-eight State Competition."

0851 "Drastic changes loom for WPA art project." *Art Digest* 13 (July 1, 1939): 8–9.

A bill in Congress will drastically cut WPA art funding.

0852 "WPA." *New Masses* 32 (July 4, 1939): 18–19.

Editorial protesting government cuts to the WPA; in inset box, describes the successes of the FAP and other WPA projects.

0853 Binsse, Harry Lorin. "Art: dubious to the value of the project." *America* 61 (July 22, 1939): 359.

An article critical of the FAP, feeling that the FTP to be a much better idea. "There is something almost beyond comprehension in the idea of subsidizing several thousand men and women to make easel paintings. It is something like

subsidizing a request of people to 'loaf and invite their souls.' For most easel painting is exactly that."

0854 "Incalculable record." *Magazine of Art* 32 (August 1939): 460–71, 494–95.

A plea (heavily illustrated in B/W photographs of works) to save the FAP; gives a number of reasons to save it. Includes a bibliography of articles in the *Magazine of Art* and other locations of articles on FAP.

0855 "Mural competition." *San Francisco Art Association Bulletin* 6 (August 1939): 3.

Section announces the "Forty-Eight State" competition.

0856 Salomen, Samuel. "The Red's mess on WPA." *National Republic* 28 (August 1939): 15, 32.

In a reactionary right-wing attack on the WPA—particularly the Art Projects—a photograph of WPA/FAP artists marching in a "Communist May Day Parade" is shown.

0857 "WPA restricted." *Art Digest* 13 (August 1, 1939): 19.

Announcement that all artists on WPA projects for more than eighteen months will be automatically dropped; if they are still in need of relief after thirty days, they will be eligible to reapply; 75% of New York City artists will be affected.

0858 "Cultural front." *Direction* 2 (September 1939): 20–21.

Notes on Gwendolyn Bennett (director of the Harlem Art Center) and Augusta Savage (sculptor and former director of the Harlem Art Center) being named as outstanding Negro women; and that the visitors to the World's Fair have voted on their favorite FAP mural. B/W photograph of Leo Lance's photo-mural at the World's Fair.

0859 "Participation—keynote of the Federal Art Project." *Direction* 2 (September 1939): 12–13.

Photo essay on the FAP's art classes, calling them one of the most important aspects of the FAP. B/W photographs of art classes.

0860 Sterner, Frank W. and Rutherford J. Gettens. "Standard for artist's materials; paint testing and research laboratory." *Magazine of Art* 32 (September 1939): 518–20, 545.

Detailed, technical account of the Paint Testing and Research Laboratory of the WPA/FAP. Illustrated with B/W photographs of the lab.

0861 "Approved by John Q. Public." *Art Digest* 13 (September 1, 1939): 12.

Philip Guston's mural at the WPA building at the World's Fair is chosen as most popular outdoor mural; Anton Refregier's work is chosen as best indoor work. Results obtained from a popularity contest sponsored by the Mural Artists' Guild and voted on by World's Fair attendees.

0862 Klein, Jerome. "Art." *Direction* 2 (October 1939): 19–20.

Comments that the morale of the artists on the WPA/FAP has been lowered by cuts and threats of cuts; Klein feels that artists must fight to gain back what was lost them as well as for peace at home and Europe.

0863 "Large commission; St. Louis mural commission awarded to Edward Millman and Mitchell Siporin." *Magazine of Art* 32 (October 1939): 594–95.

Edward Millman and Mitchell Siporin win the Section competition for the St. Louis Post Office; includes list of jury members. B/W illustrations of works by both.

0864 "Sculpture for the public schools: from the New York and Illinois art projects of the WPA." *Survey Graphics* 28 (October 1939): 607–609.

Primarily photographs of sculpture by Ruth Nickerson, Louise Pain, Joseph Nicolosi, Hugo Robus, Joseph Fleri, Rudolph Herr, and Romuald Kraus.

0865 "Millman and Siporin win $29,000 federal competition for St. Louis." *Art Digest* 14 (October 1, 1939): 12.

Edward Millman and Mitchell Siporin win Section competition for St. Louis Post Office mural. B/W illustration of works by both artists.

0866 "Pigment standard." *Art Digest* 14 (October 1, 1939): 34.

The Paint and Testing Research Laboratory of the Massachusetts WPA/FAP defines pigment standards.

0867 "Murals of Oregon embellish its new capitol." *Life* 7 (October 14, 1939): 45–47.

Photo essay on murals in the Oregon State Capitol done by Barry Faulkner and Frank H. Schwarz.

0868 "Albert Reid paints old cattle country for Sulphur, Oklahoma, post office." *Art Digest* 14 (October 15, 1939): 18.

Reviews of mural by Albert Reid for the Sulphur, OK, Post Office.

0869 "Project sponsors." *Art Digest* 14 (October 15, 1939): 21.

The WPA/FAP, with the help of local sponsors, will continue at 90% of its former level says Florence S. Kerr, Assistant WPA Commissioner, despite cuts.

0870 "Uncle Sam hires Woeltz; mural panels in the Amarillo (Texas) post office." *Art Digest* 14 (October 15, 1939): 13.

Julius Woeltz is hired by the Section to do murals in the Amarillo, Texas, Post Office. Includes a list of eleven others who received Section commissions.

0871 "Western watercolorist; a young man goes East and gets his first big showing." *Newsweek* 14 (October 16, 1939): 42.

Byron Randall, who received his first art education at the Salem Art Center, is now getting his first one-man show at

the Whyte Gallery in Washington. B/W illustrations of his work.

0872 US Federal Works Administration. Section of Fine Arts. *Bulletin. Section of Fine Arts* 20 (November 1939): 18 pp.

Note on the Corcoran Gallery exhibition of Section work by Forbes Watson; note on Mitchell Siporin and Edward Millman's mural for the St. Louis Post Office; texts of the speeches given by Senator Robert M. La Follette and Edward Bruce at the opening of the Corcoran show; very brief biographies of each of the winners of the "48 State Competition." Competition for the New Orleans, LA, Post Office (worth $14,000) announced (later won by Armia Scheler and Karl Lang).

0873 "Art." *Arts in Philadelphia* 2 (November 1939): 25–26.

Note that the Pennsylvania Art Project/WPA has just issued a pamphlet, *Art in Use* (*See* **0919**), that describes the Project's accomplishments. Praises the work of the Project artists.

0874 "Crafts." *Arts in Philadelphia* 2 (November 1939): 26.

Note that some IAD plates will be exhibited at the Philadelphia Museum of Art as part of an exhibition of folk art. B/W illustration of an IAD plate.

0875 "Cultural front." *Direction* 2 (November 1939): 20.

Note that from November 11–22, 1939 there will be an exhibition WPA/FAP work done by children held at the Whitehall Ferry Terminal (NYC).

0876 McMahon, A. Philip. "Changing New York; photographs by B. Abbot, text by Elizabeth McCausland. Review." *Parnassus* 11 (November 1939): 42.

Favorable review of *Changing New York* (1939) by Berenice Abbot and Elizabeth McCausland.

0877 "Forty-eight state competition; winning sketches exhibited at Corcoran gallery." *Magazine of Art* 32 (November 1939): 659–61.

Winners of the Section's "48 State Competition" shown at the Corcoran Gallery (Washington, DC).

0878 "New York: report on WPA art project." *Art News* 38 (November 11, 1939): 14.

Announcement that Brehon Somervell, WPA Administrator for New York City, released a report summarizing four years of WPA/FAP work; includes a summary of statistics from the report.

0879 "Winners in government's 48-states competition shown at Corcoran." *Art Digest* 14 (November 15, 1939): 12.

Summary of reviews of a show of Section's "48 State Competition" winners at the Corcoran Gallery (Washington, DC). B/W illustration of work by Peter Hurd.

0880 "Fifth anniversary." *Time* 34 (November 13, 1939): 52–53.

Overview of Section work; mixed review of "Exhibition: Painting and Sculpture for Federal Buildings" at the Corcoran Gallery (Washington, DC). B/W photograph of a mural.

0881 "Muralists' work for the federal Maecenas; exhibition at the Corcoran gallery." *Art News* 38 (November 25, 1939): 14.

Favorable review of "Exhibition: Painting and Sculpture for Federal Buildings" at the Corcoran Gallery (Washington, DC). B/W illustrations of work by David Martin and Edward Millman.

0882 "Art for the people." *Arts in Philadelphia* 2 (December 1939): 28.

Praise for, and list of accomplishments of the Pennsylvania Art Project/WPA. B/W photograph of Stewart Wheeler at work on a mural.

0883 Whiting, F.A., Jr. "Five important years." *Magazine of Art* 32 (December 1939): 676–82, 729.

Overview of the work done by the Section in the past five years. "The Section's program, though born of the emergency, settled down to a job of longer range," p. 677. Praises the "American-ness" of Section work. B/W illustration of work by Symeon Shimin.

0884 "Forty-eight state mural competition winners." *Architectural Forum* 71 (December 1939): 40.

Complete list of the winners of the "48 State Competition."

0885 "Mural awards." *Pencil Points* 20 (December 1939, supplement): 42–44.

Winners and runners-up in the Section's "48 State Competition."

0886 "Save the Index of American Design!" *Antiques* 36 (December 1939): 278.

Plea to keep the IAD alive. "The aesthetic wealth of this country has received less Governmental attention than the Japanese beetle."

0887 "New York WPA art project gives up gallery." *Museum News* 17 (December 1, 1939): 2.

Note that the WPA/FAP/NY is closing the Federal Art Gallery; includes a list of the committee members of the WPA/FAP/NY. Includes statistics of the FAP/NY (136 murals; 9,766 easel paintings; 1,909 sculptures; 48,816 prints; 2,378 print designs; and 718,189 students in art classes).

0888 "Speaking of pictures . . . this is mural America for rural Americans." *Life* 7 (December 4, 1939): 12–13, 15.

Photo essay on the Section's "48 State Competition." Small reproductions of each of the winners (artist and site identified).

0889 Boswell, Peyton. "Smoke before fire." *Art Digest* 14 (December 15, 1939): 3.

While praising Edward Bruce and his work on the Section, Boswell speaks of rumors of Bruce's resignation.

EXHIBITIONS

0890 De Young Memorial Museum. *Frontiers of American art. Works Progress Administration, Federal Art Project.* De Young Memorial Museum: San Francisco, 1939. 111 pp.

Exhibition, April 11 through October 15, 1939. Checklist of 403 works from all aspects of FAP. One of the most important FAP shows; essay by Thomas C. Parker. Numerous B/W illustrations.

0891 Federal Art Project. *99 prints.* Federal Art Gallery: New York, 1939. 1 pp.

Exhibition, January 24 through February 7, 1939. Catalog not seen (foreword by Lynd Ward, head of the Graphics Division, FAP). Invitation to opening in AAA.

0892 Federal Art Project. *Exhibition of Negro cultural work on the Federal Arts Projects of New York City Art-Music-Writers-Theatre-Historical Records.* FAP: New York, 1939. 4 p. Mimeographed.

Exhibition, February 10 through 24, 1939. Exhibition held at the Harlem Community Art Center of work by all branches of the WPA's Federal One. Includes work from the FAP's painting and sculpture divisions and by children taught in the art teaching division. Found in AAA reel 1085.153–156.

0893 Federal Art Gallery. *Exhibition. Oils, gouaches, watercolors.* Federal Art Gallery: New York, 1939. 9 ll.

Exhibition, February 14 through March 9, 1939. Checklist of seventy-six works by FAP artists on exhibit at the Federal Art Gallery. Includes a statement by Max Weber on the FAP. Foreword by Philip Evergood, George Pickens, and Murray Hartman on works in the show.

0894 Federal Art Project of New Jersey. *Work for New Jersey*

artists. Plates from the Index of American Design. Painting and sculpture. Newark Museum: Newark, NJ, 1939. 20 pp.

Exhibition, March 9 through April 16, 1939 at the Newark Museum. Checklist of 162 works from all media. List of FAP/NJ committee members. Brief introduction by Arthur F. Egner, chairman of the committee.

0895 Federal Art Gallery. *Exhibition of plates for the Index of American Design.* Federal Art Gallery: New York, 1939. 18 ll.

Exhibition, March 15 through 31, 1939. Checklist of 188 plates from the IAD. Foreword by Lincoln Rothschild (acting head, NY Unit of IAD).

0896 Federal Art Project. *Exhibition of art suitable for allocation. Painting, sculpture, prints, posters.* Russell Sage Foundation: New York, 1939. 6 ll.

Exhibition, March 27 through April 21, 1939. Checklist of 159 works from all media on exhibit at the Russell Sage Foundation, New York.

0896a Exhibition, April 11 through October 15, 1939 at the M.H. de Young Memorial Museum, *See* **0890.**

0897 Federal Art Project. *Exhibition of photographs. Changing New York, Berenice Abbott.* Federal Art Gallery: New York, 1939. 1 p.

Exhibition, April 12 through 22, 1939. Exhibition to accompany the publication of *Changing New York* by Abbott and Elizabeth McCausland (*See* **0906**). Catalog not seen. Invitation to opening in AAA.

0898 Federal Art Project. *Art in the making.* Federal Art Gallery: New York, 1939. 1 p.

Exhibition, May 3 through 21, 1939. Catalog not seen. Invitation to opening in AAA.

0899 Federal Art Project. *Functions of the Project.* Federal Art Gallery: New York, 1939. 1 p.

Exhibition, May 23 through June 24, 1939. Catalog not seen.
Last exhibition at the Federal Art Gallery, New York City.
Invitation to opening in AAA. A lecture series, "2 Outstanding Art Events," was organized with this show. The first,
"Meet the Artists," held February 27, where twelve artists
discussed how they created their work; and "The Armory
Show—25 Years Later" brought together a number of artists
who exhibited in the show that first brought "modern" art to
America.

0900 New York World's Fair. *American art today.* National
Art Society: New York, 1940. 30 pp.

Exhibition, June 1, 1939 to ?, 1940. Checklist of 1214 works
from around the country, many FAP works, on display at the
New York World's Fair.

0901 Federal Art Project. Illinois. *Exhibition of painting.*
Federal Art Gallery: Chicago, 1939. 8 pp.

Exhibition, June 22 through July 22, 1939. Checklist of
forty-one works.

0902 Federal Art Project. *Exhibition. Oils, watercolors, prints
and sculpture by artist teachers of the art teachers' division.* Federal
Art Gallery: New York, 1939. 5 pp.

Exhibition, August 1 through 23, 1939, at the Federal Art
Gallery, New York. Checklist of 132 works in a variety of
media by teachers in the teachers' division of the FAP.
Foreword by Alex R. Stavenitz.

0903 Los Angeles County Museum. *Southern California art
project.* Los Angeles County Museum: Los Angeles, 1939. 16
pp.

Exhibition, September 1 through October 8, 1939. Checklist
of 267 works from all media (plus IAD and children's work).
Foreword by Stanton Macdonald-Wright (state supervisor,
Southern California FAP). Numerous B/W illustrations of
works.

0904 Federal Art Project. Illinois. *Print show.* WPA Illinois Art Gallery: Chicago, 1939. 2 pp.

Exhibition, September 5 through 30, 1939. Checklist of thirty-one items.

0905 Public Buildings Administration. Section of Fine Arts. *Painting and sculpture designed for Federal buildings: exhibition, The Corcoran Gallery of Art, Washington, DC.* Section of Fine Arts, Public Building Administration, Federal Works Agency: Washington, DC, 1939. 26 pp.

Exhibition, November 2 through 21, 1939 at the Corcoran Gallery of Art (DC) of the winners of the "Forty-Eight State Competition." Checklist of 455 works (includes names and addresses of all artists plus a ballot for the visitor to vote for his/her favorites) broken down as follows: winners (1–49); selections of submitted works (50–170; 208–291); Missouri Post Office winner (171–72); selections from the St. Louis Post Office competition (173–207); designs for the Interior Department building (292–97); Seminole, Oklahoma Post Office (298); no item 299; New York World's Fair sculpture (300–330); work for foreign buildings, New York World's Fair (331–33); sculpture for the Interior Department building (335–37); miscellaneous Federal sculpture (338–46); and miscellaneous Federal murals (347–456).

MONOGRAPHS

0906 Abbott, Berenice and Elizabeth McCausland. *Changing New York.* E.P. Dutton: New York, 1939. 206 pp.

Crowning achievement of the FAP's photography section; Abbott's ninety-seven B/W views of New York are stunning, capturing many aspects of the city during the period 1936–1938. McCausland's brief notes on the photographs are enlightening. Reprinted in 1973 as *New York in the Thirties* (Dover: New York, 1973), changing only the title, the page layout from portrait to landscape, and putting the text on the same page as the photograph.

0907 American Artists Congress. *12 Cartoons defending WPA by members of the American Artists' Congress.* American Artists' Congress: New York, 1939. 12 pp.

Biting, satirical, political and often relevant cartoons defending the FAP. Cartoons by Abe Ajay, Maurice Becker, A. Birnbaum, Victor Candell, R.D. Fitzpatrick, Hugo Gellert, William Groper, John Groth, William Hernandez, Herb Kruckman, Jack Markow, and Anton Refregier.

0908 Biddle, George. *An American artist's story.* Boston: Little, Brown, and Co., 1939. 326 pp.

Autobiography of George Biddle, the man who suggested to FDR that some type of relief program be inaugurated for artists. A fellow student of FDR's at Groton, Biddle tells his life story through 1939 with vigor and zing. In addition to his role in persuading FDR to support artists, he tells of his work on the Section (Biddle did a number of Federal murals) and his battle for the Fine Arts bureau. The chapter, "Art and Its Social Significance" covers his life 1933–1939. B/W photographs and illustrations of his works. Biddle quotes from his letter to FDR of May 9, 1933: "The younger artists of America are conscious as they have never been of the social revolution that our country and civilization are going through; and they would be eager to express these ideals in a permanent art form if they were given the government's co-operation," p. 268.

0909 Doktor, Raphael. *Canvas adhesives.* [Technical Problems of the Artists, #2]. WPA: New York, 1939. 19 pp.

Detailed procedures for the preparation of canvases for mural work. Attempts to clear up problems artists face when mounting canvas murals on walls. Step-by-step process described clearly in words and diagrams.

0910 Emple, Adam. *Art lectures to the blind.* WPA Women's and Professional Division: Jacksonville, 1939. 45 ll.

Six lectures written and delivered by Emple on sculpture, graphic arts, ceramics, etchings, watercolors, and oil painting.

0911 Federal Art Project. *California's medical story in fresco. An illustrated account of the fresco decorations on the wall of Toland Hall, University of California Medical Center, San Francisco.* San Francisco, 1939. 24 pp.

Descriptions of the murals in Toland Hall, University of California Medical Center, San Francisco done by Bernard Zakheim and Phyllis Wrightson. B/W illustrations of selected panels.

0912 Federal Art Project. *Federal Art Project; a summary.* New York, 1939? 18 ll. Mimeographed.

Description of the WPA/FAP projects and plans. NOTE: A number of publications came out under this or similar titles usually with no date; the text is usually quite similar with some figures updated; dating is based on this internal evidence.

0913 Federal Art Project. *The Federal Art. April 1, 1939.* FAP: New York, 1939. 5 ll.

Summary of FAP activities through April 1, 1939, with a New York focus.

0914 Federal Art Project. *The Federal Art Project throughout the nation. April 1, 1939: a summary.* FAP: Washington, DC, 1939. 10 ll.

Summary of FAP activities through April 1, 1939.

0915 Federal Art Project. *40 Exhibitions at New York's Federal Art Gallery. A preview of the future.* Federal Art Project: New York, 1939. 40 ll.

Chronological list of all forty exhibitions to take place at the Federal Art Gallery, December 27, 1935, through May 23, 1939. Important document for the study of the Federal Art Gallery. Text by Robert M. Coates and Lillian Semons.

0916 Federal Art Project. *"My People," drawings, lithographs and etchings by Kaethe Kollwitz, from the collection of Erich Cohn, New York, assembled and circulated by the Federal Art Project, Works*

Progress Administration. Washington, DC, 1939. 9 ll., mimeographed.

Catalog of thirty works by Kaethe Kollwitz (a German artist exiled by Hitler). Includes a biography of Kollwitz.

0917 Federal Art Project. *Teaching art to the community: 25 selected murals.* WPA Federal Art Project of the New York World's Fair: New York, 1939. Pages unknown. Mimeographed.

NOT SEEN. CITED IN FVO (SEE 1335).

0918 Federal Art Project. New York City. *Murals by Anna Negoe. Education of youth in science and art, Lancaster high school, Lancaster, New York.* WPA Art Project: New York, 1939. 15 ll.

Brochure to accompany the mural "Education of Youth in Science and Art," by Anna Negoe in the Lancaster (NY) High School. Most of text is biographies of the famous personages depicted in the mural. Brief note on nature of the FAP.

0919 Federal Art Project. Pennsylvania. *Art in use. A brief survey of the activities of the Pennsylvania art project of the Works Projects Administration.* WPA: Philadelphia, 1939. 8 ll.

Summary of all activities of the WPA/FAP in Pennsylvania; list of murals completed and planned in the State; list of institutions receiving FAP works; mentions the invention of the carborundum print was made by Pennsylvania FAP.

0920 Federal Art Project. Southern California. *Historical murals in the Los Angeles County Hall of Records, Supervisor's Hearing Room.* FAP: Los Angeles, 1939. 28 pp.

Brochure to accompany the ten WPA/FAP murals done by Buckley MacGurrin, Charles Hulbert Davis, Ben Messick, Lorser Feitelson, Helen Lundeberg, Marius Hansen, Katherine Skelton, and Albert Rader. Detailed explication of the murals accompanied by B/W illustrations of the murals and photographs of the Hall of Records. Maps of the room showing location of each mural.

0921 Federal Art Project. Southern California. *San Diego Civic Centre fountain and Donal Hord, sculptor.* Federal Art Project of Southern California: San Diego, 1939. 23 ll.

Account of the building of the fountain for the San Diego Civic Centre by Donal Hord, a WPA/FAP project. Introduction by Stanton Macdonald-Wright, State Director for the FAP/Southern California. B/W photographs of the artist and the creation of the fountain.

0922 Federal Art Project. Southern California. *Southern California creates.* Federal Art Project Southern California and US Work Projects Administration: Los Angeles?, 1939?, 27 ll.

Overview of the work of the FAP in Southern California with reports from the following: Stanton Macdonald-Wright (overview); Lorser Feitelson (murals); Rene Van Neste; Robert Boag (mosaics); Sherry Peticolas (sculpture); Edwin Nahr (lithography); Paul Park (photography); Earle William and Arthur Vermeers (models); Christine Mayard (children's education); and Warren W. Lemmon (IAD). Numerous B/W illustrations.

0923 Federal Writers' Project. Nevada. *Calendar of annual events in Nevada.* Federal Writers' Project: Reno, NV, 1939. 32 pp.

NOT SEEN. CITED IN OCLC. Illustrated by Federal Art Project workers.

0924 Federal Writers' Project. New York City. *Reptiles and amphibians. An illustrated natural history.* Albert Whitman and company: New York, 1939. 253 pp.

Popular account of reptiles and amphibians; illustrated with prints of reptiles and amphibians between sections of the work by Ad Reinhardt on behalf of the NYC WPA/FAP.

0925 Index of American Design. *Folk arts of rural Pennsylvania, selected by the Index of American Design, Pennsylvania.* n.p., 1939. 1 p. 15 color plates.

NOT SEEN. CITED IN MOMA CATALOG. "This portfolio is selected, adapted, and compiled from original sources by Frances Lichten and Austin Davison II. Printed through the courtesy of a private sponsor."

0926 Miller, Dorothy Canning. "Painting and sculpture." In *Collier's Yearbook 1939*, pp. 529–34.

General overview of the New Deal art projects for the year 1939.

0927 New York World's Fair. *American art today*. National Art Society: New York, 1939. 342 pp.

Guidebook to the American art pavilion at the New York World's Fair. "American Art Today," an essay by Holger Cahill, describes the exhibition which included a number of New Deal artists; Cahill mentions the projects in the essay.

0928 Overmeyer, Grace. *Government and the arts*. W.W. Norton and Company: Washington, DC, 1939. 338 pp.

Excellent coverage of the New Deal art projects and the environment from which they arose. The first part of the work gives an historical sketch of art patronage throughout time around the world. The second part covers the PWAP, WPA/FAP, and the Section with many facts and figures. The numerous details on US legislation regarding the fine arts are good, but Overmeyer is a bit off on some of her bill numbers. The appendix summarizes government support for the arts in 58 countries.

0929 Pennsylvania Academy of the Fine Arts. *Master prints from the John Frederick Lewis collection of the Pennsylvania Academy of Fine Arts*. WPA: Washington, DC, 1939. 22 pp. Mimeographed.

Catalog of sixty Old Master prints from the PAFA exhibited under the auspices of the WPA/FAP. Introduction by Holger Cahill.

0930 Roosevelt, Franklin D. "Only where men are free can the arts flourish and the civilization of national culture reach full flower," Radio Dedication of the Museum of Modern Art, New York City, May 10, 1939," pp. 335–38. In *Public Papers and Addresses of Franklin Delano Roosevelt, V.8.* Macmillan: New York, 1941. 635 pp.

During the radio broadcast dedication of MOMA, FDR praises the work of the WPA artists: "I think the WPA artist exemplifies with great force the essential place which the arts have in a democratic society such as ours," p. 337.

0931 Seeley, Sidney W. *WPA art in America, regional study of Michigan.* MA Thesis, Syracuse University, 1939.

NOT SEEN. CITED IN HARPUR'S #718.

0932 Sorell, V.A., ed. *Guide to Chicago murals: yesterday and today.* Council on the Fine Arts: Chicago, 1939. Pages unknown.

NOT SEEN. CITED IN *The Federal Art Project in Illinois* (SEE 1658).

0933 Treasury Department. *Final report. Treasury Relief Art Project.* Treasury Department: Washington, DC, 1939. 54 pp. Mimeographed.

Complete list of artists employed by TRAP and list of projects. Five pages of narrative history of the TRAP. LOCATED IN THE AAA, Reel DC115.625–676.

0934 US Congress. *The statutes at large of the United States of America,* Vol. 53, Part 2, 76th (1). GPO: Washington, DC, 1939.

53 Statute Chapter 252, "Work Projects Administration" (pp. 927–29) creates the Work Projects Administration from the Works Progress Administration and transfers the latter's functions to the new office under the direction of the Federal Works Agency effective June 30, 1939. "Reorganization Plan No.1," (pp. 1423–1430): Section 301 creates the Federal

Works Agency; Section 303(b) transfers the Public Buildings
Administration (the Section's division) from the Treasury
Department to the FWA; Section 306 creates the Work
Projects Administration from the Works Progress Adminis-
tration and transfers it to the FWA. No specific mention of
the arts projects.

0935 US Congress. House of Representatives. *A bill to
establish a Division of Fine Arts in the Office of Education,
Department of Interior.* H.R. 2319, 75(1). 2 pp.

Introduced by James P. McGranery on January 11, 1939, the
bill would create a Division of Fine Arts within the Office of
Education in the Department of Interior. No mention of the
WPA cultural projects. Sent to the House Committee on
Education. Never left committee. McGranery introduced this
bill with minor variations two more times (*See* **1123** and
1205).

0936 US Congress. House of Representatives. *Investigation
and study of the Works Progress Administration. Pt. 1.* Investiga-
tive hearing, April 11, 17, 18, May 1, 2, 8–11, 15, 16, 18–20,
22, June 5–8, 13, 1939. 1357 pp.

A massive document (a second, multi hundred page part was
published that contains no references to the art projects)
covering every aspect of the WPA. Pp. 184–87, 1344–50 deal
with the FAP. Covers mainly the projects in New York City
and state (investigated by H. Ralph Burton), and Illinois
(investigated by J. McTigue; other testimony by George B.
Thorp, Illinois state FAP director).

0937 US Congress. House of Representatives. *A joint resolu-
tion to create a Bureau of Fine Arts in the Department of Interior.*
H.J. Res. 149, 76(1). 7 pp.

Introduced by William I. Sirovich on February 3, 1939, and
sent to the House Committee on Patents. Essentially an
unrevised version of H.J. Res. 671 (*See* **0781**), the resolution
went nowhere and Sirovich died ten months after its intro-
duction.

0938 US Congress. House of Representatives. Committee on Appropriations. *Further additional appropriations for work relief and relief, fiscal year 1939.* Hearings, March 15–17, 20, 21, 1939. GPO: Washington, DC, 1939. 311 pp.

Testimony by Florence Kerr (pp. 124–27) on the Division of Professional and Service Projects of the WPA; includes comments on the FAP. Statistics cited on p. 181 show that $3,638,619 was spent on the FAP between July 1, 1938, and February 28, 1939.

0939 US Congress. House of Representatives. Committee on Appropriations. *Work relief and relief for fiscal year 1940.* Hearings, May 12, 23–27, 29, 31, June 3, 1939. GPO: Washington, DC, 1939. 586 pp.

Testimony by Francis C. Harrington (p. 1ff) discussing appropriations for the WPA for FY 1940. Harrington avoids direct answers to questions such as this one by Congressman Clifton A. Woodrum of Virginia: "I would like to ask you, Colonel, what consideration is being given by the W.P.A., for instance, to this sort of situation, where you have in these white-collar projects and professional projects people for whom obviously there will never be any demand in industry when good times come. For instance, I am thinking of professional musicians, actors, and actresses of the mediocre class, and maybe artists and people of that kind that, even with the return of normal conditions, can never hope that there will be much chance of a place for them in private employment," p. 84.

0940 US Congress. House of Representatives. Subcommittee of the Committee on Appropriations. *Additional appropriations for work relief and relief, fiscal year 1939.* Hearings, January 6, 9–10, 1939. GPO: Washington, DC, 1939. 228 pp.

Hearings on appropriations bill H.J.Res. 83, 76(1). Pp.109–113 relate to the FAP. Col. Francis C. Harrington (WPA Administrator) and Agnes S. Cronin (Administrative Assistant for the Division of Women's and Professional Projects, WPA) testify on behalf of the FAP. Includes statistics on the FAP (showing 5,000 employed on art projects as of Decem-

ber 24, 1938). Rep. Clifton A. Woodrum (VA) asks the questions.

0941 US Congress. Senate. *A bill to provide for a Bureau of Fine Arts.* S. 2967, 76(1). 3 pp.

Introduced on August 5, 1939, by Claude Pepper, this bill would have created a Bureau of Fine Arts within the Federal Works Agency. Sent to the Finance Committee. "The Commissioner of Fine Arts shall employ as many artists and incidental craftsmen as are necessary to carry out the purpose of this Act," p. 3. No specific mention of the New Deal art projects. The bill never left Committee.

0942 US Congress. Senate. Committee on Appropriations. *Additional appropriations for work relief and relief, fiscal year 1939.* Hearings, January 16–18, 1939. GPO: Washington, DC, 1939. 284 pp.

Hearings on appropriations bill H.J.Res. 83, 76(1). Pp. 16–22, 183 relate to the FAP. Col. Francis C. Harrington (WPA Administrator) and Agnes S. Cronin (Administrative Assistant for the Division of Women's and Professional Projects, WPA) testify on behalf of the FAP (as well as the other projects in Federal One). Includes statistics on the FAP ($22 million will be needed to run all four art projects in the coming year). Sen. Millard E. Tydings (MD) asks the questions: "Do you not think that these cultural fields, while they are of great value to the country, may be overpopulated and we may lean a bit over in providing employment to keep alive the cultural side of the Nation in that respect?" p. 16.

0943 US Congress. Senate. Committee on Appropriations. *Work relief and public works appropriation act of 1939.* Hearing, June 20–22, 1939. GPO: Washington, DC, 1939, 351 pp.

Hearings on H.J. Res. 326, 76(1). Col. Francis C. Harrington again testifies on behalf of the WPA. Pp. 95–98 includes comments on the FAP (as well as the other Federal One projects—concentrating on the proposed elimination of the theatre project); statistics brought forward show that in FY 1939, $5,000,442 was spent on art projects and that the FAP

employed 4,624 people (as of June 7, 1939). On pp. 333–34, Basom Slemp, a citizen from Wise County, VA, testified on the good things that the FAP was doing. Senators Millard Tydings (MD), Alva B. Adams (CO), and Carl Hayden (TN) ask questions.

0944 US Public Buildings Administration. *Guide to murals and sculpture in Washington, DC.* Federal Works Agency: Washington, DC, 1939. 9 pp.

Excellent little guide to the art work of Washington's Federal buildings; gives artist, medium, and location. Maps.

0945 Works Progress Administration. *Assigned occupations of persons employed on WPA projects.* GPO: Washington, DC, 1939. 73 pp.

Report through November 1937, includes a number of fascinating statistics. FAP statistics include: 4,019 artists out of 89,347 professional and 1,566,830 total WPA employees (.39%); 917 of the artists are women (22.8%); New York City has the most artists, 1,688 (1.2% of WPA workers in New York City; 1,296 are men and 392 are women). Statistics are broken down for each state.

0946 Works Progress Administration. *Handbook of procedures for state and district Works Progress Administration.* GPO: Washington, DC, 1939 (revised April 15, 1937). Looseleaf.

Chapter IX, Section 6 (3 pp.) covers the procedures for Federal Project No. 1. How the projects are organized, special regulations, procedures, features of employment and financial procedures are covered. NOTE: FAP regulations did not change since the 1937 edition of the *Handbook* (*See* **0560**).

1940

0947 Bywaters, Jerry. "Toward an American art." *Southwest Review* 25 (January 1940): 128–42.

Giving an overview of American art history, Bywaters, himself a WPA/FAP artist, comments on the New Deal art projects and praises the contributions of the Community Art Centers. B/W illustrations.

0948 "Ernest Hamlin Baker's Mural for Wakefield, RI post office." *American Artist* 4 (January 1940): 18–19.

Three B/W illustrations of Ernest Hamlin Baker's mural for the Wakefield, RI Post Office (preliminary sketches and final version).

0949 Klein, Jerome. "A developing American art." *Direction* 3 (January 1940): 13, 28.

Comments that the WPA/FAP has helped to develop an "American art," but that recent cutbacks have hampered its growth. Governmental patronage has been much more successful than that of the rich and privileged class at fostering a democratic art.

0950 "New York City WPA Art Project." *Direction* 3 (January 1940): 14–17.

Summary of and contents of, Audrey McMahon's four-year report on the New York City WPA/FAP. B/W illustrations of work by Cesare Stea, Elliot Means, Beatrice Mandelman, Richard Sussman, Ruth Gikow, Max Baum, Walter Quirt, Axel Horr, Ruth Cheney, Harry Gottlieb, and David Feinstein.

0951 Hammer, Victor. "Architrocities; public buildings not planned for murals." *Art Digest* 14 (January 1, 1940): 11.

Victor Hammer, a Viennese artist, praises Section work, but criticizes official Washington buildings as being too much exterior with not enough planning of the interior spaces.

0952 "Minneapolis opens art center built around Walker Gallery." *Newsweek* 15 (January 15, 1940): 34.

Note on the opening of the Walker Art Center in Minneapolis. Praises its collection.

0953 Hornaday, Mary. "Everybody's art gallery." *Christian Science Monitor Weekly Magazine* (January 20, 1940): 7.

Popular account of the Section's Post Office mural projects. B/W illustrations of works by Reginald Marsh and Kindred McLeary.

0954 Morrison, Richard C. "Town art centers." *Holland's, the Magazine of the South* (February 1940): 12, 35.

Good, brief account of the activities of the WPA/FAP's community art centers in the South. B/W photographs of activities in the art centers. Lists the addresses of nine art centers in the South.

0955 "One out of three." *Art Digest* 14 (February 1, 1940): 16.

The Whitney annual includes 81 (out of 245) works from artists associated with WPA/FAP. Includes complete list of artists.

0956 US Federal Works Agency. Section of Fine Arts. *Bulletin. Section of Fine Arts* 21 (March 1940): 16 pp.

Introduction by Edward Bruce to the functions of the Section; letter to Edward Bruce from Henry Varnum Poor; text of "The Meaning of Social Security" by A.J. Altmeyer. Competition announced for six projects for the Social Security building in Washington, a sculpture competition worth

$8,000 (later won by Robert Cronbach), and five mural competitions worth $3,520, $5,280, $2,700, $5,000, and $8,000 (later won by Ben Shahn, Philip Guston, Gertrude Goodrich, and Seymour Fogel). Also announced, a project for the US Maritime Commission to decorate US ships worth $1,330 (later won by Adelaide Briggs, Ada Cecere, Willem de Kooning, L. Gardner Orme, Jean Swiggett).

0957 "Four WPA posters." *Design* 40 (March 1940): 17.

B/W illustration of four WPA/FAP posters.

0958 McCausland, Elizabeth. "Mural designs for federal buildings; exhibition, Whitney Museum." *Parnassus* 12 (March 1940): 32, 34.

Favorable review of "Mural Designs for Federal Buildings" at the Whitney Museum; works exhibited were the winners of the "Forty-Eight State Competition" sponsored by the Section. McCausland favors the continuance of the Section.

0959 "The Section of Fine Art." *New York Artist* 1 (March 1940): 5, 14.

Critical of a show of Maurice Sterne's mural work for the Department of Justice in New York City, the writer takes the opportunity to comment on the various art projects, calling pay too low and the tie to relief harmful.

0960 L., J.W. "New mural designs for federal buildings at Whitney museum." *Art News* 38 (March 9, 1940): 17.

Favorable review of "Mural Designs for Federal Buildings" at the Whitney. B/W illustration of work by Barse Miller.

0961 "Critics evaluate federal murals at the Whitney museum." *Art Digest* 14 (March 15, 1940): 8–9, 29.

Summary of reviews of mural sketches at the Whitney Museum. Includes B/W illustrations of works by Edgar Britton, George Harding, Mitchell Sioporin, Ward Lockwood, Kindred McLeary, Howard Cook.

0962 "Silk screen." *New Masses* 34 (March 26, 1940): 29–30.

In a review of a silkscreen show at Weyhe Gallery, the author comments on how the WPA/FAP, and Anthony Velonis in particular, brought the process to the world's attention. Includes a quote from Velonis's booklet (*See* **1125**) on the silk screen process.

0963 McCausland, Elizabeth. "Art project work exhibited at Museum of Modern Art." *Parnassus* 12 (April 1940): 39.

Review of traveling show, "Traveling Exhibition of Contemporary American Art" now at MOMA; show includes easel paintings and watercolors from the WPA/FAP projects; includes a partial list of exhibiting artists.

0964 "Federal competition announced." *San Francisco Art Association Bulletin* 6 (April 1940): 3, 5.

Announcement of three Section competitions.

0965 "Four American traveling exhibitions." *Museum of Modern Art Bulletin.* 7 (April 1940): 4–5.

Account of four shows with WPA/FAP connections organized by MOMA and set to travel. "Face of America" (21 paintings); "Mystery and Sentiment" (18 paintings); "35 Under 35" (35 paintings); and "Jennie Lewis" (lithographs). Includes a list of all artists represented in the shows (but no breakdown as to who was in which). B/W illustration of work by Joseph Hirsch.

0966 "Pennsylvania WPA art project." *Pennsylvania School Journal* 88 (April 1940): 271–72.

Account of the Pennsylvania WPA/FAP, what it does, and instructions on how school administrators can get their schools involved in the project. Photograph of Joseph Hirsch and Stewart Wheeler working on murals.

0967 Smith, Margery Hoffman. "Timberline lodge, a recreational hotel on the slopes of Mt. Hood." *School Arts* 39 (April 1940): 262–64.

A good account of the construction of the Timberline Lodge (a WPA project to build a resort hotel on Mt. Hood, Oregon; the lodge was completely decorated by WPA/FAP artists). A description of some of the decorative details. Photographs of the lodge.

0968 "These diverse states: mural designs for new post offices; winning sketches." *Survey Graphic* 29 (April 1940): 251–53.

Primarily illustrations of the winners of the "Forty-eight State Competition." Included are B/W illustrations of work by Edmund D. Lewandowski, Fletcher Martin, Avery Johnson, Stuart R. Purser, Alton S. Tobey. Barse Miller, David Stone Martin, and Lorin Thompson, Jr.

0969 "Bufano's pink slip." *Art Digest* 14 (April 1, 1940): 13.

Beniamina Bufano, a San Francisco sculptor, was fired because of his plan to portray a CIO leader in his frieze for the George Washington High School.

0970 "More silk screen." *New Masses* 35 (April 2, 1940): 31.

Notes on a silk screen print show ("Exhibition of Silk Screen Prints) at the Museum of Fine Arts, Springfield, IL, (through March 31, 1940, later traveled) assembled by Elizabeth McCausland that contained work by WPA/FAP artists

0971 "US competitions: decorations for Social Security building and the President Andrew Jackson." *Art Digest* 14 (April 15, 1940): 12.

The Section announces a competition for the SS *President Jackson* and the Social Security building in Washington.

0972 "Competitions for the decoration of the President Andrew Jackson and Social Security building." *Art News* 38 (April 20, 1940): 20.

The Section announces a competition for the SS *President Jackson* and the Social Security building in Washington.

0973 Thomas, Elbert D. "Addresses in honor of American artists who contributed towards decorations in Federal buildings." *Congressional Record Appendix* 8 (April 29, 1940): 2476–79.

Inserted remarks by Thomas. Full text of remarks by Edward Bruce, John M. Carmody, John Dewey, Summer Welles (Under-Secretary of State), Senator Robert M. La Follette, and Henry Morgenthau during an NBC radio broadcast on April 25, 1940, praising the Section. Dewey's remarks are of particular interest: "The work is significant both as a symbol and as an actual force in inspiring and directing activities which will extend as time goes on far beyond what is done in post offices and other public buildings. As a symbol it is an acknowledgment from official sources, with the active encouragement of persons high in Government, of the importance to our Nation of the development of art and of ability to enjoy art products," p. 2477.

0974 Ward, Lynd. "The union in the contemporary art world." *New York Artist* 1 (May–June 1940): 4–6.

"The existence of the project is a phenomenon that must, as time goes on, loom increasingly larger on the cultural horizon," p. 4. Ward claims WPA/FAP is very important and that it owes its existence to the Artists' Union. Covers concepts of artist/patron and the role of the Artists' Union in creating the project. B/W illustrations of works by Paul Lucker, Tschashasov, Willard Hirsch, and Morris Neuwirth.

0975 Klein, Jerome. "Art." *Direction* 3 (May 1940): 12–14.

Comments on MOMA's four traveling exhibitions of WPA/FAP art. B/W illustrations of work by Charles Campbell, Joseph Hirsch, and O. Louis Guglielmi.

0976 "Mural paintings and sculpture in the Social security building and President Andrew Jackson." *Architectural Forum* (May 1940 supplement): 60.

The Section announces a competition for the SS *President Jackson* and the Social Security building in Washington.

0977 Laning, Edward. "Murals for the central building." *Bulletin of the New York Public Library* 44 (May 1940): 393–94.

Brief descriptions of Edward Laning's WPA/FAP murals for the New York Public Library (unveiled by Mayor LaGuardia on April 22, 1940). B/W illustrations of the murals. NOTE: Reprinted as a four-page pamphlet entitled "The Mural Paintings of Edward Laning in the New York Public Library" in 1963.

0978 Payant, Felix. "Handcrafts." *Design* 41 (May 1940): 5.

Brief account of the IAD's efforts to record American ceramics, textiles and furniture.

0979 "Work projects show at the Brooklyn museum and Brooklyn botanic gardens." *Brooklyn Museum Bulletin* 1 (May 1940): 2.

Note on the exhibition, "This Work Pays Your Community" (May 17 through June 9, 1940) at the Brooklyn Museum. Show will contain work from all aspects of relief work, including WPA/FAP.

0980 Boswell, Peyton. "Art at the fairs." *Art Digest* 14 (May 15, 1940): 3.

Boswell comments on "Art in Action," a program of WPA/FAP artists at the San Francisco World's Fair where a mural designed by Herman Volz will be created. Some comments on the WPA/FAP work on exhibit at the New York World's Fair.

0981 Cahill, Holger. "American art today and in the world of tomorrow." *Art News* 38 (May 25, 1940, supplement): 49–51.

Cahill's account of the WPA/FAP work on exhibit at the New York World's Fair; numerous B/W illustrations

0982 "Pittsfield: exhibit of WPA art." *Art News* 38 (May 25, 1940): 14.

Favorable review of an exhibition of forty-two oils done by artists on the Massachusetts WPA/FAP at the Berkshire Museum (Pittsfield, MA); partial list of artists.

0983 "American Negro exposition." *Direction* 3 (Summer 1940): 14.

B/W illustration of work by Vertis Hayes of the WPA/FAP done for the Harlem Hospital on exhibit in Chicago (July 4 through September 2, 1940).

0984 Biddle, George. "Art under five years of federal patronage." *American Scholar* 9 (Summer 1940): 327–38.

Important article by Biddle covering the Section, WPA/FAP, and National Youth Administration. He praises all the programs, but fears for their future; claims the projects are responsible for the surge in the popularity of art in America. Of the projects: "[they are] democratic, social and anonymous rather than aristocratic, aesthetic and snobbish. I am not concerned with moral values but curious about the art trend in America," pp. 327–28.

0985 "Cultural front." *Direction* 3 (Summer 1940): 53.

Note on the "American Art Today" exhibition of WPA/FAP work at the World's Fair; and that the WPA Art Project Teaching Division is holding some new classes.

0986 "Art project highlights living American art at New York fair." *Art Digest* 14 (June 1940): 10–13.

Favorable review of "American Art Today" at the World's Fair, a changing exhibit of WPA/FAP work. B/W illustrations of work by Concetta Scaravaglione, Abraham Herriton, Jenne Magafan, Robert Archer, Manuel Tolegian, Roff Beman, Cameron Booth.

0987 "Arts." *Arts in Philadelphia* 2 (June 1940): 27–28.

Note that the Pennsylvania Art Project/WPA has 294 employees as of June 1940. B/W photographs of IAD artist at work on an IAD plate.

0988 Boswell, Peyton. "Project comes through." *Art Digest* 14 (June 1940): 3.

Editorial praising the work of art project artists included at the Contemporary American Art Galleries at the World's Fair.

0989 Devree, Howard. "I.B.M. and WPA at the fair." *Magazine of Art* 33 (June 1940): 367–69, 384–85.

Mixed review of WPA at New York's World Fair. "Little of the work is definitely bad; much of it is very good indeed," p. 384. Praises IAD and mural work. B/W illustrations of works.

0990 "Art: American art today." *Time* 35 (June 10, 1940): 55.

Comments on the "American Art Today" exhibition at the New York World's Fair; finds the WPA art lacking, but the IAD to be a good idea.

0991 Velonis, Anthony. "Silk screen process prints." *Magazine of Art* 33 (July 1940): 408–11.

Velonis gives a full account of the silk screen process he helped to revive while on the WPA/FAP. B/W illustrations of works by Hyman Warsager, Elizabeth Olds, Anthony Velonis, and Harry Gottlieb.

0992 Watson, Jane. "New carborundum print developments." *Magazine of Art* 33 (July 1940): 438–39.

Notes on the further developments of the carborundum print process (i.e. color prints) developed by the WPA/FAP.

0993 "Stalin in a stove." *Time* 36 (22 July 1940): 42.

Report on August Henkel's WPA/FAP mural for Brooklyn's Floyd Bennett Field, one of whose figures bore a striking resemblance to Joseph Stalin. The mural was ordered removed by New York WPA administrator Colonel Brehon Somervell. Henkel said of Somervell: "Somervell's a soldier

and doesn't understand what culture is." Article comments on Henkel's radical past. B/W illustration of mural.

0994 "First competition for American ship decoration." *Magazine of Art* 33 (August 1940): 483, 488.

The Section announces a competition for the SS *President Jackson.*

0995 "[Floyd Bennett Air Field.]" *National Republic* 28 (August 1940): 10.

Two B/W illustrations of August Henkel's WPA/FAP mural for the Floyd Bennett Airfield in Brooklyn with the caption: "Taxpayers paid for these two Communist murals at Bennett Air field by W.P.A. artists—recently burned because of public indignation." NOTE: The *National Republic* was an extreme Right Wing publication that could condemn the FAP in an article like this and then praise the IAD in the next (*See* **0996**).

0996 Sherman, Allan. "From cellar to museum." *National Republic* 28 (August 1940): 13, 31.

Article praising the work of the IAD; describes in detail the IAD's work on recording display signs. B/W reproductions of IAD plates.

0997 Watson, Jane. "Federation conference passes resolution stressing importance of government art projects." *Magazine of Art* 33 (August 1940): 478–79.

Text of a resolution passed by the American Federation of Arts calling the projects "of such importance in American life as to be a necessity in carrying on a full national experience," p. 478.

0998 Boswell, Peyton. "The case of the bitten hand." *Art Digest* 14 (August 1, 1940): 3.

August Henkel's mural for Brooklyn's Floyd Bennett Field is said to contain obvious Communist images and was de-

stroyed; Boswell argues that Henkel should not have done such a work, and besides, it was just plain bad to begin with.

0999 "Rising patriotism brings mural purge." *Art Digest* 14 (August 1, 1940): 19.

A discussion of August Henkel's mural at the Floyd Bennett airport in Brooklyn recently destroyed for its Communist content.

1000 Cameron, Donald. "History in cloth." *Design* 42 (September 1940): 22–24.

IAD works to preserve narrative textile designs. B/W illustrations of the textiles.

1001 Davis, Maxine. "American Renaissance." *Coronet* (September 1940): 127–31.

Overview of the work of the Section, concentrating on the personality of Edward Bruce.

1002 "Nineteen to decorate liners." *Art Digest* 14 (September 1940): 17.

Section artists to decorate new fleet of President line cruise ships. Includes a list of the artists selected. B/W illustration of work by Andre Durenceau.

1003 Payant, Felix. "Handcrafts today." *Design* 42 (September 1940): 5.

Editorial praising the efforts of the art projects to preserve and promote handcrafts.

1004 "Realism in the WPA: murals in California." *Art Digest* 14 (September 1940): 18.

Stanton Macdonald-Wright, head of the Southern California WPA/FAP, introduces new mural material suitable for modern buildings; will help architects accept murals in their work. Comments by Arthur Millier of the Los Angeles *Times*.

1005 "Rediscovered miniatures; art treasures in New Orleans discovered and catalogued by Delgado art project." *Design* 42 (September 1940): 4.

The Delgado Museum in Louisiana working with the WPA/ FAP discovered a number of early American miniatures.

1006 Watson, Jane. "Government competitions; War department building in Washington; water colors for marine hospital; Marian Anderson mural; Los Angeles." *Magazine of Art* 33 (September 1940): 543–44.

Announcement of the Section competitions listed in the title.

1007 US Public Buildings Administration. Federal Works Agency. Section of Fine Arts. *Bulletin. Section of Fine Arts* 22 (September 1940): 19 pp.

Introduction on the operations of the Section by Edward Bruce. Winners of the competition to decorate the SS *President Jackson* and five other ships: SS *President Jackson:* Adelaide Briggs, Jean Swiggett, William [*sic*] de Kooning, Ada R. Cecere, and Lydia Gardner Orme; SS *President Garfield:* Esther Bruta, R. Phillips Sanderson, Edmund J. Lewandowski, Harry Simon, and Maxine Seelbinder; SS *Monroe:* Hildreth Meiere, R. Phillips Sanderson, David Swasey, Allen D. Jones, Jr., and Philip Guston; SS *President Adams:* Philip Guston, Jean Swiggett, James L. McCreery, Musa McKim, and Cleveland Bissell; SS *President Hayes:* Aldren A. Watson, Bernard Perlin (two items), Elsa V. Shaw, and Karl Baumann; SS *President Van Buren:* Tom Dietrich, R. Phillips Sanderson, Edmund J. Lewandowski, Musa McKim, and Philip Guston. Five new competitions announced:
Carville, LA, Watercolors for Marine Hospital; $6,000 for 200 works plus $3,000 for 100 more for rest of the nation; closes 11/15/40;
Marian Anderson Mural, Department of the Interior; $1,700 (later won by Mitchell Jamieson), closes 12/2/40;
Los Angeles, Mural in the Terminal Annex, $14,400 (later won by Boris Deutsch and Archibald Garner), closes 12/3/40;

Mural, War Department Building, $12,000 (later won by
Seymour Fogel), closes 4/1/41;
Sculpture, War Department Building, $24,000 (later won by
Earl Thorp and Henry Kreis), closes 5/1/41.

1008 "Parker made director of Arts Federation." *Museum
News* 18 (September 1, 1940): 2.

Thomas C. Parker, deputy director of the WPA/FAP, resigns
to become director of the American Federation of Arts.

1009 Andrews, Paula. "Colonel Somervell's Kulture." *New
Masses* 36 (September 17, 1940): 15.

Critical attack on the outrageous acts by Colonel Brehon
Somervell (NYC WPA Supervisor) against the WPA/FAP.

1010 "New York library waits 40 years for these murals."
Life 9 (September 30, 1940): 64–66.

Photo essay on Edward Laning's murals for the New York
Public Library. Gives a history of the project. Color photo-
graphs of the artist at work and of the completed murals.

1011 Boswell, Peyton. "Fletcher Martin, painter of memo-
ries." *Parnassus* 12 (October 1940): 6–13.

In an article on Fletcher Martin, Boswell comments on
Martin's association with the WPA/FAP and Section (in-
cludes a list of his Section assignments). B/W illustrations of
his works.

1012 Davis, Maxine. "New American art; public buildings
afford opportunity for artists to record local history." *Reader's
Digest* 37 (October 1940): 107–109.

Explanation of the Section and portrait of Edward Bruce.
Reprinted from *Coronet*, September 1940 (*See* **1001**).

1013 Jones, Wendell. "Article of faith." *Magazine of Art* 33
(October 1940): 554–59.

Jones's comments on what it is like to be an artist in the world

of the Depression and war. B/W illustrations of Post Office murals.

1014 Klein, Jerome. "What is happening on the Art Project?" *Direction* 3 (October 1940): 17.

Comments on Brehon Somervell's attacks on the WPA/FAP; also, a comment supporting the WPA/FAP by Eleanor Roosevelt (written at the request by the editor of *Direction*) on cuts to the WPA/FAP.

1015 "Artists to judge Project artists." *Art Digest* 15 (October 1, 1940): 8–9.

Brehon Somervell, NYC project administrator, creates an advisory committee to judge WPA/FAP artists.

1016 Boswell, Peyton. "Impending tragedy; WPA projects may be discontinued." *Art Digest* 15 (October 1, 1940): 3.

Boswell favors continuing the WPA/FAP and feels that cutting them off would be a national tragedy.

1017 Boswell, Peyton. "More art, less politics; Col. Brehon Somervell's plan of advisory committee of established artists to help lift the aesthetic level of the Federal art project in New York city." *Art Digest* 15 (October 1, 1940): 3.

Editorial on Brehon Somervell's plan to raise the aesthetic level of the WPA/FAP in New York City; Boswell agrees with Somervell in principle, but feels the various factions of the New York art world would undermine the committee.

1018 "Kreis gets $9,000 job." *Art Digest* 15 (October 1, 1940): 22.

Harry Kreis get the $9,000 commission for the Section mural project of the War Department building; includes a brief biography of Kreis.

1019 "Oklahoma litho annual." *Art Digest* 15 (October 1, 1940): 21.

Nan Sheets, director of the Oklahoma WPA/FAP Art Center, directs the Oklahoma lithography exhibit.

1020 "On losing sleep; Cronbach won the Social Security building competition." *Art Digest* 15 (October 1, 1940): 7.

Robert Cronbach, wins the Social Security building competition; includes a brief biography.

1021 Reeves, Ruth. "Murals." *Architectural Record* 88 (October 4, 1940): 73–76.

Account of mural design in modern America; comments on the wonders and technical innovations brought about by the government art projects. Numerous B/W illustrations of murals.

1022 "Activities in Oklahoma." *Art Digest* 15 (October 15, 1940): 33.

AAPL praises Nan Sheets' work at the Oklahoma WPA Art Center.

1023 "Wanted: 300 watercolors for the walls of a Louisiana marine hospital." *Art Digest* 15 (October 15, 1940): 13.

Section announces a watercolor competition for a Louisiana marine hospital; includes list of jury members.

1024 "Federal competitions." *San Francisco Art Association Bulletin* 7 (November 1940): 4.

Announcement of five Section competitions.

1025 "First water color competition to decorate the Marine hospital at Carville, La." *Parnassus* 12 (November 1940): 34.

Section competition for watercolors announced; includes a list of jury members.

1026 Klein, Jerome. "Art." *Direction* 3 (November 1940): 15.

Comments on how the Artists' Union is fighting for the continuation of the WPA/FAP.

1027 Mayor, A. Hyatt. "Prints by living Americans." *Bulletin. Metropolitan Museum of Art* 35 (November 1940, supplement): 14–20.

Notes on an exhibition of prints at the Metropolitan (November 25 through December ?, 1940) containing a number of PWAP and WPA/FAP works. Discusses the nature and purpose of the government art projects. B/W illustrations of a number of works.

1028 "Murals at the Whitney." *Pictures on Exhibit* 4 (November 1940): 16–17.

Review of Whitney show of murals, "Exhibition by the National Society of Mural Painters" (through November 20, 1940) that include a number of Section works.

1029 "Science and the artist." *Design* 42 (November 1940): 15–16.

The Technical Division of the New York City WPA/FAP works to solve technical problems for artists; Raphael Doktor, working for project, is a big help to artists.

1030 "Detroit auto workers love Roosevelt for more than WPA murals in Union Hall." *Life* 9 (November 4, 1940): 32.

Photograph of auto workers in front of an unidentified WPA mural. NOTE: part of an article on the 1940 elections.

1031 "Shahn best of 375; mural competition for corridor of the Social Security building." *Art Digest* 15 (November 15, 1940): 8.

The Section chooses Ben Shahn from 375 entrants to do Social Security building mural. List of honorable mentions included.

1032 "Somervell to rejoin army." *Art Digest* 15 (November 15, 1940): 15.

Brehon B. Somervell will rejoin the army, stepping down from his position as administrator of the New York City WPA

office. Oliver A. Gottschalk will take over as acting administrator.

1033 "WPA advisory group to raise the artistic level." *Art Digest* 15 (November 15, 1940): 15.

Excerpted from Emily Genauer's article in the New York *World Telegram;* the WPA advisory group in NYC does a good job of raising the aesthetic level of work done in the NYC WPA/FAP.

1034 "WPA moderns at Lincoln." *Art Digest* 15 (November 15, 1940): 27.

Exhibit of surreal and abstract prints done for the New York City WPA/FAP NYC at Lincoln School of the Teacher's College; includes list of artists and prints.

1035 Biddle, George. "You can't . . . let them eat art." *California Arts and Architecture* 57 (December 1940): 20, 40.

Biddle comments on his *Harper's* article (August 1940, nothing on New Deal art); B/W illustration of his work and photograph of Biddle.

1036 "Edmond Amateis and his sculpture for the Philadelphia post office." *American Artist* 4 (December 1940): 4–8.

Detailed account of how Edward Amateis went about doing his mural for the Philadelphia Post Office; B/W illustrations of the work.

1037 Klein, Jerome. "Art." *Direction* 3 (December 1940): 2.

Comments on National Art Week and the contributions made by the WPA/FAP; derogatory comments about Brehon Somervell's aesthetic sense. B/W illustrations of work by Peter Busa and Marion Greenwood.

1038 "Peixotto passes." *Art Digest* 15 (December 15, 1940): 9.

Ernest Clifford Peixotto, muralist, died December 6, 1940; worked for WPA/FAP.

1039 "US buys 300 pictures; list of watercolors bought for hospitals." *Art Digest* 15 (December 15, 1940): 27.

Complete list of 300 watercolors bought by the Section to be given to hospitals. Each cost $30; over ten thousand artists submitted works; includes list of jury.

EXHIBITIONS

1040 National Gallery of Canada. Ottawa. *Exhibition of mural designs for Federal buildings for the Section of Fine Arts.* National Gallery of Canada: Ottawa, 1940. 26 pp.

Exhibition, April 19 through May 6, 1940. Checklist of 149 works. Winning entrants in the "Forty-eight State Competition." Text by Forbes Watson and Edward B. Rowan. Explanation of how the competitions of the Section are run. B/W illustration on cover.

1041 Section of Fine Arts. *Mural designs for Federal buildings.* Federal Works Agency: Washington, DC, 1940. 26 pp.

Exhibition, no dates or site(s). Checklist of seventy-nine works from the "Forty-eight State Competition." Text by Edward Bruce. B/W illustration of work by Howard Cook.

1042 Federal Art Project. *Paintings, sculpture, Index of American Design plates, posters [and] prints. Exhibition by artists of the New York city Art Project, Work Projects Administration arts program, from January 8 to January 30, 1940, at the American Museum of Natural History, Education hall.* New York, 1940. 16 pp.

Exhibition, January 8 through 30, 1940. Foreword by Charles Russell. Catalog of thirty-eight prints and twenty silkscreen posters. NOT SEEN. CITED IN *Arts in America. A Bibliography.* Bernard Karpel, ed. Smithsonian Institution Press: Washington, DC, 1979 (entry L65c).

1043 Whitney Museum of American Art. *Loan exhibition of mural designs for Federal buildings from the Section of Fine Arts.* Whitney Museum: New York, 1940. 9 pp.

Exhibition, February 27 through March 17, 1940. Checklist of 114 works from the Section's "Forty-eight State Competition" selected from those exhibited at the Corcoran Gallery. Introduction by Forbes Watson.

1044 Springfield Museum of Fine Arts. *Exhibition of silk screen prints.* Springfield Museum of Fine Arts: Springfield, MA, 1940. 3 pp.

Exhibition, March 12 through 31, 1940. Checklist of fifty-nine prints by twenty-four artists; nearly all done by artists associated with the WPA/FAP, but done in off hours; most for sale. Exhibition organized by and text in catalog by Elizabeth McCausland. Cover silk screen by Pauline Stiriss.

1045 Museum of Modern Art. *Four American traveling shows in collaboration with the Works Progress Administration Art Project.* MOMA: New York, 1940.

Exhibition, April 3 through May 1, 1940. Checklist of the exhibition. Shows later traveled. NOT SEEN. CITED IN MOMA LIBRARY CATALOG.

1045a April 19 through May 6, 1940. "Exhibition of mural designs for Federal buildings for the Section of Fine Arts." at the National Gallery of Canada; *See* **1040.**

1046 New York City WPA Art Project. *One hundred watercolors. An exhibition by artists of the New York City Art Project Work Projects Administration Arts Program.* WPA: New York City, 1940. 5 p. Mimeographed.

Exhibition, June 27 through July 19, 1940. Checklist of 100 works shown at Tudor City in NYC.

1047 Walker Art Center. *An exhibition of "unpopular" art.* Walker Art Center: Minneapolis, 1940. 12 ll.

Exhibition, November 7 through December 29, 1940 at the Walker Art Center of a wide range of items (Chinese bronzes, Oceanic carvings, Aztec masks, etc.). Checklist of twenty-three items (seventeen illustrated). "Unpopular" (according to the text) because they provoke annoyance or ridicule or because they are rarely seen. Introduction by LeRoy Davidson.

MONOGRAPHS

1048 Crum, Priscilla. *American mural painting.* MA thesis, Western Reserve University, 1940. 88 pp.

Part I is a general overview of the history of mural painting in America; Part II covers the work of the Section in great detail. Good summaries of the Section's *Bulletins* are included. Close readings of a number of murals is done as well as an analysis of the "48 State Competition." Plates.

1049 Department of State. *Conference on inter-American relations in the field of art. Analysis and digest of the conference proceedings.* Department of State: Washington, DC, 1940. 32 pp. Mimeographed.

Summary of conference held in Washington October 11–12, 1939 to discuss the interchange of art ideas and information in the Western Hemisphere. Those associated with the New Deal art projects taking part in the conference were: George Biddle, Edward Bruce, Holger Cahill, Stuart Davis, William Milliken, C. Adolph Glassgold, Adrian Dornbush, Rockwell Kent, Ruth Reeves, Audrey McMahon, Edward B. Rowan, and Thomas Parker. Dornbush discussed the role of WPA/FAP handicrafts; Glassgold discussed how to make the IAD more available to Latin American nations. Many of the others discussed the WPA/FAP as an important American point of contact for other nations' art programs.

1050 Federal Art Project. *The carborundum print.* WPA: Washington, DC, 1940. 16 ll. Mimeographed.

"WPA Technical Series. Art Circular, no. 5." Step-by-step procedure on how to create a carborundum print. The

carborundum print was a new printing process created by Dox Thrash, Michael J. Gallagher, and Hubert Mesibov (the first two are responsible for the carborundum print, the latter for the color carborundum print) of the Pennsylvania WPA/FAP. Includes a foreword by Francis C. Harrington.

1051 Federal Art Project. *Fresco painting: a circular presenting the technique of fresco painting.* Federal Art Project: Washington, DC, 1940. 19 pp. Mimeographed.

"WPA Technical Series. Art Circular, no. 4." Detailed description of the processes and techniques of fresco painting. Includes a sixteen-item bibliography.

1052 Index of American Design. *Carved ornamentation of the California mission period.* WPA: Los Angeles, 1940. 20 ll.

Edited by Lanier Bartlett. NOT SEEN. CITED IN *Mission motifs: a collection of decorative details from old Spanish missions of California* (*See* **1053**).

1053 Index of American Design. *Mission motifs: a collection of decorative details from old Spanish missions of California.* Index of American Design: Los Angeles, 1940. 14 pp. 24 plates.

Decorative details from twelve missions from San Miguel Arcángelin the north to San Diego de Alcaláin the south are reproduced in line drawings by the Southern California IAD. Includes a brief account of the art work at each mission and how the survey was done. Drawings by Dana Bartlett and Hal Blakeley. Edited by Lanier Bartlett.

1054 King, Albert H. *Mosaic and allied techniques.* Southern California Art Project: Los Angeles, 1940. 70 pp.

The first part of this work is a description of mural techniques, a history of mosaics from the earliest times, and a survey of the theories of the symbolism used in mosaics. The second part is heavily illustrated (B/W and color) and depicts the step-by-step process used to create mosaics. An example of the wonderful technical monographs issued under the auspices of the WPA/FAP.

1055 McDermott, W.L. *Art and government.* MA Thesis, University of Pittsburgh, 1940.

NOT SEEN. CITED IN HARPUR'S #800.

1056 Miller, Dorothy Canning. "Painting and sculpture." In *Collier's Yearbook 1940,* pp. 475–81.

General overview of the New Deal art projects for the year 1943.

1057 New York City WPA Art Program. *"Flight," a mural by James Brooks for the Sea Plane Terminal Building, Municipal Airport, La Guardia Field.* WPA: New York, 1940. 5 pp. Mimeographed.

Pamphlet to accompany Brooks's WPA/FAP mural at La Guardia airport. Description of the mural panels.

1058 Thomas, Elbert Duncan. *Addresses in honor of American artists who have decorated Federal buildings.* GPO: Washington, DC, 1940. 11 pp.

"Extension of remarks of Hon. Elbert D. Thomas of Utah in the Senate of the United States, Monday, April 29, 1940" reprinted from the *Congressional Record.* Remarks by Thomas, Edward Bruce, John Dewey (professor), Henry Morgenthau, John M. Carmody (head of the FWA), Sen. Sumner Welles, and Sen. Robert La Follette. Broadcast over the NBC Radio network, April 25, 1940. *See* **0973** for *Congressional Record* citation.

1059 US Commission of Fine Arts. *The Commission of fine arts. Thirteenth report, January 1, 1939 to December 31, 1939.* GPO: Washington, DC, 1940. 159 pp.

Various Section projects in the District of Columbia are covered on pages 52, 53, 57, 65–72, and 76. B/W illustrations of work done.

1060 Vanderkooi, Fanny Bowles. *The WPA Federal Art Project, its contribution to the American people.* MA thesis. University of Southern California, 1940. 115 ll., plates.

History and background of the WPA/FAP; overview of government art patronage. Vanderkooi analyzes the social contributions of the WPA/FAP to American life, she feels that the WPA/FAP was a positive, democratic contribution to American cultural life.

1061 Work Projects Administration. *WPA Art Program, a summary.* WPA: Washington, DC, 1940. 14 pp.

NOT SEEN.

1062 Work Projects Administration. New York City. *The story of the recorded word; murals by Edward Laning for the New York Public Library.* WPA: New York, 1940. Mimeographed. 8 pp.

Account of how Edward Laning's murals for the New York Public Library came to be; a brief biography of Laning; and a description of the murals.

1063 Work Projects Administration. Ohio. *Regulations relating to the operation of the Ohio WPA Art Program.* Federal Works Agency: Columbus, OH, 1940.

NOT SEEN. CITED IN RLIN.

1064 Writers' Program. Oregon. *Timberline Lodge; "a year-around resort." Mount Hood National Forest. A description of the completed structure, art work and furnishings. Compiled by workers of the Writers' Program of the Work Projects Administration in the state of Oregon. Sponsored by Timberline Ski Club.* Oregon, 1940. 20 pp.

Promotional pamphlet for Timberline Lodge (dedicated by FDR September 28, 1937). B/W photographs of various sights in and around the Lodge. Includes a section on the WPA/FAP art work done there.

1065 Writers' Program. Wisconsin. *The Rhinelander Logging Museum.* Rhinelander Logging Museum: Wisconsin, 1940. 47 pp.

History of the Rhinelander Logging Museum (Wisconsin) illustrated with unsigned block prints of logging scenes by the Wisconsin WPA/FAP.

1941–1943

1941

1066 "Boris Deutsch wins $14,000 competition for decoration of the Terminal annex in Los Angeles." *Art Digest* 15 (January 15, 1941): 21.

Boris Deutsch wins Section competition; includes a brief biography of Deutsch and a list of runners up; B/W illustration of work by Deutsch.

1067 "A nation in murals." *Christian Science Monitor Weekly Magazine*. (January 18, 1941): 8–9.

Coverage of a symposium sponsored by the National Society of Mural Painters at the Architectural League of New York to discuss the state of mural painting in the United States. Covers the New Deal art projects' mural works. Numerous illustrations of murals.

1068 Hellman, Geoffrey. "Roosevelt." *Life* 10 (January 20, 1941): 66–73.

A comment on p. 72 of this article by FDR on a Section work in Poughkeepsie post office mural. Comments on Edward Bruce by FDR.

1069 "America sees itself in new government murals." *Life* 10 (January 27, 1941): 42–46.

Photo essay on New Deal murals and Edward Bruce.

1070 De Brossard, Chandler. "Mural design for American ships: a Federal Art Project." *Studio* 121 (February 1941): 61–63.

Extensive report on the Section competition for decorating US ships; excellent article on this little known competition; B/W illustrations of the work done by James L. McCreery, Jean Swiggett, Bernard Purlin, R. Phillips Sanderson, Elsa V. Shaw, and David Swasey.

1071 Shanafelt, Clara. "February heroes for the collector." *Antiques* 39 (February 1941): 69–71.

George Washington and Abraham Lincoln in decorative arts; B/W illustrations from the IAD.

1072 Boswell, Peyton. " 'Life' goes to Washington; ten of the 1,125 murals commissioned by the government." *Art Digest* 15 (February 1, 1941): 3.

Editorial praising the Section and *Life* magazine; January 27, 1941, issue of *Life* reproduces 10 of 1,125 murals done for the government.

1073 "WPA art classes in New York city." *Art Digest* 15 (February 1, 1941): 29.

Art teaching division of the NYC WPA/FAP announces that in 1940, 26,000 classes were held with attendance of over 300,000.

1074 "Art and museum projects of WPA reaches total of forty-eight million." *Museum News* 18 (February 15, 1941): 2.

Note that through June 30, 1940, the WPA has spent $19,833,228 on its museums projects and $24,653,151 on the WPA/FAP. An additional $3,819,487 was provided by local sponsors.

1075 "Competitions." *Art Digest* 15 (February 15, 1941): 28.

List of two Section competitions; War Department mural and War Department sculpture; includes a list of the jury.

1076 Rich, Daniel Catton. "Art museum and the community art center." *Museum News* 18 (February 15, 1941): 10–12.

Text of paper given by Rich at the American Association of Museums meeting in Detroit (May 22–24, 1940) on the relationship between the WPA/FAP's community art centers and local museums.

1077 Federal Works Administration. Section of Fine Arts. *Bulletin. Section of Fine Arts.* 23 (March 1941): 7 pp.

List of sixteen competitions; list of two hundred winners of the Marine Hospital competition.

1078 Heineberg, Dora Jane. "The technique of wood sculpture demonstrated by William Zorach." *Parnassus* 13 (March 1941): 107–110.

Step by step process, illustrated by photographs, of how to carve wood. William Zorach demonstrates the procedure on "Man-made power," a teakwood panel for the door of the Greenville, TN court house; includes comments by Zorach.

1079 "Museum WPA work places under Holger Cahill." *Museum News* 18 (March 15, 1941): 1.

Note that the museum projects of the WPA will be consolidated with the WPA/FAP under Holger Cahill; no changes in plans are foreseen.

1080 Cahill, Holger. "The Index of American Design." *P.M.* 7 (April–May 1941): 33–48.

NOT SEEN.

1081 "Competitions amplified." *Magazine of Art* 34 (April 1941): 221–22.

Announcement of Section competitions throughout the country.

1082 "Index of American Design show." *Brooklyn Museum Bulletin* 1 (April 1941): 2.

Announcement that sixty plus plates from the IAD will be on display from April 23 through May 18, 1941 at the Brooklyn

Museum ("Index of American Design Show"). Demonstrations by artists of how they create the renderings will be done during the run of the show.

1083 "WPA art center opened by Chicago Negro community." *Museum News* 18 (April 1, 1941): 1, 4.

Note that the Southside Community Art Center (an exhibition gallery and art-and-crafts school) opened in Chicago, December 15, 1940.

1084 Federal Works Administration. Section of Fine Arts. *Bulletin. Section of Fine Arts* 24 (May 1941): 5 pp.

List of fourteen competitions.

1085 Alsberg, Henry G. "What about the Federal Arts Projects?" *Decision* (May 1941): 9–16.

Alsberg, former director of the FWP, is extremely critical of the destruction of the projects of Federal One. Seemingly critical of Holger Cahill for his staying on after the 1939 reorganization of the arts projects (the directors of the FTP, FWP, and FMP all left soon after the reorganization).

1086 "Kindred McLeary." *Magazine of Art* 34 (May 1941): cover.

Detail of Kindred McLeary's mural for the War Department building.

1087 Watson, Jane. "Water colors for hospitals." *Magazine of Art* 34 (May 1941): 240–45.

Section watercolor competition for works to be bought and given to hospitals are on display at the National Gallery of Art from Mary 15 to June 4, 1941. B/W illustrations of a number of the works.

1088 "Mrs. Force attacks WPA project art; Waylande Gregory answers." *Art Digest* 15 (May 1, 1941): 9, 24.

Juliana Force, director of the Whitney Museum (and former PWAP official), claims that WPA/FAP is lowering the quality

of art produced; Waylande Gregory, an artist, rebuts her claims.

1089 *New Yorker* 17 (May 17, 1941): cover.

Cover illustration by Virginia Snedeker depicting a New Deal muralist at work on a post office mural.

1090 "Government art shown at the National Gallery." *Art News* 40 (June 1941): 34.

Favorable review of "An Exhibition of Two Hundred American Water Colors" at the National Gallery of Art. B/W illustration of work by J.R. Sorby.

1091 Puccinelli, Dorothy. "Murals by Clay Spohn." *California Arts and Architecture* 58 (June 1941): 16.

Brief note and comments on the mural work of Clay Spohn; B/W illustrations and photographs.

1092 Watson, Jane. "War in stone; sculpture groups for War Department building." *Magazine of Art* 34 (June 1941): 325.

Section competition for sculpture commented on. B/W illustration of Jean de Marco's relief on p. 327.

1093 "Project defense work: art decorations for the Privates' Club at Fort Ord." *Art Digest* 15 (August 1, 1941): 13.

The Northern California WPA/FAP is given the task of decorating the Privates' Club at Fort Ord.

1094 "WPA covers the country: projects, commissions." *Art News* 40 (August 1941): 25.

Comments on James Brooks's mural "Flight" at the Marine Terminal, La Guardia Airport (NYC); general comments on WPA/FAP.

1095 Sacartoff, Elizabeth. "WPA's first-class posters make first-class salesmen." *P.M.* 7 (August 17, 1941): pp. unknown.

NOT SEEN.

1096 Byrne, Barry. "WPA art exhibit in New York." *America* 65 (August 23, 1941): 557.

Unfavorable review of IAD show at the Metropolitan. Generally critical comments on the New Deal projects. "The purpose that animates this W.P.A. art promotion is merely to extend into the Government-dominated area of national life the self-conscious, culture-seeking attitude that has been typical of clubwomen's activities."

1097 ["Photograph of WPA mural in Union Hall"]. *Life* 11 (August 25, 1941): 68.

Photograph of an unidentified mural in a Union Hall.

1098 "Amateis and De Lue do government reliefs at Philadelphia court house." *Art Digest* 15 (September 1, 1941): 8.

Section assigns Donald De Lue and Edmond Amateis to do reliefs at the Philadelphia Court House; B/W illustrations of work; list of jury members.

1099 "Art in defence." *Art Digest* 15 (September 1, 1941): 21.

WPA/FAP artists in Florida will be doing work on military projects such as decorating barracks.

1100 B., D. "WPA art in us." *Art News* 40 (September 1941): 22.

Comments on "Work in Use" exhibit of WPA/FAP allocation to the Metropolitan Museum; approximately 100 works; praises art to the people.

1101 Rowan, Edward. "American renaissance." *Maritime Art* 2 (October–November 1941): 15–17.

"Substance of an address delivered at the Conference of Canadian Artists." A bit of boosterism for the arts projects by Rowan. "I think our greatest importance has been in the fact

that we have taken the artists out of their ivory towers; we have encouraged them to cut their hair, to put both feet on the ground and to meet the public," p. 16. B/W illustrations of work by Victoria Huntley and Edward Laning.

1102 L., J.W. "Passing shows: watercolors." *Art News* 40 (October 1941): 21.

Unfavorable review of "An Exhibition of Two Hundred American Water Colors" at the National Gallery of Art.

1103 "WPA muralists exhibit." *Art Digest* 16 (October 1, 1941): 7.

Chicago's WPA Art Craft Project muralists show at the South Side Community Art Center; includes comments by Edgar Britton, mural division supervisor.

1104 "Government winners of competitions for Social Security building, War Department building and Manchester, Ga. post office." *Art Digest* 16 (October 15, 1941): 20.

List of winners (Gertrude Goodrich, Jerome Snyder, Earl N. Thorp, Erwin Springweiler) with brief biographies, and runners up in Section competitions; includes a list of the jury members.

1105 Watson, Jane. "Woodstock to San Francisco; Refregier to decorate San Francisco post office." *Magazine of Art* 34 (November 1941): 490, 494.

Section competition for the Rincon Annex of the San Francisco Post Office awarded to Anton Refregier.

1106 "Refregier wins $26,0000 mural commission." *Art Digest* 16 (November 1, 1941): 14.

Anton Refregier wins Section commission for the San Francisco Post Office Rincon Annex; includes a brief biography.

1107 "$26,000 commission for Refregier." *Art News* 40 (November 15, 1941): 8.

Section competition for the Rincon Annex of the San Francisco Post Office awarded to Anton Refregier.

1108 "WPA prizes and who won them; competition at the Penn State College." *Art News* 40 (November 15, 1941): 9.

List of various art project competition prizes and winners.

1109 Zigrosser, Carl. "The serigraph, a new medium." *Print Collectors Quarterly* 28 (December 1941): 443–77.

A history of the serigraph (silk screen print) and the role of the WPA/FAP (particularly Anthony Velonis) in bringing it to the world's attention. Comments on Velonis's work as a printer (B/W illustrations of his work) and writer. Includes comments on the FAP's poster work.

1110 *American Art Annual* 35 (1941–1942).

"Government Art Projects" (p. 15), covers the Section and the WPA Art Program (formerly FAP); good coverage of this important transitional time for the art projects. On pp. 89–91 the staff of the WPA/FAP are listed.

EXHIBITIONS

1111 Illinois Art Project Gallery. *The artist in defense.* Illinois Art Project Gallery: Chicago, 1941.

Exhibition, 1941. NOT SEEN. CITED IN Smith, Clark Sommer (*See* **1131**).

1112 Section of Fine Arts. *Exhibition of photographs of murals and sculpture.* Section of Fine Arts: Washington, DC, 1941. 10 pp.

Exhibition, 1941; location unknown. Exhibition of twenty-eight photographs of murals and sculpture done over that past six years of the Section. Checklist of twenty-eight items. Location of exhibition unknown.

1113 Section of Fine Arts. *Watercolors for decoration.* Section of Fine Arts: Washington, DC, 1941. 8 pp.

Exhibition, 1941; location unknown. Exhibition of selected watercolors from competitions for the Public Health Service Hospital (Lexington, KY) and Fort Stanton (NM) Hospital. Checklist of 100 works. Location of exhibition unknown.

1114 Associated American Artists. *Exhibition of children's art, by students in the classes of the New York City WPA art project, Associated Artists Galleries.* Associated Artists Galleries: New York, 1941. 7 ll.

Exhibition, April 21 through May 1, 1941. NOT SEEN. CITED IN NYPL.

1115 National Gallery of Art. *An exhibition of two hundred American watercolors.* National Gallery of Art: Washington, DC, 1941. 12 pp.

Exhibition, May 15 through June 4, 1941. Checklist of 200 works created for the Section. Text by David E. Finley (director of the NGA), Edward Bruce and Forbes Watson. NOTE: Also published as a 10-page mimeograph by the Section of Fine Arts, Public Buildings Administration, Federal Works Agency.

1116 Metropolitan Museum of Art. *"As we were"; an exhibition of plates from the Index of American Design.* Metropolitan Museum of Art: New York, 1941. 8 ll.

Exhibition, June 9 through 30, 1941. Checklist of 100 IAD plates.

1117 Whitney Museum of American Art. *Exhibition of two hundred watercolors from the national competition held by the Section of Fine Arts.* Whitney Museum: New York, 1941. 9 pp.

Exhibition, September 16 through 30, 1941. Catalog of 200 works selected from Section competition. Text by Forbes Watson (on the show) and Edward Bruce (on the Section). NOTE: This is the same show that appeared at the NGA (*See* **1115**).

MONOGRAPHS

1118 Art Week, Committee of Federal Agencies for. *National report, Art Week. "American art for every American home."* November 25th to December 1st, 1940. WPA: Washington, DC, 1941. 22 pp.

The WPA/FAP and the Section were among the Federal sponsors of Art Week. Report includes a list of events, objectives, plans, list of state committees, and letters of commendation from notable Americans.

1119 Bell, Bernard C. *Some WPA activities recorded in watercolor painting.* MA thesis, Ohio State University, 1941. 40 ll. 28 plates.

Interpretation of various WPA projects in photographs, statistics, and watercolor paintings; text includes a history of the WPA with some information on Federal One.

1120 Index of American Design. *Decorative art of Spanish California. Selected by the Index of American Design, Southern California Art Project.* Los Angeles, 1941? 1 l. 12 colored plates.

NOT SEEN. CITED IN NYPL CATALOG. "Mounted illust. and letterpress on verso of each plate."

1121 Meeks, Oliver G. *The Federal art program in Oklahoma (1934–1940).* MA Thesis, University of Oklahoma, 1941. 170 ll. Plates.

Excellent inventory/study of Federal art work (PWAP, WPA/FAP), both murals and sculpture. Lists the works done by each project with a brief history of the work and a biography of the artist (most works are illustrated with B/W plates). Also includes an account of the Oklahoma Art Center, Oklahoma City with a list of exhibitions held there, January 1936 through February 1941.

1122 Miller, Dorothy Canning. "Painting and sculpture." In *Collier's Yearbook 1941,* pp. 516–24.

General overview of the New Deal art projects for the year 1941.

1123 US Congress. House of Representatives. *A bill to establish a Division of Fine Arts in the Office of Education, Department of Interior.* H.R. 600, 77(1). 2 pp.

Introduced by James P. McGranery on January 3, 1941, the bill would create a Division of Fine Arts within the Office of Education in the Department of Interior. No mention of the WPA cultural projects. Sent to the House Committee on Education. Never left Committee. McGranery introduced this bill with minor variations one more time (*See* **1205**).

1124 US Congress. House of Representatives. Subcommittee of the Committee on Appropriations. *Work relief and relief for fiscal year 1941. Hearings held March 26, 1940.* USGPO: Washington, DC, 1941. 1261 pp.

Testimony by Francis C. Harrington (pp. 448–49) and Florence Kerr (pp. 587–90) on the WPA/FAP. The two WPA administrators discuss the increased local sponsorship of WPA/FAP activities. Tables show that there were 5,226 workers employed on the WPA/FAP on January 3, 1940 as compared to only 4,629 on June 30, 1939, the last day of Federal sponsorship.

1125 Velonis, Anthony. *Techniques of the silkscreen process.* [Technical Problems of the Artist #6]. WPA Education Program: New York, 1941. 2 v. (36 pp.).

One of the most popular publications of the WPA/FAP, Velonis gives step-by-step instruction on how to create a silk screen print. Illustrated with drawings and B/W photographs of the processes and examples.

1126 Work Projects Administration. *Manual of rules and regulations.* GPO: Washington, DC, 1941. Looseleaf, 4 volumes.

Volume 1 gives a good, clear history of the WPA and a chronology of the legislation affecting the agency; Section 1.G.010 gives the telegram code words for the FAP (1935 = VALID; 1936 = VIGIL; 1937 = VATIC; 1938 = SWAIN; from 1939 there were no more); Section 2.9.025–026 (Operating

Procedure E-9, Appendix A), "Articles for Art and Museum Projects," covers the "rental or purchase of property and impersonal services" of items related to the art projects; Volume 3 covers the general rules all WPA employees must conform to; Volume 4 covers the general financial regulations of the WPA.

1127 Work Projects Administration. Oklahoma. *News flashes [of the Oklahoma WPA art center]*. Oklahoma City, 1941–. Reproduced from typewritten copy, monthly.

NOT SEEN. CITED IN WILCOX.

1128 Work Projects Administration. Pennsylvania. *Folk art of rural Pennsylvania. Selected by the Index of American Design, Pennsylvania art project, Work Projects Administration*. Philadelphia, 1941?. 1 p. 15 colored plates.

Silk-screened prints of folk art designs selected from IAD plates; descriptive letterpress.

1942

1129 "Prize-winning design for Canastota post office mural competition." *Syracuse Museum of Fine Arts Quarterly*. 3 (January-February-March 1942): 11.

Alison Kingsbury (illustration of work) wins the Section competition for the Canastota Post Office mural; selected from ninety-three entries.

1130 "Artists invited to submit work for selection and possible purchase." *Art Digest* 16 (January 1, 1942): 11.

Section asks for works to be used for propaganda purposes; desires works that "clarify the American Public's knowledge of war and defence efforts"; $2,000 has been set aside for such purchases.

1131 Watson, Jane. "Red cross challenges the artist." *Magazine of Art* 35 (February 1942): 75.

Section sponsors a poster competition for the American Red Cross.

1132 "Creative talent mobilized." *Design* 43 (March 1942): 5.

Explanation of how WPA/FAP art workers are turning to war work.

1133 Durney, Helen. "WPA camouflage class." *Design* 43 (March 1942): 27.

Account of how the WPA/FAP in New York City is teaching camouflage classes; summarizes Homer Saint-Gauden's article, "Concealment Methods" from the *Military Engineer,* on what camouflage is.

1134 Whiting, F.A., Jr. "Call to action; pictures of national defense and war activities from the national competition." *Magazine of Art* 35 (March 1942): 96–101.

The Section along with the Office of Emergency Management sponsors a competition to produce posters suitable for propaganda purposes. 109 works were selected from 2,582 entered. Lists jury members. Selected works shown at the National Gallery of Art from February 2, 1942, forward. B/W illustration of works.

1135 "Laning completes New York library murals." *Art Digest* 16 (March 1, 1942): 16.

Edward Laning completes murals in the New York Public Library begun in 1938.

1136 "War art in Capital." *Art Digest* 16 (March 1, 1942): 18.

National Gallery of Art shows work chosen in a national competition sponsored by the Section and Office of Emergency Management; includes list of jury members and artist.

1137 "American prints between two world wars." *Art Digest* 16 (March 15, 1942): 24.

Review of "Between Two Wars" at the Philadelphia Museum of Art; includes a number of works by WPA/FAP artists. Includes B/W illustrations of work by Peggy Bacon and Lewis Daniel.

1138 "Post office panel installed." *Art Digest* 16 (March 15, 1942): 17.

Terra cotta panel by Helen Wilson installed by the Section at Lowvill, NY, Post Office.

1139 O'Connor, J., Jr. "American watercolor exhibition on circuit." *Carnegie Magazine* 16 (April 1942): 17–18.

Account of the Section competition to supply water colors for a hospital in Louisiana. One hundred of the works went to the hospital and two hundred others went on tour. Exhibit will be at the Carnegie Institute through March 12, 1942. B/W illustration of work by Charles Thwaites.

1140 Goeller, Charles L. "Home defense." *Magazine of Art* 35 (May 1942): 190.

Letter to the editor. Goeller claims that Gilmore D. Clarke is out to depose Edward Bruce as head of the Section. Calls on artists to support Bruce. Lists the evil doings of Goeller.

1141 "Quality of mercy; Red cross posters." *Magazine of Art* 35 (May 1942): 182, cover illustration.

Seventy works of 2,038 are selected in Section competition in support of Red Cross.

1142 "For the Red Cross." *Art Digest* 16 (May 15, 1942): 9.

National Gallery of Art exhibits Section works commissioned to benefit the Red Cross; seventy works in show.

1143 Taylor, Francis Henry. "Suspension of the WPA museum project." *Metropolitan Museum of Art Bulletin* 37 (June 1942): 164–65.

Announcement of the suspension of the WPA museum

project; Taylor tells what it was and thanks the WPA for what it did for the Metropolitan.

1144 "200 American watercolors from government competition." *Baltimore Museum News* 4 (June 1942): 45–46.

Note on "200 American Watercolors" (Section works) on exhibit at the Baltimore Museum of Art (June 5–28, 1942); B/W illustration of work by Paul E. Fontaine.

1145 Boswell, Peyton. "Metropolitan adopts the Index." *Art Digest* 16 (July 1, 1942): 3.

Editorial by Boswell praising the Index of American Design; claims the IAD alone was worth all the money spent on government art projects.

1146 "Metropolitan takes over Index of design." *Antiques* 42 (July 1942): 42–43.

Brief note announcing that the Metropolitan Museum of Art is taking the IAD over.

1147 "[Anton Refregier]." *New Masses* 44 (August 11, 1942): 29.

B/W illustration of the Section mural by Anton Refregier done for the Plainfield NJ, Post Office. Notes that the murals and sketches are on exhibit at ACA Gallery (NYC) through August 14, 1942.

1148 MacHarg, Katherine. "Clay of your community; art center, Duluth, Minnesota, a WPA art project." *School Arts* 42 (September 1942): 30–31.

Children at the Duluth Art Center under the auspices of the Federal Arts Project of Minnesota do clay sculpture; B/W photographs of the clay works by the children (Clarice Bonk, Donald Olson, and Fay Eilers) and a description of the classes.

1149 "Metropolitan museum to carry on WPA index." *Museum News* 20 (September 1, 1942): 1.

Note that the Metropolitan Museum will take over the IAD.

1150 Berryman, Florence S. "Guns and brushes; art projects of the US armed forces." *Magazine of Art* 35 (October 1942): 214–17.

Overview of art works being done for the war effort, primarily by the Section. B/W illustrations of works and photographs.

1151 Berryman, Florence S. "Recent achievements under Section of Fine Art: Federal Trade Commission Building, War Department Building, Social Security Building." *Magazine of Art* 35 (October 1942): 224.

Two recently completed Section projects; Michael Lantz wins the competition for Federal Trade Commission building; Seymour Fogel that for the fresco of the Social Security building. B/W illustration of a work by each artist.

1152 Colby, Merle. "Emblems of America." *Magazine of Art* 35 (October 1942): 204–207.

IAD plates on display at the Metropolitan Museum of Art ("Emblems of Unity and Freedom"); designs from the IAD showing American eagles, flags, Liberty, and other emblems of America. B/W illustrations from IAD.

1153 "History of Missouri." *Pictures on Exhibit* 6 (October 1942): 8–9.

Brief account of Edward Millman and Mitchell Siporin's mural for the St. Louis Post Office.

1154 "Mural commemorates man's conquest of air." *Art Digest* 17 (October 1, 1942): 11.

Summary of reviews of James Brooks's mural, "Flight," for the La Guardia Marine Air Terminal just completed. Comments by Edward Alden Jewell of the New York *Times* who feels it was one of the best murals done under the art projects. B/W illustration of mural.

1155 "Missouri: new murals show its history." *Life* 13 (October 12, 1942): 70–81.

Photo essay on Section murals by Edward Millman and Mitchell Siporin done for the St. Louis Post Office. Mostly B/W and color reproductions.

1156 "Gay Victorian designs at Met; exhibition entitled 'I remember that.'" *Art Digest* 17 (October 15, 1942): 17.

Favorable review of "I Remember That," a show of IAD work at the Metropolitan Museum of Art. Comments by Edward Alden Jewell of the New York *Times*.

1157 "Millman and Siporin recount Missouri; history in St. Louis murals." *Art Digest* 17 (October 15, 1942): 12–13.

High praise for murals completed for the St. Louis Post Office by Edward Millman and Mitchell Siporin. B/W illustration of the murals.

1158 "Emblems of unity and freedom." *Antiques* 42 (November 1942): 262.

Note/review of "Emblems of Unity and Freedom" at the Metropolitan. B/W illustrations from accompanying booklet.

1159 "Remember that? I remember that; exhibition at the Metropolitan." *Art Digest* 17 (December 1, 1942): 15.

Review of the catalog accompanying the "I Remember That" exhibition at the Metropolitan.

1160 Boswell, Peyton. "WPA honorably discharged." *Art Digest* 17 (December 15, 1942): 3.

Editorial praising the work done by the WPA/FAP. Despite some drawbacks and problems in the programs, Boswell hopes government support of the arts will be encouraged after the war.

EXHIBITIONS

1161 Metropolitan Museum of Art. *Emblems of unity and freedom.* Metropolitan Museum of Art: New York, 1942. 32 pp.

Exhibition, 1942. Booklet to accompany exhibition of IAD plates illustrating American symbols such as the flag, Liberty, and eagles. Text signed by Holger Cahill.

1162 Metropolitan Museum of Art. *"I remember that," an exhibition of interiors of a generation ago. The Index of American Design.* Metropolitan Museum of Art: New York, 1942. 21 pp.

Exhibition, 1942. Booklet to accompany exhibit IAD plates showing recreations of Victorian and Edwardian interiors. B/W illustrations. Text by Benjamin Knotts.

1163 Howard University Art Gallery. *Exhibition of mural sketches commissioned by the Government of the United States for Federal buildings. Lent by the Section of Fine Arts, Public Buildings Administration, Federal Works Agency.* Howard University Art Gallery: Washington, DC, 1942. 4 pp.

Exhibition, April 15 through May 17, 1942. Checklist of thirty items. Text by Forbes Watson on how the Section works. B/W illustration by Peter Hurd.

1164 Mexico. Departamento de Información para ed extranjero. *WPA expositión de trabojos del programa de arte de Pennsylvania, Palcio de bellas artes de México; catalogo, Departamento de información para el extranjero, Secretaría de relciones exteriores.* Cooperativa talleres gráfico de la nación: Mexico City, 1942. 16 pp.

Exhibition, April 20 through 25, 1942. Checklist of 107 works; selected B/W illustrations. Brief overview of the project. Biographic entries on Aharon Ben-Samuel, Isaac Lizschutz, Isidore Possof, and Herschel Levit.

1165 Whitney Museum of American Art. *Between two wars. Prints by American artists 1914–1941.* Whitney Museum of American Art: New York, 1942.

Exhibition, March 3 through 31, 1942. Checklist of 261 prints. Exhibition included a number of works by the FAP. Brief introduction by Carl Zigrosser mentions the importance of the WPA/FAP to graphic art in the United States. B/W cover illustration.

1166 Downtown Gallery. *Paintings, cartoons, photographs of the St. Louis Post Office murals by Mitchell Siporin and Edward Millman.* Downtown Gallery: New York, 1942. Pamphlet.

Exhibition, October 13 through 31, 1942. Checklist of thirteen photographs of the murals, nine oil sketches, and an unspecified number of drawings of the St. Louis Post Office murals by Edward Millman and Mitchell Siporin, a Section project. Color reproduction on the cover. Includes a reprint of the editorial from the St. Louis *Post-Dispatch* (June 14, 1942) praising the murals.

MONOGRAPHS

1167 Miller, Dorothy Canning. "Painting and sculpture." In *Collier's Yearbook 1942*, pp. 399–403.

General overview of the New Deal art projects for the year 1942.

1168 Roosevelt, Franklin D. "The President declares that WPA has earned an 'Honorable Discharge' and announces discontinuation of WPA projects. Letter to Federal Works Administrator, December 4, 1942," pp. 505–16. In *Public Papers and Addresses of Franklin Delano Roosevelt, V.11.* Harper and Brothers: New York, 1950. 552 pp.

FDR calls the WPA a "job well done, but done." In the Note to the letter are the final statistics on the WPA projects.

1169 US Congress. *US Statutes at Large* V. 56, pt. 1, pp. 634–45. Chapter 479, Section 1.

The final gasp of the WPA: Section 1(h) gives the final extension of the WPA until June 30, 1943. Signed into law, July 2, 1942.

1170 US Congress. House of Representatives. 77th (2). *H.J. Res. 324, Emergency Relief Appropriation Act of 1943.* GPO: Washington, DC, 1942.

Bill extending the operations of the WPA until June 30, 1943. Introduced into House June 9, 1942 by Rep. Joseph Cannon; passed House June 11, 1942 (279 to 52); passed Senate June 25, 1942 (by resolution); signed into law July 2, 1942 (Public Law 651; 56 Stat. 479).

1171 US Congress. House of Representatives. Subcommittee of the Committee on Appropriations. *Work relief and relief for fiscal year 1942. Hearings held May 21, 1941.* USGPO: Washington, DC, 1941. 466 pp.

Testimony of Howard O. Hunter (Acting Commissioner of the WPA) and Florence Kerr (pp.190–92, 262–63) defending the WPA/FAP against Congressmen Clifton A. Woodrum (of Virginia) and J. William Ditter (of Pennsylvania). Congressman John Taber of New York: "A lot of them [workers of the WPA] get jobs who have no ability along those lines, and the same way with art, music, and that sort of thing"; to which Hunter responded, "I think our writers' and art projects are substantial and stand up well in public opinion" p. 190.

1172 Work Projects Administration. *Furniture designed and executed for Timberline Lodge, Mt. Hood National Forest under the direction of Margery Hoffman Smith, Assistant State Director of the Division of Women's and Professional Projects.* WPA: Mt. Hood, OR?, 1942. 2 v.

NOT SEEN. CITED IN *Timberline Lodge: a Love Story* (*See* **1605**). One copy in the Multnomah County (OR) Library.

1943

1173 "Federal murals to honor the Negro." *Art Digest* 17 (January 1, 1943): 9.

Section announces a competition to record the contributions of Black Americans to American history in the Recorder of Deeds Building (Washington, DC). Includes a list of possible subjects and jury members.

1174 "Edward Bruce." *Magazine of Art* 36 (February 1943): 69.

Obituary of Edward Bruce (died January 27, 1943). Praises his work on the Section as well as his own art. "The loss of Edward Bruce will be seriously felt in all the fields in which he has distinguished himself."

1175 "Gifts from WPA projects." *El Palacio* 50 (February 1943): 43–44.

Account of how the Museum of New Mexico became the recipient of WPA/FAP works on the shutdown of the project. A brief description of the contents of the allocation.

1176 Boswell, Peyton. "Ned Bruce passes." *Art Digest* 17 (February 1, 1943): 16.

Boswell praises the work of Edward Bruce (died January 27, 1943) both as artist and administrator in this obituary. B/W photograph of Bruce.

1177 "Exhibits for circulation." *Museum News* 20 (February 15, 1943): 1–2.

Note that the Metropolitan is offering twelve different exhibits of IAD plates for circulation.

1178 "Personals." *Museum News* 20 (February 15, 1943): 3.

Obituary of Edward Bruce (died January 27, 1943). NOTE: Obituary prints the incorrect date of January 26, 1943.

1179 "Died." *Architectural Forum* 78 (March 1943): 118.

Obituary of Edward Bruce (died January 27, 1943). Includes B/W photograph of Bruce.

1179a Knotts, Benjamin. "Hand to work and hearts to God." *Metropolitan Museum of Art Bulletin* n.s. 1 (March 1943): 231–36.

Discussion of Shaker art to accompany exhibit, "Shaker Craftsmanship" (March 22, 1943 through ?) at the Metropolitan (Shaker art plus IAD plates); B/W illustrations of plates.

1180 "Guston's Social Security mural." *Art News* 42 (March 1, 1943): 8.

Philip Guston completes his Section mural for the Social Security Building (Washington, DC).

1181 "Austere beauty: Shaker art; exhibition of Index of American Design drawings and photographs at the Metropolitan." *Antiques* 43 (April 1943): 188–89.

Brief account of the Shakers; relation of IAD plates on display at the Metropolitan based on Shaker designs. B/W reproductions of IAD plates.

1182 "Mural winners of competition for the decoration of the Recorder of Deeds building." *Art Digest* 17 (April 15, 1943): 24.

Announcement of winners in Section competition for murals on Black history in the Recorder of Deeds Building (Washington, DC). Winners were Herschel Levitt, Carlos Lopez, Martyl Schweig, Maxine Seelbinder, Ethel Magafan, Austin Mecklam, and William Edward Scott. Many of the works of the winners and runners-up will be on display at Howard University (Washington, DC).

1183 "Landscapes by Olaf Krans, showing daily activities of the Bishop Hill pioneers." *Design* 44 (May 1943): 17.

Illinois IAD project has rendered sixteen objects from the daily life of the Bishop Hill pioneers (a Shaker-like sect); article primarily concerned with landscapes by the artist Olaf Krans also in the show, not an WPA/FAP artist.

1184 Whitehill, Virginia N. "American circus carving." *Magazine of Art* 36 (May 1943): 172–75, cover illustration.

Examples of circus art preserved in the IAD. B/W illustrations of IAD plates.

1185 Rothenstein, John. "State patronage of wall painting in America." *Studio* 126 (July 1943): 1–10.

Positive account of the PWAP and Section work in the US written for a British audience. Numerous B/W and color reproductions of murals.

1186 "Index of American Design to go to National Gallery." *Antiques* 44 (August 1943): 87.

Brief note on the transfer of the IAD from the Metropolitan to the National Gallery of Art.

1187 "Is a WPA mural inviolate—or whitewashable." *Art Digest* 17 (August 1, 1943): 18.

Emerson Burkhart's mural, "The Citizen," created for the Columbus Central High School, painted over in 1938, is in the news again as the Columbus Art League tries to get it restored. Includes comments from local artists and community leaders.

1188 "Metropolitan Museum of Art custodian of the WPA index." *Liturgical Arts* 11 (August 1943): 76.

Brief note on the IAD at the Metropolitan, what it is, and a recommendation for clergy and seminarians to visit it.

1189 "WPA's record: Index of American Design transferred to National Gallery." *Art News* 42 (August 1943): 36.

Announcement of the transfer of the IAD from the Metropolitan Museum of Art to the National Gallery of Art.

1190 "Another WPA mural disappears." *Art Digest* 17 (September 1943): 17.

Report by Fritzi Weisenborn of the Chicago *Times* on the destruction of WPA murals; specifically comments on a

mural by Rudolph Weisenborn (husband of Fritzi) whose mural "Steelworkers" (B/W illustration) has been destroyed.

1191 Boswell, Peyton. "Threat of the whitewash brush." *Art Digest* 17 (September 1943): 3.

When efforts are made to restore a mural by Emerson Burkhart that was covered over a few years earlier meet with controversy, Boswell questions whether it is right to whitewash any work of art; his answer is no, no matter how bad the work may be thought to be at the moment.

1192 "Threat of the whitewash brush." *Art Digest* 17 (September 1943): 16.

A pair of editorials on the Columbus Central High School mural by Emerson Burkhart whitewashed soon after its completion; present attempts to have it restored are meeting with controversy. Albert Sterner is in favor of leaving it covered; Leon Kroll wants to save it.

1193 "National Gallery of Art gets Index of design." *Museum News* 21 (September 15, 1943): 1.

Philip B. Fleming, administrator of the Federal Works Agency, announces that the National Gallery of Art will be the custodian of the IAD: "It seems to be fitting that this important work, of great interest to all Americans . . . should ultimately be located in Washington."

1193a Biddle, George, et al. "Government and the arts." *Harper's Magazine* 187 (October 1943): 427–34.

General comments on the role of government in the arts; calls for the formation of some type of Federal bureau of arts.

1194 Boswell, Peyton. "Remembering Ned Bruce." *Art Digest* 18 (October 15, 1943): 3.

Obituary for Edward Bruce who had died the previous winter; 124 artists donate small works for the Edward Bruce Memorial Collection in the Hollywood (FL) Hospital.

1195 "WPA prints for the Met." *Art Digest* 18 (November 1, 1943): 13.

Exhibition of 133 WPA/FAP prints at the Metropolitan Museum of Art selected from more than 1,700 given to the Met by the WPA.

1196 Boswell, Peyton. "A federal art bureau." *Art Digest* 18 (November 15, 1943): 3.

Editorial on George Biddle's proposal for a postwar Federal Art Bureau; Boswell comments on the WPA/FAP experience and past Federal Art Bureau attempts.

1197 Davis, Stuart. "What about modern art and democracy? with special reference to George Biddle's proposals." *Harpers Magazine* 188 (December 1943): 16–23.

Davis feels that the New Deal Art Projects—particularly the Section—effectively censored the arts by promoting Regionalism and Social Realism at the expense of abstract art. Critical of Edward Bruce and Forbes Watson.

1198 Boswell, Peyton. "The government and art." *Art Digest* 18 (December 1, 1943): 3.

Summary of readers' comments on Boswell's earlier editorial on the proposal for a Federal Art Bureau (*See* **1196**).

1198a Bridaham, Lester B. "Federal art bureau?" *Art Digest* 18 (December 15, 1943): 3.

Peyton Boswell reprints a letter from Lester B. Bridaham on how the government should handle postwar support for the artist. Cites experience with WPA/FAP and feels more of an effort should be made to support the consumption of art rather than its production. *See also* **1196** and **1198**.

MONOGRAPHS

1199 Howard, Donald S. *The WPA and Federal relief policy.* Russell Sage Foundation: New York, 1943. 879 pp.

Excellent account of the many and varied activities of the WPA; art projects are covered briefly on pp. 140, 236–40, and 319.

1200 Index of American Design. *Index of American Design study series. Prepared and executed by the New York City WPA Art Project.* Metropolitan Museum of Art: New York, 1943? 5 cases of mounted color plates (52 cm).

NOT SEEN. CITED IN MET LIBRARY CATALOG. "The plates are original water colors executed by members of the project. Mounted leaf of introductory text accompanies each case of plates."

1201 Metropolitan Museum of Art. *Pennsylvania German designs, a portfolio of silk screen prints. The Index of American Design, the National Gallery of Art, research by the Pennsylvania WPA art project.* Metropolitan Museum of Art: New York, 1943. 8 pp. 20 plates.

Large size (36 × 28.5 cm) silk-screen prints of Pennsylvania German designs with descriptive letterpress. An early attempt to mass produce IAD plates. Text by Benjamin Knotts.

1202 Miller, Dorothy Canning. "Painting and sculpture." In *Collier's Yearbook 1943,* pp. 410–16.

General overview of the New Deal art projects for the year 1943.

1203 Miller, Dorothy Canning. *The United States government art projects: a brief summary; excerpted from annual articles on painting and sculpture prepared by Dorothy C. Miller for Collier's Yearbook.* Museum of Modern Art: New York, 1943? 18 pp. Mimeographed.

Reprint of the general overviews of the New Deal art projects from *Collier's Yearbook* for the years 1935–1938, written by Dorothy Canning Miller, who was, besides a noted art critic, the wife of Holger Cahill.

1204 Section of Fine Arts. Public Buildings Administration.

Final report. Section of Fine Arts, Public Buildings Administration. GPO: Washington, DC, 1943. 31 pp. Mimeographed.

Complete list of Section artists with date of work, cost, media, and location. Done with a state-by-state breakdown. Available on AAA reel NDA 18.623–553.

1205 US Congress. House of Representatives. *A bill to establish a Division of Fine Arts in the Office of Education, Department of Interior.* H.R. 900, 78(1). 2 pp.

Introduced by James P. McGranery on January 8, 1943, the bill would create a Division of Fine Arts within the Office of Education in the Department of Interior. No mention of the WPA cultural projects. Sent to the House Committee on Education. Never left committee.

1206 US Congress. House. Committee on Appropriations. *Independent offices appropriation bill for 1944.* Hearings, January 8, 11–15, 18–20, 25, 1943. GPO: Washington, DC, 1943. 1299 pp.

Hearings on appropriations for 1944, 78th Congress, 1st session. Philip B. Fleming, administrator of the Federal Works Agency (testifying on pp. 371–81 on the status of the WPA), assures Congress that the WPA will soon cease to exist: "I can assure you there will be no such thing as the Work Projects Administration appearing any place after the 1st of July," p. 372.

1207 US Congress. House. Committee on Appropriations. *Second deficiency appropriation bill for 1943.* Hearings, January 5, 21, 1943. GPO: Washington, DC, 1943. 105 pp.

Hearings on appropriations for 1943, H.R. 3030, 78th Congress, 1st session. Philip B. Fleming, administrator of the Federal Works Agency (testifying on pp. 4–25), outlines the orderly dissolution of the WPA. Includes the text of a letter to Fleming from FDR dated December 4, 1942, expressing his wish that the WPA cease to exist in as many states as possible by February 2, 1943, and everywhere else as soon as possible: "With the satisfaction of a good job well done and with a high

sense of integrity, the Work Projects Administration has asked for and earned an honorable discharge," p. 6.

1208 Work Projects Administration. New York. *Final report of the Work Projects Administration for the city of New York, 1935 to 1943.* WPA: New York, 1943. 271 pp.

Narrative account of the WPA in New York City. Pp. 229–32 cover the "Cultural Programs," merely a brief note on the arts programs; the WPA/FAP barely mentioned. "As a result of the favorable attention attracted by public murals, art exhibitions, and sculpture done by the art project, thousands of Americans, not only in New York, but all over America, began to see their country with new eyes and to take their first interest in the art of their own country," p. 231.

1944–1969

1944

1209 Cahill, Holger. "WPA: a defense of the art project." *The League* (Winter 1944–1945): 12–13.

General defense of the WPA/FAP in answer to a recent *Life* article on the disposition of the WPA/FAP canvases (*See* **1218**); includes numerous statistics.

1210 Cahill, Holger. "Art goes to the people in the United States." *Canadian Art* 1 (February–March 1944): 102–107, 129–31.

Overview of the WPA/FAP; discussion of "popular" art in America and the democratization of art under the projects. B/W illustrations of work by John Palo-Kangas, Louis Guglielmi, Edgar Britton, Maxine Albro, and Primo Caredio.

1211 "Pennsylvania German designs. Review." *American Artist* 8 (February 1944): 36.

Brief, favorable review of *Pennsylvania German Design. A Portfolio of Twenty Plates in Full Color from the Index of American Design* (Metropolitan Museum of Art: New York, 1944). *See* **1201**.

1212 Boswell, Peyton. "Art by the ton." *Art Digest* 18 (February 15, 1944): 3.

Editorial on a junk dealer (Henry C. Roberts) selling art produced for the government under WPA/FAP. The works were sold when the government no longer wanted to pay rent for their storage.

1213 "End of the project." *Art Digest* 18 (February 15, 1944): 7.

Vivid account of the selling by the truckload of WPA/FAP art works to junk dealer Henry C. Roberts because government did not want to pay storage costs. Michael Zaga, an artist, carried away many works; the WPA headquarters office claimed the sale was legal, but refused further comment.

1214 "Cut-rate culture; relics of the WPA art project." *Time* 43 (March 6, 1944): 56.

Account of the selling by the truckload of "unallocatable" WPA/FAP work by the government; much of it purchased by Henry C. Roberts, a junk dealer. B/W photograph of Roberts with some of the works.

1215 "WPA and the junkie." *Newsweek* 23 (March 6, 1944): 96–97.

Account of the selling by the truckload of "unallocatable" WPA/FAP work by the government; much of it purchased by Henry C. Roberts. B/W photograph of Roberts with some of the works.

1216 G.,J. "Accepted by the Met: WPA artists." *Art Digest* 18 (March 15, 1944): 7.

Notice of Metropolitan accepting twenty-eight WPA/FAP works; fourteen presently on display until May 28, 1944.

1217 Reid, Albert T. "WPA—RIP!" *Art Digest* 18 (March 15, 1944): 28.

AAPL editorial crowing over the dismantling of the art project. "The WPA Art Project is now quite properly interred. Its old clothes have been sold to the second-hand man and all that is needed now is the fumigator."

1218 "End of WPA art, canvases which cost government 35,000,000 dollars are sold for junk." *Life* 16 (April 17, 1944): 85–86.

Photo essay on the sale of WPA/FAP art. B/W illustrations of work by George Nesin, Palmer Hayden, Jovan de Rocco, Phil Bard, Feinsmith, P. Gerchik, Anton Refregier, and Alice Neel.

1219 "American prints by WPA artists." *Portland Museum Bulletin* 6 (September 1944): 1.

Announcement of exhibition ("American Prints by WPA Artists,") September 10 through September 24, 1944, at the Portland Museum of Art; exhibit consisted of WPA/FAP prints allocated to the museum.

MONOGRAPHS

1220 Rubenstein, Erica Beckh. *Tax payers' murals.* Ph.D. dissertation, Radcliffe College (Harvard University), 1944. 42 ll.

One of the earliest critical/historical works on the Federal government's art sponsorship, Rubenstein traces the history and development of the art projects (1933–1943), covers the mural projects in great detail, and analyzes the public's reaction to the work done for the government.

1221 US Commission of Fine Arts. *The Commission of fine arts. Fourteenth report, January 1, 1940 to June 30, 1944.* GPO: Washington, DC, 1944. 110 pp.

Section project for Recorder of Deeds building in Washington covered (p. 59); discussion of the committee's visit to the Edward Bruce memorial exhibition at the Corcoran on September 17, 1943 (p. 40).

1945

1222 "Contemporary cottons by Lucy Baker based on plates of the Index." *Magazine of Art* 38 (April 1945): 142–43.

B/W illustrations of crewel work by Lucy Baker based on IAD plates; IAD is a basic source for textile designs that can

be used well into the twentieth century according to the author.

1223 Cahill, Holger. "Franklin Delano Roosevelt." *Magazine of Art* 38 (May 1945): 163.

Appreciation/obituary of FDR by Holger Cahill; praises FDR's role in the art projects and how he kept censorship out of them. "He would make it possible for American artists to direct their talents and energies towards the whole people because he believed in encouraging the creation and enjoyment of beautiful things we are furthering democracy itself."

1224 Cahill, Holger. "Artists in war and peace." *Studio* (July 1945): 1–16.

Excellent article by Cahill on the history of the art projects, their context in American art history, and the transition to a war environment; good coverage of the art/state issues. "One great thing the WPA did for artists, aside from giving them employment and maintaining their morale through the depression years. It accepted the thesis that the fate of the arts is as legitimate a concern of government and of the community as a whole as is education, since the arts should be an integral part of any educational system," p. 14. Numerous B/W and color illustrations.

1225 "Another Bureau of Fine Arts." *Art Digest* 20 (December 1, 1945): 32–33.

AAPL editorial against any kind of Federal fine arts bureau.

1226 Berryman, Florence S. "Government in art." *American Art Annual* 36 (1945): 11–12.

Coverage of the transition of the art projects to war work.

MONOGRAPHS

1227 ACA Gallery. *61 and 63*. ACA Gallery: New York, 1945. 15 pp.

A brief history of ACA Gallery (NYC); comments on a number of New Deal artists who exhibited there as well as three exhibitions ("Pink Slips Over Culture," "4 Out of 500 Artists Dismissed from the WPA," and "1938") linked with the New Deal projects.

1228 Willard, Irma Sompayrac. *US government sponsorship of art 1933–1943. Survey and report on documents in the National Archives, Washington, DC. Art Archives report.* Washington, DC, 1945. 19 ll. Mimeographed.

Part I is a brief outline sketch of the government art projects describing how to use the records of the period and how they are organized. Part II is a detailed description of the records at the National Archives relating to the art projects. A good, though dated, source.

1229 Wish, Harvey. *Contemporary America. The national scene since 1900.* Harper and Brothers Publishers: New York, 1945. 657 pp.

Devotes one small section to the New Deal art projects (pp. 548–51).

1946

1230 Argul, José Pedro. "Arte norteamericano; los muralistas de Franklin Delano Roosevelt." *Anuario Plastica* (1946): 170–73.

NOT SEEN.

1231 Cahill, Holger. "Can art survive with its present patronage?" *ALA News* 1 (1946): 1–3.

Excerpts from Holger Cahill's talk at the 3rd Forum of the ACA-American League of Artists Art Lecture Series at the ACA Gallery on February 15, 1946. Cahill discusses the present situation of governmental patronage in context of the New Deal experience.

1232 "WPA prints in Newark." *Art Digest* 20 (February 15, 1946): 20.

Fifty prints on exhibit at the Newark Museum (NJ); Adolf Dehn, Emil Ganso, Stuart Davis, and Arnold Blanch are among those represented at a print exhibition in Newark, NJ.

1233 "Iowa: it's not art; WPA mural at Iowa state fair grounds." *Newsweek* 28 (July 15, 1946): 31–32.

Account of how a 1939 mural done for the Iowa State Fairgrounds by Howard Johnson and Dan Rhodes was cut up for scrap lumber on the orders of State Fair manager Lloyd Cunningham. Said Cunningham: "It wasn't art. It was WPA . . . and an insult to Iowa farmers because it showed them as club-footed, coconut-headed, barrel-necked, and low-browed. Besides, plywood is rare and costs a lot today," p. 32. B/W photographs of a section of the mural and cut-up sections of it used for other purposes.

1234 "Museum pieces, homemade." *Time* 48 (August 12, 1946): 59.

Announcement of a display of 111 IAD plates at the NGA. B/W illustrations of IAD plates.

1235 "Index of American Design." *Antiques* 50 (November 1946): 307.

Editorial on the IAD; brief, concise history of the IAD.

MONOGRAPHS

1236 Bourne, Francis T., assisted by Betty Herscher. *A preliminary checklist of the central correspondence files of the Work Projects Administration and its predecessors: 1933–1944.* National Archives: Washington, DC, 1946. 65 pp.

Guide to the document collections of the WPA in the National Archives. A useful guide for finding public documents.

1237 Perkins, Frances. *The Roosevelt I knew*. Viking Press: New York, 1946. 408 pp.

Excellent first hand account of life in the Roosevelt Administration by his Secretary of Labor. Pp. 75–76 discuss the New Deal Art Projects; Perkins commenting on FDR's taste in art: "The pictures he selected from the art project for his office, while not the worst in the collection, were certainly not good," p. 76.

1947

1238 Christensen, Erwin O. "American popular art as recorded in the Index of American Design." *Art in America* 35 (July 1947): 199–208.

Full account of the IAD; B/W illustrations of plates.

1239 Gotheim, Frederick. "Eternal art and the bureaucratic flux." *Right Angle* 1 (August 1947): 3.

Commenting on the murals in federal buildings, Gotheim feels that the interiors of the buildings do not correspond to their exteriors, rendering the murals ineffective; this is just his main criticism, however. "To paint for the transitory values of bureaucracy would kill all that is great and enduring in art."

MONOGRAPHS

1240 Federal Works Agency. *Final report on the WPA program, 1935–1943*. GPO: Washington, DC, 1947. 145 pp.

An excellent work that clearly summarizes the multitudinous works of the WPA from its foundation May 6, 1935, through June 30, 1943, when it officially closed down. Short section on the WPA/FAP (proving what a small percentage of the total relief effort it actually was) gives some interesting statistics: 25,068 people took WPA/FAP art classes; 21,765 IAD plates were created; 2,566 murals were created; 108,099

easel works done; 11,285 fine print designs; and 17,744 sculptures.

1948

1241 Perkins, Frances. "An experiment in art." *Right Angle* 2 (April 1948): 1–2.

Reminiscence by Perkins on a display of PWAP art in the Interior Department building in March 1937.

1241a Hitchcock, George. "The un-American murals." *Masses and Mainstream* 1.8 (October 1948): 34–41.

Discussion of Refregier's PWAP murals for the Rincon Annex of the San Francisco Post Office.

1242 Goodrich, Lloyd. "Federal government and art." *Magazine of Art* 41 (October 1948): 236–38.

Account of Federal art patronage; some comments on the New Deal projects.

MONOGRAPHS

1243 Christensen, Erwin O. *Popular art in the United States.* Penguin Books: London, 1948. 30 pp. 30 plates.

Thirty-two illustrations from the IAD with an introduction and text by Christensen. First major publication on IAD.

1244 Kitchen, Elizabeth F. *The influence of syndicate art on government subsidized murals in the US.* MA Thesis, Yale University, 1948.

NOT SEEN. CITED IN HARPUR'S #1335. NOTE: Yale University has no evidence of this thesis.

1949

1245 "We're all Christians." *Time* 56 (May 9, 1949): 63.

Account of the adventures incurred by Section murals executed by Harold Black and Isabel Bates. They were delivered in 1942 to the Salina, KS, Post Office they were commissioned for, but the murals lay rolled up in the basement since their arrival. When postmaster Robert Pafford opened them in 1949, he didn't like them and planned to destroy them. Ernest Dewey of a nearby town, Hutchinson, offered to take them for the Hutchinson Library. All parties concerned are still debating what to do with them. Said one Hutchinson resident: "If the Government did it, it ain't art." B/W illustrations of the murals.

1245a Robinson, Amy. "Refregier paints a mural." *Artnews* 48 (October 1949): 32–34, 55–56.

Discussion of Anton Refregier's PWAP murals for the Rincon Annex of the San Francisco Post Office. B/W photographs of the murals and Refregier at work.

MONOGRAPHS

1246 Index of American Design. *Arts and crafts; a bibliography for craftsmen by the National Gallery of Art, Index of American Design, in collaboration with the Federal Security Agency, Office of Education, Division of Vocational Education.* National Gallery of Art: Washington, DC, 1949. 80 pp.

Bibliography compiled for craftsmen by the National Gallery of Art's Index of American Design curatorial staff; no other connection to the New Deal art projects.

1247 Pietan, Norman. *Federal government in the arts.* Ph.D. dissertation, Columbia University, 1949. 305 pp.

Covering all the art projects (Federal One), Pietan's work is primarily an historical survey of what preceded the Federal

One projects; what Federal One accomplished; and what the future of government sponsorship of art holds. Includes a list of WPA Community Art Centers.

1950

1248 Green, Samuel M. "Plan for the Index of American Design." *College Art Journal* 10 (Fall, 1950): 18–22.

Explanation of the IAD and its history; discusses a project in Maine to revive the IAD within Maine (Maine Index of Design).

1249 "Review. *The Index of American Design* by Erwin O. Christensen." *Art Quarterly* 13 (Autumn 1950): 357.

Brief, favorable review of *The Index of American Design* by Erwin O. Christensen (*See* **1256**).

1250 Langsner, Jules. "Review. *The Index of American Design* by Erwin O. Christensen." *Arts and Architecture* 67 (October 1950): 41–42.

Mixed review of *The Index of American Design* by Erwin O. Christensen (*See* **1256**).

1251 "Index of American Design at the Whitney." *Art Digest* 25 (October 15, 1950): 13.

Circulating exhibition curated by Erwin O. Christensen of 100 plates from the IAD arrives at the Whitney (later, Toledo, Carnegie Institute, and Baltimore Museum of Art; another version of the show will travel to the Art Institute of Chicago, Los Angeles, Dallas, and St. Louis). Includes a history of the IAD; B/W illustrations of IAD plates.

1252 Bird, Paul. "Put the Index to work." *Art Digest* 25 (November 15, 1950): 5.

Editorial in praise of the IAD and Erwin O. Christensen's book on it (*See* **1256**); Bird hopes that more of the IAD will be published.

1253 F., H.L. "Review. *The Index of American Design* by Erwin O. Christensen." *Art News* 49 (December 1950): 9.

Highly favorable review of *The Index of American Design* by Erwin O. Christensen (*See* **1256**).

1254 K., S. "Review. *The Index of American Design* by Erwin O. Christensen." *Architectural Forum* 93 (December 1950): 136.

Brief favorable review of *The Index of American Design* by Erwin O. Christensen (*See* **1256**).

1255 "Playthings from the Index of American Design." *Antiques* 58 (December 1950): 468–69.

Color plates of toys from the IAD; explanation of the IAD.

MONOGRAPHS

1256 Christensen, Erwin O. *The Index of American Design.* Macmillan: New York, 1950. 229 pp.

First attempt to publish (selections) the IAD; a good resource for the study of the IAD illustrated in B/W and color. Superseded by the microfiche edition of the complete IAD (*See* **1495**). Excellent introduction by Holger Cahill.

1257 Levitt, Marilyn M. *The Federal art projects. A study in democratic patronage.* MA thesis, Syracuse University, 1950. 120 pp.

Covers all of Federal One. WPA/FAP section deals primarily with murals, sculpture, and art education. Levitt finds much to praise about the project and government patronage of the arts in general. Includes the partial results of a survey she did of twenty-two artists involved with the WPA/FAP (valuable work); plates.

1258 Roosevelt, Elliott, ed. *F.D.R. His personal letters.* Duell, Sloan and Pearce: New York, 1950. 2 v.

Two bits of correspondence in FDR's letters are of interest to those studying the New Deal arts projects. The first is a letter

to Edward Bruce from October 2, 1941 (p. 1221) in which he
praises the work of the Section in bringing art to the people.
The second is an exchange between FDR, Winston
Churchill, and Bruce. On December 23, 1941, Bruce asked
FDR to invited Churchill to lunch with him as he was a fellow
painter (text of letter); on February 2, 1942 FDR wrote to
Churchill regarding Bruce's lunch invitation to Churchill;
unclear if Churchill ever made the lunch (pp. 1284–85).

1259 Skaug, Julius. *The Mobridge murals.* Mobridge Tribune:
Mobridge, SD, 1950? 11 pp.

Pamphlet to accompany the Section mural in the Mobridge
Municipal Auditorium (subject: Indian themes) done by
Oscar Howe. B/W illustrations of the mural. Publication date
sometime in the 1950s.

1951

1260 Filler, Louis. "Arts and the man." *Midwest Journal* 4
(Winter 1951/52): 112–22.

Highly favorable review of *The Index of American Design* by
Erwin O. Christensen (*See* **1256**) that segues into an excellent
essay defending the WPA/FAP.

1261 Barbeau, Marius. "Review. *The Index of American De-
sign* by Erwin O. Christensen." *Canadian Art* 8 (Spring 1951):
137–39.

Highly favorable review of *The Index of American Design* by
Erwin O. Christensen (*See* **1256**).

1262 Green, Samuel M. "Review. *The Index of American
Design* by Erwin O. Christensen." *Magazine of Art* 44 (May
1951): 198.

Highly favorable review of *The Index of American Design* by
Erwin O. Christensen (*See* **1256**).

1263 O'Connor, J. "Exhibition at the Institute." *Carnegie Magazine* 25 (June 1951): 186–88.

Note on an exhibition ("Index of American Design") of IAD plates at the Carnegie Institute, June 17 through July 8, 1951. Includes a description of the exhibition and the purpose of the IAD.

1264 "Review. *The Index of American Design* by Erwin O. Christensen." *Studio* 142 (November 1951): 160.

Highly favorable review of *The Index of American Design* by Erwin O. Christensen (*See* **1256**).

1265 Webster, J. Carson. "Review. *The Index of American Design* by Erwin O. Christensen." *College Art Journal* 10 (Winter 1951): 206–207.

Highly favorable review of *The Index of American Design* by Erwin O. Christensen (*See* **1256**).

1952

1266 Watson, Ernest. "A question of democracy." *American Artist* 16 (May 1952): 3, 57–58.

Editorial criticizing the attempt to remove Anton Refregier's Rincon Annex murals.

1267 Filler, Louis. "American 'art history' and contemporary creation." *College Art Journal* 12 (Fall 1952): 42–52.

Comments on *The Index of American Design* and *Popular Art in the United States* by Erwin O. Christensen (*See* **1256**). Good early article on rediscovery of IAD and art project material. REPRINT from *Midwest Journal* 4 (Winter 1951–52): 112–22.

1268 Cowdrey, Mary Bartlett. "Review. *The Index of American Design* by Erwin O. Christensen." *Art Bulletin* 34 (September 1952): 245–46.

Very unfavorable review of *The Index of American Design* by Erwin O. Christensen (*See* **1256**).

1953

1269 Scoon, Carolyn. "Review. *The Index of American Design* by Erwin O. Christensen." *New-York Historical Society Quarterly* 37 (January 1953): 94–95.

Favorable review of *The Index of American Design* by Erwin O. Christensen (*See* **1256**), by Scoon, who had worked on the New York IAD.

MONOGRAPHS

1270 Firm, Ruth M. *Art in a democracy: 1900–1950.* MA Thesis, Columbia University, 1953.

NOT SEEN. CITED IN HARPUR'S #2039.

1271 US Congress. House of Representatives. *Joint resolution directing the Administrator of General Services to remove the mural paintings from the lobby of the Rincon Annex Post Office Building in San Francisco, California. H.J. Resolution 211 (83rd Congress, 1st Session).* GPO: Washington, DC, 1953.

Resolution introduced by Hubert B. Scudder (CA) on March 5, 1953 to remove Anton Refregier's murals from the San Francisco Rincon Annex Post Office as they are "artistically offensive and historically inaccurate." A nasty little invective against Communists. *See* **1272** for hearings on this resolution.

1272 US Congress. House of Representatives. Committee on Public Works, Subcommittee on Public Buildings and Works. *Rincon Annex murals, San Francisco, California (83rd Congress, 1st Session).* GPO: Washington, DC, 1953.

Hearings on H.J. 211 (*See* **1271**). One of the most fascinating documents to come out on the New Deal art projects in

the 1950s. Rep. Hubert B. Scudder (CA), acting on the behalf of some of his constituents, introduced legislation to remove Anton Refregier's Section murals from the Rincon Annex Post Office in San Francisco. In addition to numerous letters and testimony from various patriotic groups demanding the removal of the murals (on rather vague grounds) there is a strong show of support for the murals from artists' groups. Scudder questioned Refregier's citizenship (he had become a citizen in 1930), brought up his ties to the Communist Party, and, in the most dubious part of his investigation, questioned the life-styles of the three jury members who chose Refregier. Jurors Victor Arnautoff and Arnold Blanch were both shown to be subversive with ties to Communist organizations. The third member of the jury, Philip Guston (who voted against Refregier's design), had no record. Scudder also gives a detailed analysis of the murals showing him to have not only no aesthetic sense, but little historical knowledge either. Rep. John F. Shelley (CA) counters with a rebuttal to Scudder's analysis of the murals. List of groups and individuals who have expressed opposition or support for the murals included.

1954

Nothing

1955

1273 "The angry art of the Thirties." *Fortune* 51 (March 1955): 88–91.

Brief overview of the New Deal projects; primarily illustrations; not all New Deal art. Illustrations of work by Reginald Marsh, Philip Evergood, James N. Rosenberg, William Gropper, Alexandre Hogue, Ben Shahn, Max Weber, O. Louis Guglielmi, Jack Levine, and Anton Refregier.

1274 New York Public Library. Art Division. *A group of mural paintings executed under the auspices of the United States Works Progress Administration; photographs. Arranged by the Art Division of the New York Public Library.* New York, 1955. 4 ll. 123 plates.

NOT SEEN. CITED IN NYPL.

1274a Kent, Rockwell. *It's me, O Lord: the autobiography of Rockwell Kent.* Dodd, Mead: New York, 1955. 617 p.

Autobiography of Rockwell Kent. Kent includes a description of his impressions of the New Deal art projects and includes a long account of the controversy that surrounded his own Section mural for the Post Office Building. NOTE: Reprinted by Da Capo Press in 1977. B/W illustrations.

MONOGRAPHS

1275 Skull, Carl. *The development of the community art center in form and function.* Ph.D. Dissertation, Ohio State University, 1955.

NOT SEEN.

1956

1276 Geist, Sidney. "Prelude: 1930's." *Arts* 30 (September 1956): 49–55.

Geist states that though the WPA/FAP did not create any great artists or styles (except for a "heavy mural style"), it did let mature artists continue to work and young artists to keep doing what they were doing; critical of social realism; praises José Clemente Orozco and Diego Rivera; includes B/W illustrations.

MONOGRAPHS

1277 Osborne, David S. *Mural projects of the United States Government in the Bay Area of Northern California.* MA thesis, University of California, Berkeley, 1956. 76 pp.

History of the New Deal art projects both nationally and in Northern California; philosophical analysis of the projects; technical and artistic analysis of major works in Northern California; and a checklist of all Bay Area murals the author located.

1278 Purcell, Ralph. "New stirrings." In *Government and art. A study of the American experience,* pp. 46–80. Public Affairs Press: Washington, DC, 1956, 129 pp.

Chapter 3: "New Stirrings," pp. 46–80, provides a good overview of the various art projects from a still recent point of view.

1957

1279 Harrison, John M. "Creativity: the state's role; review of *Government and Art* by Ralph Purcell." *Saturday Review* 40 (February 2, 1957): 14–15.

Favorable review of Purcell's works (*See* **1278**). B/W illustration of work by Edward Laning.

1280 Christensen, Erwin O. "Index of American Design; opportunities for research." *College Art Journal* 17 (Fall 1957): 61–67.

Overview of IAD and its present state at the NGA. B/W illustrations of IAD plates.

1281 Cahill, Holger. *The reminiscences of Holger Cahill.* Transcript of interviews conducted by the Oral History Research Office of Columbia University in 1957. 629 pp. (Microfiche edition issued in 1975.)

Interviews conducted April–June 1957 by Joan Pring. Invaluable source of information on the life of Holger Cahill. Cahill discusses his entire life, his work on the New Deal art projects (pp. 314–477), his work in American folk art, the disposition of the IAD, and a number of other topics.

Outspoken and direct, the reminiscence is full of anecdotes and stories.

1958

1282 Baugh, Virgil and W. Lane Van Neste. *Preliminary inventories. Records of the Public Buildings Service, RG 110.* National Archives: Washington, DC, 1958. 108 pp.

Pp. 28–41 of this guide to records in the National Archives covers the art projects of the Treasury Department.

1959

Nothing

1960

1283 Beckh, Erica. "Government art in the Roosevelt era; an appraisal of federal art patronage in the light of present needs." *College Art Journal* 20 (Fall 1960): 2–8.

Good overview of the art projects; covers attempts to form a Bureau of Fine Arts (Coffee-Pepper bill); a critique of the projects in light of the present art/government situation. B/W illustrations of works by Ben Shahn, Anton Refregier, Rico Lebrun, Philip Guston, Stuart Davis, and Jack Levine; and photographs from the era.

1284 "Holger Cahill." *Art News* 59 (September 1969): 7.

Obituary of Holger Cahill (died July 9, 1960).

1285 "Obituaries." *Arts* 34 (September 1960): 11.

Obituaries of Holger Cahill (died July 9, 1960) and Forbes Watson (died May 31, 1960).

1961

1286 Shaffer, Helen B. "Government and the arts." *Editorial Research Reports, no. 5* 2 (August 2, 1961): 561–78.

Review of the history of the New Deal art projects in the context of contemporary legislation on the arts. Good, brief overview of PWAP, WPA/FAP, and Section.

1287 C., L. "Paintings from the WPA." *Art News* 60 (September 1961): 14.

Brief, favorable review of "Art of the Thirties" (September 16–October 7, 1961) at Smolin Gallery (NYC); partial list of artists and works; B/W illustration of work by Mark Rothko.

1288 Tillim, Sidney. "Art of the Thirties—review of Smolin Gallery exhibit, September 16-October 7, 1961." *Arts Magazine* 36 (November 1961): 38–39.

Favorable review of "Art of the Thirties" (September 16–October 7, 1961) at Smolin Gallery (NYC); calls for a full-scale exhibition of New Deal project art work to all for a true appraisal of the work.

1289 Strobridge, Truman R. "Art documents in the National Archives." *Art Journal* 21 (Winter 1961–62): 105–106.

Brief but good description of the WPA, WPA/FAP, Section, TRAP, PWAP records and how to use them at the National Archives; official papers of Edward Bruce and Edward Rowan also mentioned.

1290 Billington, Ray A. "Government and the arts: the WPA experience." *American Quarterly* 13 (Winter 1961): 466–79.

Survey of the work of Federal One. Includes an overview of Federal support for the arts before the 1930s.

MONOGRAPHS

1291 Refregier, Anton. "A national arts program is needed," pp. 69–87. In *Public Ownership in the USA: Goals and Practices*, edited by Helen L. Alfred. Peace Publications: New York, 1961. 238 pp.

Excellent essay on government sponsorship of the arts; Refregier covers the attempts to create a Federal Bureau of Fine Arts, Federal One, the Section, and the controversy surrounding his own Rincon Annex mural project. "Nowhere in the western part of the world, during the depression period of the thirties, did there exist such a concrete example of the vast energy of the cultural worker, and the hunger for culture on the part of the population of the United States, as was demonstrated by the Federal Arts Program," p. 71. Also discusses present governmental activity in art patronage. Also printed separately as *Government sponsorship of the arts* (Peace Publications: New York, 1961. 10 pp.).

1962

1292 "WPA paintings in New York." *Art Journal* 21 (Spring 1962): 206.

Review of "Art of the 30's" (September 25–October 13, 1962) at the Smolin Gallery (NYC); includes a very brief history of the New Deal art projects.

1293 "Growth of archives." *Archives of American Art Journal* 2 (June 1962): 1, 6.

Announcement of the acquisition of the papers of Edward Bruce; explains Bruce's association with the projects and description of the papers.

EXHIBITIONS

1294 Smolin Gallery. *Art of the 30's.* Smolin Gallery: New York, 1962. 1 sheet pamphlet.

Exhibition, September 25 through October 13, 1962. Checklist of fifty works. Notes that children's WPA art work will also be shown and an art class will taught by Sid Gotcliffe.

1963

1295 Dows, Olin. "The New Deal's Treasury art programs. A memoir." *Arts in Society* 2 (1963–64): 50–88.

An excellent introduction to the Treasury Department's art programs. Dows covers all the projects, both Treasury and WPA, but focuses on the Treasury programs on which he was intimately involved. Detailed portrait of how the Treasury programs were run on a day-to-day basis with numerous anecdotes and interesting stories. Numerous B/W illustrations. Includes a very abbreviated list of artists participating in the Treasury projects. Later reprinted in *The New Deal Art Projects: An Anthology of Memoirs* by Francis V. O'Connor (*See* **1367**).

1296 Goodrich, Lloyd. "The government and the creative artist." *AFA Quarterly* 1 (1963, #1): 40–47.

General discussion of government and art with some background on the New Deal art projects.

1297 "WPA and after." *Newsweek* 62 (August 5, 1963): 66.

Review of "The US Government Art Projects: Some Distinguished Alumni" at the Washington Gallery of Modern Art (DC). Comments by Jack Tworkov and Theodor Rozsak on the New Deal art projects and how they lead to Abstract Expressionism. B/W illustrations of work by Jack Tworkov.

1298 Fuller, Mary. "Emblems of sorrow: the WPA art project in San Francisco." *Artforum* 2 (November 1963): 34–37.

An excellent article on all the New Deal art projects in San Francisco; includes a partial list of artists who worked in San Francisco. B/W illustrations of works by Reuben Kadish,

David Slivka, Lucien Labaudt, Shirley Triest, George Post, and Dong Kingman.

EXHIBITIONS

1299 Washington Gallery of Modern Art. *The US Government Art Projects: some distinguished alumni.* Washington Gallery of Modern Art: Washington, DC, 1963. 1 p.

Exhibition, July 9 through August, 1963. Invitation in NMAA/NPG Library VF.

MONOGRAPHS

1300 Bernstein, Joel. *Government subsidization of art during the New Deal.* MA thesis, University of Wyoming, 1963. 100 ll.

Excellent coverage of the PWAP and the WPA/FAP. Bernstein covers with clarity and detail the founding of both projects and the major work both did. Concludes that the projects were good ideas, but failed because they were lumped together with Public Works instead of under an arts oriented agency.

1301 Dows, Olin. *Government in art; the New Deal's Treasury Art program. A memoir by Olin Dows.* University of Wisconsin Press: Madison, 1963? 40 pp.

Excellent memoir by Dows on each of the four art projects (PWAP, Section, TRAP, WPA/FAP), but concentrating on the first three. Dows explains how each was run, and how the artists and juries were chosen. Includes a partial list of artists associated with the Treasury art projects. REPRINTED in *Arts in Society* and *Federal Support for the Visual Arts* (*See* **1295** and **1367**).

1302 Feldman, Francis T. *American painting during the Great Depression, 1929–1939.* Ph.D. Dissertation, New York University, 1963. 289 ll.

Good overview of the state of American painting during the Great Depression; discusses the three major art movements

(Social Realism, American Scene, and Abstraction); good overview of the New Deal art projects. Pp. 66–83 devoted to "Federal Assistance to Art." Examines the work of a number of individual artists, many of whom worked on New Deal art projects.

1303 Searle, Charles F. *Minister of relief, Harry Hopkins and the Depression.* Syracuse University Press: Syracuse, NY, 1963. 286 pp.

Good account of the career of Harry L. Hopkins and the WPA, but no mention of the art projects.

1964

1304 Woolfenden, William E. "The New Deal and the arts." *Archives of American Art Journal* 4 (January 1964): 1–5.

Description of the plans by the Archives of American Art to document federal patronage of the arts; includes a list of people planned for oral history interviews, future goals, list of papers to be microfilmed, and list of artists and others whose papers the AAA presently has. Illustrated with photographs of project era.

1305 "Edward Millman, 1907–1964." *Art Journal* 24 (Fall, 1964): 40.

Obituary of Edward Millman (administrator of the PWAP and WPA/FAP); reprinted from the New York *Herald Tribune,* February 14, 1964.

1306 "Federal art project." *Archives of American Art Journal* 4 (October 1964): 6.

Announcement of the acquisition by the Archives of American Art of National Archives records relating to the WPA/FAP, 1935–1941.

MONOGRAPHS

1307 National Gallery of Art. *Index of American Design. Traveling exhibitions and color slides.* NGA: Washington, DC, 1964. 8 pp.

Pamphlet that briefly describes the IAD and how to arrange for an exhibition of plates or to borrow slides. Thirty prepackaged IAD exhibitions and twenty-three slide sets are described. FOUND IN AAA Reel 1086.239–47.

1965

1308 Smith, Sherwin D. "Boondoggle that helped 38 million people." *New York Times Magazine* (May 2, 1965): 37, 68, 72, 74, 76.

General article on the WPA; WPA/FAP covered on p. 74. B/W photographs.

1309 McCoy, Garnett. "A preliminary guide to the collections of the Archives of American Art." *Archives of American Art Journal* 5 (June 1965): 3–4.

In collection guide, the following records relate to the federal art projects:
"Edward Bruce (1879–1943) Papers, 12,000 items."
"Olin Dows Papers, 200 items."
"Edward B. Rowan Papers, 2,500 items."
"PWAP, TRAP, Section, FAP, 80,000 items."
"Forbes Watson Papers, 8,000 items."
Also includes a list of taped interviews relative to the New Deal.

1310 McCoy, Garnett. "Poverty, politics and artists 1930–1945." *Art in America* 53 (August-September 1965): 88–107.

After a brief introduction to the various art projects, the majority of the article is made up of excerpts from letters,

diaries, memoranda, and so on, from artists and administrators of the projects. Included are George Biddle, Edward Bruce, Reginald Marsh, Ben Shahn, Burgoyne Diller, Henry Varnum Poor, and Louise Nevelson. B/W illustrations of works and photographs of artists at work.

MONOGRAPHS

1311 Smith, Clark Sommer. *Nine years of federally sponsored art in Chicago 1933–1942.* MA thesis, University of Chicago, 1965. 80 ll.

An excellent account of the art projects in Chicago; covers all aspects of the development of the art projects including the formation of the Chicago WPA/FAP and a thorough coverage of mural, easel painting, and design work. Includes a list of murals completed in Illinois.

1966

1312 Randle, Mallory B. "Texas muralists of the PWAP." *Southwestern Art* 1 (Spring 1966): 51–70.

Invaluable article on PWAP mural activity in Texas. Includes a detailed account of PWAP murals in Texas Post Offices, libraries, high schools, and colleges. Includes a city-by-city inventory of PWAP murals. B/W and color illustrations of murals by Douthitt Wilson, Granville Bruce, Jerry Bywaters, Alexandre Hogue, John Douglass, Otis Dozier, Olin Travis, and Thomas Stell.

1313 Stevens, Elizabeth. "The thirties revived, 'Federal Art Patronage, 1933–1943'; WPA art in Maryland." *Artforum* 4 (June 1966): 43.

Mixed review (Stevens liked the concept of the show, but felt the works themselves were not that good) of "Federal Art Patronage, 1933–1943" at the University of Maryland, curated by Francis V. O'Connor. Detailed critiques of individ-

ual works. B/W illustrations of works by Jackson Pollock, George Biddle, Adolph Gottlieb, Seymour Fogel, Ad Reinhardt, Fletcher Martin, Emil Bisttram, William Gropper, and Symeon Shimin.

1314 "New Deal art at University of Maryland." *Art Journal* 26 (Fall 1966): 74–76.

Review of "Federal Art Patronage: 1933 to 1943" at the University of Maryland, curated by Francis V. O'Connor. Eighty-three paintings, mural studies, sculpture and IAD plates. B/W illustrations of works by Symeon Shimin, William Gropper, Ben Shahn, George Biddle, Fletcher Martin.

1315 Humphrey, Hubert H. "Four decades of art and the federal government." *Arts* 41 (December 1966): 6–7.

Sen. Humphrey recounts briefly the history of Federal art projects in the 1930s and 1940s and relates them to the present. B/W illustration of work by James Brooks.

EXHIBITIONS

1316 O'Connor, Francis V. *Federal art patronage 1933–1943.* University of Maryland: College Park, 1966. 60 pp.

Exhibition, April 6 through May 13, 1966. O'Connor's exhibition awakened art historians and the general public to the riches of New Deal art. After this exhibition, the floodgates of scholarship began. Checklist of eighty-three works; excellent introductory essay. B/W illustrations of works.

MONOGRAPHS

1317 Wahl, Jo Ann. *Art under the New Deal.* MA thesis, Columbia University, 1966. 80 ll.

Covering all aspects of New Deal art (PWAP, Section, WPA/ FAP), Wahl attempts to dispel the notion that New Deal art is "bad" art. Good, early critical work on the period. Plates.

1967

1318 Bendiner, Robert. "The thirties: when culture came to main street." *Saturday Review* 50 (April 1, 1967): 19–21.

An excellent article on the Federal One projects; covering all the projects of Federal One, concentrating on the FWP.

1319 McCoy, Garnett. "Preliminary guide to the collections, part 2." *Archives of American Art Journal* 7 (June 1967): 18.

Additions to previous list (*See* **1309**); acquisitions relative to the federal arts projects include list of tape recorded interviews and list of artists, many of whom had project connections.

EXHIBITIONS

1320 YM-YWHA of Essex County, New Jersey. *WPA artists: then and now.* YM-YWHA: West Orange, NJ, 1967. 9 pp.

Exhibition, October 29 through November 26, 1967. Brief introduction by Mildred Baker; twelve brief "reminiscences" by WPA/FAP artists; checklist of eighty works, forty from the thirties and forty recent works. B/W illustrations of works by Arshile Gorky, Paul Cadmus, Moses Soyer, O. Louis Guglielmi, Hugo Robus, and Reginald Marsh.

MONOGRAPHS

1321 Contreras, Belisario R. *The New Deal Treasury Department art programs and the American artist, 1933 to 1943.* Ph.D. dissertation, American University, 1967. 389 ll.

An excellent and thorough account of the various Treasury Department programs; explores the involvement of Edward Bruce and the nature of relief versus Art; brief coverage of other art projects. Plates.

1322 Freedman, Elizabeth L. *Federal patronage and the fine arts.* Senior thesis, Bryn Mawr College, 1967. NOT SEEN. CITED IN OCLC.

1323 Mavigliano, George T. *The Federal Art Project: A governmental folly?* MA Thesis, Northern Illinois University, 1967. NOT SEEN.

1324 Randle, Mallory Blair. *Murals and sculpture of the Public Works of Art Project and the Treasury Section in the Southwest.* MA thesis, University of Texas, 1967. 223 ll.

Good overview of the PWAP and Section in the Southwest; bulk of the thesis is a catalog of sculpture and murals done by the two divisions in Arizona, Colorado, New Mexico, Oklahoma, and Texas. Includes details about each work. Plates.

1325 Rose, Barbara. "The thirties: reaction and rebellion." In *American art since 1900: a critical history*, pp. 114–154. New York: Praeger Publications, 1967. 320 pp.

Good account of the artistic milieu from which the government art projects were created. Reprinted in 1975.

1968

1326 O'Connor, Francis V. "New Deal murals in New York." *Artforum* 7 (November 1968): 41–49.

O'Connor covers all aspects of New Deal mural work in New York. B/W illustrations of murals by Kindred McLeary, Ben Shahn, Peter Blume, Edward Laning, Marion Greenwood, James Brooks, Moses Soyer, Philip Guston, and Reginald Marsh.

EXHIBITIONS

1327 Milwaukee Art Center. *Midwest—the 1930s.* Milwaukee Art Center: Milwaukee, 1968. 25 pp.

Exhibition, March 1968. Text by Ronald C. Stokes. NOT SEEN.

1327a McKinzie, Richard D. *The New Deal for artists: Federal subsidies, 1933–1943.* Ph.D. dissertation, Indiana University, Bloomington, 1968. 331 pp.

NOT SEEN. CITED IN *DAI* 30/03A, p. 1113. Covering the WPA/FAP and Section, McKinzie gives a good overview of the New Deal art projects. *See also* **1377** for the book that came out of this dissertation.

1969

1328 O'Connor, Francis. "New Deal art projects in New York. *American Art Journal* 1 (Fall 1969): 58–79.

Explanation of the projects and what was done; complete list of Section and TRAP commissions in New York State; a good source for statistical information.

EXHIBITIONS

1329 Columbia Museum of Art. *Art under the New Deal. A selection of paintings, graphics and mural sketches produced under Federal Work Relief programs from 1933 to 1943.* Columbia Museum of Art: Columbia, SC, 1969. 13 pp.

Exhibition, February 12 through March 10, 1969. Brief introduction and checklist of sixty-eight works. B/W illustrations of works by Peter Blume, Millard Sheets, Yasuo Kuniyoshi, and Lee Allen.

1330 Manhattanville College Art Gallery. *WPA sculpture.* Manhattanville College Art Gallery: Purchase, NY, 1969.

Exhibition, March 10 through April 11, 1969. NOT SEEN.

1331 Westby Gallery. Glassboro State College. *Graphic art of the Depression era: WPA 1935–1943.* Westby Gallery: Glassboro, NJ, 1969. 3 pp.

Exhibition, November 5 through 25, 1969. Checklist of
thirty-six works from the National Museum of American Art.
Text by Lynd Ward. NOTE: This show was organized by Jacob
Kainen of the NMAA and was shown there October through
December 1968 (no catalog).

MONOGRAPHS

1332 Carr, Eleanor M. *The New Deal and the sculptor: a study
of Federal relief to the sculptor on the New York City Federal Art
Project of the Works Progress Administration, 1935–1943.* Ph.D.
dissertation, New York University, 1969. 246 pp.

Study of the WPA/FAP's work with sculptors in New York
City. NOT SEEN. CITED IN *DAI* v.30/08a, p. 3389.

1333 Kunkel, Gladys M. *Mural paintings of Anton Refregier in
the Rincon Annex of the San Francisco Post Office.* MA Thesis,
Arizona State University, 1969.

NOT SEEN. CITED IN OCLC.

1334 McDonald, William Francis. *Federal relief administration
and the arts; the origins and administrative history of the arts
projects of the Works Progress Administration.* Ohio State Univer-
sity Press: Columbus, 1969. 869 pp.

Originally compiled at the termination of the WPA, the work
was not published until 1969. One of the most authoritative
sources for the study of the administrative complexities of
the federal art projects (includes all non-fine art projects).
Well stocked with statistics, figures, and tables, McDonald
also reproduces or quotes from numerous hard to find WPA
administrative orders, internal memos, and other such docu-
ments. A book that must be at the side of every researcher of
the New Deal art projects. Critics of the work who find it
heavy reading have no appreciation of the difficulty in
making administrative histories clear, let alone entertaining.

1335 O'Connor, Francis V. *Federal support for the visual arts:
the New Deal and now; a report on the New Deal art projects in New
York City and State with recommendations for present-day Federal*

support for the visual arts to the National Endowment for the Arts. New York Graphic Society: Greenwich, CT, 1969. 227 pp.

The major study of the projects (with emphasis on New York State and City), covering all aspects of Federal involvement in the fine arts; full of statistics, reports, lists of artists, and other important information. Reprints O'Connor's essay from his 1966 exhibition catalog, *See* **1316.** Reprinted in 1971 with an updated bibliography.

1970–1974

1970

1336 Carr, Eleanor. "The New Deal and the sculptor: a study of Federal relief to the sculptor on the New York City Federal Art Project of the Works Progress Administration, 1935–1943." *Marsyas* 15 (1970–1971): 114.

Note on the author's dissertation of the same title.

1337 Morgan, Theodora. "Federal support for the arts—a once and sometime thing." *National Sculpture Review.* 19 (Summer 1970): cover, 6, 30.

Brief mention of the projects in the context of today's government funding the of arts; B/W illustrations of works by Edmond Amateis and William M. McVey and photographs.

1338 Bernstein, Joel H. "The artist and the Government: PWAP." *Canadian Review of American Studies* 1 (Fall 1970): 100–115.

An excellent, clear and concise overview of the PWAP discussing all the major points, criticisms, controversies, and accolades.

1339 Craig, Lois. "Beyond 'leaf-raking:' WPA's lasting legacy." *City* (National Urban Coalition, Washington, DC) 4 (October–November 1970): 23–29.

Though primarily on the WPA in general, Craig's article does cover the WPA/FAP and IAD; B/W and color photographs; illustration of work by Stuart Davis.

1340 Laning, Edward. "Memoirs of a WPA painter." *American Heritage* 21 (October 1970): 38–44, 56–57, 86–89.

Excerpts from Edward Laning's memoir in Francis V. O'Connor's New Deal Art Project: Anthology of Memoirs (*See* **1367**). B/W and color illustrations of works by Laning, Burgoyne Diller, Charles Campbell, Boris Gorelick, Mark Rothko, and Jackson Pollock. Includes a nice, large section of illustrations of murals selected by Francis V. O'Connor.

EXHIBITIONS

1341 University of Wisconsin, Milwaukee. *WPA + 35: Milwaukee handicrafts project retrospective exhibition January 4–30, 1970.* University of Wisconsin: Milwaukee, 1970. 6 pp.

Exhibition, January 4 through 30, 1970. Text by Elsa Ulbricht covers what the Milwaukee Handicraft Project was (WPA Project #1170 ran from November 6, 1935, through 1943 and had Wisconsin artists creating contemporary crafts—it was not, technically, an art project). Exhibit included a number of works done, 1935–1943.

MONOGRAPHS

1342 Terkel, Louis (Studs). *Hard times; an oral history of the Great Depression.* Pantheon Books: New York, 1970. 462 pp.

One of the classic works on the Depression, Terkel devotes only a brief section to the New Deal art projects. Robert Gwathmey and Knud Anderson reminisce about the period.

1971

1343 Kainen, Jacob. "Prints of the thirties: reflections on the Federal Art Project." *Artists Proof* 11 (1971): 34–41.

Excellent overview of printmaking in the 1930s with emphasis on the Graphics Division of the WPA/FAP; B/W illustrations of works by Louis Lozowick, John Gross-Bettelheim,

Werner Drewes, Jackson Pollock, Stuart Davis, Arshile Gorky, and Louis Schanker.

1344 "WPA art: rescue of a US treasure." *US News and World Report* 70 (June 21, 1971): 75–78.

Excellent account of the GSA program to record and preserve New Deal art. Numerous B/W photographs of art works, then and now.

1345 Freeman, Richard B. "Damaged murals." *Art Journal* 31 (Winter 1971–72): 178, 180.

Report on "Western Pennsylvania," a Section mural done by Niles Spencer for the Aliquippa (PA) Post Office, which was damaged in removal.

MONOGRAPHS

1346 Goode, James M. *Smithsonian Associates' tour of the sculpture, murals, and architectural features of the Federal Triangle.* Washington, DC, 1971. 26 pp. Typescript.

Tour guide to the sculpture, mural, and architectural features of the Federal Triangle; includes many WPA/FAP and Section works. Map.

1347 Marling, Karal Ann. *Federal patronage and the Woodstock colony.* Ph.D. dissertation, Bryn Mawr College, 1971. 587 ll.

An exhaustive study of the interrelations of federal patronage and the independent artists' colony of Woodstock in New York. Includes a history of the Woodstock colony and an overview of all the federal art projects; also a checklist of Section murals completed by Woodstock colony artists. Covers the "effects of government art programs of the period 1933 to 1943 upon the Woodstock art colony, Ulster County, New York" (preface). Plates.

1348 Monroe, Gerald M. *The Artists' Union of New York.* Ed.D. dissertation, New York University, 1971. 270 ll.

The Artists' Union was one of the important backers of the WPA/FAP; Monroe gives a brief history of the WPA/FAP and other art projects before covering in detail their relationship to the Artists' Union. Also details the Artists' Union support and fight for the various fine arts bills of the 1930s.

1349 Petravage, Jacqueline. *An introduction to the New Deal art projects and the work section in Wyoming.* n.p., 1971? 35 ll.

Narrative account of a number of mural and sculpture projects in Wyoming. Good introduction to the projects and their implementation in Wyoming.

1350 Werthman, Jean. *The New Deal Federal Art Projects.* Ph.D. dissertation, St. John's University, 1971. 265 pp.

Survey of government support for the arts and the reactions by artists, politicians, and citizens to the projects. NOT SEEN. CITED IN DAI v.33/022a, p. 713.

1972

1351 Osnos, Nina Felshin. "New Deal for New Deal art." *Art in America* 60 (January 1972): 19.

Report on the Government Services Administration's National Fine Arts Inventory (a project to locate New Deal art in Federal buildings including Post Offices) and the Smithsonian Institution/National Collection of Fine Art's Register of New Deal Art (a project to locate and preserve WPA/FAP 1935–1943 art, assisted by Francis V. O'Connor).

1352 Davidson, Marshall B. "The WPA's amazing artistic record of American design." *American Heritage* 23 (February 1972): 65–80.

Good, well-illustrated (all color) account of the IAD. *See* **1354** for part 2 of the article.

1353 "GSA launches survey of federally-sponsored art."
Progressive Architecture 53 (February 1972): 31.

Report on GSA plan to inventory work created for the
government, 1933–1943.

1354 Davidson, Marshall B. "The legacy of craftsmen."
American Heritage 23 (April 1972): 81–96.

Continuation of Davidson's article on the IAD (*See* **1352**).
Numerous color reproductions of the IAD plates.

1355 Rosenberg, Harold. "Profession of art; artists during
the Depression." *New Yorker* 48 (June 3, 1972): 85–91.

The eminent art theorist Rosenberg discusses the New Deal
art projects. Covering all the projects, he feels the notion of
"art for the people" to be a sham and that art can never be a
profession and still be Art. A thought-provoking, though
negative, critique of the New Deal art projects. "How shallow
were the roots of art as a profession in nineteen-thirties
America was dramatically demonstrated by the rapid drying
up of the Art Project with the start of the defence program
and their rapid closing down after Pearl Harbor," p. 90.

1356 Carr, Eleanor. "New York sculpture during the fed-
eral project." *Art Journal* 31 (Summer 1972): 397–403.

Good overview of the New York sculpture projects of the
WPA/FAP. Includes a detailed analysis of a number of works.
B/W illustrations of works by a number of sculptors.

1357 Yasko, Karel. "Treasures from the Depression." *His-
toric Preservation* 24 (July 1972): 26–31.

Excellent account of the Treasury projects and the GSA plan
to catalog and preserve the New Deal works; Yasko directed
the GSA project. B/W and color illustrations of works by
Henry Bernstein, Frank Mechau, Edward Laning, William
Gropper, Stuart Davis, Heinz Warneke, and Symeon Shimin.

1358 Monroe, Gerald M. "The Artists Union of New York."
Art Journal 32 (Fall 1972): 17–20.

Good account of the pressure exerted by organized artists to get jobs, higher wages, and exemption from relief work. Monroe points out that artists received the highest WPA wages and had generous exemption from the relief requirements; concentrates on the Artists' Union.

1359 Ajay, Abe. "Working for the WPA." *Art in America* 60 (September–October 1972): 70–75.

Memoir by Abe Ajay, who worked on the WPA/FAP's Graphics Division project. He looks back at this as a good time in his life; a time when artists were brought together; Ajay saw no political problems in the projects. Ends with a call for a program to document WPA work and halt its deterioration. Ajay remembers nothing wrong and none of the troubles: "Like sex, art is best learned about in the gutter or behind the barn from those who make it. Leaving the place of WPA/FAP in art history entirely to the art historians is not the peachiest idea in the world," p.75. B/W illustrations of the works of Arshile Gorky, Stuart Davis, and Philip Evergood. Photographs of various artists at work.

1360 "Review of The New Deal Art Projects: An Anthology of Memoirs by Francis V. O'Connor." *American Artist* 36 (September 1972): 66–67.

Highly favorable review of O'Connor's important book; reviewer draws some analogies between the 1930s and the 1970s.

1361 Harrison, Helen A. "American art and the New Deal." *Journal of American Studies.* 6 (December 1972): 289–96.

A very general overview of the New Deal art projects by Harrison, an American living in Great Britain.

EXHIBITIONS

1362 Illinois. Southern Illinois University, Carbondale. University Galleries. *WPA revisited, an exhibit: art works from the permanent collection of University Galleries, Southern Illinois*

University at Carbondale, Mitchell Gallery, February 1 through February 28, 1972. The Galleries: Carbondale, IL, 1972. 24 pp.

Exhibition, February 1 through 28, 1972. Checklist of fifty-five works from the Illinois WPA/FAP on permanent loan to Southern Illinois University, Carbondale. Selected works from catalog are illustrated in B/W. Three brief essays ("Thoughts for the Present," by Evert A. Johnson; "Some Thoughts for the Future," by Ernest L. Grauber; and "A Matter of History: New Deal and the Arts," by George J. Mavigliano).

1363 Kingsbury, Martha. *Art of the thirties; the Pacific Northwest.* University of Washington Press: Seattle, 1972. 95 pp.

Exhibition, April 1972. Covering all aspects of art in the Pacific Northwest during the 1930s, the show includes 289 works from all media (many WPA/FAP works). B/W illustrations of many works in exhibition.

MONOGRAPHS

1364 Clapp, Jane. *Art censorship: a chronology of proscribed and prescribed art.* Scarecrow Press: Metuchen, 1972. 582 pp.

Chronological list of cases of art censorship; lists the major cases involving New Deal art.

1365 Curtis, Philip Campbell. *Phoenix Art Center, W.P.A. Art Program, 1937–1940.* Phoenix, 1972. 185 photos on 24 sheets and 4 pp. text.

"Photographs of art work and activities of the Phoenix Art Center. Accompanied by a 4-page history of the Phoenix Art Center program, 1937–1940, by Philip C. Curtis." NOT SEEN. CITED IN OCLC.

1366 Hornung, Clarence Pearson. *Treasury of American design; a pictorial survey of popular folk art based upon watercolor renderings in the Index of American Design, at the National Gallery of Art.* Abrams: New York, 1972. 2 v.

A handy, profusely illustrated guide to the IAD; organized by subject. Introduction by Holger Cahill reprinted from Index of American Design by Christensen (*See* **1256**).

1367 O'Connor, Francis V., ed. *The New Deal art projects. An anthology of memoirs.* Smithsonian Institution Press: Washington, DC, 1972. 339 pp.

One of the single most important works on the New Deal art projects (primarily WPA/FAP); a collection of memoirs by those who administered the projects and created art on the projects. "The first attempt to publish in depth the recollections of artists and administrators who worked on the New Deal art projects of the 1930's," p. 2. Includes brief biographies of the contributors. Memoirs by:

Olin Dows, "The New Deal Mural Projects";
Audrey McMahon, "A General View of the WPA Federal Art Project";
Edward Laning, "The New Deal Mural Projects";
Joseph Solman, "The Easel Division of the WPA Federal Art Project";
Robert Cronbach, "The New Deal Sculpture Projects";
Jacob Kainen, "The Graphic Arts Division of the WPA Federal Art Project";
Lincoln Rothschild, "Artists' organizations of the Depression Decade";
Rosalind Bengelsdorf Browne, "The American Abstract Artists and the WPA Federal Art Project";
Olive Lyford Gavert, "The WPA Federal Art Project and the New York World's Fair, 1939–1940";
Marchal E. Landgren, "A Memoir of the New York City Municipal Art Galleries, 1936–1939."

Book concludes with a roundtable discussion with McMahon, Landgren, Gavert, and O'Connor talking about various aspects of the project.

1368 Petravage, Jacqueline. *A study of three New Deal art projects in Wyoming: their administration and their legacy.* MA Thesis, University of Wyoming, 1972. 107 ll.

NOT SEEN. CITED IN OCLC.

1973

1369 Marling, Karal Ann. "Unhallowed museum of Cleveland art." *Cleveland* 1 (February 1973): 100–102.

Popular account of the New Deal art projects in Cleveland, particularly the mural projects. B/W illustration of work by Ora Coltman.

1370 "Dall "progressive era" al New Deal, la questione di Muscle Shoals." *Casabella* 41 (May 1973): 35–43.

NOT SEEN.

1371 Dieterich, Herbert R. and Jacqueline Petravage. "New Deal art in Wyoming: some case studies." *Annals of Wyoming* 45 (Spring 1973): 53–67.

Overview of all New Deal art projects in Wyoming, with details on six Section projects assigned to Eugene Kingman, Louise Ronnebeck, Verona Burkhard, Manuel Bromberg, George Vander Sluis, and Gladys Fisher. Most of the authors' information is drawn from official correspondence between the artists and Section officials.

1372 Harney, Andy Leon. "WPA handicrafts rediscovered." *Historic Preservation* 25 (July 1973): 10–15.

History of the WPA handcrafts projects (including Timberline Lodge in Oregon); B/W photographs of some of the projects.

1373 Monroe, Gerald M. "Art Front." *Archives of American Art Journal* 13.3 (1973): 13–19.

Full account of the radical left magazine *Art Front* published by the Artists' Union and which carried many articles on the projects. B/W photographs.

1374 Evett, Kenneth. "Back to WPA; Federal Art Project." *New Republic* 169 (November 24, 1973): 21–22.

Using Francis V. O'Connor's Art for the Millions (*See* **1378**) as a touchstone, Evett praises the WPA in its ability to unify

artists and calls for some type of similar project for today's artists. "While I hope we will be spared the pious pronouncements and heavy visual exhortations of the WPA, a revived interest in the social force of art could now lead to a strong new manifestation of the age-old exchange between art and life," p. 22.

1374a Bernstein, Barbara. "Federal art: not gone, just forgotten." *Chicago Tribune Magazine* (December 2, 1973). NOT SEEN. Reprinted by the Public Art Workshop as a six-page pamphlet in 1973. A brief discussion of the Illinois WPA/FAP.

1374b Mathews, Marcia M. "George Biddle's contribution to Federal art." *Records of the Columbia Historical Society* 49 (1973–74): 493–520.

Overview of George Biddle's artistic career; focuses on his contributions to the PWAP and the Section. B/W illustrations of Biddle's mural work for the Department of Justice.

EXHIBITIONS

1375 Kent State University. Division of Art History. *New Deal federally sponsored works of art: Ohio post office murals.* Kent State University: Kent, OH, 1973. 4 pp.

Exhibition, 1973 (no dates). Checklist of sixty-nine photographs of post office murals (from all projects) in Ohio. Brief text by Paul Kalinchak on the history of public murals in Ohio.

1376 Illinois State Museum. *Federal art patronage: art of the 1930s.* Illinois State Museum: Springfield, 1973.

Exhibition, October 28 through December 9, 1973. Catalog by Robert J. Evans. NOT SEEN.

MONOGRAPHS

1377 McKinzie, Richard D. *The New Deal for artists.* Princeton University Press: Princeton, NJ, 1973. 203 pp.

An excellent account of the formation and operations of the various federal art programs. One of the best-researched and most important works in the field. Illustrated with many B/W reproductions of works as well as photographs of artists and administrators.

1378 O'Connor, Francis V., ed. *Art for the millions; essays from the 1930s by artists and administrators of the WPA Federal Art Project.* New York Graphic Society: Greenwich, CT, 1973. 317 pp.

An important collection of essays on New Deal art. Originally planned as a national report on the WPA/FAP by Holger Cahill in 1936, the process of collecting and editing the essays was drawn out for a number of years; plans were made to have the book published commercially in the later 1930s, but these fell through. With the termination of the WPA/FAP in 1943, the manuscripts lay forgotten amongst the papers of Cahill until they were eventually resurrected and edited by O'Connor. O'Connor also includes an excellent essay on the history of the WPA/FAP. Included are a foreword by Cahill adapted from a speech given in 1938. Appendices list the complete manuscripts planned for Art for the Millions (the present edition is incomplete and also contains condensed or amalgamated versions of some essays; others, whose existence is known of, were lost over the years). The contents are as follows:
Evergood, Philip, "Concerning mural painting," pp. 47–49;
Norman, Geoffrey, "The development of American mural painting," pp. 50–55;
Goodwin, Jean (Ames), "California mosaics," pp. 56–59;
Newell, James Michael, "The evolution of Western Civilization," pp. 60–63;
Siporin, Mitchell, "Mural art and the midwestern myth," pp. 64–67;
Knaths, Karl, "Mural education," pp. 67–68;
Diller, Burgoyne, "Abstract murals," pp. 69–71;
Gorky, Arshile, "My murals for the Newark Airport: an interpretation," pp. 72–73;

Hiler, Hilaire, "An approach to mural decoration," pp. 74–75;

Bloch, Lucienne, "Murals for use," pp. 76–77;

Quirt, Walter, "On mural painting," pp. 78–81;

Piccoli, Girolamo, "Report to the sculptors of the WPA/FAP," pp. 82–87;

Cashwan, Samuel, "The sculptor's point of view," pp. 88–89;

Smith, David, "Modern sculpture and society," pp. 90–92;

Gershoy, Eugene, "Fantasy and humor in sculpture," pp. 92–93;

Gregory, Waylande, "Planning a public fountain," pp. 94–95;

Hunter, Vernon, "Concerning Patrocinio Barela," pp. 96–99;

Macdonald-Wright, Stanton, "Sculpture in Southern California," pp. 100–103;

Hord, Donal, "Symphony in stone," pp. 104–06;

Bufano, Beniamino Benvenuto, "For the present we are busy," pp. 107–112;

Guglielmi, O. Louis, "After the locusts," pp. 113–15;

Bloch, Julius, "The people in my pictures," pp. 115–16;

Levine, Jack, "Some technical aspects of easel painting," pp. 117–20;

Davis, Stuart, "Abstract painting today," pp. 121–27;

Sommer, William, "Some of my working methods," pp. 128–31;

Trentham, Eugene, "Golden Colorado," pp. 132–33;

Bear, Donald J., "Easel painting on the WPA/FAP: a statement and a prophecy," pp. 133–37;

Warsager, Hyman, "Graphic techniques in progress," pp. 138–41;

Olds, Elizabeth, "Prints for mass production," pp. 142–44;

Limbach, Russell T., "Lithography: stepchild of the arts," pp. 145–47;

Eichenberg, Fritz, "Eulogy on the woodblock," pp. 148–50;

Dwight, Mabel, "Satire in art," pp. 151–54;

Velonis, Anthony, "A graphic medium grows up," pp. 154–56;

Jacobi, Eli, "Street of forgotten men," p. 157;

Abbott, Berenice, "Changing New York," pp. 158–62;
Rourke, Constance, "What is American design?" pp. 165–66;
Glassgold, C. Adolph, "Recording American design," pp. 167–69;
Cornelius, Charles, "The New York Index," pp. 170–72;
Smith, Gordon M., "The Shaker arts and crafts," pp. 173–75;
Floethe, Richard, "Posters," pp. 176–78;
Graham, Ralph, "The poster in Chicago," pp. 179–82;
Federal Writers' Project, "The builders of Timberline Lodge," pp. 183–89;
Gettens, Rutherford J., "The materials of art," pp. 190–93;
Marantz, Irving J., "The artist as social worker," pp. 196–98;
Jones, Lawrence A., "The New Orleans WPA/FAP project," pp. 198–99;
Ogburn, Hilda Lanier, "Puppetry as a teacher," pp. 199–201;
Stavenitz, Alexander R., "The therapy of art," pp. 201–203;
Clapp, Thaddeus, "Art within reach," pp. 204–207;
Bird, Elzy J., "Birth of an art center," pp. 208–209;
Hayes, Vertis, "The Negro artist today," pp. 210–12;
Bennett, Gwendolyn, "Harlem Community Art Center," pp. 213–15;
Sutton, Harry H., "High noon in art," pp. 216–17;
Morris, Carl, "The Spokane WPA Community Art Center," pp. 218–20;
Curtis, Philip C., "The Phoenix Art Center," pp. 221–22;
Defenbacker, Daniel S., "Art in action," pp. 223–27;
Morsell, Mary, "The exhibition program of the WPA/FAP," pp. 228–31;
Ludins, Eugene, "Art comes to the people," pp. 232–33;
La More, Chet, "The Artists' Union of America," pp. 236–38;
Wolff, Robert Jay, "Chicago and the Artists' Union," pp. 239–42;
Heiberg, Einar, "The Minnesota Artists' Union," pp. 243–47;
Davis, Stuart, "American Artists' Congress, pp. 248–50;
Rothschild, Lincoln, "The American Artists' Congresses," pp.250–52;
Gellert, Hugo, "Artists' Coordination Committee," pp.254–57;

Smith, E. Herdon, "The organization of supervisors of the WPA/FAP," pp.257–58;
McMahon, Audrey, "The WPA/FAP and the organized artist," pp.259–60;
Greene, Balcomb, "Society and the modern artist," pp.262–65.

1379 Shapiro, David, ed. *Social realism: art as a weapon.* Frederick Ungar Publishing Co.: New York, 1973. 340 pp.

An excellent collection of essays on Social Realism; a number of the essays deal with aspects of the New Deal art projects.

1380 Stott, William. *Documentary expression and thirties America.* Oxford University Press: New York, 1973. 361 pp.

Covering all aspects of documentary expression in the 1930s, pp. 102–118 are most relevant to the New Deal art projects. An excellent book on the 1930s. B/W illustrations of works by James Michael Newhall, Emanuel Jacobsen, and Edgar Britton as well as of various thirties images.

1974

1381 Sokol, David M. "Government support of the arts, a survey, part I." *American Art Review* 1 (January–February 1974): 81–86.

Brief overview of the projects; discussion of the relationship between TRAP and WPA/FAP. B/W illustrations of works by William Gropper and Paul Cadmus. NOTE: No second part published.

1382 Monroe, Gerald M. "Artists as militant trade union workers during the Great Depression." *Archives of American Art Journal* 14 (January 1974): 7–10.

Good account of Artists Union; brief section on its association to project artists. B/W illustrations.

1382a Scoon, Carolyn. "Review of C.P Hornung's *Treasury of American design; a pictorial survey of popular folk art based upon watercolor renderings in the Index of American Design, at the National Gallery of Art.*" *New-York Historical Society Quarterly* 58 (January 1974): 67–68.

Favorable review of Hornung's selections from the Index of American Design (*See* **1366**).

1383 Baldwin, Carl. "Review of Documentary Expression and Thirties America, by William Stott." *Artforum* 12 (March 1974): 67–68.

Generally favorable review of Stott's book (*See* **1380**).

1384 Carr, Eleanor. "Review of The New Deal Art Projects: An Anthology of Memoirs, by Francis V. O'Connor." *Art Bulletin* 56 (March 1974): 147–49.

Favorable review of O'Connor's important book (*See* **1367**).

1385 Green, Christopher. "Review of New Deal Art Projects: An Anthology of Memoirs, by Francis V. O'Connor." *Burlington Magazine* 116 (March 1974): 166.

Favorable review of O'Connor's important book (*See* **1367**).

1386 Monroe, Gerald M. "The New Deal for artists." *Journal of American History* 60 (March 1974): 1178–79.

Favorable review of McKinzie's overview of the New Deal art projects (*See* **1377**).

1387 Dennis, James M. "Government art: relief, propaganda, or public beautification? [Review of The New Deal for Artists, by Richard D. McKinzie]." *Reviews in American History* 2 (June 1974): 275–82.

In an extended (and favorable—with reservations) review of McKinzie's book (*See* **1377**), Dennis takes the opportunity to give an overview of the secondary literature of the New Deal art projects as well as a comparison of the WPA/FAP and the Section.

Annotated Bibliography

287

1388 *Federal Art Patronage Notes* 1 (September 1974): 4 pp.

First issue of a newsletter edited by Francis V. O'Connor covering both contemporary and historical issues of Federal art patronage. Notes on three exhibitions: "Federal Art in Cleveland: 1933–1943" at the Cleveland Public Library (September 16–November 1, 1974; extended to December 27, 1974); "New Deal Art: California" (a forthcoming show at the De Saisset Art Gallery); and "Art in New Mexico: the Depression Years" at the Museum of New Mexico (February 18–April 22, 1973).

1389 Marling, Karal Ann. "William M. Milliken and federal art patronage of the Depression decade." *Cleveland Museum Bulletin* 61 (October 1974): 360–70.

Excellent account of the life and career of William M. Milliken (regional director for the PWAP, advisor for WPA/FAP and TRAP, and director of the Cleveland Museum of Art); covers his life before, during, and after his association with federal art patronage. Numerous B/W illustrations of works and photographs.

1390 Monroe, Gerald M. "The '30's: art, ideology and the WPA." *Art in America* 63 (November–December 1974): 64–67.

An excellent article that examines the role of the Communist Party among WPA/FAP artists and the Artists' Union. B/W photographs of artists.

1391 "Review." *Federal Art Patronage Notes* 1 (December 1974-January 1975): 2.

Favorable review of "Federal Art in Cleveland: 1933–1943." B/W illustration of work by Kalman Kobinyi.

EXHIBITIONS

1392 Marling, Karal Ann. *Federal art in Cleveland, 1933–1943; an exhibition, September 16 to November 1, 1974, the*

Cleveland Public Library. Cleveland Public Library: Cleveland, 1974. 125 pp.

Exhibition, September 16 through November 1, 1974. Checklist of the exhibition of 442 works from all the arts projects at the Cleveland Public Library; essay includes a summary of the effects of the Depression on Cleveland and traces the history and organization of the projects. Numerous B/W illustrations of works.

MONOGRAPHS

1393 Baigell, Matthew. *The American scene: American painting of the 1930's.* Praeger: New York, 1974. 214 pp.

Basic, well-illustrated work on the American Scene painters of the 1930s. Covers all the New Deal art projects as well as non-project works. Numerous B/W and color illustrations.

1394 Blumberg, Barbara Marilyn. *The Works Progress Administration in New York City: A case study of the New Deal in Action.* Ph.D. dissertation, Columbia University, 1974. 623 pp.

Covers all aspects of New Deal activity in New York City; some coverage of Federal One. NOT SEEN. CITED IN DAI v. 35/10a, p. 6624.

1395 Donaldson, Jeff Richardson. *"306"—Harlem, New York.* Ph.D. dissertation, Northwestern University, 1974. 334 pp.

Comments on African-American participation in the WPA/FAP, particularly the Harlem Art Workshop. NOT SEEN. CITED IN DAI v. 35/10a, p. 6595.

1396 Hall, Daniel August. *Federal patronage of art in Arizona from 1933 to 1943.* MA thesis, Arizona State University, 1974. 211 ll.

Detailed coverage of all aspects of Federal art in Arizona, 1933 to 1943. Hall feels the greatest achievement of the projects in Arizona was the founding of the Phoenix Art

Museum and in raising the art consciousness of Arizonans. Includes an appendix of original documents regarding the arts projects in Arizona; lists as many of the art works created as he could find.

1397 Rogers, Kathleen Grisham. *Incidence of New Deal art in Oklahoma: an historical survey*. MA Thesis, University of Oklahoma, 1974. 115 ll.

Concentrating on the mural projects and the Federal Art Centers in Oklahoma, Rogers gives an overview of the projects in Oklahoma, a description of typical mural themes (cowboys and Indians); an excellent account of the Oklahoma Art Centers which were among the most active in the country. Includes a list of all Oklahoma murals with their condition cited.

1398 Sherwood, Leland Harley. *The Federal sponsored Community Art Centers of Iowa as part of the New Deal*. Ph.D. dissertation, Indiana University, 1974. 212 pp.

Describes the WPA/FAP's Community Art Centers in Iowa, focusing on their educational activities; feels the programs were good and useful. NOT SEEN. CITED IN DAI v. 38/08a, pp. 4581–82.

1399 Spurlock, William H. *Federal support for the visual arts in the state of New Mexico: 1933–1943*. MA Thesis, University of New Mexico, 1974. 115 ll.

NOT SEEN. CITED IN OCLC.

1400 Tritschler, Thomas Candor. *The American Abstract Artists 1937–1941*. Ph.D. dissertation, University of Pennsylvania, 1974. 144 pp. Plates.

Complete history of the American Abstract Artists (AAA) group which included a core group of artists who had worked on the WPA/FAP. Extensive commentary on the relationship of the AAA and the WPA/FAP, particularly through the activities of Burgoyne Diller of the New York WPA/FAP. Good coverage of the WPA/FAP work on the Williamsburg Housing Project murals in New York City.

1975–1979

1975

1401 "WPA: it wasn't all leaf-raking." *Newsweek* 85 (January 20, 1975): 57.

Note on the contributions of the WPA to American life. "The great bulk of WPA money was spent on construction, but many of the agency's most lasting contributions were in the arts."

1402 "What's the best investment?" *Dun's Review* 105 (May 1975): 41–45, 92.

In an article on investments, John Train, an investment counselor, comments: "WPA art, right now, if you know what you're buying, could probably do well. But to buy it, you would have to find it—and that might require tearing down a post office wall in Bangor," p. 92.

1403 Sherman, Randi E. "New Deal sculpture and ceramics in Cleveland, 1933–1943." *American Art Review* 2 (July–August 1975): 107–19.

Account of ceramic and sculpture programs in Cleveland under the PWAP and WPA/FAP. Illustrated with a number of B/W and color photographs of ceramic and sculptural works.

1404 Key, Donald. "Milwaukee's art of the Depression era." *Historic Messenger of the Milwaukee County Historical Society* 31 (Summer 1975): 38–49, cover.

Excellent account of the New Deal art projects in Milwaukee; mentions the Milwaukee Handicrafts Project. Numerous artists mentioned. B/W illustrations of work by Schomer
290

Lichtner, Robert Schellin, Paul Sand, Francis Scott Bradford Jr., and a photograph of Robert Von Neumann.

1405 Dawson, Oliver B. "Ironwork of Timberline." *Oregon Historical Quarterly* 76 (September 1975): 258–68.

Historical account of the ironwork done at the Timberline Lodge (a WPA project done on Mt. Hood, Oregon) by Dawson (who worked on the Lodge). B/W photographs of the ironwork.

1406 Matthews, Jane De Hart. "Art and the people: the New Deal quest for a cultural democracy." *Journal of American History* 62 (September 1975): 316–39.

A description of the struggle in the New Deal art projects between high art and an art that was acceptable to the people; Matthews feels that cultural democracy was only partially realized in the projects.

1407 "Portrait of the artist as a civil servant." *The Economist* 256 (September 20, 1975): 76.

In commenting on the CETA program of job training, the brief article gives an overview of the WPA/FAP and Section. B/W illustration of the WPA/FAP mural for the WPA Building at the New York World's Fair.

1408 Werner, Alfred. "WPA and social realism." *Art and Artists* 10 (October 1975): 24–31.

After a brief history of the projects from a British point of view, Werner comments on the reciprocal relationship of social realism and the projects. B/W illustrations of works by Ben Shahn, Raphael Soyer, Jack Levine, and Louis Lozowick.

1409 Jewett, Masha Zakheim. "The murals in Coit Tower." *California Living* (December 14, 1975, newspaper supplement): 30–34.

Detailed description of each of the twenty-five murals in San Francisco's Coit Tower. Illustrations of each panel and photographs of many of the artists at work.

1410 *Federal Art Patronage Notes* 1 (Winter 1975/Spring 1976): 4 pp. + 14 pp. supplement.

Notes on "WPA/FAP Graphics" (Smithsonian Institution traveling show opening at Timberline Lodge, OR, May 1, 1975); the publication of New Deal Murals in Oklahoma (*See* **1426**); "Accomplishments: Minnesota Art Projects in the Depression Years" at the University of Minnesota; and "New Deal Art: California" at the De Saisset Art Gallery and Museum. Supplement is a report on "Fine Arts and the People" the New Deal Culture Conference held at Glassboro State College (NJ), October 31 to November 2, 1975. Includes a summary of conference proceedings.

MONOGRAPHS

1411 Berman, Greta. *The lost years. Mural painting in New York City under the WPA Federal Art Project, 1935–1943.* Ph.D dissertation, Columbia University, 1975. 427 ll.

An excellent dissertation on the WPA/FAP mural projects in New York City. Covers technical, aesthetic, and political areas of the murals' creation. Berman concludes that the WPA/FAP work in New York laid the groundwork for the emergence of the Abstract Expressionists and the leadership of New York in the postwar art world. NOTE: Printed by Garland Publishers in 1978 as part of their "Outstanding dissertations in the fine arts" series.

1412 Forest Service. *Timberline Lodge.* Department of Agriculture: Washington, DC, 1974. 52 pp., 19 ll. of plates.

NOT SEEN. CITE IN OCLC.

1413 Harrison, Helen Amy. *Social consciousness in New Deal murals.* MA Thesis, Case Western Reserve University, 1975. 344 pp.

NOT SEEN. CITED IN OCLC.

1976

1414 O'Connor, Francis V. "Economy of patronage: Arshile Gorky on the art projects." *Arts* 50 (March 1976): 94–95.

Excellent account of Arshile Gorky's work on the arts project, summer 1937 to July 2, 1941. Gorky was assigned to the mural division, but spent nearly all his time on easel painting. Lists his total salary on projects: $7,356.15. Illustrated with B/W photographs of Gorky at work.

1415 "When art was fun and fabulous." *City of San Francisco* 10 (February 4, 1976): entire issue.

Special issue of City of San Francisco dedicated to the New Deal projects.
Hinckle, Warren. "Art for the Millions: A Pictorial Survey," pp. 16–19. Introduction to the special issue plus numerous photographs of various works.
"The WPA and the Great Coit Tower Controversy: The Artists look Back," pp. 20–23. Reminiscences by artists involved with the Coit Tower project.
Gelber, Steven M. "The Irony of San Francisco's 'Commie Art': an Artistic and Political Appraisal," pp. 24–41. Excellent account of the Communist controversy surrounding the Coit Tower project and other Bay Area WPA/FAP projects.
O'Hanlon, Richard. "Benny Bufano's Boffo WPA Years," pp. 42–43. Illustration of works by, and brief biography of, Beniamino Bufano.
"Guide to Bay Area WPA Art," p. 44. List of WPA art in the Bay Area.
Hinckle, Warren. "Editorial: Renaissance in the Mission," p. 45. A comparison of WPA/FAP murals and present-day murals done in San Francisco's Mission District.

1416 "Interview: Burgoyne Diller talks with Harlan Phillips." *Archives of American Art Journal* 16.2 (1976): 14–21.

Burgoyne Diller, Head of the Mural Division in NYC (1935–1942) and champion of abstract artists, discusses his association with the WPA/FAP; B/W photographs. Reprinted in Archives of American Art Journal 30.1–4 (1990): 27–34.

1417 Monroe, Gerald M. "Mural burning by the New York City WPA." *Archives of American Art Journal* 16.3 (1976): 8–11.

Good account of the Red scare issue in the WPA/FAP projects; discussion of the role of Brehon Burke Somervell, NYC administrator of the WPA and firm hater of Communists; B/W illustration of the Floyd Bennett Field mural by August Henkel.

1418 Berman, Greta. "Does 'Flight' have a future?" *Art in America* 64 (September–October 1976): 97–99.

Discusses James Brooks' mural "Flight" at the La Guardia Marine Air Terminal (completed 1942) painted over in 1955. Includes a biography of Brooks, a history of the mural and an analysis of the work. B/W photographs of the mural and Brooks at work.

EXHIBITIONS

1419 International Exhibitions Foundation. *American textiles lent by the National Gallery of Art from the Index of American Design.* International Exhibitions Foundation, 1976. 4 pp.

Exhibition, 1976. Fifty works shown. NOT SEEN.

1420 De Saisset Art Gallery and Museum. *New Deal art, California.* De Saisset Art Gallery and Museum, University of California: Santa Clara, CA, 1975. 172 pp.

Exhibition, January 17 through June 15, 1976. Excellent introduction to New Deal art in California. Checklist of 288 works from all aspects of federal art patronage. Introduction by Francis V. O'Connor; essay, "The New Deal and Public Art in California" by Steven M. Gelber. Appendices include a list

of videotape projects (artists' interviews, visits to sites) done
for exhibition research, list of sites photographed for exhibi-
tion research, and list of murals created in California with
full information (location, condition, etc.). Numerous B/W
illustrations.

1421 Vassar College Art Gallery. *Seven American Women: the
Depression decade.* Vassar College Art Gallery: Poughkeepsie,
NY, 1976. 40 pp.

Exhibition, January 19 through March 5, 1976. The seven
women are: Rosalind Bengelsdorf Browne, Lucienne Bloch,
Minna Citron, Marion Greenwood, Doris Lee, Elizabeth
Olds, and Concetta Scaravaglione. Catalog of seventy-seven
works from all media. Organized by Helen A. Harrison; essay
by Karal Ann Marling. Numerous B/W illustrations of works.

1422 New Muse Community Museum of Brooklyn. *The
Black artists in the WPA 1933–1943.* New Muse Community
Museum of Brooklyn: Brooklyn, NY, 1976. 18 pp.

Exhibition, February 15 through March 30, 1976. Exhibition
consisted of thirty-two works by fifteen artists. Curated by
Charlene Claye Van Derzee and George Carter. Catalog of
the thirty-two works plus selected B/W illustrations. Brief
introduction.

1422a Tweed Museum of Art, University of Minnesota.
*Accomplishments: Minnesota art projects in the Depression
years: essay and catalog.* Tweed Museum of Art: Duluth, 1976.
39 ll.

Exhibition, April 28 through May 30, 1976. Catalog of 88
works. Includes brief biographies of each of the 29 artists
represented. Excellent essay by Nancy A. Johnson on the
New Deal art projects in Minnesota.

1423 Smithsonian Institution Traveling Exhibition Service.
WPA/FAP graphics. SITES: Washington, DC, 1976. 23 pp.

Exhibition organized by SITES to travel throughout the
country during May 1976–1977. Consisted of 72 works plus a

process portfolio of twenty-nine prints. Introduction by Francis V. O'Connor. B/W illustrations.

1424 Smithsonian Institution Traveling Exhibition Service. *WPA/FAP Graphics handbook.* SITES: Washington, DC, 1976. 47 pp.

Education handbook to accompany above exhibition. Text by Kathy L. Bell and Regina L. Lipsky. Includes suggestions on how to display the exhibition, public programs to stage, etc.

1425 Allan Frumkin Gallery. *Berenice Abbott photographs: Changing New York.* Allan Frumkin Gallery: Chicago, 1976. Pamphlet.

Exhibition, October 8 through November 6, 1976.

MONOGRAPHS

1426 Calcagno, Nicholas A. *New Deal murals in Oklahoma. A bicentennial project.* Pioneer Print: Miami, OK, 1976. 52 pp.

List of known New Deal murals in Oklahoma; brief biographies of the artists and notes on the works. B/W and color illustrations of some of the murals.

1427 Meltzer, Milton. *Violins and shovels: the WPA arts projects.* Delacorte Press: New York, 1976. 160 pp.

A pleasant-to-read, anecdotal narrative of the projects of Federal One. B/W photographs and illustrations of works by Raphael Soyer, Lucienne Bloch, Symeon Shimin, Louis O. Guglielmi, Karl Knaths, Robert Cronbach, Concetta Scaravaglione, and Will Barnet.

1428 O'Neal, Hank, et al. *A vision shared, a classic portrait of America and its people.* St. Martin's Press: New York, 1976. 309 pp.

Primarily illustrated with photographs by FSA workers, there is a section on Ben Shahn's photographs of artists at work. Additional text by Bernarda Bryson Shahn.

1429 Rowin, Fran. *Federally sponsored murals in Florida post offices during the Depression.* MA thesis, University of Miami, 1976. 166 pp.

Detailed account of the mural work done in Florida post offices done under the Section. Fourteen locations identified; works of Denman Fink, Edward Buk Ulreich, Charles Rosen, George Snow Hill, Lucille Blanch, Charles Herdman, Elizabeth Terrell, Charles Knight, Pietro Lazzari, Thomas Laughlin, and Stevan Dohanos illustrated (B/W).

1430 Truman, Priscilla. *WPA murals.* MA Thesis, University of California, Riverside, 1976.

NOT SEEN.

1430a Solman, Joseph. "Review of *New Deal for Art: The Government art projects of the 1930s with examples from New York City and State.*" *Print Review* 7 (1977): 92–93.

Favorable review of Park and Markowitz's book (*See* **1569**); B/W illustration of a Harry Gottlieb work.

1977

1431 "Extensions downtown." *New Yorker* 53 (February 28, 1977): 24–25.

At the "W.P.A," a restaurant in SoHo, Harry Gottlieb, David Margolis, Augustus Goertz, and Sarah Berman Beach gather to discuss their work for the New Deal art projects.

1432 "Preservation notice." *Federal Art Patronage Notes* 2 (March 1977): 4.

A request for readers to ask that preservation action be taken on Ben Shahn's mural in the Bronx Post Office; two small B/W photographs showing its poor condition (*See* **1435**).

1433 "30's arts projects on German TV." *Federal One* 2 (April 1977): 4.

Note on the production of four one-hour documentaries (Bread and roses: a New Deal for the arts, 1935–1943) on the Federal Project One (one for each project) made for German TV.

1434 "Un protagonista del New Deal: Rexford G. Tugwell (1891–1979)." *Casabella* 45 (April 1977): 44–47.

NOT SEEN.

1435 "Preservation note." *Federal Art Patronage Notes* 2 (May 1977): 1, 4.

Note that the Ben Shahn mural in the Bronx Post Office will be repaired (*See also* **1432**).

1436 Marling, Karal Ann. "New Deal ceramics: the Cleveland workshops." *Ceramic Monthly* 25 (June 1977): 25–31.

Good account of one of the lesser-known aspects of the WPA/FAP, the ceramics program. Illustrations of a number of the finished works by the following artists: Alexander Blazys, George Vander Sluis, Henry Olmer, Le Roy Flint, Emily Scrivens, Henry Keto, Edris Eckhardt, Frank Gentot, Woodhull Homer, John Tenkacs, and Louis Regalbisto.

1437 Berman, Greta. "Walls of Harlem." *Arts* 52 (October 1977): 122–26.

Account of six African-American artists (Charles Alston, Vertis Hayes, Georgette Seabrooke, Sara Murrell, Selma Day, and Elba Lightfoot) who worked on murals at the Harlem Hospital in 1936. Berman explains the controversy over the works (murals included "too much Negro subject matter" according to hospital administrators); a critique of the works; general information on Blacks on the art projects; and a plea to save the murals.

1438 Griffin, Rachel. "New peak at Timberline." *Craft Horizons* 37 (October 1977): 14–17.

Timberline Lodge in Oregon was decorated by WPA/FAP artists in the 1930s; Griffin explains why and discusses

restoration efforts; comments on recent exhibition of contemporary crafts to help fund the restoration. B/W illustrations and photographs of the lodge and its decorations (the works of Virginia Darcé, Florence Thomas, and O.B. Dawson shown).

1439 "Federal art plan to provide funds for needy artists." *Art News* 76 (November 1977): 156.

Reprint of Art News article from December 16, 1933 (*See* **0010**).

1440 Berman, Greta. "Review of The New Deal for Artists, by Richard D. McKinzie." *Art Bulletin* 59 (December 1977): 653–54.

Mixed review of McKinzie's important book (*See* **1377**); Berman finds no fault with his history, but feels he lacks the critical art historical skills to write about the actual work created under the projects.

EXHIBITIONS

1441 Vassar College Art Gallery. *Woodstock: an American art colony 1902–1977.* Vassar College Art Gallery: Poughkeepsie, 1977. ca.200 pp.

Exhibition, January 23 through March 4, 1977. Catalog of seventy-seven object and art works. Text by Karal Ann Marling discusses briefly the relationship between the Woodstock colony and the New Deal art projects, particularly the PWAP. B/W illustrations.

1442 Park, Marlene S. and Gerald E. Markowitz. *New Deal for art; the Government art projects of the 1930's with examples from New York City and State.* Gallery Association of New York State: Hamilton, NY, 1977. 172 pp.

Exhibition, January 25 through February 13, 1977 (Tyler Art Gallery, SUNY College of Arts and Sciences). Catalog of a traveling exhibition (seven other sites) of 147 works and artifacts from the arts projects; many B/W illustrations; essay

covers the history of the various projects, particularly in New York.

1443 Park, Marlene S. and Gerald E. Markowitz. *New Deal for art; the Government art projects of the 1930's with examples from New York City and State.* Gallery Association of New York State: Hamilton, NY, 1977. 16 pp.

Separately published checklist to accompany above exhibition; B/W illustrations, other text.

1444 The Studio Museum in Harlem. *New York/Chicago: WPA and the Black artist.* Studio Museum in Harlem: New York, 1978. 24 pp.

Exhibition, November 13, 1977, through January 8, 1977. Checklist of sixty-one works from all media. Essay on the nature of the work of African-American artists from New York and Chicago WPA/FAP projects by Ruth Ann Stewart. B/W illustrations of sixteen works.

1445 De Cordova Museum and Park. *By the people, for the people: New England.* De Cordova Museum: Lincoln, MA, 1977. 91 pp.

Exhibition, September 25 through November 27, 1977. Detailed catalog of 117 works with brief biographies of the artists. Includes a memoir by Charles H. Sawyer of his involvement as WPA/FAP administrator in New England.

1446 Joe and Emily Lowe Gallery. *The mural art of Ben Shahn: original cartoons, drawings, prints and dated paintings.* Joe and Emily Lowe Gallery: Syracuse, 1977. 24 pp.

Exhibition, September 28 through October 20, 1977. Checklist of fifty-four works (twenty-seven original works, twenty-five photographs of murals, and two slides of murals) covering the mural work of Ben Shahn. Includes a chronological list of the murals of Shahn (five of which were PWAP/Section productions). Numerous B/W illustrations.

1447 Parsons School of Design. *New York City WPA art: then 1934–1943 and . . . now 1960–1977.* NYC WPA Artists: New York, 1977. 101 pp.

Exhibition, November 8 through December 10, 1977, 65 artists (130 works) one from their WPA period and one more recent work; four essays by Norman Barr, Audrey McMahon, Emily Genauer, and Greta Berman. Checklist of exhibition also published separately in pamphlet form.

1448 New York Public Library. *WPA prints.* NYPL: New York, 1977. 7 ll. Reproduced from typescript.

Exhibition, November 18, 1977, through February 28, 1978. Typed checklist of seventy-two WPA/FAP prints from NYPL collections.

MONOGRAPHS

1449 Blumberg, Barbara. "Unemployed artists and the WPA," in *The New Deal and the unemployed. The view from New York City,* pp. 183ff. Lewisburg: Bucknell University Press; London: Associated University Press, 1977.

Chapter 8 covers all aspects of the art projects; calls the art projects "most daring and humanizing segments of the New Deal employment relief effort." B/W photographs of artists at work.

1450 Pound, Beverly Anne. *The Federal Art Project mural paintings of San Francisco.* M. A. Thesis, Lone Mountain College, 1977. 92 ll.

NOT SEEN. CITED IN OCLC.

1451 Retson, Nancy. *The Federal Art Project in Wisconsin 1936–1939.* MA Thesis, University of Wisconsin, 1977. 77 ll.

NOT SEEN. CITED IN OCLC.

1452 Weir, Jean Burwell. *Timberline Lodge: a WPA experiment in architecture and crafts.* Ph.D. dissertation, University of Michigan, 1977. 841 ll.

Full account of Timberline Lodge, Mt. Hood, OR. NOT
SEEN. CITED IN DAI v. 38/11a, p. 6363.

1978

1453 "Preservation notice #2." *Federal Art Patronage Notes* 3
(Spring/Summer 1978): supplement.

Request for readers to protest the proposed removal of
Anton Refregier's Rincon Annex Section murals.

1454 Dennis, James M. "The mural projects of Grant
Wood." *The Iowan* 26 (Summer 1978): 22–27.

Good account of the production of Grant Wood's PWAP
murals for the Iowa State Library (Ames). Numerous illustra-
tions of the murals.

1455 Freidman, Jeannie. "WPA poster project: when gov-
ernment sponsors art." *Print* 32 (July–August 1978): 68–73.

Good analysis of the poster division of the WPA/FAP from a
graphic artist's point of view. Numerous B/W and color
reproductions of posters.

1456 Monroe, Gerald M. "Artists on the barricades: the
militant artists union treats with the New Deal." *Archives of
American Art Journal* 18.3 (1978): 20–23.

Coverage of the Artists' Union protests for the continuation
and expansion of the WPA/FAP. B/W photographs.

EXHIBITIONS

1457 Wichita Art Museum. *New Deal art in Kansas.* Wichita
Art Museum: Wichita, KS, 1978. 13 pp.

Exhibition, April 4 through May 21, 1978. Catalog of fifty-five
items from all the New Deal art projects. Exhibit co-
sponsored by the Office of Museum Programs, Curriculum
Services Division, Wichita Public Schools. B/W illustrations

of work by Margaret Whittmore, William J. Dickerson, Ted Hawkins, and Mary Huntoon.

1458 Emily Lowe Gallery. Hofstra University. *Art for the people—New Deal murals on Long Island.* Emily Lowe Gallery, Hofstra University: New York, 1978. 60 pp.

Exhibition, November 1 through December 31, 1978. Catalog of thirty-seven (illustrated) works on exhibit plus a list of murals still extant on Long Island. Includes essays by the following: Gerald Markowitz ("A Case Study in Conservation: Max Spivak's Murals of Puppets and Circus Characters in the Children's Room of the Astoria Branch of the Queensborough Public Library"); Marlene Park ("The Preservation of Public Art: Problems and Proposals"); Greta Berman ("A Study of Four Murals"); David Shapiro ("New Deal Murals and the Tradition"); a reprint of Francis V. O'Connor's essay from Federal Support for the Visual Arts (*See* **1335**); and Helen Harrison ("Toward a 'Fit Plastic Language': Six muralists of the New York World's Fair").

1459 NO ENTRY

1460 Newark Museum. *Murals without walls; Arshile Gorky's aviation murals rediscovered.* Newark Museum: Newark, NJ, 1978. 96 pp.

Exhibition, November 15, 1978, through March 11, 1979. Exhibition of sketches, photographs and restoration material from Arshile Gorky's murals for the Newark Airport. Includes the following essays: Arshile Gorky ("My Murals for the Newark Airport: an Interpretation"); Francis V. O'Connor ("A Note on the Texts of Gorky's Essay"); Francis V. O'Connor ("Arshile Gorky's Newark Airport Murals; the History of their Making"); Frederick T. Kiesler ("Murals Without Walls: Relating to Gorky's Newark Project" reprint of Art Front article, *See* **0315**); Ruth Bowman ("Arshile Gorky's 'Aviation' Murals Rediscovered"); and Jim M. Jordan ("The Place of the Newark Murals in Gorky's Art").

MONOGRAPHS

1461 Griffin, Rachel and Sarah Munro. *Timberline Lodge.* Friends of Timberline: Portland, OR, 1978. 89 pp.

Excellent picture book account of Timberline Lodge, Mt. Hood, OR. Essays on the history and architecture of the lodge by Sarah Munro; on the arts and furnishings by Jean Weir; and on the lodge's restoration by Rachel Griffin. Illustrated with a number of B/W photographs of the lodge. Includes a complete inventory of the original and restored furnishings as well as biographical sketches of the artisans.

1462 Sahadi, Natasha. *Works Progress Administration/Federal Art Project, Federal Project One. Art Education projects and programs.* MA Thesis, University of Toledo, 1978. 13 ll.

NOT SEEN. CITED IN OCLC.

1463 Shealy, Oscar. *Defining the role of the Federal government in the support of art.* MA Thesis, San Diego State University, 1978.

NOT SEEN. CITED IN OCLC.

1979

1464 Marling, Karal Ann. "A note on New Deal iconography: futurology and the historical myth." *Prospects* 4 (1979): 420–40.

Marling applies Erwin Panofsky's iconographical theories to the study of New Deal art; she feels Social Realism to be an imprecise form and that the New Deal murals were the best expression of New Deal art. Numerous B/W illustrations of works and photographs of the artists. NOTE: Also reprinted in the *4th Annual of American Cultural Studies* (Burt Franklin and Company: New York, 1979).

1465 Chadwyck-Healey, Charles. "The reproduction of visual material on microform: our first five years and the future." *Microform Review* 8 (Summer 1979): 180–82.

Chadwyck-Healey discusses a number of microforming projects his company has been involved with, including the soon-to-be-published Index of American Design project.

1466 Gelber, Steven M. "Working to prosperity: California's New Deal murals." *California History* 58 (Summer 1979): 98–127.

An excellent overview of the New Deal art projects in California, including critical and public response. Gelber covers the major controversies (the Rincon Annex murals, the Coit Tower murals, and Leo Katz's mural for the Frank Wiggin's Trade School in Los Angeles). Numerous B/W photographs and illustrations of works.

1467 "New Deal art projects: selected bibliography." *Federal Art Patronage Notes* 3 (Summer 1979): 1–3.

41-item selected bibliography with brief annotations.

1468 Gurney, George. "Sculpture and the Federal Triangle." *National Sculpture Review* 28 (Fall 1979): 18–23, 28.

Discussion of NCFA exhibition of the same title (October 26, 1979–January 6, 1980); Gurney explains how the exhibition came about and discusses his research methodology. B/W illustrations.

1469 Park, Marlene. "City and country in the 1930's: a study of New Deal murals in New York." *Art Journal* 39 (Fall 1979): 37–47.

Park compares and contrasts the mural work done by the WPA/FAP and Section in New York City and New York State on grounds of themes, style, and execution. B/W illustrations of murals.

1470 Berman, Greta. "Murals under wraps." *Arts* 54 (September 1979): 168–71.

Essay on the significance of murals to the pluralism of the 1930s; includes a defence of the "WPA style"; decries the destruction and/or degeneration of murals; deals specifically with certain painted over murals. Illustrated with B/W photographs of murals.

1471 Taylor, Joshua C. "A poignant, relevant backward look at the artists of the Great Depression." *Smithsonian* 10 (October 1979): 44–53.

Excellent article on the social, economic, and artistic forces that created the projects; covers all aspects of federal patronage of the visual arts and comments on the three exhibitions at the Smithsonian Institution on New Deal art (*See* **1460,** **1475,** and **1476**); profusely illustrated with color reproductions of works.

1472 Jackson, David. "Black artists and the WPA." *Encore* 8 (November 19, 1979): 22–23.

Good, popular account of the African-American experience in the WPA/FAP. B/W and color illustrations of works by Eldzier Cortor and Jacob Lawrence.

1473 Paul, April J. "Byron Browne in the thirties: the battle for abstract art." *Archives of American Art Journal* 19.4 (1979): 9–24.

Good account of the work of Byron Browne's work for the WPA/FAP. Paul also covers struggles of abstract artists in the New Deal projects for acceptance. Drawn from her MA thesis, *Byron Browne: A Study of His Art and Life to 1940.*

EXHIBITIONS

1474 Mecklenburg, Virginia M. *The public as patron. A history of the Treasury Department mural program illustrated with paint-*

ings from the collection of the University of Maryland art gallery. University of Maryland: College Park, MD, 1979. 118 pp.

Exhibition, 1979. Overview of the projects; exhibit includes finished murals and sketches from Section commissions; checklist of 120 works plus brief biographies of the artists and comments on the works.

1475 National Collection of Fine Arts. Smithsonian Institution. *Prints for the people. Selections from New Deal graphics projects.* NCFA: Washington, DC, 1979. 6 pp.

Exhibition, September 14 through December 2, 1979. Checklist of sixty-seven works. Text by Janet A. Flint. B/W illustrations.

1476 National Collection of Fine Arts. Smithsonian Institution. *After the Crash.* NCFA: Washington, DC, 1979. 5 pp.

Exhibition, October 24, 1979, through January 13, 1980. Checklist of thirty-four works from all media. Text by Sara Hutchinson. B/W illustration of work by James N. Rosenberg.

1477 National Collection of Fine Arts. *Sculpture and the Federal Triangle.* NCFA: Washington, DC, 1979. 21 l.

Exhibition, October 26, 1979, through January 6, 1980. "A walking tour of the Federal Triangle"; covers Section work in the Federal Triangle. To accompany an exhibition at the NCFA. Text by George Gurney.

MONOGRAPHS

1478 Blumberg, Barbara. *The New Deal and the unemployed. The view from New York City.* Bucknell University Press: Lewisburg, 1979. 332 pp.

Chapter 8, "Unemployed Artists and the WPA," covers all aspects of the arts projects; Blumberg calls the arts projects the "most daring and humanizing segments of the New Deal employment relief efforts." B/W photographs of artists at work.

1479 Bruner, Ronald Irvin. *New Deal art works in Colorado, Kansas and Nebraska.* MFA Thesis, University of Denver, 1979. 108 ll.

NOT SEEN. CITED IN MAI 18/03, p. 170.

1480 Tolbert, Bernice. *A critical study of Black artists who participated in the WPA program.* MA Thesis, Case Western Reserve University, 1979.

NOT SEEN. CITED IN OCLC.

1481 Wyman, Marilyn. *An annotated research bibliography on the Federal Arts Projects, 1934–1943.* MA Thesis, University of Southern California, 1979. 124 ll.

Brief overview of the New Deal art projects followed by an annotated bibliography (arranged alphabetically). Exhibition catalogs and government documents not annotated; no index.

1980–1985

1980

1482 Harrison, Helen. "John Reed Club artists and the New Deal: radical responses to Roosevelt's 'peaceful revolution.'" *Prospects* 5 (1980): 241–68.

Examines the role of New Deal artists in John Reed Clubs and the Communist Party. B/W illustrations of works by Bernarda Bryson Shahn, Louis Lozowick, Paul Meltsner, William Gropper, Anton Refregier, Ben Shahn, Hugo Gellert, and Jacob Burck.

1483 Sundell, Michael G. "Berenice Abbott's work in the 1930's." *Prospects* 5 (1980): 269–92.

Good coverage of Berenice Abbott's photographic work for the WPA/FAP. Illustrated with 60 B/W examples of her work.

1484 Tonelli, Edith A. "The avante-garde in Boston: the experiments of the WPA Federal art project." *Archives of American Art Journal* 20:1 (1980): 18–24.

Excellent account of how Boston's conservatism in the art field made it a fruitful area for WPA/FAP experimentalism as previously underrepresented artists were given a forum for their work; many B/W photographs and illustrations. NOTE: This article was reprinted in *Archives of American Art Journal* 30:1–4 (1990): 41–47.

1484a Jones, Dan Burne. "The murals of Rockwell Kent." *The Kent Collector* 7 (Summer 1980): 3–16.

Full discussion of the Section murals of Rockwell Kent. Includes an account of his controversial mural for the US

Post Office Department. Reprints *New Masses* article of November 16, 1937 (*See* **0500**). B/W and color illustrations of murals.

1485 Bush, Donald. "New Deal—Southwest: Phoenix Art Museum." *Artweek* 11 (June 21, 1980): 3.

Favorable review of the catalog and exhibition, "The New Deal in the Southwest; Arizona and New Mexico," May 24 through July 13, 1980.

1486 York, Hildreth. "The New Deal art projects in New Jersey." *New Jersey History* 98 (Fall–Winter 1980): 133–74.

Excellent account of the New Deal art projects in New Jersey (tied in to Rutgers show, *See* **1549**). Includes a list of resident New Jersey artists who worked on the projects; list of New Deal murals, reliefs, and public sculpture in New Jersey. B/W illustrations of work by Louis Lozowick, Gerald Foster, Tanner Clark, Arshile Gorky, Alex Monastersky, Michael Lenson, and Waylande Gregory.

1487 Dieterich, Herbert R. "The New Deal culture projects in Wyoming: a survey and appraisal." *Annals of Wyoming* 52 (Fall 1980): 30–44.

Covers the two Federal One projects active in Wyoming (FAP and FWP); Dieterich feels the WPA/FAP created a base of art appreciation in Wyoming. Surveys the other art projects' activities and finds that there was only minimal PWAP work in Wyoming, no TRAP work, but a substantial amount of WPA/FAP and Section activity. B/W illustrations of work by Ernest E. Stevens, Lynn Fausett, and Virginia Pitman.

EXHIBITIONS

1488 Bermingham, Peter. *The New Deal in the Southwest, Arizona and New Mexico.* University of Arizona: Tucson, 1980. 67 pp.

Exhibition, January 18 through February 15, 1980, at the University of Arizona Museum of Art. Checklist of seventy-

nine works. Good account of New Deal projects in Arizona and New Mexico. Numerous B/W illustrations and photographs. Show traveled to Northern Arizona University Art Gallery, Flagstaff March 27 through April 28; and Phoenix Art Museum May 24 through July 13.

1489 Leigh Yawkey Woodson Art Museum. *Wisconsin's New Deal art.* The Leigh Yawkey Woodson Art Museum: Wausa, WI, 1980. 32 pp.

Exhibition, January 19 through February 24, 1980, representing fifty-four Wisconsin New Deal artists from all projects; checklist of works, many B/W and color reproductions. Brief essays by Karel Yasko and Mary Michie, covers the contribution of Wisconsin State WPA/FAP director, Charlotte Partridge.

1490 Robeson Gallery. *New Deal art, New Jersey. Robeson Gallery Center, Rutgers in Newark and City without Walls Gallery, Newark, March 26–April 20, 1980, New Jersey State Museum, Trenton, May 3–July 20, 1980.* Newark Museum: Newark, NJ, 1980. 76 pp.

Exhibition, March 26 through April 20, 1980, at the Robeson Center Gallery and City without Walls Gallery, Newark, NJ. Checklist of ninety-two works in the exhibition, a number illustrated in B/W. Text by Hildreth York. Includes a list of completed New Jersey murals. Show traveled to the New Jersey State Museum, Trenton, May 3 through July 20, 1980.

1491 University of Illinois at Urbana-Champaign. *Remembering the thirties: public work programs in Illinois, a traveling exhibition.* University of Illinois at Urbana-Champaign: Urbana, 1980. 19 pp.

Exhibition, Fall 1980 through Spring 1981. Traveling exhibition organized by the Department of Urban and Regional Planning at the University of Illinois at Urbana-Champaign. Covers all aspects of relief projects in Illinois; pp. 12–17 cover the art projects, TRAP, and Section. B/W illustrations of works by Mitchell Siporin, Charles White, Charles Umlauf, Freeman Schoolcraft, and Edgar Britton.

1492 Chrysler Museum. *Portrait of New York: Berenice Abbott.* Chrysler Museum: Norfolk, 1980. Pamphlet.

Exhibition, October 17, 1980, through January 1, 1981. Checklist of forty-three photographs from Abbott's WPA/FAP years. Six B/W photographs.

1493 Neue Gesellschaft für Bildende Kunst. *Amerika: Traum und Depression, 1920/1940.* Neue Gesellschaft für Bildende Kunst: Berlin, 1980. 544 pp.

Exhibition, November 9 through December 28, 1980, at the Akademie der Künst (Berlin). Checklist of 1080 objects (paintings, prints, photographs—hundreds of the objects are FSA photographs, objects such as FWP books, etc.). Of the number of essays in the catalog on American life and culture during the Depression, three deal most directly with the New Deal art projects: Joshua C. Taylor's "Kunst und úffentlichkeit in Amerika," pp. 12–20; Thomas Ferguson's "Von Versailles zum New Deal. Der Triumph des multinationalen Liberalismus in Amerika," pp. 436–51; and Francis V. O'Connor's "Entwicklungsgeschichte der Projecte zur bildenden Kunst im New Deal 1933–1943," pp. 452–63. Numerous B/W photographs and illustrations. Show traveled to the Kunstverein (Hamburg) January 11 through February 15, 1981.

MONOGRAPHS

1494 Howe, Carolyn. *The production of culture on the Oregon Federal Arts Project of the Works Progress Administration.* MA Thesis, Portland State University, 1980. 210 pp.

NOT SEEN. CITED IN *MAI* 19/03, p. 276.

1494a *The people and the land: the California post office murals.* Merrillville, GA: Interphase Two Productions, 1980. 13 ll. 50 slides. 1 cassette tape.

Audiovisual package describing California Post Office mural projects.

1495 Tinkham, Sandra Shaffer, ed. *The Consolidated catalog to the Index of American Design.* Somerset House: Teaneck, NJ; Chadwyck-Healey: Cambridge, 1980. 800 pp.

Full, detailed index to the microfiche edition of the IAD. Indexed by date of manufacture; name of maker; place of origin of original work; date of rendering; the artist who did the rendering; and the IAD accession number. See the following ten entries for details of the microfiche collection.

1496 Index of American Design. *Catalog of textiles, costume, and jewelry in the Index of American Design.* Chadwyck-Healey: Cambridge; Somerset House: Teaneck, NJ, 1980. 122 pp.

Part 1 of microfiche edition of the IAD.

1497 Index of American Design. *Catalog of the art and design of utopian and religious communities in the Index of American Design.* Chadwyck-Healey: Cambridge; Somerset House: Teaneck, NJ, 1980. 80 pp.

Part 2 of microfiche edition of the IAD.

1498 Index of American Design. *Catalog of architecture and naive art in the Index of American Design.* Chadwyck-Healey: Cambridge; Somerset House: Teaneck, NJ, 1980.

Part 3 of microfiche edition of the IAD.

1499 Index of American Design. *Catalog of tools, hardware, firearms, and vehicles in the Index of American Design.* Chadwyck-Healey: Cambridge; Somerset House: Teaneck, NJ, 1980.

Part 4 of microfiche edition of the IAD.

1500 Index of American Design. *Catalog of domestic utensils in the Index of American Design.* Chadwyck-Healey: Cambridge; Somerset House: Teaneck, NJ, 1980.

Part 5 of microfiche edition of the IAD.

1501 Index of American Design. *Catalog of furniture and decorative accessories in the Index of American Design.* Chadwyck-

Healey: Cambridge; Somerset House: Teaneck, NJ, 1980. 76 pp.

Part 6 of microfiche edition of the IAD.

1502 Index of American Design. *Catalog of wood carvings and weathervanes in the Index of American Design.* Chadwyck-Healey: Cambridge; Somerset House: Teaneck, NJ, 1980.

Part 7 of microfiche edition of the IAD.

1503 Index of American Design. *Catalog of ceramics and glass in the Index of American Design.* Chadwyck-Healey: Cambridge; Somerset House: Teaneck, NJ, 1980. 100 pp.

Part 8 of microfiche edition of the IAD.

1504 Index of American Design. *Catalog of silver, copper, pewter, and toleware in the Index of American Design.* Chadwyck-Healey: Cambridge; Somerset House: Teaneck, NJ, 1980. 32 pp.

Part 9 of microfiche edition of the IAD.

1505 Index of American Design. *Catalog of toys and musical instruments in the Index of American Design.* Chadwyck-Healey: Cambridge; Somerset House: Teaneck, NJ, 1980. 44 pp.

Part 10 of microfiche edition of the IAD.

1506 Lawson, Richard A. and George J. Mavigliano. *Fred E. Meyers, wood-carver.* Southern Illinois University Press: Carbondale, 1980. 151 pp.

Fred E. Meyers (1910–1950), a wood-carver, worked for the WPA/FAP from 1939–1942. Good account of his career; includes a catalogue raisonée of his work. Numerous B/W photographs of the carvings.

1507 Melville, Annette, compiler. *Special collections in the Library of Congress.* Library of Congress: Washington, DC, 1980. 464 pp.

"Work Projects Administration Poster Collection" section describes the collection of 250 WPA/FAP posters in the

collection of the Library of Congress; and mentions the large collection of WPA/FAP prints in the Library of Congress's Prints and Photographs collection.

1981

1508 Bystryn, Marcia N. "Variation in artistic circles." *Sociological Quarterly* 22 (Winter 1981): 120–32.

Bystryn analyzes the interaction of three artistic circles active in the 1930s: the American Artists' Congress, the American Abstract Artists, and the Surrealists. Examines how they grew out of interaction of a number of artists while they were in the WPA/FAP. Stuart Davis and Arshile Gorky are discussed. An interesting article examining the effects of the WPA/FAP on the sociological interaction of artists in the 1930s.

1509 Chadwyck-Healey, Charles. "America: culture and society: defining and describing a visual archive." *Microform Review* 10 (Summer 1981): 159–61.

Text of Charles Chadwyck-Healey's talk at the ARLIS/NA conference on February 25, 1981, describing the fiche edition of the IAD and three other microform projects of Chadwyck-Healey.

1510 Harrison, Helen A. "Subway art and the Public Use of Arts Committee." *Archives of American Art Journal* 21:2 (1981): 3–12.

Interesting article on the Public Use of Art Committee in New York City and its efforts to have the WPA/FAP create art for the New York City subway (very little was ever done); B/W illustration of work by Anton Refregier. NOTE: This article was reprinted in *Archives of American Art Journal* 30:1–4 (1990): 61–70.

1511 Miller, Lillian B. "Review of *Index of American Design* microfiche." *Microform Review* 10 (Summer 1981): 192–93.

Favorable review of the microfiche edition of the IAD (*See* **1495ff**); Miller finds the fiche well done and useful.

1511a Whitney Museum of American Art. *American art of the 1930s.* Whitney Museum of American Art: New York, 1981. 29 pp.

Exhibition, 1981–1983. Essay by Patterson Sims. Checklist of eighty-two works. Catalog to accompany a traveling exhibition organized by the Whitney Museum of American Art of works from its collection. Numerous B/W illustrations. Traveled to ten sites around the country: Cedar Rapids Art Center (October 4 through November 29, 1981); Ackland Art Museum, The University of North Carolina at Chapel Hill (December 16, 1981 through February 7, 1982); The Art Gallery, The University of Maryland at College Park (February 24 through April 18, 1982); San Antonio Museum of Art (May 5 through June 27, 1982); Phoenix Art Museum (July 14 through September 5, 1982); Minnesota Museum of Art, St. Paul (September 22 through November 14, 1982); Columbus Museum of Art (December 4, 1982 through January 15, 1983); The Boise Gallery of Art (February 17 through April 3, 1983); Edwin A. Ulrich Museum of Art, Wichita State University (April 20 through June 12, 1983); and the Whitney Museum of Art, Fairfield County, CT (July 8 through August 31, 1983).

EXHIBITIONS

1512 Baltimore Museum of Art. *WPA prints from the 1930's.* Baltimore Museum of Art: Baltimore, 1981. 6 pp.

Exhibition, 1981. Thirty-one works shown. Text by Jay M. Fisher. NOT SEEN. CITED IN RILA.

1513 National Museum of American Art. Smithsonian Institution. *Perkins Harnly: from the Index of American Design.* NMAA: Washington, DC, 1981. 15 pp.

Exhibition, October 16, 1981, through February 15, 1982 at the NMAA. Checklist of twenty-nine IAD plates (most illustrated in B/W) done by Perkins Harnly for the IAD. Includes

a brief biography and photograph of Harnly. Text by Virginia Mecklenburg and Lynda Roscoe Hartigan.

1514 ACA Gallery. *Social art in America 1930–1945.* ACA Gallery: New York, 1981. 61 pp.

Exhibition, November 5 through 28, 1981. Catalog of 118 works (many by New Deal artists or done on the projects), all illustrated (B/W and color). Essay by Milton Brown on the art of the thirties.

1514a Crosby, Patricia Dunn. *The New Deal art projects in Louisiana.* MA Thesis, Tulane University, 1981. 311 ll.

NOT SEEN.

MONOGRAPHS

1515 Kornfeld, Paul Ira. *The educational program of the Federal Art Project.* Ed.D. dissertation, Illinois State University, 1981. 191 pp.

Historical study of the WPA/FAP's educational programs and their influence on art education in the US. The author felt that though the impact of the WPA/FAP was minimal due to its brevity, it still made an important contribution. NOT SEEN. Cited in *DAI* v. 42/05-A, p. 1913.

1516 Scheinman, Muriel. *Art collecting at the University of Illinois: a history and catalogue.* Ph.D. dissertation, University of Illinois at Urbana-Champaign. 592 pp.

Appendix B lists the Krannert Art Gallery's (University of Illinois at Urbana-Champaign) collection of WPA/FAP art works. NOT SEEN. CITED IN *DAI* v. 42/02-A, p. 433.

1517 Tonelli, Edith Ann. *The Massachusetts Federal Art Project: a case study in government support.* Ph.D. dissertation, Boston University, 1981. 410 pp.

A study of the WPA/FAP and its contributions viewed through the contributions of Holger Cahill. Looking carefully at the Massachusetts and New England manifestations

of the WPA/FAP, Tonelli feels that Cahill's personality
played a vital role in the shaping of WPA/FAP policy.

1982

1518 Meyers, John. "A letter from the publisher." *Time* 119
(February 1, 1982): 3.

In an issue devoted to FDR, Meyers discusses the WPA/FAP
association of Alice Neel, who did the cover portrait of FDR
for this issue.

1519 Ames, Kenneth L. "Review of *The Index of American
Design.*" *Journal of the Society of Architectural Historians* 41
(March 1982): 68–69.

Review of the microfiche edition of the IAD (*See* **1495ff**).
Ames finds the project well done, but questions its interest
and value to today's designers or material historians: "Today
we can see the *Index* as a relic of the Depression, as history."

1520 Narber, Gregg R. and Lea Rosson De Long. "The
New Deal murals in Iowa." *Palimpsest* 63 (n.3 1982): 86–96.

A good account of the Iowa mural projects under WPA/FAP,
PWAP, and the Section. Numerous B/W and color illustra-
tions of works by Richard Haines, Marion Gilmore, Orr
Fisher, Harry D. Jones, Criss Glassell, John Bloom, William
Henning, Tom Savage, Robert Tabor, and Herbert O. Myres.

1521 Brown, Milton W. "New Deal art projects: boondog-
gle or bargain?" *Art News* 81 (April 1982): 82–87.

Brief outline of the history of the projects; traces the reac-
tions to the projects in later years; Brown feels that FDR was a
motivating force behind the projects even though he did not
do that much to support them; in the final verdict, Brown
feels the projects were more bargain than boondoggle. B/W
and color illustrations of numerous works.

1522 "Conference on New Deal culture." *Federal One* 7 (May 1982): 1–7.

Account of the conference held on New Deal culture at the National Archives and George Mason University, October 15–17, 1981. Papers presented dealing with the fine arts projects were: "Meaning and Motif in the Arts of the 1930's" by Karal Ann Marling; "Craft Arts in the New Deal Art Programs" by Hildreth York; and "Visual Arts of the 1930's" by Sue Ann Kendall. In the same issue is a note on the founding of the Institute on the Federal Theatre Project and New Deal Culture at George Mason University and on two films, "Artists at Work" and "The New Deal for Artists."

1523 Berman, Greta. "Abstraction for public spaces, 1935–1943." *Arts* 56 (June 1982): 81–86.

Excellent account of abstract murals done under the art projects; account of Burgoyne Diller, head of the New York City mural division who encouraged abstract art. Illustrated with numerous B/W photographs of murals.

EXHIBITIONS

1524 National Museum of American Art. Smithsonian Institution. *Roosevelt's America: New Deal paintings from the National Museum of American Art.* NMAA: Washington, DC, 1982. Pamphlet.

Exhibition, January 9 though September 26, 1982. Checklist of seventeen New Deal paintings from the collection of the NMAA. Brief text by Virginia Mecklenburg covering the history of the various New Deal art projects and the collection at the NMAA.

1525 Hirshhorn Museum and Sculpture Garden. Smithsonian Institution. *Five distinguished alumni: the WPA Federal Art Project. An exhibition honoring the Franklin Delano Roosevelt centennial.* Hirshhorn Museum: Washington, DC, 1982. 8 pp.

Exhibition January 21 through February 22, 1982, consisting of contemporary work by five artists (Ilya Bolotowsky, Alice Neel, James Brooks, Willem de Kooning, and Ibram Lassaw) who had worked on one of the Federal art projects. Checklist of fifteen works; includes comments by each artist on their involvement in the projects. Other text by Judith Zilczer.

1526 University of Maryland. Art Gallery. *The spirit of the thirties: selections from the collection of the University of Maryland gallery.* University of Maryland: College Park, MD, 1982. 42 pp.

Exhibition, February 24 through April 8, 1982. Checklist of eighteen works (many New Deal art project works, but others included); B/W illustration of most. Essay on how the university acquired the works and brief history of the art projects.

1527 Muhlenburg College Center for the Arts. *Can you spare a dime?: art of the WPA era.* Muhlenburg College Center for the Arts: Allentown, PA, 1982.

Exhibition, February 28 through April 6, 1982. Catalog by Linda Weintraub. NOT SEEN.

1528 National Museum of American Art. *Berenice Abbott: the 20's and the 30's.* Smithsonian Institution Press: Washington, DC, 1982. 22 pp.

Exhibition, June 4 through August 29, 1982. Catalog of fifteen works (not all WPA/FAP). Introduction by Barbara Shissler Nosanow. Exhibition first shown at the International Center of Photography, November 22, 1981, through January 10, 1982 (no catalog).

1529 Museum of the Borough of Brooklyn at Brooklyn College. *Brooklyn themes: art in the years of Roosevelt and La Guardia.* Museum of the Borough of Brooklyn: Brooklyn, 1982. Pamphlet.

Exhibition, October 26 through December 7, 1982. Illustrated brochure with text by Shelly M. Dinhofer. B/W illustrations. No checklist.

MONOGRAPHS

1530 Allyn, Nancy Elizabeth. *Defining American design. A history of the Index of American Design, 1935–1942.* MA Thesis, University of Maryland, 1982. 96 ll.

A history of the IAD, specifically how the IAD interacted with antique collectors and creator of decorative arts; a good section on the trials and troubles of the eventual allocation of the IAD plates first to the Metropolitan and then the NGA.

1531 Bloxom, Marguerite D. *Pickaxe and pencil: references for the study of the WPA.* Library of Congress: Washington, DC, 1982. 87 pp.

Far-ranging but superficial survey of references on all aspects of the WPA. Individual chapters on the WPA/FAP as well as the WPA/FAP in relation to the other art projects of Federal One (music, theatre, and writers). Brief annotations. A good introduction to the other projects of the New Deal.

1532 De Long, Lea Rosson and Gregg R. Narber. *A catalog of New Deal mural projects in Iowa.* Des Moines, 1982. 80 pp.

Detailed, comprehensive account of New Deal murals in Iowa. Full history of a number of the murals. Illustrated with B/W photographs of artists at work, various Depression scenes, and mural reproductions. List of extant and destroyed murals in Iowa.

1533 Desjardijn, D. *En de kindertjes de moeders.* Stachelswine: Amsterdam, 1982? 32 pp. 2 ll. of plates.

NOT SEEN. CITED IN OCLC.

1534 Marling, Karal Ann. *Wall-to-wall America: a cultural history of Post Office murals in the Great Depression.* University of Minnesota Press: Minneapolis, 1982. 348 pp.

Dealing only with the Post Office work of the Section, Marling explains in a clear, narrative prose the multi-layered relationships between the artist, the public, and the artist's governmental patron. An excellent and important work for

placing the work of these New Deal artists in the broader context of 1930s America. Numerous B/W illustrations.

1534a Mecklenburg, Virginia. "Federal art projects," pp. 30–35. In *FDR, the intimate presidency: Franklin Delano Roosevelt, communication, and the mass media in the 1930s: an exhibition to commemorate the 100th anniversary of the birth of the 32nd President of the United States, January 1982.* Bruton, Elsa M., ed. National Museum of American History, Smithsonian Institution: Washington, DC, 1983. 64 pp.

Essay on the nature of the New Deal art projects. Primarily B/W illustrations of artists at work on murals and the murals themselves. IAD mentioned on p. 37.

1535 Wyman, Marilyn. *A New Deal for art in Southern California: murals and sculpture under government patronage.* Ph.D. dissertation, University of Southern California, 1982. 564 ll.

Good, basic coverage of the New Deal art projects; Wyman attempts to define New Deal art in a Southern California context. Includes a catalog of New Deal murals and sculpture in Southern California. Plates.

1983

1536 Hagerty, Donald J. "Hard times, new images: artists and the Depression years in California." *Pacific Historian* 27 (Winter 1983): 11–19.

Overview of the artistic milieu in California during the Depression. Discussion of the work of the New Deal art projects in California. Artists Maynard Dixon and Millard Sheets discussed. B/W illustrations of their works.

1536a Swain, Martha H. "The forgotten woman: Ellen S. Woodward and women's relief in the New Deal." *Prologue* 15 (Winter 1983): 201–13.

Profile of Ellen S. Woodward, overseer of the WPA/FAP. B/W illustrations.

1537 "Busy doing nothing: the story of government job creation." *The Heritage Foundation; Policy Review* (Spring 1983): 87ff.

NOT SEEN.

1538 Rhoads, William B. "The artistic patronage of Franklin D. Roosevelt: art as historical record." *Prologue* 15 (Spring 1983): 5–21.

Tracing the origins of FDR's aesthetic tastes, Rhoads discusses his influence on the Section's Poughkeepsie Post Office project (it being near his home, FDR made a number of suggestions). Rhoads claims that FDR saw art purely as an instructional or educational tool to illustrate history and not the expression of imagination. B/W illustrations of work by Olin Dows and Gerald Foster.

1539 Ducato, Theresa and John C. Carlisle. "Forgotten images of America: post office murals." *Historic Preservation* 35 (May–June 1983): 48–51.

Account of John C. Carlisle (a professor at Purdue) who travels the country photographing New Deal post office murals. Numerous color photographs of the murals by Carlisle.

1540 Stretch, Bonnie Barrett. "American art: a New Deal for WPA prints." *Portfolio—The Magazine of the Fine Arts* 5 (May-June 1983): 27.

Note on the NYPL's exhibition of over 1,200 WPA prints (*See* **1545**); comments by Mary Ryan (of Mary Ryan Gallery) and Ellen Sragow (an art dealer), that WPA/FAP prints are increasing in value. B/W illustration of work by Will Barnet.

1541 "50th anniversary decade: 1982–93." *Federal Art Patronage Notes* 4 (Summer 1983): 1–8.

Call to commemorate the upcoming fiftieth anniversary of New Deal culture; includes a chronology of New Deal culture projects in tabular form. Also adds twenty items (pp. 4–5) to the selected bibliography published earlier (*See* **1467**).

1542 Cole, John Y. "Amassing American 'stuff.' " *Quarterly Journal of the Library of Congress* 40 (Fall 1983): 356–89.

Covering all of Federal One, this profusely illustrated article (B/W and color illustrations of works by Yasuo Kuniyoshi, Doris Spiegel, and Raphael Soyer) is a good introduction to WPA/FAP (and Federal One) material at the Library of Congress. Cole tells the interesting story of then Librarian of Congress Archibald MacLeish's unsuccessful attempt to gain possession of the IAD at the end of the WPA.

1543 Gambrell, Jamey. "An art of protest and despair." *Art in America* 71 (December 1983): 92–99.

Review of "Social Concern and Urban Realism: American Painting of the 1930's" (shown at Gallery 1199, NYC; Boston University Art Gallery, Boston; and others) curated by Patricia Hills. Includes a brief history of art projects and the social milieu of the 1930s. Work other than WPA/FAP artists included. B/W illustrations of many of the works in the show.

1544 Greer, Nora Richter. "Nurturing the heritage of WPA art." *AIA Journal* 72 (December 1983): 26–27.

Account of the GSA inventory of New Deal art under the direction of Karel Yasko; mostly illustrated with a good selection of murals. William Gropper, Gertrude Goodrich, Symeon Shimin, Emil Bisttram, George Biddle, Harry W. Scheuch, Glenn Chamberlain, George Grooms, Nicolai Cikovsky, and Orr C. Fisher.

EXHIBITIONS

1545 New York Public Library. Stokes Gallery. *FDR and the arts. The WPA art projects.* New York Public Library: New York, 1983. 16 pp.

Exhibition, January 1 through March 31, 1983. Brochure to accompany an exhibition that covered all aspects of New Deal support for the arts. Includes a section on the WPA/FAP, the WPA/FAP graphics division, and one on Berenice Abbott's *Changing New York*. B/W photographs of the era,

and illustrations of works by Fred Becker, Will Barnet, Julia Rogers, and Berenice Abbott.

1546 ACA Galleries and A.M. Adler, Fine Art, Inc. *Joseph Solman: work of the thirties.* ACA Galleries and A.M. Adler, Fine Art, Inc.: New York, 1983. 32 pp.

Joint exhibition held March 5 through 26, 1983 at the two galleries. Introduction by Greta Berman. Joseph Solman was an important artist as well as editor of *Art Front;* he worked in the Easel Division of the WPA/FAP from 1935–1941. Numerous B/W and color illustrations of his work.

1547 Illinois State Museum. *After the Great Crash: New Deal art in Illinois.* Illinois State Museum: Springfield, 1983. 32 pp.

Exhibition, April 3 through May 29, 1983. Illustrated catalog (B/W) of eighty-five works in all media and all projects. Text by Maureen A. McKenna. An extensive, though incomplete, list of artists who worked on New Deal art projects in Illinois.

1548 Grunwald Center for the Graphic Arts. UCLC. *Berenice Abbott: Changing New York.* Grunwald Center: Los Angeles, 1983. Pamphlet.

Exhibition, September 27 through November 13, 1983. Checklist of eighty photographs. Text by Lucinda H. Gedeon and Celia A. Johnson.

1549 The Jane Voorhees Zimmerli Art Museum, Rutgers University. *Harry Gottlieb: the silkscreen and social conscious of the WPA era.* Rutgers University: New Brunswick, 1983. 28 pp.

Exhibition, November 6 through December 31, 1983 at the Jane Voorhees Zimmerli Art Museum (January 8 through February 12, 1984 at the Sordoni Art Gallery, Wilkes College). Checklist of thirty works. Essays by Gregory Gilbert and Sheryl Conkelton cover Harry Gottlieb's work both as a graphic artist and as a radical member of the WPA/FAP artists' cadre. Includes an interview with Gottlieb. B/W and color illustrations.

MONOGRAPHS

1550 Baer, Lynne. *William Gropper's "Construction of a Dam":
a case study of a mural.* MA thesis, University of California,
Davis, 1983. 118 ll.

Very detailed account of William Gropper's mural, "Con-
struction of a Dam," for the Department of Interior Build-
ing. Brief biography of Gropper, account of the Section, and
a detailed study of the mural. Plates.

1551 Contreras, Belisario R. *Tradition and innovation in New
Deal art.* Bucknell University Press: Lewisburg, 1983. 253 pp.

Revision of the author's dissertation (*See* **1321**). One of the
best works on the contributions of Edward Bruce and Holger
Cahill to the success and personality of the New Deal art
projects.

1552 Jewett, Masha Zakheim. *Coit Tower, San Francisco. Its
history and art.* Volcano Press: San Francisco, 1983. 136 pp.

Indispensable guide to Coit Tower and its New Deal associa-
tions. Complete history of the Tower (built in 1933); the life
of its unwitting creator, Lillie Coit (who left money to create
a memorial to San Francisco's firemen); and a detailed
account of the creation of the PWAP murals that decorate its
interior. A detailed analysis of the murals, their creation, the
controversy that surrounded them (fears of Communist
influences on the artists and in the murals led many to call
for their destruction); brief biographies of the twenty-six
artists involved in the project; and the story of the later
deterioration and neglect of the murals and their present
restoration. B/W and color photographs of artists at work on
the murals as well as a complete photographic survey of the
murals.

1553 Kays, Judith S. *Easel paintings from the Federal Art Project
allocation of the San Francisco Museum of Modern Art.* MA Thesis,
John F. Kennedy University, 1983. 155 ll. 12 plates.

Excellent, in-depth study of the WPA/FAP allocation of easel paintings to the San Francisco Museum of Modern Art. Kays gives the history of the allocation as well as specific information on every artist and work. Includes checklist of an exhibition, "The WPA Allocation: Easel Paintings from the Federal Art Project" at the San Francisco Museum of Modern Art (March 5 through September 8, 1983, curated by Kays). B/W and color plates of works and installation photographs from exhibition. Appendix of photocopied documents relating to the allocation.

1554 National Museum of American Art. Smithsonian Institution. *Descriptive catalogue of paintings and sculpture of the National Museum of American Art.* G.K. Hall and Company: Boston, 1983. 304 pp.

"Index of New Deal Works," pp. 295–304 is a checklist of New Deal works in the collection of the NMAA as of October 31, 1982. Includes work from PWAP, Section, WPA/FAP, and the Civilian Conservation Corps. Citation includes artist, title, medium, and project of origin.

1555 Schrader, Robert Fay. *The Indian Arts and Crafts Board: an aspect of New Deal Indian policy.* University of New Mexico Press: Albuquerque, 1983. 364 pp.

Brief comments on attempts to integrate Native Americans into the PWAP, Section, and WPA/FAP.

1556 Scott, Barbara Kerr and Sally Soelle. *New Deal art: the Oklahoma experience; 1933–1943.* Cameron University: Lawton, OK, 1983. 24 pp.

Full coverage of all New Deal art projects in Oklahoma. Good account of Native Americans as artists and subjects. Includes a list of known murals. B/W illustrations of work by Richard West, Derald Swineford, Acee Blue Eagle, Stephen Mopope, Jules Struppeck, Dorothea Stevenson, Arthur Van Arsdale, Robert Shead, Ila McAfee Turner, and José Rey Toledo.

1984

1557 Hendrickson, Kenneth E., Jr. "A case study in the politics of culture: the Federal Art Project in Iowa." *Upper Midwest History* 4 (1984): 29–38.

Good coverage of all the New Deal art projects in Iowa; good account of the Sioux City Art Center.

1558 Meixner, Mary L. "Lowell Houser and the genesis of a mural." *Palimpsest* 66 (January–February 1984): 2–13, cover.

Account of the life and work of Lowell Houser, an Iowa artist who later moved to San Diego; covers his association with the PWAP and Section.

1559 Saxe, Myrna. "The transfer and conservation of the Long Beach mosaic." *APT Bulletin* 16 (1984, no. 2); 26–31.

Interesting account of the saving of the WPA/FAP mural by Stanton Macdonald-Wright, Henry Nord, and Albert H. King when the Long Beach Auditorium was demolished in 1975. The mosaic was kept in storage until 1982 when it was moved to a new location. Photographs of the operations to save and move the mosaic.

1560 "Letter from Holger Cahill to Edgar P. Richardson on Federal patronage of the arts." *Archives of American Art Journal* 24 (n. 3 1984): 22–23.

Text of letter from Holger Cahill to Edgar P. Richardson dated June 30, 1954, "setting the record straight" on the WPA/FAP.

1561 Maviglione, George. "Federal Art Project: Holger Cahill's program of action." *Art Education* 37 (May 1984): 26–31.

Description of how Holger Cahill utilized the aesthetic ideas of John Dewey in running the WPA/FAP. B/W photographs of WPA/FAP activities.

1562 Kiehl, David W. "American printmaking in the 1930s: some observations." *Print Quarterly* 1 (June 1984): 96–100, 105–11.

Overview of American printmaking activities of the 1930s, with a concentration on the work of the WPA/FAP Graphic Division. B/W illustrations of work by Kalman Kobinyi, Blanche M. Grambs, Reginald Marsh, Jacob Kainen, Ida Abelman, and Florence Kent.

MONOGRAPHS

1563 Allyn, Nancy E. *The Index of American Design.* National Gallery of Art: Washington, DC, 1984. 32 pp.

Brochure, illustrated with B/W and color reproductions of plates, to the IAD collection at the National Gallery of Art.

1564 Beckham, Sue Bridewell. *A gentle reconstruction: Depression post office murals and Southern culture.* Ph.D. dissertation, University of Minnesota, 1984. 331 pp.

A detailed account of mural work in the South. "This is the story of the South as recorded in those murals and in the mostly white Southern reaction to them," p. 3. Plates. *See also* **1648.**

1565 Boyens, Charles William. *The WPA mural projects: the effects of constraints on artistic freedom.* Ed.D. dissertation, Columbia Teachers' College, 1984. 224 pp.

Postulates that censorship, both overt and implied, by the administrators of the projects made it impossible to create great mural art. Particularly critical of the Treasury Department programs, which Boyens finds reactionary.

1566 Cohen, Paul. *Timberline Lodge: the manifestation of a culture.* Completed as course work for Reed College, 1984. 28 ll.

NOT SEEN. CITED IN *Timberline Lodge: A Love Story* (*See* **1605**).

1567 Forest Service. *Timberline Lodge: an expression of hope and purpose.* Department of Agriculture: Washington, DC, 1984. 12 pp.

NOT SEEN. CITE IN OCLC.

1568 Lang, Sherryl P. *The New Deal art projects: a comparison of the ideas of Edward Bruce and Holger Cahill as seen in the Section of Painting and Sculpture and the Federal Art Project.* MA Thesis, Virginia Commonwealth University, 1984. 99 ll.

Compares roles of Holger Cahill and Edward Bruce in the New Deal art project.

1569 Park, Marlene and Gerald E. Markowitz. *Democratic vistas: Post offices and public art in the New Deal.* Temple University Press: Philadelphia, 1984. 247 pp.

The authoritative treatise on the Section and its work in not only the nation's Post Offices, but other federal buildings. A complete history of the Section and its relation to the other projects, biographies of the principle administrators, analysis of the content of Section art and movements that influenced it (American Scene, Regionalism), and an account of how the Section operated. The authors praise the work of the Section and its contribution to American art. Numerous B/W and color illustrations.

1569a Soelle, Sally. *New Deal art projects in Oklahoma, 1933–1943.* MA Thesis, University of Oklahoma, 1984. 101 ll.

NOT SEEN.

1570 Stein, Pauline Alpert. *A vision of El Dorado: the Southern California New Deal art program.* Ph.D. dissertation, UCLA, 1984. 439 pp.

Covering all the New Deal art projects in Southern California (and the four projects of Federal One), Stein concludes that the projects had a meritorious effect on the creation of an indigenous Southern California art style. NOT SEEN. CITED IN *DAI* v. 47/01-A, p. 293.

1571 Vasaio, Antonio. *The fiftieth anniversary of the US Department of Justice building, 1934–1984.* GPO: Washington, DC, 1984. 106 pp.

Excellent account of the Department of Justice building and the Section murals inside. Pp. 64–99 deal exclusively (with numerous illustrations) with the murals done by Boardman Robinson, Maurice Sterne, Emil Bisttram, John Ballator, Symeon Shimin, George Biddle, Leon Kroll, John Steuart Curry, Henry Varnum Poor, and Louis Bouche. Each mural entry includes a biography and photograph of the artist. Also includes a reproduction of the famous letter from George Biddle to FDR calling for Federal aid to artists.

1985

1572 Rose, Barbara. "Life on the project." *Partisan Review* 52 (n. 2 1985): 74–86.

A good, scholarly account of the lives of abstract painters on WPA/FAP work; concentrates on the lives of Jackson Pollock and Lee Krasner. A fascinating overview of the projects and the influence of the Communist Party on the artists.

1572a "Review of *Democratic Vistas: Post Offices and Public Art in the New Deal.*" *Journal of American History* 72 (September 1985): 440–41.

Overall favorable review of *Democratic Vistas* (*See* **1569**).

1572b Norman Turano, Jane van. "Review of *Democratic Vistas: Post Offices and Public Art in the New Deal.*" *American Art Journal* 17 (Spring 1985): 90–1.

Positive review of *Democratic Vistas* (*See* **1569**).

1573 "The political economy of art in 1985." *The Economist* 294 (March 9, 1985): 93ff.

NOT SEEN.

1574 Vlach, John Michael. "Holger Cahill as folklorist."
Journal of American Folklore 98 (April–June 1985): 148–62.

Excellent biographical sketch of the life of Holger Cahill,
concentrating on his activities to increase the visibility of
folk art. Good discussion of his role as director of the
WPA/FAP in relation to folk art, particularly as it relates to
the IAD.

1575 "WPA art, who owns it?" *Maine Antique Digest* 13 (May
1985): 35d.

Discussion of the WPA/FAP and how the General Services
Administration still considers the art created to be US
Government property. "Scattered they may have been, but
now the G.S.A. is attempting to rectify that, and if you own a
W.P.A. painting or print, you may find that ownership in
question." B/W illustrations of works by Francis Dunham
and Hirshel Abramson.

1575a Blakey, George T. "Review of *Democratic Vistas: Post
Offices and Public Art in the New Deal.*" Register of the Ken-
tucky Historical Society 83 (Autumn 1985): 376–77.

Positive review of *Democratic Vistas* (*See* **1569**).

1576 Burden, Florence Canfield. "New Deal artist Ernest S.
Stevens." *Nebraska History* 66 (Fall 1985): 224–33.

Brief biography of Ernest S. Stevens (1872–1938) who
worked for both the PWAP and the WPA/FAP; in the
WPA/FAP, he first worked as an artist, and later, director of
the Torrington (CT) Federal Art Gallery. Includes a list of
major holders of his work. B/W illustrations of his works and
a portrait photograph of Stevens.

1576a J., F. "Review of *Democratic Vistas: Post Offices and
Public Art in the New Deal.*" *American Artist* 49 (November
1985): 34.

Positive review of *Democratic Vistas* (*See* **1569**). Color repro-
duction of work by Natalie Smith Henry.

1577 Malone, Molle. "Unseen and unsung artists." *Artweek* 16 (November 30, 1985): 6.

Review of exhibition at the Oakland Museum of thirty WPA/FAP lithographs by West Coast artists. B/W illustration of work by Hilaire Hiler.

1578 "[Watonga post office, pt.1]." *Federal One* 10 (December 1985): 3.

Note on how Cheyenne Indians protested their depiction in the Watonga Post Office mural done by Ethel Mahier in 1941 (*See* **1594, 1598**).

EXHIBITIONS

1579 Nebraska State History Society. *Depression era art at the State Museum of History.* State Historical Society: Lincoln, NE, 1985.

Exhibition, 1985. NOT SEEN.

1580 University of Michigan. Museum of Art. *The Federal Art Project: American prints from the 1930s in the collection of the University of Michigan Museum of Art.* University of Michigan Museum of Art: Ann Arbor, MI, 1985. 220 pp.

Exhibition, June 28 through July 31, 1985. An essential work for the study of New Deal printmaking; consists of 163 works in all print media from all projects; introduction by Christine Nelson Ruby; numerous B/W illustrations.

1581 Fowler, Harriet W. *New Deal art: WPA works at the University of Kentucky.* University of Kentucky Art Museum: Lexington, KY, 1985. 119 pp.

Exhibition, August 25 through October 27, 1985, of fifty artists. Excellent, brief biographies of the artists and critiques of the works. Essay is an overview of the projects. B/W illustrations.

1582 Wooden, Howard E. *American art of the Great Depression: two sides of the coin.* Wichita Art Museum: Wichita, KS,

1985. 152 pp.

Exhibition, October 27 through December 1, 1985, at the Wichita Art Museum. Checklist of 131 artists represented by 163 works, many B/W illustrations. Good historic and aesthetic account of the projects.

MONOGRAPHS

1583 Gurney, George. "The Final phase and the new direction: the Section of Painting and Sculpture," pp. 291–411, in *Sculpture and the Federal Triangle*. Smithsonian Institution Press: Washington, DC, 1985. 464 pp.

Excellent coverage of the Section's work on the Federal Triangle of government office buildings in Washington; particularly the Federal Trade Commission Building, at the apex of the Triangle.

1584 Lawson, Alan. *The cultural legacy of the New Deal*, pp. 155–86. In *Fifty Years Later: the New Deal evaluated*, edited by Harvard Sitkoff. Temple University Press: Philadelphia, 1985. 240 pp.

Covers all aspects of New Deal cultural projects, specifically Federal One, setting them against an ideological background.

1585 Lucie-Smith, Edward. "Patronage of the arts in America." In *Art of the 1930s—the age of anxiety*, pp. 248–54. New York: Rizzoli, 1985. 264 pp.

Brief overview of government and the arts in the 1930s; good perspective on the arts projects in a global setting. B/W illustrations of works.

1586 McKinzie, Richard D. "Federal Art Project," pp. 128–29. In *Franklin D. Roosevelt: His Life and Times. An Encyclopedic View*. Edited by Otis L. Grahan, Jr. and Meghan Robinson Wander. G.K. Hall: Boston, 1985. 483 pp.

General overview of the WPA/FAP; B/W photographs of objects and artists at work.

1587 Townsend, Helen Ann Beckstorm. *Ideology and government participation in the arts: the Federal Art Project in Tennessee.* Ph.D. dissertation, Vanderbilt University, 1985. 272 pp.

Discussing the changes in American culture during the 1930s, Townsend analyzes the ideology of the Tennessee WPA/FAP, 1935–1939. NOT SEEN. CITED IN *DAI* v. 46/08-A, p. 2448.

1588 Wells, Richard D. *Elizabeth Green: a patronage portrait.* Ph.D. dissertation, Saint Louis University, 1985.

Analysis of the art patronage of Elizabeth Green in relation to the St. Louis art community. Her attempts to persuade Holger Cahill and the WPA/FAP to take a greater interest in Missouri is explored. NOT SEEN. CITED IN *DAI* v. 46/12-A, p. 3764.

1589 Willett, Ralph. "Naive, human, eager and alive: the Federal Art Project and the response from magazines," pp. 177–93. In *Nothing else to fear: new perspectives on America in the thirties.* Baskerville, Stephen W., editor. Manchester University Press: Manchester, England, 1985. 294 pp.

Interesting discussion of the coverage of the WPA/FAP in the popular press (*Time, Life, The New Republic,* etc.), the art press (*Art Digest, Art News,* etc.), and the radical press (*Art Front*). Postulates that the WPA/FAP had generally unfavorable press everywhere but in the more radical or Left Wing publications.

1589a "Review of *Democratic Vistas: Post Offices and Public Art in the New Deal.*" *American Journal of Sociology* 92 (1): 233–35.

NOT SEEN.

1986–1992

1986

1590 Harris, Jonathan. "Art, histories and politics: the New Deal art projects and American modernism." *Ideas and Production* 5 (1986): 104–19.

Excellent theoretical article placing the New Deal art projects in the context of the later developments of American modernism and Abstract Expressionism

1591 Cohen, E.L. "Miami murals." *Interior Design* 57 (January 1986): 220–23.

NOT SEEN. CITED IN *Art Index.*

1592 Dubin, Steven C. "Artistic production and social control." *Social Forces* 64 (March 1986): 667–88.

Comparison of the New Deal art projects and the Comprehensive Employment Training Act (CETA) art programs. Dubin is particularly interested in the issues of censorship and social control of the artist.

1593 "Exhibits." *Federal One* 11 (April 1986): 6.

Note on "The New Deal in Philadelphia: Work by and for the People" at the Philadelphia National Archives (through July 1986); and on a Norwalk, CT, effort to raise $250,000 to restore a Depression-era mural in the town.

1593a Schneider, Eric. "Review of *Democratic Vistas: Post Offices and Public Art in the New Deal.*" *Pennsylvania Magazine of History and Biography* 110 (April 1986): 304–305.

336

Positive review of *Democratic Vistas* (*See* **1569**).

1594 "Watonga's day in the sun, pt. 2." *Federal One* 11 (April 1986): 7.

Further account of the Watonga mural protests (*See* **1578, 1598**).

1595 Greengard, Stephen Neil. "Ten crucial years: the development of United States sponsored artist programs, 1933–1943: a panel discussion by six WPA artists." *Journal of Decorative and Propaganda Arts* 1 (Spring 1986): 40–61.

Panel discussion introduced and edited by Greengard on March 30, 1985 in Miami, FL. Artists taking part were: Gustave von Groschwitz, Jerry Roth, Riva Helfond, Harold Lehman, Minna Citron, and Harry Gottlieb. A fascinating set of first-hand accounts of the WPA/FAP and Section. Includes audience questions.

1595a O'Connor, Francis V. "Review of *Democratic Vistas: Post Offices and Public Art in the New Deal.*" *Winterthur Portfolio* 21 (Spring 1986): 94–96.

Extremely negative review of *Democratic Vistas* (*See* **1569**); O'Connor raises a number of points regarding the state of New Deal art project scholarship in the course of his review.

1596 De Noon, Christopher. "WPA posters." *Communication Arts Magazine* 28 (May/June 1986): 60–69.

Good introduction to the work of the poster unit of the WPA/FAP; description of the contributions of project supervisor Anthony Velonis. Seventeen illustrations of WPA/FAP posters. *See* **1622** for De Noon's book on the same subject.

1596a Kwolek-Folland, Angel. "Review of *Democratic Vistas: Post Offices and Public Art in the New Deal.*" *Journal of the West* 25 (July 1986): 88.

Positive review of *Democratic Vistas* (*See* **1569**).

1596b	*American Art Notes from Janet Marqusee Fine Arts* (Autumn 1986): entire issue, 8 pp.

The Janet Marqusee Gallery in New York City is dedicated to art of the 1920s, 1930s and 1940s. In this issue, the following New Deal artists have brief biographical sketches and illustrations of their works: Judson Smith, David Fredenthal, George Melville Smith, Theresa Bernstein, Amy Jones, Mitchell Siporin, Edward Millman, and Robert Ryland.

1596c	Kahler, Bruce R. "Review of *Democratic Vistas: Post Offices and Public Art in the New Deal.*" *Illinois Historical Journal* 79 (Autumn 1986): 214–15.

Positive review of *Democratic Vistas* (*See* **1569**).

1597	De Noon, Christopher. "Social messages (graphic artists of the WPA.)" *Industrial Design* 33 (September–October 1986): 56–59.

Brief text describing the WPA/FAP poster project. B/W and color reproductions of WPA/FAP posters. *See* **1622** for De Noon's book on the same subject.

1598	"Watonga mural controversy, pt. 3." *Federal One* 11 (November 1986): 3.

Brief account of the controversy surrounding the Section mural by Edith Mahier in Watonga, OK (*See* **1578, 1594**).

1599	Williams, Reba and David Williams. "The early history of the screen print." *Print Quarterly* 3 (December 1986): 287–321.

Good historical account of the WPA/FAP's work with the silk screen. Most of the article is a list of American silk-screen artists. Numerous B/W and color illustrations of works (few FAP).

EXHIBITIONS

1600	Burke, Dan E. *Utah art of the Depression.* Utah State Art Collection: Salt Lake City, 1986. 111 pp.

Exhibition, May 2 through July 27, 1986, at the Chase Home Liberty Park, Salt Lake City. Checklist of sixty-three works (color illustrations) plus a selection (B/W illustrations) of works owned by the State of Utah, but not in the exhibition. Includes biographies of the artists; list of Federal work in Utah; and an "Inventory of PWAP, WPA/FAP Artists and Organizations that Acquired Artwork."

1601 Washburn Gallery. *50 years ago: WPA/AAA.* Washburn Gallery: New York, 1986. 32 pp.

Exhibition, November 4 through 29, 1986. Brief text on the abstract WPA/FAP murals done at the Williamsburg Houses public housing project (Bronx) by Ilya Bolotowsky (color cover reproduction). Catalog is made up of B/W reproductions of the American Abstract Artists (AAA) works which first shown at the same time.

1602 Phantom Gallery. *WPA art, New York City, 1935–1943.* Phantom Gallery: Los Angeles, 1986. 20 pp.

Exhibition, November 5, 1986 through ?. Checklist of works by nine artists (Joseph Solman, Joseph Delaney, Joseph Wolins, Norman Barr, Lucia Satemime, Charles Keller, Jules Halfant, Seymour Franks, and Riva Helfond). Numerous B/W and color reproductions.

MONOGRAPHS

1603 Burke, Dan E. *Utah art of the Depression.* MA Thesis, University of Utah, 1986. 100 ll.

NOT SEEN. CITED IN OCLC.

1604 Doty, Ann V. *New Deal art projects in Michigan: art in public policy.* Michigan, 1986. 38 ll.

NOT SEEN. CITED IN OCLC. "Course work completed for history 770."

1605 Gleason, Catherine, ed. *Timberline Lodge: a love story.* Friends of Timberline: Government Camp, OR, 1986. 128 pp.

Good account of Timberline Lodge, Mt. Hood, OR. Essays on its history and arts by Gideon Bosker, Terrence O'Donnell, Patricia Failing, Jane Van Cleve, Jack Mills, Tom McAllister, Lute Jurstad, and Sarah Munro. Illustrated with a number of color plates.

1606 Look, David W. and Carole L. Lerrault. *The Interior Building, its architecture and its art.* US Department of Interior, National Park Service: Washington, DC, 1986. 201 pp.

Chapter 8, "Murals and Sculpture" (pp. 110–71), covers the numerous Section murals and sculpture in the Interior building. Includes brief biographical sketches of the artists and a bibliography on each work. Numerous B/W photographs of the art work.

1607 Rosenzweig, Roy, ed. *Government and the arts in thirties America. A guide to oral histories and other research materials.* George Mason Press: Fairfax, VA, 1986. 329 pp.

Thorough and informative guide to archival resources of documents related to the New Deal arts projects. Detailed guide to the Archives of American Art's New Deal collection (perhaps the single greatest collection of such documents).

1608 Ruby, Christine M. Nelson. *Art for the people: art in Michigan sponsored by the Treasury Section of Fine Arts, 1934 to 1943.* Ph.D. dissertation, University of Michigan, 1986. 474 pp.

A basic introduction to the New Deal art projects; in-depth account of the Section, particularly its activities in Michigan; and a summary of the public's reaction to the work. Includes a list of Section post office murals in Michigan. Plates.

1609 US Public Buildings Service. *GSA list of New Deal art in museums.* GSA: Washington, DC, 1986. 295 ll.

Computer printout of New Deal art in public buildings as of 1986; alphabetical list of artists; other information includes title/date of work, city/state where located, address of work, status (size and medium). Note: This is a draft version of the list located in the NMAA/NPG Library, Smithsonian Institution.

1610 US Public Buildings Service. *GSA list of New Deal art in state offices.* GSA: Washington, DC, 1986. 110 pp.

Computer printout of New Deal art in state offices as of 1986; geographical list of works (state/city/artist); other information includes title/date of work, city/state where located, address of work, status (size and medium). Note: This is a draft version of the list located in the NMAA/NPG Library, Smithsonian Institution.

1987

1611 Ickstadt, Heinz. "The writing on the wall: American painting and the Federal Art Project." *European Contributions to American Studies* 12 (1987): 221–47.

NOT SEEN.

1611a *American Art Notes from Janet Marqusee Fine Arts* (Winter 1987): entire issue, 8 pp.

The Janet Marqusee Gallery in New York City is dedicated to art of the 1920s, 1930s, and 1940s. In this issue, the following New Deal artists have brief biographical sketches and illustrations of their works: Mitchell Siporin, Theresa Bernstein, George Picken, and Andrée Ruellan.

1612 Fraden, Rena. "Feels good,—can't hurt—Black representation on the Federal Arts projects." *Journal of American Culture* 10 (Winter 1987): 21–29.

Discussion of the role of African-Americans on the New Deal Art Projects; concerned mostly with the FWP and FTP, though some mention of how African-Americans portrayed Black life on the WPA/FAP.

1613 Harris, Jonathan. "State power and cultural discourse: Federal Art Project murals in New Deal USA." *Block* 13 (Winter 1987/1988): 28–42.

A "hegemonic discourse" reading the WPA/FAP mural work as an attempt to recreate the artist as a meaningful player in American society, i.e. the Artist as Citizen. Concentrates on work done in hospitals, prisons, schools, and housing projects. An excellent example of the theoretical work now beginning to be done on the New Deal art projects. Numerous B/W illustrations. "Within this hegemonic discourse, art, with its therapeutic application in institutions and detachment from both the modernist coterie and academic establishment, would assist in the building of America's future. The community of practitioners and consumers of art would have an 'appreciation' of it based on far more than 'passive visual perceptions' or 'instruction in history and aesthetics.' It would be based rather on art's practiced capacity to unify both individual bodies and souls as well as the corpus constituting American as Nation," p. 42.

1614 Masters, Greg. "From the 1930s–40s; Fifty years ago: WPA/AAA." *Arts* 61 (February 1987): 106.

Favorable reviews of two exhibitions: "From the 1930s–40s" at the Ellen Sragow Gallery (NYC, October 25 to November 30, 1986), which dealt with the social realism side of the WPA/FAP; and "50 years ago: WPA/AAA" at the Washburn Gallery (NYC, November 4–29, 1986), an exhibit of abstract works from project artists. Includes a brief history of the art projects and an B/W illustration of a work by Arshile Gorky.

1615 McKinzie, Richard. "Review of *Democratic Vistas*." *American Historical Review* 92 (February 1987): 236.

Favorable review of *Democratic vistas. Post offices and public art in the New Deal* (*See* **1569**) by Marlene Park and Gerald E. Markowitz.

1615a Larson, Kay. "Up against the walls." *New York* (February 2, 1987): 46–51.

Covering murals throughout New York City, special attention is paid to New Deal mural work. Attempts at rescue and restoration of the murals are detailed. Color illustrations of

murals by James Brooks, Ben Shahn, Lucienne Bloch, and Ernest Fiene.

1616 Olin, Dirk. "Fifty years later, the Government reissues WPA art." *Washington Post Magazine* (February 15, 1987): 36–38.

Description of the plans of the Government Services Administration to issue WPA/FAP works in poster for the decoration of federal buildings. "Soon, the GSA is officially hoping, federal employees will beaver away beneath works by artists who proved too controversial for the skittish McCarthy era," p. 38. Illustrations of work by Stuart Davis, William E.L. Bunn, and Moses Soyer.

1616a *American Art Notes from Janet Marqusee Fine Arts* (Spring 1987): entire issue, 8 pp.

The Janet Marqusee Gallery in New York City is dedicated to art of the 1920s, 1930s, and 1940s. In this issue, the following New Deal artists have brief biographical sketches and illustrations of their works: James Penney, Robert Lepper, Thomas Donnelly, Emil Bisttram, Nicolai Cikovsky, and James Baare Turnbull.

1617 Vishny, Michael. "On the walls: murals by Ben Shahn, Philip Guston, and Seymour Fogel for the Social Security building, Washington, DC." *Arts* 61 (March 1987): 40–43.

History of the projects; detailed description and high praise of the murals by Ben Shahn, Philip Guston, and Seymour Fogel for the Social Security building in Washington, DC. B/W illustrations of the murals.

1617a Gore, Deborah, ed. "Regionalist art and literature." *The Goldfinch: Iowa History for Young People* 8 (April 1987): 25 pp.

NOT SEEN. Special issue of young persons' magazine devoted to regionalist art and the New Deal art programs in Iowa.

1618 Chilcoat, George W. "Visualizing the 1930s in the classroom: Depression pop art." *Social Studies* 78 (no. 3 1987): 109–113.

Brief explanation of the New Deal art projects as the author goes on to offer practical suggestions for the teaching of the history of the Great Depression in the classroom via the creation of graphic images by the students.

1618a Clarke, Orville O. "Social statements in art: WPA murals." *Antiques and Fine Art* (December 1987): cover, 54–59.

Comments in the mural work of the Mexican Mural School in California and its relation to the New Deal murals there. Notes on the various New Deal fine arts projects and their relationship to social issues of the time. Reproductions of work by Douglas Parshall, Anton Refregier, Milford Zornes, Bernard B. Zakheim, and Fletcher Martin.

EXHIBITIONS

1619 Anchorage Museum of Art and History. *Works Progress Administration's Alaska art project 1937. A retrospective exhibition.* Anchorage Museum of Art and History: Anchorage, 1987. 47 pp.

Exhibition, March 10 through August 31, 1987, at the Anchorage Museum of Art and History. Checklist of fifty-three works. Good account of the WPA/FAP in Alaska. Show traveled to two other Alaskan sites (University of Alaska Museum, October 31 through December 13, 1987, and the Alaska State Museum, January 1 through March 5, 1988). Curated by Lynn Bintek, Karl E. Fortress, and Merlin F. Pollack.

1620 Hudson River Museum. *The graphic art of Harold Faye.* Hudson River Museum: Yonkers, NY, 1987. 32 pp.

Exhibition, July 26 through October 18, 1987. Checklist of forty-three lithographs and drawings (fifteen illustrated— many done for WPA/FAP). Harold Knickerbocker Faye

(1910–1980) worked in the FAP Graphics Division 1935–39. Includes a brief biography. Text by Ron Netsky, Grant Holcomb, and Jan S. Ramirez.

MONOGRAPHS

1621 Lujan, Joe Roy. *Dennis Chavez and the Roosevelt era, 1933–1945*. Ph.D. dissertation, 1987. 586 pp. NOT SEEN. CITED IN *DAI* 49/06-A, p. 1497.

1622 De Noon, Christopher. *Posters of the WPA*. Wheatley in association with the University of Washington Press: Los Angeles, 1987. 175 pp.

Invaluable guide to the poster work done by all segments of the WPA. Hundreds of, mostly color, reproductions of the full variety of posters done by the various WPA projects (for the FTP, FAP, education, medical information, etc.). Additional text by Francis V. O'Connor (reminiscing about discovering a cache of WPA posters at the Library of Congress), Anthony Velonis (who was responsible for the revival of the silk-screen process as an art form), Richard Floethe (in charge of the poster division), and Jim Heiman.

1623 Foresta, Merry and Pete Daniel, Maren Stange, Sally Stein. *Official images: New Deal photography*. Smithsonian Institution Press: Washington, DC, 1987. 196 pp.

"Art and Document: Photographs of the Works Progress Administration's Federal Art Project," by Merry Foresta, pp. 148–193, covers both the artistic and documentary photographic work of the WPA/FAP. The rest of the book is devoted to other aspects of New Deal photography. Photographers illustrated are: Le Roy Robbins, David Robbins, Max Yavno, Sol Horn, Arnold Eagle, Berenice Abbott, Edward Weston, Cyril Mypass, Mark Nadir, Andrew Herman, Leo Lance, Sol Libsohn, and Helen Levitt.

1624 Hailey, Gene, ed. and Ellen Schwartz. *California art research*. Laurence McGilvery: La Jolla, CA, 1987. 12 microfiche plus pamphlet.

Microfiche edition of Hailey's monumental work on California artists (*See* **0564**); additional comments, a history of the work, and bibliography by Schwartz.

1625 Hubbard, Carole Ann Challberg. *Roots of African-American art: the early years through the 1930s.* Ph.D. dissertation, Pennsylvania State University, 1987. 143 pp.

Briefly covers the role of the WPA/FAP in the art education of African-Americans and its role in sustaining and encouraging them in their art. NOT SEEN. CITED IN *DAI* v. 49/04-A, p. 705.

1626 Kyvig, David E. and Mary-Ann Blasio, compilers. *New Day/New Deal: a bibliography of the Great American Depression, 1929–1941.* Greenwood Press: New York, 1987. 306 pp.

Excellent, though non-annotated, bibliography of all aspects of the Great Depression. Includes a small section on the arts projects. Good reading for background sources on Depression.

1627 Schnee, Alix Sandra. *John Cotton Dana, Edgar Holger Cahill, and Dorothy C. Miller: three art educators.* Ed.D. dissertation, Columbia University Teachers College, 1987. 234 pp.

Examines the role of Holger Cahill, Dorothy Miller, and John Cotton Dana in art education.

1627a US General Services Administration. *Federal Art, portrait of the nation: presenting a new portfolio of public art in two specially prepared poster series, to celebrate the golden anniversary of the New Deal arts program and the silver anniversary of the General Services Administration's art-in-architecture program.* Washington: GSA, 1987. 1 sheet [8 p.].

Pamphlet to accompany poster sets (one with three posters, one with five) of New Deal art. NOT SEEN.

1628 Wheat, Ellen Harkins. *Jacob Lawrence.* Ph.D. dissertation, University of Washington, DC, 1987. 477 pp.

Covers Jacob Lawrence's career in the WPA/FAP in the larger

context of his entire career (not primarily WPA/FAP information). NOT SEEN. CITED IN *DAI* v. 48/12-A, p. 3000.

1629 White, John Franklin, ed. *Art in action. American art centers and the New Deal.* Scarecrow Press: Metuchen, NJ, 1987. 195 pp.

Excellent collection of essays on the WPA/FAP's local art centers, perhaps the most "democratic" aspect of the art projects. Illustrated with B/W photographs of the centers. Appendix lists the WPA Community Art Centers and Extension Art Galleries. Contents:

"The Walker Art Center: A Crowning Achievement," by J.F. White;

"The Federal Gallery System in Oklahoma: A Successful Experiment," by Nicholas A. Calcagno and Barbara K. Scott;

"Design for Democracy: The People's Art Center in St. Louis," by Martin G. Towey;

"The Spokane Art Center," by Sue Ann Kendall;

"A WPA Art Center in Phoenix: 1937–40," by Daniel A. Hall;

"Chicago's South Side Community Art Center: A Personal Recollection," by Margaret Goss Burroughs;

"The Utah State Art Center," by Dan E. Burke;

"North Carolina's Community Art Centers," by Ola Maie Foushee;

"Community Art Centers and Exhibitions," by Mildred Holzhauer Baker.

1988

1630 Barrett, Catherine. "The writing on the wall." *Art and Antiques* (March 1988): 90–99, 124–125, 128.

Discusses the poor conditions of many murals and includes reminiscences of mural artists (B/W illustrations of works by Saul Levine, Clarence Carter, Bernarda Bryson Shahn, Paul Cadmus, Mitchell Siporin, and Ethel Magafin.)

1631 Mahoney, Robert. "Painting America: mural art in the New Deal era." *Arts Magazine* 62 (March 1988): 95.

Favorable review of "Painting America: Mural Art in the New Deal Era," a joint exhibition (March 2–April 9, 1988) by Janet Marqusee and Midtown Galleries. B/W illustration of work by Robert Lepper.

1631a Hendrickson, Kenneth E., Jr. "The WPA Arts Projects in Texas." *East Texas Historical Journal* 26.2 (1988): 3–13.

Discussion of all the Federal Arts projects (FAP, FWP, FMP, and FTP) in East Texas.

1632 Marling, Karal Ann. "Painting and place: Frederick C. Knight in Scranton." *Journal of Decorative and Propaganda Arts* 8 (Spring 1988): 26–39.

Good account of the life and work of Frederick C. Knight, an artist who had worked on the PWAP, WPA/FAP, TRAP, and Section. Numerous B/W and color reproductions of his works.

1633 Phagan, Patricia E. "Images of the 1930s: WPA prints." *Bulletin of the Georgia Museum of Art* 13 (Spring 1988): 1–32.

Exhibition checklist/catalog of ninety-eight prints from the WPA/FAP Graphic Division (exhibition held April 30 through July 18, 1988 at the Georgia Museum of Art); text by Patricia E. Phagan. Numerous B/W illustrations of prints.

1633a Batchen, Geoffrey. "Review of *Official images, New Deal photography.*" *Afterimage* 15 (April 1988): 17–18.

Generally favorable review of *Official images, New Deal photography* (*See* **1623**). Included B/W illustrations.

1634 McElvaine, Robert S. "Art for our sake: the democratic vision of the WPA poster." *Washington Monthly* 20 (May 1988): 55–57.

Favorable review of *Posters of the WPA* by Christopher De Noon (*See* **1622**); continues with a discussion of the WPA/FAP's poster projects. Number of B/W and color illustrations of posters.

1635 C., K. "Review of 'Painting America: Mural Art in the New Deal Era.' " *Southwest Art* (June 1988): 22.

Very brief review of exhibition and catalog for "Painting America: Mural Art in the New Deal Era," a joint exhibition (March 2–April 9, 1988) by Janet Marqusee and Midtown Galleries. Primarily a discussion of projects, little on show or catalog.

1636 Pontello, Jacqueline M. "Special Delivery: murals for the New Deal era." *Southwest Art* 18 (June 1988): 32, 34, 36.

Overview of New Deal mural projects produced to accompany National Museum of American Art's exhibition, "Special Delivery: Murals for the New Deal era," (*See* **1636**). Color reproductions of work by Rockwell Kent, Jenne Magafan, Woodrow Crumbo, William E.L. Bunn, and Oscar Galgiani.

1636a Clarke, Orville O. "New Deal artist." *Pomona College Today* (Fall 1988): 18–21.

Profile of Pomona College alumnus Milford Zornes. Zornes created Claremont (CA) Post Office mural for the TRAP. Illustrations of the mural and a contemporary photograph of Zornes in the post office.

1636b Collins, Amy Fine. "Jacob Lawrence: art builder." *Art in America* 32.4 (1988): 212–14.

Brief discussion of Jacob Lawrence's career as a New Deal artist. Illustrations of Lawrence's work

1637 Kidd, Stuart. "Redefining the New Deal: some thoughts on the political and cultural perspectives of revisionism." *Journal of American Studies* 22 (December 1988): 389–415.

In the third section of his review of the recent trends in New Deal scholarship, Kidd looks at the cultural achievements of the period. Brief account of the WPA/FAP and the Section; does not seem to consider the fine art projects important to New Deal culture. B/W illustration of work by George Biddle.

1637a Cusick, Nancy. "Women artists of the New Deal: National Museum of Women in the Arts. [exhibition review]." *Women Artists News* 13 (Winter 1988–1989): 29–30.

Review of "Women artists of the New Deal" at the National Museum of Women in the Arts, Washington, DC (*See* **1643**). B/W illustrations.

EXHIBITIONS

1638 National Museum of American Art. Smithsonian Institution. *Special delivery. Murals for the New Deal era.* NMAA: Washington, DC, 1988. Pamphlet.

Exhibition, January 15 through September 11, 1988. Pamphlet to accompany exhibition. Brief account of the New Deal art projects, Federal patronage and the mural project. Text by Virginia Mecklenburg. B/W detail of mural by Jenne Magafan.

1639 Midtown Galleries. *Painting America. Mural art in the New Deal era.* Midtown Gallery: New York, 1988. 39 pp.

Exhibition, March 2 through April 9, 1988. Forty-six artists represented; brief biographies and notes on the works. B/W and color illustrations of works. Includes a brief introduction on the history of federal art patronage and the mural projects by Janet Marqusee.

1640 Francey, Mary. *Depression printmakers as workers: redefining traditional interpretations.* Utah Museum of Fine Arts: Salt Lake City, UT, 1988. 83 pp.

Exhibition, May 1 through June 12, 1988. Twenty-three artists represented—most were WPA/FAP, by fifty-one prints; includes brief biographies; B/W illustrations of works; checklist of exhibit. Traveled to the Boise Art Museum (September 1 through October 23, 1988).

1641 The Heckscher Museum. *Berenice Abbott's New York. Photographs of the 30's and 40's.* Heckscher Museum: Huntington, NY, 1988. Pamphlet.

Exhibition, September 10 through October 30, 1988. No checklist. Text by Pat Ralph. A number of B/W photographs reproduced.

1642 Sioux City Art Center. *New Deal art of the upper Midwest. An anniversary exhibition.* Sioux City Art Center: Sioux City, IA, 1988. 40 pp.

Exhibition, October 8 through December 31, 1988. Checklist of seventy-five works in various media, forty-one prints, twelve posters and a number of FSA photographs. History of the Sioux City Art Center (one of the few WPA/FAP art centers still extant); includes B/W illustrations of a number of works in the exhibition. Essays by Lea Rosson De Long, Michael Gontesky, and Julie D. Nelson.

1643 Harrison, Helen A. and Lucy R. Lippard. *Women artists of the New Deal era.* National Museum of Women in the Arts: Washington, DC, 1988. 40 pp.

Exhibition, October 18, 1988, through January 8, 1989. Checklist of seventy-nine prints and drawings, primarily from the collection of Ben and Beatrice Goldstein. Good essay on the role of women in the New Deal art projects. Numerous B/W illustrations of works. Includes an interview with Ben Goldstein.

1643aa Tweed Gallery. *For a permanent public art: WPA murals in the Health and Hospitals Corporation's collection.* New York: Tweed Gallery, 1988. 32 pp.

Exhibition, December 5, 1988, through January 25, 1989. Catalog of sixty-six murals commissioned through the WPA/ FAP for New York City hospitals. Essays by Gladys Peña, Barbara Hager, and Alan Farancz; interview with mural artist Axel Horn; introductions by Edward I. Koch and Jo Ivey Boufford. Numerous B/W and color illustrations of the murals (including those not included in the exhibition). Brief biographies of the four mural artists included in the exhibition (Abram Champanier, Charles Davis, Axel Horn, and William Palmer).

1643a Markowitz, Gerald and Park, Marlene. "Not by bread alone: Post Office art of the New Deal." *Timeline* 6.3 (1989): 2–19.

Discussion of the role of local history in the Section's post office mural work. B/W illustrations.

1643bb *American Art Notes from Janet Marqusee Fine Arts* (Winter 1989): entire issue, 8 pp.

The Janet Marqusee Gallery in New York City is dedicated to art of the 1920s, 1930s, and 1940s. In this issue, the following New Deal artists have brief biographical sketches and illustrations of their works: Sarah Blakeslee, Otis Oldfield, Ernest Fiene, Emil Ganso, and Albert Pels.

1643b Mullen, Michael. *"Democratic Vistas,* [review]." *Annals of Iowa* 49 (Winter 1989): 619–20.

Favorable review of *Democratic Vistas* (*See* **1569**).

1989

1644 Herzfeld, John. "Medical recovery." *Artnews* 88 (January 1989): 14.

Description of the discovery and restoration of William Palmer's WPA/FAP mural, "The Development of Medicine," lost since 1954 in a forgotten storage site at the Queen's General Hospital. Color illustration of mural detail.

1644a Loughery, John. "National Museum of Women in the Arts revisited." *Woman's Art Journal* 10 (Spring–Summer 1989): 52–53.

In a review of exhibits at the National Museum of Women in the Arts, Loughery includes a discussion of the exhibition, "Women artists of the New Deal era: a selection of prints and drawings," (*See* **1643**).

1644b O'Sullivan, Thomas. "Joint venture or testy alliance? The Public Works of Art Project in Minnesota, 1933–34." *Great Plains Quarterly* 9.2 (1989): 89–99.

Detailed discussion of the PWAP and its work in Minnesota. B/W illustrations of work.

1645 Carlisle, John C. "The big picture: murals in post offices across Texas are reminders of earlier hard times." *Texas Monthly* 17 (August 1989): 94–103.

Excellent pictorial account of New Deal art project murals throughout Texas. Numerous color illustrations of murals.

1645a *American Art Notes from Janet Marqusee Fine Arts* (Autumn 1989): entire issue, 8 pp.

The Janet Marqusee Gallery in New York City is dedicated to art of the 1920s, 1930s, and 1940s. In this issue, the following New Deal artists have brief biographical sketches and illustrations of their works: Saul Berman, Saul Levine, and Simka Simkhovitch.

1645b Gutman, Judith Mara. "The worker and the machine: Lewis Hine's national research project photographs." *Afterimage* 17 (September 1989): 13–15.

Overview of Lewis Hine's documentary photography for the WPA/FAP. B/W illustrations.

1646 Forbes, Malcolm. " '. . . Nothing will destroy our culture while people are free to create . . .' " *Forbes* 144 (October 2, 1989): 20, 262, 264.

Interview with James F. Cooper, editor of *American Art Quarterly*, by Malcolm Forbes. Cooper briefly discusses how the WPA/FAP was an important force in 1930s art world: "[the projects] . . . in the arts began as a relief measure initiated by the Roosevelt Administration during the Great Depression. Much of the important art of that era was created by the WPA projects."

EXHIBITIONS

1647 Lehman College Art Gallery. *Black printmakers and the WPA*. The Lehman College Art Gallery, CUNY: Bronx, NY, 1989. 35 pp.

Exhibition February 23 through June 6, 1989. Checklist of exhibition, fifty-two works by twenty artists; includes a brief history of African-American printmaking. Curated by Leslie King-Hammond. Good exploration of the opportunities created by the WPA/FAP for African-American artists as well as examples of the discrimination practiced against African-Americans.

1647a Washington County Museum of Fine Arts. *WPA prints: Washington County Museum of Fine Arts, April 1–30, 1989.* Hagerstown, MD: The Museum, 1989. 36 pp.

Exhibition, April 1 through 30, 1989. Essay on WPA/FAP prints by Erik S. Nord. Checklist of seventy-seven prints from the collection of the Washington County Museum of Fine Arts. B/W illustrations of thirty-one prints with brief biographies of the artists.

MONOGRAPHS

1648 Beckham, Sue Bridewell. *Depression post office murals and Southern culture: a gentle reconstruction.* Louisiana State University Press: Baton Rouge, 1989. 338 pp.

Excellent account of the Section Post Office murals in the South. Beckham analyzes the murals in a Southern context. Includes an appendix that lists the locations and present disposition of most Section work done in the Southern and Border states. Numerous B/W illustrations.

1649 Carraro, Betty Francine. *A regionalist rediscovered: a biography of Jerry Bywaters.* Ph.D. dissertation, University of Texas at Austin, 1989. 485 pp.

Biographical account of Williamson Gerald (Jerry) Bywaters (1906–1989), who worked on six mural projects in Texas.

NOT SEEN. CITED IN *DAI* v. 50/11-A, p. 3633.

1650 Hurlburt, Laurance P. *The Mexican muralists in the United States.* University of New Mexico Press: Albuquerque, 1989. 320 pp.

Excellent history and critique of the Mexican muralists (José Clemente Orozco, Diego Rivera, and David Alfara Siqueiros) work in the United States and the affect they had on WPA/FAP and Section muralists. B/W and color illustrations.

1651 McDermott, Inez. *The Rincon Annex murals: content and controversy.* MA Thesis, Boston University, 1988.

NOT SEEN.

1652 Rubin, Cynthia Elyce. *ABC Americana from the National Gallery of Art.* Harcourt Brace Jovanovich: San Diego, 1989. 30 pp.

ABC book illustrated with plates from the IAD. Excellent color reproductions of the IAD plates.

1652a Villeponteaux, Mary Alline. *The New Deal: art and democracy.* MA thesis. Virginia Polytechnic Institute and State University, 1989. 100 ll.

1652b Anderson, Elizabeth. "Depression legacy: Nebraska's Post Office art." Nebraska History 71.1 (1990): 23–33.

Discussion of Section Post Office murals in Nebraska. B/W illustrations of murals.

1652c *American Art Notes from Janet Marqusee Fine Arts* (Spring 1990): entire issue, 32 pp.

The Janet Marqusee Gallery in New York City is dedicated to art of the 1920s, 1930s, and 1940s. In this issue, the following New Deal artists have brief biographical sketches and illustrations of their works: Emil Bisttram, James Daugherty, Emil Ganso, Simka Simkhovitch, Mitchell Siporin, and Anthony Sisti.

1652d Brigham, David R. "Bridging identities: Dox Thrash as African American and artist." *Smithsonian Studies in American Art* 4.2 (1990): 27–39.

Discussion of the WPA/FAP work of Dox Thrash. B/W illustrations.

1652e Evans, Ingrid. "Ben Cunningham (1904–1975)." *Nevada Historical Society Quarterly* 33.2 (Summer 1990): 149–53.

Brief discussion of the life and career of Nevadan Ben Cunningham, muralist for the PWAP Coit Tower project and later administrator of the Northern California WPA/FAP.

1652f Growdon, Marcia Cohn. "Robert Cole Caples (1908–1979)." *Nevada Historical Society Quarterly* 33.2 (Summer 1990): 158–61.

Brief discussion of the life and career of Robert Cole Caples, Nevada artist and administrator of the Nevada WPA/FAP.

1652g Yox, Andrew P. "An American Renaissance: art and community in the 1930s." *Mid-America* 72.2 (1990): 107–18.

The contributions of the New Deal Art Projects are covered in a general discussion of the art community of Muncie, IN, during the 1930s. B/W illustrations.

1652h South, Will. "The Federal Art Project in Utah: out of oblivion or more of the same?" *Utah Historical Quarterly* 58.3 (1990): 277–95.

Detailed discussion of the WPA/FAP in Utah. The career of Utah WPA/FAP Elzy J. Bird is covered. B/W illustrations.

NOT SEEN.

1990

1653 "Wilfrid Berg." *American Libraries* 21 (July/August 1990): 628.

Color photograph of Wilfrid Berg completing a mural at the Hackley Public Library (Muskegon, WI) that he had begun for the PWAP in 1934.

1653aa "New Deal art brought culture to postal lobbies: extensive collection still provides enjoyment to customers throughout the nation." *Buckslip* 18 (September 1990): 6–7. NOT SEEN.

1653a Rosenzweig, Roy and Barbara Melosh. "Government and the arts: voices from the New Deal era." *Journal of American History* 77 (September 1990): 596–608.

Overview of oral history projects relating the Federal One. Includes a description of the work done on the New Deal art projects and a survey of the existing literature. Description of the New Deal oral history collections of the Archives of American Art and George Mason University. B/W illustration of cartoon by William Gropper.

1653b Clarke, Orville O. "Visions of our past." *Southern California Home and Garden* (November 1990): 55–61, 90–91.

Overview of New Deal art project contributions in Southern California. Concentrates on public art contributions of the Section, TRAP, and PWAP. Illustrations of works by Belle Baranceanu, Donal Hord, Gordon Grant, Ray Strong, Maynard Dixon, Edward Biberman, George Stanley, Paul Julian, Boris Deutsch, Arthur Ames, and Jean Goodwin.

1654 "WPA artist completes mural." *Federal One* 15 (November 1990): 5.

Note on Wilfrid Berg completing a mural at the Hackley Public Library (Muskegon, WI) that he had begun for the PWAP in 1934.

1654a Brooklyn Museum. *The Williamsburg murals, a rediscovery: five monumental works from the 1930s by Ilya Bolotowsky, Balcomb Greene, Paul Kelpe, and Albert Swinden.* Brooklyn Museum: Brooklyn, 1990. 1 folded sheet.

Exhibition, March 30 through ?, 1990. Installation relating the abstract murals done by the WPA/FAP for the Williamsburg Housing Project in Brooklyn. Text by Barbara Dayer Gallati. NOT SEEN.

1654b Associated American Artists. *The people work.* Associated American Artists: New York, 1990. 16 pp.

Exhibition, June 6 through 29, 1990. Sale exhibition of ninety-three prints depicting images of Labor; many done on the WPA/FAP. Introductory essay by Roberta Lehrman places the prints in their New Deal art project context. Numerous B/W and color illustrations of the prints.

EXHIBITIONS

1655 South Carolina State Museum. *New Deal art in South Carolina: government-supported images from the Great Depression.* South Carolina State Museum: Columbia, 1990. 86 pp.

Exhibition, June 16 through October 14, 1990. Exhibition included FSA as well as WPA/FAP and Section work executed in South Carolina. Curated by Lise C. Swensson. Additional text by Susan Giaimo Hiott, Sue Bridwell Beckham, and F. Jack Hurley. Index of South Carolina New Deal artists. Numerous B/W and color illustrations.

1656 Michael Rosenfeld Gallery. *Figures of speech: social realism of the WPA era.* Michael Rosenfeld Gallery: New York, 1990. 5 pp. typed checklist.

Exhibition, October 9 through November 17, 1990. Checklist of fifty-seven paintings.

MONOGRAPHS

1657 Berman, Avis. *Rebels on Eighth Street: Juliana Force and the Whitney Museum of American Art.* Atheneum: New York, 1990. 572 pp.

Excellent biography of Juliana Force. Extensive coverage of her tenure as New York regional director of the PWAP.

Force's relationship with Edward Bruce as well as her later criticism of the WPA/FAP are also discussed.

1657a Carlton-Smith, Kimn. *A New Deal for Women: women artists and the Federal Art Project, 1935–1939.* Ph.D. dissertation, Rutgers—The State University of New Jersey, 1990. 347 pp.

In depth discussion of the participation of women in the WPA/FAP in New York City.

1657b Clarke, Orville Oliver. *Milford Zornes' Treasury Relief Art Project murals for the Claremont, California, United States Post Office.* MA Thesis, California State University, Fullerton, 1990. 188 pp.

Brief history of the New Deal Art Projects, specifically the TRAP. Detailed study of Milford Zorne's TRAP murals in the Claremont, CA, Post Office. Includes tables showing Section mural and sculptural projects by thematic subject and state. B/W illustrations of Zorne's murals.

1657c Euler, Susan Ray. *Art for a democracy: the WPA's art education programs in Minnesota, 1935–1943.* Ph.D. dissertation, University of Minnesota, 1990. 335 pp.

A general overview of the WPA/FAP program with special emphasis on the work done by WPA/FAP education programs in Minnesota.

1657d Friedlander, Sue. *Broome County, New York's government sponsored Post Office murals of the 1930s.* MA thesis, State University of New York, Binghamton, 1990.

NOT SEEN

1658 Mavigliano, George J. and Richard A. Lawson. *The Federal Art Project in Illinois, 1933–1943.* Southern Illinois University Press: Carbondale, 1990. 257 pp.

In depth study of the WPA/FAP in Illinois with a full background of art relief programs in the state. Covers the careers of the three State WPA/FAP directors (Increase

Robinson, 1935–38; George Thorpe, 1938–41; and Fred Biesel, 1941–43). Appendices list all WPA/FAP artists working in Illinois; all WPA/FAP public sculpture in Illinois; all murals in the state; renderings done for the IAD in Illinois; weekly WPA/FAP employment quotas for Illinois; and WPA/FAP job classifications and salaries for artists. An excellent example of documenting the New Deal art projects. Numerous B/W illustrations of works and photographs of artists at work.

1658a Megraw, Richard. *The uneasiest state: art, culture and society in New Deal Louisiana, 1933–1943.* Ph.D. dissertation, Louisiana State University, 1990. 444 pp.

Thorough examination of the FAP/WPA and Federal patronage in Louisiana. Covers all four of the Federal Arts Projects. Good overview of the work in the state. B/W illustrations.

1659 Phagan, Patricia. *New Deal art in Georgia: a guide to post office murals and sculpture.* Georgia Museum of Art, University of Georgia: Athens, GA, 1990. 8 pp.

Useful guide to Section murals in Georgia. Introductory text describes the nature of the Section in Georgia; guide lists Section art work in thirty-four cities. Brief biographies of artists included. B/W illustrations of work by Jack McMillen, Arthur E. Schwartz, Georgina Klitgaard, Orlin E. Clayton, and Carlo Ciampaglia.

1991

1660 Harris, Jonathan. "Nationalizing art: the community art centre programme of the Federal Art Project 1935–1943." *Art History* 14 (June 1991): 250–69.

Theory-filled overview of the Community Art Center project of the WPA/FAP and its overall relation to the goals and agendas of the New Deal.

1661 Delong, Lea Rosson. "Review of *The Federal Art Project in Illinois: 1935–1943.*" Annals of Iowa 51 (Fall 1991): 219–20.

Review of *The Federal Art Project in Illinois: 1935–1943* (*See* **1658**).

1662 Motian-Meadows, Mary. "Western visions: Colorado's New Deal Post Office Murals." *Colorado Heritage* (Autumn 1991): 15–35.

Detailed discussion of the creation and preservation of TRAP and Section murals in Colorado. B/W illustrations.

1663 Clarke, Orville O. "Of murals, messages and memories." *Los Angeles Times Magazine* (October 13, 1991): 28–29.

Brief essay on New Deal murals in Southern California. Color reproductions of works by Paul Julian, Suzanne Miller, Haldane Douglas, Ray Strong, Caspar Duchow, and Edward Biberman.

1664 DiMichele, David. "Back in the bad old days." *Artweek* 22 (November 28, 1991): 10–11.

Review of exhibition, "Federal Art in Long Beach" at the FHP Hippodrome Gallery (*See* **1671**).

1665 "Newly published book studies gender in New Deal art." *Federal One* 16 (December 1991): 3.

Review of *Engendering culture: manhood and womanhood in New Deal public art and theatre* (*See* **1672**).

1666 Garvey, Timothy J. "*Review of The Federal Art Project in Illinois: 1935–1943.*" *Illinois Historical Journal* 84 (Winter 1991): 287–88.

Review of *The Federal Art Project in Illinois: 1935–1943* (*See* **1658**).

1667 Reid, Robert L. "Review of *The Federal Art Project in Illinois: 1935–1943.*" *Journal of American History* 78.3 (December 1991): 1131–32.

Review of The Federal Art Project in Illinois: 1935–1943 (*See* **1658**).

EXHIBITIONS

1668 Associated American Artists. Federal Art Project: NYC: WPA. Associated American Artists: New York, 1991. 8 pp.

Exhibition, June 11 through July 3, 1991. Sale exhibition of prints from the WPA/FAP, 1935–1943. Checklist of seventy-six prints with numerous B/W illustrations. Exhibition organized by Roberta Lehrman.

1669 Francey, Mary. *American women at work: prints by women artists of the nineteen thirties.* Utah Museum of Fine Arts: Salt Lake City, 1991. 50 pp.

Exhibition, June 23 through August 4, 1991. Brief essays by Francey and Ellen Sragow discuss the role of women in the New Deal art projects, particularly the WPA/FAP. B/W illustrations of works by, and brief biographies of, Ida Abelman, Lucienne Bloch, Helen Green Blumenschein, Minna Citron, Mabel Dwight, Wanda Gag, Riva Helfond, Barbara Latham, Doris Lee, Beatrice Mandelman, Kyra Markham, Claire (Millman) Mahl Moore, Elizabeth Olds, Betty Waldo Parish, Lucia Autorino Salemme, Bernarda Bryson Shahn. Checklist of fifty-five prints.

1670 Milwaukee Art Museum. *'30s America: prints from the Milwaukee Art Museum.* Milwaukee: The Milwaukee Art Museum, 1991. 30 pp.

Exhibition, September 27 through December 8, 1991. Exhibition of 1930s era prints, including WPA/FAP works, from the collection of the Milwaukee Art Museum. Essay by Terrence L. Marvel discusses American printmaking in the 1930s, including the contributions of the WPA/FAP. Checklist of forty prints. B/W illustrations of sixteen prints. Exhibition traveled to three additional Wisconsin sites: Rahr West Art Museum, Manitowoc (July 7 through August 25, 1991); Leigh Yawkey Woodson Art Museum, Wausau (January 11 through March 1, 1992); and the Bergstrom-Maler Museum, Neenah (March 15 through May 10, 1992).

1671 FHP Hippodrome Gallery. *Federal Art in Long Beach: a heritage rediscovered.* FHP Hippodrome Gallery: Long Beach, 1991. 48 pp.

Exhibition, September 29 through December 21, 1991. Exhibition of photographs, prints and artifacts relating to the WPA/FAP activities in the Long Beach, CA, area. Detailed descriptions of eight projects. Artists profiled include: Suzanne Miller, Stanton Macdonald-Wright, Olinka Hrdy, Jean Swiggett, Ivan Bartlett, Carlos Dyer, Arthur Ames, Jean Goodwin, and Grace Clemens. Full account of the Long Beach Municipal Auditorium mosaic. Text by Douglas Hinkey covers history of New Deal art projects in general as well as in California and the Long Beach area. Numerous B/W and color illustrations, a map to New Deal art in the Long Beach area, and a list of lost art.

MONOGRAPHS

1672 Melosh, Barbara. *Engendering culture: manhood and womanhood in New Deal public art and theater.* Washington: Smithsonian Institution Press, 1991. 297 pp.

Explores the depiction of gender in Section projects and Federal Theatre productions. Extensive appendix updates Park and Markowitz's (*See* **1569**) inventory of Section projects. Numerous B/W and color illustrations.

1673 Patrick, Stephen A. *Wendell Cooley Jones: the Johnson City Post Office mural.* MA thesis, East Tennessee State University, 1991.

NOT SEEN.

1674 Emerson, Kimberly Marie. *Guidelines for the rehabilitation of Depression era post offices in Oregon.* MA thesis, University of Oregon, 1991. 289 pp.

Guidelines for the preservation and rehabilitation of Section murals in Oregon Post Offices. Includes case studies of the Post Offices in Bend, Coos Bay, and Eugene.

1675 Tyler, Francine. *Artists respond to the great depression and the threat of Fascism: the New York Artists' Union and its magazine "Art Front" (1934–1937).* Ph.D. dissertation, New York University, 1991. 427 pp.

An extended examination of the role of the Artists' Union and its journal, *Art Front.* Includes a discussion of the WPA/FAP and Section and coverage of these New Deal art projects in *Art Front.*

1676 Westphal, Ruth Lilly and Janet B. Dominik, editors. *American scene painting: California, 1930s and 1940s.* Irvine, CA: Westphal Publishing, 1991. 238 pp.

General overview of California art in the thirties and forties; frequent mention of the New Deal art projects. B/W and color illustrations.

1992

1677 Melosh, Barbara. "Public art and the democratic spirit: a guide to Washington's New Deal masterpieces." *Washington Post Magazine* (January 12, 1992): 1, 17–21.

Guide and discussion of the Section's mural and sculptural work in the Federal buildings of Washington. Color illustrations of the work of William Gropper, George Biddle, Carlos Lopez, Emil Bisttram, Seymour Fogel, Ben Shahn, and Michael Lantz.

1678 Friedman, Martin. "Citywide WPA Arts Festival begins in Cleveland this month." *Federal One* 17.1 (March 1992): 5.

Brief note that the "Cleveland Festival of the WPA: the Golden Years of Federal Support to the Arts," will be held March 5 through June 27 and will include a display of WPA/FAP graphics at the Cleveland Public Library and a reunion of Cleveland WPA/FAP artists.

1679 Vishny, Michele. "Lucienne Bloch: the New York City murals." *Woman's Art Journal* 13 (Spring–Summer 1992): 23–28.

NOT SEEN.

1680 Marling, Karal Ann. "Review of *Engendering Culture: manhood and womanhood in New Deal public art and theater.*" *Art in America* 80 (April 1992): 43, 45, 47.

Generally favorable review of *Engendering Culture: manhood and womanhood in New Deal public art and theater* (*See* **1672**); B/W illustration of work by Sally F. Haley.

MONOGRAPHS

1681 Desalvo, Lora B. *A more abundant life for all: the murals of Massachusetts.* MA thesis. Boston College, 1992. 101 pp.

Written text to accompany an MA thesis film. Examination of Section murals in Massachusetts.

1682 Janet Marqusee Fine Arts. *James Daugherty, 1887–1974: American modernist; works on paper from the New Deal era.* New York: The Gallery, 1992. 16 pp.

Sale catalog of works on paper by James Daugherty. Text by Janet Marqusee. B/W and color reproductions of works by Daugherty.

1683 Lloyd, Lucille. *"California's name": three WPA-sponsored murals.* Sacramento: California State Senate, 1992. 28 pp.

Discussion of three WPA/FAP murals in California. Researched and written by Kathy Humphrey.

1684 New Mexico. Secretary of State. *Discover New Mexico's New Deal treasures.* Santa Fe: Office of the Secretary of State, 1992. 32 pp.

Pamphlet to accompany a 1992 state-wide celebration of New Deal art work in New Mexico. City-by-city guide to New Deal art (primarily Section murals) in the state. Includes a list of

WPA/FAP artists who worked in the state. Essay by Sandra D'Emilio. B/W and color illustrations of work by Russell Vernon Hunter, Emil Bisttram, Lloyd Moylan, William P. Henderson, and Howard Schleeter.

1685 Trebel, Darren Paul. *Anton Refregier's murals in the Rincon Post Office Annex, San Francisco: a Marxist history of California.* M.A. Thesis, University of Virginia, 1992. 91 ll.

Brief overview of the life and career of Anton Refregier. Discussion of the Social Realism movement. Detailed account of the creation and controversies surrounding Refregier's PWAP murals in the Rincon Post Office Annex, San Francisco. B/W illustrations of the mural panels.

EXHIBITIONS

1686 Michael Rosenfeld Galleries. *The WPA Era: Urban views and visions.* New York: The Galleries. 16 pp.

Exhibition, May 12 through June 27, 1992. Checklist of twenty-six works; text by Francis V. O'Connor. Color illustrations.

APPENDIX A:
WHO'S WHO IN THE NEW DEAL FINE
ARTS PROJECTS

Alsberg, Henry G. (1856–1956). Well-known writer and editor, Alsberg became national director of the Federal Writers' Project in 1935. Resigned in 1939.

Baker, Jacob (1895–1945). Administrator of the Federal Emergency Relief Administration and later of the WPA, Baker was one of the principal architects of Federal One and the WPA/FAP. Internal politics and personality conflicts shortened his tenure on the project he created (1935–1936).

Bennett, Gwendolyn (1902–). Artist employed on the PWAP (1934) and WPA/FAP (1935–1941); director of the Harlem Community Art Center (1937–1940).

Biddle, George (1885–1973). Artist. A friend of FDR's since their days at Groton and Harvard, Biddle's letter to the president calling for relief for artists is considered the seed of all the New Deal art projects. Biddle completed a number of works for the Section.

Bruce, Edward (1880–1943). Businessman, lawyer, banker, artist, and head of the Section of Fine Art. Though he showed an early aptitude for art, Bruce established a successful career as a businessman in the Far East. Then at age 42 he left the Far East and his business career to study painting in Italy. After three years of study with Maurice Sterne, he returned and embarked on a successful career as a painter. In 1933, he was instrumental in the creation of the PWAP and was named its chief. Actively working for a successor

organization, he oversaw the creation of the Treasury Department's Section of Painting and Sculpture. Fighting for the integrity and vision of the Section through its various name and administrative changes sapped Bruce's strength, and he died of a heart attack in early 1943.

Cahill, Holger (1887–1960). Born Sveinn Kristján Bjarnarson in Iceland, at an early age Cahill's parents brought him to North America. To escape a difficult childhood, Cahill left home at thirteen, working on ranches, railroads, and as a merchant marine. Deciding to become a writer, he moved to New York City. He took journalism courses at New York University at night and made friends with artists in his Greenwich Village neighborhood. In 1922 he joined the Newark Museum; in 1932 he became exhibitions director of the Museum of Modern Art. While at MoMA, Cahill organized a number of important exhibitions of American folk art. A writer of fiction since the 1920s, Cahill published novels and short stories as well as doing museum work until 1935 when he was chosen as the National Director of the Federal Art Project (1935–1943). Upon leaving the WPA/FAP, he resumed his writing career.

Carmody, John Michael (1881–1963). As first administrator of the Federal Works Agency (July 1, 1939), Carmody oversaw both the WPA/FAP and the Section.

Coffee, John Main (1899–). Democratic representative from Washington (1937–1947). Coffee was responsible for the Bureau of Fine Arts legislation of 1937–1938.

Davis, Stuart (1894–1964). Artist. Davis was an outspoken advocate of government aid for artists as well as an avid proponent of nonrepresentational art. Davis expressed his views in the magazine *Art Front* and other publications.

Defenbacher, Daniel S. (1906–). State Director of the WPA/FAP in North Carolina (1935–1936). After successfully developing the community art center concept in North Carolina, in 1936 Defenbacher was named Assistant to the

National Director in charge of Community Art Centers. In 1939 he resigned to become Director of the Walker Art Center in Minneapolis.

Dows, Olin (1904–1981). Artist and art administrator. Dows was director of the Treasury Relief Art Project (1935–1938) and an important aide to Edward Bruce. His memoirs are a good source of information on the TRAP and Section.

Flanagan, Hallie (1890–1969). National director of the Federal Theatre Project (1935–1939).

Floethe, Richard (1901–). Graphic artist and Head of the New York City WPA/FAP Poster Studio (1936–1943).

Force, Juliana (1876–1948). One of the prime movers and shakers of the Whitney Museum of American Art (c.1913–1948), Force was named New York Regional supervisor of the PWAP (1933–1934). Her administration of the project was controversial.

Harrington, Francis Clark (1887–1940). A member of the US Army Corps of Engineers (1909–1935), Colonel Harrington was named Assistant Administrator of the WPA in 1935; he was named Administrator in 1938 when Harry L. Hopkins left the WPA. His position was retitled Commissioner when the Works Progress Administration became the Work Projects Administration.

Hopkins, Harry Lloyd (1890–1946). A social worker, Hopkins was appointed director of the Federal Emergency Relief Administration in 1933. With bold plans and unfailing energy, he quickly took over the massive Federal relief efforts, culminating in the creation of the WPA in 1935. In December 1938, he was named Secretary of Commerce and held the post for two years. A close friend of FDR, Hopkins helped manage his 1940 campaign and was tapped to lead the Lend-Lease program with the United Kingdom in 1941. Throughout the war, Hopkins remained FDR's closest advisor.

Hunter, Howard Owen (1896–1964). Hunter was successor to Francis C. Harrington as Commissioner of the WPA (acting Commissioner, 1940; Commissioner, October 1941–1943).

Ickes, Harold Le Clair (1874–1952). An important member of the New Deal, Ickes, as head of the Public Works Administration (1933–1938) oversaw the construction of billions of dollars worth of Federal buildings, many of which were adorned with New Deal art.

Kainen, Jacob (1909–). Painter, printmaker, and art historian, Kainen was an employee on the New York City WPA/FAP during the 1930s. After moving to Washington, he became a curator in the Graphic Arts department of the Smithsonian Institution and later head of the graphic arts department of the Smithsonian's National Collection of Fine Arts where he assisted in the collection of New Deal art.

McGranery, James Patrick (1895–1962). Democratic representative from Pennsylvania (1937–1943). McGranery introduced a number of unsuccessful bills attempting to create a Federal art presence.

Macdonald-Wright, Stanton (1890–1973). Artist and arts administrator. Macdonald-Wright worked on mural projects for the PWAP in Santa Monica and then went on to become state director of the WPA/FAP for Southern California (1935–1943). An important proponent of the nonrepresentational styles of art on the New Deal projects.

McMahon, Audrey. Art critic and administrator; McMahon was director of the College Art Association and editor of its journal, *Parnassus.* From the onset of the Depression, McMahon worked for artists' relief and in 1935 was named as director of the New York City WPA/FAP. A tireless supporter of the artist, McMahon fought cuts to the WPA/FAP, but was unable to please all her critics.

Miller, Dorothy Canning (1905–). Art historian and critic. Miller, a curator at the Museum of Modern Art, married

Holger Cahill in 1938. She was responsible for the first major exhibition of New Deal art since the close of the projects in 1963 ("The U.S. Government Art Projects: Some Distinguished Alumni").

Morgenthau, Henry, Jr. (1891–1967). Secretary of the Treasury (1934–1945), Morgenthau and his first wife Elinor (d. 1949) were great supporters of the arts. A good friend of FDR's since the 1920s, Morgenthau was a direct line to the president from Edward Bruce's Section until the Section was placed under the Federal Works Agency (1939).

O'Connor, Francis Valentine (1937–). Art historian. O'Connor's work in the mid-1960s was responsible for resurrecting interest in the New Deal art projects. A writer and editor of a number of works on New Deal art, O'Connor has also contributed to numerous exhibition catalogs.

Parker, Thomas C. (1905–1964). Assistant Director of the WPA/FAP (1935–1940). During the critical 1939–1940 period, Parker served as acting director while Holger Cahill was on sabbatical to work on the New York World's Fair. Parker left the WPA/FAP to become director of the American Federation of Arts (1940–1952).

Peoples, Christian J. Director of the Treasury Department's Office of Procurement. Peoples was Edward Bruce's direct supervisor.

Pepper, Claude Denson (1900–1989). Democratic senator from Florida (1936–1950). Pepper was a strong supporter of the New Deal arts projects. The Coffee-Pepper Federal Bureau of Fine Arts bill (1937–1938) would have permanently established governmental support of the arts. Pepper returned to Congress as a Democratic Representative from Florida in 1963 and served till his death.

Roberts, Lawrence W. Assistant Secretary of the Treasury, Roberts was one of the principal instigators of the PWAP. He wrote the comprehensive final report of the PWAP in 1934.

Roosevelt, Franklin D. (1882–1945). It took some time for FDR's promise of a New Deal to eventually reach America's artists, but when it did, it was on a scale never before seen in governmental patronage of the arts. Key advisors, including Henry and Elinor Morgenthau, George Biddle, Edward Bruce, and FDR's wife Eleanor were able to convince or cajole him into action on behalf of the nation's creative talent.

Roosevelt, Eleanor (1884–1962). A frequent speaker or guest at important gatherings or exhibition openings, Eleanor Roosevelt gave generously of her time and prestige to the New Deal arts projects.

Rothschild, Lincoln (1902–1983). Artist and art administrator. Director of the Index of American Design (1937–1941).

Rowan, Edward Beatty (1898–1946). Art administrator. Rowan and Forbes Watson were second in importance to Edward Bruce at the Section. Working closely with Bruce on all aspects of the program, Rowan oversaw much of the daily work of the Section.

Sirovich, William Irving (1882–1939). Democratic representative from New York City (1927–1939). Medical doctor, lecturer, playwright, and editor as well as statesman, Sirovich was responsible for a number of important pieces of legislation that attempted to make permanent the projects of the WPA's Federal One. A strong supporter of the WPA/FAP, his death stilled an important voice in the Congress for the arts.

Sokoloff, Nikolai (1886–1965). National director of the Federal Music Project (1935–1939).

Somervell, Brehon Burke (1892–1955). A graduate of West Point (1914), Somervell quickly found his niche transporting supplies to American troops during World War I. Working on a number of engineering and supply projects after the war, he was named head of the New York City WPA in 1936. A tough administrator and no friend of the arts, Somervell's

tenure was marked by controversy, protest, and, on the part
of the artists, unbridled hatred. His cutting of wages and
employment allotments and the destruction of a WPA/FAP
mural at Floyd Bennett Field for supposed Communistic
propaganda made him an easy target for the artists. He
returned to military duty in November 1940.

Thrash, Dox (1892–1965). Thrash, an African-American
artist working for the Philadelphia office of the WPA/FAP,
was responsible for the development of the carborundum
print process.

Velonis, Anthony (1911–). Graphic artist. Velonis was
largely responsible for the birth of the silk-screen process
(serigraphy) as a medium for the fine arts. Working in the
poster division of the New York City Graphics Division of the
WPA/FAP (1935–1939), Velonis and the artists who worked
with him created some of the finest work of the New Deal art
projects. His pamphlet, *Technical Problems of the Artist: Tech-
nique of the Silk-Screen Process,* was one of the most popular
publications of the WPA/FAP.

Watson, Forbes (1880–1960). Art critic and administrator.
Watson was one of Edward Bruce's closest advisors on the
Section. His numerous articles in the art and popular presses
reinforced the Section's image as the "quality" federal art
program.

Woodward, Ellen Sullivan (d. 1971). Joining the FERA in
1933, Woodward took over control of Federal One from
Jacob Baker in July 1936 and remained in charge of the
projects through December 1938. Woodward was responsi-
ble for overseeing the restructuring of Federal One as the
needs and goals of the WPA as a whole were modified.

APPENDIX B:
EXHIBITIONS OF NEW DEAL ART,
1934–1990

The following list includes only those exhibitions for which either a catalog/checklist was located or a mention was made of in the form of a review, or note in another publication. Exhibitions held at the Community Art Centers are not noted unless they were nationally organized or of some other note. Needless to say, there are have been many more small local shows of New Deal art—both at the time and now—for which documentation was not located. Numbers in **bold** refer to items in the bibliography.

1934

February 1934
"[Exhibition of PWAP Work]"
M.H. de Young Museum, San Francisco
0052

March 1934
"The Public Works of Art Project: 14th region—Southern California"
Los Angeles County Museum
0124

March 1934
"[PWAP Art Exhibition]"
Cleveland Art Museum
0059

March–August 1934
"Exhibition of Paintings, Water Colors, and Sculpture by
Artists Enrolled in the Public Works of Art Project"
Minneapolis Institute of Art
0057, 0070, 0074

First three weeks in April, 1934
"Exhibition of Public Works of Art Project for Maryland"
Baltimore Museum of Art
0063

April 1–?, 1934
"[PWAP Art Exhibition]"
Kansas City Art Institute
0065, 0070

April 13–29, 1934
"Public Works of Art Project Exhibition"
Cincinnati Museum
0066

April 24–May 20, 1934
"National Exhibition of Art by the Public Works of Art
Project"
Corcoran Gallery of Art, Washington, DC
**0076, 0078, 0079, 0080, 0082, 0083, 0088, 0090, 0091, 0115,
0125**

May 6–13, 1934
"[Exhibition of Works Produced in Washington, Maryland,
and Virginia, PWAP]"
National Museum, Smithsonian Institution, Washington, DC
0126

June 1934?
"[PWAP Art Exhibition]"
Philadelphia Museum of Art
0095

October 1934?
"[PWAP Art Exhibition]"
Newark Museum
0110

October 4–5, 1934
"[PWAP Art Exhibition]"
Nebraska State Historical Society
0135

November 1934?
"[PWAP Art Exhibition]"
Museum of Modern Art, New York City
0116

1935

1935?
"[PWAP Art Exhibition]"
Department of Labor Building, Washington, DC
0210

February 14–16, 1935
"Mural Painting in America"
Grand Central Art Galleries, New York City
0143, 0202

June 6–30, 1935
"Our Government in Art"
Milwaukee Art Institute
0164

October ?, 1935
"[PWAP Print Exhibition]"
University of Colorado, Boulder
0183

October ?, 1935
"[Exhibition of Section Work]"

Corcoran Gallery of Art, Washington, DC
0189, 0196

December 27, 1935–January 11, 1936
"Mural Sketches"
Federal Art Gallery, New York
0203, 0228, 0915

1936

1936?
"[Purposes; Mosaics at the University of California Art Gallery]"
UC Berkeley Art Gallery and M.H. de Young Museum
0332

January 16–28, 1936
"Creative Work of Artist-Teachers"
Federal Art Gallery, New York
0915

February 2–15, 1936
"Easel Paintings"
Federal Art Gallery, New York
0915

February 19–29, 1936
"Graphic Prints and Water Colors"
Federal Art Gallery, New York
0246, 0251, 0259, 0915

March 1936
"[Federal Art Project Exhibition]"
Museum of New Mexico (Santa Fe)
0249

March 1936
"[Federal Art Project Exhibition]"
Salt Lake City State Capitol
0238

March 4–13, 1936
"Paintings by Children"
Federal Art Gallery, New York
0915

March 18–April 4, 1936
"Joint Project Exhibition"
Federal Art Gallery, New York
0915

April 9–20, 1936
"Sculpture"
Federal Art Project Gallery, New York
0915

April 30–May 13, 1936, extended through June 25
"Exhibition of Graphic Prints, Etchings, Lithographs, Wood
 Cuts"
Federal Art Gallery, New York
0263, 0333, 0915

May ?, 1936
"[Section Exhibition]"
Museum of New Mexico, Santa Fe
0255

May 25–June 12, 1936, extended to June 25
"Index of American Design"
Federal Art Gallery, New York
0915

June 5–30, 1936
"The Federal Art Project. Southern California" Los Angeles
 County Museum
0334

June 15–July 5, 1936
"National exhibition. Mural Sketches, Oil Paintings, Water
 Colors and Graphic Arts. Federal Art Project"
Phillips Memorial Gallery, Washington, DC
0262, 0270, 0272, 0275, 0276, 0335

June 20–July 15, 1936
"Drawings for Index of American Design"
R.H. Macy and Company, New York
0336

June 26–July 24, 1936
"Second Easel Paintings, Oil"
Federal Art Gallery, New York
0337, 0915

July 19–August 26, 1936
"Water Colors and Drawings from Easel"
Federal Art Gallery, New York
0915

September 14–October 12, 1936
"New Horizons in American Art"
Museum of Modern Art
**0278, 0284, 0285, 0286, 0287, 0292, 0294, 0296, 0297, 0301,
 0313, 0338, 0387, 0429, 0444, 0488**

October 6–November 6, 1936
"Treasury Department Art Projects Sculpture and Paintings
 for Federal Buildings"
Whitney Museum of American Art
**0261, 0279, 0296, 0299, 0300, 0305, 0306, 0308, 0339,
 0387**

October 19–November 6, 1936
"Exhibition by teachers of the Federal Art Project"
Federal Art Gallery, New York
0340, 0915

November 1–27, 1936
"Purposes; Mosaics at University of California Art Gallery"
M.H. de Young Museum and UC Art Gallery, Berkeley
0341

November 11–December 4, 1936
"Posters"
Federal Art Gallery, New York
0317, 0915

November 17–December 13, 1936
"Treasury Department Art Projects. Painting and Sculpture
 for Federal buildings"
Corcoran Gallery of Art, Washington, DC
0261, 0342, 0393

December 1–?, 1936
"[Federal Art Project Exhibition]"
Southwest Museum, Los Angeles
0377

December 11–24, 1936
"Resettlement Administration Photographs"
Federal Art Gallery, New York
0915

1937

1937?
"Sculpture and Paintings for Federal Buildings for the
 Treasury Art Projects"
Garfield Park Art Gallery, Chicago
0517

January 4–31, 1937
"Prints for the People"
International Art Center, New York City
0382, 0518

January 4–20, 1937
"Children's Paintings"
Federal Art Gallery, New York
0389, 0915

January 26–February 18, 1937
"Second Sculpture Exhibition"
Federal Art Gallery, New York
0915

January 27–February 10, 1937
"Index of American Design"
Fogg Art Museum, Harvard University, Cambridge, MA
0519

February 1937
"[Federal Art Project Exhibition]"
Stendahl Galleries, Los Angeles
0398

February 2–?, 1937
"Local WPA Project"
Portland (OR) Museum of Art
0402

February 16–March 13, 1937
"Exhibition. Mural Studies"
Federal Art Gallery, Boston
0520

February 23–March 23, 1937
"Exhibition of Oil Paintings by Artists in the Easel Division of
 the U.S. Works Progress Administration Federal Art Pro-
 ject [Third Easel Exhibition]"
Federal Art Gallery, New York
0521, 0915

March 1937
"New Horizons in American Art"
Palace of the Legion of Honor, San Francisco
0400, 0410

March 15–April 3, 1937
"National Exhibition, Index of American Design"
Marshall Field and Company, Chicago
0522

March 24–April 21, 1937
"New Horizons in American Art"
Portland (OR) Art Museum
0404

March 30–April 27, 1937
"Recent Fine Prints: Lithographs, Etchings, Drypoints, Mon-
 otypes, Wood Engravings: Made by Artists in the Graphic
 Arts Division of the Works Progress Administration Fed-
 eral Art Project [Exhibition of Recent Fine Prints]"
Federal Art Gallery, New York
0415, 0422, 0523, 0915

May 12–June 9, 1937
"Photography Division of Federal Art Project"
Federal Art Gallery, New York
0915

May 15–June 15, 1937
"Exhibition of Wood Carvings by Patrocino Barcla"
Palace of the Legion of Honor, San Francisco
0423

May 22–June 23, 1937
"Federal Art in New England, 1933–1937"
Addison Gallery, Phillips Academy, Andover, MA
0437, 0441, 0524

May 24–June 3, 1937
"Exhibition of Lithographs and Water Colors of San Fran-
 cisco Golden Gate Bridge"
Emporium Department Store, San Francisco
0423

May 24–June 4, 1937
"Exhibition of Four Mural Panels by Arthur Murray"

San Francisco Museum of Art
0423

?–June 3, 1937
"California Index of American Design"
San Francisco Public Library
0423

June ?–July 11, 1937
"Index of American Design"
Los Angeles Exposition Park
0423

June 1–July 7, 1937
"Exhibition of Lithographs"
Glendora Public Library, CA
0423

June 3–15, 1937
"General Exhibition"
Oregon State Museum Association, Salem
0423

June 15–22, 1937
"General Exhibition"
San Mateo Public Library, CA
0423

July ?, 1937
"Fourth Annual Exhibition of Student Work by the Art
 Division of WPA—Adult Education Program of the New
 York City Board of Education"
Metropolitan Museum of Art, New York City
0449

July 31–August 14, 1937
"Pink Slips Over Culture"
ACA Gallery, New York
0454, 0459

August 1–September 12, 1937
"Federal Art in New England, 1933–1937"
Springfield (MA) Museum of Fine Arts
0427, 0524

August 2–31, 1937
"All-California Process Exhibition. Sculpture, Mosaics, Lithographs, Murals"
Stendahl Galleries, Los Angeles
0526

August 30–September 11, 1937
"4 Out of 500 Artists Dismissed from WPA"
ACA Gallery, New York
0527

September 18–October 10, 1937
"Federal Art in New England, 1933–1937"
Worcester Art Museum, MA
0524

September 28–October 9, 1937
"American Folk Art Sculpture; Drawings of Objects Displayed by the Index of American Design"
Downtown Gallery, New York
0480, 0528

October 1937
"[Index of American Design Exhibition]"
Renaissance Society of the University of Chicago
0528a

October 8–November 7, 1937
"New Horizons in American Art"
Milwaukee Art Institute
0476

October 12–30, 1937
"Water Colors and Drawings"
Federal Art Gallery, New York
0529, 0915

October 16–November 14, 1937
"Federal Art in New England, 1933–1937"
Wadsworth Athenaeum, Hartford, CT
0524

October 30–November 14, 1937
"Posters and Prints. WPA Federal Art Project, Pennsylvania"
Chester County Art Association, PA
0530

November ?, 1937
"Changing New York"
The Museum of the City of New York
0502

November 10–24, 1937
"Regional Art Exhibition"
Federal Art Gallery, New York
0915

November 20–December 11, 1937
"Federal Art in New England, 1933–1937"
Gallery of Fine Arts, Yale University, New Haven, CT
0524

December 1–20, 1937
"Exhibition. Posters and Art Processes, Methods, Materials
and Tools in Sculpture, Graphic Art, Fresco and Poster
Processes"
Federal Art Gallery, New York
0532, 0915

December 3, 1937–January 2, 1938
"Representative Exhibition of the Work of the Rochester
Federal Arts Project"
Rochester Memorial Gallery of Art, New York
0503

December 17, 1937–January 13, 1938 (years are estimated)
"State Museum Exhibition"

Pennsylvania State Museum, Harrisburg, PA
0533

December 23, 1937–January 8, 1938
"Children's Art"
Federal Art Gallery, New York
0534, 0915

1938

January 3–22, 1938
"National Exhibition, Index of American Design, Federal Art Project"
Stix, Baer, and Fuller, St. Louis
0744

January 7–February 6, 1938
"New Horizons in American Art"
Rochester Memorial Gallery, Rochester, NY
0564

January 7–February 6, 1938
"National Exhibition, Index of American Design, Federal Art Project of the Works Progress Administration"
Rochester Memorial Gallery, Rochester, NY
0564

January 8–February 6, 1938
"Federal Art in New England, 1933–1937"
Currier Gallery of Art, Manchester, NH
0524

January 10–31, 1938
"An Exhibition of Selected Skills of the Unemployed. As Demonstrated on WPA Non-Construction Projects."
Smithsonian Institution, Washington, DC
0745

January 19–February 9, 1938
"Printmaking, A New Tradition"
Federal Art Gallery, New York
0577, 0746, 0915

February 12–March 6, 1938
"Federal Art in New England, 1933–1937"
L.D.M. Sweat Memorial Art Museum, Portland, ME
0524

February 16–March 12, 1938
"Illinois Federal Art Project"
Federal Art Gallery, New York
0747, 0915

March 12–April 3, 1938
"Federal Art in New England, 1933–1937"
Robert Hull Flemming Museum, Burlington, VT
0524

March 23–April 6, 1938
"Sculpture"
Federal Art Gallery, New York
0622, 0624, 0748, 0915

April 27–May 11, 1938
"Exhibition: Easel and Water Color"
Federal Art Gallery, New York
0749, 0915

May 10–28, 1938
"Exhibition: WPA Prints, Water Colors"
Federal Art Gallery, Boston
0750

May 24–June 15, 1938
"Murals for the Community"
Federal Art Gallery, New York
0651, 0654, 0655, 0751, 0915

June ?, 1938
"Color Prints in Various Techniques by Four Young WPA
 Artists"
Brooklyn Museum
0656

June 21–July 15, 1938
"Drawings for the Index of American Design"
R.H. Macy and Company, New York
0664, 0752

July 1938
"1938 Dedicated to the New Deal"
ACA Gallery, New York
0658, 0753

July 11–August 12, 1938
"Summer Print Show"
Federal Art Gallery, Chicago
0754

July 20–August 11, 1938
"Exhibition of Work by Teachers in the Art Teaching Division"
Federal Art Gallery, New York
0683, 0755, 0915

July 28–October 9, 1938
"Art for the Public by Chicago Artists"
Art Institute of Chicago
0619, 0670, 0672, 0677, 0684, 0685, 0686, 0687, 0692, 0695, 0698, 0702, 0708, 0756

?–August 20, 1938
"[Harlem Community Art Center Show]"
YWCA, Chicago
0679

August 16–September 8, 1938
"New York and New Jersey Artists"
Federal Art Gallery, New York
0915

September 20–October 11, 1938
"East Side—West Side"
Federal Art Gallery, New York
0757, 0915

October ?, 1938
"[Columbus: WPA Showing at the State Fair]"
Ohio State Fair
0710

October 7–30, 1938
"National Exhibition of Two Hundred Prints by Graphic
Artists"
National Collection of Fine Arts, Smithsonian Institution,
Washington, DC
0719, 0720

October 21–November 11, 1938
"Paintings, Prints, Sculpture, Murals. Four Art Exhibition of
the Federal Art Project"
Federal Art Gallery, New York
0724, 0758, 0915

October 24–November 10, 1938
"Exhibition: Art and Psychopathology"
Harlem Community Art Center
0759

November 18–December 8, 1938
"Regional Poster Exhibition"
Federal Art Gallery, New York
0760, 0915

December ?, 1938
"[Index of American Design]"
Albright Art Gallery, Buffalo
0742

December 10–?, 1938
"Federal Art"
District of Columbia Allocations Gallery
0761

December 22, 1938–January 10, 1939
"Exhibition: Paintings, Prints, Murals, Sculpture, Crafts by
Children"

Federal Art Gallery, New York
0762, 0915

December 22, 1938–January 22, 1939
"Modern Design in Everyday Life"
Spokane Art Center, Spokane, WA
0763

1939

January 24–February 7, 1939
"99 Prints"
Federal Art Gallery, New York
0891, 0915

February 10–24, 1939
"Exhibition of Negro Cultural Work on the Federal Arts
 Projects of New York City Art—Music—Writers—Theatre—
 Historical Records"
Harlem Community Art Center
0892

February 14–March 4, 1939
"Exhibition of Oils, Gouaches, and Water Colors"
Federal Art Gallery, New York
0893, 0915

February 20–March 11, 1939
"American Hands in Action"
E.F. Wahl Department Store, Duluth, MN
1410

February 22–March 8, 1939
"[Graphic Works: WPA/FAP]"
Duluth Art Center
1410

March ?, 1939
"[Providence: Watercolor Renderings of American Crewel
 Embroidery]"

Museum, School of Design, Providence, RI
0814

March 9–April 16, 1939
"Work of New Jersey Artists. Plates from the Index of American Design. Painting and Sculpture"
Newark Museum
0813, 0894

March 15–31, 1939
"Exhibition of Plates from the Index of American Design"
Federal Art Gallery, New York
0895, 0915

March 27–April 21, 1939
"Exhibition Suitable for Allocation. Painting, Sculpture, Prints, Posters"
Russell Sage Foundation, NY
0896

April 4–October 15, 1939
"Frontiers of American Art"
M.H. de Young Museum, San Francisco
0824, 0834, 0835, 890

April 12–30, 1939
"Changing New York"
Federal Art Gallery, New York
0897, 0915

May ?, 1939
"[Middletown: Prints and Paintings of the WPA Pass in Review]"
Davidson Art Rooms, Olin Memorial Library, Wesleyan University, CT
0833

May 3–21, 1939
"Art in the Making"
Federal Art Gallery, New York
0898, 0915

May 23–June 24, 1939
"Functions of the Project"
Federal Art Gallery, New York
0899, 0915

June 1, 1939–late 1940
"American Art Today"
New York World's Fair
0737, 0739, 0822, 0823, 0858, 0861, 0900, 0927, 0980, 0981, 0985, 0986, 0987, 0989, 0990

June 22–July 22, 1939
"Exhibition of Painting"
Federal Art Gallery, Chicago
0901

August 1–23, 1939
"Exhibition: Oils, Watercolors, Prints and Sculpture by Artist Teachers of the Art Teachers' Division"
Federal Art Gallery, New York
0902, 0915

September 1–October 8, 1939
"Southern California Art Project"
Los Angeles County Museum
0903

September 5–30, 1939
"Print Show"
WPA Illinois Art Gallery
0904

November 2–21, 1939
"Exhibition: Painting and Sculpture Designed for Federal Buildings"
Corcoran Gallery of Art, Washington, DC
0879, 0880, 0881, 0905

November 11–22, 1939
"[Exhibition of WPA/FAP Work Done by Children]"

Whitehall Ferry Terminal, NYC
0875

1940

1940
"Mural Designs for Federal Buildings"
Location Unknown
1041

January 8–30, 1940
"Paintings, Sculpture, Index of American Design Plates, Posters [and] Prints. Exhibition by Artists of the New York City Art Project, Work Projects Administration Arts Program"
The American Museum of Natural History, New York
1042

February 27–March 17, 1940
"Loan Exhibition of Mural Designs for Federal Buildings from the Section of Fine Arts"
Whitney Museum of American Art
0958, 0960, 0961, 1043

March ?, 1940
"Exhibition of New Color Prints"
Weyhe Gallery, New York
0962

March 12–31, 1940
"Exhibition of Silk Screen Prints"
Springfield (MA) Museum of Fine Arts
0970, 1044

April 1940
"Mystery and Sentiment"
Museum of Modern Art, New York City
0965, 0975, 1045

April 1940
"Face of America"
Museum of Modern Art, New York City
0965, 0975, 1045

April 1940
"Jerome Lewis"
Museum of Modern Art, New York City
0965, 0975, 1045

April 1940
"35 Under 35"
Museum of Modern Art, New York City
0965, 0975, 1045

April 19–May 6, 1940
"Exhibition of Mural Designs for Federal Buildings for the
 Section of Fine Arts"
National Gallery of Canada, Ottawa
1040

May ?, 1940
"[WPA Art]"
Berkshire Museum, Pittsfield, MA
0982

May 17–June 9, 1940
"This Work Pays Your Community"
Brooklyn Museum
0979

June 27–July 19, 1940
"One Hundred Watercolors an Exhibition by Artists of the
 New York City Art Project"
Tudor City [exhibition space], New York
1046

?–November 20, 1940
"Exhibition by the National Society of Mural Painters"
Whitney Museum of American Art, New York City
1028

November ?, 1940
"[WPA Modern Art]"
Lincoln School of the Teacher's College, New York
1034

November 7–December 29, 1940
"An Exhibition of 'Unpopular' Art"
Walker Art Center, MN
1047

1941

1941
"The Artist in Defense"
Illinois Art Project Gallery, Chicago
1111

1941
"Exhibition of Photographs of Murals and Sculpture"
Location Unknown, Section of Fine Arts
1112

1941
"Watercolors for Decoration"
Location Unknown, Section of Fine Arts
1113

April 21–May 1, 1941
"Exhibition of Children's Art, by Students in the Classes of
 the New York City WPA Art Project"
Associated Artists Galleries, New York
1114

April 23–May 18, 1941
"Index of American Design Show"
Brooklyn Museum
1082

May 15–June 4, 1941
"An Exhibition of Two Hundred American Water Colors"
National Gallery of Art, Washington, DC
1087, 1090, 1102, 1115, 1142

June 9–30, 1941
"As We Were"
Metropolitan Museum of Art, New York City
1116

September ?, 1941
"Work in Use"
Metropolitan Museum of Art, New York City
1100

September 16–30, 1941
"Exhibition of Two Hundred Watercolors from the National
 Competition Held by the Section of Fine Arts"
Whitney Museum of American Art
1117

1942

1942
"I Remember That; An Exhibition of Interiors of a Genera-
 tion Ago"
Metropolitan Museum of Art, New York City
1156, 1159, 1162

March 3–31, 1942
"Between Two Wars"
Whitney Museum of American Art, New York City
1137

April 15–May 17, 1942
"Exhibition of Mural Sketches Commissioned by the Gov-
 ernment of the United States for Federal Buildings. Lent

by the Section of Fine Arts, Public Buildings Administration, Federal Works Agency"
Howard University Art Gallery, Washington, DC
1163

April 20–25, 1942
"WPA Exposición de Trabajos del Programa de Arte de Pennsylvania"
Palcio de bellas artes de México, Mexico City
1164

June 5–28, 1942
"200 American Watercolors"
Baltimore Museum of Art
1144

?–August 14, 1942
"[Anton Refregier]"
ACA Gallery, New York
1147

October 13–31, 1942
"Paintings, Cartoons, Photographs of the St. Louis Post Office Murals by Mitchell Siporin and Edward Millman"
Downtown Gallery, New York
1166

?–November 10, 1942
"Emblems of Unity and Freedom"
Metropolitan Museum of Art, New York City
1152, 1158, 1161

1943

March 22–?, 1943
"Shaker Craftsmanship"
Metropolitan Museum of Art, New York City
1179a, 1181

1944

September 10–24, 1944
"American Prints by WPA Artists"
Portland (OR) Museum of Art
1219

1946

February ?, 1946
"WPA prints in Newark"
Newark Museum
1232

1950

October ?, 1950
"[Index of American Design]"
Whitney Museum of American Art, New York City
1251

1951

June 17–July 8, 1951
"Index of American Design"
Carnegie Institute, Pittsburgh, PA
1263

1961

September 16–October 7, 1961
"Art of the Thirties"
Smolin Gallery, New York
1287, 1288

1962

September 25–October 13, 1962
"Art of the 30s"
Smolin Gallery, New York
1294

1963

July 9–August, 1963
"The U.S. Government Art Projects: Some Distinguished
 Alumni"
Washington Gallery of Modern Art, Washington, DC
1297, 1299

1966

April 6–May 13, 1966
"Federal Patronage: 1933–1943"
University of Maryland Art Gallery
1313, 1316

1967

October 29–November 26, 1967
"WPA Artists: Then and Now"
YM-YWHA of Essex County, NJ
1320

1968

March 1968
"Midwest—The 1930's"

Milwaukee Art Center
1327

October–November, 1968
"Graphic Art of the Depression Era: WPA 1935–1943"
National Collection of Fine Arts, Smithsonian Institution, Washington, DC
1331

1969

February 12–March 10, 1969
"Art Under the New Deal. A selection of Paintings, Graphics and Mural Sketches Produced Under Federal Work Relief Programs from 1933 to 1943"
Columbia Museum of Art, SC
1329

March 10–April 11, 1969
"WPA Sculpture"
Manhattanville College Art Gallery, Purchase, NY
1330

November 5–25, 1969
"Graphic Art of the Depression Era: WPA 1935–1943"
Westby Gallery, Glassboro, NJ
1331

1972

February 1–28, 1972
"WPA Revisited, an Exhibit: Art Works from the Permanent Collection of University Galleries, Southern Illinois University at Carbondale, Mitchell Gallery"
University Galleries, Southern Illinois University at Carbondale, Mitchell Gallery
1362

April 1972
"Art of the Thirties; the ⌐acific Northwest"
University of Washingtoι., Seattle
1363

1973

1973
"New Deal Federally Sponsored Works of Art: Ohio Post
 Office Murals"
Kent State University, OH
1375

February 17–April 22, 1973
"Art in New Mexico: The Depression Years—Federally Spon-
 sored Art in New Mexico, 1933–1943"
Museum of New Mexico, Santa Fe
1388

October 28–December 9, 1973
"Federal Art Patronage: Art of the 30's"
Illinois State Museum, Springfield
1376

1974

September 16–November 1, 1974
"Federal Art in Cleveland, 1933–1943; An Exhibition"
The Cleveland Public Library
1388, 1391, 1392

1976

1976
"American Textiles Lent by the National Gallery of Art from
 the Index of American Design"

International Exhibition Foundation
1419

January 17–June 15, 1976
"New Deal Art, California"
De Saisset Art Gallery and Museum, Santa Clara, CA
1388, 1410, 1420

January 19–March 5, 1976
"Seven American Women: The Depression Decade"
Vassar College Art Gallery, Poughkeepsie, NY
1421

February 15–March 30, 1976
"The Black Artists in the WPA 1933–1943"
New Muse Community Museum of Brooklyn
1422

April 28–May 30, 1976
"Accomplishments: Minnesota Art Projects in the Depression Years"
Tweed Museum of Art, University of Minnesota
1410

May 1976–1977
"WPA/FAP Graphics"
Smithsonian Institution Traveling Exhibition Service [numerous sites across the US]
1410, 1424

October 8–November 6, 1976
"Berenice Abbott Photographs: Changing New York"
Allan Frumkin Gallery
1425

1977

January 23–March 4, 1977
"Woodstock: An American Art Colony 1902–1977"

Vassar College Art Gallery, Poughkeepsie, NY
1441

January 25–February 13, 1977
"New Deal for Art; The Government Art Projects of the
 1930's with Examples from New York City and State"
Tyler Art Gallery, State University of New York College of
 Arts and Sciences, Oswego, NY
1442, 1443

September 25–November 27, 1977
"By the People, for the People: New England"
De Cordova Museum, Lincoln, MA
1445

September 28–October 20, 1977
"The Mural Art of Ben Shahn: Original Cartoons, Drawings,
 Prints and Dated Paintings"
Joe and Emily Lowe Gallery, Syracuse, NY
1446

November 8–December 10, 1977
"New York City WPA Art: Then 1934–1943 and . . . Now
 1960–1977"
Parsons School of Design, New York City
1447

November 13, 1977–January 8, 1978
"New York/Chicago: WPA and the Black Artist" Studio
 Museum in Harlem
1444

November 18, 1977–February 28, 1978
"WPA Prints"
New York Public Library
1448

1978

April 4–May 21, 1978
"New Deal Art in Kansas"

Wichita Art Museum
1457

November 1–December 31, 1978
"Art for the People—New Deal Murals on Long Island"
Emily Lowe Gallery, Hofstra University, Hempstead, NY
1458

November 15, 1978–March 11, 1979
"Murals Without Walls; Arshile Gorky's Aviation Murals
 Rediscovered"
Newark Museum
1460

1979

1979
"The Public as Patron: A History of the Treasury Department
 Mural Program Illustrated with Paintings from the Collec-
 tion of the University of Maryland Art Gallery"
University of Maryland Art Gallery
1474

September 14–December 2, 1979
"Prints for the People: Selections from the New Deal Graph-
 ics Projects"
National Collection of Fine Arts, Smithsonian Institution,
 Washington, DC
1471, 1475

October 4–November 25, 1979
"Murals Without Walls; Arshile Gorky's Aviation Murals
 Rediscovered"
Hirshhorn Museum and Sculpture Garden, Smithsonian
 Institution, Washington, DC
1460, 1471

October 24, 1979–January 13, 1980
"After the Crash"

National Collection of Fine Arts, Smithsonian Institution,
 Washington, DC
1471, 1476

October 26, 1979–January 6, 1980
"Sculpture and the Federal Triangle"
National Collection of Fine Arts, Smithsonian Institution,
 Washington, DC
1468, 1477

1980

January 18–February 15, 1980
"The New Deal in the Southwest, Arizona and New Mexico"
University of Arizona, Tucson
1488

January 19–February 24, 1980
"Wisconsin's New Deal Art"
The Leigh Yawkey Woodson Art Museum, Wausaw, WI
1489

March 26–April 20, 1980
"New Deal Art, New Jersey"
Robeson Gallery Center, Rutgers in Newark, and City without Walls Gallery, Newark
1490

March 27–April 28, 1980
"The New Deal in the Southwest, Arizona and New Mexico"
Northern Arizona University Art Gallery, Flagstaff
1488

May 3–July 20, 1980
"New Deal Art, New Jersey"
New Jersey State Museum, Trenton
1490

May 24–July 13, 1980
"The New Deal in the Southwest, Arizona and New Mexico"
Phoenix Art Museum
1485, 1488

Fall 1980–Spring 1981
"Remembering the Thirties: Public Work Programs in Illinois, a Traveling Exhibition"
University of Illinois at Urbana-Champaign, Urbana
1491

October 4–November 29, 1981
"American Art of the 1930s"
Cedar Rapids Art Center, IA
1511a

October 17, 1980–January 1, 1981
"Portrait of New York: Berenice Abbott"
Chrysler Museum, Norfolk, VA
1492

November 9–December 28, 1980
"Amerika: Traum und Depression, 1920/1940"
Akademie der Künst, Berlin, Germany
1493

1981

1981
"WPA Prints from the 1930's"
Baltimore Museum of Art
1512

January 11–February 15, 1981.
"Amerika: Traum und Depression, 1920/1940"
Kunstverein, Hamburg, Germany
1493

October 16, 1981–February 15, 1982
"Perkins Harnly: From the Index of American Design"
National Museum of American Art, Smithsonian Institution,
 Washington, DC
1513

November 5–28, 1981
"Social Art in America 1930–1945"
ACA Gallery, New York
1514

November 22, 1981–January 10, 1982
"Berenice Abbott: The 20's and the 30's"
International Center of Photography, New York
1528

December 16, 1981–February 7, 1982
"American Art of the 1930s"
Ackland Art Museum, The University of North Carolina at
 Chapel Hill
1511a

1982

January 9–September 26, 1982
"Roosevelt's America: New Deal Paintings from the National
 Museum of American Art"
National Museum of American Art, Smithsonian Institution,
 Washington, DC
1524

January 21–February 22, 1982
"Five Distinguished Alumni: the WPA Federal Art Project.
 An Exhibition Honoring the Franklin Delano Roosevelt
 Centennial"
Hirshhorn Museum and Sculpture Garden, Smithsonian
 Institution, Washington, DC
1525

February 24–April 8, 1982
"American Art of the 1930s"
The Art Gallery, The University of Maryland at College Park
1511a

February 24–April 8, 1982
"The Spirit of the Thirties: Selections from the Collection of
 the University of Maryland Gallery"
University of Maryland Art Gallery
1526

February 28–April 6, 1982
"Can You Spare a Dime?: Art of the New Deal Era"
Muhlenberg College Center for the Arts, Allentown, PA
1527

May 5–June 27, 1982
"American art of the 1930s"
San Antonio Museum of Art
1511a

June 4–August 29, 1982
"Berenice Abbott: the 20's and the 30's"
National Museum of American Art, Smithsonian Institution,
 Washington, DC
1528

July 14–September 5, 1982
"American Art of the 1930s"
Phoenix Art Museum
1511a

September 22–November 14, 1982
"American Art of the 1930s"
Minnesota Museum of Art, St. Paul
1511a

October 26–December 7, 1982
"Brooklyn Themes: Art in the Years of Roosevelt and La
 Guardia"

Museum of the Borough of Brooklyn
1529

December 4, 1982–January 15, 1983
"American Art of the 1930s"
Columbus Museum of Art
1511a

1983

January 1–March 31, 1983
"FDR and the Arts. The WPA Art Projects"
New York Public Library, Stokes Gallery
1540, 1545

February 17–April 3, 1983
"American Art of the 1930s"
The Boise Gallery of Art
1511a

March 5–26, 1983
"Joseph Solman: Work of the Thirties"
ACA Galleries and A.M. Adler, Fine Art, Inc., New York City
1546

April 20–June 12, 1983
"American Art of the 1930s"
Edwin A. Ulrich Museum of Art, Wichita State University
1511a

May 5–September 8, 1983
"The WPA Allocation: Easel Painting from the Federal Art
 Project"
San Francisco Museum of Modern Art
1553

April 3–May 29, 1983
"After the Great Crash: New Deal Art in Illinois"

Illinois State Museum, Springfield
1547

July 8–August 31, 1983
"American Art of the 1930s"
Whitney Museum of Art, Fairfield County, CT
1511a

September 27–November 13, 1983
"Berenice Abbott: Changing New York"
Grunwald Center for the Graphic Arts, UCLA
1548

November 6–December 31, 1983
"Harry Gottlieb: the Silkscreen and Social Conscious of the
 WPA Era"
The Jane Voorhees Zimmerli Art Museum, Rutgers Univer-
 sity, New Brunswick, NJ
1549

1985

1985
"Depression Era Art at the State Museum of History"
Nebraska State History Society
1579

June 28–July 31, 1985
"Federal Art Project: American Prints from the 1930s in the
 Collection of the University of Michigan Museum of Art"
University of Michigan Museum of Art
1580

August 25–October 27, 1985
"New Deal Art: WPA Works at the University of Kentucky"
University of Kentucky Art Museum
1581

October 27–December 1, 1985
"American Art of the Great Depression: Two Sides of the
 Coin"
Wichita Art Museum
1582

1986

May 2–July 27, 1986
"Utah Art of the Depression"
Chase Home Liberty Park, Salt Lake City
1600

October 25–November 30, 1986
"From the 1930s–40s"
Ellen Sragow Gallery, New York
1614

November 4–29, 1986
"50 Years Ago: WPA/AAA"
Washburn Gallery, New York
1601, 1614

November 5–?, 1986
"WPA Art, New York City, 1935–1943"
Phantom Gallery, Los Angeles
1602

1987

March 10–August 31, 1987
"Works Progress Administration's Alaska Art Project 1937. A
 Retrospective Exhibition"
Anchorage Museum of Art and History
1619

July 26–October 18, 1987
"The Graphic Art of Harold Faye"
Hudson River Museum, Yonkers
1620

October 31–13, 1987
"Works Progress Administration's Alaska Art Project 1937. A
 Retrospective Exhibition"
University of Alaska Museum
1619

1988

January 1–5, 1988
"Works Progress Administration's Alaska Art Project 1937. A
 Retrospective Exhibition"
Alaska State Museum
1619

January 15–September 11, 1988
"Special Delivery. Murals for the New Deal Era"
National Museum of American Art, Smithsonian Institution,
 Washington, DC
1636, 1638

March 2–April 9, 1988
"Painting America: Mural Art in the New Deal Era"
 Janet Marqusee and Midtown Galleries, New York
1631, 1635, 1639

April 30–July 18, 1988
"Images of the 1930s: WPA Prints"
Georgia Museum of Art
1633

May 1–June 12, 1988
"Depression Printmakers as Workers: Re-defining Tradi-
 tional Interpretations"
Utah Museum of Fine Arts, Salt Lake City
1640

September 1–October 23, 1988
"Depression Printmakers as Workers: Re-defining Traditional Interpretations"
Boise Art Museum, ID
1640

September 10–October 30, 1988
"Berenice Abbott's New York. Photographs of the 30's and 40's"
Heckscher Museum, Huntington, NY
1641

October 8–December 31, 1988
"New Deal Art of the Upper Midwest. An Anniversary Exhibition"
Sioux City Art Center, IA
1642

October 11, 1988–January 28, 1989
"Prints, Drawings and Paintings"
US General Services Administration, Region 3, Philadelphia
1593

October 18, 1988–January 8, 1989
"Women Artists of the New Deal Era"
National Museum of Women in the Arts, Washington, DC
1637a, 1643, 1644a

December 5, 1988–January 25, 1989
"For a permanent public art: WPA murals in the Health and Hospitals Corporation's collection"
Tweed Gallery, New York
1643aa

1989

February 23–June 6, 1989
"Black Printmakers and the WPA"

The Lehman College Art Gallery, CUNY, Bronx, NY
1647

April 1–30, 1989
"WPA prints: Washington County Museum of Fine Arts"
Washington County Museum of Fine Arts, Hagerstown, MD
1647a

1990

March 30–?, 1990
"The Williamsburg Murals, a Rediscovery: Five Monumental
 Works from the 1930s by Ilya Bolotowsky, Balcomb
 Greene, Paul Kelpe, and Albert Swinden"
Brooklyn Museum
1654a

June 6–29, 1990
"The People Work"
Associated American Artists Gallery, New York City
1654b

June 16–October 14, 1990
"New Deal Art in South Carolina: Government Supported
 Images from the Great Depression"
South Carolina State Museum
1655

October 9–November 17, 1990
"Figures of Speech: Social Realism of the WPA Era"
Michael Rosenfield Gallery, New York
1656

1991

June 11–July 3, 1991
"Federal Art Project: NYC: WPA"

Associated American Artists, New York
1668

June 23–August 4, 1991
"American women at work: prints by women artists of the
 nineteen thirties"
Utah Museum of Fine Arts
1669

July 7–August 25, 1991
" '30s America: prints from the Milwaukee Art Museum"
Rahr West Art Museum, Manitowoc, WI
1670

September 27–December 8, 1991
" '30s America: prints from the Milwaukee Art Museum"
Milwaukee Art Museum
1670

1992

January 11–March 1, 1992
" '30s America: prints from the Milwaukee Art Museum"
Leigh Yawkey Woodson Art Museum, Wausau, WI
1670

March 5–June 27, 1992
"[WPA/FAP Graphics]"
Cleveland Public Library
1678

March 15–May 10, 1992
" '30s America: prints from the Milwaukee Art Museum"
Bergstrom-Maler Museum, Neenah, WI
1670

May 12–June 27, 1992
"The WPA Era: Urban views and visions"

Michael Rosenfeld Galleries, New York City
1686

September 29–December 21, 1991
"Federal Art in Long Beach: a heritage rediscovered"
FHP Hippodrome Gallery, Long Beach, CA
1664, 1671

APPENDIX C:
SECTION COMPETITIONS,
OCTOBER 16, 1934, TO JULY 1943

List of mural and other competitions conducted by the Section. Date given is the closing date for the competition. All competitions are for murals in post office buildings except where noted. Eventual winner(s) of each competition are noted when known. Compiled from Archives of American Art Reel NDA 18, frames 654–66 and Section *Bulletins* #1–24.

Please note that a number of Section commissions were not assigned via competition, but by direct selection of the artist by the Section. These Section works are not included in this list.

Items marked with an asterisk (*) were part of the "48 State Competition," a nationwide competition to ensure that at least one Section mural was in every state of the Union.

ALABAMA

October 2, 1939*
Eutaw
Robert Gwathney

ALASKA

October 27, 1941
Anchorage, Post Office and Court House
Arthur Kerrick
Richard Haines

ARIZONA

April 4, 1937
Phoenix, Post Office and Court House
LaVerne Block
Oscar Berninghaus

October 2, 1939*
Safford
Seymour Fogel

ARKANSAS

October 2, 1939*
Paris
Joseph P. Vorst

CALIFORNIA

March 18, 1935
Beverly Hills
Charles Kassler

February 15, 1939
Burbank
Barse Miller

December 3, 1940
Los Angeles Terminal Annex
Boris Deutsch
Archibald Garner

August 1, 1939
Los Angeles Post Office and Court House (Sculpture)
James Hanson

October 2, 1939*
Los Banos
Lew E. Davis

October 30, 1935
Merced

Dorothy Puccinelli
Helen Forbes

January 15, 1937
San Pedro
Fletcher Martin

July 15, 1936
Santa Barbara (Sculpture)
William Atkinson

May 1, 1935
Stockton
Moya del Pino
Frank Bergman

October 1, 1941
San Francisco, Rincon Postal Annex
Anton Refregier

COLORADO

May 15, 1941
Denver, South Denver
Ethel Magafan

October 2, 1939*
Littleton
John Fraser

CONNECTICUT

April 1, 1935
Bridgeport
Arthur Covey
Robert Lambdin

October 2, 1939*
Hartford, East Hartford Branch
Alton S. Tobey

June 1, 1935
New London
Tom La Farge

September 5, 1941
Southington
Ann H. Spencer

DELAWARE

October 2, 1939*
Selbyville
William Calfee

April 10, 1937
Wilmington
Albert Pels
Harry Zimmerman

DISTRICT OF COLUMBIA

January 15, 1938
Federal Trade Commission Building (Sculpture)
Michael Lantz

April 30, 1937
Interior Department Building
Louis Bouche

October 15, 1936
(September 15, 1935 competition closed without a winner chosen)
Justice Department Building
John Ballator
Emil Bisttram
Symeon Shimin

September 15, 1935
Post Office Department Building (Murals)
Aldred Crimi

Karl Free
George Harding
Doris Lee
Ward Lockwood
William Palmer
Frank Mechau

September 15, 1935
Post Office Department Building (Sculpture)
Stirling Calder
Gaetano Cecere
Chaim Gross
Arthur Lee
Orensio Maldarelli
Berta Margoulies
Attilio Piccirilli
Concetta Scaravaglione
Carl Schmitz
Louis Slobodkin
Heinz Warneke
Sidney Waugh

September 3, 1940
Social Security Building (Sculpture)
Robert Cronbach

October 15, 1940
Social Security Building
Ben Shahn (Lobby)
Philip Guston (Auditorium)

September 1, 1941
Social Security Building (Cafeteria)
Gertrude Goodrich

October 15, 1940
Social Security Building (Front Lobby)
Seymour Fogel

April 1, 1941
War Department Building (Front Keyblocks)
Henry Kreis

August 9, 1940
War Department Building (Relief)
Jean de Marco

September 17, 1941
War Department Building (Two sculptural groups)
Earl Thorp

FLORIDA

October 2, 1939*
DeFuniak Springs
T.I. Laughlin

May 23, 1941
Lake Worth
Joseph D. Myers

March 10, 1937
Miami (competition #1)
NO AWARD

May 2, 1938
Miami (competition #2)
Denman Fink

GEORGIA

October 2, 1939*
Conyers
Elisabeth Terrell

HAWAII

October 25, 1941
Honolulu, Scheffield Barracks (Sculpture)
Roy King

October 25, 1941
Lihue (Sculpture)
Marguerite Blasingame

IDAHO

October 2, 1939*
Kellogg
Fletcher Martin

ILLINOIS

June 15, 1935
Carthage
Karl Kelpe

June 15, 1935
East Alton
Frances Fey

June 15, 1935
East Molina
Edgar Britton

June 15, 1935
Fairfield
William Schwartz

June 15, 1935
Gillespie
Gustaf Dalstrom

June 15, 1935
Melrose Park
Edwin B. Johnson

June 15, 1935
Moline
Edward Millman

June 15, 1935
Vandalia
Aaron Bohrod

June 15, 1935
Wood River
Archibald Motley

October 1, 1941
Chicago, Uptown Station (Ceramic mural)
Henry Varnum Poor

October 1, 1936
Decatur
Edgar Britton
Mitchell Siporin
Edward Millman

March 1, 1939
Evanston (Sculpture)
Armia A. Scheler

October 2, 1939*
Hamilton
Edmund H. Lewandowski

INDIANA

November 30, 1939
Jasper
Jessie A. Mayer

September 1, 1935
Lafayette
Henrik M. Mayer

October 2, 1939*
Spencer
Joseph Meert

IOWA

November 1, 1935
Ames
Lowell Houser

November 1, 1935
Harlan
Richard Gates

November 1, 1935
Cresso
Richard Haines

November 1, 1935
Independence
Robert Tabor

October 2, 1939*
Corning
Marion Gilmore

July 15, 1935
Dubuque
Bertrand Adams
William E.L. Bunn

February 1, 1939
Marion
Dan Rhodes

KANSAS

January 15, 1937
Fort Scott
Oscar Berninghaus

July 15, 1941
Hutchinson
Lumen M. Winter

April 4, 1939
Salina (Sculpture)
Carl Mose

October 2, 1939*
Seneca
Joe Jones

May 1, 1935
Wichita
Ward Lockwood

KENTUCKY

September 15, 1939
Baron
Frank Long

October 2, 1939*
Hickman
William E.L. Bunn

April 15, 1935
Louisville
Henrik M. Mayer

LOUISIANA

November 15, 1940
Carville (Watercolors)
300 works selected

October 2, 1939*
Kunigo
Laura B. Lewis

March 1, 1940
New Orleans, Federal Office Building (Sculpture)
Armia Scheler
Karl Lang

October 1, 1941
New Orleans, Municipal Hall
Jules Struppeck

MAINE

October 2, 1939*
Dover-Foxcroft
Barrie Greenbie

MARYLAND

November 30, 1939
Bethesda
Robert Gates

October 2, 1939*
Elkton
Alexander Clayton

December 1, 1935
Hagerstown
Frank Long

December 1, 1935
Hyattsville
Eugene Kingman

MASSACHUSETTS

July 15, 1935
Holyoke
Ross Moffett

April 15, 1935
Lynn
William Eiseman

October 1, 1936
Somerville
Ross Moffett

October 2, 1939*
Stoughton
Jean Watson

May 2, 1938
Worcester
Ralf Nickelson

MICHIGAN

June 2, 1941
Birmingham
Carlos Lopez

September 15, 1941
Detroit, Jefferson Station (Sculpture)
NO AWARD/SUSPENDED

September 15, 1941
Kalamazoo (Sculpture)
NO AWARD/SUSPENDED

October 2, 1939
Grand Lodge
James Calder

November 30, 1939
East Detroit
Frank Cassara

MINNESOTA

January 2, 1936
Rochester
David Granahan

October 2, 1939*
St. Paul, North Street
Don Humphrey

February 1, 1939
White Bear Lake
Nellie Best

MISSISSIPPI

August 15, 1935
Jackson, Post Office and Court House
NO AWARD

February 15, 1936
Jackson, Post Office and Court House
Simka Simkovitch

October 2, 1939*
Leland
Stuart R. Purser

June 1, 1941
Newton
Mary Beggs

May 14, 1938
Vicksburg, Post Office and Court House
H. Amiard Oberteuffer

MISSOURI

October 2, 1939*
Jackson
James B. Turnbull

September 1, 1939
St. Louis
Edward Millman
Mitchell Siporin

February 1, 1939
St. Louis, Wellston Station
Lumen Winter

MONTANA

February 15, 1939
Deer Lodge
Verona Burkhard

September 1, 1937
Dillon
Elizabeth Lochrie

June 29, 1941
Glasgow
Forest Hill

NEBRASKA

October 2, 1939*
Schuyler
Philip Von Salton

NEVADA

October 2, 1939*
Yerrington, Post Office
Adolph Gottlieb

NEW HAMPSHIRE

October 2, 1939*
Milford
Philip Von Salton

NEW JERSEY

September 3, 1936
Arlington
Albert Kotin

October 2, 1939*
Bordentown
Avery Johnson

May 10, 1939
Freehold
Gerald Foster

June 30, 1935
Newark (Sculpture)
Romauld Kraus

July 26, 1935
Newark (Mural)
Tanner Clark

June 15, 1941
North Bergen
Avery Johnson

October 5, 1935
Summit
Fiske Boyd

NEW MEXICO

October 2, 1939*
Hot Springs
Boris Deutsch

NEW YORK

September 1, 1936
Binghamton
Kenneth Washburn

August 1, 1936
Buffalo, Municipal Hall
William Rowe

September 16, 1941
Canastota
Alison N. Kingsbury

October 2, 1939*
Delhi
Mary Early

February 21, 1938
Flushing, Forest Hills Postal Station (Sculpture)
Sten Jacobsson

June 1, 1935
Hempstead
Pepino Mangravite

December 1, 1939
New Rochelle
David Hutchinson

May 15, 1936
Bronx (Sculpture)
Henry Kreis

January 15, 1938
Bronx (Mural)
Ben Shahn

April 1, 1939
Poughkeepsie
George Klitgaard
Charles Rosen

NORTH CAROLINA

October 2, 1939*
Boone
Alan Thompkins

February 1, 1939
Burlington
Arthur Bairnsfather

July 1, 1935
New Borne
David Silvette

September 10, 1941
Statesville (Sculpture)
Sahl Swars

June 15, 1939
Wilmington
William Pfehl

NORTH DAKOTA

October 2, 1939*
New Rockford
Eduard B. Ulreich

OHIO

May 1, 1935
Barnesville
Michael Sarisky

October 2, 1939*
Bridgeport
Richard Kemah

April 1, 1935
Cleveland
Jack Greitzer

May 15, 1941
Cuyoga Falls
Clifford James

December 1, 1939
Medina
Richard Zoellner

May 15, 1935
Portsmouth
Clarence Carter
Richard Zoellner

April 3, 1935
Haveman
Clarence Carter

April 15, 1935
Springfield
H.H. Wessel

OKLAHOMA

May 15, 1941
Channa
Richard West

October 2, 1939*
Purcell
Fred Conway

OREGON

October 2, 1939*
Burns
Jack Wilkinson

July 1, 1941
Eugene
Carl Morris

February 15, 1939
Salem
Andrew Vincent

June 15, 1935
St. Johns
John Ballator

PENNSYLVANIA

July 15, 1935
Jeannette
Alexander Kestallow

October 2, 1939*
Noreer
Lorin Thompson

April 1, 1935
Norristown
Paul Mays

October 1, 1936
North Philadelphia
George Harding

May 15, 1935
Philadelphia Customs House and Appraisers
George Harding

July 1, 1935
Pittsburgh, Post Office and Court House
Howard Cook
Kindred McLeary
Stuyvesant Van Veen

May 15, 1941
Pittsburgh, Squirrel Hill Postal Station
Alan Thompson

March 4, 1941
York (Sculpture)
George Kratina
Carl Schmidt

PUERTO RICO

February 1, 1939
Maygues
José Maduro

SOUTH CAROLINA

October 2, 1939*
Mullins
Lee Gatch

SOUTH DAKOTA

October 2, 1939*
Flandroom
M.E. Ziegler

TENNESSEE

May 27, 1935
Chattanooga Post Office and Court House
NO AWARD

November 20, 1936
Chattanooga Post Office and Court House
Hilton Leech

October 2, 1939*
Lensix City
David Stone Martin

TEXAS

August 15, 1939
Amarillo
Julius Woeltz

May 2, 1938
Dallas
Peter Hurd

April 2, 1937
El Paso
Tom Lea

October 2, 1939*
Lampasas
Ethel Edwards

May 24, 1941
Longview
Thomas M. Stoll

May 14, 1937
San Antonio
Howard Cook

UTAH

October 2, 1939*
Helper
Jenne Magafan

June 14, 1941
Provo
Everett Thorpe

VIRGINIA

September 10, 1941
Harrisonburg
William Calfee

October 1, 1941
Newport News (Sculpture)
Mary B. Fowler

September 20, 1936
Petersburg
William Calfee
Edwin S. Lewis

October 2, 1939*
Phoebus
William Calfee

WASHINGTON

October 2, 1939*
Shelton
Richard Haines

February 15, 1939
Wenatchee
Peggy Strong

October 15, 1941
Yakima (Sculpture)
Robert Penn
(Contract postponed due to WW II)

WEST VIRGINIA

October 2, 1939*
Mannington
Richard Zoellner

WISCONSIN

October 2, 1939*
Shelton
Charles W. Thwaites

June 9, 1941
Milwaukee, West Allis Branch
Frances Foy

November 30, 1939
Wausau
Gerrit Van W. Sinclair

WYOMING

October 2, 1939*
Greybull
Manuel A. Bronberg

Competitions Conducted for Other Agencies

December 17, 1935
Poster Competition, Treasury Department
Lawrence Wilbur, 1st
David Granahan, 2nd
Sebastian Simonet, 3rd

April 15, 1938
Jefferson Nickel
Treasury Department, US Mint
Felix Schlag

June 1, 1938
New York World's Fair (Sculpture)
Harry P. Camden

September 1, 1938
New York World's Fair (Mural)
George Harding
James O. Mahoney

December 2, 1940
Department of the Interior
Marion Anderson Mural
Mitchell Jamieson

June 1, 1940
US Maritime Commission
Murals aboard the S.S. *President Jackson* and 4 other ships
(*Monroe, Van Buren, Garfield,* and *Hays*)
Adelaide Briggs
Ada Cecere
Willem de Kooning
I. Gardner Orme
Jean Swiggett

January 15, 1942
Office for Emergency Management
109 watercolors, drawings, and prints purchased

January 15, 1942
American Red Cross
Office for Emergency Management
109 watercolors, drawings and prints purchased

March 18, 1942
American Red Cross
71 watercolors, prints, and drawings purchased

March 1, 1943
Recorder of Deeds Building (Washington, DC)
Herschel Levit
Maxine Seelbinder
Ethel Magafan
Carlos Lopez
William Scott
Martyl Schweig
Austin Mecklem

APPENDIX D:
WPA/FAP COMMUNITY ART CENTERS

ALABAMA

Birmingham
Extension Gallery
Healey School Art Gallery
Mobile
Mobile Art Center, Public Library Building

ARIZONA

Phoenix Art Center

DISTRICT OF COLUMBIA

Children's Art Gallery

FLORIDA

Bradenton Art Center
Coral Gables Art Gallery, Coral Gables, Extension Gallery
Daytona Beach Art Center
Jacksonville Art Center
Jacksonville Beach Art Gallery, Extension Gallery
Jacksonville Negro Art Gallery, Extension Gallery
Jordan Park Negro Exhibition Center, St. Petersburg
Key West Community Art Center
Miami Art Center
Milton Art Gallery, Milton, Extension Gallery
New Smyrna Beach Art Center
Ocala Art Center
Pensacola Art Center
Pensacola Negro Art Gallery, Extension Gallery

St. Petersburg Art Center
St. Petersburg Civic Exhibition Center
Tampa Art Center
West Tampa Negro Art Gallery

ILLINOIS

South Side Community Art Center

IOWA

Mason City Art Center
Ottumwa Art Center
Sioux City Art Center

KANSAS

Topeka Art Center

MINNESOTA

Walker Art Center

MISSISSIPPI

Delta Art Center, Greenville
Oxford Art Gallery
Sunflower County Art Center

MISSOURI

The Peoples' Art Center, St. Louis

MONTANA

Butte Art Center
Great Falls Art Center

NEW MEXICO

Gallup Art Center
Melrose Art Center
Roswell Museum Art Center

NEW YORK CITY

Brooklyn Community Art Center
Contemporary Art Center
Harlem Community Art Center
Queensboro Community Art Center

NORTH CAROLINA

Cary Gallery, Extension Gallery
Crosby-Garfield School, Extension Gallery
Greenville Art Gallery
Meedham Broughton High School, Extension Gallery
Raleigh Art Center
Wilmington Art Center

OKLAHOMA

Oklahoma Art Center
 Extension Galleries:
Bristow Art Gallery
Claremore Art Gallery
Clinton Art Gallery
Cushing Art Gallery
Edmond Art Gallery
Marlow Art Gallery
Okmulgee Art Center
Sapulpa Art Gallery
Shawnee Art Gallery
Skiatook Art Gallery
Will Rogers Public Library

OREGON

Curry County Art Center (Grand Beach)
Grande Ronde Valley Art Center
Salem Art Gallery

PENNSYLVANIA

Somerset Art Center

TENNESSEE

Anderson County Art Center
Hamilton County Art Center
LaMoyne Art Center
Peabody Art Gallery

UTAH

Utah State Art Center
 Extension Galleries:
Cedar City Art Exhibition Association
Helper Community Gallery
Price Community Gallery
Provo Community Gallery

VIRGINIA

Big Stone Gap Art Gallery
Children's Art Gallery (Richmond)
Lynchburg Art Gallery
 Extension Galleries:
Alta Vista Extension Gallery
Middlesex County Museum (Saluda)

WASHINGTON

Spokane Art Center
 Extension Galleries:
Lewis County Exhibition Center (Chalhalis)
Washington State College (Pullman)

WEST VIRGINIA

Morgantown Art Center
Parkersburg Art Center
 Extension Gallery:
Scott's Run Art Gallery

WYOMING

Laramie Art Center
 Extension Galleries:
Casper Art Gallery
Lander Art Gallery
Newcastle Art Gallery
Rawlins Art Gallery
Riverton Art Gallery
Rock Springs Art Gallery
Sheridan Art Gallery
Torrington Art Gallery

APPENDIX E:
PWAP REGIONS AND REGIONAL DIRECTORS

Region 1: New England States
Francis H. Taylor

Region 2: New York City and State
Juliana Force

Region 3: Pennsylvania, Delaware, and New Jersey
Fiske Kimball

Region 4: District of Columbia, Maryland, and Virginia
Duncan Phillips

Region 5: Georgia, North and South Carolina, Tennessee, and Florida
J.J. Haverty

Region 6: Louisiana, Arkansas, Mississippi, and Alabama
Ellsworth Woodward

Region 7: Missouri, Kansas, Nebraska, and Iowa
Louis La Beaume

Region 8: Pennsylvania (west of the Susquehanna River) and West Virginia
Homer St. Gaudens

Region 9: Ohio, Indiana, Kentucky, and Michigan
William Milliken

Region 10: Illinois, Wisconsin, and Minnesota
Walter Brewster

Region 11: Colorado, Wyoming, North Dakota, and South Dakota
George L. Williamson

Region 12: Texas and Oklahoma
John S. Ankeney

Region 13: New Mexico and Arizona
Jesse Nusbaum

Region 14: Southern California
Merle Armitage

Region 15: Northern California, Nevada, and Utah
Walter Heil

Region 16: Oregon, Washington, Idaho, and Montana
Burt Brown Barker

APPENDIX F:
LEGISLATION FOR A PERMANENT ART PROJECT

Thirteen attempts were made during the course of the New Deal art projects to create some type of permanent art division within the Federal government.

March 18, 1935
H.J. Res. 220, 74th Congress, First Session
William I. Sirovich (D-NY)
A joint resolution providing for the establishment of an Executive department to be known as the Department of Science, Art, and Literature.
(Hearings held April-May, 1935, House of Representatives, Committee on Patents)

January 5, 1937
H.J. Res. 79, 75th Congress, First Session
William I. Sirovich (D-NY)
A joint resolution providing for the establishment of an executive department to be known as the Department of Science, Art and Literature.

January 5, 1937
H.R. 1512, 75th Congress, First Session
Allard H. Gasque (D-SC)
A Bill to establish a National Bureau of Fine Arts.

August 3, 1937
H.R. 8132, 75th Congress, First Session
James P. McGranery (D-PA)
A bill to establish a Division of Fine Arts in the Office of Education, Department of Interior.

August 16, 1937
H.R. 8239, 75th Congress, First Session
John M. Coffee (D-WA)
A bill to provide for a permanent Bureau of Fine Arts.

January 21, 1938
S. 3296 75th Congress, Third Session
Claude Pepper (D-FL)
A bill to provide for a permanent Bureau of Fine Arts.
(Hearings held February-March, 1938, Senate, Committee
on Education and Labor)

January 21, 1938
H.R. 9102 75th Congress, Third Session
John M. Coffee (D-WA)
A Bill to provide for a permanent Bureau of Fine Arts.

February 7–11, 1938
Hearings held on H.R. 9102 and H.J. Res. 79
US Congress. House of Representatives. Committee on Patents

May 4, 1938
H.J. Res. 671 75th Congress, Third Session
William I. Sirovich (D-NY)
*A joint resolution to create a Bureau of Fine Arts in the Department
of Interior.*

May 26, 1938
House Report 2486 75th Congress, Third Session
U.S. Congress. House of Representatives
Creating a Bureau of Fine Arts.

January 11, 1939
H.R. 2319, 75th Congress, First Session
James P. McGranery (D-PA)
*A bill to establish a Division of Fine Arts in the Office of Education,
Department of Interior.*

February 3, 1939
H.J. Res. 149, 76th Congress, First Session
William I. Sirovich (D-NY)

A joint resolution to create a Bureau of Fine Arts in the Department of Interior.

August 5, 1939
S. 2967, 76th Congress, First Session
Claude Pepper (D-FL)
A bill to provide for a Bureau of Fine Arts.

January 3, 1941
H.R. 600, 77th Congress, First Session
James P. McGranery (D-PA)
A bill to establish a Division of Fine Arts in the Office of Education, Department of Interior.

January 8, 1943
H.R. 900, 78th Congress, First Session
James P. McGranery (D-PA)
A bill to establish a Division of Fine Arts in the Office of Education, Department of Interior.

AUTHOR INDEX

Note: Numbers refer to entry numbers, not book pages.

A.M. Adler, Fine Art, Inc., 1546
Abbott, Berenice, 0906, 1378
ACA Gallery, 0527, 0753, 1227, 1514, 1546
Adams, Grace, 0690
Adams, Katherine Langhorne, 0083
Adlow, Dorothy, 0409
Ajay, Abe, 1369
Alexander, Stephen, 0145
Allan Frumkin Gallery, 1425
Allyn, Nancy Elizabeth, 1530
Alsberg, Henry G., 0127, 1085
Altmeyer, A.J., 0956
American Artists' Congress, 0343, 0907
American Artists' Professional League, 0034, 0072, 0086, 0100, 0108, 0161, 0609, 0627, 0635, 0678
American Federation of Artists, 0997
Ames, Kenneth L., 1519
Anastasi, Anne, 0743
Anchorage Museum of Art and History, 1619
Anderson, Elizabeth, 1652b
Andrews, Paula, 1009
Angly, Edward, 0256, 0365
Ankeney, John S., 0069

Architectural League of New York, 0344
Argul, José Pedro, 1230
Armitage, Merle, 0048
Arms, John Taylor, 0061, 0523
Art in Federal Buildings, Inc., 0764, 0765
Art Institute of Chicago, 0756
Art Week, Committee of Federal Agencies for, 1118
Associated American Artists, 1114, 1654b, 1668
Aswell, Edward C., 0797

B., D., 1100
Baer, Lynne, 1550
Baigell, Mathew, 1393
Baker, Mildred Holzhauer. *See also* Holzhauer, Mildred
Baldwin, Carl, 1382
Baltimore Museum of Art, 1512
Barbeau, Marius, 1261
Barnett, Catherine, 1630
Baron, H., 0753
Barr, Norman, 1447
Bartlett, Lanier, 1052, 1053
Batchen, Geoffrey, 1633a
Baugh, Virgil, 1282
Bear, Donald J., 1378

Beckh, Erica, 1283. *See also*
	Rubenstein, Erica Beckh
Beckham, Sue Bridewell,
	1564, 1648, 1655
Beer, Richard, 0011
Bell, Bernard C., 1119
Bendiner, Robert, 1318
Bengelsdorf, Rosalind, 1367
Bennett, Charles Alpheus,
	0592
Bennett, Gwendolyn, 0413,
	1378
Benson, E.M., 0304
Benson, Elmer A., 0614
Berdanier, Paul F., 0673
Berkman, Aaron, 0146
Berman, Avis, 1657
Berman, Greta, 1411, 1418,
	1437, 1440, 1447, 1458,
	1470, 1546
Bermingham, Peter, 1488
Bernstein, Barbara, 1374a
Bernstein, Joel H., 1300,
	1338
Berryman, Florence S.,
	1150, 1151, 1226
Biddle, George, 0092, 0096,
	0105, 0593, 0610, 0660,
	0691, 0908, 0984, 1035,
	1058, 1115, 1193a
Billington, Ray A., 1290
Binsse, Harry Lorin, 0301,
	0628, 0853
Bintek, Lynn, 1619
Bird, Elzy J., 1378
Bird, Paul, 1252
Birk, Louis P., 0797
Blakey, George T., 1575a
Blasio, Mary-Ann, 1626
Bloch, Julius, 1378
Bloch, Lucienne, 1378
Bloxom Marguerite D., 1531
Blumberg, Barbara Marilyn,
	1394, 1449, 1478

Boag, Robert, 0922
Bosker, Gideon, 1605
Boswell, Peyton, 0076, 0077,
	0120, 0160b, 0162, 0380,
	0482, 0496, 0512, 0576,
	0599, 0606, 0626, 0636,
	0639, 0650, 0668, 0709,
	0735, 0794, 0835, 0889,
	0980, 0988, 0998, 1011,
	1016, 1017, 1072, 1145,
	1160, 1176, 1191, 1194,
	1196, 1198
Boufford, Jo Ivey, 1643aa
Bourne, Francis T., 1236
Bowman, Ruth, 1460
Boyens, Charles William,
	1565
Breeskin, Adelyn D., 0061
Brenner, Anita, 0625
Breuning, Margaret, 0306
Bridaham, Lester B., 1198a
Brigham, David R., 1652d
Brodinsky, Ben P., 0064
Brooklyn Museum, 1654a
Broun, Heywood, 0385,
	0832
Brown, Milton W., 1514,
	1521
Browne, Rosalind Ben-
	gelsdorf. *See also* Ben-
	gelsdorf, Rosalind
Bruce, Edward, 0042, 0054,
	0061, 0078, 0089, 0171,
	0345, 0956, 0973, 1041
Bruner, Ronald Irvin, 1479
Buchalter, Helen, 0090
Bufano, Beniamino Benve-
	nuto, 1378
Bulliet, Charles Joseph, 0297
Burck, Jacob, 0146
Burden, Florence Canfield,
	1576
Burke, Dan E., 1600, 1603
Burnett, Whit, 0797

Burroughs, Margaret Goss,
 1629
Bush, Donald, 1485
Butler, Harold E., 0321
Byrne, Barry, 1096
Bystryn, Marcia N., 1508
Bywaters, Jerry, 1096

C., K., 1635
C., L., 1287
Cahill, Holger, 0338, 0367,
 0464, 0535, 0661, 0774,
 0823, 0927, 0929, 0981,
 1080, 1161, 1209, 1210,
 1223, 1224, 1231, 1281,
 1560
Calcagno, Nicholas A., 1426,
 1629
Calverton, V.F., 0444, 0701
Cameron, Donald, 1000
Carlisle, John C., 1539, 1645
Carlton-Smith, Kimn, 1657a
Carmody, John M., 0973,
 1058
Carr, Eleanor M., 1332,
 1336, 1356, 1382
Carraro, Betty Francine,
 1649
Carroll, Gordon, 0648
Carter, George, 1422
Cashwan, Samuel, 1378
Chadwyck-Healey, Charles,
 1465, 1509
Chilcoat, George W., 1618
Christensen, Erwin O., 1238,
 1243, 1280, 1256
Chrysler Museum, 1492
Citizens' Committee for Sup-
 port of the WPA, 0525
Clapp, Jane, 1364
Clapp, Thaddeus, 1378
Clarke, Orville O., 1618a,
 1636a, 1653b, 1657b, 1663
Clements, Grace, 0230

Clough, F. Gardner, 0458
Coates, Robert M., 0749,
 0797, 0915
Coffee, John Main, 0471,
 0555, 0582, 0588, 0594,
 0780
Cohen, E.L., 1591
Cohen, Paul, 1566
Colby, Merle, 1152
Cole, John Y., 1542
Collins, Amy Fine, 1636b
Columbia Museum of Art,
 1329
Commercial Artists Section of
 the Artists' Union, 0140
Comstock, Helen, 0111
Conkelton, Sheryl, 1549
Contreras, Belisario R.,
 1321, 1551
Cooper, Charlotte Gowing,
 0533
Cornelius, Charles, 1378
Cowan, Sarah E., 0061
Cowdrey, Mary
 Bartlett, 1268
Craig, Lois, 1339
Craton, Ann, 0047, 0053
Craven, Junius, 0035
Cronbach, Robert, 1367
Crosby, Patricia Dunn,
 1514a
Crum, Priscilla, 1048
Cunningham, Ben, 0469
Curtis, Philip Campbell,
 1365
Cusick, Nancy, 1637a

D'Amico, Victor E., 0762
Damrosch, Walter, 0766
Daniel, Pete, 1623
Danysh, Joseph A., 0026,
 0036, 0193, 0250, 0563
Davidson, Jo, 0046
Davidson, Le Roy, 1047

Davidson, Marshall B., 1352,
 1354
Davidson, Martha, 0296,
 0488, 0605
Davis, Maxine, 1001, 1012
Davis, Stuart, 0167, 0172,
 1197, 1378
Dawson, Oliver B., 1405
De Brossard, Chandler, 1070
De Cordova Museum and
 Park, 1445
Defenbacker, Daniel S.,
 0355, 0362, 1378
De Kruif, Henri, 0037
De Long, Lea Rosson, 1520,
 1532, 1642, 1661
D'Emilio, Sandra, 1684
Dennis, James M., 1387,
 1454
De Noon, Christopher,
 1596, 1597, 1622
Department of State, 1049
De Saisset Art Gallery and Mu-
 seum, 1420
Desalvo, Lora B., 1681
Desjardijn, D., 1533
Devree, Howard, 0989
Dewey, John, 0434, 0973,
 1058
de Young Memorial Museum,
 0890
Dieterich, Herbert R., 1371,
 1487
Diller, Burgoyne, 1378
DiMichele, David, 1664
Dinhofer, Shelly M., 1529
Dixon, Francis S., 0061
Dodgson, Campbell, 0513
Doktor, Raphael, 0909
Dominik, Janet B., 1676
Donaldson, Jeff Richardson,
 1395
Dooley, William Germain,
 0365

Doty, Ann V., 1604
Douglas, Elizabeth A., 0641
Downes, Olin, 0578
Downtown Gallery, 0528,
 1166
Dows, Olin, 0166, 0194,
 0374, 0726, 1295, 1301,
 1367
Draper, Theodore, 0328
Driscoll, H.Q., 0674
Dubin, Steven C., 1592
Ducato, Theresa, 1539
Dungan, H.L., 0483
Dunsmore, John Ward, 0061
Durney, Helen, 1133
Dwight, Mabel, 1378

Eglinston, Laurie, 0061
Egner, Arthur F., 0894
Eichenberg, Fritz, 1378
Emerson, Kimberly Marie,
 1674
Emily Lowe Gallery, Hofstra
 University, 1458
Emple, Adam, 0910
Ennis, George Pearse, 0061
Euler, Susan Ray, 1657c
Evans, Ingrid, 1652e
Evans, Robert J., 1376
Evergood, Philip, 0616,
 0893, 1378
Evett, Kenneth, 1374

F., H.L., 1253
Failing, Patricia, 1605
Farancz, Alan, 1643aa
Federal Art Committee,
 0600
Federal Art Gallery (Boston),
 0750
Federal Art Gallery (Chicago),
 0754
Federal Art Gallery (NYC),
 0203, 0332, 0333, 0334,

0335, 0336, 0337, 0348,
0893, 0895
Federal Art Project, 0204,
0205, 0206, 0332, 0333,
0334, 0335, 0336, 0337,
0340, 0346, 0347, 0349,
0350, 0351, 0352, 0353,
0354, 0355, 0356, 0357,
0358, 0423, 0526, 0529,
0531, 0534, 0536, 0537,
0538, 0539, 0540, 0541,
0542, 0544, 0746, 0747,
0748, 0749, 0751, 0755,
0757, 0758, 0759, 0760,
0762, 0767, 0768, 0769,
0770, 0891, 0892, 0896,
0897, 0898, 0899, 0902,
0911, 0912, 0913, 0914,
0915, 0916, 0917, 1042,
1050, 1051
Federal Art Project (IL),
0901, 0904
Federal Art Project (NYC),
0543, 0771, 0772, 0918,
1046, 1057
Federal Art Project (PA),
0530, 0919
Federal Art Project (Southern
California), 0920, 0921,
0922
Federal Works Agency,
0956, 1077, 1084, 1240
Federal Writers' Project,
1378
Federal Writers' Project (MA),
0773
Federal Writers' Project (NV),
0923
Federal Writers' Project (NYC),
0774, 0924
Federal Writers' Project (OR),
1064
Federal Writers' Project (San
Francisco), 0775

Federal Writers' Project (WI),
1065
Feitelson, Lorser, 0922
Feldman, Francis T., 1302
Ferguson, Thomas, 1493
Ferstadt, Louis, 0343
FHP Hippodrome Gallery,
1671
Filler, Louis, 1260, 1267
Finley, David E., 1115
Firm, Ruth M., 1270
Fisher, Jay M., 1512
Flint, Janet A., 1475
Floethe, Richard, 1378
Foley, John P., 0743
Forbes, Malcolm, 1646
Force, Juliana R., 0056, 0069
Ford, Ford Madox, 0433,
0525
Forest Service, 1412, 1567
Foresta, Merry, 1623
Fortress, Karl E., 1619
Foushee, Ola Maie, 1629
Fowler, Harriet W., 1581
Fraden, Rena, 1612
Frances, Emily A., 0061
Francey, Mary, 1640, 1669
Freedman, Elizabeth L.,
1322
Freeman, Richard B., 1345
Freidman, Jeannie, 1455
Fried, Alexander, 0653
Friedlander, Sue, 1657d
Friedman, Arnold, 0244,
0343
Friedman, Martin, 1678
Friend, Leon, 0438
Frost, Rosamund, 0624
Fuller, Mary, 1298

G.J., 1216
Gallati, Barbara Dayer,
1654a
Gambrell, Jamey, 1543

Gardner, Albert Teneyck, 0692
Garfield Park Art Gallery, 0517
Garvey, Timothy J., 1666
Gasque, Allard H., 0554
Gavert, Olive Lyford, 1367
Gedeon, Lucinda H., 1548
Geist, Sidney, 1276
Gelber, Steven M., 1415, 1420, 1466
Gellert, Hugo, 1378
Genauer, Emily, 0287, 1447
Gershoy, Eugene, 1378
Gettens, Rutherford J., 0860, 1378
Gilbert, Gregory, 1549
Glassgold, C. Adolph, 1378
Gleason, Catherine, 1605
Godsoe, Robert Ulrich, 0251, 0263, 0414
Goeller, Charles L., 1140
Gold, Michael, 0511
Goldthwaite, Anne, 0061
Gontesky, Michael, 1642
Goode, James M., 1346
Goodrich, Lloyd, 1242, 1296
Goodwin, Jean (Ames), 1378
Gore, Deborah, 1617a
Gorelick, Boris, 0376
Gorky, Arshile, 1378, 1460
Gosliner, Leo S., 0400
Gosselin, Grace, 0069
Gotheim, Frederick, 1239
Graeme, Alice, 0424
Grafly, Dorothy, 0176, 0579
Graham, Ralph, 1378
Grahan, Otis L., Jr., 1586
Grand Central Art Galleries, 0202
Grauber, Ernest L., 1362
Green, Christopher, 1385
Green, Samuel M., 1248, 1262

Greene, Balcomb, 1378
Greengard, Stephen Neil, 1593
Greer, Nora Richter, 1544
Gregory, Waylande, 1378
Gridley, Katherine, 0113
Griffin, Rachael, 1438, 1461
Groschwitz, Gustav von, 0234, 0518, 0746
Grow, M.E., 0738
Growdon, Marcia Cohn, 1652f
Grunwald Center for the Graphic Arts, UCLA, 1548
Guglielmi, O. Louis, 1378
Gurney, George, 1468, 1477, 1583
Gutieri, Ralph, 0757
Gutman, Judith Mara, 1645b

Hager, Barbara, 1643aa
Hailey, Gene, 0546, 1624
Hall, David August, 1396, 1629
Hall, Helen, 0434
Halpert, Edith, 0061, 0461
Hamlin, Gladys E., 0547, 0849
Hamlin, T.F., 0790a
Hammer, Victor, 0951
Harney, Andy Leon, 1372
Harrington, Francis C., 1050
Harrington, M.R., 0377, 0465
Harris, Alexandrina Robertson, 0061
Harris, Jonathan, 1590, 1613, 1660
Harrison, Helen A., 1361, 1413, 1421, 1458, 1482, 1510, 1643
Harrison, John M., 1279
Hart, Henry, 0776

Hartigan, Lynda Roscoe, 1513
Hartman, Murray, 0893
Hartmann, Sadakichi, 0259, 0663
Hayes, Vertis, 1378
Heckscher Museum, 1641
Heiberg, Einar, 1378
Heineberg, Dora Jane, 1078
Hellman, Geoffrey, 1068
Hendrickson, Kenneth E., Jr., 1557, 1631a
Herscher, Betty, 1236
Herzfeld, John, 1644
Hiler, Hilaire, 1378
Hinckle, Warren, 1415
Hinkey, Douglas, 1671
Hiott, Susan Giaimo, 1655
Hirshhorn Museum and Sculpture Garden (Smithsonian Institution), 1525
Hitchcock, George, 1241a
Holcomb, Grant, 1620
Holme, B., 0313, 0595
Holzhauer, Mildred, 1320, 1629
Hood, Richard, 0727
Hopkins, Harry L., 0795
Hopper, Inslee A., 0196
Hord, Donal, 1378
Hornaday, Mary, 0953
Hornung, Clarence Pearson, 1366
Houston, Raymond W., 0069
Howard, Donald S., 1199
Howard, Henry T., 0003
Howard University Art Gallery, 1163
Howe, Carolyn, 1494
Howe, Thomas Carr, Jr., 0048
Hubbard, Carole Ann Challberg, 1625

Hudson River Museum, 1620
Hugh-Jones, E.M., 0472
Humphrey, Hubert H., 1315
Humphrey, Kathy, 1683
Hunt, Edwyn A., 0808
Hunter, Vernon, 1378
Hurlburt, Laurance P., 1650
Hurley, F. Jack, 1655
Hutchinson, Sara, 1476
Hutson, Ethel, 0634

Ickstadt, Henry, 1611
Illinois Art Project Gallery, 1111
Illinois State Museum, 1376, 1547
Illinois. Southern Illinois University, Carbondale. University Galleries, 1362
Index of American Design, 0519, 0744, 0752, 0925, 1052, 1053, 1120, 1132, 1246, 1497, 1498, 1499, 1500, 1501, 1502, 1503, 1504, 1505
International Art Center, 0518
International Exhibitions Foundation, 1419
Isis, 0303

J., F., 1576a
Jackson, David, 1472
Jacobi, Eli, 1378
Jane Voorhees Zimmerli Art Museum, Rutgers University, 1549
Janet Marqusee Gallery, 1596b, 1611a, 1616a, 1643bb, 1645a, 1652c, 1682
Jewell, Edward Alden, 0473
Jewett, Masha Zakheim, 1409, 1552

Joe and Emily Lowe Gallery, 1446
Johnson, Celia A., 1548
Johnson, Evert A., 1362
Johnson, Nancy A., 1422a
Jones, Dan Burne, 1484a
Jones, Lawrence A., 1378
Jones, Wendell, 1013
Jordan, Jim M., 1460
Jourdan, Albert, 0142
Judd, Maurice B., 0801
Jurstad, Lute, 1605

K., J., 0246, 0386, 0432
K., S., 1254
Kahler, Bruce R., 1596c
Kainen, Jacob, 0343, 1343, 1367
Kalinchak, Paul, 1375
Kaufman, Sidney, 0285, 0302
Kays, Judith S., 1553
Kellner, Sidney, 0618
Kellogg, Florence Loeb, 0093
Kendall, Sue Ann, 1522, 1629
Kent, Rockwell, 0500, 1274a
Kent State University, Division of Art History, 1375
Kerr, Florence, 0825
Key, Donald, 1404
Keyes, Helen Johnson, 0395
Kidd, Stuart, 1637
Kiehl, David W., 1562
Kiesler, Frederick T., 0315, 0386, 1460
King, Albert H., 1054
King-Hammond, Leslie, 1647
Kingsbury, Martha, 1363
Kitchen, Elizabeth F., 1244

Klein, Jerome, 0415, 0862, 0949, 0975, 1014, 1026, 1037
Knaths, Karl, 1378
Knotts, Benjamin, 1162, 1179a, 1201
Kober, Arthur, 0797
Koch, Edward I., 1643aa
Kohn, Robert, 0434
Koller, Selma, 0061
Kopenhaven, Josephine, 0548
Kornfeld, Paul Ira, 1515
Kraemer, Charles J., 0069
Kroll, Leon, 0061, 0069
Kunkel, Gladys M., 1333
Kwolek-Folland, Angel, 1596a
Kyvig, David E., 1626

L., J., 0480
L., J.W., 0960, 1102
Labaudt, Lucien, 0474
La Follette, Robert M., 0973, 1058
La Follette, Suzanne, 0049
Lamade, Eric, 0401
La More, Chet, 1378
Landgren, Marchal E., 1367
Lang, Sherryl P., 1568
Langsner, Jules, 1250
Laning, Edward, 0977, 1340, 1367
Larson, Cedric, 0847
Larson, Kay, 1615a
Lawson, Alan, 1584
Lawson, John Howard, 0797
Lawson, Richard A., 1506, 1658
Leboit, Joseph, 0492
Lehman College Art Gallery, 1647
Lehrman, Roberta, 1654b, 1668

Leigh Yawkey Woodson Art
Museum, 1489
Lemon, Warren W., 0922
Lerrault, Carole L., 1606
Levine, Jack, 1378
Levitas, Louise, 0817
Levitt, Marilyn M., 1257
Lewis, R. Edward, 0608
Lie, Jonas, 0169
Limbach, Russell T., 0260,
0746, 1378
Lindeman, Eduard C., 0418
Lindin, I., 0549
Lippard, Lucy R., 1643
Lipsky, Regina L., 1424
Lloyd, Lucille, 1683
Look, David W., 1606
Los Angeles County Museum,
0124, 0903
Loughery, John, 1644a
Lowe, Jeannette, 0655
Lucie-Smith, Edward, 1585
Ludins, Eugene, 1378
Ludins, Ryah, 0389
Lujan, Joe Roy, 1621

McAllister, Tom, 1605
Macbeth, Robert W., 0061
McCausland, Elizabeth,
0288, 0452, 0505, 0906,
0958, 0963, 1044
McCoy, Garnett, 1309, 1310,
1319
McDermott, Inez, 1651
McDermott, W.L., 1055
McDonald, William Francis,
1334
Macdonald-Wright, Stanton,
0903, 0922, 1378
McElvaine, Robert S., 1634
McGranery, James P., 0553,
0935, 1123, 1205
Mac-Gurrin, Buckley, 0398
MacHarg, Katherine, 1148

McKinzie, Richard D.,
1327a, 1377, 1586, 1615
McLaurin, B.F., 0434
McMahon, A. Philip, 0876
McMahon, Audrey, 0001,
0061, 0069, 0223, 0529,
0771, 1367, 1378, 1447
Mahoney, Robert, 1631
Malone, Molle, 1577
Manhattanville College Art
Gallery, 1330
Marantz, Irving J., 1378
Marin, C.S., 0652
Markowitz, Gerald, 1442,
1443, 1458, 1569, 1643a
Marling, Karal Ann, 1347,
1369, 1389, 1392, 1421,
1436, 1441, 1464, 1522,
1534, 1632, 1680
Marqusee, Janet, 1639, 1682
Marshall Field and Company,
0522
Marshall, Margaret, 0283
Marvel, Terrence L., 1670
Masters, Greg, 1614
Mathews, Marcia M., 1374b
Matthews, Jane De Hart,
1406
Mavigliano, George T.,
1323, 1362, 1506, 1561,
1658
Maxey, Stevens, 0621
Mayor, A. Hyatt, 1027
Mecklenburg, Virginia M.,
1474, 1513, 1524, 1638
Meeks, Oliver G., 1121
Megraw, Richard, 1658a
Meixner, Mary L., 1558
Melosh, Barbara, 1653a,
1672, 1677
Meltzer, Milton, 1427
Melville, Annette, 1507
Metropolitan Museum of Art,
1116, 1161, 1201

Mexico, Departamento de Información para ed extranjero, 1164
Meyers, John, 1518
Michael Rosenfeld Gallery, 1656, 1686
Michie, Mary, 1489
Midtown Gallery, 1639
Miller, Dorothy Canning, 0208, 0360, 0550, 0777, 0926, 1056, 1122, 1167, 1202, 1203
Miller, Lee G., 0831
Miller, Lillian B., 1511
Millier, Arthur, 0177, 0485, 0680
Mills, Jack, 1605
Milwaukee Art Center, 1327
Milwaukee Art Museum, 1670
Monroe, Gerald M., 1348, 1358, 1373, 1382, 1386, 1390, 1417, 1456
Morgan, Theodora, 1337
Morgenthau, Henry, 0973, 1058
Morris, Carl, 1378
Morrison, Richard C., 0524, 0954
Morsell, Mary, 0013, 0079, 0475, 0826, 1378
Morton, Charlotte, 0423
Morton, Leonora, 0061
Motian-Meadows, Mary, 1662
Muhlenburg College Center for the Arts, 1527
Mullen, Michael, 1643a
Mumford, Lewis, 0259, 0286, 0329, 0525
Munro, Sarah, 1461, 1605
Museum of Modern Art, 0338, 1045

Museum of the Borough of Brooklyn at Brooklyn College, 1529

Nahr, Edwin, 0922
Narber, Gregg R., 1520, 1532
National Collection of Fine Arts (Smithsonian Institution), 1475, 1476, 1477
National Gallery of Art, 1115, 1307
National Gallery of Canada, Ottawa, 1040
National Museum (Smithsonian Institution), 0126
National Museum of American Art (Smithsonian Institution), 1513, 1528, 1554, 1638
National Park Service, 0361
Naylor, Blanche, 0425
Nebraska State History Society, 1579
Nelson, Julie D., 1642
Netsky, Ron, 1620
Neue Gesellschaft für Bildende Kunst, 1493
New Mexico, Secretary of State, 1684
New Muse Community Museum of Brooklyn, 1422
New York Public Library, 1274, 1448, 1545
New York World's Fair, 0900, 0927
Newark Museum, 1460
Newell, James Michael, 1378
Noble, Elizabeth, 0278, 0305, 0502, 0580
Nord, Erik S., 1647a
Norman, Geoffrey, 1378

Norman Turano, Jane van, 1572b
Nosanow, Barbara Shissler, 1528

O'Connor, Francis V., 1316, 1326, 1328, 1335, 1340, 1367, 1378, 1388, 1410, 1414, 1423, 1458, 1460, 1493, 1595a, 1686
O'Connor, J., Jr., 1139, 1263
O'Donnell, Terrence, 1605
O'Hanlon, Richard, 1415
Ogburn, Hilda Lanier, 1378
Olds, Elizabeth, 1378
Olin, Dirk, 1616
O'Neal, Hank, 1428
Osborne, David S., 1277
Osnos, Nina Felshin, 1351
O'Sullivan, Thomas, 1644b
Overmeyer, Grace, 0928
Overstreet, Harry, 0433

P., N.H., 0439
Paris, Dorothy, 0061
Park, Marlene S., 1442, 1443, 1458, 1469, 1569, 1643a
Parker, Thomas C., 0486, 0632, 0646, 0890
Parsons School of Design, 1447
Patrick, Stephen A., 1673
Paul, April J., 1473
Payant, Felix, 0378, 0791, 0978, 1003
Pearson, Ralph M., 0149, 0168, 0316, 0343, 0379
Peixotto, Ernest, 0061
Pemberton, Murdock, 0799
Peña, Gladys, 1643aa
Pennsylvania Academy of the Fine Arts, 0929

Pennsylvannia State Museum, 0533
Pepper, Claude, 0582, 0594, 0784, 0941
Perkins, Frances, 1237, 1241
Petersen, William J., 0792
Peticolas, Sherry, 0922
Petravage, Jacqueline, 1349, 1367
Phagan, Patricia E., 1633, 1659
Phantom Gallery, 1602
Piccoli, Girolamo, 0748, 1378
Pickens, George, 0893
Pietan, Norman, 1247
Piper, Natt, 0676
Pollack, Merlin F., 1619
Pontello, Jacqueline M., 1636
Pound, Beverly Anne, 1450
Pousette-Dart, Nathaniel, 0642
Price, Frederic Newlin, 0061
Public Buildings Administration, 0905
Public Use of Art Committee, 0659
Public Works of Art Project, 0017, 0018, 0125, 0128, 0129, 0130, 0131, 0132, 0201, 0209
Puccinelli, Dorothy, 1091
Purcell, Ralph, 1278

Quill, Michael, 0434
Quirt, Walter, 1378

Raleigh Art Center, 0362
Ralph, Pat, 1641
Ramirez, Jan S., 1620
Randau, Carl, 0797

Randle, Mallory Blair, 1312, 1324
Randolph, A. Philip, 0567
Reeves, Ruth, 0506, 0631, 1021
Refregier, Anton, 1291
Reid, Albert T., 1217
Reid, Robert L., 1667
Renaissance Society of the University of Chicago, 0528a
Retson, Nancy, 1451
Rhoads, William B., 1538
Rich, Daniel Catton, 0756, 1076
Robeson Gallery, 1490
Robinson, Amy, 1245a
Robinson, Mary Turlay, 0061
Rogers, Bob, 0493
Rogers, Kathleen Grisham, 1397
Rohde, Gilbert, 0289
Roosevelt, Eleanor, 0103, 0684
Roosevelt, Elliott, 1258
Roosevelt, Franklin D., 0019, 0210, 0551, 0930, 1168
Rose, Barbara, 1325, 1572
Rosenberg, Harold, 0591
Rosenberg, Harold, 1355
Rosenburg, Jacob, 0434
Rosenwald, Janet, 0552
Rosenzweig, Roy, 1607, 1653a
Rothenstein, John, 1185
Rothman, Henry, 0317
Rothschild, Lincoln, 0723, 0895, 1378, 1367
Rourke, Constance, 0274, 0419, 0501, 0519, 1378
Rowan, Edward B., 0051, 0104, 0166, 1040, 1101
Rowin, Fran, 1429

Rubenstein, Erica Beckh, 1220. *See also* Erica Beckh
Rubenstein, Lewis, 0261
Rubin, Cynthia Elyce, 1653
Ruby, Christine M. Nelson, 1653
Rugg, Harold, 0397, 0839
Russell, Charles, 1042
Ryder, Worth, 0119

Sacartoff, Elizabeth, 1095
Sahadi, Natasha, 1462
Salomen, Samuel, 0856
Sawyer, Charles H., 1445
Saxe, Myrna, 1558
Sayre, A.H., 0241
Schack, William, 0290
Scheinman, Muriel, 1516
Schnee, Alix Sandra, 1627
Schneider, Eric, 1593a
Schoonmaker, Nancy, 0440
Schrader, Robert Fay, 1555
Schwankovsky, Frederick J., 0182
Schwartz, Ellen, 1624
Schwartz, Manfred, 0061
Scoon, Carolyn, 1269, 1382a
Scott, Barbara Kerr, 1556, 1629
Searle, Charles F., 1303
Sears, Arthur W., 0318
Section of Painting and Sculpture, 0147, 0153, 0155, 0166, 0175, 0181, 0194, 0211, 0222, 0235, 0261, 0277, 0339, 0342, 0399, 0443, 0590, 0643, 0689, 0798, 0842, 0872, 0905, 0956, 1007, 1041, 1112, 1113, 1204
Seeley, Evelyn, 0101
Seeley, Sidney W., 0931
Seldes, George, 0797
Semons, Lillian, 0751, 0915

Shaffer, Helen B., 1286
Shanafelt, Clara, 1071
Shapiro, David, 1379, 1458
Shealy, Oscar, 1463
Sherman, Allan, 0996
Sherman, Randi E., 1403
Sherwood, Leland Harley, 1398
Sidney, Sylvia, 0797
Sims, Patterson, 1511a
Sioux City Art Center, 1642
Siporin, Mitchell, 1378
Sirovich, William I., 0212, 0482, 0556, 0649, 0781, 0937
Sizer, T., 0165
Skaug, Julius, 1259
Skull, Carl, 1275
Smith, Clark Sommer, 1311
Smith, David, 1378
Smith, E. Herdon, 1378
Smith, Gordon M., 1378
Smith, Margery Hoffman, 0967
Smith, Sherwin D., 1308
Smithsonian Institution Traveling Exhibition Service, 1423, 1424
Smolin Gallery, 1294
Soelle, Sally, 1556, 1569a
Sokol, David M., 1381
Solman, Joseph, 1367, 1430a
Sommer, William, 1378
South Carolina State Museum, 1655
South, Will, 1652h
Spokane Art Center, 0763
Springfield Museum of Fine Arts, 1044
Spurlock, William H., 1399
Sragow, Ellen, 1669
Stange, Maren, 1623
Stanley-Brown, Katherine, 0098

Starobin, Joseph, 0838
Stavenitz, Alexander R., 0755, 0759, 0902, 1378
Stein, Pauline Alpert, 1570
Stein, Sally, 1623
Steinbach, Sophia, 0392, 0573
Sterner, Frank W., 0860
Stevens, Elizabeth, 1313
Stewart, David Ogden, 0797
Stewart, Ruth Ann, 1444, 1447a
Stott, William, 1380
Stretch, Bonnie Barrett, 1539
Strobridge, Truman R., 1289
Studio Museum in Harlem, 1447a
Sundell, Michael G., 1483
Sutton, Harry H., 1378
Swain, Martha H., 1536a
Swensson, Lise C., 1655

Taylor, Francis Henry, 0229
Taylor, Henry White, 0584
Taylor, Joshua C., 1471, 1493
Terkel, Louis (Studs), 1342
Thomas, Elbert Duncan, 0973, 1058
Thompson, Archie, 0549
Tillim, Sidney, 1288
Tinkham, Sandra Shaffer, 1493
Tobias, Beatrice, 0585
Tolbert, Bernice, 1480
Tone, Franchot, 0797
Tonelli, Edith Ann, 1484, 1517
Toomey, Anne, 0707
Towey, Martin G., 1629
Townsend, Helen Ann Beckstorm, 1587

Treasury Department. *See also* Section of Painting and Sculpture
Treasury Department Art Project, 0779
Trebel, Darren Paul, 1685
Trentham, Eugene, 1378
Tritschler, Thomas Candor, 1400
Truman, Priscilla, 1430
Tweed Gallery (NYC), 1643aa
Tweed Museum of Art (University of Minnesota), 1422a
Tyler, Francine, 1675

US *See also* under the individual agencies
US Commission of Fine Arts, 1059, 1221
US Congress, 0133, 0934, 0936, 0937, 1169
US Congress. House of Representatives, 0212, 0553, 0554, 0555, 0556, 0780, 0781, 0782, 0935, 1123, 1170, 1205
US Congress. House of Representatives. Committee on Appropriations, 0557, 0938, 0939, 1206, 1207
US Congress. House of Representatives. Committee on Patents, 0213, 0783
US Congress. House of Representatives. Committee on Public Works, 1272
US Congress. House of Representatives. Subcommittee of the Committee of Appropriations, 0940, 1124, 1171
US Congress. Senate, 0784, 0941

US Congress. Senate. Committee on Appropriations, 0785, 0942, 0943
US Congress. Senate. Committee on Education and Labor, 0786
US Federal Emergency Relief Administration, 0363
US General Services Administration, 1627a
US Public Buildings Administration, 0944
US Public Buildings Service, 1609, 1610
University of California (Berkeley Art Gallery), 0341
University of Illinois at Urbana-Champaign, 1491
University of Maryland (Art Gallery), 1526
University of Michigan (Museum of Art), 1580
University of Wisconsin, Milwaukee, 1341

Van Cleve, Jane, 1605
Vanderkooi, Fanny Bowles, 1060
Van Derzee, Charlene Claye, 1422
Vane, Peter, 0416
Van Neste, Rene, 0922
Van Neste, W. Lane, 1282
Vasaio, Antonio, 1571
Vassar College Art Gallery, 1421, 1441
Velonis, Anthony, 0991, 1125, 1378
Vermeers, Arthur, 0922
Villeponteaux, Mary Alline, 1652a
Vishny, Michael, 1617, 1679

Vlach, John Michael, 1574
Von Wiegand, Charmion, 0442, 0450, 0454

Wahl, Jo Ann, 1317
Walker Art Center, 1047
Wander, Meghan Robinson, 1586
Ward, Lynd, 0891, 0974
Warsager, Hyman, 0492, 1378
Washburn Gallery, 1601
Washington County Museum of Fine Arts, 1647a
Washington Gallery of Modern Art, 1299
Watrous, Harry W., 0046, 0061
Watson, Ernest, 1266
Watson, Forbes, 0022, 0023, 0067, 0075, 0116, 0138, 0165a, 0173a, 0237, 0339, 0342, 0345, 0816, 1040, 1043, 1115, 1163
Watson, Jane, 0997, 1006, 1085, 1092, 1131, 1105
Weaver, John Henry, 0044, 0160
Weber, Max, 0478, 0527
Webster, J. Carson, 1265
Wechsler, James, 0515
Weinstock, Clarence, 0319
Weintraub, Linda, 1527
Weir, Jean Burwell, 1452, 1461
Weisenborn, Fritzi, 0830
Wellman, Rita, 0661
Wells, Richard D., 1588
Wells, Summer, 0973, 1058
Werner, Alfred, 1408
Werthman, Jean, 1350
Wessels, Glenn, 0052, 0298

Westby Gallery (Glassboro State College, NJ), 1331
Westphal, Ruth Lilly, 1676
Wheat, Ellen Harkins, 1628
White, John Franklin, 1629
Whitehill, Virginia N., 1184
Whiting, F.A., Jr., 0117, 0275, 0406, 0508, 0848, 0883, 1134
Whiting, Philippa, 0151
Whitney Museum of American Art, 1043, 1117, 1165, 1511a
Wichita Art Museum, 1457
Wilcox, Jerome Kear, 0134
Willard, Irma Sompayrac, 1228
Willett, Ralph, 1589
William, Earle, 0922
Williams, David, 1599
Williams, Reba, 1599
Wish, Harvey, 1229
Witte, Ernest F., 0135
Wolff, Robert Jay, 1378
Wooden, Howard E., 1582
Woodward, Ellen S., 0568
Woolfenden, William E., 1304
Works Progress Administration (after 1939 Work Projects Administration), 0214, 0215, 0216, 0217, 0218, 0219, 0220, 0221, 0292, 0359, 0364, 0365, 0366, 0367, 0368, 0369, 0370, 0524, 0558, 0559, 0560, 0561, 0745, 0787, 0778, 0779, 0780, 0781, 0782, 0783, 0784, 0785, 0786, 0787, 0788, 0789, 0945, 0946, 1061, 1062, 1063, 1126, 1127, 1128, 1172, 1208. See also Federal Art

Project; Federal Writers'
Project
Wright, Philip, 0365
Wyman, Marilyn, 1481,
1535

Yasko, Karel, 1357, 1489
YM-YWHA of Essex County,
New Jersey, 1320

York, Hildreth, 1486, 1490,
1522
Yountz, Philip N., 0433
Yox, Andrew P., 1652g

Zigrosser, Carl, 0746, 1109,
1165
Zilczer, Judith, 1525
Zorach, William, 0434

SUBJECT INDEX

Note: Numbers refer to entry numbers, not book pages.

Aalbu, Olaf, 0807
Abbott, Berenice, 0569, 1483, 1545, 1623
Abelman, Ida, 1562, 1669
Abraham Lincoln High School (NYC), 0143
Abramovitiz, Albert, 0234
Abramson, Hirshel, 1575
Abstract Art, 1411, 1416, 1523, 1572, 1590, 1601, 1614
Abstract Expressionism, 1411, 1572, 1590
ACA Gallery (NYC), 0386, 0454, 0459, 0524, 0527, 0658, 0753,
 1147, 1227, 1231, 1514, 1546
Adams, Alva B., 0943
Adams, Bertrand R., 0155, 0235
Adams, Kenneth M., 0174, 0240, 0277
Addison Gallery (MA), 0437, 0441, 0524
African-American artists, 0359, 0413, 0892, 0983, 1173, 1378,
 1395, 1422, 1437, 1447a, 1472, 1480,1612, 1625, 1628, 1647,
 1652d
Agriculture Building, Department of, 0082, 0085
Aid for artists, 0150
Ajay, Abe, 0844, 0907, 1359
Akademie der Kunst (Berlin), 1493
Alameda County Court House (CA), 0497
Alaska, 0462, 1619
Alaska State Museum, 1619
Albinson, E. Dewey, 0093
Albright-Knox Gallery (NY), 0742
Albrizzio, Conrad A., 0277
Albro, Maxine, 0318, 0475, 0546, 1210
Allen, Lee, 1329
Allocation Gallery (DC), 0761
Alston, Charles Henry, 1437
Amateis, Edmond Romulus, 0399, 1036, 1098, 1337

American Abstract Artists, 1367, 1400, 1601, 1614
American Artists' Congress, 0183, 0243, 0309, 0343, 0429, 0612,
 0844, 0907
American Association of Adult Education, 0089
American Association of Museums, 0486, 1076
American Federation of Artists, 0103, 0104, 0105, 0478, 0572,
 0997
American Indians. *See* Native Americans
American Institute of Architects, 0447
American Museum of Natural History (NYC), 1042
American scene, 1393, 1617a, 1569
Ames, Arthur, 1653b, 1671
Anchorage Museum of Art and History (AK), 1619
Anderson, Knud, 0399, 1342
Anderson, Mary, 0685
Archer, Robert, 0986
Architectural League of New York, 0570
Archives of American Art (Smithsonian Institution), 1293, 1304,
 1306, 1309, 1653a
Arizona, 1365, 1396, 1485, 1488
Arnautoff, Victor Michail, 0730, 1272
Arsena, Mick, 0294
Art Front, 1373, 1675
Art in Federal Buildings (Review), 0394, 0406, 0426, 0439, 0507
Art Institute of Chicago, 0324, 0619, 0670, 0672, 0684, 0685,
 0686, 0692, 0695, 0698, 0702, 0708, 0756
Art instruction, 0064, 0104, 0340, 0392, 0425, 0721, 0791, 0859,
 0902, 0917, 0922, 0985, 1073, 1148, 1462, 1515, 1618,
 1627
Art Interests, the Artists' Cooperative, 0044, 0160
Artists' League, 0612
Artists' Union, 0112, 0136, 0138, 0172, 0230, 0260, 0320, 0327,
 0380, 0387, 0403, 0412, 0414, 0423, 0439, 0475, 0498, 0509,
 0527, 0546, 0572, 0574, 0631, 0632, 0683, 0807, 0974, 1026,
 1348, 1358, 1378, 1382, 1390, 1456, 1675
Associated American Artists, 1668
Atchison, Anthony J., 0213
Atkinson, William, 0235, 0399
Austin, Darral, 0402
Austin, Ralph, 0283

Bacon, Peggy, 1137
Bairnsfather, Arthur, 0689

Baizerman, Earl, 0416
Baker, Ernest Hamlin, 0948
Baker, Lucy, 1222
Ballator, John R., 0155, 0194, 0222, 0296, 0764
Baltimore Museum of Art, 0063, 1144, 1512
Baranceanu, Belle, 1653b
Barcla, Patrocino, 0255, 0284, 0423
Bard, Peter, 1218
Barnet, Will, 0492, 1427, 1540, 1545
Barr, Alfred H., Jr., 0116, 0433
Bartlett, Dana, 1053
Bartlett, Ivan, 1671
Basile, Alphonse, 0310
Bates, Isabel Miriam, 1245
Baum, Max, 0950
Baumann, Karl, 1007
Beach, Sarah Berman, 1431
Bear, Donald, 0190
Becker, Fred, 0390, 0591, 1545
Becker, Maurice, 0844, 0907
Bellevue Hospital, 0721, 0759
Belmont High School (Los Angeles), 0457
Beman, Roff, 0986
Benevento, Tiberio, 0310
Bengelsdorf, Rosalind, 1421
Bennett, Gwendolyn, 0858
Bennett, Rainey, 0464, 0798
Ben-Samuel, Aharon, 1164
Benson, Emanuel, 0680
Benton, Thomas Hart, 0313
Berdanier, Paul F., 0691
Berg, Wilfrid, 1653, 1654
Bergmann, Frank Walter, 0153
Bergstrom-Maler Museum, Neenah (WI), 1670
Berkeley (CA), 0119, 0332, 0341
Berkshire Museum (MA), 0982
Berman, Saul, 1645a
Bernardinelli, Dennis, 0595
Berninghaus, Oscar, 0261, 0277, 0399
Bernstein, Henry, 1357
Bernstein, Theresa, 1596b, 1611a
Bessinger, Frederic, 0132
Biberman, Edward, 1653b, 1663

Bibliographies, 0134, 1246, 1467, 1481, 1531, 1626
Biddle, George, 0092, 0299, 0316, 0383, 0399, 0426, 0504, 0644,
 0673, 0738, 0764, 0908, 1049, 1194, 1310, 1313, 1374b, 1544,
 1571, 1637, 1677
Biesel, Fred, 1658
Bird, Elzy J., 1652h
Birnbaum, A., 0844, 0907
Bishop Hill Colony, 0549, 1183
Bissell, Cleveland, 1007
Bisttram, Emil James, 0137, 0174, 0222, 0269, 0764, 1313, 1544,
 1571, 1616c, 1652c, 1677, 1684
Black artists. *See* African-American artists
Black, Harold, 1245
Black, La Verne, 0399
Blakeley, Hal, 1053
Blakeslee, Sarah, 1643bb
Blanch, Arnold, 0288, 1232, 1272
Blanch, Lucille, 1429
Bloch, Julius, 0083, 0093
Bloch, Lucienne, 0223, 0464, 1421, 1427, 1615a, 1669, 1679
Block, Lou, 0169
Bloom, John Vincent, 1520
Bloom, Peter, 0127
Blue Eagle, Acee, 1556
Blume, Peter, 1326, 1329
Blumenschein, Ernest Leonard, 0174, 0443
Blumenschein, Helen Green, 1669
Bohrod, Aaron, 0155, 0235
Bolotowsky, Ilya, 1525, 1654a
Bonk, Clarice, 1148
"Boondoggling," 0156, 0428, 0515, 1339, 1401, 1521, 1537
Booth, Cameron, 0986
Borglum, Gutzon, 0213, 0786
Boston, 1484
Boston University Art Gallery, 1543
Boswell, Peyton, 0077
Bouche, Louis, 0399, 0764, 1571
Bowan, Karl M., 0721
Bowers, Frank, 0477
Boyd, Byron, 0399
Boyd, Fiske, 0175, 0235
Boynton, Ray, 0235
Boza, Daniel, 0240
Bradford, Francis Scott, Jr., 1404

Brann, Louise, 0566
Breinin, Raymond, 0307
Briggs, Adelaide, 0956, 1007
Brinckerhoff, A.F., 0783
Britton, Edgar, 0155, 0222, 0235, 0961, 1101, 1210, 1380, 1491
Bromberg, Manuel, 1371
Bronx Post Office, 1432, 1435
Brooklyn, 1654a
Brooklyn Museum, 0241, 0656, 0979, 1082
Brooks, James D., 0153, 0175, 0397, 0431, 1057, 1094, 1315, 1326,
 1418, 1525, 1684
Brooks, Richard, 0277
Broome County (NY), 1657d
Brown, Aldis B., 0261
Brown, Samuel L., 0272, 0287, 0307, 0359
Browne, Byron, 1473
Browne, Rosalind Bengelsdorf. *See* Bengelsdorf, Rosalind
Bruce, Edward, 0009, 0021, 0048, 0081, 0082, 0091, 0120, 0121,
 0138, 0142, 0171, 0213, 0374, 0416, 0570, 0604, 0667, 0735,
 0821, 0889, 0973, 1001, 1012, 1049, 1068, 1141, 1174, 1176,
 1178, 1179, 1194, 1197, 1221, 1258, 1289, 1293, 1309, 1310,
 1321, 1657
Bruce, Granville, 1312
Brunner, Frederick A., 0261
Bruta, Esther, 1630
Bruton, Helen, 0318, 0475
Bryson, Bernada, 0648, 0689, 1428, 1482, 1630, 1669
Bufano, Beniamino Benvinuto, 0223, 0969, 1415
Bulliet, Charles Joseph, 0709
Bunn, William Edward Lewis, 0155, 0235, 1616, 1636
Burck, Jacob, 1482
Burg, Copeland, 0819
Burkhard, Verona, 0689, 1371
Burkhart, Emerson, 1187, 1191, 1192
Burlingame, Dennis Meighan, 0813
Burton, H. Ralph, 0936
Busa, Peter, 1037
Bywaters, Jerry, 0025, 0707, 1312, 1649

Cadmus, Paul, 0296, 0411, 0420, 1320, 1381, 1630
Cahill, Holger, 0187, 0217, 0274, 0320, 0416, 0473, 0476, 0575,
 0697, 0698, 0720, 0728, 0737, 0783, 1049, 1085, 1284, 1285,
 1560, 1561, 1574, 1588, 1627
Calder, Stirling, 0181, 0191

Caldwell, Gladys, 0261
Calfee, William, 0235, 0277
California, 0122, 0124, 0132, 0193, 0250, 0291, 0314, 0318, 0332,
 0334, 0607, 0642a, 0681, 0729, 0808, 0903, 0920, 0921, 1004,
 1052, 1053, 1054, 1093, 1120, 1277, 1298, 1333, 1388, 1409,
 1415, 1420, 1466, 1494a, 1535, 1536, 1558, 1559, 1570, 1624,
 1652e, 1653b, 1663, 1676, 1683
Callahan, Kenneth, 0261
Camden, John Poole, 0590, 0662
Campbell, Charles, 0261, 0975, 1340
Candell, Victor, 0907
Caples, Robert Cole, 1652f
Carborundum prints, 0727, 0992, 1050
Caredio, Primo, 1210
Carlisle, John C., 1539
Carmody, John M., 0973
Carter, Clarence Holbrook, 0147, 0166, 1630
Cassidy, Gerald, 0226
Cecere, Ada, 0956, 1007
Cecere, Gaetano, 0181
Censorship, 1364
Ceramics, 0617, 0633, 1403, 1436
Chamberlain, Glenn, 1544
Chamberlain, Norman Stiles, 0222
Champanier, Abram, 1643aa
Changing New York (Review), 0828, 0876, 0897, 0906
Chapman, Manville, 0545
Chassaing, Edouard, 0685
Cheney, Ruth, 0587, 0950
Chicago, 0380, 1311, 1447a
Children and art, 0284, 0310, 0340, 0392, 0425, 0461, 0479, 0498,
 0509, 0534, 0572, 0574, 0631, 0632, 0645, 0658, 0679, 0696,
 0715, 0743, 0825, 0875, 0892
Childrens' Art Gallery (DC), 0479, 0630, 0645, 0675, 0696, 0743
Christian, Grant Wright, 0261
Chrysler Museum (VA), 1492
Churchill, Winston, 1258
Ciampaglia, Carlo, 1659
Cikovsky, Nicolai, 0689, 1544, 1616a
Cincinnati Museum, 0066
Citron, Minna, 1421, 1595, 1669
City Without Walls Gallery (NJ), 1490
Civil Works Administration (CWA), 0005, 0009, 0017, 0024, 0025,
 0026, 0027, 0036, 0038, 0041

Claremont (CA), 1636a, 1657b
Clark, Tanner, 0153, 0261, 1486
Clarke, Gilmore D., 1141
Clay Club (NYC), 0717
Clayton, Orlin E., 1659
Clemens, Grace, 1671
Cleveland, 1678
Cleveland Public Library, 1397, 1678
Cocchini, A., 0632
Coit, Lillie, 1552
Coit Tower, 0003, 0099, 0101, 1409, 1415, 1466, 1552, 1652e
College Art Association, 0069
Colorado, 0102, 0183, 0255, 0269, 1479, 1662
Coltman, Ora, 1369
Columbia (SC) Museum of Art, 1329
Communism, 0099, 0101, 0468, 0673, 0680, 0692, 0701, 0856,
 0995, 0998, 0999, 1271, 1272, 1390, 1417, 1482, 1572, 1675
Community Art Centers, 0362, 0486, 0539, 0543, 0623, 0681,
 0697, 0713, 0741, 0947, 0954, 1019, 1022, 1076, 1083, 1121,
 1127, 1148, 1247, 1275, 1365, 1378, 1397, 1398, 1629, 1660
Comprehensive Employment Training Act (CETA), 1407, 1592
Congress of Industrial Organizations (CIO), 0803, 0810, 0969
Congressional Record, 0042, 0089, 1058
Connecticut, 0094, 0165, 1593
Connely, Ruth, 0209
Constant, George, 0313
Consulex, Zacrer, 0127
Cook, Howard, 0153, 0194, 0277, 0961, 1041
Cooke, Regina Tatum, 0255
Cooper, Charlotte Gowing, 0710
Cooper, James F., 1646
Cooper-Union (NYC), 0021
Corcoran Gallery of Art (Washington, DC), 0076, 0078, 0079,
 0080, 0082, 0083, 0088, 0090, 0091, 0103, 0105, 0115, 0125,
 0188, 0196, 0201, 0261, 0277, 0342, 0393, 0872, 0879, 0880,
 0881, 0905, 1221
Cortor, Eldzier, 1472
Cosmopolitan Club (Washington, DC), 0042
Costumes, 0241
Covey, Arthur Sinclair, 0147, 0166
Coye, Lee Brown, 0637
Craft, Paul, 0097
Craton, Ann, 0047, 0053
Craven, Junius, 0035

Creedon, Daniel M., 0700
Crimi, Alfredo De Giorgio, 0181, 0191, 0296, 0645
Criss, Francis H., 0655
Crockwell, Douglass, 0240
Cronbach, Robert, 0956, 1020, 1427
Cronin, Agnes S., 0804, 0940, 0942
Cross, Bernice Francine, 0508
Crumbo, Woodrow, 1636
Cummings, Homer Stillé, 0629
Cuneo, Rinaldo, 0138
Cunning, John, 0071
Cunningham, Ben, 1652e
Cunningham, Lloyd, 1233
Curran, Mary, 0776
Curry, John Steuart, 0240, 0441, 0443, 0764, 1571

Dalstrom, Gustaf, 0155
Dana, John Cotton, 1627
Daniel, Lewis C., 1137
Danysh, Joseph A., 0025, 0036
Darcé, Virginia, 1438
Daugherty, James Henry, 0453, 1652c, 1682
Davidson, Jo, 0046
Davis, Charles Holbert, 0920, 1643aa
Davis, Stuart, 0786, 1049, 1232, 1283, 1337, 1343, 1357, 1359,
 1508, 1615
Davis, Watt, 0464
Dawson, O.B., 1438
Day, Selma, 1437
Decorative arts, 0552
De Cordova Museum and Park (MA), 1445
De Diego, Julio, 0695
Defenbacher, Daniel S., 0362
Dehn, Adolf, 0313, 0438, 1232
De Kruif, Henry Gilbert, 0037
Delaney, Joseph, 1602
Delgado Museum (LA), 1005
Del Pino, Moya, 0153, 0222
De Lue, Donald, 1098
De Marco, Jean Antoine, 1092
Democratic Vistas (Review), 1430a, 1572a, 1572b, 1575a, 1576a,
 1589a, 1593a, 1595a, 1596a, 1596c, 1615, 1643b
Denver Art Museum, 0102
Departmento de Informacion para ed extranjero (Mexico
 City), 1164

De Rocco, Jovan, 1218
De Saisset Art Gallery (CA), 1420
Design Laboratory, 0231, 0289, 0450
Deutsch, Boris, 1007, 1066, 1653b
Dewey, Ernest, 1245
Dewey, John, 0434, 0973, 1561
de Young Museum (CA), 0052, 0332, 0820, 0824, 0834, 0835,
 0890
Dickerson, William J., 1457
Dickson, Helen, 0114
Dietrich, Tom, 1007
Diller, Burgoyne, 1310, 1340, 1400, 1416, 1523
Dirk, Nathaniel, 0566
District of Columbia, 0126, 1677
Ditter, J. William, 1171
Dixon, Maynard, 1536, 1653b
Documentary Expression and Thirties America (Review), 1383
Documentary films, 1433, 1522
Dohanos, Stevan, 0424, 1429
Doi, Isami, 0591
Doktor, Raphael, 1029
Doniphan, Dorsey, 0040
Donnelly, Thomas, 0261, 1616a
Doreman, Hyman, 0632
Douglas, Haldane, 1663
Douglass, John, 1312
Downtown Gallery (NYC), 0381, 0480, 0528, 1166
Dows, Olin, 0166, 0194, 0416, 1295, 1309, 1538
Dozier, Otis, 1312
Drewes, Werner, 1343
Duccinii, Gaetano, 0497
Duchow, Caspar, 1663
Dungan, H.C., 0512
Dunham, Francis, 1575
Dunton, William Herbert, 074
Durenceau, Andre, 1002
Dwight, Mabel, 0234, 1669
Dyer, Carlos, 1671

Eagle, Arnold, 1623
Eckhardt, Edris, 1436
Eckle, Julia, 0093
Edwards, Paul, 0694
Egri, Ruth, 0645
Eichenberg, Fritz, 0391, 0513

Eilers, Fay, 1148
Ellen Sragow Gallery (NYC), 1614
Ellis Island, 0723
Emergency Relief Act (1935), 0210
Emergency Relief Act (1938), 0557, 0785
Emergency Relief Act (1939), 0938, 0940, 0942, 0943
Emergency Relief Act (1940), 0940, 1124
Emergency Relief Act (1942), 1171
Emergency Relief Act (1943), 1170
Emporium Department Store (CA), 0653
Engendering Culture (Review), 1665, 1680
Englehorn, Elmer, 0325
Evergood, Philip, 0325, 0357, 0391, 1273, 1359
Executive Orders, 0019, 0127, 0210
Exhibitions (Non-New Deal Art), 0071, 0087, 0109, 0116, 0121,
 0143, 0197, 0344, 0384, 0386, 0411, 0420, 0429, 0432, 0454,
 0459, 0514, 0524, 0527, 0535, 0641, 0656, 0717, 0753, 0763,
 0803, 0955, 0959, 0962, 0970, 1028, 1044, 1047, 1100, 1137,
 1147, 1165, 1221, 1227, 1341, 1511a, 1514, 1526, 1528, 1543,
 1546, 1549, 1601, 1620, 1640, 1641, 1656, 1669, 1670. *See also*
 New Deal Art (Exhibitions); Index of American Design
 (Exhibitions); Section of Painting and Sculpture (Exhibi-
 tions); WPA/FAP (Exhibitions); and individual museums or
 galleries

Farley, James A., 0499
Farm Security Agency (FSA), 1428, 1623, 1642, 1655
Faulkner, Barry, 0867
Fausett, Lynn, 1487
Federal Art Bureau (General), 0094a, 0098, 0098a, 0140, 0141,
 0232, 0236, 0254, 0259, 0260, 0263, 0309, 0321, 0371, 0451,
 0773, 0774, 0775, 0923, 0924, 1193a, 1198a, 1225
Federal Art Bureau (1935–38, General), 0516, 0578, 0606, 0608,
 0613, 0621, 0625, 0626, 0642, 0647, 0658, 0766; Criti-
 cism, 0165a, 0173a, 0512, 0578, 0584, 0600, 0634, 0635;
 Praise, 0511, 0580, 0586, 0616, 0652; H.J. Res. 220
 (1935), 0155, 0160a, 0160b, 0165a, 0173a, 0212, 0213; H.J.
 Res. 79 (1937), 0482, 0496, 0556, 0581, 0583, 0588; H.J.
 Res. 671 (1938), 0649, 0657, 0666, 0678, 0781, 0782, 0783;
 H.R.1512 (1937), 0554; H.R.8132 (1937), 0553;
 H.R.8239 (1937), 0466, 0471, 0490, 0491, 0511, 0555,
 0562, 0572; H.R.9102 (1938), 0572, 0576, 0578, 0579,
 0580, 0581, 0583, 0584, 0585, 0586, 0588, 0593, 0594, 0596,
 0598, 0599, 0600, 0608, 0609, 0614, 0625, 0626, 0634, 0641,

0741a, 0780, 0783; S.3296 (1938), 0580, 0581, 0583, 0584, 0585, 0586, 0784, 0786
Federal Art Bureau (1939–43, General), 0790, 0790a, 0794a, 1196, 1197; H.J. Res. 149 (1939), 0847, 0937; H.R.2319 (1939), 0935; H.R.600 (1941), 1123; H.R.900 (1943), 1205; S.2967 (1939), 0941;
Federal Art Galleries (General), 0242, 0282, 0348
Federal Art Gallery (Boston), 0520, 0750
Federal Art Gallery (Chicago), 0754
Federal Art Gallery (NYC), 0203, 0227, 0228, 0236, 0246, 0251, 0317, 0333, 0337, 0340, 0348, 0370, 0389, 0415, 0417, 0422, 0488, 0495, 0521, 0522, 0523, 0529, 0531, 0534, 0577, 0605, 0622, 0624, 0651, 0654, 0655, 0683, 0724, 0746, 0747, 0748, 0749, 0751, 0755, 0757, 0758, 0760, 0762, 0802, 0812, 0843, 0886, 0891, 0893, 0895, 0897, 0898, 0899, 0902, 0915
Federal Art Project. *See* WPA/FAP
Federal Art Project in Illinois (Review), 1661, 1666, 1667
Federal Arts Committee, 0600, 0621
Federal Emergency Relief Administration (FERA), 0007, 0131, 0363
Federal Music Project, 0180
Federal One, 0180, 0186, 0214, 0215, 0216, 0217, 0218, 0219, 0397, 0418, 0428, 0452, 0472, 0515, 0560, 0570, 0640, 0659, 0701, 0797, 0825, 0832, 0837, 0846, 0847, 0943, 1085, 1247, 1257, 1290, 1318, 1427, 1462, 1487, 1531, 1584, 1612, 1631a, 1641, 1658a, 1672
Federal Theatre Project, 0180, 1672
Federal Trade Commission Building, 1151
Federal Triangle (Washington, DC), 1346, 1468, 1477, 1583
Federal Works Agency (FWA), 1193, 1206, 1207
Federal Writers' Project, 0180, 0545, 0558, 0571, 0591
Feinsmith, 1218
Feinstein, David, 0950
Feitelson, Lorser, 0920
Fenelle, Stanford, 0632
Ferguson, Nancy Maybin, 0104
Ferstadt, Louis, 0142, 0169
FHP Hippodrome Gallery, 1664, 1671
Fiene, Ernest, 1615a, 1643bb
Fine Arts Bureau (Proposed). *See* Federal Art Bureau
Fine Arts Federation of New York, 0583, 0596
Fink, Denman, 0277, 0443, 0689, 1429
Finucane, Daniel Leo, 0372, 0508
Fisher, Gladys, 1371

Fisher, Orr Cleveland, 1520, 1544
Fitzpatrick, David, 0844
Fitzpatrick, R.D., 0907
Flavell, Thomas, 0703
Flavelle, Alan Page, 0372, 0508
Fleck, Joseph Amadeus, 0281
Fleming, Philip B., 1193, 1206, 1207
Fleri, Joseph C., 0864
Flint, Le Roy, 1436
Floethe, Richard, 0740
Florida, 0107, 1099, 1429, 1591
Floyd Bennett Field (NY), 0993, 0994, 0995, 0998, 0999, 1417
Fogel, Seymour, 0223, 0822, 0956, 1151, 1313, 1617, 1677
Fogg Museum (Harvard University), 0519
Fontaine, Paul E., 1144
Forbes, Helen K., 0147, 1094
Force, Juliana, 0008, 0009, 0016, 0039, 0060, 0061, 0068, 1088,
 1657
Ford, Ford Maddox, 0433
Fossum, Syd, 0807
Foster, Gerald, 0078, 0153, 0175, 0240, 1486, 1538
Foy, Frances M., 0155, 0222
Frank Wiggins' Trade School (Los Angeles), 0182, 1466
Franks, Seymour, 1602
Fredenthal, David, 0381, 1596b
Free, Carl, 0181
French, Jared, 0444, 0805, 0812
Frescos, 0477, 0660, 0673, 0815, 1051
Freund, Harry Louis, 0261
Fried, Alexander, 0653

Gag, Wanda, 0313, 1669
Galgiani, Oscar, 1636
Gallagher, Michael, 0703, 0719, 0727, 1050
Gallery, 1199, 1543
Ganso, Emil, 0505, 1232, 1643bb, 1652c
Gardner, Walter Henry, 0261
Garfield Park Art Gallery (Chicago), 0517
Garner, Archibald, 1007
Gates, Richard F., 0166
Gates, Robert Franklin, 0424, 0689
Gebhardt, William Edwin, 0097
Geller, Todros, 0677, 0695
Gellert, Hugo, 0844, 0907, 1482

Genauer, Emily, 1033
Gender studies, 1672
Gentot, Frank, 1436
George Mason University, 1653a
George Washington High School, 0969
Georgia, 1659
Gerchik, P., 1218
Gikow, Ruth, 0950
Gilbert, Dorothy, 0078
Gilbertson, Boris, 0689
Gilmore, Marion, 1520
Glassell, Criss, 1520
Glassgold, C. Adolph, 1049
Glenn Dale Tuberculosis Sanitarium (MD), 0372, 0508
Glickman, Maurice, 0624
Godwin, Bernard, 0783
Goertz, Augustus Frederick, 1431
Goldthwaite, Anne, 0443
Gonzales, Xavier, 0078, 0277
Good, Minnetta, 0720
Goodelman, Aaron J., 0632
Goodrich, Gertrude, 0956, 1104, 1544
Goodwin, Jean, 1653b, 1671
Gordon, Witold, 0739
Gorelick, Boris, 0438, 1340
Gorham, Aimee, 0402
Gorky, Arshile, 0315, 1320, 1343, 1359, 1414, 1460, 1486, 1508,
 1614
Gosselin, Grace H., 0811
Gotcliffe, Sid, 1294
Gottlieb, Harry, 0320, 0413, 0950, 0991, 1430a, 1431, 1549, 1595
Gottschalk, Oliver A., 1032
Government patronage, 0330, 0360, 0430, 0536, 0595, 0610,
 0616, 0639, 0650, 0674, 0738, 0928, 1055, 1060, 1110, 1197,
 1198, 1199, 1202, 1203, 1220, 1226, 1228, 1231, 1242, 1244,
 1247, 1257, 1270, 1278, 1279, 1283, 1291, 1301, 1302, 1315,
 1322, 1334, 1337, 1347, 1377, 1380, 1381, 1408, 1463, 1517,
 1585, 1587, 1607, 1621; Praise, 0418, 0474, 0949; Criti-
 cism, 0257, 0385, 0416, 0484, 0673
Government Services Administration (GSA), 1344, 1351, 1353,
 1357, 1544, 1575, 1609, 1610, 1616
Graphic Arts, 0234, 0246, 0251, 0273, 0288, 0324, 0328, 0329,
 0382, 0438, 0492, 0505, 0513, 0514, 0577, 0656, 0719, 0720,
 0727, 0746, 0754, 0802, 0833, 0836, 0891, 0962, 0970, 0991,

1019, 1027, 1034, 1044, 1050, 1109, 1125, 1165, 1232, 1331, 1343, 1367, 1378, 1423, 1424, 1448, 1475, 1512, 1540, 1562, 1577, 1580, 1599, 1623, 1640, 1642, 1643, 1644a, 1645, 1647, 1647a, 1648, 1668, 1669, 1670, 1678

Grafly, Dorothy, 0579
Grambs, Blanche, 0467, 1562
Granahan, David Milton, 0181, 0235
Grand Central Art Galleries (NYC), 0143, 0202
Grant, Gordon, 1653b
Green, Elizabeth, 1588
Greene, Balcomb, 0391, 1654a
Greenwood, Marion, 0316, 1037, 1326, 1421
Gregory, Waylande De Santis, 1088, 1486
Greitzer, Jack J., 0127, 0147, 0175, 0307
Griffith, John A., 0078
Grooms, George, 1544
Gropper, William, 0806, 0816, 0907, 1273, 1313, 1357, 1381, 1482, 1544, 1549, 1653a, 1677
Gross-Bettelheim, John, 0283, 1343
Groth, John August, 0844, 0907
Grunwald Center for the Graphic Arts (UCLA), 1548
Guglielmi, O. Louis, 0313, 0616, 0975, 1210, 1273, 1320, 1427
Guston, Philip, 0654, 0822, 0956, 1007, 1180, 1272, 1283, 1326, 1617
Guy, James, 0616
Gwathmey, Robert, 1342

Haines, Richard, 0147, 0166, 0175, 1520
Haley, Sally F., 1680
Halfant, Jules, 1602
Hall, Helen, 0434
Halpert, Edith Gregor, 0461
Hamilton, Bernice, 0460
Hamilton, Curtis Smith, 0773
Hamilton, Edith, 0484
Hammer, Victor, 0951
Hansen, Marius, 0920
Hanson, James, 0798
Harding, George, 0153, 0175, 0235, 0590, 0706, 0711, 0961
Harlem Artists' Guild, 0413
Harlem Community Art Center, 0537, 0566, 0567, 0575, 0615, 0679, 0724, 0892, 1378
Harlem Hospital (NYC), 0245, 1437
Harnly, Perkins, 1513

Harrington, Francis C., 0939, 0940, 0942, 0943, 1124
Harriton, Abraham, 0386, 0391
Hauser, Alonzo, 0800
Hawkins, Ted, 1457
Hayden, Carl, 0943
Hayden, Palmer C., 0615, 1218
Hayes, Vertis, 0615, 1437
Health and Hospitals Corporation's collection, 1643aa
Hecht, Zoltan, 0488
Heckscher Museum (NY), 1641
Helfond, Riva, 1595, 1602, 1669
Heller, Helen West, 0325, 0391, 0587
Henderson, William P., 1684
Henkel, August, 0993, 0995, 0998, 0999, 1417
Henning, William Edwin, 1520
Henricksen, Ralf Christian, 0307, 0826
Henry, Natalie Smith, 1576a
Herdle, Isabel C., 0331, 0565
Herdman, Charles, 1429
Herman, Andrew, 1623
Hernandez, William, 0907
Herr, Rudolph, 0864
Herriton, Abraham, 0986
Herron, Jason, 0457
Hibbard, Henry, 0132
Higgins, Victor, 0137, 0174
Hiler, Hilaire, 1577
Hill, George Snow, 1429
Himmun, Lew Tree, 0255
Hine, Lewis, 1645b
Hirsch, Joseph, 0965, 0966, 0975
Hirsch, Willard Newmann, 0974
Hirshhorn Museum and Sculpture Garden (Smithsonian Institution), 1525
Hogue, Alexandre, 0025, 1273, 1312
Holmes, Henry, 0615
Holmes, Stuart, 0261
Homer, Woodhull, 1436
Hood, Richard, 0591
Hopkins, Harry L., 0007, 0335, 0795, 1303
Hord, Donal, 0921, 1653b
Horn, Axel, 1643aa
Horn, Sol, 1623
Horr, Axel, 0950

Houser, Lowell, 0166, 0235, 1556
Howard, John Langley, 0101
Howard University Art Gallery (Washington, DC), 1163, 1182
Howe, Oscar, 1259
Hrdy, Olinka, 0463, 1671
Hudson River Museum, 1620
Hunter, Howard O., 1171
Hunter, (Russell) Vernon, 0147, 1684
Huntley, Victoria Ebbels Hutson, 1101
Huntoon, Mary, 1457
Hurd, Peter, 0443, 0689, 0798, 0879, 1163
Hutchinson, David, 0689, 0798
Hutson, Ethel, 0634

Ickes, Harold L., 0462
Illinois, 0544, 0605, 0619, 0670, 0677, 0684, 0685, 0686, 0692,
 0695, 0698, 0702, 0708, 0747, 0756, 0864, 0901, 0904, 0932,
 1083, 1103, 1111, 1311, 1374a, 1376, 1491, 1516, 1547, 1658
Illinois State Museum, 1376, 1547
Index of American Design (Exhibitions), 0417, 0423, 0480, 0519,
 0522, 0528, 0528a, 0530, 0564, 0653, 0658, 0664, 0669, 0687,
 0742, 0744, 0752, 0812, 0814, 0874, 0895, 1082, 1096, 1116,
 1152, 1156, 1158, 1159, 1161, 1162, 1177, 1179a, 1181, 1234,
 1251, 1263, 1306, 1419, 1513. *See also* New Deal Art (Exhibi-
 tions)
Index of American Design (General), 0395, 0419, 0436, 0445,
 0455, 0506, 0549, 0564, 0592, 0661, 0669, 0692, 0788, 0987,
 1000, 1049, 1052, 1053, 1071, 1080, 1120, 1128, 1146, 1149,
 1186, 1188, 1189, 1193, 1200, 1201, 1222, 1235, 1238, 1243,
 1256, 1280, 1281, 1339, 1352, 1354, 1465, 1495, 1509, 1534a;
 Accomplishments, 0290, 0350, 0353, 0769, 0925, 0978;
 Administration, 0347, 0349, 0351, 0352, 0358, 0378; Crea-
 tion, 0239, 0535; Illustrations, 0445, 0506, 0809, 0818,
 0827, 0925, 1071, 1200, 1211, 1255, 1366, 1382a, 1495, 1496,
 1497, 1498, 1499, 1500, 1501, 1502, 1503, 1504, 1505, 1652;
 Praise, 0284, 0375, 0378, 0436, 0501, 0704, 0886, 0996,
 1145, 1252. *See also* WPA/FAP
Index of American Design (1950, Review), 1249, 1250, 1252, 1253,
 1254, 1256, 1260, 1261, 1262, 1264, 1265, 1267, 1268, 1269;
 (1980, Review), 1511, 1519
Indiana, 0106, 0128, 0460, 1652g
Intellectualism, 0168
Interior Building, Department of, 0226, 0407, 0408, 0421, 0806,
 1007, 1241, 1550, 1606

International Art Center (NYC), 0382, 0518
Iowa, 0547, 0623, 0792, 0849, 1233, 1398, 1454, 1520, 1532, 1557, 1558, 1617a

Jacobsen, Emanuel, 0826, 1380
Jacobsson, Sten, 0443, 0689
Jamieson, Mitchell, 0424, 0798, 1007
Jane Voorhees Zimmerli Art Museum (NJ), 1549
Janet Marquess Gallery (NYC), 1631, 1635
Jennewein, Carl Paul, 0764
Jerome, Mildred, 0114
Jewell, Edward Alden, 1154, 1156
Joe and Emily Lowe Gallery (NY), 1446
John Reed Clubs, 1472
Johnson, Avery Fischer, 0968
Johnson, Edwin B., 0155
Johnson, Howard, 1233
Johnson, James Weldon, 0575
Johnson, Malvin Gray, 0078
Johnson City (TN), 1673
Jones, Allen D., Jr., 1007
Jones, Amy, 0689, 1596b
Jones, Burton J., 0449
Jones, Harry Donald, 1520
Jones, Wendell Cooley, 0798, 1673
Julian, Paul, 1653b, 1663
Justice Building, Department of, 0152, 0153, 0168, 0194, 0195, 0504, 0629, 0660, 0764, 0806, 1374b, 1571

Kadish, Reuben, 1298
Kainen, Jacob, 0527, 1562
Kallem, Herbert, 0416
Kansas, 1457, 1479
Kansas Art Institute, 0065, 0070
Karp, Ben, 0587
Kassler, Charles, 0114, 0147, 0166
Katz, Leo, 1466
Keller, Charles, 1602
Kelpe, Karl, 0155, 0294, 0313, 0826
Kelpe, Paul, 1654a
Kent, Florence, 1562
Kent, Rockwell, 0373, 0443, 0499, 0500, 0783, 1049, 1274a, 1484a, 1636
Kent State University, 1375

Kerr, Florence S., 0869, 0938, 1124, 1171
Keto, Henry, 1436
King, Albert, 0607, 0675, 0676, 1589
Kingman, Dong M., 0607, 1589
Kingman, Eugene, 0166, 1371
Kingsbury, Alison Mason, 1129
Kleemann-Thorman Gallery (NYC), 0071
Klitgaard, Georgina, 0798, 1659
Kloss, Gene, 0255, 0283, 0591
Knaths, Karl, 0278, 0464, 1427
Knight, Charles, 1429
Knight, Frederick C., 1632
Knotts, Ben, 0138
Knutesen, Edwin B., 0800
Kobinyi, Kalman, 1391, 1562
Kohn, Robert D., 0434, 0447
Kollwitz, Kaether, 0916
Kooning, Willem de, 0956, 1007, 1525
Kotin, Albert, 0235
Krasner, Lee, 1572
Kraus, Romuald, 0153, 0689, 0864
Krause, Erik Hans, 0503
Kreis, Henry, 0222, 0261, 0443, 1007, 1018
Kroll, Leon, 0028, 0443, 0680, 0764, 1192, 1571
Kruckman, Herb, 0907
Kuniyoshi, Yasuo, 1329, 1542
Kunstverein (Hamburg), 1493

La Farge, Thomas, 0153, 0175, 0178
La Follette, Robert M., 0973
La Guardia Airport, 1057, 1094, 1154, 1418
Laguna Beach, CA, 0642a
Labaudt, Lucien, 1298
Labor Building, Department of, 0201
Lacher, Gisella Loeffler, 0255
Lambdin, Robert Lynn, 0147, 0166
Lancaster (NY) High School, 0918
Lance, Leo, 0858, 1623
Landon, Alf, 0302
Lang, Karl, 0872
Laning, Edward, 0595, 0671, 0680, 0723, 0837, 0977, 1010, 1062, 1101, 1135, 1279, 1326, 1357
Lantz, Michael, 0399, 1151, 1677
Lassaw, Ibram, 1525

Latham, Barbara, 1669
Laughlin, Thomas, 1429
Lawrence, Jacob, 1472, 1628, 1636b
Lazzari, Pietro, 1429
Lea, Tom, 0277, 0399, 0689
Leboit, Joseph, 0580
Lebrun, Rico, 1283
Lee, Arthur, 0181
Lee, Doris, 1421, 1669
Legislation (Miscellaneous), 0133, 0140, 0934. *See also* Federal
 Art Bureau; Emergency Relief Act
Lehman, Harold, 1595
Lehman College Art Gallery, 1647
Leigh Yawkey Woodson Art Museum (WI), 1489, 1670
Le More, Chet, 0492, 0505, 0783
Lenson, Michael, 1486
Lepper, Robert, 1616a, 1631
Levi, Julian, 0834
Levine, Jack, 0294, 1273, 1283, 1408
Levine, Saul, 1630, 1645a
Levit, Herschel, 1164, 1182
Levitt, Helen, 1623
Levy, Edmund H., 0293
Lewandowski, Edmund D., 0968, 1007
Lewis, Edwin S., 0235
Leyendecker, Joseph Christian, 0685
Library of Congress, 1507, 1622
Libsohn, Sol, 1623
Lichtner, Schomer Frank, 0078, 1404
Lie, Jonas, 0158, 0167
Life, 0837, 0845
Lightfoot, Elba, 1437
Liguore, Donald, 0310
Limbach, Russell T., 0656, 0778
Lincoln Hospital (NY), 0645
Lincoln School (NY), 1034
Lishinsky, Abraham, 0739
Living American Artists, Inc., 0302
Lizschutz, Isaac, 1164
Lochrie, Elizabeth, 0399
Lockwood, Ward, 0137, 0147, 0174, 0175, 0396, 0816, 0961
Lo Medico, Thomas Gaetano, 0638, 0717
Long Beach (CA), 1671
Long Beach Auditorium (CA), 0675, 0676, 0768, 1664, 1671

Long, Frank, 0166, 0798
Lopez, Carlos, 1182, 1677
Los Angeles, 0457
Los Angeles County Museum of Art, 0124, 0334, 0903
Louisiana, 1005, 1025, 1139, 1514a, 1658a
Lozowick, Louis, 1343, 1408, 1482, 1486
Lucker, Paul, 0974
Lundeberg, Helen, 0920
Lurie, Nan, 0283, 0438, 0492

MacCoy, Anne Guy, 0138
McCreery, James L., 1007, 1070
McDonald, Harold, 0460
Macdonald-Wright, Stanton, 0132, 0185, 0675, 0676, 1004, 1559,
 1671
MacGurrin, Buckley, 0607, 0920
MacLeish, Archibald, 1542
McKim, Musa, 1007
McLaurin, B.F., 0434
McLeary, Kindred, 0153, 0194, 0706, 0953, 0961, 1086, 1326
McLeish, Norman, 0677
McMahon, Audrey, 0187, 0253, 0258, 0265, 0324, 0325, 0380,
 0446, 0473, 0771, 0812, 0950, 1049
McMillen, Jack, 1659
McTigue, J., 0936
McVey, William M., 0443, 1337
Macy's Department Store (NYC), 0241, 0336, 0658, 0664, 0752
Maduro, José, 0689
Magafan, Ethel, 0798, 1182, 1630
Magafan, Jenne, 0986, 1636, 1638
Mahier, Ethel, 1578, 1598
Mahoney, James Owen, 0590, 0706, 0711
Maine, 1248
Maldarelli, Oronzio, 0181
Mandelman, Beatrice, 0950, 1669
Manhattanville College Art Gallery (NY), 1330
Manship, Paul, 0277
Margolis, David, 1431
Margoulies, Berta, 0181
Markham, Kyra, 1669
Markow, Jack, 0907
Marsh, Mrs. Chester G., 0041
Marsh, Reginald, 0222, 0299, 0383, 0396, 0953, 1273, 1310, 1320,
 1326, 1562

Marshall Field and Company (Chicago), 0522
Martin, David Stone, 0881, 0968
Martin, Fletcher, 0261, 0722, 0968, 1011, 1313, 1618a
Maryland, 0063, 0126
Massachusetts, 0700, 0750, 0773, 0982, 1517, 1681. *See also* New
 England
Maxey, Stevens, 0621
Mayer, Henrik Martin, 0147, 0166
Mayer, Jesse A., 0689, 0798
Mays, Paul Kirtland, 0153, 0166, 0177
Means, Elliot, 0950
Mechau, Frank Albert, 0114, 0181, 0183, 0188, 0197, 0223, 0240,
 0379, 0707, 1357
Mecklam, Austin Merrill, 1182
Meiere, Hildreth, 1007
Mellon, Andrew, 0385
Meltsner, Paul, 1482
Mesibov, Hubert, 1050
Messick, Benjamin Newton, 0920
Metropolitan Life Insurance Company, 0638
Metropolitan Museum of Art, 0241, 0449, 1027, 1096, 1100, 1116,
 1143, 1146, 1149, 1152, 1156, 1158, 1159, 1161, 1162, 1188,
 1189, 1177, 1181, 1195, 1216
Mexican mural movement, 0037, 1276, 1618a, 1650
Mexico, 1164
Meyers, Fred E., 1506
Michael Rosenfield Gallery (NYC), 1656
Michalov, Ann, 0632, 0826
Michigan, 0931, 1604, 1608
Midtown Gallery (NYC), 0197, 0411, 0420, 0481, 0485, 1631,
 1635, 1639
Midwest U.S., 1327, 1642
Milch Gallery (NYC), 0116, 0121
Miller, Barse, 0689, 0960, 0968
Miller, Dorothy Canning, 1627
Miller, Lee G., 0831
Miller, Suzanne, 1663, 1671
Millier, Arthur, 0177, 0680
Milliken, William M., 0097, 1049, 1389
Millman, Edward, 0155, 0235, 0277, 0426, 0464, 0702, 0798, 0834,
 0863, 0865, 0872, 0881, 1153, 1155, 1157, 1166, 1305, 1596b
Milwaukee, 0164
Milwaukee Art Institute, 0476
Milwaukee Art Museum, 1670

Milwaukee Handicrafts Project, 1404
Minnesota, 0057, 0323, 0807, 0952, 1148, 1378, 1422a, 1629,
 1644b, 1657c
Minnesota Institute of Arts, 0057, 0070, 0074
Missouri, 1588, 1629
Mobridge Municipal Auditorium (SD), 1259
Modern Art, 0014, 0031, 0085
Moffett, Ross E., 0155, 0194, 0235
Monastersky, Alex, 1486
Moore, Claire (Millman) Mahl, 1669
Mopope, Steven, 1556
Moreno, Samuel, 0238
Morgenthau, Henry, Jr., 0733, 0734, 0973
Morris, Lawrence S., 0786
Mosaics, 0318, 0332, 0475, 0497, 0526, 0675, 0676, 0705, 0768,
 1054, 1378, 1559
Mosco, Mike, 0287, 0632
Mose, Carl, 0689
Mose, Eric, 0175, 0464, 0473, 0645
Moylan, Lloyd, 1684
Muhlenberg Gallery Center for the Art, 1527
Municipal Art Commission (NYC), 0158, 0167
Mural Painters' Association, 0194
Murals, 0025, 0032, 0050, 0064, 0081, 0082, 0091, 0096, 0107,
 0122, 0132, 0137, 0143, 0148, 0163, 0173, 0177, 0178, 0240,
 0247, 0315, 0345, 0383, 0399, 0423, 0453, 0460, 0464, 0548,
 0648, 0651, 0655, 0663, 0691, 0700, 0751, 0799, 0808, 0826,
 0849, 0909, 0911, 0917, 0920, 0932, 0951, 1004, 1013, 1021,
 1030, 1048, 1062, 1066, 1067, 1072, 1089, 1091, 1097, 1220,
 1230, 1239, 1241a, 1244, 1245, 1245a, 1274a, 1277, 1324,
 1325, 1333, 1340, 1367, 1375, 1378, 1411, 1417, 1426, 1430,
 1446, 1454, 1466, 1470, 1484a, 1494a, 1520, 1532, 1534,
 1534a, 1535, 1539, 1558, 1564, 1565, 1569, 1615a, 1618a,
 1630, 1631, 1639, 1643a, 1643aa, 1652b, 1653aa, 1654a,
 1657d, 1659, 1662, 1673, 1674, 1677, 1679, 1683
Murray, Arthur, 0423
Murray, Hester Miller, 0287
Murrell, Sara, 1437
Museum of Modern Art, 0116, 0275, 0276, 0278, 0284, 0285,
 0286, 0287, 0292, 0294, 0296, 0297, 0313, 0337, 0387, 0930,
 0963, 0965, 0975, 1045
Museum of New Mexico, 0249, 1175
Museum of the City of New York, 0241, 0502
Museum of the Borough of Brooklyn, 1529

Mypass, Cyril, 1623
Myres, Herbert O., 1520

Nadir, Mark, 0753, 1623
National Academy of Design, 0167
National Archives, 1228, 1236, 1282, 1289, 1607
National Art Week, 0108, 1037, 1118
National Collection of Fine Arts (Smithsonian Institution), 0719,
 0720, 1475, 1476, 1477. *See also* National Museum of Ameri-
 can Art
National Gallery of Art, 0385, 1087, 1090, 1102, 1115, 1136, 1142,
 1189, 1186, 1193, 1234, 1246, 1280, 1306, 1419
National Gallery of Canada, 1040
National Museum (Smithsonian Institution), 0126
National Museum of American Art, 1513, 1524, 1528, 1554, 1636,
 1638. *See also* National Collection of Fine Arts
National Museum of Women in the Arts (Washington, DC),
 1637a, 1643, 1644a
National Park Service, 0465
Native Americans, 0174, 0209, 1555, 1556, 1578, 1594, 1598
Nebraska, 1479, 1575, 1579, 1652b
Nebraska State Historical Society, 0135, 1579
Neel, Alice, 1218, 1518, 1525
Negoe, Anna, 0918
Nesin, George, 1218
Neumann, J.B., 0320
Neuwirth, Morris, 0974
Nevada, 1652e, 1652f
Nevelson, Louise, 1310
New Deal Art (General), 1273, 1286, 1289, 1296, 1300, 1304,
 1305, 1309, 1317, 1318, 1325, 1328, 1334, 1344, 1349, 1350,
 1361, 1367, 1377, 1393, 1394, 1396, 1402, 1406, 1407, 1431,
 1471, 1514a, 1521, 1534a, 1541, 1542, 1544, 1551, 1569,
 1569a, 1570, 1618, 1627a, 1652a. *See also* Section of Painting
 and Sculpture; WPA/FAP; Index of American Design; Pub-
 lic Works of Art Project
New Deal Art (Analysis and Criticism), 1355, 1464, 1508, 1522,
 1534, 1538, 1568, 1584, 1587, 1589, 1590, 1595, 1613, 1637,
 1643a
New Deal Art (Exhibitions), 0366, 1327, 1363, 1375, 1376, 1388,
 1391, 1392, 1410, 1421, 1423, 1424, 1441, 1442, 1457, 1458,
 1471, 1475, 1476, 1485, 1488, 1489, 1490, 1491, 1493, 1511a,
 1524, 1525, 1527, 1529, 1545, 1547, 1579, 1582, 1593, 1631,
 1635, 1636, 1637a, 1638, 1639, 1642, 1643, 1655, 1664, 1671.

See also Exhibitions (Non-New Deal Art); Index of American Design (Exhibitions); WPA/FAP (Exhibitions); Section of Painting and Sculpture (Exhibitions)

The New Deal Art Projects: An Anthology of Memoirs (Review), 1360, 1384, 1385

The New Deal for Artists (Review), 1386, 1387, 1440

New England, 0034, 0045, 0427, 0437, 0441, 0524, 1445. *See also* the individual states

New Jersey, 0043, 0055, 0110, 0206, 0531, 0760, 0812, 0894, 1486, 1490

New Mexico, 0174, 0209, 0226, 0238, 0255, 0267, 0269, 0281, 0545, 0769, 1388, 1389, 1391, 1392, 1403, 1436, 1684

New School for Social Research, 0432, 0641

New York (City), 0370, 0380, 0569, 0587, 0713, 0760, 0772, 0857, 0878, 0886, 0914, 0950, 1009, 1014, 1017, 1029, 1032, 1114, 1200, 1208, 1332, 1335, 1336, 1394, 1400, 1411, 1416, 1417, 1442, 1443, 1447, 1449, 1447a, 1478, 1510, 1523, 1529, 1602, 1615a, 1643aa, 1657b, 1679

New York (State), 0032, 0041, 0173, 0531, 0742, 0805, 0864, 1068, 1073, 1129, 1138, 1325, 1328, 1347, 1356, 1458, 1469, 1657d

New York City Municipal Art Gallery, 0053, 0077, 1367

New York Public Library, 0013, 0671, 0682, 0977, 1010, 1062, 1135, 1274, 1448, 1540, 1545

New York State Vocational Institution, 0805, 0812

New York World's Fair. *See* World's Fair, New York (1939–40)

Newark Airport, 0315, 1460

Newark Museum, 0110, 0535, 0894, 1460

Newell, James Michael, 0444, 1380

Newspapers: Baltimore *Sun*, 0046; Boston *Evening Transcript*, 0365; Chicago *American*, 0819; Chicago *Daily News*, 0297; Chicago *Times*, 0830, 1190; Kalamazoo *Gazette*, 0365; Los Angeles *Times*, 0484, 0680; New York *Daily News*, 0162; New York *Herald-Tribune*, 0060, 0256, 0365, 0462, 0663, 1305; New York *Post*, 0327; New York *Sun*, 0227; New York *Times Herald*, 0327; New York *Times*, 0016, 0091, 0365, 1154, 1156; New York *Tribune*, 0326; New York *World Telegram*, 0295, 0393, 0831, 1033; Oakland *Tribune*, 0512; Philadelphia *Art News*, 0584; Philadelphia *Inquirer*, 0176, 0608; Philadelphia *Public Ledger*, 0087; Philadelphia *Record*, 0579; Saint Louis *Post-Dispatch*, 1166; San Francisco *Argonaut*, 0026, 0036, 0298; San Francisco *Examiner*, 0653; San Francisco *News*, 0035; Troy *Times*, 0046; Washington *Post*, 0733

Nickelson, Ralf, 0443, 0689

Nickerson, J. Ruth Greacen, 0864
Nicolosi, Joseph, 0864
Nisonoff, Louis, 0527
Noheimer, Mathias John, 0097
Nord, Henry A., 0675, 0676, 1589
Norman, Bill, 0807
Norman, Jeffery, 0786
North Carolina, 0355, 0362, 1629
North Carolina Medical Center, 0911
Northern Arizona University Art Gallery, 1488
Novar, Louis, 0310

Oakland High School, 0705
Oakland Museum, 1577
Oberteuffer, Henrietta Amiard, 0443, 0689
O'Connor, Francis V., 1313, 1351
Official Images, New Deal Photography (Review), 1633a
Ohio, 0633, 0710, 0712, 1187, 1192, 1369, 1375, 1388, 1389, 1391,
 1392, 1403, 1436
O'Keeffe, Georgia, 0326
Oklahoma, 0868, 1019, 1022, 1121, 1127, 1397, 1426, 1556,
 1569a, 1594, 1598, 1629
Oldfield, Otis, 1643bb
Olds, Elizabeth, 0273, 0438, 0489, 0790, 0991, 1421, 1669
Olmer, Henry, 1436
Olson, Donald, 1148
Olson, T. Frank, 0155
Oral History, 1653a
Oregon, 0401, 0402, 0867, 0871, 1494, 1674
Orme, L. Gardner, 0956, 1007
Orozco, José Clemente, 1276, 1650
Overstreet, Harry, 0433

Padilla, Emilio, 0267
Pafford, Robert, 1245
Pain, Louise, 0864
Palace of the Legion of Honor (CA), 0400, 0410, 0483
Palmer, William C., 0181, 0198, 0481, 0485, 0701, 1643aa
Palo-Kangas, John, 0314, 1210
Pan Pacific Exposition (San Francisco, 1939–40), 0980
Panofsky, Erwin, 1464
Parish, Betty Waldo, 1669
Parker, Thomas C., 0697, 0786, 1008, 1049
Parshall, Douglas, 1618a

Parson's School of Design, 1447
Partridge, Charlotte, 1489
Partridge, Nelson H., 0122
Peat, Wilbur D., 0106
Pech, Augustus, 0656
Peixotto, Ernest Clifford, 0291, 1038
Pels, Albert, 0277, 0399, 1643bb
Penney, James, 0223, 1616a
Pennsylvania, 0052, 0084, 0271, 0530, 0533, 0703, 0776, 0873,
 0882, 0919, 0925, 0966, 0987, 1108, 1128, 1164, 1201, 1211,
 1345, 1593
Pennsylvania Academy of Fine Arts, 0929
Peoples, Christian J., 0155, 0213
Pepper, Claude, 0786
Perkins, Frances, 1237
Perlin, Bernard, 1007
Pershing, Louise, 0084
Pfehl, William, 0798
Phantom Gallery (Los Angeles), 1602
Philadelphia, 0716, 0727, 0776, 0841, 1036, 1098
Philadelphia Museum of Art, 0087, 0095, 0716, 0874, 1137
Phillips, Bert Greer, 0137
Phillips, Duncan, 0270, 0272
Phillips Memorial Gallery (Washington, DC), 0262, 0270, 0272,
 0276, 0335
Phoenix Art Center, 1365, 1378, 1629
Phoenix Art Museum, 1488
Photography, 0142, 0361, 0569, 0792, 0897, 1425, 1483, 1492,
 1528, 1544, 1623, 1645b
Piccirilli, Attilio, 0181
Picken, George Alexander, 0222, 1611a
Pierce, Waldo, 0786
Pitman, Virginia, 1487
Pollock, Jackson, 1313, 1340, 1343, 1572
Ponier, Arthur, 0477
Poor, Henry Varnum, 0383, 0764, 0788, 1310, 1571
Popper, Martin, 0783, 0785
Portland Art Museum, 0402, 0404, 1219
Portraiture, 0161
Possc f, Isidore, 1164
Post, George, 1298
Post Office Building, 0082, 0152, 0153, 0168, 0181, 0188, 0191,
 0192, 0194, 0195, 0247, 0373, 0499, 0500, 0509, 0765, 0957b,
 1274a, 1484a

Posters, 0532, 0618, 0740, 0760, 0801, 1095, 1131, 1455, 1507, 1533, 1596, 1597, 1616, 1622, 1634
Posters of the WPA (Review), 1634
Prestopino, Gregorio, 0307
Price, C.S., 0402
Printmaking. *See* Graphic Arts
Public Use of Art Committee, 0414, 1510
Public Works of Art Project (PWAP), 0046, 0048, 0049, 0053, 0061, 0065, 0072, 0075, 0077, 0086, 0089, 0093, 0103, 0105, 0111, 0114, 0115, 0118, 0123, 0127, 0131, 0138, 0142, 0144, 0146, 0160, 0162, 0171, 0209, 0237, 0303, 0397, 0707, 0928, 1185, 1312, 1324, 1338, 1374b, 1555, 1644b, 1657; Accomplishments, 0026, 0029, 0030, 0034, 0035, 0040, 0047, 0051, 0053, 0056, 0067, 0131; Controversies, 0016, 0039, 0060, 0061, 0082, 0084, 0099, 0101, 0107, 0182, 0411, 1241a 1245a, 1652e, 1685; Creation, 0005, 0007, 0009, 0012, 0014, 0015, 0017, 0020, 0021, 0022, 0023, 0031, 0036, 0041, 0042, 0044, 0045, 0048, 0062, 0092; Criticism, 0058, 0060, 0068, 0073, 0100, 0113, 0144, 0176, 0230
Public Works of Art Project (Exhibitions), 0052, 0057, 0059, 0063, 0065, 0066, 0070, 0074, 0076, 0078, 0079, 0080, 0082, 0083, 0088, 0090, 0091, 0095, 0103, 0104, 0110, 0115, 0116, 0124, 0125, 0126, 0135, 0164, 0183, 0201, 0202, 1027, 1241
Puccinelli, Dorothy Wagner, 0147, 0194, 0674
Purlin, Bernard, 1070
Purser, Stuart Robert, 0968
Pusterla, Attilio, 0032
Putnam, Brenda, 0277
Pyle, Clifford Colton, 0705

Queen's General Hospital (NYC), 0481, 0485, 1644
Quill, Michael, 0434
Quirt, Walter, 0950

Racism, 0245
Rader, Albert, 0920
Rahr West Art Museum, Manitowoc (WI), 1670
Randall, Byron, 0871
Randolph, Asa Philip, 0567, 0575
Ratskor, Max, 0587
Rauso, Louise, 0389
Rawlinson, Elaine, 0399
Read, Herbert, 0391

Recorder of Deeds Building (Washington, DC), 1173, 1182, 1221
Red Cross, 1131, 1141, 1142
Reed, Stanley, 0691
Reeves, Ruth, 1049
Refregier, Anton, 0651, 0907, 1105, 1106, 1107, 1147, 1218,
 1241a, 1245a, 1266, 1271, 1272, 1283, 1453, 1482, 1510,
 1618a, 1685
Regalbisto, Louis, 1436
Reid, Albert, 0868
Reilly, Frank Joseph, 0711
Reindel, Edna, 0027
Reinhardt, Ad, 0774, 0924, 1313
Relief (Artists', general), 0001, 0004, 0028
Relief (General), 0159, 1070, 1334, 1439
Relief for Museums, 0006, 0024, 0568
Rexroth, Andre, 0287
Rhinelander's Logging Museum (WI), 1065
Rhode Island, 0948
Rhode Island School of Design, 0814
Rhodes, Dan, 0689, 1233
Richardson, Edgar Preston, 1560
Richmond Hill Colony, 0357
Richter, Mischa, 0797, 0838
Rico, Dan, 0416
Rikers Island, 0167
Rincon Annex (San Francisco Post Office), 1105, 1106, 1107,
 1241a, 1245a, 1266, 1271, 1272, 1333, 1453, 1651, 1685
Ringola, Joseph, 0587
Riseman, William, 0147, 0166
Rivera, Diego, 0326, 1276, 1650
Robbins, David, 1623
Robbins, Le Roy, 1623
Roberts, Henry C., 1212, 1213, 1214, 1215
Roberts, Lawrence W., 0021, 0048
Robeson Gallery Center (NJ), 1490
Robinson, Boardman, 0443, 0764, 1571
Robinson, Increase, 1658
Robinson, Joseph T., 0042
Robus, Hugo, 0864, 1320
Rochester (NY), 0331
Rochester Memorial Art Gallery, 0503, 0504, 0564, 0565
Rogers, Julia, 1545
Romano, Emanuel, 0470
Ronnebeck, Louise, 1371

Roosevelt, Eleanor, 0021, 0048, 0684, 1014, 1534a
Roosevelt, Franklin D., 0092, 0100, 0129, 0326, 0393, 0405, 0468, 0478, 0527, 0738, 0908, 1030, 1064, 1068, 1069, 1207, 1223, 1237, 1258, 1518, 1521, 1525, 1534a, 1538
Rosen, Charles, 0798, 1429
Rosenberg, James N., 1273
Rosenburg, Jacob, 0434
Ross, Louis, 0269
Roszak, Theodore, 1297
Rothko, Mark, 1287, 1340
Rothschild, Lincoln, 0199
Rousseff, W. Vladimir, 0222
Rowan, Edward Beatty, 0166, 0416, 0730, 1049, 1289, 1309
Rowe, William B., 0155, 0194
Rudy, Charles, 0222, 0261
Ruellan, Andrée, 1611a
Russell Sage Foundation (NY), 0896
Russin, Robert I., 0834
Rutgers University Art Gallery, 1490
Ruth High School (El Monte, CA), 0477
Ruth, Jerry, 1595
Rutka, Dorothy, 0591
Ryland, Robert, 1596b

Saint-Gaudens, Homer, 0009, 1133
Saint Louis Post Office, 1153, 1155, 1157, 1166, 1588
Salemme, Lucia Autorino, 1602, 1669
Sambugnac, Alexander, 0689
Sample, Paul, 0043
San Diego, 0920
San Francisco, 0052, 1241a, 1245a, 1298, 1415, 1450, 1532, 1553
San Francisco Museum of Modern Art, 1553
San Francisco World's Fair. *See* Pan Pacific Exposition
Sand, Paul, 1404
Sanderson, Raymond Phillips, 1007, 1070
Sanger Isaac J., 0746
Santa Fe Museum, 0255
Santa Monica High School, 0463
Santa Monica Public Library, 0132, 0185
Sardeau, Helene, 0306
Sarisky, Michael A., 0127, 0147, 0166
Satemime, Lucia, 1602, 1669
Satire, 0011, 0013, 0113, 0387, 0511, 0663, 0712
Savage, Augusta Christine, 0575, 0858

Savage, Thomas Michael, 0078, 1520
Sawkill Painters and Sculptors, 0440
Sawyer, Charles Henry, 1445
Scaravaglione, Concetta Marie, 0181, 0223, 0287, 0296, 0986, 1421, 1427
Schanker, Louis, 0655, 0656, 1343
Schardt, Bernard P., 0438
Scheler, Armia A., 0689, 0872
Schellin, Robert, 1404
Scheuch, Harry William, 1544
Schleeter, Howard, 1684
Science, Art, and Literature, Department of. *See* Federal Art Bureau
Schlag, Felix, 0443
Schmitz, Carl Ludwig, 0181
Schoolcraft, Freeman, 1491
Schwartz, Arthur E., 1659
Schwartz, Lester O., 0283
Schwartz, William Samuel, 0155, 0591, 0605, 0677
Schwarz, Frank Henry, 0867
Schweig, Martyl, 1182
Scott, William Edward, 1182
Scrivens, Emily, 1436
Scudder, Hubert B., 1272
Sculpture, 0152, 0192, 0208, 0222, 0225, 0235, 0272, 0314, 0345, 0360, 0365, 0421, 0434, 0457, 0463, 0480, 0483, 0525, 0526, 0532, 0541, 0550, 0590, 0597, 0603, 0622, 0624, 0638, 0658, 0662, 0665, 0725, 0726, 0736, 0748, 0758, 0777, 0825, 0864, 0887, 0892, 0910, 0922, 0926, 0944, 0956, 0969, 1007, 1036, 1056, 1075, 1078, 1092, 1122, 1167, 1202, 1203, 1240, 1257, 1314, 1324, 1330, 1332, 1336, 1356, 1367, 1378, 1468, 1535, 1659, 1677
Sea, Cesare, 0822, 0950
Seabrook, Georgette, 1437
Section of Painting and Sculpture (later, Section of Fine Arts), 0139, 0147, 0183, 0198, 0200, 0211, 0330, 0345, 0383, 0409, 0516, 0644, 0734, 0735, 0793, 0956, 1001, 1012, 1028, 1040, 1048, 1056, 1059, 1072, 1122, 1134, 1150, 1151, 1167, 1202, 1203, 1274a, 1295, 1321, 1324, 1327a, 1334, 1345, 1357, 1374b, 1377, 1534, 1555, 1564, 1569, 1571, 1583, 1595, 1608, 1648, 1643a, 1652b, 1655, 1659, 1672, 1681; Accomplishments, 0281, 0603, 0665, 0777, 0821, 0842, 0880, 0883, 0926, 0944, 0948, 0953, 0984, 1138, 1204; Competitions, 0147, 0152, 0153, 0154, 0155, 0166, 0168,

0174, 0175, 0181, 0188, 0191, 0195, 0222, 0224, 0248, 0261, 0266, 0271, 0277, 0280, 0396, 0399, 0407, 0408, 0443, 0590, 0597, 0602, 0636, 0543, 0662, 0667, 0668, 0689, 0699, 0706, 0711, 0712, 0725, 0729, 0732, 0736, 0798, 0829, 0842, 0863, 0865, 0868, 0870, 0871, 0872, 0956, 0964, 0971, 0972, 0976, 1006, 1007, 1018, 1020, 1023, 1024, 1025, 1031, 1039, 1066, 1075, 1077, 1081, 1084, 1087, 1092, 1098, 1104, 1105, 1106, 1107, 1112, 1113, 1115, 1117, 1129, 1130, 1136, 1141, 1142, 1173, 1182; Controversy, 0163, 0499, 0500, 0508, 1274a, 1453, 1651; Creation, 0117, 0120, 0123, 0908 1374b; Criticism, 0157, 0158, 0168, 1069, 0416, 0959, 1197, 1239; Forty-Eight State Competition, 0842, 0850, 0855, 0872, 0877, 0879, 0888, 0905, 0968, 1040; Maritime Commission Competition, 0956, 0971, 0972, 0976, 0994, 1002, 1007, 1070. *See also* New Deal Art; Praise, 0151, 0316, 0733, 0735, 0815, 0951, 0973, 1101, 1140, 1185

Section of Painting and Sculpture (Exhibitions), 0188, 0196, 0255, 0261, 0272, 0279, 0296, 0299, 0300, 0305, 0306, 0308, 0339, 0342, 0387, 0393, 0483, 0517, 0872, 0879, 0880, 0881, 0905, 0958, 0960, 0961, 1040, 1041, 1043, 1102, 1136, 1139, 1342, 1144, 1163, 1166, 1182, 1474, 1477

Seelbinder, Maxine, 1007, 1182

Shahn, Ben, 0138, 0167, 0169, 0648, 0956, 1031, 1273, 1283, 1310, 1326, 1408, 1428, 1431, 1435, 1446, 1482, 1615a, 1617, 1677

Shahn, Bernada Bryson. *See* Bryson, Bernarda

Shaw, Elsa Vick, 1007, 1070

Shead, Robert, 1556

Sheets, Millard Owen, 0093, 0114, 1329, 1536

Shelley, John F., 1272

Sheridan, Joseph, 0705

Shimin, Symeon, 0222, 0764, 0883, 1313, 1357

Shore, Henrietta Mary, 0261, 0808

Siqueiros, David Alfara, 1650

Silvette, David, 0153, 0194

Simkhovitch, Simkha, 0261, 1645a, 1652c

Simon, Louis A., 0155

Simpson, Marian, 0119, 0318, 0497

Sinclair, Gerrit V., 0689, 0798

Sioux City Art Center, 1642

Siporin, Mitchell, 0235, 0272, 0464, 0798, 0863, 0865, 0872, 0961, 1153, 1155, 1157, 1166, 1491, 1596b, 1611a, 1630, 1652c

Sirovich, William I., 0212, 0213, 0482, 0641, 0657, 0782, 0785, 0937

Skelton, Katherine, 0920
Sisti, Anthony, 1652c
Slemp, Basom, 0943
Slivka, David, 1298
Slobodkin, Louis, 0277, 0662
Smith, George Melville, 1596b
Smith, Judson De Jonge, 0713, 1596b
Smithsonian Institution, 0719, 0720, 0745, 1471
Smolin Gallery (NYC), 1287, 1288, 1292
Snedeker, Virginia, 1089
Snyder, Jerome, 1104
Social Realism, 0237, 1379, 1408, 1413, 1654b, 1656
Social Security Building, 1020, 1031, 1104, 1151, 1180, 1617
SoHo, 1431
Solman, Joseph, 1546, 1602
Somervell, Brehon Burke, 0878, 1009, 1014, 1015, 1017, 1032,
 1037, 1417
Sorby, J. Richard, 1090
Soules, Lyman, 0365
South Carolina, 1655
South Carolina State Museum, 1647, 1655
Southern Illinois University, 1362
Southern States Art League, 0634
Southern U.S., 0242, 0282, 1564
Southwest Museum (Los Angeles), 0377, 0465
Southwestern U.S., 1324
Soyer, Moses, 0223, 1320, 1326, 1616
Soyer, Raphael, 0438, 1408, 1427, 1542
Spekman, Russell, 0826
Spencer, Niles, 1345
Spiegel, Doris, 1542
Spivak, Max, 0464
Spohn, Clay, 1091
Spokane Art Center, 0763, 1378
Springfield Museum of Fine Arts (MA), 0427, 0970, 1044
Springweiler, Erwin Frederick, 0689, 1104
Staffel, Rudolph Henry, 0078
Stanley, George, 1653b
Steele, Mary, 0479
Stell, Thomas, 1312
Stendahl Galleries (CA), 0398, 0527
Stephens, Harold M., 0691
Sterne, Maurice, 0764, 0959, 1571
Sterner, Albert Edward, 1192

Stevens, Ernest S., 1487,1575
Stevenson, Dorothea, 1556
Stewart, Dorothy, 0238
Stieglitz, Alfred, 0326
Stiriss, Pauline, 1044
Stockwell, Gale, 0127
Stokes, Isaac Newton Phelps, 0671
Stone, Harlan J., 0691
Stone, Harold, 0446
Strong, Peggy, 0689
Strong, Ray, 1653b, 1663
Struppeck, Jules, 1556
Studio Museum in Harlem, 1447a
Supreme Court, 0691
Sussman, Richard, 0950
Swasey, David, 1007, 1070
Swift, Florence, 0475
Swiggett, Jean, 0956, 1007, 1070, 1671
Swinden, Albert, 1654a
Swineford, Derald, 1556
Syracuse Museum of Fine Arts, 0637
Szukalksi, Stanislaus, 0124

Taber, John, 1171
Tabor, Robert, 0093, 0166, 0227, 1520
Tamatzo, Chuzo, 0422
Tamayo, Ruffino, 0488
Taskey, Harold Le Roy, 0234
Taylor, Francis Henry, 0009, 0045
Taylor, Henry White, 0584, 0600
Taylor, Jeanne, 0807
Tenkacs, John, 1426
Tennessee, 1587, 1673
Terminal Annex (Los Angeles, CA), 1066
Terrell, Elizabeth, 1429
Texas, 0148, 0707, 0729, 0870, 1312, 1631a, 1645
Textiles, 1222
Thomas, Florence, 1438
Thompson, Lorin Hartwell, Jr., 0968
Thorp, Earl Norwell, 1007
Thorp, George B., 0936, 1104
Thorpe, George, 1658
Thrash, Dox, 1050, 1652d
Thwaites, Charles Winstanley, 1139

Timberline Lodge, 0369, 0558, 0559, 0589, 0967, 1064, 1173,
 1372, 1378, 1405, 1410, 1412, 1438, 1452, 1461, 1566, 1567,
 1605
Tobey, Alton S., 0968
Toledo, José Rey, 1556
Tolegian, Manuel J., 0986
Train, John, 1402
Travis, Olin, 1312
Treasury of American Design (Review), 1382a
Treasury Relief Art Project (TRAP), 0166, 0175, 0179, 0181,
 0194, 0200, 0221, 0235, 0487, 0516, 0779, 0933, 1295, 1301,
 1328, 1357, 1367, 1389, 1636a, 1657b, 1662
Triest, Shirley, 1298
True, Bob, 0269
Tschashasov, 0974
Tsihnahjinnie, Andy, 0127
Tugwell, Rexford G., 0009
Turnbull, James Baare, 1616a
Turner, Ila McAfee, 1556
Turzak, Charles, 0261
Tweed Gallery (NYC), 1643aa
Tweed Museum of Art (University of Minnesota), 1422a
Tworkov, Jack, 1297
Tydings, Millard E., 0942, 0943
Tyrone, 0093

Ulreich, Eduard Buk, 1429
Umlauf, Charles, 1491
Unionism, 0170, 1367
United American Artists, 0587
University of Arizona Art Gallery, 1488
University of Colorado, 0183
University of Illinois (Urbana-Champaign), 1491, 1516
University of Kentucky, 1581
University of Maryland Art Gallery, 1313, 1314, 1316, 1474, 1526
University of Michigan Museum of Art, 1580
University of Washington, 1363
University of Wisconsin, 1341
Utah, 0741, 1600, 1603, 1629, 1652h
Utah Museum of Fine Arts, 1669

Van Arsdale, Arthur, 1556
Van Beek, William, 0638
Vander Sluis, George, 1371, 1436

Van Veen, Stuyvesant, 0153
Varian, Lester E., 0102
Vassar College Art Gallery, 1421, 1441
Velonis, Anthony, 0962, 0991, 1109, 1596
Vidar, Frede, 0313
Vincent, Andrew, 0689
Virgin Islands, 0424
Virginia, 0126
Von Groschwitz, Gustave, 1595
Von Meyer, Michael, 0296
Von Minckwitz, Katherine, 0527
Von Neumann, Robert, 1404
Von Pribosic, Viktor, 0334

W.P.A. (Restaurant, NYC), 1431
Walcott, Frederic C., 0089
Walker Art Gallery, 0807, 0952, 1047
Walker, Hudson D., 0323, 0384
Waltemath, William, 0384
Wannamaker's Department Store (Philadelphia), 0109
War Department Building, 1007, 1018, 1075, 1086, 1104
Ward, Lynd, 0836
Warneke, Heinz, 0181, 0296, 1357
Warsager, Hyman J., 0505, 0656, 0991
Washburn Gallery (NY), 1601, 1614
Washburn, Kenneth, 0235, 0277
Washington (DC). See District of Columbia
Washington (State), 1363, 1629
Washington County (MD) Museum of Fine Arts, 1647a
Washington Gallery of Modern Art, 1297, 1299
Watkins, Charles Law, 0190
Watrous, Harry Willson, 0046
Watson, Aldren A., 1007
Watson, Forbes, 0009, 0015, 0021, 0045, 0048, 0138, 0416, 0821, 1197, 1285, 1309
Watson, Sargent, 0119
Waugh, Sidney, 0181, 0191, 0247
Webb, Albert J., 0234, 0591
Weber, Max, 1273
Weidinger, Desire, 0326
Wein, Albert, 0638
Weinberg, Emily Sievert, 0119
Weisenborn, Fritzi, 0834, 1190
Weisenborn, Rudolph, 1190

Wells, Summer, 0973
Wesleyan University, 0833
Wessel, H.H., 0147, 0235
Wessels, Glenn Anthony, 0078, 0298
West, Richard, 1556
Westby Gallery (Glassboro State College), 1331
Weston, Edward, 1623
Weston, Harold, 0409
Weyhe Gallery (NYC), 0962
Wheeler, Stewart, 0882, 0966
White, Charles, 1491
White, Gilbert, 0082, 0085, 0600
Whitehall Ferry Terminal (NYC), 0875
Whitney Museum of American Art, 0061, 0068, 0261, 0277, 0279,
 0296, 0299, 0300, 0305, 0306, 0308, 0339, 0387, 0955, 0958,
 0960, 0961, 1028, 1043, 1117, 1164, 1511a, 1657
Whittmere, Margaret, 1457
Whyte Gallery (Washington, DC), 0871
Wiley, Lucia, 0222
Williamsburg Housing Projects (NYC), 1400, 1601, 1654a
Willis, J.R., 0255
Wilson, Douthitt, 1312
Wilson, Helen, 1138
Wiltz, Arnold, 0294
Winser, Beatrice, 0043, 0055, 0110
Winter, Lumen, 0689
Winter, Vinal, 0138
Wisconsin, 1065, 1404, 1451, 1489, 1653, 1654, 1670
Woeltz, Julius, 0798, 0870
Wolins, Joseph, 1602
Women, 1672
Women Artists, 1421, 1637a, 1643, 1644a, 1657a, 1669
Wood, Grant, 0127, 1454
Woodrum, Clifton A., 0838, 0936, 0939, 0940, 1171
Woodside (NY) Public Library, 0431
Woodstock Colony (NY), 1347, 1441
Woodward, Ellen S., 0783, 0786, 1536a
Woolley, Virginia, 0642a
Work Progress Administration (WPA; after 1939, Work Projects
 Administration), 0243, 0364, 0365, 0366, 0367, 0405,
 0430, 0551, 0589, 0601, 0787, 0789, 0795, 0804, 0851, 0852,
 0945, 1126, 1169, 1170, 1208, 1236, 1240, 1301, 1308, 1334,
 1339, 1401

World's Fair, New York (1939–40), 0473, 0590, 0625, 0638, 0643, 0662, 0667, 0668, 0689, 0706, 0711, 0737, 0739, 0822, 0823, 0861, 0900, 0927, 0980, 0981, 0985, 0986, 0987, 0989, 0990, 1367, 1407, 1458

WPA/FAP (Exhibitions), 0203, 0228, 0238, 0246, 0249, 0251, 0259, 0262, 0263, 0270, 0272, 0275, 0276, 0278, 0284, 0285, 0286, 0287, 0292, 0294, 0296, 0297, 0301, 0313, 0317, 0332, 0333, 0334, 0335, 0337, 0338, 0340, 0341, 0377, 0382, 0387, 0389, 0390, 0398, 0400, 0402, 0404, 0410, 0415, 0422, 0423, 0427, 0429, 0437, 0441, 0444, 0449, 0476, 0481, 0485, 0488, 0502, 0503, 0518, 0520, 0521, 0522, 0523, 0524, 0526, 0527, 0529, 0530, 0531, 0532, 0533, 0534, 0565, 0577, 0605, 0619, 0622, 0624, 0651, 0654, 0655, 0670, 0672, 0677, 0679, 0683, 0684, 0685, 0686, 0692, 0695, 0698, 0702, 0708, 0710, 0719, 0720, 0724, 0745, 0746, 0747, 0748, 0749, 0750, 0751, 0754, 0755, 0756, 0757, 0758, 0759, 0760, 0761, 0762, 0802, 0812, 0820, 0823, 0824, 0833, 0834, 0835, 0843, 0875, 0890, 0891, 0892, 0893, 0894, 0896, 0897, 0898, 0899, 0900, 0901, 0902, 0903, 0904, 0915, 0963, 0965, 0975, 0979, 0980, 0981, 0982, 0983, 0985, 0986, 0989, 0990, 1027, 1042, 1045, 1046, 1087, 1090, 1103, 1111, 1114, 1164, 1195, 1216, 1219, 1232, 1287, 1288, 1292, 1294, 1297, 1299, 1313, 1314, 1316, 1320, 1329, 1330, 1331, 1362, 1388, 1422a, 1445, 1448, 1447a, 1460, 1492, 1512, 1540, 1548, 1553, 1577, 1580, 1581, 1602, 1619, 1633, 1647, 1647a, 1654b, 1668, 1686. *See also* New Deal Art (Exhibitions); Index of American Design (Exhibitions)

WPA/FAP (General), 0206, 0233, 0250, 0312, 0322, 0331, 0346, 0365, 0367, 0379, 0391, 0403, 0446, 0451, 0466, 0488, 0516, 0536, 0543, 0563, 0595, 0688, 0713, 0790, 0794, 0817, 0831, 0840, 0857, 0862, 0928, 1009, 1016, 1037, 1049, 1056, 1060, 1122, 1167, 1168, 1175, 1199, 1202, 1203, 1210, 1212, 1218, 1224, 1229, 1281, 1308, 1313, 1314, 1323, 1327a, 1332, 1334, 1335, 1339, 1342, 1359, 1367, 1374, 1377, 1378, 1555, 1560, 1561, 1565, 1572, 1575, 1586, 1595, 1611, 1613, 1646, 1653a, 1655, 1658; Accomplishments, 0199, 0204, 0205, 0206, 0258, 0307, 0354, 0356, 0368, 0370, 0448, 0462, 0465, 0538, 0541, 0542, 0601, 0620, 0726, 0767, 0770, 0771, 0772, 0777, 0778, 0789, 0795, 0804, 0815, 0860, 0866, 0873, 0878, 0882, 0886, 0912, 0913, 0914, 0926, 0938, 0940, 0945, 0954, 0984, 1029, 1061, 1074, 1079, 1109, 1119, 1132, 1133, 1183, 1184, 1245; Controversy, 0265, 0267, 0325, 0328, 0387, 0470, 0478, 0508, 0790, 0812, 0969, 0993, 1187, 1190, 1191, 1192, 1209, 1212, 1213, 1214, 1215, 1417, 1418, 1437, 1456, 1470;

Creation, 0180, 0187, 0190, 0193, 0218, 0219, 0535; Criticism, 0224, 0252, 0267, 0292, 0297, 0298, 0304, 0319, 0326, 0380, 0416, 0458, 0468, 0628, 0673, 0680, 0690, 0709, 0776, 0853, 0856, 0936, 1014, 1088, 1096, 1217, 1233, 1245; Praise, 0223, 0229, 0237, 0243, 0251, 0263, 0274, 0282, 0303, 0311, 0322, 0329, 0376, 0387, 0415, 0428, 0433, 0434, 0435, 0442, 0444, 0447, 0466, 0469, 0472, 0491, 0492, 0493, 0511, 0540, 0551, 0562, 0598, 0611, 0620, 0800, 0811, 0815, 0830, 0844, 0848, 0852, 0854, 0930, 0949, 0987, 0997, 1003, 1014, 1026, 1030, 1033, 1160; Regulations, 0219, 0220, 0221, 0320, 0366, 0796, 0869, 1008, 1032. *See also* Index of American Design; New Deal Art
Wright, Mabel Truthen, 0564
Wright, Sidney V., 0700
Wrightson, Phyllis, 0911
Wulf, Lloyd, 0775
Wyeth, N.C., 0644
Wyoming, 0269, 0494, 1349, 1368, 1371, 1487, 1578

Yasko, Karel, 1544
Yavno, Max, 1623
YM-YWHA of Essex County, New Jersey, 1320
Yountz, Philip N., 0433

Zaga, Michael, 1210
Zakheim, Bernard Baruch, 0469, 0911, 1618a
Zerbe, Karl, 0287, 0441
Zilzer, Gyula, 0527
Zimmerman, Harry, 0277, 0399
Zoellner, Richard Charles, 0147, 0175, 0426, 0798
Zorach, William, 0060, 0299, 0434, 1078
Zornes, Milford, 1618a, 1636a, 1657b

ABOUT THE AUTHOR

MARTIN R. KALFATOVIC (BA, MSLS, The Catholic University of America) is the Information Access Coordinator for the Smithsonian Institution Libraries and formerly a librarian at the National Museum of American Art/National Portrait Gallery. He is the author of *Nile Notes of a Howadji: A Bibliography of Traveler's Tales from Egypt, from the Earliest Times to 1918* (Scarecrow Press, 1992) and co-author of the forthcoming *Travels to India, Antiquity through 1761* (Scarecrow Press).